BY DAVID LYNCH

ROOM TO DREAM
CATCHING THE BIG FISH

BY KRISTINE MCKENNA

ROOM TO DREAM
TALK TO HER
BOOK OF CHANGES
THE FERUS GALLERY: A PLACE TO BEGIN

ROOM
to
DReaM

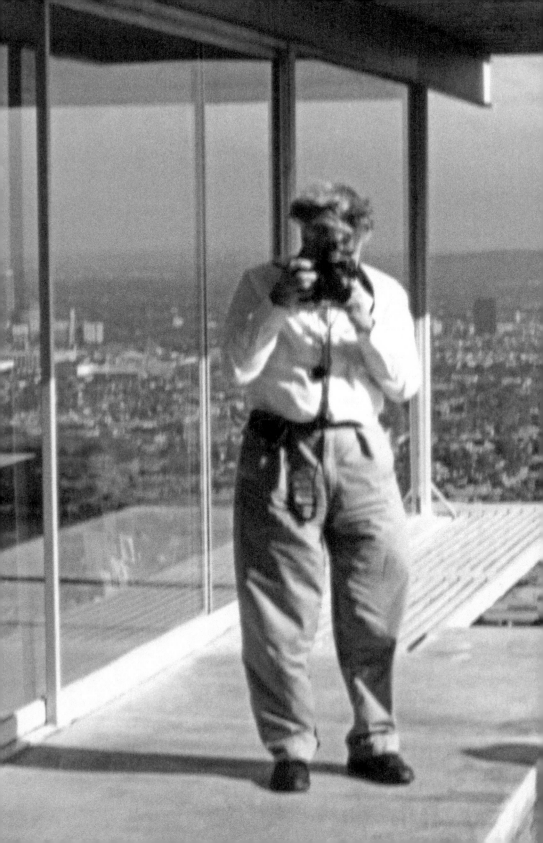

david *lynch* and *kristine mckenna*

RooM
to
DReaM

Random House New York

Published in the United States by Random House, an imprint
and division of Penguin Random House LLC, New York.

Photo credits appear on pages 549–54.

RANDOM HOUSE and the HOUSE colophon are registered
trademarks of Penguin Random House LLC.

LIBRARY OF CONGRESS CATALOGING-IN-PUBLICATION DATA
Names: Lynch, David author. | McKenna, Kristine author.
Title: Room to dream / David Lynch, Kristine McKenna.
Description: New York : Random House, 2018. | Includes bibliographical
references.
Identifiers: LCCN 2017058580 | ISBN 9780399589195 (hardback) | ISBN
9780399589201 (ebook)
Subjects: LCSH: Lynch, David, 1946– | Motion picture producers and
directors—United States—Biography. | BISAC: BIOGRAPHY &
AUTOBIOGRAPHY / Entertainment & Performing Arts. | BIOGRAPHY &
AUTOBIOGRAPHY / Personal Memoirs. | ART / Film & Video.
Classification: LCC PN1998.3.L96 A3 2018 | DDC 791.4302/33092
[B]—dc23
LC record available at https://lccn.loc.gov/2017058580

Printed in the United States of America on acid-free paper

randomhousebooks.com

9 8 7 6 5 4 3 2 1

FIRST EDITION

Book design by Simon M. Sullivan
Hand lettering by David Lynch

Dedicated to His Holiness Maharishi Mahesh Yogi
and
the world family

CONTENTS

When we decided to write *Room to Dream* together a few years back there were two things we wanted to achieve. The first was to get as close as we could to producing a definitive biography; that means all the facts, figures, and dates are correct, and all the pertinent participants are present and accounted for. Second, we wanted the voice of the subject to play a prominent role in the narrative.

Toward that end we devised a way of working that some might find strange; our hope, however, is that the reader is able to discern a kind of rhythm in it. First, one of us (Kristine) would write a chapter employing the customary tools of biography, including research and interviews with more than one hundred people—family members, friends, ex-wives, collaborators, actors, and producers. Then, the other (David) would review that chapter, correct any errors or inaccuracies, and produce his own chapter in response using the memories of others to unearth his own. What you're reading here is basically a person having a conversation with his own biography.

No ground rules were laid down and nothing was declared off-limits when we embarked on the book. The many people who graciously agreed to be interviewed were free to tell their version of events as they saw fit. The book is not intended to be an exegesis on the films and artworks that are part of this story; material of that sort is abundantly available elsewhere. This book is a chronicle of things that happened, not an explanation of what those things mean.

As we approached the completion of our collaboration we were both left with the same thought: The book seems short and barely scratches the surface of the story at hand. Human consciousness is too vast to fit between the covers of a book, and every experience has too many facets to count. We aimed to be definitive, but it's still merely a glimpse.

—*DAVID LYNCH & KRISTINE MCKENNA*

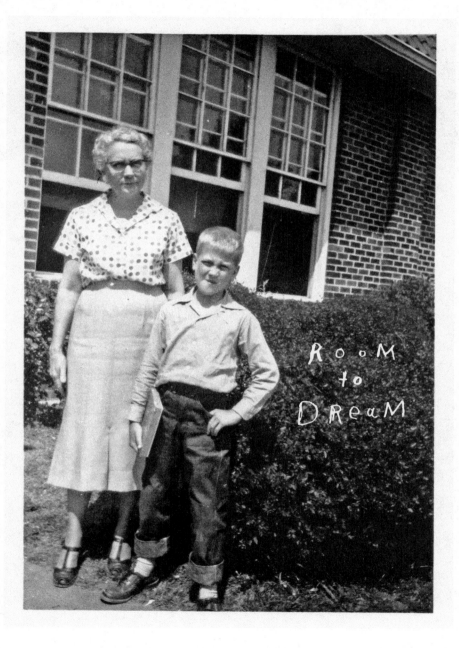

ROOM
to
DREAM

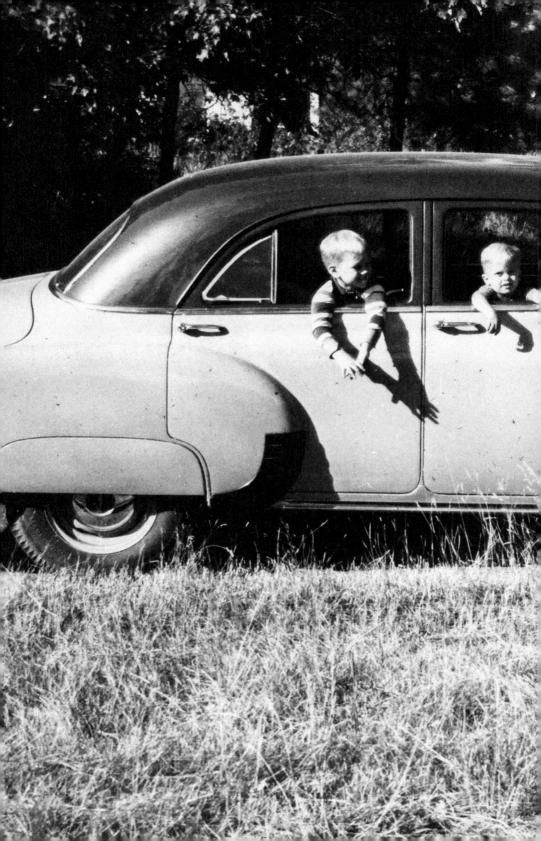

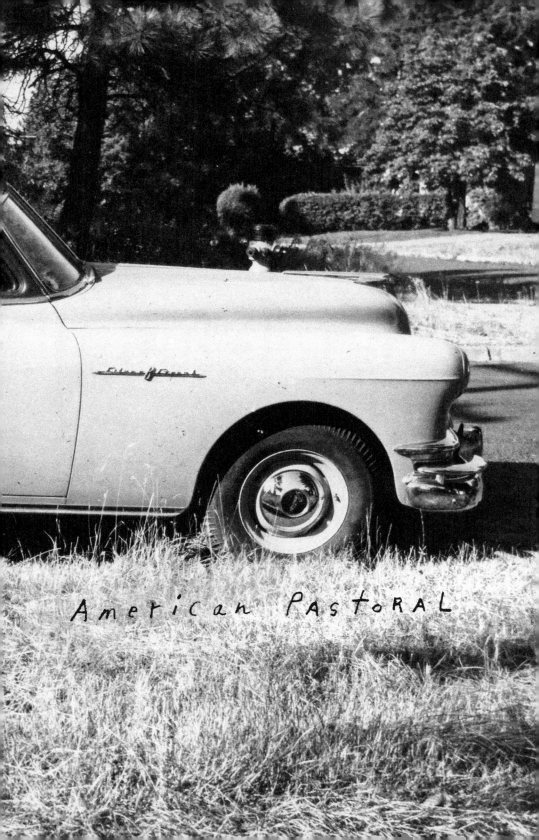

American Pastoral

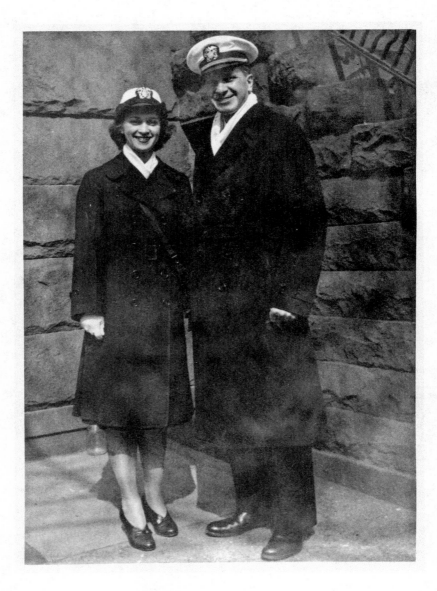

D avid Lynch's mother was a city person and his father was from the country. That's a good place to begin this story, because this is a story of dualities. "It's all in such a tender state, all this flesh, and it's an imperfect world," Lynch has observed, and that understanding is central to everything he's made.[1] We live in a realm of opposites, a place where good and evil, spirit and matter, faith and reason, innocent love and carnal lust, exist side by side in an uneasy truce; Lynch's work resides in the complicated zone where the beautiful and the damned collide.

Lynch's mother, Edwina Sundholm, was the descendant of Finnish immigrants and grew up in Brooklyn. She was bred on the smoke and soot of cities, the smell of oil and gasoline, artifice and the eradication of nature; these things are an integral part of Lynch and his worldview. His paternal great-grandfather homesteaded land in the wheat country near Colfax, Washington, where his son, Austin Lynch, was born in 1884. Lumber mills and soaring trees, the scent of freshly mowed lawns, starry nighttime skies that only exist far from the cities—these things are part of Lynch, too.

David Lynch's grandfather became a homesteading wheat farmer like his father, and after meeting at a funeral, Austin and Maude Sullivan, a girl from St. Maries, Idaho, were married. "Maude was educated and raised our father to be really motivated," said Lynch's sister, Martha Levacy, of her grandmother, who was the teacher in the one-room schoolhouse on the land she and her husband owned near Highwood, Montana.[2]

Austin and Maude Lynch had three children: David Lynch's father, Donald, was the second, and he was born on December 4th, 1915, in a house without running water or electricity. "He lived in a desolate place and he loved trees because there were no trees on the prairie," said David's brother, John. "He

was determined not to be a farmer and live on the prairie, so he went into forestry."[3]

Donald Lynch was doing graduate work in entomology at Duke University, in Durham, North Carolina, when he met Edwina Sundholm in 1939. She was there doing undergraduate work with a double major in German and English, and they crossed paths during a walk in the woods; she was impressed by his courtesy when he held back a low-hanging branch to allow her to pass. Both of them served in the navy during World War II, then on January 16th, 1945, they married in a navy chapel on Mare Island, California, twenty-three miles northeast of San Francisco. A short time later, Donald landed a job as a research scientist for the U.S. Department of Agriculture in Missoula, Montana. It was there that he and his wife began building a family.

David Keith Lynch was their first child. Born in Missoula on January 20th, 1946, he was two months old when the family moved to Sandpoint, Idaho, where they spent two years while Donald worked for the Department of Agriculture there. They were living in Sandpoint in 1948 when David's younger brother, John, was born, but he, too, came into the world in Missoula: Edwina Lynch—known as Sunny—returned to Missoula to deliver her second child. Later that year the family moved to Spokane, Washington, where Martha was born in 1949. The family spent 1954 in Durham while Donald completed his studies at Duke, returned to Spokane briefly, then settled in Boise, Idaho, in 1955, where they remained until 1960. It was there that David Lynch spent the most significant years of his childhood.

The period following World War II was the perfect time to be a child in the United States. The Korean War ended in 1953, blandly reassuring two-term President Dwight Eisenhower was in the White House from 1953 through 1961, the natural world was still flourishing, and it seemed as if there just wasn't a lot to worry about. Although Boise is Idaho's state capital, it had the character of a small town at the time, and middle-class children there grew up with a degree of freedom that's unimaginable today. Playdates had yet to be invented, and kids simply roamed their neighborhood streets with their friends, figuring things out for themselves; this was the childhood Lynch experienced.

"Childhood was really magical for us, especially in the summertime, and my best memories of David took place in the summer," recalled Mark Smith,

who was one of Lynch's closest friends in Boise. "My back door and David's back door were maybe thirty feet apart, and our parents would give us breakfast, then we'd run out the door and play the whole day long. There were vacant lots in our neighborhood and we'd take our dads' shovels and build big subterranean forts and just kind of lay in there. We were at the age when boys really get into playing army."[4]

Lynch's mother and father each had two siblings, all but one of whom married and had children, so theirs was a big family with lots of aunts, uncles, and cousins, and everybody occasionally gathered at the home of Lynch's maternal grandparents in Brooklyn. "Aunt Lily and Uncle Ed were warm, welcoming people, and their house on Fourteenth Street was like a haven—Lily had a huge table that took up most of the kitchen and everyone would get together there," recalled Lynch's cousin Elena Zegarelli. "When Edwina and Don and their children came it was a big deal, and Lily would make a big dinner and everyone would come."[5]

By all accounts, Lynch's parents were exceptional people. "Our parents let us do things that were kind of crazy and you wouldn't do today," said John Lynch. "They were very open and never tried to force us to go one way or another." David Lynch's first wife, Peggy Reavey, said, "Something David told me about his parents that was extraordinary was that if any of their kids had an idea for something they wanted to make or learn about, it was taken absolutely seriously. They had a workshop where they did all kinds of things, and the question immediately became: How do we make this work? It moved from being something in your head to something out in the world real fast, and that was a powerful thing.

"David's parents supported their kids in being who they were," Reavey continued, "but David's father had definite standards of behavior. You didn't treat people crappy, and when you did something you did it well—he was strict about that. David has impeccable standards when it comes to craft, and I'm sure his father had something to do with that."[6]

Lynch's childhood friend Gordon Templeton remembered Lynch's mother as "a great homemaker. She made clothes for her kids and was quite a seamstress."[7] Lynch's parents were romantic with each other, too—"they'd hold hands and kiss each other goodbye," said Martha Levacy—and in signing correspondence Lynch's mother sometimes wrote "Sunny," and drew a sun next to her name, and "Don," with a drawing of a tree next to his. They were devout

Presbyterians. "That was an important part of our upbringing," said John Lynch, "and we went to Sunday school. The Smiths next door were a real contrast to our family. On Sundays the Smiths would get in their Thunderbird convertible and head up to ski, and Mr. Smith would be smoking a cigarette. Our family got in the Pontiac and went to church. David thought the Smiths were cool and that our family was stodgy."

David's daughter Jennifer Lynch remembers her grandmother as "prim and proper and very active in her church. Sunny had a great sense of humor, too, and she loved her children. I never got the sense that David was favored, but he was definitely the one she worried about the most. My father deeply loved both of his parents, but he also despised all that goodness, the white picket fence and all that. He has a romantic idea of that stuff, but he also hated it because he wanted to smoke cigarettes and live the art life, and they went to church and everything was perfect and quiet and good. It made him a little nutty."[8]

The Lynches lived on a cul-de-sac with several boys of approximately the same age within a few houses of one another, and they all became friends. "There were around eight of us," said Templeton. "There was Willard 'Winks' Burns, Gary Gans, Riley 'Riles' Cutler, myself, Mark and Randy Smith, and David and John Lynch, and we were like brothers. We were all into *Mad* magazine, we rode bikes a lot, hung out at the swimming pool in the summer, and went to our gal friends' houses and listened to music. We had a lot of freedom— we'd be out riding our bikes until ten at night, take the bus downtown by ourselves, and we all looked out for each other. And everybody liked David. He was friendly, gregarious, unpretentious, loyal, and helpful."

Lynch seems to have been a savvy kid who hungered for a kind of sophistication that was hard to come by in Boise in the 1950s, and he's spoken of "longing for something out of the ordinary to happen" when he was a child. Television was bringing alternate realities into American homes for the first time and beginning to chip away at the unique regional character of towns and cities throughout the country. One imagines that an intuitive child like Lynch might've sensed the profound change that was beginning to transform the country. At the same time, he was very much of his time and place and was a committed member of the Boy Scouts; as an adult he's occasionally touted his status as an Eagle Scout, the highest rank a Scout can achieve.

"We were in Troop 99 together," said Mark Smith. "We had all these

activities—swimming, knot tying—and one of them was a one-night survival camp where some guy taught us what you could eat in the forest to survive, how to catch a squirrel and cook it, and so forth. We had a few sessions learning this stuff, then we went into the mountains to survive. Before we left we bought all the candy we could, and after the first hour we'd eaten it all. So we get to this lake and we're told to catch a fish—which none of us could do—and by nightfall we thought we were going to die of starvation. Then we noticed a plane circling overhead, and out came a box on a parachute. It was really dramatic. The box was full of things like powdered eggs and we all survived."

Lynch was one of those children with a natural ability to draw, and his artistic talent became evident at an early age. His mother refused to give him coloring books—she felt they constricted the imagination—and his father brought loads of graph paper home from work; Lynch had all the materials he needed and was encouraged to go where his mind took him when he sat down to draw. "It was right after the war and there was a lot of army surplus stuff around, and I'd draw guns and knives," Lynch has recalled. "I got into airplanes, bombers and fighter planes, Flying Tigers, and Browning automatic water-cooled submachine guns."[9]

Martha Levacy remembered, "Most kids wore plain T-shirts then, and David started making customized shirts for all the neighborhood kids with Magic Markers, and everybody in the neighborhood bought one. I remember Mr. Smith next door buying one for a friend who was turning forty. David made a kind of 'Life Begins at 40' drawing of a man staring at a nice-looking woman."

A gifted, charismatic child, Lynch was "definitely somebody people were attracted to," said Smith. "He was popular and I can easily see him running a movie set—he always had lots of energy and lots of friends because he could make people laugh. I have a memory of sitting on the curb in fifth grade and reading stuff in *Mad* magazine out loud to each other and just howling, and when I saw the first episode of *Twin Peaks* I recognized that same sense of humor." Lynch's sister concurred that "a lot of the humor from that period in our lives is in David's work."

Lynch was president of his seventh-grade class and played trumpet in the school band. Like most able-bodied citizens of Boise, he skied and swam—he was good at both, said his sister—and he played first base in Little League baseball. He also liked movies. "If he went to a movie I hadn't seen, he'd come

home and tell me about it in detail," said John Lynch. "I remember one he particularly loved called *The Man Who Shot Liberty Valance* that he went on and on about." The first movie Lynch recalls seeing was *Wait Till the Sun Shines, Nellie,* a downbeat drama directed by Henry King in 1952, which culminates with the lead character being gunned down in a barbershop. "I saw it at a drive-in with my parents, and I remember a scene where a guy is machine-gunned in a barber's chair and another scene of a little girl playing with a button," Lynch has recalled. "Suddenly her parents realize she's gotten it caught in her throat, and I remember feeling a real sense of horror."

In light of the work Lynch went on to produce, it's not surprising to learn that his childhood memories are a mixture of darkness and light. Perhaps his father's work dealing with diseased trees imbued him with a heightened awareness of what he has described as "the wild pain and decay" that lurk beneath the surface of things. Whatever the reason, Lynch was unusually sensitive to the entropy that instantly begins eating away at every new thing, and he found it unsettling. Family trips to visit his grandparents in New York made Lynch anxious, too, and he has recalled being highly disturbed by things he encountered there. "The things I'd be upset by were mild compared with the feelings they'd give me," he's said. "I think people feel fear even when they don't understand the reason for it. Sometimes you walk into a room and you can sense that something's wrong, and when I'd go to New York that feeling covered me like a blanket. Being out in nature there's a different kind of fear, but there's fear there, too. Some very bad things can happen in the country."

A painting Lynch made in 1988, titled *Boise, Idaho,* speaks to these sorts of memories. Positioned in the lower right quadrant of a black field is an outline of the shape of the state, surrounded by tiny collaged letters that spell out the title of the painting. Four jagged vertical lines disrupt the black field, and a menacing tornado shape in the left of the image plane seems to be advancing on the state. It's a disturbing image.

Apparently the more turbulent currents of Lynch's mind weren't evident to his Boise playmates. Smith said, "When that black car is winding up the hill in *Mulholland Drive* you just know something creepy is going to happen, and that's not the person David was as a kid. The darkness in his work surprises me and I don't know where it came from."

In 1960, when Lynch was fourteen years old, his father was transferred to Alexandria, Virginia, and the family moved again. Smith recalled that "when

David's family moved it was like somebody unscrewed the bulb in the street-light. David's family had a 1950 Pontiac and the Pontiac symbol was the head of an Indian, so there was an ornament of an Indian head on the hood of the car. The nose on their Indian was broken, so we called the car Chief Broken Nose, and they sold the car to my mom and dad before they moved." Gordon Templeton remembers the day the Lynches moved, too. "They left on the train and a bunch of us rode our bikes to the station to see them off. It was a sad day."

Though Lynch flourished as a high school student in Alexandria, the years he spent in Boise have always held a special place in his heart. "When I pic-ture Boise in my mind, I see euphoric 1950s chrome optimism," he's said. When the Lynch family left Boise, a few other neighbors moved, too, and John Lynch recalled David saying, "That's when the music stopped."

Lynch had begun edging out of childhood prior to leaving Boise. He's re-called the dismay he felt as a young boy when he learned he'd missed Elvis Presley's debut on *The Ed Sullivan Show,* and he'd become seriously inter-ested in girls by the time the family moved. "David started going steady with a really cute girl," said Smith. "They were so in love." Lynch's sister recalled that "David always had a girlfriend, starting when he was pretty young. When he was in junior high I remember him telling me he kissed every single girl on a hayride his seventh-grade class went on."

Lynch returned to Boise the summer after he completed ninth grade in Virginia and spent several weeks staying with different friends. "When he came back he was different," Smith remembered. "He'd matured and was dressing differently—he came back with a unique style and had black pants and a black shirt, which was unusual in our group. He was really self-confident, and when he told stories about experiences in Washington, D.C., we were im-pressed. He had a sophistication that made me think, My friend has gone somewhere beyond me.

"After high school David stopped coming back to Boise and we lost touch," Smith continued. "My youngest daughter is a photographer who lives in L.A., and one day in 2010 she was assisting a photographer who told her, 'We're shooting David Lynch today.' When they took a break during the shoot she approached him and said, 'Mr. Lynch, I think you might know my dad, Mark Smith, from Boise.' David said, 'You're shitting me,' and the next time I visited my daughter I got together with David at his house. I hadn't seen him since

high school and he gave me a big hug, and when he introduced me to people at his office, he said, 'I want you to meet Mark, my brother.' David's very loyal, and he stays in touch with my daughter—as her dad, I'm glad David's there. I wish he still lived next door to me."

The 1950s have never really gone away for Lynch. Moms in cotton shirtwaist dresses smiling as they pull freshly baked pies out of ovens; broad-chested dads in sport shirts cooking meat on a barbecue or heading off to work in suits; the ubiquitous cigarettes—everybody smoked in the 1950s; classic rock 'n' roll; diner waitresses wearing cute little caps; girls in bobby sox and saddle shoes, sweaters and pleated plaid skirts—these are all elements of Lynch's aesthetic vocabulary. The most significant aspect of the decade that stayed with him, however, is the mood of the time: The gleaming veneer of innocence and goodness, the dark forces pulsing beneath it, and the covert sexiness that pervaded those years are a kind of cornerstone of his art.

"The neighborhood where *Blue Velvet* was shot looks very much like our neighborhood in Boise, and half a block from our house was a creepy apartment building like the one in the movie," said John Lynch. *Blue Velvet*'s opening sequence of idyllic American vignettes was drawn from *Good Times on Our Street*, a children's book that permanently lodged itself in David's mind. "The joyride in *Blue Velvet* came from an experience in Boise, too. David and a few of his buddies once wound up in a car with an older kid who claimed he was going a hundred miles an hour down Capitol Boulevard. I think it was frightening, this crazy older kid with a hot car driving dangerously, and that memory stuck with David. He draws on his childhood a lot in his work."

Lynch does reference his childhood in his work, but his creative drive and the things he's produced can't be explained with a simple equation. You can dissect someone's childhood searching for clues that explain the person the child grew up to be, but more often than not there is no inciting incident, no Rosebud. We simply come in with some of who we are. Lynch came in with an unusually intense capacity for joy and a desire to be enchanted, and he was confident and creative from the start. He wasn't one of the boys buying a T-shirt with an irreverent drawing on it. He was the boy who was making them. "David was a born leader," said his brother, John.

I T'S NICE OF my brother to say I was a born leader, but I was just a regular kid. I had good friends, and I didn't think about whether or not I was popular and never felt like I was different.

You could say that my grandfather on my mother's side, Grandfather Sundholm, was a working-class guy. He had fantastic tools down in his basement woodshop and he had these exquisitely made wooden chests, all inset locking systems and stuff like that. Apparently the relatives on that side of the family were expert cabinetmakers and they built a lot of cabinets in stores on Fifth Avenue. I went to visit those grandparents on the train with my mom when I was a little baby. I remember it was winter and my grandfather would stroller me around, and apparently I talked a lot. I'd talk to the guy who ran the newsstand in Prospect Park, and I think I could whistle, too. I was a happy baby.

We moved to Sandpoint, Idaho, right after I was born, and the only thing I remember about Sandpoint is sitting in this mud puddle with little Dicky Smith. It was like a hole under a tree they filled with water from the hose, and I remember squeezing mud in that puddle and it was heaven. The most important part of my childhood took place in Boise, but I also loved Spokane, Washington, which is where we lived after Sandpoint. Spokane had the most incredible blue skies. There must've been an air force base nearby, because these giant planes would fly across the open sky, and they went real slow because they were propeller planes. I always loved making things, and the first things I made were wooden guns that I made in Spokane. I'd carve them and cut them with saws and they were pretty crude. I loved to draw, too.

I had a friend named Bobby in Spokane who lived in a house at the

end of the block, and there was an apartment building down there, too. So, it's winter, and I go down there in my little snowsuit, and let's say I was in nursery school. I'm in a little snowsuit and my friend Bobby is in a snowsuit and we're going around and it's freezing cold. This apartment building is set back from the street and we see that it has a corridor that goes down to these doors, and the door to one of the apartments is open. So we go in there and we're in an apartment and no one's home. Somehow we get this idea and we start making snowballs and putting them in the drawers of this desk. We put snowballs in all the bureau drawers—any drawers we could find, we'd make a hard snowball and put one in there. We made some big snowballs, about two feet across, and set them on the bed, and put some more snowballs in other rooms. Then we got the towels out of the bathroom and laid them in the street, like flags. Cars would come and they'd slow down, then the driver would say, "Screw it," and they'd drive right over these towels. We saw a couple of cars go over the towels, and we're in our snowsuits rolling more snowballs. We finish up and go home. I'm in the dining room when the phone rings, but I don't think anything of it. In those days the phone hardly ever rang, but still, I'm not panicked when the phone rings. My mother might've answered, but then my father took it, and the way he's talking, I'm starting to get a feeling. I think my dear dad had to pay quite a lot of money for damages. Why did we do it? Go figure . . .

After Spokane we moved to North Carolina for a year so my dad could finish school, and when I hear the song "Three Coins in the Fountain" I'm a certain height and I'm looking up at this building at Duke University and there was a fountain there. It was sunny 1954 light, and it was incredible with that song going in the background.

My grandparents Sundholm lived in a beautiful brownstone on 14th Street, and they had a building that my grandfather oversaw on Seventh Avenue. There might've been some storefronts in the building and it was a residential building, too. People lived there, but they weren't allowed to cook. I once went there with my grandfather and the door to one of the apartments was open and I saw a guy cooking an egg on a flat iron. People find ways of doing stuff. It's true that going to New York would upset me when I was growing up. Everything about New York made me fearful. The subways were just unreal. Going down into this place, and

the smell, and this wind would come with the trains, and the sound—I'd see different things in New York that made me very fearful.

My father's parents, Austin and Maude Lynch, lived on a wheat ranch in Highwood, Montana. My father's dad was like a cowboy and I loved to watch him smoke. I came in wanting to smoke, but he reinforced that desire. My dad smoked a pipe when I was real little, but then he got pneumonia and quit. All his pipes were still around, though, and I loved to pretend to be smoking them. They put Scotch tape around the mouthpieces because they figured they were dirty, so I had all these scotch-taped pipes, some curved, some straight, and I loved them. I started smoking when I was really young.

My grandparents had a ranch, and the closest big town was Fort Benton. At a certain point in the fifties they moved from the ranch to a small farm in Hamilton, Montana, where they had a farmhouse and quite a bit of land. It was real rural. They had a horse called Pinkeye I would ride, and I remember Pinkeye taking a drink out of a creek and it took everything I had not to slide right down that horse's neck and head into the creek. You could go out and shoot a gun in the backyard and not hit anything. I grew up loving trees, and I had a strong connection with nature when I was a kid. It was all I knew. When the family drove anywhere across the country, we'd pull over and my dad would set up a tent and we'd camp—we never stayed in motels. In those days there were campsites all along the roads, but those are gone now. On the ranch you had to fix stuff yourself, so there were tons of tools for everything, and my dad always had a woodshop. He was a craftsman and he rebuilt people's musical instruments and made ten or eleven violins.

Projects! The word "project" was so thrilling to everyone in my family. You get an idea for a project, and you get your tools together, and tools are some of the greatest things in the world! That people invent things to make things more precise—it's incredible. Like Peggy said, my parents took it seriously when I got ideas for things I wanted to make.

My parents were so loving and good. They'd had good parents, too, and everybody loved my parents. They were just fair. It's something you don't really think about, but when you hear other people's stories you realize how lucky you were. And my dad was a character. I always said if you cut his leash he'd go right into the woods. One time my dad and I

went deer hunting. Hunting was part of the world my dad grew up in and everybody had guns and hunted some, so he was a hunter, but not an avid hunter. And if he killed a deer we'd eat it. You'd rent a freezer and every once in a while you'd go down to the freezer in the basement and get a piece of meat, and for dinner we'd have venison, which I hated. I never shot a deer, and I'm glad I didn't.

Anyway, I was around ten at the time and we were going deer hunting, so we drive out of Boise and we're on a two-lane highway. The only light is from the headlights of the car and it's pitch-black. It's hard for people today to imagine this, because there are no roads that are pitch-black, hardly ever. So this is pitch-black; we're going on these winding roads up into the mountains, and a porcupine races across the road. My dad hates porcupines because they eat the tops of trees and the trees die, so he tries to run over the thing but it makes it across the road. So he screeches to the side of the road and slams on the brakes, pops open the glove compartment, takes out this .32 pistol, and says, "Come on, Dave!" We run across the highway and we're following the porcupine up this rocky mountain, and we're sliding down while we're trying to go up this hill, and at the top of this little mountain are three trees. The porcupine goes up one of them, so we start throwing rocks to see which tree it's in. We figure out which one it's in, my dad starts climbing the tree, and he says, "Dave! Throw a rock and see if it moves. I don't see it!" So I throw a rock, and he yells, "No! Not at me!" So I throw some more rocks, and he hears it running, and — Bam! Bam! Bam! — it rolls down out of the tree. We get back in the car and go deer hunting and on the way back we stopped and found that porcupine and it had flies all over it. I got a couple of quills from it.

I went to the second grade in Durham, North Carolina, and my teacher's name was Mrs. Crabtree. My father had gone back to school in Durham to get his doctorate in forestry, so he studied every night at the kitchen table and I would study with him. I was the only kid in my class that got straight A's. My second-grade girlfriend, Alice Bauer, got a couple of B's, so she came in second. One night my dad and I are sitting there studying and I hear my mother and father talking about a mouse that's in the kitchen. On Sunday my mother takes my brother and sister to church with the idea that my dad is going to stay home and get rid of

this mouse. He had me kind of helping him move the stove, and this little mouse ran out of the kitchen and across the living room and leapt up inside a closet with clothes hanging. My dad took a baseball bat and beat these clothes until this little bloody mouse fell out.

Idaho City used to be the biggest city in the state of Idaho, but when we moved to Boise there were probably a hundred people living in Idaho City in the summer and fifty in the winter. That's where the research center was for the Boise Basin Experimental Forest, and my dad was in charge of the Experimental Forest. The word "experimental" is so beautiful. I just love it. They did tests on erosion, insects, and disease and tried to figure out how to get healthier trees. All the buildings were white with green trim, and in the yard there were posts with little wooden houses on top. They were kind of like birdhouses with doors, and when you opened them up you'd find all sorts of devices inside that were checking things like humidity and temperature. They were beautifully made and were painted white with green trim, just like all the buildings. Then you go into some office and there are billions of little drawers, and you open them up and there are insects in there on little pins. There were big greenhouses with seedlings going, and if you went into the forest a lot of the trees had little tags on them for some kind of experiment or something. They'd check them.

That's when I would shoot chipmunks. My dad would drive me into the woods in the Forest Service pickup, and I loved these pickups—they run so smooth, and they're Forest Service green. I'd get out with my .22 and my lunch and he'd pick me up at the end of the day. I was allowed to shoot as many chipmunks as I could, because the forest was overrun with them, but I couldn't shoot any birds. One time I was out there and a bird flew way up in the top of a tree and I raised my gun and pulled the trigger. I never thought I'd hit it but I must've hit it dead center, because the feathers just exploded and it came twirling down and plopped into a creek and swirled away.

We lived on Parke Circle Drive in Boise, and next door were the Smiths. There was Mr. and Mrs. Smith; the four boys, Mark, Randy, Denny, and Greg; and the grandmother, who was called Nana. Nana was always out doing gardening, and you knew when she was out gardening because you'd hear this little tinkle of ice against a glass. She'd be out

there with these gardening gloves on, with a mixed drink in one hand and a little spade in the other hand. She got the Pontiac that my family sold to the Smiths. She wasn't completely deaf, but she was deaf enough that when she started the car she'd almost floorboard the thing so she could hear that it was on. There'd be this gigantic roar in the garage and you'd know Nana was going somewhere. On Sundays people in Boise went to church, and the Smiths went to an Episcopalian church. They had a Ford station wagon they'd drive to church, and Mr. and Mrs. Smith would sit up front with a carton of cigarettes. Not just a couple of packs. A carton.

Kids then had a lot of freedom to run around. We went everywhere and we weren't inside in the day, ever. We were out doing stuff and it was fantastic. It's horrible that kids don't get to grow up that way anymore. How did we let that happen? We didn't have a TV until I was in the third grade, and I watched some TV as a child, but not very much. The only show I really watched was *Perry Mason*. Television did what the Internet is doing more of now: It homogenized everything.

That's something about the fifties that's so important and is never going to come back: There used to be differences in places. In Boise the girls and the guys dressed a certain way, and if you go to Virginia they dressed in a completely different way. If you go up to New York City they dress in a completely different way there, too, and they listen to different music. You go to Queens and the girls looked like—you'd never seen anything like it in your life! And in Brooklyn they're even different than in Queens! That Diane Arbus photograph of the couple with the baby, and the girl has a certain type of big beautiful hair? You would never see that in Boise or Virginia. And the music. If you catch the vibe of the music in a place, you just look at these girls and listen to what they're listening to, and you've got a whole picture. The world they live in is completely strange and unique and you want to know about that world and what they're into. Those kinds of differences are pretty much gone now. There are still minor differences, like there are the hipsters, but you'll find hipsters in other cities that are just like the hipsters in your town.

I had a girlfriend every year starting when I was really young, and all of them were great. In kindergarten I walked to school with a girl and

we'd carry our nap towels. That was the thing you did with girls in kindergarten. My friend Riley Cutler that my son Riley's named after—well, in the fourth grade I had a girlfriend named Carol Cluff, and in the fifth grade she became Riley's girlfriend and they're still married today. Judy Puttnam was my girlfriend in fifth and sixth grade, and then in junior high I had a new girlfriend every two weeks. You'd have a girlfriend for a while and then you move on to a different girlfriend. I have a picture of me kissing Jane Johnson at a party in a basement in Boise. Jane's father was a doctor, and she and I looked at medical books together.

I'll tell you about a kiss I really remember. My father's boss was named Mr. Packard, and one summer the Packard family came and stayed at the research station. There was a beautiful girl in the family named Sue, who was my age, and she brought her neighbor boy up and they were having sex. I was so far away from having sex, and it just completely boggled my mind that they were so cavalier when they were telling me about this. One day Sue and I ditched her boyfriend and got off on our own. On the ponderosa pine forest floor are interwoven pine needles maybe two feet thick, and this stuff is called duff. It's so soft it's incredible, and we would run through these trees and dive into it and go into a long kiss. It was so dreamy. That was a kiss that got deeper and deeper, and it was lighting some fire.

Mostly I remember summers because winter meant school, and we human beings block out school because it's horrible. I barely remember ever being in a schoolroom, and I don't remember any of my classes except my art class. Even though I had a very conservative art teacher I remember really loving it. I still liked being outside more, though.

We skied at this place called Bogus Basin, which was eighteen miles away, up these winding mountain roads, and it was real good snow, much better snow than Sun Valley. It was small, but when you're a kid it seemed real big. In the summer you could work off your season pass by doing a few days of work at Bogus Basin, clearing brush and doing stuff. We were up there working one summer when we found this dead, bloated cow by a stream. We had these pickaxes, so we thought we'd try to pop this cow. One side of a pickax is kind of a blade and the other end is a pointed

piece of steel, so we slammed the pointed end of one of these things into the cow, but as soon as it hit we realized we were in trouble. You'd bang the pickax into this cow and it would fly off of this thing—it could've killed somebody. The cow would fart when you hit it really hard, and it was a poisonous odor because it was decaying, but we could not pop this cow. I think we gave up. I don't know why we wanted to pop it. You know, kids . . . you want to do stuff.

This place had a T-bar rather than a chairlift to get to the top of the mountain, and in the summer you could find stuff in the area where people stood in line for the T-bar. People would drop things in the snow, then we'd find them after the snow melted. You'd find five-dollar bills, all kinds of change—it was so beautiful to find money. One time I was walking past the junior high on the way to the ski bus, and there were six inches of snow on the ground, and I look over and there's this fat little blue coin purse. I pick it up, it's sopping wet from the snow, and I open it and there's a roll of Canadian money, which works great in America. I spent quite a bit of that money that day skiing. They had Danishes at the lodge, and I might've bought some for my friends. I took the rest of the money home and my father made me run an ad in the paper in case somebody lost it, but nobody claimed it so I got to keep it.

My fourth-grade teacher was named Mrs. Fordyce, and we called her Mrs. Four-Eyes. I sat three or four seats from the front of the room, and there was this girl who sat behind me who'd wear this bracelet and just rub herself like crazy. It's like she couldn't stop herself. I sort of knew what she was doing, but I didn't really know. Kids learn about this stuff in little bits. My sixth-grade girlfriend, Judy Puttnam, had a friend named Tina Schwartz. One day at school the girls were all asked to go to a different room, then they came back. I'm very curious. What's the deal? That afternoon I go to Judy's house, then we walk down to Tina Schwartz's house, and Tina says, "I'll show you what they told us." She comes out with this Kotex and squats down and shows me how this thing was supposed to be worn, and that was really something to me.

People came of age much later in life during the fifties. In the sixth grade there was a story going around about a guy in our class who had to shave and was bigger than most kids. The story was that he went into the boys' room and did this thing with his penis and this white fluid came

out. I said, What? I can't believe what I'm hearing, but something tells me it's true. I equate that with transcending with meditation. You can't really believe that someone could become enlightened, but something inside tells you it could be true. It was the same thing. So I thought, I'm going to try this tonight. It took forever. Nothing was happening, right? And all of a sudden this feeling—I thought, Where is this feeling coming from? Whoa! The story was true and it was unbelievable. It was like discovering fire. It was just like meditation. You learn this technique and, lo and behold, things start changing and there it is. It's real.

I remember discovering rock 'n' roll when I was a kid, too. Rock 'n' roll makes you dream and gives you a feeling, and it was so powerful when I first heard it. Music has changed since the birth of rock 'n' roll, but the difference isn't anywhere near as great as it was when rock 'n' roll came in, because what had preceded it was so different. It's like it came out of nowhere. They were doing rhythm and blues but we weren't hearing it, and we weren't hearing jazz really, either, except Brubeck. In 1959 the Dave Brubeck Quartet released "Blue Rondo à la Turk" and I just went crazy. Mr. Smith had the album and I listened to it at the Smiths' house and fell in love with it.

Movies weren't a big part of Boise in the fifties. I remember seeing *Gone with the Wind* at an outdoor theater in Camp Lejeune, North Carolina, on a beautiful mowed lawn. Seeing *Gone with the Wind* on a giant screen, outside, on a summer evening—that was nice. I don't remember telling my brother about movies, and I don't remember when I first saw *The Wizard of Oz*, but it stuck with me, whenever it was. But I'm not alone. It stuck with a lot of people.

That fifties small-town thing, it's different, and to catch that mood is important. It's dreamy, that's what it is. The fifties mood isn't completely positive, though, and I always knew there was stuff going on. When I was out after dark and going around on my bike, some houses had lights on inside that were kind of warm, or I knew the people who lived in the house. Other houses, the lights were dim, and with some houses they were almost out and I didn't know the people who lived there. I'd get a feeling from these houses of stuff going on that wasn't happy. I didn't

dwell on it, but I knew there were things going on behind those doors and windows.

I was out one night with my brother and we were down at the end of the street. Everything is lit up at night now, but in the fifties in small towns like Boise, there were streetlights, but they were dimmer and it was much darker. It makes night kind of magical because things just go into black. So, we were down at the end of this street at night, and out of the darkness—it was so incredible—came this nude woman with white skin. Maybe it was something about the light and the way she came out of the darkness, but it seemed to me that her skin was the color of milk, and she had a bloodied mouth. She couldn't walk very well and she was in bad shape, and she was completely naked. I'd never seen that, and she was coming toward us but not really seeing us. My brother started to cry and she sat down on the curb. I wanted to help her but I was young and didn't know what to do. I might've asked, Are you okay? What's wrong? But she didn't say anything. She was scared and beat up, but even though she was traumatized, she was beautiful.

I didn't see my friends every time I left the house on Parke Circle Drive. One day I went out and it was kind of a cloudy day and it might've been early in the morning. The next house over from the Smiths' was the Yontz family's, and the Smith lawn sort of blended with the Yontz lawn, and between the two houses was a little space with bushes on one side and a fence on the other and a gate that opened to a dead-end street. Sitting on the ground on this side of the gate was this kid I'd never seen before, and he was crying. I went over to him and I said, "Are you okay," but he didn't answer me. So I moved closer to him and asked him what happened and he said, "My father died." He was crying so hard he could hardly get the words out and the way he said it just killed me. I sat down next to him for a little bit but I realized I couldn't help him. Death is far away and abstract when you're a child, so you don't worry about it so much, but I felt this thing with that kid that was just horrible.

Up on Vista Avenue were all kinds of little stores, like hobby shops and hardware stores, and we got stuff there to build bombs. We learned how to make pipe bombs, and we made three of them in Riley Cutler's basement,

and they were powerful. Riley blew up one of them on his own near this big irrigation canal and he said it was incredible. I threw the second one in front of Willard Burns's house. We all played baseball so we had good arms, and I threw this thing really high; it came down, it hit and bounced up, but it didn't go off. So I threw it again, and this time when it hit the ground it bounced up and blew like crazy. It turned this pipe into shrapnel and blew a board off of Gordy Templeton's fence next door. Gordy was on the throne while this was going on and he came out pulling his pants up, holding toilet paper. We said, Wait a minute, this could've killed somebody or blown our heads off, so we threw the last one in an empty swimming pool, where it could detonate and not hurt anybody.

It made a huge noise when it exploded in the pool, so Gordy and I go one way and everybody else went the other way. I went to Gordy's house, and his living room had a huge picture window looking out to the front. We're there on the couch and Mrs. Templeton made tuna fish sandwiches and chips, which is something I never encountered at home unless they were on top of a tuna fish casserole. Those were the only chips I ever had. And no sweets except maybe oatmeal cookies with raisins. Healthy stuff. Anyhow, we're having our sandwiches, and then gliding into view outside the picture window was a gold and black and white giant motorcycle and a giant cop. He put his helmet under his arm and walked to the door and rang the bell and he took us to the station. I was the seventh-grade president, and I had to write a paper for the police on the duties and obligations of leadership.

I got in trouble for other stuff. My sister, Martha, was in elementary school when I was in junior high, and she had to walk by the junior high to get to school. I told my dear little sister that when she walked by the junior high she should stick up her middle finger at people because that meant friendship. I don't know if she ever did it, but she asked my dad about it and he got really upset with me. Another time this kid stole a bunch of .22 bullets from his father and he gave me some of them. They have such great weight, .22 bullets; they're sort of like little jewels. I kept them for a while, then I started thinking I'd get in trouble for having them, so I wadded them up in newspaper, put them in a bag, and threw them in the trash. In the winter my mother would burn trash in the fireplace, so she put all this paper in the fire-

place and lit it and pretty soon bullets started flying all around the living room. I got in trouble for that.

One day we were having a badminton tournament in the back of the Smiths' house and we heard this giant explosion and ran to the street, and we saw smoke rising at the end of the block. We walked down and there was this guy named Jody Masters who was older than us. Jody Masters was building a rocket out of a pipe and it accidentally ignited and cut his foot off. His mother, who was pregnant, came out, and she saw her oldest son and he couldn't get up. He tried, but his foot was hanging by tendons in a pool of blood and billions of burned-out match heads. They sewed his foot back on and it was fine. There was a lot of bomb building and gasoline-powered things in Boise.

We left Boise and moved to Alexandria, Virginia, after I finished eighth grade, and I was upset when we moved from Boise. I can't express how upset I was, and it was the end of an era — my brother is right when he says that's when the music stopped. Then, the summer after ninth grade, my mother and sister and brother and I went back to Boise on the train.

My grandfather Lynch died that summer, and I was the last person to see him alive. He'd had his leg amputated and it never really healed because he had such bad hardening of the arteries, so he was staying in a regular neighborhood house with five or six other people, being taken care of by nurses. My mother and grandmother visited him every day, but one day they couldn't go, and they said, "David, would you go visit your grandfather today because we can't go?" and I said yes. Some of the day went by and it got late, then I remembered about visiting him, so I borrowed a bike from this kid in front of the South Junior High swimming pool and I rode out Shoshone Street. There he was in a wheelchair out in the front yard, getting some air. So I sat with him and we had a really great talk. I can't remember what we talked about — maybe I asked him some questions about the old days, and there were some stretches where nobody talked — but I always loved just sitting with him. Then he said, "Well, Dave, I better go back in now," and I said, "Okay, Granddad." I got on my bike, and as I was riding away I look back and I see nurses coming out to get him. I'm riding down the street and I get to a green wooden garage that blocks my view, so the last thing I see is some nurses coming toward him.

From there I went to Carol Robinson's house because her cousin, Jim Barratt, had built a bomb as big as a basketball and he was going to set it off. He set the bomb in the freshly mowed backyard and it smelled so beautiful. I haven't smelled that in a really long time and don't know of any mowed lawns around here in L.A. Anyhow, there was a porcelain washbowl about a foot and a half in diameter, and he set it on top of the bomb and lit the fuse and this thing went off like you cannot fuckin' believe. It blew this dish two hundred feet in the air, it blew dirt everywhere, and smoke was coming out of the lawn in a really beautiful way ten or fifteen feet out. It was an amazing thing that I saw.

Then some moments pass and I hear sirens and think maybe the police are on their way, so I hightail it to the pool and give the kid's bike back to him. As I'm walking home to my grandparents' apartment, I see my mother out in the front. She was headed to the car, but when she saw me she started waving wildly, so I go faster and I get to her and say, "What is it?" She says, "It's your grandfather." I drove her fast to a hospital in downtown Boise where my grandfather was, and I double-parked and my mother went in. She came out fifteen minutes later and I could immediately tell something was wrong, and when she got in the car she said, "Your grandfather died."

I'd been with him just fifteen minutes before it happened. When he said, "Dave, I better go back in now," I'm pretty sure, playing it back, that something was going wrong in him—I think he had internal bleeding—and he didn't want to say it in front of me. That night I sat with my grandmother and she wanted to hear all about my visit with him. Later I put two and two together and I realized those sirens weren't for the bomb; they were going to get my grandfather. I was very close to my grandparents, all four of them, and he was the first one I lost, and I loved him so much. It was a huge thing for me when my grandfather Lynch died.

I went back to Boise another time, in 1992, to find out what happened to a girl I knew there who committed suicide in the seventies. This story started a long time before that, though. When I left Boise for Alexandria after the eighth grade, my girlfriend was Jane Johnson, and during that first year in Alexandria—my worst year, ninth grade—I wrote to Jane and kind of kept that relationship going. When we went back to Boise the

following summer of 1961, Jane and I broke up within the first two weeks, but while we were there I started hanging out with this other girl, and after we went back to Alexandria she became the girl I was writing to. We wrote to each other for years, and in those days you wrote long letters.

The summer after I graduated from high school I went to visit my grandmother on a Greyhound bus. This bus had a big engine that made a lot of noise, and the driver was going seventy or eighty miles an hour on these two-lane highways, and the whole trip is basically sagebrush. I remember there was this guy on the bus who looked like a real cowboy. He had on a cowboy hat all stained with sweat, and his face was totally lined, like leather skin, and he had steel-blue eyes, and he just stared out the window the whole trip. An old-style cowboy. So we get to Boise and I go to my grandmother's place, where she's living with Mrs. Foudray, and they're old ladies but they doted on me. They thought I was so handsome. It was really great.

My grandmother let me use her car and I went to this hotel, up to the mezzanine level, which was kind of strange and dark, and there was a soda fountain there where this girl I'd been writing to worked. I asked her if she wanted to go to the drive-in that night, and after I had dinner with my grandmother and Mrs. Foudray, this girl and I went to the drive-in. In those days there were drive-ins everywhere. It was fantastic. So we start making out at the drive-in and she's telling me things about herself and I realize this is a really wild girl. She had strange boyfriends after that, probably because so-called regular guys like me were sort of afraid of her. I remember her saying to me, "Most people don't know what they want to do in life and you are so lucky that you know what you want to do." I think her life was already headed in a dark direction.

We continued writing to each other—in fact, I was still writing to her, and two other girls, when I married Peggy. I'd been writing to these three girls for years, and finally one day Peggy said, "David, you're married now; you gotta stop writing to these girls." Peggy wasn't the jealous type at all, but she said, "Look, you write a nice little letter and they'll understand," like I was a little kid. And I stopped writing to them.

Many years later, in 1991, I'm up shooting *Twin Peaks: Fire Walk with Me*, and during lunch I go into my trailer and meditate. One day after I finish meditating, I open up the trailer door and there's somebody on the

film saying, "There's a man named Dick Hamm here, and he says he knows you." I said, "Dick Hamm? Are you kidding?" I'd gone to elementary school with Dick Hamm and hadn't seen him in decades. I go over and there he is with his wife from New York City, and it was great to see him. I asked him if he'd run into this girl I'd gone to the drive-in with and he said, "No, she's dead. She jumped into the big canal and killed herself." I started wondering, What is the story here? What happened to her? So I went back to Boise after the film wrapped and looked into this thing. I went to the library and read articles about this girl, and I saw police reports about the day she died.

This girl had married an older guy who her brother and father hated, and she was also having an affair with this guy who was a prominent citizen in Boise. One Friday night this guy broke it off with her and she was devastated. She couldn't hide her sadness, so maybe her husband suspected something. The following Sunday morning a neighbor down the street was having a brunch, and she and her husband went there separately. The story goes that her husband left the brunch and went home, and a little while later she comes home and goes into the bedroom and gets this Western-style .22 pistol, then goes into the laundry room, points it into her chest, pulls the trigger, then staggers out of the house and dies on the front lawn. I wondered, If you were committing suicide, why would you stagger out on the lawn?

As far as the police looking into this, I think they got word from the guy she was having the affair with: This is a suicide; don't go anywhere near it, because it's going to come back to me; don't fuck around, guys. Put it under the rug. I went to the police department and tried to trick them by saying, "I'm looking for a story for a film; do you have any girls who committed suicide during this period?" It didn't work, because they were never going to bring up that story. I got permission to get a photograph of the crime/suicide scene, and I filled out these forms and turned them in, and they said, "We're sorry, but that year's stuff was thrown away." I knew this girl from the beginning, when she was young, and I can't explain why her life went the way it did.

But I do know that a lot of who we are is already set when we get here. They call it the wheel of birth and death, and I believe we've been around many, many times. There's a law of nature that says what you sow

is what you reap and you come into life with the certainty that some of your past is going to visit you in this life. Picture a baseball: You hit it and it goes out and it doesn't come back until it hits something and starts traveling back. There's so much empty space that it could be gone for a long time, but then it starts coming back and it's coming back to you, the person who set the baseball in motion.

I think fate plays a huge role in our lives, too, because there's no explaining why certain things happen. How come I won an independent-filmmaker grant and got to go to the Center for Advanced Film Studies at the American Film Institute? How come you meet certain people and fall in love with them and you don't meet all those other people? You come in with so much of who you are, and although parents and friends can influence you a little, you're basically who you are from the start. My children are all really different and they're their own people and they came into the world with their little personalities. You get to know them really well and you love them, but you don't have that much to do with the path they're going to travel in life. Some things are set. Childhood experiences can shape you, though, and my childhood years in Boise were hugely important to me.

It was an August night in 1960. It was our last night in Boise. There's a triangle of grass separating our driveway from the Smiths' driveway next door, and my dad, my brother, my sister, and I were out in that triangle saying goodbye to the Smith boys, Mark, Denny, Randy, and Greg. Suddenly Mr. Smith appears and I see him talking to my dad, then shaking his hand. I stared at this and started feeling the seriousness of the situation, the huge importance of this last night. In all the years living next to the Smiths I had never spoken one-on-one with Mr. Smith and now here he was walking toward me. He held out his hand and I took it. He might've said something like, "We're going to miss you, David," but I didn't really hear what he said—I just burst into tears. I realized how important the Smith family was to me, then how important all my Boise friends were, and I felt it building on a deeper and deeper level. It was beyond sad. And then I saw the darkness of the unknown I'd be heading into the next day. I looked up through tears at Mr. Smith as we finished shaking hands. I couldn't speak. It was definitely the end of a most beautiful golden era.

The Art Life

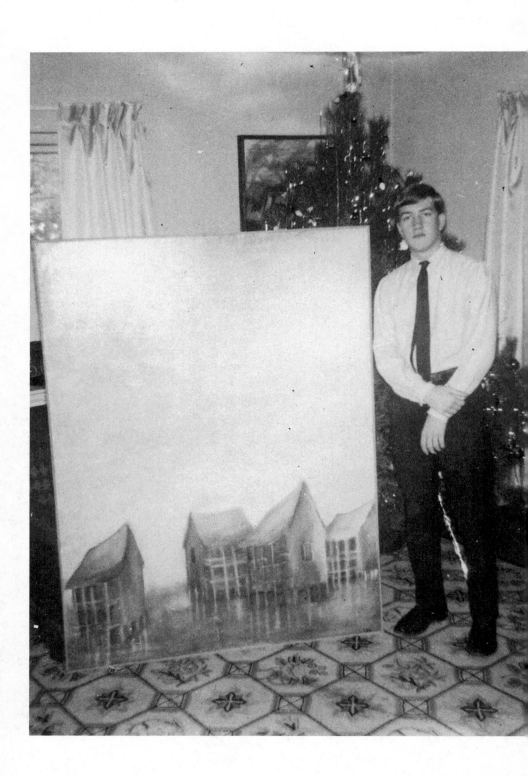

Alexandria, Virginia, was a very different world. A relatively sophisticated city seven miles south of downtown Washington, D.C., it's essentially a suburb of D.C. and is home to thousands of government workers. Alexandria had a population five times the size of Boise's during the early sixties, but Lynch was apparently unfazed by the bigger world he stepped into. "From everything I've heard, David was a star in high school and had that sense of being the golden boy," said Peggy Reavey. "From the start he had that."

Lynch's course in life clarified itself significantly when he befriended Toby Keeler shortly after beginning his freshman year. "I met David on the front lawn of his girlfriend's house, and my first impression was of her, not David," said Keeler, who proceeded to woo the girlfriend, Linda Styles, away from Lynch. "David lived in another part of town, but the driving age in Alexandria was fifteen, and he'd driven his family's Chevy Impala, with big wings on it, to her house. I liked David immediately. He's always been one of the most likable people on the planet, and we've joked for years about the fact that I stole his girlfriend. We were both in a fraternity at Hammond High School whose secret phrase was 'Trust from beginning to end,' but the David I knew wasn't a partying frat boy."[1]

Lynch and Keeler became close friends, but it was Toby's father, artist Bushnell Keeler, who really changed Lynch's life. "Bush had a big effect on David, because he had the courage to break away from the life he'd been living and get a studio and just start making art," said Toby. "David said a bomb went off in his head when he heard what Bushnell did. *'A fine-art painter? You can do that?'*"

Bushnell Keeler's younger sibling, David, remembered his brother as "a very up-and-down guy. Bush got a degree from Dartmouth College in business

administration and married someone from a wealthy Cleveland family. He was a junior executive and was doing well but he hated it, so he and his family moved to Alexandria so he could study to become a minister, but after two years he realized he didn't want to do that, either. He was a pretty angry young man, always challenging things, and he was taking a lot of upper and downer drugs, which didn't help. Finally he realized that what he really wanted to do was be an artist, and that's what he did. The marriage didn't survive that decision.

"Bush understood something nobody else did at the time, which was that David really and truly wanted to be an artist," David Keeler continued about his brother, who died in 2012. "Bush thought he was at a good point in life to get a boost with that, and I guess David wasn't getting it from his parents, so Bush was absolutely fully behind him. David often stayed at his house, and Bush made space in his studio for David to work."[2]

Lynch's commitment to art deepened further when he met Jack Fisk during his freshman year, and they laid the foundations for an enduring friendship that continues to this day. Now a widely respected production designer and director, Fisk—who went by the name Jhon Luton at the time—was a rangy, good-looking kid born in Canton, Illinois, the middle in a family of three children; his sister Susan was four years older, and his sister Mary was a year younger. Following the death of Fisk's father in a plane crash, his mother married Charles Luton, whose job overseeing the building of foundries required the family to make frequent moves. (Later in life Fisk reverted to his birth name, as did his sister Mary.) Fisk attended a Catholic military school as a boy, and at various points the family lived in Kalamazoo, Michigan; Richmond, Virginia; and Lahore, Pakistan. Finally, they settled in Alexandria when Fisk was fourteen years old.

"David and I had heard about each other because we were both interested in painting," said Fisk. "I remember him standing in a doorway at school introducing himself—he told me he was a sophomore, but I knew he was just a freshman. We sometimes laugh about the fact that he lied to me that day. I was working as a soda jerk at Herter's Drug Store, and he came there and got a job driving their jeep around, delivering prescriptions."[3]

Lynch's job took him all over town, and he didn't go unnoticed. "I had a newspaper route, and for maybe two years before I met David I'd see this guy with these little bags, knocking on doors," said artist Clark Fox, who attended

high school with Lynch. "He didn't quite fit in. If you had your hair long back then it was kind of rough, but he had his hair as long as it could be without getting in trouble, and he was really pale. He always had a tie and jacket on when he was working for the drugstore. He was very distinctive."[4]

Fisk's childhood had been tumultuous while Lynch's was bucolic and secure, and their temperaments were different, but the two of them shared the goal of committing their lives to art, and they fell into step. "Because I'd moved around so much I was kind of a loner, but David was easy to make friends with. Everybody liked him," Fisk said. "When David talks you want to listen, and he was always that way. David was eccentric from the start, too. We were in a straight school that had fraternities—everybody was in one, although I wasn't—and all the guys wore madras shirts and khaki pants. David ran for school treasurer—his campaign slogan was 'Save with Dave'—and we had an assembly where the candidates spoke and he got up to speak wearing a seersucker suit with tennis shoes. That doesn't seem crazy today, but at the time no one would think of wearing tennis shoes with a suit."

Lynch won that election for high school treasurer, but at approximately the same time his interest in painting began to eclipse pretty much everything else in his life. "He didn't want to do stuff like be high school treasurer anymore," Fisk recalled. "I don't know if he was removed or he resigned, but it didn't last long."

Rebellion is a standard part of most people's teenage years, but Lynch's recalcitrance was different in that he didn't rebel just for the hell of it; he rebelled because he'd found something outside of school that was vitally important to him. "It was unusual in that time and place for somebody like David to get so interested in oil painting," said John Lynch, "and our parents were upset with how he was going astray. His rebellion began in the ninth grade, and although he never got into trouble with the law, there was partying and drinking, and the first year in Alexandria he snuck out at night a few times and got caught. Then there was dinner. My mom would make normal dinners, but David thought they were *too* normal—he'd say, 'Your food is too clean!' When David was in Boise he was serious about Boy Scouts, but when we moved to Virginia he rebelled against that, too. My dad encouraged him to keep going and get his Eagle Scout rank, and David did it, but I think he partially did it for our dad."

Lynch bid a kind of farewell to the Scouts on his fifteenth birthday, when he

was among a handful of Eagle Scouts selected to seat VIPs for the inaugura-
tion parade at John Kennedy's swearing-in. He remembers seeing Kennedy,
Dwight Eisenhower, Lyndon Johnson, and Richard Nixon cruising by in limou-
sines just a few feet from where he stood.

Impressive, no doubt, but Lynch's mind was on other things. Martha
Levacy said, "Not long after we moved to Alexandria, all David wanted to do
was paint, and I was the mediator. I'd talk to David about things that were
bothering my parents, then I'd talk to my parents about his point of view, and
I tried to keep the peace. Our parents were real patient people and David was
always respectful of them so there weren't big fights, but there were dis-
agreements."

His cousin Elena Zegarelli described Lynch's parents as "very straight,
conservative, religious people. Sunny was a pretty woman with a soft, sweet
voice, but she was strict. I remember being in a restaurant in Brooklyn with
the whole family at a birthday celebration for our great-grandmother Hermina.
David was sixteen at the time and everybody was drinking wine and celebrat-
ing, but David's mother didn't want him to have a glass of wine. When you see
David's work it's hard to believe he's from the same family. My sense was that
because his family was so straitlaced, that made him go the other way."

Regardless of the constraints he encountered at home, Lynch was on his
way. "David had already rented a room from Bushnell Keeler when we met,"
Fisk recalled, "and he said, 'Do you want to share my studio?' It was really
tiny, but I shared the studio with him—it was around twenty-five dollars a
month—and Bushnell would come in and give us critiques. Bushnell told him
about Robert Henri's book, *The Art Spirit,* and David turned me on to it, and
he sat around reading it and talking to me about it. It was great finding some-
body who wrote about being a painter—suddenly you didn't feel alone any-
more. Because of the Henri book we knew about artists like van Gogh and
Modigliani, and anybody in France in the 1920s interested us."

A leading figure in the Ashcan School of American art, which advocated a
tough, gritty realism, Robert Henri was a revered teacher, whose students in-
cluded Edward Hopper, George Bellows, and Stuart Davis. Published in 1923,
The Art Spirit is a usefully technical distillation of several decades of his teach-
ing, and it had a big impact on Lynch. The language and syntax of the book
seem dated today, but the sentiment it expresses is timeless. It's a quietly
remarkable and encouraging book with a simple message: Give yourself per-

mission to express yourself as freely and completely as possible, have faith that this is a worthy endeavor, and believe that you can do it.

Early in 1962, when he was sixteen years old, Lynch decided it was time for him to move out of Bushnell Keeler's studio and get one of his own, and his parents agreed to contribute to the rent. "It was a big step for them to take," said Levacy. John Lynch recalled that "Bushnell talked to our parents about David getting his own studio and said, 'David's not goofing off. He's using the studio as a place to paint.' David got a job and helped pay for it, and it was real cheap. In the 1960s there was a section called Old Town that was kind of the skid row of Alexandria. [Today, this area is an upscale district full of boutiques and expensive coffee emporiums.] The streets were lined with brick houses that were built two hundred years ago and were just junk, and one of them that was even less than junk was the one David and Jack rented. They had the second floor, and the building had narrow old stairs that creaked when you walked on them. There was a little partying going on but they really did use it as a studio, and David went there every night and stayed pretty late. He had a curfew, and there was an electric clock he was supposed to unplug when he got home so our parents would know what time he got in. Still, it was always hard for him to wake up in the morning, and Dad would take a wet washcloth to his face sometimes. David hated that."

During high school both Fisk and Lynch attended classes at the Corcoran School of Art, in D.C., and their focus shifted increasingly to their lives off campus. "I got a failure notice in art in school, and I think David was doing pretty poorly in his art class, but we were painting all the time and had many different studios together," said Fisk. "I remember one on Cameron Street where we managed to rent a whole building, and we painted one room black and that was where you could go to think. When I first met David he was doing Paris street scenes, and he had a way of doing them with cardboard and tempera paint that was kind of nice. One day he came in with an oil painting of a boat by a dock. He was putting the paint on really thick at that point and a moth had flown into the painting, and as it struggled to get out of the paint it made this beautiful swirl in the sky. I remember he got so excited about that, seeing that death mixed in with his painting.

"If David was going in a certain direction with his art, I found another way to go," Fisk continued. "We were always pushing each other to get better, and it worked well in helping our work evolve. My work grew increasingly abstract,

and David got into painting darker things—docks at night, animals dying—real moody stuff. David's always had a cheerful disposition and sunny personality, but he's always been attracted to dark things. That's one of the mysteries of David."

Meanwhile, back at home, Lynch's parents were bewildered. "David could draw the Capitol Building perfectly, and he did drawings of the homes of both of our sets of grandparents that were perfect," said Levacy. "I remember my mom saying, 'Why don't you draw something that looks good like you used to?'" Lynch was finding the courage to defy what was deemed normal behavior, and these shifts in his personality took him into rocky waters at home. Some things about him didn't change, however. Lynch is essentially a kind person, and this was evident in something as simple as how he treated his younger brother. "David and I shared a room in high school and we'd have our fights, but David would do things for me," said John Lynch. "He was very popular in school, and instead of being ashamed of his little brother, he would kind of bring me in and I would meet his friends, and my friends would sort of become part of that same crowd. Some of my friends were on the nerdier side, too."

American movies were in the doldrums during the first half of the 1960s when Lynch was a teenager. The social revolution that breathed new life into American cinema had yet to begin, and U.S. studios were cranking out chaste romantic comedies starring Doris Day, beach-party pictures, Elvis Presley musicals, and bloated historical epics. It was the golden era of foreign film, though, and Pier Paolo Pasolini, Roman Polanski, Federico Fellini, Michelangelo Antonioni, Luis Buñuel, Alfred Hitchcock, Jean-Luc Godard, François Truffaut, and Ingmar Bergman were producing masterpieces during those years. Stanley Kubrick was one of the few U.S. filmmakers breaking new ground, and Lynch has expressed great admiration for Kubrick's 1962 adaptation of Vladimir Nabokov's erotic comedy *Lolita*. He has fond memories of seeing *A Summer Place,* with Sandra Dee and Troy Donahue, too. Although his brother recalls Lynch seeing films by Bergman and Fellini during those years, David has no memory of them.

Lynch's most significant girlfriend during his teenage years was Judy Westerman: They were voted the cutest couple at school, and there's a picture in their high school yearbook of the two of them on a bicycle built for two. "David had a really straight girlfriend, but he also used to date some of the 'fast'

women at school," said Clark Fox. "He used to talk about what he referred to as these 'wow women,' and although he didn't get into a lot of detail about them, I know they were kind of wild. He was intrigued by the wild side of life."

Fisk recalled that "David and Judy were pretty tight, but it wasn't one of those relationships that developed into anything physical. He wasn't really a ladies' man, but he would have fascinations with women." When Lynch met Fisk's younger sister, Mary, there was no instant fascination, but they both remember that first meeting. "I was fourteen or fifteen when I met David," recalled Mary Fisk, who became Lynch's second wife, in 1977. "I was sitting in the living room at home and Jack walked through the room with David and said, 'This is my sister Mary.' There was a brass vase holding cigarettes in the living room, and I guess that shocked him because his family didn't smoke. I don't know why, but for some reason he's always associated me with cigarettes—he's often said that.

"David was going steady with Judy Westerman then, but he was really in love with Nancy Briggs," Mary Fisk continued. "I had a crush on David the summer before my senior year and I was smitten—he has an extraordinary ability to connect with people. We went on a few dates but it wasn't serious, because we were both dating other people, too. That was the summer after David and Jack graduated from high school, so we all went our separate ways that fall."[5]

Lynch graduated from high school in June of 1964, and three months later his father's work took the family to Walnut Creek, California, just as Lynch started classes at Boston's School of the Museum of Fine Arts. At the same time, Jack Fisk began studies at Cooper Union, a private university in Manhattan. It was and is an excellent school—at the time the faculty included Ad Reinhardt and Josef Albers—but Fisk dropped out after a year and headed to Boston to reconnect with Lynch. "I was shocked when I entered his apartment, because it was full of paintings and they were different kinds of paintings," Fisk said. "They were orange and black, which was kind of bright for David, and I was impressed by how much he'd done. I remember thinking, My God, this guy has been working. One reason he was able to produce so much was because he stayed home and painted instead of going to school. School was a distraction for him."

It's interesting to note the disparity between Fisk and Lynch's involvement in art and what was happening in Manhattan, which was the international

center of the art world at the time. The heyday of abstract expressionism had passed, and late modernism was conceding the playing field to pop art, which had catapulted to the front lines in terms of advancing the narrative of art history. Robert Rauschenberg and Jasper Johns were developing new strategies for bridging the gap between art and life, and conceptualism and minimalism were on the march. Boston was a short train trip to Manhattan, where Fisk was living, but what was happening outside of their studios seems to have been of marginal interest to Lynch and Fisk, who were following the lead of Robert Henri rather than *Artforum.* For them, art was a noble calling that demanded discipline, solitude, and a fierce single-mindedness; the cool sarcasm of pop and cocktail-party networking of the New York art world had no place in their art-making practices. They were romantics in the classic sense of the word and were on another trajectory entirely.

By the end of Lynch's second semester in Boston his grades were circling the drain, and after failing classes in sculpture and design he quit school. Getting out of Boston was not without complications, though. "He made a mess of his apartment in Boston with his oil paint, and the landlord wanted him to pay for the damages, so my dad hired an attorney to negotiate a deal," said John Lynch. "Dad wouldn't yell at you but you knew when he was angry, and I think he was disappointed in David."

Where to next? Bushnell Keeler's brother had a travel agency in Boston and wrangled free flights to Europe as tour conductors for Fisk and Lynch; their duties began and ended with meeting a group of girls at the airport and escorting them onto a plane. The two of them headed to Europe in late spring of 1965, planning to study at the Salzburg International Summer Academy of Fine Arts, an institution located in a castle called Hohensalzburg Fortress. Also called the "School of Vision," it was founded in 1953 by Austrian expressionist Oskar Kokoschka in the city where the squeaky-clean movie musical of 1965, *The Sound of Music,* is set. Lynch has recalled, "I realized pretty quickly I didn't want to make my work there." Arriving two months before classes were scheduled to start in a city that turned them off, Fisk and Lynch were at a loss as to what to do with themselves. "Between us we had maybe two hundred and fifty dollars, and David loved Coca-Cola, which cost a dollar, and Marlboro cigarettes, which cost a dollar a pack, and I watched the money dwindle," Fisk said. They lasted fifteen days.

"When I got back home my stepfather gave me a thousand dollars, which

was a lot of money then, and I applied to the Pennsylvania Academy of the Fine Arts, because they were drafting people for Vietnam and you could get a student deferment," Fisk continued. "I went to Philadelphia but I didn't get into school because I'd applied too late, so I got a job at *The Philadelphia Inquirer* checking ads for their TV guide. A week or two later President Johnson escalated the war and they started drafting more people, and the school called and said, 'We're gonna let you in,' so that's how I got in. I rented a tiny room for thirty dollars a month at Twenty-first and Cherry Street."

It wasn't so easy for Lynch. "His parents were furious that he wasn't going to school and they told David, 'You're on your own,'" recalled Peggy Reavey. "He spent the rest of 1965 living in Alexandria, working at a series of bad jobs, and I know he had some really rough times. I think it was during that time that he was drafted—he got out of that, probably from a nervous stomach. He had a lot of trouble with his stomach when he was young." (Lynch had a bad back that kept him out of the service.)

When Lynch returned from Europe and headed back to Alexandria, the Keelers took him in. He did various odd jobs around the house, including painting the upstairs bathroom, which Toby Keeler said "took him forever. He used a teeny little brush and spent three days painting the bathroom, and probably a day alone painting the radiator. He got into every nook and cranny and painted that thing better than when it was new. My mother still laughs when she thinks of David in that bathroom."[6] One night when the Keelers were entertaining dinner guests, Bushnell announced, "David has decided he's going to be moving out and finding his own place." Lynch was hearing this news for the first time, but Keeler felt Lynch should get on with his life and begin living among his peers.

"David was gobbling up all the art he could," said David Keeler, "and he always seemed cheerful—he'd use naïve expressions like 'nifty.' His favorite was 'swingin' enough.' Bush would suggest that he try this or that, and David would say, 'Okay, swingin' enough, Bushnell!' Still, I think he was adrift at that point. He was kind of desperate and needed money because he'd gotten his own place, so I got him a job as a blueprint boy at an engineering firm where I worked as a draftsman. David worked by himself in the blueprint room and loved experimenting with the materials. He'd come over to my desk and say, 'Hey, Dave! What do you think of this? Look at this!' He spent a lot of time not doing company business. I can't remember which of us got fired first.

"David was very hard to get up in the morning, too," Keeler continued. "I walked by his place on the way to work, and I'd holler up to his window, 'Lynch! Get up! You're gonna be late!' He was living in a building owned by a guy named Michelangelo Aloca, and there was a frame shop just below David's room that Aloca owned. He was a paraplegic, great big guy, very strong and intimidating-looking."

After losing his job at the engineering firm, Lynch was hired by Aloca to work in his frame shop. He lost that job, too, when he scratched a frame, and Aloca then gave him a job as a janitor. He was making the best of things but it was a difficult period, and Lynch was relieved when he again crossed paths with Fisk. "At some point I went home to Alexandria and found David working in an art store, sweeping—David's a great sweeper," said Fisk. "He still likes to sweep, and takes great pride in it, but he was being paid next to nothing. He was living in this apartment that was beautifully decorated with inexpensive stuff—I remember it had orange drapes—but I think his life was kind of stagnant. I said, 'You should come up to Philly,' so he came to look at the school, then he enrolled."

Lynch headed for Philadelphia at the end of that year and he left Alexandria for good, but not without leaving a mark. Fisk's mother was the property manager of the rented house where the Lynches had lived, and he'd painted a mural on the ceiling of his bedroom. "After they moved out they had such a problem getting that mural off," said Fisk. "David painted it in Prussian blue, which was one of his favorite colors, and it kept bleeding through."

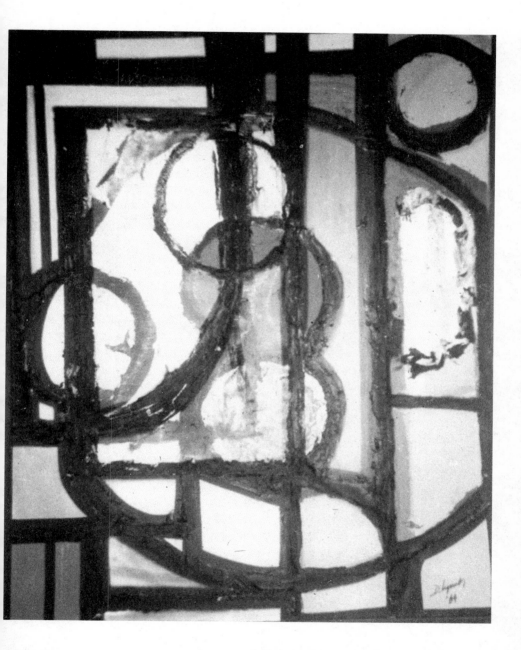

NINTH GRADE WAS the worst year of my life. I missed my friends in Boise and the feel of the place, the light and the smell, and Virginia seemed very dark. I hated the nature in Alexandria—the forests were completely different from Boise—and I got in with some bad guys and sort of became a juvenile delinquent. One of these guys, kind of the ringleader, was way older than his years and was like an adult. A smoothie. He looked like a smaller Rock Hudson, and he'd steal his neighbor's car and pick up different people, and we'd go into D.C. at two or three in the morning, a hundred and twenty miles an hour down Shirley Highway, and go to novelty shops or drinking or whatever. The thing that drew me to this guy was that I didn't like my life, and I liked the idea of doing strange things, sort of. I liked it and I didn't like it. This guy came up to the house once and he had a cigarette behind his ear and a pack of cigarettes rolled up in his T-shirt sleeve, and my parents met him. They weren't real happy. They thought, Poor Dave, he's into something. . . .

This guy had lots of girlfriends and I think he quit school. I visited Boise during the summer after ninth grade, and when I got back to Alexandria he was gone. Then one day at lunch I was out in the parking lot, probably going over to the smoking section, and he drives up in this convertible with this girl and it was just perfect. All happy; Mr. Cool. I don't know what became of him.

My bedroom opened onto a patio on the second floor and I could climb down and sneak out; then the next day I'd have to go to school. One time I got home and the minute my head hit the pillow I heard the alarm go off. It was crazy, and my parents knew I snuck out, but they didn't know what I was doing. I wasn't that wild, but I did get really drunk

a few times, and one time it was on gin. I was drinking gin and telling these girls it was water and I ended up in Russell Kefauver's front yard. I woke up and saw this wooden post with a number on it, and I kept looking at this number, then I realized I was in a yard on my back and that I was at Russell's house. I don't know how I got home.

My parents worried about me when I was in the ninth grade. Magazines then had these contests that said, "Draw me," and just to see if I could do it, I drew this thing and sent it in. Then one night this man came to the house and told my parents that my drawing was so good that I'd won some kind of fake scholarship. I was upstairs, and my parents were downstairs meeting with this man in the living room and it was so sweet. They were trying to help me find a better direction to go in.

I guess I believed in God in my own way when I was growing up. I didn't really think about it, but I knew there was something kind of running the thing. Then one Sunday morning when I was fourteen I thought to myself, I'm not getting anything out of going to church. I knew I wasn't getting the real thing, and looking back, I can see I was headed for Maharishi. When I was working on *Eraserhead*, I'd see photographs of Indian masters and think, This face knows something that I don't know. Could it be that there's such a thing as enlightenment? Is that real or is it just some Indian thing? Now I know it's real. Anyhow, I stopped going to church.

Like in every school, the jocks at Hammond High were the most popular. Then there were fraternities, and they weren't exactly the bad boys, but they didn't give a shit about sports and were into other things. I was in a fraternity and Lester Grossman was our president and Lester was a supreme character. After school Lester worked in a shoe store and every night he stole a metal shoehorn, and when he got home he'd throw it on the floor in his bedroom, and there was a big pile of shoehorns in there. A relative of Lester's got us a bunch of light bulbs for super cheap and we sold them door-to-door. We were selling them like hotcakes and we made a truckload of money, then we threw a giant party. It wasn't just for our high school. It was for Washington, D.C.–area high schools, and it was huge. We hired this band called the Hot Nuts, and there was an admission fee and we made a lot of money. We had so much money that

we all spent a week in Virginia Beach, and the fraternity paid for little bungalows and dinner every night and maybe even some spending money. I went my junior and senior year and was in a fraternity the whole way through high school. People had slow-dance parties in basements, too, and I'd also go to those. Movies didn't mean anything to me when I was a teenager. The only time I went to movies was when I'd go to the drive-in, and I'd go there for making out. I went to movie theaters a few times, but why go to the theater? It's cold and dark and the day is going by outside. You could be doing so many things.

I dress the same way now that I dressed then, and I wasn't aware in high school that I had my own style. I got my clothes at Penney's. I loved khaki pants and I liked wearing a coat and tie—it was just something I felt comfortable with. I wore three ties for a long time, two bow ties and a regular tie, but I wouldn't tie the bow ties—they'd just be knotted at the top. I've always buttoned the top button of my shirt because I don't like air on my collarbone and I don't like anyone touching my collarbone. It makes me crazy and I don't know why. It might've been one of the reasons for the ties, to protect my neck.

I met Jack Fisk at school and we became friends because we were both interested in art, but the thing I really liked about Jack is that he's a dedicated worker. When you see the seriousness of him working and building stuff, it's a beautiful thing. I have tremendous respect for Jack, and because I met him when we were young, those are friends that you keep longer. I probably haven't talked to him in months, but Jack is my best friend. I remember meeting his sister Mary very well, too. She was a fox and I was always attracted to her. We dated a little bit and I made out with her and I think Jack got really upset.

Linda Styles was my girlfriend during my freshman year. Linda was petite and real dramatic and we used to make out in her basement. Her parents were nice—her father was in the navy and her mom was real sweet, and they let me smoke there. Most people didn't mind smoking in those days. Later on Linda ended up going with this ringleader guy, and I think he was screwing her. See, I didn't get there until I was eighteen, the summer after high school. Maybe I was slow, but I think I was pretty normal for those days. It was a different time. After Linda Styles I saw

some other girls. If I had a type, I guess you could say I liked brunettes the best, and I kind of liked librarian types, you know, their outer appearance hiding smoldering heat inside. . . .

Judy Westerman was my main high school girlfriend, and I loved her so much. She sort of looked like Paula Prentiss. Was I faithful to her? No. I mean, I was and I wasn't. I was seeing some different girls and getting further with them because Judy was a Catholic. We probably did more on the early dates than later, because she kept going to catechism and finding out more things she wasn't allowed to do. Only one girl broke my heart and her name was Nancy Briggs. She was the girlfriend of my friend Charlie Smith, and I don't know if he knew I loved his girlfriend. She didn't love me, though. I was nuts for her all during the first half of my year at college in Boston, and I was just brokenhearted.

During Christmas break when I was going to college in Boston, I went down to Virginia and I was pining away, and David Keeler said, "Why don't you just take her to lunch and see what's going on?" So I called Nancy and we went to McDonald's. We took our food to the car and I asked her if she loved me, and she said no, and that was it. I just sort of carried it for a long time and I'd have dreams about her. What was it about Nancy Briggs? I just loved her, and who knows why you fall in love with somebody. Nothing ever happened with her, but I just couldn't get her out of my system. After I finished shooting *Blue Velvet* I was in Wilmington, and for some reason I decided, I'm going to call Nancy Briggs. Somehow I got her number and I called her up, and the second I heard her voice the pining was completely lifted. It went from a dream to reality, and the dream was the powerful thing. It's amazing what we do in our brains. Why did I pine for all those years? Go figure . . .

Things were changing in the country at the end of the fifties, so the change I felt when we moved to Virginia was also happening in Boise. Then when Kennedy was assassinated it got really bad. I remember that day. I was setting up an art display by myself in these big glass cases in the entrance hall to the school, right next to the administration office, and I heard something about the president on the radio in there. They hadn't said he'd died, but he was in the hospital and the buzz started. When I

finished what I was doing, this woman said, "You have to go back to your class," so I went back to class and they made the announcement and closed the school. I walked Judy home and she was sobbing so much she couldn't talk. Kennedy was Catholic like her and she loved him so much. She lived in an apartment building on the second floor, so we walked up and went inside and her mom was in the living room. Judy walked away from me, passed her mom, turned a corner, went into her room, and didn't come out for four days.

At the time I didn't question who killed Kennedy, but you start looking into things. They say, Look who's got the motive. LBJ lived in Texas and got him down there, and LBJ wanted to be president since he was three feet tall. LBJ was the most powerful senator they say there ever was, and he gave that up to be vice president? He was one twenty-five-cent bullet away from the presidency, and I think he hated Kennedy and he organized it so he could be president. That's my theory.

In the eighth grade I liked science for some reason, so when I started ninth grade I signed up for all science classes. Now I can hardly believe it. The whole four years is booked in science! Then in ninth grade I meet Toby Keeler and he tells me his father is a painter—no, not a house painter, a *fine-art* painter—and, literally, boom! A bomb goes off in my head. All these things must've just flown together like a hydrogen bomb and that was it, that's all I wanted to do. But I had to go to school, and high school was the worst. To go to that building for so many hours every day just seemed ridiculous. I have about three high school classroom memories, and none of them are good. I remember saying to Sam Johnson, "Tell me, tell me, tell me!" We were about to have a test, and he would tell me things and I'd try to remember them long enough to take the test. I never studied and couldn't get out of these science classes, and I got thrown off the student council because I flunked physics and refused to go to class. Instead of going, I'd go down to the front office and beg, "Let me out of this; I don't want to be a physicist," and they said, "David, there are some things in life you have to do whether you like it or not." My little brother was into electronics from an early age and that's what he wound up going into, and I think you know what you're going to do when you're a kid. They should take us out of school and just let us concentrate on whatever that thing is. Holy smokes! I could've been

painting all that time I spent in school! And I remember zip. Zip! I can't remember a fuckin' thing I learned in school.

The weekend after I met Toby Keeler he took me to his father's studio, and at that point Bushnell had a studio in Georgetown that was so fucking great. He was living the art life and painting all the time. I only saw his Georgetown studio once, and the next thing I know he's moved from Georgetown to Alexandria, where he had a whole building. I wanted a studio and Bushnell offered to rent me a room in his new place, so I talked to my father and he said, "I'll pay half if you get a job and pay the other half." So I got a job at Herter's Drug Store delivering prescriptions in the store's red-and-white jeep. It was an open jeep with a stick shift. I can't believe I did that. I'd have to find people's addresses and take drugs to them, and that's a lot of responsibility. On weekends I'd sometimes work the cigar counter at Herter's. During that period Bushnell would get models and I'd get to sit in on these things and draw, and he always had coffee going. A guy named Bill Lay went in on the room with me but he never showed up there.

Jack had started working in my room at Bushnell's, though, and it wasn't big enough for both of us so we moved into a studio above a shoe store. Our landlady was named Mrs. Marciette, and she didn't have any teeth. She complained to us a lot—"I'm not burning the light all night for two alley cats; clean up; I'm sick; I don't know why I rent to you"— and she was always around. When I turned the lights on in my room, just for a millisecond I'd see ten million cockroaches, which would instantly disappear. The place was riddled with cockroaches, but Jack and I each had a room, and there was a kitchen, and it was a great place to paint.

Living in the attic above Jack and me was this guy named Radio, and we got to know him. He was a hunchback, and he would go up these real narrow back stairs that led to this wooden door with a padlock on it. That was his room. Radio didn't have too many teeth, either, and in his room he had maybe fifty porno magazines lying around, a hot plate where he made steaks—just steaks—and cheap hard liquor. He was a phone man for the circus, and he'd travel to cities ahead of the circus and phone prominent businessmen and get them to donate money to send needy children to the circus. The circus would rent a room somewhere and have twelve phones put in and there would be all these guys phoning

people, and it was a racket. They would send maybe one busload of needy children to the circus and pocket the rest of the dough. Radio says, "They call me Radio because they can't turn me off." Jack and I had a phone, and one night he came down and asked if he could use our phone. We said, "Sure, Radio," so he comes in and there's this little table with a rotary dial phone on it. He goes to the phone and his hand goes down and begins dialing, and the number was instantly dialed. I've never seen anybody dial a phone like this. It's as if he put all the fingers on his hand into this rotary dial at the same time, and in a fraction of a second he's got somebody on the phone and he starts talking. If you closed your eyes you'd swear you were listening to a highly intelligent saint telling you about these needy children. Radio was incredible.

Right next door to Mrs. Marciette's was Frankie Welch, this woman who looked like a brunette Doris Day. This area was right by city hall but it was pretty bad, and Frankie Welch was the first person down there. She had a vision and she had this super high-end place where she sold clothes. She also designed clothes and she ended up being really close to Betty Ford and did clothes for her. When she found out we were artists, she had me making signs with oil paint that were really cool-looking. But then Mrs. Marciette asked us to leave. We were in there a lot late at night and we'd leave the lights on and she was paying for electricity and there was paint all over the place. I didn't used to leave properties better than they were when I got there. It wasn't like we purposely trashed the place like rock stars, but when you're painting, paint gets around. After we moved out, I saw Radio one more time. He was downtown, this hunchback with a battered little suitcase, waiting for the bus that would take him to the next town.

I went to a doctor when I was in high school because I was having spasms of the intestines, which were caused by nerves and all the things I was doing wrong. When I was in high school I had a studio life, a fraternity life, and a home life, and I didn't want any of them to mix. I never brought friends home and I didn't want my parents to know about anything. I knew how to behave at home, and it was different from how I behaved at the fraternity, and that was different from how I was at the studio. I had a lot of tension and nervousness about living all of these separate lives.

• • •

I didn't care about the New York art world, and going to college there didn't mean a thing to me. I don't know why I picked the Boston Museum School—I just got a thing in my mind. I wanted to go to Boston. It sounded so cool, the Boston Museum School, but I didn't like it at all and I almost couldn't go to school because I was afraid to leave the apartment. I had agoraphobia and still have it a little bit. I don't like going out. My dad told me I had to get a roommate because my apartment was too expensive, so I put a thing on the wall at school, and this guy Peter Blankfield—who later changed his name to Peter Wolf and became the singer in the J. Geils Band—came up to me and said, "I'd like to be your roommate." I said, "Fine," and he came over that night.

Another guy, Peter Laffin, had a pickup truck, so the three of us get in this truck and go from Boston down to Brooklyn or the Bronx or someplace to get Peter's stuff. They were smoking dope in the car and I'd never smoked dope, so I'm getting high just from being in the car, and they gave me some tokes. They knew how marijuana works and knew I didn't know, so they say, "Hey, David, wouldn't a donut be good right now?" I said, "I gotta have a donut!" So we got twenty-four day-old powdered-sugar donuts and I was so eager to eat one that I inhaled a mountain of powdered sugar into my lungs. You've got to be careful.

So it's my turn to drive, and we're driving down the freeway and it's real quiet, then I hear somebody say, "David." Then it was quiet again, and then somebody said, "David! You've stopped on the freeway!" I was watching these lines on the road and they were going slower and slower, and I was loving them, and I was going slower and slower until the lines finally stopped moving. This was an eight-lane freeway at night and cars are just flying by us and I'd stopped the car! It was so dangerous!

For some reason we then stopped by some guy's apartment, which was lit by just a few Christmas bulbs, mostly red. He's got his giant motorcycle in the living room all taken apart, and a few chairs, and it seemed like we'd entered hell. Then we go to Peter's house and go down in the basement, and while we're down there I cup my hands, they fill up with dark water, and there, floating on the surface of the water, was Nancy Briggs's face. I was just looking at her. That was the first time I smoked mari-

juana. The next morning we loaded Peter's stuff and went to see Jack, who told me that some of the students at his school were taking heroin. I went to a party in Jack's building and there was this kid in a silk shirt kind of huddled up, and he was on heroin. You started seeing hippies around during that period, too, and I didn't look down on them, but it seemed like a fad, and a lot of them were raisin and nut eaters. Some of them dressed like they were from India and they'd say they were meditators, but I didn't want anything to do with meditation then.

I threw my roommate Peter out after just a few months. What happened was I went to a Bob Dylan concert and ended up sitting next to this girl I'd just broken up with. I couldn't believe I was sitting next to her. Obviously I'd made the date while we were going together, but then we broke up, so I went to the concert alone and I was stoned and there she was! I remember thinking what a weird coincidence it was that I was sitting next to her. We had really bad seats and we were *way* in the back of a giant auditorium, far, far, away. This was 1964 and Dylan didn't have a band with him—it was just him up there alone and he looked incredibly small. Using my thumb and my forefinger I started sighting and measuring his jeans and I said to this girl, "His jeans are only a sixteenth of an inch big!" Then I measured his guitar and I said "His guitar is just a sixteenth of an inch, too!" It seemed like the strangest magic act and I got super paranoid. Finally there was an intermission and I went running outside and it was cold and fresh and I thought, Thank God, I'm out, and I walked home. So I'm at home and Peter comes in with a bunch of friends and he says "What? Nobody walks out on Dylan!" And I said, "*I* fuckin' walk out on Dylan. Get the hell out of here." And I threw them all out. I remember the first time I heard Dylan on the car radio I was riding with my brother and we started laughing like crazy. It was "Blowin' in the Wind," and it was so cool the way he sang, but it was cool funny.

I only went to the Boston Museum School for two semesters, and I didn't even go to classes the second half. The only class I liked was sculpture, which was held in the attic of the museum. The room was around twenty-five feet wide, but it was a hundred feet long and had incredibly high ceilings with a skylight running through the whole thing. There were big bins of materials like plaster and clay, and that's where I learned casting. The teacher was named Jonfried Georg Birkschneider, and

when he got his paycheck he'd sign it over in a Boston bar with a polished dark wooden bar a hundred feet long, and he'd just drink. His girlfriend's name was Natalie. After my first semester I went home to Alexandria at Christmas and I let him stay at my place with Natalie. When I came back to Boston I let them keep staying with me in my apartment, and they stayed for a few months. I was painting in one room, and he and Natalie took over another room, and he just sat there, but it didn't bother me. He turned me on to Moxie, which is this kind of cola they drink in Boston. I hated it until I discovered that if you put the bottles in the freezer the lid will pop off and there would be soft ice that tasted so good. It was like a Moxie slush. I don't know what became of Jonfried Georg Birkschneider.

So I left college and Jack and I went to Europe. We went because it's part of the art dream, but it was completely half-baked. I was the only one who had money—although Jack probably could have gotten some if he'd written home—but we really did have a good time, sort of. The only place we didn't like was Salzburg, and once that went belly-up we were just free-floating. We had no plan. We went from Salzburg to Paris, where we spent a day or two, then we took the real Orient Express, all electric trains, to Venice, and then coal-burning trains down to Athens. We got there at night, and when I woke up the next morning there were lizards on the ceiling and the walls of my room. I wanted to go to Athens because Nancy Briggs's father had been transferred and was going to be there two months later, and Nancy would've been there, but we only stayed in Athens for one day. I thought, I'm seven thousand miles from where I really want to be and I just want to get out of here. I think Jack did, too.

But we were truly out of money by then. We went back to Paris, and on the train we met four schoolteachers and somehow we got an address where they were staying in Paris. We get to Paris and Mary has sent Jack a ticket home, but I don't have a ticket, and Jack's going to the airport. Before he left we went to the address these girls had given us, but they weren't home, so we went to a sidewalk café and I ordered a Coca-Cola and gave Jack the last bit of money for a cab to the airport. I'm sitting there alone; I finish my Coke and go and knock on their door, and they're still not there. I go back to the café and sit, then I go back and knock on

their door and they're home. They let me take a shower and gave me twenty dollars. I couldn't reach my parents, because they were on vacation, so I called my grandfather and woke him up at four in the morning, and he got the money for a ticket to me fast; then I flew back and went to Brooklyn. I had all these European coins when I got home, and I gave them to my granddad. When he passed away they found this little purse with a slip of paper he'd safety-pinned to it that said, "These are coins that David brought me from Europe." I still have it somewhere.

That was a strange period after I got back from Europe. My parents were upset when they found out I wouldn't be going to school in Salzburg, and when I got back to Alexandria I stayed at the Keeler house. Bushnell and his wife were away and just Toby was there, and he was shocked to see me. I was going to be gone for three years, and fifteen days later I'm knocking on the door. After Toby's I got my own place, and I always like to fix up a place. It's almost like painting. I want the place where I live to be a certain way that feels good and where I can work. It's something about the mind; it wants to have a certain thing, a setup.

Michelangelo Aloca was a fifties action painter who had a frame shop, and he gave me a job. He was a strange guy. His head was as big as a five-gallon can, and he had a huge beard and giant torso and the legs of a three-year-old. He was in a wheelchair, but he was very strong on top. One time we were driving and we passed these giant iron H-beams and he crawled out of the car, went over and grabbed this H-beam, and lifted it up and slammed it down. He was a nut. His wife was beautiful and he had a beautiful child. Knockout wife! He fired me from the job in his frame store and then hired me as a janitor to sweep out. One day he said, "You want to make five dollars extra?" I said, "Sure." He said, "The girls just vacated their place in the building. Go clean their toilet." This toilet . . . if a little wind came, it would slop over. It was right to the top of the toilet, brown, white, and red water, right to the brim. I cleaned it until you could eat off it. It was clean as a whistle.

One time I went into Mike Aloca's place and he was in there talking with this black guy. After the guy left Mike says, "You want a free TV?" I said, "Sure," and he said, "Take this money and this gun and go to this place and this guy's gonna take you to these TVs." I got Charlie Smith and somebody else to go with me and we went to D.C. and found the

guy, and he tells us where to drive, then he says, "Stop here—I'll go in and get the TVs." He goes in, then he comes back and says, "They won't give me the TVs; they want the money first." We say no, so he goes in and comes out again without the TVs, telling us he needs the money first. We say no, then he makes another trip, and this time he brings out a TV box and we decide to take a chance. We give him the money, he goes in and never comes out again, and there we were with a loaded pistol under the front seat. Luckily, Mike just laughed when we told him what happened. Mike could be scary. He once said I was spending all the money he paid me on paint and he said, "I want you to show me food you buy; you gotta eat." I must've looked sickly or something. So I show him my milk and peanut butter and loaf of bread and he said, "Good for you."

I got fired from every job I ever had. For a while I was working for an artist living in Alexandria who did these circles of red, blue, and yellow on Plexiglas and had a little store that he had me running. Nobody came in there, and every once in a while I'd steal a dime and get a Coca-Cola. One day Jack came in and said he was joining the navy, but he wanted to do that for three seconds, because the next thing I know he's up at the Pennsylvania Academy of the Fine Arts in Philadelphia. So he's up there and I'm down here.

Bushnell knew it wasn't the best thing for me to be in Alexandria, and he knew Jack was at the Academy, so he said, "Let's make it really not fun for Dave around here." Bushnell and his brother started shunning me, and I didn't know why they were doing it, and it hurt. Then Bushnell wrote a letter to the Academy telling them how great I was, and I think that letter helped me get into the Academy. Bushnell started me out by making me realize I wanted to be a painter, then he gave me a studio; he was an inspiration to me, then he wrote that letter—he helped me in so many ways. He and his wife were the ones who told me about the American Film Institute. They heard I made two little films and told me the AFI was giving grants. He was a huge, huge, important person in my life.

Bushnell helped a lot during those years, but, generally, being a teenager wasn't that great for me. Being a teenager is so euphoric and thrilling, but it's mixed with a kind of chain to jail, which is high school. It's such a torment.

Smiling Bags of Death

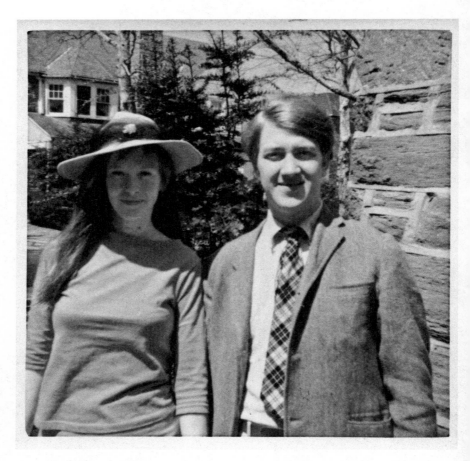

Philadelphia was a broken city during the 1960s. In the years following World War II, a housing shortage, coupled with an influx of African Americans, triggered a wave of white flight, and from the 1950s through the 1980s the city's population dwindled. Race relations there had always been fraught, and during the 1960s black Muslims, black nationalists, and a militant branch of the NAACP based in Philadelphia played key roles in the birth of the black power movement and ratcheted up tensions dramatically. The animosity that simmered between hippies, student activists, police officers, drug dealers, and members of the African American and Irish Catholic communities often reached a boiling point and spilled over into the streets.

One of the first race riots of the civil rights era erupted in Philadelphia less than a year and a half before Lynch arrived there, and it left 225 stores damaged or destroyed; many never reopened, and once-bustling commercial avenues were transformed into empty corridors of shuttered storefronts and broken windows. A vigorous drug trade contributed to the violence of the city, and poverty demoralized the residents. Dangerous and dirty, it provided rich mulch for Lynch's imagination. "Philadelphia was a terrifying place," said Jack Fisk, "and it introduced David to a world that was really seedy."

Situated in the center of the city like a demilitarized zone was the Pennsylvania Academy of the Fine Arts. "There was a lot of conflict and paranoia in the city, and the school was like an oasis," recalled Lynch's classmate Bruce Samuelson.[1] Housed in an ornate Victorian building, the Academy, the oldest art school in the country, was regarded as a conservative school during the years Lynch was there, but it was exactly the launching pad he needed.

"David moved in with me in the little room I'd rented," said Fisk. "He came in November of 1965 and we lived there until he started classes in January.

The room had two couches, which we slept on, and I'd collected a bunch of dead plants that were scattered around—David likes dead plants. Then, on New Year's Day, we rented a house for forty-five dollars a month that was across the street from the morgue in a scary industrial part of Philadelphia. People were afraid to visit us, and when David walked around he carried a stick with nails sticking out of it in case he got attacked. One day a policeman stopped him, and when he saw the stick he said, 'That's good, you should keep that.' We worked all night and slept all day and didn't interact with the instructors much—all we did was paint."

Lynch and Fisk didn't bother going to school too often but quickly fell into a community of like-minded students. "David and Jack showed up kind of like the dynamic duo and became part of our group," recalled artist Eo Omwake. "We were the fringy, experimental people, and there were about a dozen in our group. It was an intimate circle of people and we encouraged each other and all lived a frugal, bohemian lifestyle."[2]

Among the circle was painter Virginia Maitland, who remembered Lynch as "a corny, clean-cut guy who drank a lot of coffee and smoked cigarettes. He was eccentric in how straight he was. He was usually with Jack, who was tall like Abraham Lincoln and was kind of a hippie, and Jack's dog, Five, was usually with them. They made an interesting pair."[3]

"David always wore khakis with Oxford shoes and big fat socks," said classmate James Havard. "When we met we became friends right off because I liked his excitement about working—if David was doing something he loved, he'd really get into it. Philadelphia was very rough then, though, and we were all just scraping by. We didn't run around much at night, because it was too dangerous, but we were wild in our own way and David was, too. We'd all be at my place listening to the Beatles, and he'd be beating on a five-pound can of potato chips like it was a drum. He'd just bang on it."[4]

Samuelson recalled being struck by "the gentlemanly way David spoke and the fact that he wore a tie—at the time nobody but the faculty wore ties. I remember walking away the first time we met and sensing something was wrong, and when I turned and looked back I saw that he had two ties on. He wasn't trying to draw attention to himself—the two ties were just part of who he was."

Five months before Lynch arrived at the Academy, Peggy Lentz Reavey started classes there. The daughter of a successful lawyer, Reavey graduated

from high school, went straight to the Academy, and was living in a dorm on campus when she first crossed paths with Lynch. "He definitely caught my eye," she recalled. "I saw him sitting there in the cafeteria and I thought, That is a beautiful boy. He was kind of at sea at that point and many of his shirts had holes in them, and he looked so sweet and vulnerable. He was exactly the kind of wide-eyed, angelic person a girl wants to take care of."

Both Reavey and Lynch were involved with other people when they met, so the two were just friends for several months. "We used to eat lunch together and enjoyed talking, but I remember thinking he was a little slow at first because he had no interest in the things I grew up loving and associated with being an artist. I thought artists weren't supposed to be popular in high school, but here's this dreamy guy who'd been in a high school fraternity and told wonderful stories about a world I knew nothing about. Class ski trips, shooting rabbits in the desert outside Boise, his grandfather's wheat ranch—so foreign to me, and funny! Culturally, we came from completely different worlds. I had this cool record of Gregorian chant I played for him, and he was horrified. 'Peg! I can't believe you like this! It's so depressing!' Actually, David was depressed when we were getting to know each other."

Omwake concurred: "When David was living near the morgue, I think he went through a depressed period—he was sleeping, like, eighteen hours a day. One time I was at the place he shared with Jack, and Jack and I were talking when David woke up. He came out, drank four or five Cokes, talked a little bit, then went back to bed. He was sleeping a lot during that period."

When he was awake Lynch must have been highly productive, because he progressed quickly at school. Five months after starting classes he won an honorable mention in a school competition, with a mixed-media sculpture involving a ball bearing that triggered a chain reaction featuring a light bulb and a firecracker. "The Academy was one of the few art schools left that stressed a classical education, but David didn't spend much time doing first-year classes like still-life drawing," said Virginia Maitland. "He moved into advanced classes fairly quickly. There were big studios where they put everybody in the advanced category, and there were five or six of us in there together. I remember getting a real charge out of watching David work."

Lynch was already technically skilled when he arrived at the Academy but hadn't yet developed the unique voice that informs his mature work, and during his first year he tried on several different styles. There are detailed graph-

ite portraits rendered with a fine hand that are surreal and strange—a man with a bloody nose, another vomiting, another with a cracked skull; figures Lynch has described as "mechanical women," which combine human anatomy with machine parts; and delicate, sexually charged drawings evocative of work by German artist Hans Bellmer. They're all executed with great finesse, but Lynch's potent sensibility isn't really there yet. Then, in 1967, he produced *The Bride,* a six-by-six-foot portrait of a spectral figure in a wedding dress. "He was diving headlong into darkness and fear with it," said Reavey of the painting, which she regards as a breakthrough and whose whereabouts are unknown. "It was beautifully painted, with the white lace of the girl's dress scumbled against a dark ground, and she's reaching a skeletal hand under her dress to abort herself. The fetus is barely suggested and it's not bloody . . . just subtle. It was a great painting."

Lynch and Fisk continued to live across the street from the morgue until April of 1967, when they relocated to a house at 2429 Aspen Street, in an Irish Catholic neighborhood. They moved into what's known as a "Father, Son, and Holy Ghost" row house, with three floors; Fisk was on the second, Lynch was on the third, and the bottom floor was the kitchen and living room. Reavey was living in an apartment a bus ride away, and by that point she and Lynch had become a couple. "He made a point of calling it 'friendship with sex,' but I was pretty hooked," recalled Reavey, who became a regular presence on Aspen Street and wound up living there with Lynch and Fisk, until Fisk moved into a loft above a nearby auto-body shop a few months later.

"David and Jack were hilarious together—you laughed around those two constantly," said Reavey. "David used to ride his bike beside me when we walked home from school, and one day we found an injured bird on the sidewalk. He was very interested in this and took it home, and after it died he spent most of the night boiling it to get the flesh off the bird so he could make something with the skeleton. David and Jack had a black cat named Zero, and the next morning we were sitting drinking coffee, and we heard Zero in the other room crunching the bones to pieces. Jack laughed his head off over that.

"David's favorite place to eat was a drugstore coffee shop on Cherry Street, and everybody in the place knew us by name," continued Reavey of her first few months with Lynch. "David would tease the waitresses and he loved Paul, the elderly gentleman at the cash register. Paul had white hair and glasses

and wore a tie, and he always talked to David about his television. He talked about shopping for it and what a good one he'd gotten, and he'd always wind up this conversation about his TV by saying, with great solemnity, 'And, Dave . . . I am blessed with good reception.' David still talks about Paul and his good reception."

The core event of the David Lynch creation myth took place early in 1967. While working on a painting depicting a figure standing among foliage rendered in dark shades of green, he sensed what he's described as "a little wind" and saw a flicker of movement in the painting. Like a gift bestowed on him from the ether, the idea of a moving painting clicked into focus in his mind.

He discussed collaborating on a film with Bruce Samuelson, who was producing visceral, fleshy paintings of the human body at the time, but they wound up scrapping the idea they developed. Lynch was determined to explore the new direction that had presented itself to him, though, and he rented a camera from Photorama, in downtown Philadelphia, and made *Six Men Getting Sick (Six Times),* a one-minute animation that repeats six times and is projected onto a unique six-by-ten-foot sculpted screen. Made on a budget of two hundred dollars and shot in an empty room in a hotel owned by the Academy, the film pairs three detailed faces cast in plaster, then fiberglass—Lynch cast Fisk's face twice and Fisk cast Lynch's face once—with three projected faces. Lynch was experimenting with different materials at the time, and Reavey said, "David had never used polyester resin before *Six Men Getting Sick,* and the first batch he mixed burst into flames."

The bodies of all six figures in the piece have minimal articulation and center on swollen red orbs representing stomachs. The animated stomachs fill with colored liquid that rises until the faces erupt with sprays of white paint that trickle down a purple field. The sound of a siren wails throughout the film, the word "sick" flashes across the screen, and hands wave in distress. The piece was awarded the school's Dr. William S. Biddle Cadwalader Memorial Prize, which Lynch shared with painter Noel Mahaffey. Fellow student H. Barton Wasserman was impressed enough to commission Lynch to create a similar film installation for his home.

"David painted me with bright-red acrylic paint that burned like hell and rigged up this thing with a showerhead," Reavey recalled of the Wasserman commission. "In the middle of the night he needed a showerhead and length

of hose, so he goes out into the alleyway and comes back with them! That kind of thing happened to David a lot." It took Lynch two months to shoot two minutes and twenty-five seconds of film for the piece, but when he sent it to be processed, he discovered the camera he'd been using was broken and the film was nothing but a long blur. "He put his head in his hands and wept for two minutes," said Reavey, "then he said, 'Fuck it,' and sent the camera to be fixed. He's very disciplined." The project was decommissioned, but Wasserman allowed Lynch to keep the remainder of the funds he'd allotted for it.

In August of 1967, Reavey learned she was pregnant, and when the fall semester began a month later, Lynch left the Academy. In a letter to the school administration, he explained, "I won't be returning in the fall, but I'll be around from time to time to have some Coca-Cola. I just don't have enough money these days, and my doctor says I'm allergic to oil paint. I am developing an ulcer and pinworms on top of my spasms of the intestines. I don't have the energy for continuing my conscientious work here at the Penn. Academy of the Fine Arts. Love—David. P.S.: I am seriously making films instead."[5]

At the end of the year Reavey left school, too. "David said, 'Let's get married, Peg. We were going to get married anyway. Let's just get married,'" Reavey recalled. "I couldn't believe I had to go and tell my parents I was pregnant, but we did, and it helped that they adored David.

"We got married on January 7th of 1968 at my parents' church, which had just gotten a new minister, who was great," she continued. "He was on our side: Hey, you guys found love, fantastic. I was about six months pregnant at the time and wore a floor-length white dress, and we had a formal ceremony that David and I both found funny. My parents invited their friends and it was awkward for them, so I felt bad about that, but we just rolled with it. We went to my parents' house afterward for hors d'oeuvres and champagne. All our artist friends came and there was plenty of champagne flowing and it was a wild party. We didn't go on a honeymoon, but they booked us a room for one night at the Chestnut Hill Hotel, which is beautiful now but was a dump then. We stayed in a dismal room, but we were both happy and had a lot of fun."

Using the funds remaining from the Wasserman commission, along with financial aid from his father, Lynch embarked on his second movie, *The Alphabet.* A four-minute film starring Reavey, *The Alphabet* was inspired by Reavey's story of her niece giving an anxious recitation of the alphabet in her sleep. Opening with a shot of Reavey in a white nightgown lying on a white-

sheeted bed in a black void, the film goes on to intercut live action with anima-tion. The drawings in the film are accompanied by an innovative soundtrack that begins with a group of children chanting "A-B-C," then segues into a male baritone (Lynch's friend Robert Chadwick) singing a nonsensical song in sten-torian tones; a crying baby and cooing mother; and Reavey reciting the entire alphabet. Described by Lynch as "a nightmare about the fear connected with learning," it's a charming film with a menacing undercurrent. It concludes with the woman vomiting blood as she writhes on the bed. "The first time *The Alphabet* screened in an actual movie theater was at this place called the Band Box," Reavey recalled. "The film started but the sound was off." Lynch stood up and shouted, "Stop the film," then raced up to the projection booth with Reavey behind him. Reavey's parents had come to see the movie, and Lynch remembers the evening as "a nightmare."

"David's work was the center of our life, and as soon as he made a film it was all about him being able to make another one," said Reavey. "I had no doubt that he loved me, but he said, 'The work is the main thing and it has to come first.' That's just the way it was. I felt extremely involved in David's work, too—we really did connect in terms of aesthetics. I remember seeing him do stuff that just wowed me. I'd say, 'Jesus! You're a genius!' I said that a lot, and I think he is. He would do stuff that seemed so right and original."

Reavey had begun working in the bookstore at the Philadelphia Museum of Art in 1967, and she continued at her job until she went into labor. Jennifer Chambers Lynch arrived on April 7th, 1968, and Reavey recalled, "David got a kick out of Jen but had a hard time with the crying at night. He had no toler-ance for that. Sleep was important to David, and waking him up was not fun—he had issues with his stomach and always had an upset stomach in the morning. But Jen was a great, really easy kid and was the center of my life for a long time—the three of us did everything together and we were an idyllic family."

When Reavey and Lynch married, Reavey's father gave them two thousand dollars, and Lynch's parents contributed additional funds that allowed them to purchase a house. "It was at 2416 Poplar, at the corner of Poplar and Ring-gold," Reavey said. "Bay windows in the bedroom—into which our bed was tucked—looked onto the Ukrainian Catholic church, and there were lots of trees. That house made a lot of things possible, but aspects of it were pretty rough. We ripped up all the linoleum and never finished sanding the wooden

floors, and parts of it were really bitten up—if I spilled something in the kitchen, it just soaked into the wood. David's mother visited us right before we moved to California and said, 'Peggy, you're going to miss this floor.' Sunny had a wonderful, very dry sense of humor. She once looked at me and said, 'Peggy, we've worried about you for years. David's wife . . .' She could be funny, and Don had a great sense of humor, too. I always had fun with David's parents."

Life as Lynch's wife was interesting and rich for Reavey; however, the violence of Philadelphia was no small thing. She'd grown up there and felt it wasn't any rougher than any other large Northeastern city during the 1960s, but she conceded that "I didn't like it when somebody got shot outside our house. Still, I went out every day and pushed the baby coach all over town to get film or whatever we needed, and I wasn't afraid. It could be creepy, though.

"One night when David was out I saw a face at a window on the second floor, then after David got home we heard someone jump down. The next day a friend loaned David a shotgun, and we spent the night sitting on our blue velvet couch—which David still pines for—with him gripping this rifle. Another time we were in bed and heard people trying to bash in the front door downstairs, which they succeeded in doing. We had a ceremonial sword under the bed that my father had given us, and David pulled his boxer shorts on backward, grabbed the sword, ran to the top of the stairs, and yelled 'Get the hell out of here!' It was a volatile neighborhood, and a lot happened at that house."

Lynch didn't have a job when his daughter was born, nor was he looking for one when Rodger LaPelle and Christine McGinnis—graduates of the Academy and early supporters of Lynch's art—offered him a job making prints in a shop where they produced a successful line of fine-art etchings. McGinnis's mother, Dorothy, worked at the printshop, too, and LaPelle recalled, "We all had lunch together every day, and the only thing we talked about was art."[6]

The strongest paintings Lynch made during his time in Philadelphia were produced during the final two years that he lived there. Lynch had seen and been impressed by an exhibition of work by Francis Bacon, which ran from November through December of 1968 at the Marlborough-Gerson Gallery in New York. He wasn't alone in his admiration, and Maitland said that "most of us were influenced by Bacon then, and I could see Bacon's influence on David

at the time." Bacon is inarguably there in the paintings Lynch completed during this period, but his influence is largely subsumed by Lynch's vision.

As is the case with Bacon's work, most of Lynch's early pictures are portraits, and they employ simple vertical and horizontal lines that transform the canvases into proscenium stages, which serve as the setting for curious occurrences. The occurrences in Lynch's pictures are the figures themselves. Startling creatures that seem to have emerged from loamy soil, they're impossible conglomerations of human limbs, animal forms, and organic growths that dissolve the boundaries customarily distinguishing one species from the next; they depict all living things as parts of a single energy field. Isolated in black environments, the figures often appear to be traveling through murky terrain that's freighted with danger. *Flying Bird with Cigarette Butts* (1968) depicts a figure hovering in a black sky with a kind of offspring tethered to its belly by a pair of cords. In *Gardenback* (1968–1970), an eagle seems to have been grafted onto human legs. Growths sprout from the rounded back of this figure, which walks in profile and has a breastlike mound erupting from the base of the spine.

It was during the late 1960s that Lynch made these visionary paintings, and although the latest Beatles album was usually on permanent rotation on the turntable at home, the deeper waters of the counterculture were of little interest to him. "David never did drugs—he didn't need them," Reavey recalled. "A friend once gave us a lump of hash and told us we should smoke it and then have sex. We didn't know what we were doing, so we smoked all of it, sitting there on the blue velvet couch, and we could barely crawl upstairs by the time we were done. Drinking was never a huge thing in our lives, either. My dad used to make this thing he called 'the Lynch Special' out of vodka and bitter lemon that David liked, but that was about the extent of his drinking."

"I never saw David intoxicated other than at my wedding, where everybody was falling-down drunk," said Maitland. "Later, I remember my mother saying, 'Your friend David was jumping up and down on my nice yellow couch!' It's probably the only time David's been that drunk."

With encouragement from Bushnell Keeler, Lynch applied for a $7,500 grant from the American Film Institute in Los Angeles and submitted *The Alphabet,*

along with a new script he'd written called *The Grandmother,* as part of his application. He received $5,000 to make *The Grandmother,* the story of a lonely boy who's repeatedly punished by his cruel parents for wetting the bed. A thirty-four-minute chronicle of the boy's successful attempt to plant and grow a loving grandmother, the film starred Lynch's co-worker Dorothy McGinnis as the grandmother. Richard White, a child from Lynch's neighborhood, played the boy, and Robert Chadwick and Virginia Maitland played the parents.

Lynch and Reavey transformed the third floor of their house into a film set, and Reavey recalled "trying to figure out how to paint the room black and still define the shape of a room; we ended up using chalk at the joints where the ceiling meets the wall." The creation of the set also called for the elimination of several walls, and "That left a big mess," she said. "I spent lots of time filling little plastic bags with plaster and putting them in the street to be picked up. Big bags would've been too heavy, so we used little bags that had ties on them like bunny ears. One day we were looking out the window when the trash guys came, and David was falling down laughing because we'd filled the street with these little bags and it looked like a huge flock of rabbits."

Maitland said that her participation in *The Grandmother* began with an overture from Reavey. "Peggy said, 'Do you want to do this? He'll pay you three hundred dollars.' I have strong memories of being in their house and how bleak it was the way he had it set up. David had us put rubber bands around our faces to make us look strange and made all of our faces up with white. There's a scene where Bob and I are in the ground buried up to the neck, and he needed a place where he could dig deep holes, so we shot that scene at Eo Omwake's parents' house in Chadds Ford, Pennsylvania. David dug the holes, which we got into, then he covered us up with dirt, and I remember being in the ground for what seemed like *way* too long. But that's the thing about David that makes him so great—he was an incredible director, even then. He could get you to do anything, and he'd do it in the nicest way."

A crucial element of *The Grandmother* fell into place when Lynch met Alan Splet, a kind of freelance genius of sound. "David and Al getting together was a cool thing—they just really clicked," said Reavey. "Al was an eccentric, sweet guy who'd been an accountant for Schmidt's Brewery, and he was just naturally gifted with sound. He had the red beard, red hair, and intense eyes of Vincent van Gogh and was skinny as a pencil and blind as a bat, so he

couldn't drive and had to walk everywhere, which was fine with him. He was a totally uncool dresser who always wore these cheap short-sleeved shirts and was a wonderful cellist. When he was living with us in L.A., we'd sometimes come home and he'd be blasting classical music on the record player and sitting there conducting."

Lynch discovered that existing libraries of sound effects were inadequate for the needs of *The Grandmother,* so he and Splet produced their own effects and created an unconventional soundtrack that's vital to the film. *The Grandmother* was almost completed in 1969 when the director of the American Film Institute, Toni Vellani, took a train from Washington, D.C., to Philadelphia for a screening; he was excited by the film and vowed to see to it that Lynch was invited to be a fellow at the AFI's Center for Advanced Film Studies for the fall semester of 1970. "I remember David had a brochure from the AFI and he used to just sit and stare at it," Reavey recalled.

Vellani kept his word, and in a letter to his parents dated November 20th, 1969, Lynch said, "We feel that a miracle has occurred for us. I will probably spend the next month trying to get used to the idea of being so lucky, and then after Christmas Peggy and I will 'roll 'em' as they say in the trade."

Philadelphia had worked its strange magic and exposed Lynch to things he hadn't previously been familiar with. Random violence, racial prejudice, the bizarre behavior that often goes hand in hand with deprivation—he'd seen these things in the streets of the city and they'd altered his fundamental worldview. The chaos of Philadelphia was in direct opposition to the abundance and optimism of the world he'd grown up in, and reconciling these two extremes was to become one of the enduring themes of his art.

The ground had been prepared for the agony and the ecstasy of *Eraserhead,* and Lynch headed for Los Angeles, where he'd find the conditions that would allow the film to take root and grow. "We sold the house for eight thousand dollars when we left," said Reavey. "We get together now and talk about that house and that blue couch we bought at the Goodwill—David gets so excited talking about the stuff we got at the Goodwill. He'll say, 'That couch was twenty dollars!' For some reason Jack was in jail the day before we left Philadelphia, so he couldn't help us move it. David still says, 'Damn it! We should've brought that couch with us!'"

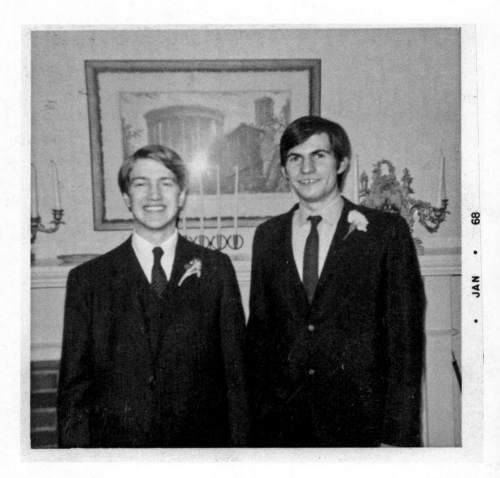

JAN • 68

I KNEW NOTHING ABOUT politics or the conditions in Philadelphia before I went there. It's not that I didn't care—I just didn't know, because I wasn't into politics. I don't think I even voted in those days. So I got accepted at the Academy and I got on a bus and went up there, and it was fate that I wound up at that school. Jack and I didn't go to classes— the only reason we were in school was to find like-minded souls, and we found some, and we inspired each other. All the students I hung out with were serious painters, and they were a great bunch. Boston was a bad bunch. They just weren't serious.

My parents supported me as long as I was in school, and my dear dad never disowned me, but there's some truth to Peggy and Eo Omwake saying I was a little depressed when I first got to Philadelphia. It wasn't exactly depression—it was more like a melancholy, and it didn't have anything to do with the city. It was like being lost. I hadn't found my way yet and maybe I was worried about it.

I went there at the end of 1965 and stayed with Jack in his little room. When I got there Jack had a puppy named Five, so there was newspaper all over the floors because he was housebreaking him. When you walked around the place there was the sound of rustling newspaper. Five was a great dog and Jack had him for many years. Next door to us was the Famous Diner, which was run by Pete and Mom. Pete was a big guy and Mom was a big gal who had weird yellow hair. She looked like the picture of the woman on the bags of flour—you know, the blue-apron waitress thing. The Famous Diner was a train-car diner, and it had a long counter and booths along the wall and it was so fantastic. They'd deliver the jelly donuts at five-thirty in the morning.

Jack's place was small so we needed to move, and we found a place at 13th and Wood. We moved on New Year's Eve and I remember moving like it was yesterday. It was around one in the morning and we moved with a shopping cart. We had Jack's mattress and all his stuff in there, and I just had one bag of stuff, and we were pushing the cart along and we passed this happy couple, drunk probably, and they said, "You're moving on New Year's Eve? Do you need any money?" I yelled back, "No, we're rich!" I don't know why I said that, but I felt rich.

Our place was like a storefront, and in the back was a toilet and wash-basin. There was no shower or hot water, but Jack rigged up this stainless-steel coffee maker that would heat up water and he had the whole first floor, I had a studio on the second floor next to this guy Richard Childers, who had a back room on the second floor, and I had a bedroom in the attic. The window in my bedroom was blown out so I had a piece of plywood sitting in there, and I had a cooking pot I'd pee in then empty out into the backyard. There were lots of cracks in my bedroom walls, so I went to a phone booth and ripped out all the white pages—I didn't want the yellow pages, I wanted the white pages. I mixed up wheat paste and papered the entire room with the white pages, and it looked really beautiful. I had an electric heater in there, and one morning James Havard came to wake me up and give me a ride to school and the ply-wood had blown out of the window, so there was a mound of fresh snow on the floor in my room. My pillow was almost on fire because I had the heater close to my bed, so he maybe saved my life.

James was the real deal. He was older and he was a great artist and he worked constantly. You know the word "painterly"? This guy was paint-erly. Everything he touched had this fantastic, organic painterly thing, and James had a lot of success. Six or seven of us went to New York once because James was in a big show way uptown. By the end of the opening we were all drunk and we had to go way downtown, and I don't know if I was driving, but I remember this as if I was driving. It was one or two in the morning and we hit every single green light from way uptown all the way to the bottom of the city. It was incredible.

Virginia Maitland turned out to be a serious painter, but I sort of re-member her as a party girl. She was out in the street one day and there was a young man whistling bird calls on the corner. She took him home

and he did bird calls in her living room and she liked that so she kept him, and that was Bob Chadwick. Bob was a machinist and his boss loved him—Bob could do no wrong. He worked at this place that had a thirty-five-foot lathe with ten thousand different gears to do complicated cuttings, and Bob was the only one who could run it. He just intuitively knew how to do things. He wasn't an artist, but he was an artist with machines.

Our neighborhood was pretty weird. We lived next door to Pop's Diner, which was run by Pop and his son Andy, and I met a guy at Pop's who worked in the morgue, and he said, "Anytime you want to visit, just let me know and ring the doorbell at midnight." So one night I went over there and rang the bell and he opened the door, and the front was like a little lobby. It had a cigarette machine, a candy machine, old forties tile on the floor, a little reception area, a couch, and this corridor that led to a door into the back. He opened that door and said, "Go on in there and make yourself at home," and there was nobody working back there, so I was alone. They had different rooms with different things in them, and I went into the cold room. It was cold because they needed to preserve the bodies, and they were in there stacked up on these bunk-bed-type shelves. They'd all been in some kind of accident or experienced some violence, and they had injuries and cuts—not bleeding cuts, but they were open wounds. I spent a long time in there, and I thought about each one of them and what they must've experienced. I wasn't disturbed. I was just interested. There was a parts room where there were pieces of people and babies, but there wasn't anything that frightened me.

One day on the way to the White Tower to get lunch, I saw the smiling bags of death at the morgue. When you walked down this alley you'd see the back of the morgue opened up, and there were these rubber body bags hanging on pegs. They'd hose them out and water and body fluids would drip out, and they sagged in the middle so they were like big smiles. Smiling bags of death.

I must've changed and gotten kind of dirty during that period. Judy Westerman was at the University of Pennsylvania then and I think she was in a sorority, and one time Jack and I got a job driving some paintings up there. I thought, Great, I can see Judy. So we go up there and deliver this stuff, then I go to her dormitory and walk in and this place

was so clean, and I was in art school being a bum, and all the girls are giving me weird looks. They sent word to Judy that I was there, and I think I embarrassed her. I think they were saying "Who the hell is that bum over there?" But she came down and we had a really nice talk. She was used to that part of me, but they weren't. That was the last time I ever saw Judy.

We once had a big party at 13th and Wood. The party's going on and there's a few hundred people in the house, and somebody comes up to me and says, "David, so-and-so's got a gun. We gotta get it from him and hide it." This guy was pissed off at somebody, so we got his gun and hid it in the toilet—I grew up with guns, so I'm comfortable around them. There were lots of art students at this party, but everybody wasn't an art student, and there was one girl who seemed a little bit simple, but she was totally sexy. A beautiful combo. It must've been winter, because everybody's coats were on my bed in the attic, so when somebody was leaving I'd go up and get their coat. One time I go to my room and there on my bed, against a kind of mink coat, is this girl with her pants pulled down, and she'd obviously been taken advantage of by someone. She was totally drunk and I helped her up and got her dressed, so that was going on at this party, too.

It was pretty packed and then the cops show up and say, "There's been a complaint; everybody's got to go home." Fine, most everybody left, and there were maybe fifteen people still hanging around. One guy was quietly playing acoustic guitar, it was real mellow, and the cops come back and say, "We thought we told you all to leave." Just then this girl named Olivia, who was probably drunk, walks up to one of the cops and gives him the finger and says, "Why don't you go fuck yourself." "Okay, everybody in the paddy wagon," and there was one parked out front and everybody got in—me, Jack, Olivia, and these other people—and they drive us to the police station. In interrogation they find out that Jack and I are the ones who live at the house, so we're arrested as proprietors of a disorderly house and put in jail. Olivia was the one who mouthed off, so she goes to the women's jail. Jack and I get put in a cell and there are two transvestites—one named Cookie in our cell, and another one down the way—and they talked to each other all night. There was a murderer—he had the cot—and at least six other people in the cell. The next morning

we go before the judge and a bunch of art students came and bailed us out.

We got to Philadelphia just before hippies and pigs and stuff like this, and cops weren't against us at first, even though we looked strange. But it got bad during the time we were there because of the way things were going in the country. Richard had a truck, and one night I went with him to a movie. When we were driving home Richard looked in the rearview mirror and there was a cop behind us. We were approaching an intersection and when the light turned yellow Richard stopped, which I guess tipped off the cops that we were nervous. So the light turns green and we go through the intersection and the sirens and the lights go on. "Pull over!" Richard pulls over to this wide sidewalk next to a high rock wall. This cop walks around to the front of our car and he's standing in the headlights and he puts his hand on his gun and says, "Get out of the truck!" We get out of the truck. He says, "Hands against the wall!" We put our hands against the wall. They start frisking Richard, and I thought, They're frisking Richard, not me, so I lowered my arms and immediately this hand slammed me into the wall. "Hands against the wall!" Now there's a paddy wagon and like twenty cops, and they put us in the paddy wagon and we're riding along in this metal cage. We hear somebody talking over the cop radio describing two guys and what they're wearing, and Richard and I look at each other and realize we look exactly like the guys being described. We get down to the station and in comes this old man holding a bloody bandage to his head, and they bring him over to us and he looks at us, then says, "No, these aren't the guys," and they let us go. That made me really nervous.

I'm quoted saying that I like the look of figures in a garden at night, but I don't really like gardens except for a certain kind. I once did a drawing of a garden with electrical motors in it that would pump oil, and that's what I like—I like man and nature together. That's why I love old factories. Gears and oil, all that mechanical engineering, great big giant clanging furnaces pouring molten metal, fire and coal and smokestacks, castings and grinding, all the textures and the sounds—it's a thing that's just gone, and everything's quiet and clean now. A whole kind of life

disappeared, and that was one of the parts of Philadelphia that I loved. I liked the way the rooms were in Philadelphia, too, the dark wood, and rooms with a certain kind of proportions, and this certain color of green. It was kind of a puke green with a little white in it, and this color was used a lot in poor areas. It's a color that feels old.

I don't know if I even had an idea when I started *Six Men Getting Sick*—I just started working. I called around and found this place called Photorama, where 16mm cameras were way cheaper than other places. It was kind of sleazy, but I went and rented this Bell and Howell windup camera that had three lenses on it, and it was a beautiful little camera. I shot the film in this old hotel the Academy owned, and the rooms there were empty and gutted, but the hallways were filled with rolled-up Oriental carpets and brass lamps and beautiful couches and chairs. I built this thing with a board, like a canvas, propped on top of a radiator, then I put the camera across the room on top of a dresser that I found in the hallway and moved into the room. I nailed the dresser to the floor to make sure the camera didn't move at all.

I have no idea what gave me the idea to do the sculpture screen. I don't think the plastic resin burst into flame when I mixed it, but it did get so hot it steamed like crazy. You mixed this stuff in these paper containers, and I loved mixing it hot. The paper would turn brown and scorch and it would heat so much that you'd hear it crackling and you'd see these gases just steaming out of this thing. When the film was done I built this kind of erector-set structure to take the film up to the ceiling and back down through the projector, and I had a tape recorder with a siren on a loop that I set on the stage. It was in a painting and sculpture show, and the students let me turn the lights off for fifteen minutes out of every hour, and that's pretty damn good.

Bart Wasserman was a former Academy student whose parents died and left him a lot of money, and when he saw *Six Men Getting Sick* he told me he wanted to give me a thousand dollars to make a film installation for his house. I spent two months working on this film for Bart, but when it was developed it was nothing but a blur. Everybody said I was really upset when that film didn't come out, so I probably was, but almost immediately I started getting ideas for animation and live action. I

thought, This is an opportunity and there's some reason this is happening, and maybe Bart will let me make that kind of film. I called Bart and he said, "David, I'm happy for you to do that; just give me a print." I later met Bart's wife in Burgundy, France—she moved over there—and she told me Bart never did an altruistic thing in his life except for the thing he did for me. That film not coming out ended up being a great doorway to the next thing. It couldn't have been better. I never would've gotten a grant from AFI if that hadn't happened.

The film I made with the rest of Bart's money, *The Alphabet*, is partly about this business of school and learning, which is done in such a way that it's kind of a hell. When I first thought of making a film, I heard a wind and then I saw something move, and the sound of the wind was just as important as the moving image—it had to be sound and picture moving together in time. I needed to record a bunch of sounds for *The Alphabet*, so I went to this lab, Calvin de Frenes, and rented this Uher tape recorder. It's a German tape recorder, a real good recorder. I recorded a bunch of stuff then realized that it was broken and was distorting these sounds—and I was loving it! It was incredible. I took it back and told them it was broken, so I got it for free, and I got all these great sounds, too. Then I took everything into Bob Column at Calvin de Frenes, and he had a little four-track mixing console and I mixed it there with Bob. This mixing and getting stuff in sync was magical.

Before I got together with Peggy, I'd have brief relationships with people then move on. I dated a girl named Lorraine for a while, and she was an art student who lived with her mother in the suburbs of Philadelphia. Lorraine looked Italian and she was a fun girl. We'd be at her mom's house and all three of us would go down to the basement and open up the freezer and pick out a TV dinner. This freezer was packed with all different kinds of TV dinners, and her mom would heat 'em up for us. You just put them in the oven and pretty soon you've got a dinner! And they were good! Lorraine and her mom were fun. Lorraine ended up marrying Doug Randall, who took some still photos for me on *The Grandmother*. There was also this girl Margo for a while, and a girl

named Sheila, and I really liked Olivia, the girl who got arrested, but she wasn't really my girlfriend. There's a film called *Jules and Jim*, and Olivia and Jack and I were kind of like that—we'd go places together.

Peggy was the first person I fell in love with. I loved Judy Westerman and Nancy Briggs, but they didn't have a clue about what I did at the studio and were destined to live a different kind of life. Peggy knew everything and appreciated everything and she was my number-one fan. I didn't know how to type and Peggy typed my scripts, and she was incredible to me, so incredible. We started out being friends and we'd sit and talk at the drugstore next to the Academy and it was great.

One day Peggy told me she was pregnant, and one thing led to another and we got married. The only thing I remember about our wedding is that Jack wore a taxicab-driver shirt to it. I loved Peggy but I don't know that we would've gotten married if she hadn't been pregnant, because marriage doesn't fit into the art life. You'd never know I think that, though, because I've been married four times. Anyhow, a few months later Jennifer was born. When Jen was born fathers were never in the delivery room, and when I asked if I could go in, the guy looked at me funny. He said, "I'll watch you and see how you do," so he took blood from Peggy and I didn't pass out, and she puked up a bunch of stuff and that didn't bother me, so he said, "You're good to come in." So I scrubbed up and in I went. It was good. I wanted to see it just to see. Having a child didn't make me think, Okay, now I've got to settle down and be serious. It was like . . . not like having a dog, but it was like having another kind of texture in the house. And babies need things and there were things I could contribute. We heard that babies like to see moving objects, so I took a matchbook and bent all the matches in different directions and hung it from a thread, and I'd dangle this thing in front of Jen's face and spin it, like a poor man's mobile. I think it boosted her IQ, because Jen's so smart!

I always felt that the work was the main thing, but there are fathers now who love spending time with their children and go to school functions and all that. That wasn't my generation. My father and mother never went to our baseball games. Are you kidding me? That was *our* thing! What are they going to go for? They're supposed to be working

and doing *their* thing. This is *our* thing. Now all the parents are there, cheering their kids on. It's just ridiculous.

Not long before Jen was born, Peggy said, "You gotta go and see Phyllis and Clayton's house. They've got a setup that's unbelievable." So I rode my bike over to see this artist couple we knew and they were living in this huge house. Both of them were painters and each of them had their own floor to work in, and they showed me around and I said, "You guys are so lucky—this is great." Phyllis said, "The house next door is for sale," so I went and looked at this place and it was a corner house that was even bigger than their house. There was a sign with the name of the real estate company, so I rode over to Osakow Realty and introduced myself to this nice plump lady in a little office and she said, "How can I help you?" I said, "How much is that house at 2416 Poplar?" and she said, "Well, David, let's take a look." She opened up the book and said, "That house is twelve rooms, three stories, two sets of bay windows, fireplaces, earthen basement, oil heat, backyard, and tree. That house is three thousand, five hundred dollars, six hundred dollars down." I said, "I'm buying that house," and we did. It was right on the borderline between this Ukrainian neighborhood and a black neighborhood, and there was big, big violence in the air, but it was the perfect place to make *The Grandmother* and I was so lucky to get it. Peggy and I loved that house. Before we bought the place it had been a communist meeting house, and I found all kinds of communist newspapers under the linoleum flooring. The house had kind of a softwood floor, and they'd put newspaper down then put linoleum on top of the newspaper. This linoleum was really old, so I was breaking it up and throwing it away and one day I was working at the front of the house and I hear this noise like the sound of many waters. It was weird, something really unusual. I opened the blinds and looked out and there were ten thousand marchers coming down the street, and it freaked me out. That was the day Martin Luther King was killed.

We didn't go to the movies a lot. Sometimes I would go to the Band Box, which was the art house where I saw French new wave and all that for the first time, but I didn't go there much. And even if I was in the middle of making a film, I wasn't ever thinking I'm in that world. Not in

a million years! My friend Charlie Williams was a poet, and when he saw *The Alphabet*, I said to Charlie, "Is this an art film?" He said, "Yes, David." I didn't know anything. I did love *Bonnie and Clyde*, although that's not why I started wearing an open-road Stetson panama-style hat. I started wearing one just because I found one at the Goodwill. When you take those hats off you sort of pinch the front of the brim, so they start coming apart. The Stetsons I was buying were already old, so the straw would break and pretty soon there would be a hole there. There are lots of pictures of me in hats with holes in them. I had two or three of them and I loved them.

The Goodwill in Philadelphia was incredible. Okay, I need some shirts, right? I go down Girard Avenue to Broad Street and there's the Goodwill and they've got racks of shirts. Clean. Pressed. Some even starched! Mint. Like brand-new! I'd pick out three shirts, take them up to the counter: How much is this? *Three dimes.* I was into medical lamps, and this Goodwill had lamps that had all kinds of adjustments and different things, and I had fifteen medical lamps in our living room. I left them in Philadelphia because Jack was supposed to help pack the truck I drove out to Los Angeles, but he worked in a porno place that was busted and he was in jail the day we were loading the truck. It was just my brother and Peggy and me loading, and some good stuff got left behind.

When I got with Peggy, Jack moved into this place over an auto-body shop owned by a guy from Trinidad named Barker, and everybody loved Barker. He had legs like rubber and could crouch and then spring up, and he was built for auto-body work. One day he walked me past all these cars on racks to the very back of the place, where there was this old dusty tarp covering something. He pulls this tarp back and said, "I want you to have this car. This is a 1966 Volkswagen with hardly any miles on it. It was rear-ended and totaled, but I can fix this car and you can have it for six hundred dollars." I said, "Barker, that is great!" So he fixed it up and it was like brand-new—it even smelled new! It rode so solid and smooth and it was a dream car in mint condition. I loved that car. When I brushed my teeth in the second-floor bathroom, I'd look out the window and see it down there parked in the street and it was so beautiful. So I'm brushing my teeth one morning and I look out and I think, Where

did I park my car? It's not there. That was my first car and it was stolen. So I moved on to my second car. There was a service station at the end of the street where Peggy's family lived, and Peggy's father took me down there and said to the guy who ran the place, "David needs a car. What used cars do you have?" I got this Ford Falcon station wagon and it was a dream, too. It was three-on-the-tree, the plainest Ford Falcon station wagon there could be—it had a heater and a radio and nothing else, but it had snow tires on the back and it could go anywhere. I sort of fell in love with that car.

I had to wait for the license plate for the Ford Falcon to come in the mail, so I decided to make one for the meantime. The license plate was a really fun project. I cut some cardboard, and it was a good piece of cardboard that was the same thickness as a license plate. I cut it in exactly the shape of a real license, then went to a car and measured the height of the letters and numbers, and looked at the colors, and made a Day-Glo registration sticker. The problem was that the license I copied had either all letters or all numbers, and my license had letters *and* numbers, and I later learned that letters and numbers aren't the same height. So this rookie cop spots my license as a fake because everything was the same height, and this cop was a hero at the precinct for spotting this thing. So cops came to the door and Peggy was crying—it was serious! They came back later and wanted the license plate for the police museum. It was a fuckin' beautiful job! That was the first time a museum acquired my work.

One night I came home from a movie and went up to the second floor and started to tell Peggy about it, and her eyes are like saucers because someone is outside the bay window. So I go downstairs where our phone is, and our next-door neighbor Phyllis calls right then. She's a character and she's talking away until I interrupt her and say, "Phyllis, I've gotta hang up and call the police. Somebody was trying to break in." While I'm on the phone with her I see a pipe move, then I hear breaking glass, and I see someone outside the window and realize someone was in the basement, too—so there were two people. I don't remember sitting on the couch the next night with a gun like Peggy said—I don't think we ever had a gun at that place. But, yeah, these sorts of things happened there. Another time I'm sound asleep and I'm woken by Peggy's face like

two inches from mine. "David! There's somebody in the house!" I get up and put my underpants on backward and reach under the bed and get this ceremonial sword Peggy's father gave us, and I go to the head of the stairs and yell, "Get the hell out of here!" There were two black couples standing down there and they're looking at me like I'm totally fucking crazy, right? They'd come in to make love or party or something because they thought it was an abandoned house. They said, "You don't live here," and I said, "The hell I don't!"

By the time Jen was born I'd left school and I wrote that bullshit letter to the administration. Then I got a job. Christine McGinnis and Rodger LaPelle were both painters, but to make money Christine would knock out these animal engravings, and she had her mother, Dorothy, who was known as Flash, in there printing. It was the perfect job for me. Flash and I worked next to each other and there would be a little TV in front of us, and behind us were a hand press and some sinks. You'd start by inking the plate, then you'd take one of these used nylon socks Rodger would get and you'd fold it in a certain way, then you'd dance this nylon over the plate, hitting the mountains and leaving the valleys. Then you'd run a print on real good paper. While I was working in the shop, Rodger told me, "David, I'll pay you twenty-five dollars to paint on the weekends and I'll keep the paintings you make." After I moved to L.A. he would send me paper and pencils to do drawings for him, still paying me. Rodger was and is a friend to artists.

One afternoon I found a used Bolex with a beautiful leather case for four hundred fifty dollars that I wanted to buy at Photorama, but they said, "David, we can't put a hold on this camera. If someone comes in and wants it, we have to sell it. If you're here tomorrow morning with the money and it's still here, you can have it." I panicked because I didn't want anybody else to get this thing. I couldn't wake up in the morning in those days, so Jack and his girlfriend, Wendy, and I took amphetamines and stayed up all night, and I was at the store when they opened. I got the camera.

I did some great drawings on amphetamines. In those days girls were going to doctors and getting diet pills, and it's like they were giving out scoopfuls of these pills. They'd come home from the doctor with big bags of pills! I wasn't anti-drug. Drugs just weren't important to me. One

time Jack and I were going to go up to Timothy Leary's farm at Millbrook and drop acid and stay up there, but that turned out to be a pipe dream that lasted just a couple of days. We didn't go to the concert at Woodstock, but we did go to Woodstock. It was in the winter and we went up there because we'd heard about this hermit who lived there, and I wanted to see this hermit. Nobody could ever see him. He built this kind of mound place out of earth and rocks and twigs with little streamers on them, and when we went there it was covered with snow. He lived in there, and I think he had places he could peek out to see if someone was coming near him, but you couldn't see him. We didn't see him, but we felt him being there.

I don't know where the idea for *The Grandmother* came from. There's a scene where Virginia Maitland and Bob Chadwick come up out of holes in the ground, and I can't explain why I wanted them to come up out of the earth—it just had to be that way. It wasn't supposed to look real but it had to be a certain way, and I dug these holes and they got in them. When the scene opens you just see leaves and bushes, then all of a sudden out come these people. Bob and Ginger did great. They weren't really buried in there, and mostly they had to struggle out of leaves. Then Richard White comes out of his own hole and the two of them bark at him, and there are distorted close-ups of barking. I was doing some sort of stop motion, but I couldn't tell you how I did it. It was poor man's stuff but it worked for me. I always say that filmmaking is just common sense. Once you figure out how you want it to look, you kind of know how to do it. Peggy said things went my way when I was making those films, and that's sort of true. I could just find stuff. I'd just get it.

When it came time to do the sound for *The Grandmother*, I went and knocked on the sound department door at Calvin de Frenes and Bob opens the door and he says, "David, we have so much work that I had to hire an assistant, and you'll be working with my assistant, Alan Splet." My heart kind of dropped and I look over and see this guy—pale, skinny as a rail, old shiny black suit—and Al comes up wearing Coke-bottle glasses and smiles and shakes my hand, and I feel the bones in his arm rattle. That's Al. I tell him I need a bunch of sounds, so he played me some sound-effects records and said, "Something like this?" I said no. He plays another track and he says, "Maybe this?" I said no. This goes on for

a while, then he said, "David, I think we're going to have to make these sounds for you," and we spent sixty-three days, nine hours a day, making sounds. Like, the grandmother whistles, right? They hardly had any equipment at Calvin de Frenes and they didn't have a reverb unit. So Al got an air-conditioning duct that was thirty or forty feet long. We went to a place where I whistled into this duct and Al put a recorder at the other end. Because of the hollowness of the duct, that whistle was a little bit longer by the time it reached the other end. Then he'd play the recording through a speaker into the duct and record it again, and now the reverb is twice as long. We did that over and over until the reverb sounded right. We made every single sound and it was so much fun I cannot tell you. Then I mixed the thing at Calvin de Frenes, and Bob Column very seriously said, "David, number one, you can't take the film out of here until you pay your bill. Number two, if they charge an hourly rate your bill is going to be staggering. If they charge a ten-minute reel rate, it's going to be an incredibly good deal for you." He talked to the people he worked for and I got the ten-minute reel rate.

You had to submit a budget to the AFI to get a grant, and I wrote that my film would cost $7,119, and it ended up costing $7,200. I don't know how I did that, but I did. The original grant was for $5,000 but I needed $2,200 more to get the film out of Calvin, so Toni Vellani took the train from Washington, D.C. I picked him up at the train station and showed him the film and he said, "You got your money." While I was driving him back to the train station he said, "David, I think you should come to the Center for Advanced Film Studies in Los Angeles, California." That's like telling somebody, You have just won five hundred trillion dollars! Or even greater than that! It's like telling somebody, You're going to live forever!

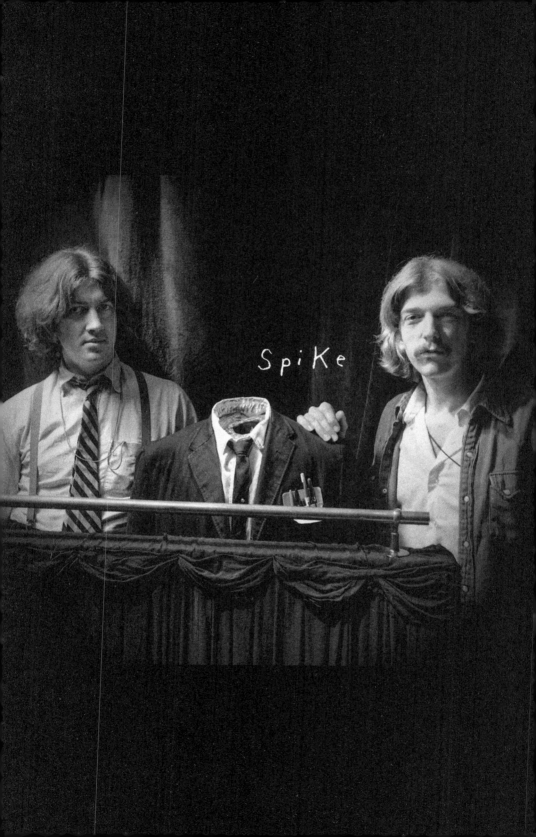

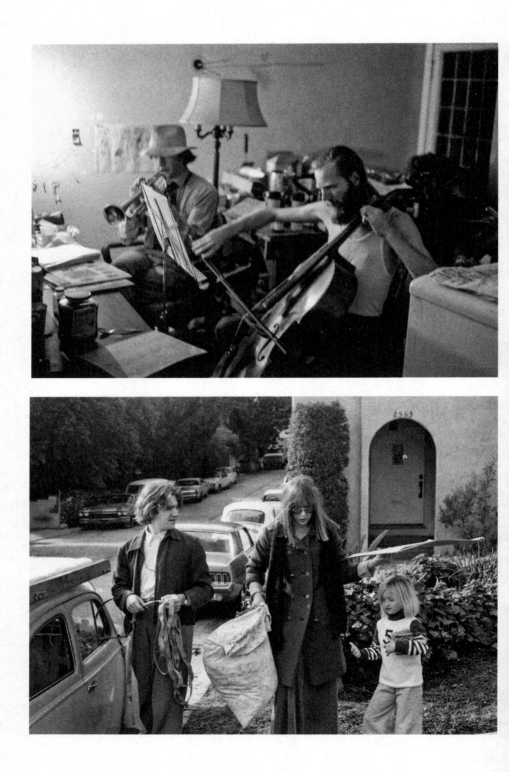

When Lynch left Philadelphia to attend the American Film Institute in Los Angeles in 1970, it was like stepping out of a dark closet into shimmering sunshine. At the time the AFI was housed in Greystone Mansion, a lavish fifty-five-room Tudor Revival–style residence situated on eighteen acres of land, which was built in 1928 by oil baron Edward Doheny. Acquired by the city of Beverly Hills in 1965 to prevent it from being demolished, Greystone Mansion was leased to the AFI from 1969 through 1981 for one dollar a year in the hopes that the school would restore and maintain the property. Founded by George Stevens, Jr., the American Film Institute was directed by Toni Vellani from 1968 through 1977; it was these two who recognized Lynch's talent and brought him to the school.

John Lynch graduated from Cal Poly, San Luis Obispo, shortly before his brother moved west, so he drove to Philadelphia, helped him pack his belongings into a yellow Hertz truck, and left his car in the backyard of a friend of David's so he could accompany him on the drive to Los Angeles. "At the last minute Jack Fisk decided to come along with his dog, so it was three guys and a dog, and we had a good time," recalled John Lynch.

Vellani and Stevens had been so impressed by Alan Splet's work on *The Grandmother* that they'd made him head of the AFI's sound department. Splet moved to L.A. in July and was already settled in when Lynch arrived in late August to stay with him. After spending two weeks sorting out living arrangements, Lynch and his brother headed to Berkeley to visit their parents—who lived there for a brief period—and collect Peggy and Jennifer.

"David's father gave us two hundred fifty dollars a month for two years, which was how long it was supposed to take to graduate from the AFI, and the rent on our house was two twenty a month," Reavey recalls. "Our place wasn't

big but it had lots of little rooms, and our part of the rent was eighty dollars because we had all these people living with us." The Lynch house was flanked by three-story apartment buildings—"one of them blasted the Jackson 5's 'I'll Be There' for hours at a time," said Reavey—"and we found an old washing machine that we installed on the back porch. We didn't have a dryer, so there was usually wash hanging out back."

Fisk's sister Mary was in and out of the picture in L.A. during the early 1970s, too. She wanted to live near her brother, who'd relocated to L.A. shortly after Lynch settled there, so after training to be an airline stewardess for Pan American Airways, she moved to L.A. and rented the place next door to the Lynches.

Lynch began classes on September 25th, joining the members of the AFI's first graduating class, which included filmmakers Terrence Malick, Caleb Deschanel, Tim Hunter, and Paul Schrader. At that point the school curriculum largely revolved around watching films and discussing them, and of particular importance to the thirty students in Lynch's class were studies in film analysis taught by Czechoslovakian filmmaker Frank Daniel. Daniel came to the United States in 1968 under the agency of George Stevens, Jr., who sent plane tickets to him and his family when the Soviets invaded Czechoslovakia, and he's cited by many AFI alumni as an inspiring presence. It was Daniel who devised what's known as the sequencing paradigm for screenwriting, which advocates devising seventy elements relating to specific scenes, writing each of them on a note card, then organizing the note cards in a coherent sequence. Do this and you'll have a screenplay. It's a simple idea that proved useful to Lynch.

The AFI was a loose, freewheeling place, but being a fellow was not without pressure; students were expected to find their own way, and Lynch spent much of his first year struggling to find a direction. "He'd been working on the script for *Gardenback,* which was a film about infidelity inspired by a painting he made in Philadelphia, but that wasn't what he was feeling in his heart," said Reavey, "so he couldn't get anywhere with it."

Frank Daniel and Caleb Deschanel were fans of *Gardenback,* and Deschanel took the script to a producer friend at Twentieth Century Fox who offered Lynch fifty thousand dollars to expand the forty-page treatment into a full-length feature. Lynch participated in a series of writing sessions with Daniel, Vellani, and writer Gill Dennis, but by the time he'd arrived at a feature-length

script he'd lost interest in the project, and he abandoned it in late spring of 1971.

Then, over the summer months, *Eraserhead* began to crystallize in his mind. Lynch has commented that "I *felt* Eraserhead, I didn't think it," and anyone who fully surrenders to the film understands what he means. Much has been made of the queasy humor of *Eraserhead,* but to focus on its comical aspects is to give a superficial reading of a multi-layered work. A magisterial film that operates without filters of any sort, *Eraserhead* is pure id. The narrative of the movie is simple. Living in a dismal, post-industrial dystopia, a young man named Henry Spencer meets a girl named Mary, who becomes pregnant. Henry is gripped with anxiety at the arrival of their deformed infant and longs for release from the horror he feels. He experiences the mystery of the erotic, then the death of the child, and, finally, the divine intercedes and his torment ends. In a sense, it's a story about grace.

Lynch's screenwriting style is direct and clear, and the *Eraserhead* script has the rigor and exactitude of a Beckett play. Just twenty-one pages long, it has a minimum of stage direction and mostly focuses on evocative description; it's apparent that the film's mood—palpable and slightly sinister—was of primary importance to Lynch. The first half of the movie we've come to know matches the script pretty much word for word; however, the narrative in the second half of the film differs significantly from the script. In Lynch's original vision, the film concluded with Henry being devoured by the demonic baby. This doesn't occur in the film; rather, a new character is introduced in the third act and she transforms the conclusion of the story. Lynch experienced a spiritual awakening over the five years *Eraserhead* was in production, and it makes sense that the film changed along the way.

"*Eraserhead* is about karma," said Jack Fisk, who plays a character called the Man in the Planet. "I didn't realize it when we were working on it, but the Man in the Planet is pulling levers that symbolize karma. There are so many spiritual things in *Eraserhead,* and David made it before he started meditating. David's always been that way, and he's gotten more spiritual over time."

Lynch himself has said that "*Eraserhead* is my most spiritual film, but no one has ever gotten that from it. The way it happened was I had these feelings, but I didn't know what it really was about for me. So I get out the Bible and start reading, and I'm reading along, reading along, and I come to this sentence and I say, 'That's exactly it.' I can't say which sentence it is, though."

When Lynch returned to the AFI in September of 1971, he found that he'd been assigned to classes with first-year students and was furious at the school. He was preparing to quit altogether when he received an enthusiastic go-ahead to make *Eraserhead,* so he decided to stick around. His film needed funding, but the financial politics at the AFI were at a weird juncture at that point. The previous year the school had given a substantial sum to student Stanton Kaye to complete *In Pursuit of Treasure,* which was to be the first feature produced by the AFI. A lot of money was spent on Kaye's film, which was never finished and was deemed a complete failure, and the prospect of financing another student feature was anathema to the AFI for quite a while afterward. This wasn't a problem for Lynch, whose minimal script for *Eraserhead* appeared to be for a short, so the school committed ten thousand dollars to the film, which went into pre-production as 1971 wound to a close.

Nestled below the main mansion at the AFI was a complex of abandoned servants' quarters, garages, a greenhouse, stables, and a hayloft; Lynch planted his flag among these crumbling brick buildings and created a modest studio he was to occupy for the next four years. There was a camera room, a bathroom, a food room, an editing area, a green room, and a vast loft where the sets were housed. There was privacy, too; the school gave Lynch access to its equipment and left him in peace to make his movie.

In assembling his cast and crew, Lynch looked first to trusted friends and asked Splet, Fisk, and Herb Cardwell, a director of photography who'd worked at Calvin de Frenes, to participate. A significant member of the crew fell into place when Doreen Small took the job of production manager. Born and raised in New York, Small visited friends in Topanga Canyon in 1971, then rented a place in Laurel Canyon. Shortly after she'd moved in, her landlord, James Newport, mentioned that he was assisting Jack Fisk on the blaxploitation film *Cool Breeze* and they needed assistants. "I ran around getting props and costumes," Small recalled, "then Jack said, 'I have a friend at the AFI who needs help. Would you go and meet David?'

"So I went to the stables and met David," she continued. "He was wearing three neckties, a panama hat, a blue oxford shirt with no elbows, baggy khaki pants, and work boots. He was very pretty and it was immediately clear he was a unique individual—everybody who met David saw that spark. He told me that what he really needed was a production manager, and asked, 'Can you do that?' and I said 'Sure.' Then he said, 'I need a script supervisor, too; can you

do that?' I said, 'Sure,' and he bought me a stopwatch so I could do continuity."[1]

Shortly after meeting Lynch, Small was at a party in Topanga and was introduced to Charlotte Stewart, who was a prominent young television actress at the time. The two decided to rent a place together and were roommates for the next two years. "Doreen knew David needed an actress for his film, so she invited him to dinner in Topanga, which was a pretty rural area back then," Stewart recalled. "I open the door and here stands this guy and Peggy, and he's this eager young man. He had a sack of wheat seeds in his hand, which he handed to me, and I thanked him, but I'm thinking, What the hell? I guess he figured, Hey, they live in the country—maybe they'd like to plant some wheat.

"At dinner he seemed like a nice person, and he seemed very young," she continued. "He brought the script for Eraserhead, and I thumbed through it and didn't understand a word of it—as far as I could tell it was something about a young couple and a baby who wasn't really a baby. There wasn't much dialogue, and I thought, Fine, I can do this in a few weeks."[2]

Lynch was looking for his leading man when he met Catherine Coulson and Jack Nance. Coulson and her family moved to California from Illinois when her father was hired to run a radio station in Riverside, and she made her radio debut there at the age of four on a local broadcast called Breakfast with the Coulsons. She was an art history major at Scripps College in Claremont, and by the time Coulson enrolled in graduate school at San Francisco State, the focus of her life had shifted to theater. In 1967, members of the Dallas Theater Center were artists in residence at San Francisco State, and among the company was actor Jack Nance. Coulson and Nance became a couple, and after marrying in La Jolla, California, in 1968, they became members of David Lindeman's Interplayers Circus, a theater company founded by Lindeman, who briefly attended the AFI in 1971. Lindeman mentioned to Lynch that Nance might be good for the part of Henry Spencer, and Lynch agreed Nance was perfect.

A few actors with small parts in Eraserhead came through Coulson, and several other cast members—including Judith Roberts (Beautiful Girl Across the Hall), Allen Joseph (Mr. X), and Jeanne Bates (Mrs. X)—were members of the repertory company Theater West. Bates was a seasoned veteran of movies and television and was well into her fifties when she was cast in Eraser-

head. Lynch was nonetheless worried that she was too pretty for the role, so he fashioned a mole sprouting a single hair for her face. Like most people who met Lynch, Bates was enchanted by him. "I remember Jeanne sitting there patiently while he applied this ugly mole to her face," Small said. "David was working with very experienced actors, and from the start they thought he was a genius and trusted him."

The cast for the film fell into place fairly quickly; creating the realm where *Eraserhead* takes place demanded a good deal more, and this is where Lynch's genius really became evident. Largely built out of scavenged materials, Henry's world is some kind of miracle in that Lynch did so much with so little. Everything was repurposed and repeatedly reused to create meticulously built sets that included an apartment, a lobby, a theater stage, a pencil factory, a suburban home, an office, and a front porch. Lynch and Splet soundproofed the sets with blankets and fiberglass insulation in burlap bags, and Lynch rented the equipment he needed for special sequences. *Eraserhead* includes several complex effects shots, and answers to technical questions often involved cold calls to effects people at local studios. Lynch is a practical person who enjoys problem-solving, and he learned through trial and error.

Doreen Small scoured flea markets and thrift stores for clothing and props, and Coulson and Nance emptied their own living room to furnish the lobby of Henry's apartment. A particularly valuable resource was Coulson's aunt, Margit Fellegi Laszlo, who lived in a seventeen-room house in Beverly Hills. A designer for bathing-suit company Cole of California, Laszlo had a basement full of stuff, and Coulson and Lynch often dug through it looking for props. "That's where we found the humidifier for the baby," Coulson recalled.[3]

The props list for *Eraserhead* included things considerably more offbeat than a humidifier. "David wanted a dog with a litter of nursing puppies, so I called vets to find people who had dogs with new litters, then called them and asked if they'd loan us their dogs," Small recalled. "To get umbilical cords I lied to hospitals and told them the cords would just be in jars in the background in a movie scene. Those are real umbilical cords in the film, and we got five or six of them—Jack called them 'billy cords.' I had to find some unusual things."

The baby in *Eraserhead*—christened "Spike" by Nance—is the most crucial prop in the film, and Lynch began working on it months before the shoot started; he's never disclosed how he created the baby, nor have any of the

cast and crew. The film also called for two large props—a planet and a baby head—which were fashioned out of various materials. The "giant baby head," which is how they referred to it, was constructed in Lynch's yard and took several months to complete. "It sat out there for quite a while, and the neighbors referred to it as 'the big egg,'" Reavey recalled.

As part of pre-production, Lynch screened *Sunset Boulevard* and *A Place in the Sun* for his cast and crew. The black-and-white photography in both films is particularly saturated and rich, and Small recalled that "he wanted us to understand his concept of the color black. He also encouraged us to go see this guy named James in some canyon and have our horoscopes read."

Principal photography began on May 29th, 1972, and the first scene on the shooting schedule was Henry's dinner with Mary's parents, Mr. and Mrs. X. "I couldn't believe how long everything took that first night," recalled Charlotte Stewart, "and the reason it took so long was because David had to do everything himself—really, he did *everything.* The light fixtures had to be just so; he made the chickens for the dinner—he had to touch everything on the set. I remember thinking, Oh my God, this kid is never going to make it; he doesn't understand that you can't take this long in this business. I felt bad for him that he didn't know this."

The film progressed at a glacial pace, and a year into the shoot DP Herb Cardwell decided he needed a job that could pay him a living wage and left the film. This created an opening for cinematographer Fred Elmes. Born in East Orange, New Jersey, Elmes studied still photography at the Rochester Institute of Technology, then enrolled in the film-studies program at New York University. When an instructor there told him about the AFI, he headed west.

Elmes began classes at the AFI in the fall of 1972 and recalled, "A few months after I arrived, Toni Vellani said, 'We have a filmmaker here who needs a DP and you should meet him.' I met David and he showed me a reel of scenes and I had no idea what to make of what I was seeing, but I was captivated. It was shot in this beautiful black and white and was so curious and beautifully designed, and the acting style was fascinating. Everything about it knocked me out and I couldn't possibly say no.[4]

"One of the main challenges was how to light a black movie that you could see," Elmes continued of the film, which was shot almost entirely at night.

That's what *Eraserhead* demanded in terms of mood, of course, but it was also the only time the AFI grounds were quiet enough for Lynch to work. "We'd shoot all night," said Coulson, "then at a certain point Alan Splet would say, 'Birds, I hear birds,' and we knew it was time to stop working."

And the film "couldn't be dark enough," said Elmes, who spent two weeks working with Cardwell to get up to speed prior to his departure. "David and I would look at dailies and say, 'I see a detail in that black shadow that shouldn't be there—let's make it darker.' David and I agreed that the mood you create is the most important thing. Yes, there's the writing and the acting, but the mood and the feeling of the light is what makes a film take off. With *Eraserhead,* David told the story almost purely through mood and the way things look."

For the film's few daytime exterior shots, Coulson recalled, "We shot many of the exteriors, including the opening scene, beneath a bridge in downtown L.A. We worked fast when we shot on location because we never had permits, so it was kind of stressful but it was fun."

"People love working for David," said Reavey. "If you do something as minor as getting him a cup of coffee, he makes you feel like you've done the greatest thing in the world. It's, like, fantastic! And I think that's really how he feels. David likes to feel excited about stuff."

"David is a charismatic, powerful person," said Elmes, "and we all felt very involved. Certainly we were making David's movie, but he was thankful for everyone's work, and without thinking about it he kind of raised the bar on everything around him. He was constantly drawing, for instance, and seeing that was inspiring. It made us all want to work hard and try new things."

Lynch had no time to spend in a painting studio while *Eraserhead* was in production, but he never stopped making visual art during those years. Any blank surface would do, and he completed several bodies of work, including series on matchbooks, diner napkins, and cheap notebook paper. The materials he used were humble, but the work can't be dismissed as doodling. It's too polished and thought out for that.

Intricate renderings executed on empty matchbooks, the works in the matchbook series are tiny universes that feel vast and expansive, despite their size. Another series revolves around obsessive patterning and operates differently: The nests of patterned lines are imploded and dense and feel slightly threatening. The napkin drawings are composed of odd shapes rendered in

red, black, and yellow, floating in white fields; they *almost* look like something identifiable but are pure geometric abstraction. And there are drawings that are clearly preparatory studies for *Eraserhead.* There's a portrait of Henry staring at a mound of dirt on a bedside table, and an image of the baby lying next to a volcano form with a lone branch protruding from the top. A sketch of the baby after its white swaddling has been cut open has a lyrical quality that the related scene in the film, which is quite gruesome, definitely does not have.

Lynch always knew what was right for *Eraserhead,* but he encouraged input from the cast and embraced a good idea when he saw one. Charlotte Stewart was given the task of styling Nance's hair the evening shooting commenced, and she began back-combing it frenetically. Everyone in the room with her was laughing, but when Lynch walked in he took one look and declared, "That's it." Henry Spencer's signature hairstyle was the result of happenstance.

Stewart's take on her own character seemed intrinsically correct to Lynch, too. "I asked David if it would be all right for me to make my own dress, because Mary seems like a girl who sews her own clothes, but not very well, and nothing fits right—we wanted the top to be kind of ill-fitting so you could see her bra strap falling off her shoulder," Stewart recalled. "Mary has no confidence, which is why she's so stooped and closed in, and she has ear infections. Before we'd shoot, David always made a drippy ear infection in the outside of my right ear. It never showed, but we knew it was there.

"I have no idea why David thought I was right for the part. David casts people very strangely, and he doesn't care what your background is and never makes actors read. He meets you and talks to you about wood or whatever and sees what he needs. And the way he worked with actors on *Eraserhead* is the same way he works with actors now," said Stewart, who went on to appear in all three seasons of *Twin Peaks.* "He's very private with actors and never gives you direction when other people are listening. He comes up to you very quietly and whispers in your ear. It's real confidential direction."

Lynch is big on rehearsal, and although Henry Spencer doesn't seem to do much, it took considerable effort to achieve that effect; Lynch choreographed Henry's movements so intricately that the slightest gesture is fraught with

meaning. Reflecting on his working relationship with Lynch, Nance recalled that "we had these long, strange conversations, skull sessions, and things would reveal themselves a lot as we went along. And Henry was very easy. It was like putting on a comfortable suit to put on that character. I would put on the coat and tie and there was Henry."[5]

The cast for *Eraserhead* was small, but the crew was even smaller and often came down to just Coulson. "I did everything from rolling paper to make it look like the elevator was moving to pushing the dolly," said Coulson, who worked as a waitress at the time and often contributed tips and food to the production. "Fred was my mentor and he taught me how to shoot stills and be a camera assistant. I was also the courier to the lab that processed our film. We had to have it in by a certain time, and I'd get in the VW Bug and speed over to Seward Street in the middle of the night to get it to Mars Baumgarten, this great guy who worked there on the night shift. Because we worked long hours we had meals at the stables, and I cooked everything on a little hot plate with a frying pan. It was almost always the same food because David usually likes to eat only one thing, and it was grilled cheese or egg salad sandwiches then."

Eraserhead was beginning to consume Lynch's life, but throughout 1972 his ties to his family remained relatively sturdy. "We had a round oak table in the dining room, and for my birthday David and Jen got all this mud and piled it up into a peak on the table, and carved nooks and caves into it, and made clay figures and stuck them in there," recalled Reavey. "I loved it. We had to eat in the living room with plates in our laps for quite a while because nobody wanted to dismantle the mound. It was on the table for several months."

There were momentary diversions, but *Eraserhead* was the central concern in the Lynch household from the moment he began working on it. "Maybe this is a testament to my father's brilliance as a director, but he convinced us that *Eraserhead* was the secret of happiness and he was just letting us in on it," said Jennifer Lynch. "I was on that set a lot, and *Eraserhead* was just part of my childhood. I thought it was great and I didn't realize there was anything different about my childhood until I was ten or eleven years old. I never felt like my father was a weirdo and I was always proud of him. Always."

Lynch felt his cast and crew should be paid, so each of them received twenty-five dollars a week for the first two years of the shoot. (By the time the film wrapped, he'd been forced to cut salaries to $12.50.) It was a modest

wage, but Lynch still went through the money the AFI had given him by spring 1973. He was told he could continue using school equipment but no additional funds would be forthcoming, and *Eraserhead* went on a forced hiatus that continued intermittently for almost a year.

"David was always trying to get money for the film, and I gave him some when I came back from doing *Badlands,*" said Fisk, who was the art director on Terrence Malick's debut film of 1973. (Lynch and Splet introduced Fisk to Malick.) "I was used to making a hundred dollars a week and suddenly I was making a lot more, and it almost felt like free money. Over the years I probably gave David around four thousand dollars, and I've gotten all that back and more."

Co-starring in *Badlands* was actress Sissy Spacek, who married Fisk a year after they met and was ushered into the world of *Eraserhead.* "When I met Jack on *Badlands,* he told me all about his best friend, David, and as soon as we got back to L.A. he took me to meet him," Spacek recalled. "We went in the dead of night and everything was shrouded in intrigue and secrecy. David was living in the stables at the AFI, where he'd shoot all night and his crew would lock him in on the set during the day and he'd sleep. You had to knock a certain number of times and have the key, and it was like getting into Fort Knox.

"Jack was the first real artist I'd ever met," Spacek continued, "and he introduced me to all these incredibly talented people, including David. I've always felt grateful that I met them at a time in my life and career when they were able to influence me. David and Jack are artists through and through—they throw themselves into every aspect of their work, they would never sell out, ever, and they love creating things."[6]

After having returned to the East Coast, Fisk's sister Mary was back in L.A. by 1973. She was in a brief marriage at the time and lived in Laurel Canyon for six months prior to separating from her husband and returning east. While in L.A., she'd worked for Nash Publishing and helped Reavey get a job there as a receptionist.

Lynch did various odd jobs during the hiatus, and money that allowed the shoot to resume materialized in fits and starts; the irregular shooting schedule coupled with the painstaking craftsmanship Lynch brought to his work made patience an essential quality for his cast and crew. Lynch's team had to be

ready to jump back into action at a moment's notice and committed enough to wait while he perfected things on set.

"We did lots of waiting, and that's one reason Jack Nance was the ideal person to play Henry—Jack could sit quietly for a very long time," said Stewart. "David was always busy fiddling with a prop or something, and Catherine was busy doing whatever David wanted her to do, and Jack and I sat around and waited and nobody got crabby. Everybody was going through domestic ins and outs and we all became friends."

Approximately a year into the shoot, Doreen Small began living on the *Eraserhead* set. "It was a long commute from Topanga," she recalled, "and I wound up having a personal relationship with David—it happened one day in the music room and it was an intense relationship. My dad died during the shoot and my mom moved to Santa Monica, and David would sometimes stay with us. We all became very close, and my mom would buy clothes and art supplies for David."

Needless to say, Lynch's home life was unraveling and he and Reavey were headed toward a separation. "In Philadelphia I'd been an integral part of everything David did, but in L.A. that changed," said Reavey. "I wasn't part of it anymore, and there were all these assistant-type girls around—there was no place for me. My sister came to L.A. and visited the set, and she came back and said, 'You know they're all in love with him,' and I said, 'Isn't that nice?' I was very naïve."

This was a stressful period for Lynch. He was making a film he passionately believed in but money was a constant problem, and his personal life was becoming complicated. More significant, he felt unsettled on a profound level that went beyond money or love. Lynch's parents moved to Riverside in 1973, so his sister, Martha Levacy, was in Southern California regularly, and she was about to play a central role in a transformative event that spoke to the deeper feelings he was experiencing.

This story began in 1972, when Levacy was in Sun Valley training to be a ski instructor. Early one morning she was scheduled to attend a teacher's clinic on top of the mountain, "and I was riding up the chairlift next to a nice young man," she recalled. "I mentioned how alert he seemed for such an early hour, and he told me about the deep rest that's a benefit of Transcendental Medita-

tion and talked to me about it the whole trip up the mountain. I learned to meditate and it became an important part of my life."[7]

Shortly after Levacy began meditating, she was speaking to Lynch on the phone and he detected something different in her voice. He asked her what was going on and she told him about TM, then directed him to the Spiritual Regeneration Movement center. "That was the ideal place for David to take the next step," Levacy said. "Not every center might've gotten him excited, but this was the perfect fit—he liked the feeling of it and on July 1st, 1973, he learned to meditate. David told me long before any of this happened that he'd been thinking about the bigger picture, and TM's belief that there is enlightenment out there resonated with him."

The Spiritual Regeneration Movement center was directed by Charlie Lutes, who was one of the first people in America to enroll in Maharishi Mahesh Yogi's meditation program, which revolves around a simple technique that allows practitioners to reach the deepest levels of consciousness and is rooted in ancient Vedic wisdom. After bringing TM to the United States in 1959, Maharishi opened hundreds of centers around the world in partnership with Lutes, including the first U.S. TM center, in Santa Monica, where Lutes's weekly lectures drew large crowds during the 1970s. Lynch attended regularly. "Charlie was like a brother to Maharishi, and he was pivotal for David," said Levacy. "He became very close to Charlie and his wife, Helen."

Everyone who knew Lynch was struck by how meditation changed him. "David was a lot darker before he started meditating," recalled Small. "It made him calmer, less frustrated, and it lightened him. It was as if a burden had been lifted from him."

After devoting every waking moment to *Eraserhead* for nearly two years, Lynch made room in his life for meditation. "We all went to see Maharishi when he was on *The Merv Griffin Show,*" said Levacy. "Catherine came with David and he was wearing a nice blazer and a white shirt, and as they were walking in someone said, 'You two! This way!' They guided them down to the front row—I guess they liked the way they looked—so David landed right in front, lookin' good, and it had to be a thrill."

Lynch made several drawings during this period that are reflective of how he was changing. In *Infusing the Being,* a pair of images of dark, treelike forms are positioned side by side; there's a prism of color at the base of the form on the left, while the form on the right has color at both the base and the crown.

Images evocative of growth depict underground forms that are pushing to the surface, and there are untitled compositions that combine recognizable elements—trees, clouds—with abstract patterning and have the feeling of entryways into domed cathedrals.

"I was five when Dad started meditating, and I was definitely aware of a change in him when that happened," recalled Jennifer Lynch. "I remember there was less yelling, but it was then that I also started feeling like he was around less."

Meditation brought something into Lynch's life that he needed, but it exacerbated the growing schism in his marriage. "David worshipped Charlie Lutes, who was a nice guy, but nothing he said was of any interest to me," Reavey recalled. "David couldn't understand why I wasn't excited about meditation, because he really wanted spirituality at that point, but I wanted to go out and have fun."

Mary Fisk had returned to the East Coast by this point and was working for Georgia Senator Herman Talmadge in Washington, D.C. "One night I was in the office, talking to Jack on the WATS line, and David got on the phone and started talking to me about meditation—that's really when we began communicating," said Fisk, who moved back to Los Angeles at the end of that year.

Lynch took her to the Spiritual Regeneration Movement center and she began attending regularly. "Charlie Lutes was a dynamic, handsome, perceptive man who could change the energy in a room," Fisk recalled. "The Beatles called him Captain Kundalini—he was impressive.

"Meditation changed David and he got conservative—he stopped eating meat and smoking," Fisk continued. "He told me there were months when he went around with a five-foot cigarette in his head—he couldn't stop thinking about it—but he managed to stop smoking. He also started dressing differently, and the two ties and the moth-eaten hats vanished. He dressed nicely when he went to the center."

During this period Lynch's marriage deteriorated further. "One day I came home from work for lunch and David was there," Reavey recalled, "and I said, 'I wonder if we should think about separating.' He said, 'You don't love me as much as you used to, do you?' meaning that he didn't love me as much, either, and I said, 'I guess not.' I'd reached a point where I wasn't as fascinated with how his mind worked as I'd once been and I wanted some time to myself. It's

claustrophobic to live inside somebody else's head. Plus, what are you going to do? Fight to keep a marriage? I wouldn't be competing with some neighborhood girl. It would've been me versus loads of women, plus Hollywood."

During those years Lynch lived a completely nocturnal life, and shortly after splitting up with Reavey he took a job delivering *The Wall Street Journal* for $48.50 a week. Levacy once accompanied him on his midnight route and recalled it as "a great experience. He got it all organized, with the papers piled up in the passenger seat, and I sat in the back seat of his VW Bug because he needed both windows free. He knew the route like the back of his hand and made an art out of whisking the papers out the windows. He liked hitting certain windows a certain way because a light would come on in the house."

Shooting on *Eraserhead* resumed in May 1974 and continued sporadically for the next year. At approximately the same time, Splet left L.A. to spend several months at Findhorn, a utopian community in northern Scotland whose founders, Peter Caddy and Dorothy Maclean, claimed to have direct contact with the spirits of the natural world. Not long after Splet left, Doreen Small moved to Santa Barbara and things got harder for Lynch. George Stevens, Jr., made arrangements with Sid Solow, director of Consolidated Film Industries laboratory, to process Lynch's film for free, but the AFI began retrieving pieces of equipment and, as usual, there was no money. "At one point David said, 'I think we have to stop,'" Elmes recalled. "Catherine, Jack, and I looked at each other and said, 'David, we can't stop—it's not done. We'll figure it out.'"

So they kept at it. One day Lynch was sitting in the food room sketching, and a figure that came to be known as the Lady in the Radiator took shape on his drawing pad. Lynch recognized the character as the element needed to bring Henry's story to a close, and to his delight, he discovered that the radiator that happened to be part of the set was designed in such a way that it could accommodate his vision of how the character would function in the story. Played by vocalist Laurel Near, the Lady in the Radiator lives in a place of protection and warmth and represents unity and hope; her arrival marks a shift in the narrative trajectory and allows the film to conclude on a note of optimism and possibility. A wide-eyed blonde with grotesquely exaggerated cheeks, the Lady in the Radiator required a great deal of makeup, which

Lynch spent hours applying, and he wrote lyrics to a song for her to sing, called "In Heaven." His friend Peter Ivers put the lyrics to music and sang the song for the soundtrack; it's Ivers's voice you hear in the film.

Eraserhead's frequent periods of downtime left Lynch free to search for funding—certainly one of the most odious parts of being a filmmaker—but occasionally he had some fun. In 1974, executives at the AFI were trying to decide whether to use Ampex or Sony videotape for school directing projects and asked Elmes to shoot a comparison test of the two. Lynch got wind of this and asked Elmes to let him write a scene for the test; he quickly wrote a script for a short called *The Amputee,* and Coulson agreed to star in it. "David plays a doctor who's bandaging an amputee's stumps, and he wrote a monologue for the amputee, who I play, to do in voice-over," Coulson recalled. "We shot it twice using the different tape stocks, in one of the many deserted rooms in the Greystone Mansion, then Fred took it to a gorgeous screening room at the AFI to show these executives. When the film ended I remember somebody yelling, 'Lynch! Lynch had something to do with this!'"

By late 1974 Lynch's marriage had officially ended. "I went to legal aid and paid fifty dollars for the forms I needed, then a girlfriend went with me to court, where I filed them," Reavey recalled of her remarkably amicable divorce from Lynch. "My parents adored David and they were upset when we split up. I loved David's parents, and although they made an effort to maintain the connection between us, it was still a real loss for me when we divorced." As for Jennifer Lynch, she said, "It was excruciating for me when my parents divorced. I hated it."

Lynch was living on the *Eraserhead* set when his divorce was finalized but was ordered to vacate the AFI stables at the end of 1974 and moved into a bungalow on Rosewood Avenue in West Hollywood. "It had a tiny fenced-in yard with a picket fence, and a big orange tree in the yard that parrots loved—there were always lots of parrots out there," said Mary Fisk of the house, which rented for eighty-five dollars a month. "David put skylights in the house and built a shelf you could cook on in the kitchen, which didn't have a sink; when you only eat tuna fish sandwiches you don't need much of a kitchen. I remember Jen spending weekends there with David. He had very little money and wasn't able to take good care of himself, much less a child."

"When I stayed with Dad he didn't 'take care of me' in conventional ways," Jennifer Lynch recalled. "We did adult things. We delivered papers and walked

around oil pits; we'd talk about ideas and dig in dumpsters and pull stuff out, and we'd eat at Bob's. It was great. I remember when *Eraserhead* was playing at the Nuart, we'd go to Bob's, and you know those little plastic stands that hold pieces of cardboard listing the day's specials? We'd take those out and flip them so the blank side was out, and we'd write, "Go see *Eraserhead*" on them and put them back in the plastic stand. When he was living on Rosewood he was really into stuff like bee pollen and soybeans and ginseng, and I'd watch him take his vitamins and get a little dose. He was hugely into that stuff.

"I didn't realize we were poor until I was around nine," she continued. "I brought a friend over for the weekend when Dad was living on Rosewood, and Mary Fisk took us to Disneyland, and we built a dollhouse with David, and we went bowling. It was a great weekend, right? I got sick on Sunday night and missed school Monday, and when I got to school Tuesday morning, people said to me, 'Sherry says you live in a garage.' No one got invited over again for a long time."

Lynch is a creature of habit, and around this time he established a ritual that was to remain part of his life for the next eight years: Every day at two-thirty he went to Bob's Big Boy and consumed several cups of coffee and a chocolate milkshake. If someone had a meeting with Lynch during those years, it probably took place at Bob's. (He was open to other coffee shops, too, however, and also frequented Du-par's, in the San Fernando Valley; Ben Frank's, on Sunset Boulevard; and Nibblers, on Wilshire Boulevard.)

A few months after Lynch's move, Splet returned from Scotland, and they transformed the double garage adjoining the Rosewood bungalow into a post-production facility where Splet took up residence. From summer 1975 until early 1976, Lynch cut picture while Splet cut sound, and it was during these eight months of intensive work that *Eraserhead* became the masterpiece that it is. There's an almost unbearable tension in the soundtrack to *Eraserhead*, and the layers of sound—the menacing barking of a dog, the whistle of a distant train, the hiss of churning machinery, the hollow room tone that's the very embodiment of loneliness—are so complex and rich it's as if you could close your eyes and experience the film simply by listening to it. "David and Alan harnessed the power of industrial sounds and really made them work in terms of controlling the mood and the feeling of the movie," said Elmes. "The way they built that soundtrack is brilliant."

Mary Fisk had taken an apartment a few blocks from Lynch's bungalow

during this phase of post-production, and the two had begun dating. "David and Alan agreed that neither of them would date until they finished the film," said Fisk, "but David would meet me for lunch every day and not tell Alan. At the time David was also dating Martha Bonner, a friend of ours from the center, and he went back and forth between us for two years. David didn't try to hide it from me that he was attracted to Martha, but she knew he was seeing me and that he was trouble, so things never went anywhere with her."

Regardless of the status of their relationship, Fisk was a firm believer in *Eraserhead,* and she persuaded family friend Chuck Hamel to invest ten thousand dollars in the film. These indispensable funds allowed Lynch to focus on the completion of *Eraserhead,* and once he and Splet finalized the sound, he had a finished cut of the film. At that point he asked the principal cast and crew to meet him at Hamburger Hamlet, a now-defunct restaurant on Sunset Boulevard, and to everyone's surprise told them they were among fourteen beneficiaries who would be receiving a percentage of any future profits the film made. He wrote the terms of the agreement on napkins, and "a few years later we all got checks in the mail," said Coulson. "It's pretty amazing that he did that." All the beneficiaries continue to receive annual checks.

Eraserhead had its unofficial premiere in a cast-and-crew screening at the AFI. "When David first showed us the film, it seemed like an eternity," recalled Stewart of the screening, which ran for an hour and fifty minutes. "He called me afterward and asked me what I thought, and I said, 'David, it was like a toothache—it hurt so bad.' It was grueling to sit through." Lynch listened to what his inner circle had to say but wasn't yet ready to edit anything out of the film.

Representatives from the Cannes Film Festival were visiting the AFI when Lynch happened to be there mixing the film, and they expressed enthusiasm over the footage they saw; at that point he set himself the goal of getting *Eraserhead* into Cannes. This proved to be a fruitless ordeal, and *Eraserhead* was then rejected by the New York Film Festival, too. This was not a good period for Lynch. "I remember meeting him for lunch at Bob's after we divorced, and he said, 'I'm ready to be in the inner circle—I'm tired of being outside,'" said Reavey. "Yes, his sensibility is underground and dark, but once he got involved in Hollywood he didn't want to be this weirdo, and he wanted to operate in the field where the real stuff was happening—and that's the way it

should be. I'd hate to live in a world where somebody like David doesn't get to do his thing."

When the Los Angeles International Film Exposition—Filmex—began reviewing movies for its 1976 program, Lynch was too demoralized to consider submitting *Eraserhead*. Fisk insisted that he submit it, though, and it was accepted and screened for a public audience for the first time at the festival. It got a nasty review in *Variety,* and watching the movie with an audience was an enlightening experience for Lynch. He realized the film would be better with a tighter edit, so he cut a composite print and discarded twenty minutes of footage containing at least four substantial scenes, including Henry kicking a piece of furniture in the lobby of his apartment; and Coulson and her friend V. Phipps-Wilson bound to beds with battery cables, being threatened by a man holding an electrical device. Lynch loved the scenes but knew they were dragging the film down and had to go.

Word of *Eraserhead* made its way to Ben Barenholtz, in New York, and he requested a print. A producer and distributor who's been a hero in the world of independent film for decades, Barenholtz was the originator of the midnight movie programming that's served as a lifeline for iconoclastic filmmakers who couldn't get their work seen any other way. His innovation allowed films like John Waters's *Pink Flamingos* to find their audiences, and his support was crucial to *Eraserhead.* Barenholtz's company, Libra Films, agreed to distribute the film, and he sent his colleague, Fred Baker, to L.A. to seal the deal with Lynch. The official handshake took place at Schwab's Pharmacy, which is the setting for a scene in *Sunset Boulevard* and thus had particular meaning for Lynch.

As *Eraserhead* began making its way safely into port, Lynch's personal life continued to be messy. "One day not long after Ben agreed to take *Eraserhead,* David told me he wanted to be with Martha Bonner," said Fisk. "David and I had moved in together by that point, and I said, 'Fine, I'm moving back to Virginia,' and I left. Three days after I left, David called and asked me to marry him. My mother was against it because he had no money, and my brother didn't think I should marry him, either. He sat me down and said, 'David is different, Mary, the marriage won't last,' but I didn't care. David has this incredible love inside of him, and when you're with him you feel like you're the most important person in the world. Just the tone of his voice and the amount of caring he gives people is extraordinary."

On June 21st, 1977, Lynch and Fisk married in a small ceremony at the church his parents attended in Riverside. "We were married on a Tuesday and David's father had arranged to have the flowers from the Sunday service saved for us, so we had flowers, and he also hired an organist," said Fisk. "We had a traditional wedding, then went on a honeymoon of one night in Big Bear."

Sixteen days later Lynch registered a treatment with the Writers Guild for what he hoped would be his next film, *Ronnie Rocket,* then he and Fisk headed to New York City. Lynch lived in Barenholtz's apartment there for three months while he worked with a lab, attempting to get a satisfactory release print of *Eraserhead.* Barenholtz paid to clear the rights to the Fats Waller music that plays an integral role in setting the mood of the film, and it was good to go. It premiered at Cinema Village in Manhattan that fall, with a birth announcement serving as the invitation to its official opening.

Getting a distributor for *Eraserhead* did nothing to solve Lynch's money problems, and after returning from New York he spent the next few months living in Riverside, where he worked with his father remodeling a house they planned to flip. While Lynch was in Riverside, Fisk worked in the property-management division of Coldwell Banker and visited him on weekends. "We lived with David's parents on and off for a while after we got married," said Fisk. "He and his dad would come home from working on that house and his mother would rush to the door with her arms open and hug David and his dad. They're a very loving family. The profit on the renovated house was seven thousand dollars, and David's parents gave it all to him. They worried about him because they didn't see the dreams he saw for himself—and yet they helped fund *The Grandmother.* It's extraordinary that they would look at a son making work they could never grasp and support it anyway."

At the end of 1977 Lynch was still in a black hole financially, so he converted his post-production facility into a workshop and began what he's referred to as his "shed-building" phase, which means exactly that—he was building sheds and picking up odd carpentry jobs. Discouraging though this may sound, Lynch's hopes were undimmed. "He was excited," said Mary Fisk. "He'd finished the film, it had been at Filmex, and there was a buzz. I'd wake up to David and he'd have this big smile, ready for the day. He was ready for the next thing.

"Our social life revolved around spending time with the meditation com-

munity at the center," she continued. "We were there every Friday night, and the people there became our closest friends. We'd meet up with them and go to movies—I saw lots of movies with David—but we weren't caught up in the movie business at all."

Meanwhile, *Eraserhead* was quietly becoming a word-of-mouth sensation on the midnight movie circuit and was in the early days of what turned out to be a four-year run at Los Angeles theater the Nuart. *Eraserhead* came along at an opportune time in that precisely the sort of hip audience capable of appreciating it was coalescing in Los Angeles then. Radical performance art was in its heyday, punk rock was gathering steam, and outré publications like *Wet* magazine, *Slash,* and the *L.A. Reader,* which celebrated all things experimental and underground, were flourishing. People from these factions of the city filled the seats at the Nuart and embraced Lynch as one of their own. John Waters encouraged his fans to see *Eraserhead,* Stanley Kubrick loved the film, and Lynch's name started to get around.

He was still an outsider, but Lynch's life had been transformed. He had a spiritual practice that anchored him, he had a new wife, and he'd made a film that was exactly what he set out to make. "I stayed real true to my original idea with *Eraserhead,*" Lynch has said, "to the point that there are scenes in the movie that feel like they're more inside my head than they are on the screen." And, finally, he had a handful of industry insiders and thousands of moviegoers who understood what he'd achieved with the film.

"David connects with a lot more people than you'd expect, and there's something about his vision that people identify with," concluded Jack Fisk. "The first time I saw *Eraserhead* was at a midnight screening at the Nuart, and the audience was riveted and knew all the dialogue. I thought, Oh my God! He's found an audience for his stuff!"

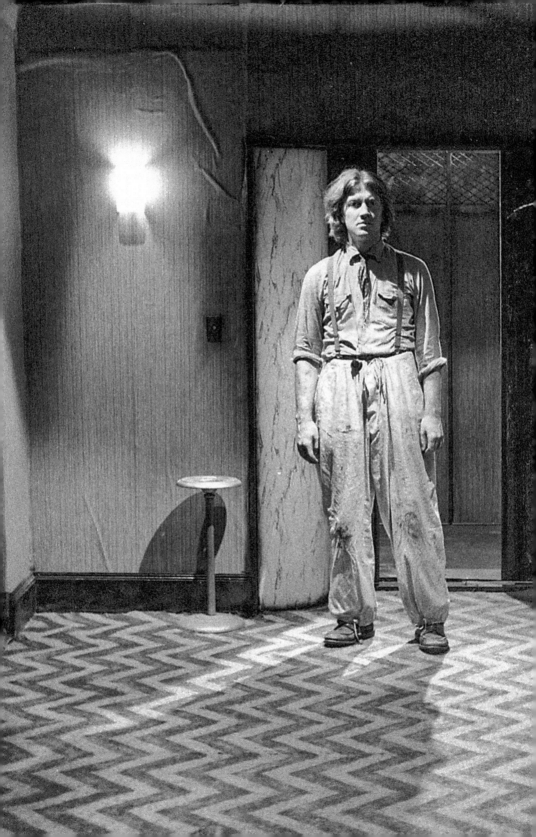

*J*ACK, JACK'S DOG Five, and my brother, John, drove cross country from Philly with me, and the drive west was beautiful. I remember one point when we were driving down into this gigantic valley and the sky was so big that when you came up over the ridge you could see four different kinds of weather at the same time. There was sunshine in one part of the sky and a violent storm in another part. We drove thirty hours straight to Oklahoma City, where we stayed with my aunt and uncle, then the second day we drove a long way and pulled off the road at night in New Mexico. It was a moonless night and we went down into these bushes to sleep. It was real quiet, then suddenly there was a whooshing sound and we saw a horse tied to one of the bushes. When we woke up the next morning there were Indians in pickup trucks driving in circles around us. We were on an Indian reservation and they probably wondered why the hell we were on their property, and I don't blame them. We didn't know we were on a reservation.

We got into L.A. after midnight on the third day. We drove down Sunset Boulevard, then turned at the Whisky a Go Go and went to Al Splet's place, where we spent the night. The next morning I woke up and that's when I discovered L.A. light. I almost got run over, because I was standing in the middle of San Vicente Boulevard—I couldn't believe how beautiful the light was! I loved Los Angeles right off the bat. Who wouldn't? So I'm standing out there looking at the light and I look over and there's 950 San Vicente with a FOR RENT sign. Within a couple of hours I rented that house for two hundred twenty dollars a month.

I'd sold the Ford Falcon back in Philly and I needed a car, so Jack,

John, and I walked down to Santa Monica Boulevard and stuck our thumbs out. We got a ride with this actress and she said, "All the used-car lots are on Santa Monica Boulevard down in Santa Monica and I'm going that way, so I'll take you right there." We went in and out of a few places, then my brother spotted a 1959 Volkswagen with faded gray paint. My brother knows about cars, so he looked it over and said, "This is a good car." I'd just won second prize in the Bellevue Film Festival for *The Grandmother* and the prize was two hundred and fifty dollars, so I used that money to buy the car, which cost maybe two hundred. I needed insurance and right across the street is State Farm, so I walk up these wooden steps to this nice guy on the second floor and he took care of the insurance. In a day I had a car with insurance and a house. It was unreal. Lots of people lived with us in that house on and off—Herb Cardwell was there, and Al Splet, and my brother, and Jack was with us for a while, too. It didn't bother me having all those people living with us, but it would really bother me now.

The day Jack and my brother and I walked up to the AFI and I saw this mansion for the first time, I couldn't believe it. I was so happy to be there. When I arrived in L.A. I wanted to make *Gardenback* and I'd finished a forty-page script; then I met Caleb Deschanel and he liked the script. He thought it was a horror film, sort of, and he took it to this producer he knew who made low-budget horror films. This guy says, "I want to make this and I'm going to give you fifty thousand dollars, but you gotta make the script a hundred or a hundred and twenty pages." That really depressed me. The whole story was there but I still spent the next whole fuckin' school year meeting with Frank Daniel and this student named Gill Dennis, who was kind of Frank's sidekick, padding this thing with mundane dialogue I hated. In the back of my mind I was thinking, Do I really want to make this? Because I'd started getting ideas for *Eraserhead*.

One day during my first year at the AFI, Toni Vellani told me, "I want you to come and meet Roberto Rossellini." So I walked over to Toni's office and there was Roberto. We shook hands and sat down and talked and we just clicked. He told Toni, "I'd like David to be an exchange student and come to Rome and attend my film school, the Centro Sperimentale di Cinematografia." They wrote it up in *Variety* that I was going

there, but the next thing I know Rossellini's school goes belly-up. It's fate. I wasn't supposed to go there. Still, it was nice meeting him.

I needed money, so Toni said, "You can intern with this guy Ed Parone who's doing *Major Barbara* at the Mark Taper Forum," so I interned there. What I was doing as an intern was getting coffees for Ed Parone. The play starred David Birney and Blythe Danner, and it was the debut of Richard Dreyfuss, who stole the show. I hated the play and didn't like the director. He wasn't very nice to me. Maybe I wasn't getting good coffees for him, I don't know. I had a bad attitude and had zero interest in theater. Blythe Danner was nice, though.

Toni knew I built things so he then got me a job in Utah, building props for Stanton Kaye's film *In Pursuit of Treasure*. Before I got there I heard stories about Stanton Kaye, like they had to push him up the hill to go direct, he wasn't on time, he didn't give a shit or whatever—he was acting weird. I went to Utah and started building the treasure for *In Pursuit of Treasure*. I was making Aztec gods and gold bricks, just making stuff up, and it was just me in a basement with this guy named Happy, who worked at a circus and was a carny. "Happ," I called him. I was only supposed to be there for a week, and after two weeks of this I wanted to go home, so I said, "My buddy Jack can do this stuff." So Jack came and met a lot of people who saw that he was great, and it opened doors for him. I think that was a kind of a turning point for Jack.

The first day of my second year I go up to the AFI and I've been put in first-year classes, like I'd flunked. Plus, I'd wasted the last fucking year, and anger came up in me like unreal. I stormed down the hall, and Gill saw me and saw the look on my face and he said, "David, stop! Stop!" He chased me but I went right up to Frank's office, past Mierka, his assistant, and walked in and said, "I quit!" I stormed out and went to see Alan and he said, "I quit, too!" So the two of us went to Hamburger Hamlet and griped and bitched and had coffee. A few hours later I went home and when Peggy saw me she said, "What's going on? The school's calling and they're really upset that you left." So I went up there and Frank said, "David, when you want to quit, we're doing something wrong. What do you want to do?" I said, "I want to do *Eraserhead*," and he said, "Then you'll do *Eraserhead*."

Once I started working on *Eraserhead* I stopped going to classes, but

I'd go up from time to time to see a film. The projectionist in the big room at the AFI was a film buff beyond the beyond and when he'd say, "David, you've *got* to see this film," I knew it would be something special. One thing he showed me was *Blood of the Beasts*, this French film that intercuts between two lovers walking through these streets in a little French town and a big old-style slaughterhouse. Cobblestone courtyard, big chains, and steel things. They bring a horse out and there's steam coming out of the nostrils; they put this thing on the horse's forehead and boom! Down the horse would go. Chains around his hooves hoist him up and they had him skinned in no time, blood going in the grate; then cut to this couple walking. It was something.

I was looking for actors for *Eraserhead* and there was a theater director named David Lindeman who I remember as a student at the AFI. I described the character of Henry to him and asked if he knew any actors who could play that, and he gave me two names. One of them was Jack Nance, so I decided to meet Jack. With *Eraserhead*, the first person I met was the person I cast, every single one. It's not like I would take just anybody, but they were all perfect.

The Doheny mansion was built on a hill and it had a ground floor, a second floor, and underneath the ground floor was a basement with rooms that had been turned into offices. There was also a bowling alley there and a laundry room where the Dohenys had their wash done. Because sunlight is good for cleaning clothes, they had this pit that you couldn't see from the street or from any angle. It had, like, sixteen-foot walls and was just an open pit where they hung their laundry. Beautiful pit. Concrete walls and real nice steps going up and out. That's where I built the stage the Lady in the Radiator performs on. It sat there for a while because it took a long time to build it, probably because I didn't have any money.

Anyhow, Jack Nance and I met in one of those basement offices. He came in and he was in a grumpy mood, like, What the fuck is this student-film bullshit. We sat and talked but it was real stilted and didn't go well. When we finished talking, I said, "I'll walk you out," and we walked down this hall, not saying anything, and out some doors to a parking lot. We got out there and Jack looked at this car we passed and said, "That's a cool roof rack." I said, "Thanks," and he said, "Is that yours? Oh

my God!" Suddenly he was a completely different person. We started talking about Henry right then, and I said, "Henry's got a confused look," so Jack did a confused look. I said, "No, no, that's not it. Let's say Henry looks lost." Jack did a lost look and I said, "No, that's not it, either. Maybe it's like he's wondering," and he put a wondering face on. I said no again, then finally I took him by the shoulders and I said, "Just be a total blank." And he went blank and I said, "Jack, that's it!" After that Jack went around saying, "Henry is a total blank." I took him home and showed him to Peggy and she gave him a thumbs-up behind his back, then I took him back to the AFI. Jack was absolutely perfect in every way. I've thought about who else could've played Henry, everybody in the whole world I've seen since then, and there's nobody. It was fate. Jack was perfect and, like Charlotte said, Jack didn't mind waiting. He'd sit around thinking so many things in his head, and he doesn't care what's going on around him.

When I met Jack he had this kind of afro. We didn't want his hair to look freshly cut for the film, so about a week before we began shooting I got a barber to come to the stables and he took Jack into the hayloft and cut his hair. I wanted it short on the sides, long on the top—that's the look and it was very important. For some reason that's just a thing I liked from the get-go in life. Jack's haircut was very important, but it wasn't until the first night of shooting when Charlotte ratted his hair that it really got there. It stood up way taller than I probably would've gone for, so she played a major role in the creation of Henry.

There was this incredible studio way down on the eastern end of Sunset Boulevard that was closing up shop, so I rented a thirty-five-foot flatbed truck and Jack and I went over there on a cloudy day and they were selling everything. We left there with this truck piled twelve feet high with flats, kegs of nails, wire, a thirty-by-forty-foot black backdrop, the radiator that's in Henry's room—different things. We said, "How much," and the guy said, "Hundred bucks." I built every set for the film out of those flats. There was a rug place on that same stretch of Sunset that looked like an old gas station or car-repair place. It was stucco and had a faded sign, and it was real dark and dusty as hell, and there were huge stacks of rugs piled up on a dirt floor. You'd look through these piles, lifting them up as you go, and when you found one you liked, these guys

would come out of the darkness and roll back the pile and pull it out for you. If you didn't like it they'd throw it back on top and the dust would fly. I got all the rugs in the film there, and we got all the sound stock we needed out of bins at Warner Bros. The bins were filled with beautiful rolls of mag that had been thrown away. Al and I had taken the back seat out of the Volkswagen and we got away with hundreds of rolls of used sound stock. You can reuse sound stock if you put it in a degausser, and Al would do this. I didn't want to go near this thing, because it's a huge magnet, and you feed the stock into the degausser and you have to turn it a certain way, and you're rearranging the molecules, and then you bring it out a certain way and it's clean.

Nobody was using the stables at the AFI, so I set up there and had a pretty-good-size studio for four years. Some people from the school came down the first night of shooting and they never came down again. I was so lucky—it was like I'd died and gone to heaven. During that first year the only people there were the actors, Doreen Small, Catherine Coulson, Herb Cardwell, then Fred when he took over from Herb, and me. Al was there when we shot location sound, but other than that nobody else was there. Ever. Over a four-year period there were a few weekends when extra people showed up to help, but day in and day out that was the crew. Right there. That's it.

Doreen Small was integral to *Eraserhead* and she did great work. I never made anybody go have their chart done, though. People say things like, "David made me learn TM," but you can't force people to do things like that. It's got to come from their desire to do it.

Alan Splet is the one who told me about this guy James Farrell, who lived in a little house in Silver Lake where you'd park on a patch of dirt. So I go see James and he's an astrologer but he's also a psychic, and this guy was something else. He was a very special psychic and gave magical readings. You'd get there and say hello to his wife, then she'd leave and he'd give a reading. I had no money, but I was able to see him many times because he was very reasonable—in those days everything was reasonable.

Many years later, sometime during *Dune*, I wanted to talk to him and

now he's living in an apartment building in Century City. He opens the door and he looks different, he's almost floating, and he says, "David, I've gone totally gay!" He was so happy being gay, just no problem, and I say fine, and then he gave me a reading. I asked him about these girls that I was seeing and he said, "David, they all know each other." Meaning that girls, they've got the surface, but there's part of them that knows much more, and it made sense to me the way he said it. Girls are more advanced in many ways because they're mothers, and this mothering thing is so important. Maharishi said the mother is ten times more important than the father for children. If women ran the world, I think peace would be way closer.

Five years or so after that reading, I'm talking with Mark Frost in a booth in Du-par's on Ventura Boulevard. People are coming and going and at one point somebody walked by with a woman and I glimpsed some guy's pants, a kind of orangey-pink sweater, and a little bit of a brownish-pink head. So I'm talking to Mark and then the coins started dropping. I turned around, and just then he turned around, and I said, "James?" And he said, "David?" I went over and talked to him, and there was something strange about him. His skin had sort of a red-orange hue to it, then later I heard that James died of AIDS. He was a brilliant astrologer and an incredible psychic and a really good person.

I played Wagner's *Tannhäuser* and *Tristan und Isolde* in the food room at the stables, and Jack and I would listen to it at sunset as it got dark before we started shooting. I played it really loud, and I also played Vladimir Horowitz's *Moonlight Sonata*. Oh my God, this guy could play it. He plays it slow, and I heard that he had the ability to play a piano key in one hundred different intensities, from the tiniest little note to a break-the-window note. Such soul comes through when he plays it. And Beethoven wrote that damn thing when he was deaf! Just amazing. Captain Beefheart was really a great artist, and I used to listen to *Trout Mask Replica* all the time then, too. People would start showing up at the stables at around six o'clock, and while we were waiting, Jack and I would sit in the food room and crank the music. We were in the best part of Beverly Hills, and we'd sit and watch the woods and the sunlight getting dimmer and smoke cigarettes and listen to this really loud music.

During that first year working on the film, I was drifting away from

home, but not on purpose—I was just working all the time. Peggy and I were always friends and there was no dispute at home, because she's an artist, too. When Jennifer and I made her a mud sculpture on the dining room table for her birthday, we got buckets and buckets of mud, and the mound went up at least three feet and to the very edge of the table. How many wives would love that in their dining room? About one! They'd fucking freak out! They'd say, You're ruining the table! Peg just went crazy for it. She's a great girl and she was letting me be an artist, but she had to take the back seat for a long time and I think she got depressed. It wasn't a good time for her.

I ran out of money a year into shooting *Eraserhead* and Herb left, but I understood why Herb had to leave. Herb was a very interesting fellow. He was an excellent pilot because he thought in three dimensions, and he was a great mechanical engineer. One time Herb said to Peggy and me, "I'm getting an airplane. How would you like to fly out to the desert with me for the day?" We said, "Great." When we got back it was getting dark, and as he was taxiing in he got on the radio and said good night to the tower. The way he said good night to the tower made the hair on the back of my neck go up. I had this feeling that in another time Herb was a long-distance space pilot. The way he said good night was just so beautiful, like he'd been saying it for a billion years.

One time Herb and Al decided to fly back east. Al is legally blind but he's going to navigate, so they take off to go across the country, headed first for Pocatello, Idaho. They fly up there and Herb radios ahead to the little airport up there, and the guy said, "I'll have a rental car here for you with the keys in the car. Turn off the lights and lock up when you leave." So Herb parks the plane and they get in the rental car and start driving into Pocatello. They're driving along at night on a two-lane highway with Herb driving, and Herb starts talking. As he's talking, his voice starts to go up in pitch and he starts going off the road. Al says, "Herb!" Herb gets back on the highway. He keeps talking and his voice is going up even higher and he's going off the road again, then he goes off the road completely and his voice is super high. Al is screaming at him, *"Herb!"* Finally Herb comes out of it and gets back on the road and he's okay. Who knows what that was about.

Sometimes we'd get through shooting at two or three in the morning

and it was too late to start another shot, so we'd all leave. Herb was living with us, but he wouldn't come home. No one knew where Herb went, and then at nine in the morning his car would pull into the driveway. He'd come in and not say a word and you sort of knew not to ask. Jen remembers Herb in the morning and he moved real slow, not grumpy but not happy, and he'd reach up into this stash he had of chocolate breakfast bars that no one was allowed to touch. Jen wanted one of those breakfast bars so bad and I don't think he ever shared one with her.

When Herb was working at Calvin de Frenes, there were times when you'd need high-security clearance to work on films because they were government films, and Herb had that clearance—a lot of people thought Herb worked for the CIA. Herb got a job designing 16mm projections for airplanes and had to go to London on a job. He's traveling with some guys and they all know Herb's an interesting guy. They were supposed to meet one morning in the Gatwick area, so these guys show up and they're waiting for Herb and he's not showing up. They call his room and there's no answer, so they call the manager of his hotel and ask him to check Herb's room, and they go up there and Herb is dead in the bed. They did an autopsy in London and find no cause of death. His mother has a funeral home in North Carolina and they did an autopsy, too, but they couldn't find a cause of death, either. That was Herb.

Fred Elmes came in after Herb left, and the film changed as it went along. I'm always drawing stuff in the food room, so I'm in there and I'm drawing this little woman and when I finish the drawing I'm looking at her and that's when the Lady in the Radiator got born. I don't know if I had the lyrics for "In Heaven" then, but the lady was there, and I knew she lived in the radiator where it's warm. I ran into Henry's room because I'd forgotten what the radiator in there looked like, and of all the radiators I've seen since then, none of them have what this radiator had, which was a little compartment where someone could live. I couldn't believe it. These things you just don't argue with. The final shot of Henry with the Lady in the Radiator is so beautiful because it just burned out white. Glowing.

Whenever we had to build a set someplace on the grounds other than the stables, we'd have to work Friday, Saturday, and Sunday and get it cleaned up by Monday before the gardeners came in. If we were in their

way, we could get in trouble. We shot the scene where we come in on the planet in an area at the AFI where they stored firewood, and we did the fetus floating in space in my garage. The shots of Henry floating and of the planet surface were done in Fred's living room. I built this long piece at my place then brought it to Fred, and he put together a beautiful track for the camera to be aimed down at this steep angle and track along. So you're moving in on a planet, then you cut in and you're traveling along the surface of the planet. Fred would tap in above the electrical box at his house, so we were stealing electricity, and we had big cables coming into his place. When we had questions about special effects, we'd talk to C-movie places—not B movies, C movies. We met some real characters and I learned something every place I went. Mostly I learned that it's all common sense and that we could figure out how to do the effects shots ourselves.

I built the planet so it would break in a certain place, and I wanted to build a catapult that would shoot a chunk of the planet backed with lead or steel so when it hit the planet it would explode. Al had a completely different catapult idea, and I said, "That won't work," and he said, "No, yours won't work," so we built both of them and neither of them worked. Finally I just threw a chunk of the planet at it but it only broke half of the piece, and I threw another chunk. So it worked out great because there were two explosions instead of just one.

We had to shoot lots of things twice. Like the Beautiful Girl Across the Hall: Herb lit that scene with little pools of hard light, but Judith didn't look beautiful under this light and the mood wasn't right. So Herb relit the thing so it was like a soft wind of inky-black light, just beautiful.

One weekend we were shooting what was called the dime scene and I'd emptied my bank account and gotten sixty dollars worth of dimes. This was based on a dream I had about a dirt adobe wall. I scratch the surface of it and I see a little bit of silver, and inside the earth wall were rows and rows of dimes. You could just dig them out! It was incredible.

In the scene, which Henry witnesses from his apartment window, some kids find the dimes and then some adults come and chase them away and start fighting over them. So I bring in all this earth and these pipes and make a pond of dirty oil water. Then we had to set the camera up so it was angled from the point of view of somebody looking down on

this scene. It took us so long, carrying these heavy things up a hill and building this thing, and we only have three days to do it. I remember Jack saying to me, "Lynch, they'll never know," and in a way that's true with everything. So much goes on that people will never know about with every film. You can tell all the stories you want, but you still haven't gotten across what the experience was like. It's like telling somebody a dream. It doesn't give them the dream.

So we got the scene done but only a small part of it wound up in the film. Jack had been drinking that night, and after we finished shooting, Catherine took me aside and said, "David, Jack is putting the dimes in his pocket." So I went over and said, "Jack, I want those dimes back," and he said, "Yeah, Lynch, you want it all!" And it hit me. I decided that night that I would give people points in the film because they'd been with me all the way through. That was the night that did it.

Jack was pissed off at Catherine for ratting on him about the dimes and he says to her, "Get in the stall, horse face!" Catherine is bigger than Jack, and she hauled back and slammed him in the nose and her ring cut his nose and he went down. So she left and I'm there with Jack and I say, "Come on, Jack, let's go get some coffee," and we drove to the Copper Penny and we had the greatest talk that night.

I was a seeker before I found TM and I'd been looking into different forms of meditation. Al was into Ouspensky and Gurdjieff, but they left me cold, and sometimes Al and I would get in big arguments about this stuff. Al didn't drink all the time because he couldn't afford to, but when he drank he'd get argumentative, and a lot of times he'd storm out and go home. We'd have good arguments.

Peggy's father read constantly, and one day he gave me a book on Zen Buddhism. He never gave me any other books. I read it and a week later I went for a walk in the woods with him, and we're walking along and he says, "That book says life is a mirage; do you understand that?" I said, "Yeah, I think I do." And I did understand it. He was a really interesting guy. When we were living in Philadelphia we'd go to Peggy's parents' house for dinner on Sunday nights. These were the days before I got my car, so I was taking the train to work, and one Sunday night Peggy's father

said, "Okay, Wednesday morning when you get to the train station, go to platform nine. My train will be coming in and your train won't have left yet. Hide behind the train, and at exactly 9:07 come out from behind the train and wave and then go away. I'll do the same thing. Let's coordinate our watches right now." It had to be Wednesday, so I had to remember this thing for two days. Wednesday comes and I go to the station and I'm hiding behind my train, I'm there waiting and waiting, twenty seconds more, waiting and waiting, five, four, three, two, one; out I go, and I see him come out across the way from behind a train and we wave and go away. That was it, and it was so good for me because I did not let him down.

I was looking for something but I hadn't found it yet, and one day I'm talking to my sister on the phone and she starts telling me about Transcendental Meditation. I said, "A mantra! I've gotta have a mantra," and I got off the phone and said to Catherine, "Do you want to start meditating with me?" and she said, "Sure." I told her to call and find out where we should go, and she happened to dial the Spiritual Regeneration Movement center. In L.A. then there was the Students International Meditation Society and SRM, and my sister is right when she says SRM was the perfect place for me. Charlie Lutes was giving introductory lectures, and Charlie was the right guy for me because he was interested in the spiritual side of meditation as opposed to the scientific side. Thank goodness for Charlie and Helen—I loved both of them and learned so much from them. Charlie would see I had holes in my shirts and give me shirts that were old for him but were mint condition for me. They sort of looked after me a little bit.

Charlie loved Maharishi, and in the early days he was pretty much his right-hand man. Before Charlie met Maharishi he was into all kinds of things, though, and sometimes he would tell tall tales about different things, like one night he was picked up by aliens and flew from L.A. to Washington, D.C., and then back to L.A. in a matter of minutes. One night after his lecture he said, "Did you see it?" I said, "See what?" He said, "There was a huge angel in the back of the room during my lecture." He wasn't nuts, but he was on another frequency big time. Before Charlie and Helen moved to Scottsdale, they went to Vlodrop to see Maharishi and he said to Charlie, "Come here and be with me," and

Charlie said, "Our dogs need taking care of," and Maharishi just waved his hand dismissively. A lot of people around Maharishi were upset with Charlie, but Maharishi wasn't. He didn't really get upset.

I didn't care one bit about meditation when the Beatles were meditating, but then it was as if a switch had been thrown and I couldn't get enough. Everything in me changed when I started meditating. Within two weeks of starting, Peggy comes to me and says, "What's going on?" I said, "What are you talking about?" because she could've been referring to any number of things. And she says, "Your anger. Where did it go?" I used to be really bad in the morning and if I didn't have my cereal exactly right I would make life miserable for Peggy. She'd see me start to get up and she'd race up to the Sun Bee Market on Sunset and race back home with cereal. I was not happy in those days and I took it out on her. I once showed Doreen Small something I was writing before I started meditating, and it made her cry because there was so much anger in it. When I started meditating the anger went away.

Before I started meditating I worried that doing it would make me lose my edge, and I didn't want to lose the fire to make stuff. I found out it gives you more fire to make stuff and more happiness in the doing and way more of an edge. People think anger is an edge, but anger is a weakness that poisons you and the environment around you. It's not a healthy thing and it's not good for relationships, for sure.

I moved into the stables when Peggy and I split up, and that was the greatest place. I'd lock myself in Henry's room and I loved sleeping there, but eventually I had to leave and I moved into a bungalow on Rosewood Avenue. Edmund Horn was my landlord, and my place was at the end of his driveway in the back. There's a scene in *Eraserhead* of a bum on a bus bench, and the bum is wearing Edmund's sweater. Edmund was around sixty years old when I met him and he was a concert pianist who traveled with Gershwin in the thirties. He was a homosexual who lived to be over a hundred years old, and because he didn't have children he started buying properties, and he wound up owning lots of places in West Hollywood. He was a multimillionaire but he didn't care about money; his clothes were filthy and he dressed like a bum. He was persnickety and he could get in a bad mood and turn on you, but I got along with him great. He tolerated all the things I wanted, and I think he thought I was

a good tenant because I'd do odd jobs for him. I put in a lot of hot water heaters for Edmund and I kind of loved that job. When I had my paper route I always had some leftover newspapers, and I'd leave them on Edmund's back porch and he loved to read them.

He had a Volkswagen parked outside his house, but it had refrigerator cardboard on top and the tires were cracked and he never drove it. He walked everywhere. He used to collect rainwater in these porcelain dishes, and he'd take this rainwater inside and shave his underarms with rainwater. Nothing was ever updated in his house—it was all stuff from the twenties—and he had one forty-watt bulb in there. He'd watch TV at night and that would be the only light in the house. He was very frugal. One night I hear this pounding coming from inside Edmund's house and I go out and listen, and he's banging on his walls with his fists, crying, "Help me," from the depths of his being. He wasn't calling for people to help him. He was crying out to the cosmos for help.

When you rent a place a garage usually goes with it, but with Edmund you didn't get a garage. Edmund, why don't I get the garage? Look in the garage. What's in the garage? Cardboard boxes. He loved cardboard boxes. His favorites were waxed fruit boxes. And Edmund's boxes weren't folded up—they were stacked, floor to ceiling, cardboard boxes. I talked Edmund into letting me build him a new garage and taking over the garage that was already there, which was a big garage. I built Edmund a new garage and he was happy with it, but he upped my rent a little bit and all his boxes had to be moved from the old garage to the new one. Then I built an L-shaped gable shed in the yard and a second shed, where I could store my tools. I had my table saw out in the yard and I sprayed WD-40 on it all the time so it wouldn't rust out, and I covered it with a canvas. This old garage of Edmund's was where I did the postproduction on *Eraserhead*. I had a really old Moviola, but it wasn't a bubble-top Moviola; it was upgraded to have a viewer and it was really kind to film. So I was cutting on a Moviola, not even a flatbed, and I had all my film in racks, and I had an editing table and some synchronizers in there.

I was still working on the film when Al left for Findhorn, and it really depressed me when he left. Al was a funny one. He's a hell-bent-for-leather person, and when he gets on a thing he just goes and does it.

Fine. But I really wanted him to help me with *Eraserhead*. So off he goes. I think he enjoyed it for a while but he came back after several months, and I was really glad to see him when he did. He lived in my garage after he got back and he'd have his salads, and he eats his salads the same way he did everything. Mixing and eating salads was just ferocious. Al had a desk on one side of the garage, and although we hardly had any sound equipment Al was over there doing sound. Al did this thing in the morning we called "putting in his eyes," and he'd have the same setup each time. He'd have a paper towel and he'd fold it a specific way and he'd have a shallow bowl with liquid in it and his little container of contacts. He'd open up this container and take one of the contacts and move it around in the solution really fast, then he'd put it in and blot his fingers on the paper towel. Then he'd do the other one, work that contact like crazy in the solution, put it in, and he'd be done.

There was a big room in the Doheny mansion called the Great Hall that was originally a ballroom, and the AFI built a slanted floor in there and put in a big screen and a projection booth with dubbers in a balcony that was originally a place for an orchestra. Down below they had the mixing console. The Great Hall had a chandelier that would rise up into the ceiling and dim as it went up, so when you saw a film there it was quite a show. One day Al and I were in there mixing and these people came in. I didn't want anybody in there and I told them to leave, then somebody else came in and said, "These people from Cannes are here. Could they come in and see something? This could be really good for you, David." Normally I would say no but I said okay, just a little bit. I didn't really see them but I pictured a bunch of people wearing berets, and they saw maybe five or seven minutes. Later I was told they said, "He out-Buñueled Buñuel," and that I should take the film to New York, where they were screening films for Cannes.

That opened the door to thinking maybe we could get into Cannes, and Al said, "If you want to make that date we have to work around the clock and you have to stop going to Bob's." It almost killed me. I had to give up milkshakes. Al felt sorry for me, though, and one day he said, "Let's take a break and go to Hamburger Hamlet." So we go and have coffee and I see this piece of Dutch apple pie in the case. I get a slice and it's so good but it's expensive, so I can't do that again. One day I'm in the

supermarket and I see an entire Dutch apple pie that costs just a little more than that slice did, so I buy the pie, read the instructions, put it in the oven, and it cooks. I'd cut a slice and wrap it in tinfoil and hide it under my jacket, then go to Hamburger Hamlet for coffee and sneak bites of the pie while we were having coffee. And we finished the film in time for Cannes.

I used to go to Du-par's at the Farmers Market, where they had these tall blue-gray wooden shopping carts with two wheels, so I found the office of the manager of the Farmers Market and went up these wooden steps to this beautiful office on the second or third floor of a building there. This guy invited me in and I said, "I've gotta take twenty-four rolls of film to New York City. Could I borrow a shopping cart to take them there?" He said, "Listen, pal, people steal those fuckin' things all the time and they don't ever come in and ask. It's nice of you to ask, so of course you can. And good luck to you." I had twelve rolls of picture and twelve rolls of sound and I loaded them all onto this heavy cart, taped it all together, and checked it in as baggage. I took all my money out of the bank for a ticket on the red-eye, and I was really sick when I flew there, with a bad cold and a fever. The Lady in the Radiator's sister lived there and she gave me breakfast, then helped me get in a cab, and I went to a theater downtown. I took the film in and this guy said, "Just set it there— these films here are ahead of you," and he pointed to a long row of films. I went and got coffees and donuts and all day long I was pacing out front, then finally the projectionist started running it late in the afternoon. I'm listening at the door—the film seemed so long! He finally said, "Okay, it's done," and I packed it up and went home.

Maybe a week later I found out no one was in the screening room and he was screening to an empty house. I felt pretty bad about that. Then I submitted it to the New York Film Festival and it got rejected there, too. I wasn't even going to submit it to Filmex, but Mary Fisk said, "I'm driving you down there and you're going to submit it," so I loaded up the film and drove over there with a big chip on my shoulder. I set the thing down and said, "Rejected from Cannes, rejected from the New York Film Festival—you'll probably reject it, too, but here it is." The guy said, "Hold on there, buddy. We're our own people. We don't care where it's been rejected," and it played at midnight at Filmex.

I thought the film was done when it got into Filmex, but it needed to be cut, and it was the Filmex screening that made me do it. The film screened in this giant room and they said, "David, sit here in this back seat. Feel this little button underneath the seat? Every time you push the button it raises the sound one dB." So I'm sitting there and the film starts and it's real low, so I hit the button like three times. It's still too low so I hit it again, and it's *still* too low. I might've hit it a couple more times. I had it up so loud that when Henry sets his knife down on his plate at Mary's house, the sound just about severed the heads of the people in the front row. I left the theater and was outside pacing in the lobby for the rest of the film. Fred drove me that night, and on the way home I said, "Fred, I'm fuckin' cutting the film," and he said, "David, don't." I said, "I know exactly what to cut and I'm gonna cut it," and I stayed up all night working on it. I didn't cut the film willy-nilly—I thought about it—but I made the mistake of cutting a composite print. It wasn't exactly a mistake—I knew I was cutting a composite print—and it was stupid that I did, but that's the way I did it. So it was twenty minutes longer at Filmex—it was one hour and fifty minutes. Now it's one hour and thirty minutes.

This young guy who was into distributing films saw *Eraserhead* and thankfully realized Ben Barenholtz was the right guy for it, and he contacted Ben and Ben asked to see it. Ben is a real character. He's kind of serious and he's a business guy, but he's really an artist business guy, and he's the grandfather of the midnight movie screenings. He said to me, "I'm not going to advertise much, but I guarantee you within two months there will be lines around the block." And it came true.

After Peggy and I got divorced, Mary came out and stayed with Jack and Sissy, when they lived in Topanga. Apparently they weren't paying much attention to Mary and she wasn't happy, and we started up a thing and one thing led to another. I got married again because I loved Mary.

Right after we got married, Mary and I went to New York to finish the film. Mary was there for a week—she got tired of it fast—but I spent the summer living in Ben's apartment, working with this place called Precision Lab. Maybe there are labs around that are kind of like artistes?

These guys were more like truck drivers. It was a blue-collar lab, and they couldn't believe I wanted the film as dark as I wanted it and they wouldn't print it that dark. They said, "No, you can't print it that dark." I'd say darker, and they'd make it a *tiny* bit darker, and I'd say, no, darker. They ran the negative through every time they made a print and it took two months to get the print as dark as I wanted it. Many fuckin' prints were made and it was horrible. I finally got a print I loved and the film opened at Cinema Village. I didn't go to the premiere, but they had launch-party screenings on Thursday and Friday with mostly legal people and friends of theirs, then it opened on Saturday. I heard there were twenty-six people there on opening night and twenty-four people the next night.

I still didn't have any money after the film opened, so when I got back to L.A. I went to Riverside and worked with my father on a house. I didn't feel demoralized, though. No way! I was so thankful because the film was finished and it was being distributed. I wouldn't exactly call it a success, but everything's relative. If you're talking about money, *Jaws* is a success. If you're talking about feeling good about getting the job done and having a place for people to see it—that was a success to me. So I worked with my dad every day and we'd come home at night and my mom would have dinner ready for us. We'd eat dinner together, then I'd excuse myself and go to my room, and I'd get in bed and write ten pages of *Ronnie Rocket, or the Absurd Mystery of the Strange Forces of Existence.* I couldn't go to sleep until I wrote ten pages, because I had it all in my head. In those days if you took the train from D.C. to New York you'd pass through *Ronnie Rocket* territory. It was before graffiti and there were old factories that weren't completely run-down yet, and factory neighborhoods, and it was so beautiful. And then it just went. The world I saw from the train disappeared. I didn't make any money on *Eraserhead,* but I loved that world I'd seen, and I was thinking about making *Ronnie Rocket.*

The Young AmeriCan

EM-5470

Lynch was indeed finding an audience for his work, but his next screenplay, *Ronnie Rocket,* proved to be a tough sell. The opening image—a raging wall of fire shooting two hundred feet high on a theater stage—set the tone for all that follows. There are so many surreal elements in the story that it would've been all but impossible to film in the late 1970s, when computer-generated imagery was still in its infancy: A bird with a broken neck does backward somersaults; electrical wires move like hissing snakes; romantic love triggers explosions in the sky and streamers raining down; a talking pig walks on his hind legs.

Ronnie Rocket is set in a land where "black clouds race over a dark, soot-covered city," and we're reminded of Philadelphia as well as *Eraserhead.* The approach to storytelling in *Ronnie Rocket* differs significantly from the narrative minimalism of *Eraserhead,* however, in that it interweaves two complex story lines. One of them follows a detective who travels into a forbidden zone known as the inner city in pursuit of a villain who's hijacked all the electricity and reversed it so that it produces darkness rather than light. The second story line tracks the sorry adventures of a sixteen-year-old boy who's a kind of Frankenstein monster, subject to fits generated by electricity. Lynch has described the film as having a lot to do with the birth of rock 'n' roll, and Ronnie Rocket becomes a rock star who is exploited for financial gain but remains uncorrupted. The central metaphor in the screenplay is electricity, and it erupts everywhere—it snaps and pops from electrical wiring, shoots from fingertips, arcs and dances on train cables that stretch above the town. Woven throughout the script are elements that recur in Lynch's work, including peculiar sexual encounters, a dysfunctional family, and extravagant flourishes of violence.

These disparate elements come together to create a parable for the spiritual beliefs that had become central to Lynch's life. The detective in the story is counseled by a wise man on the importance of maintaining consciousness; in this story, to lose this is to die, and love and pain are the energies that allow people to remain conscious. The recurring motif of the circle—the detective visits a nightspot called the Circle Club and is told that "things keep going round and round" and "life is a donut"—alludes to the wheel of karma and rebirth. The film closes on an image of a figure with four arms dancing on a lily pad, reaching for a golden egg. The sacred Hindu texts, the Vedas, tell us that the material universe, which emerged from the mind of Brahma, is a golden egg that floats like a dream in the waters of divine consciousness.

Lynch has described *Ronnie Rocket* as being about coal, oil, and electricity, but it's also a strange tale of enlightenment cloaked in dark humor, and it's surprising that it did generate a bit of interest. In the months following *Eraserhead*'s release, Lynch got a call from Marty Michelson, an agent with the William Morris Agency, who was interested in representing Lynch, and he tried to secure financing for *Ronnie Rocket* but was unable to get anything going.

At that point Stuart Cornfeld, who helped lead Lynch to his next film, *The Elephant Man,* stepped in. Born in Los Angeles, Cornfeld was a student in the AFI's producer's program, where he focused his energies on its directing workshop for women. Actress Anne Bancroft was a student there at the time, and Cornfeld produced a half-hour short for her. After working with Cornfeld on a second short, *Fatso,* Bancroft made him the producer when she expanded it into her feature directorial debut.

Cornfeld's graduating class of 1976 included director Martin Brest, who encouraged Cornfeld to see *Eraserhead* at the Nuart. "I absolutely loved it," Cornfeld recalled. "David kind of broke the code on how to do a dark movie, because he's able to go really dark but still hit a transcendent beat at the end. He creates a frightening hole you fall through, and under normal circumstances you'd be freaked out by the fall, but there's a certain peace underlying his work. I was totally blown away by *Eraserhead*."

Cornfeld continued, "I knew David had gone to the AFI, so I got his number from the school and called him and said, 'Your movie is amazing; what are you doing now?' So we met at a coffee shop called Nibblers and started hanging out. He was poor at the time and was living on Rosewood, and I remember

going to his place shortly after we met. He had one Voice of the Theatre speaker, and he played '96 Tears' on his record player for me. We started having lunch once a week, and he was always fun and had the right kind of sense of humor. I like dark humanists.

"He gave me the script for *Ronnie Rocket,* which I thought was incredible, and I took it around but couldn't get anywhere with it. David had already experienced a negative reaction to *Eraserhead* from mainstream Hollywood, and I told him, 'The main thing is you've just gotta get another movie going.'"[1] It was then that Lynch began considering directing something written by another screenwriter.

Anne Bancroft introduced Cornfeld to her husband, Mel Brooks, who hired Cornfeld to be his assistant during the making of his hit film of 1977, *High Anxiety;* the first AD on the film was a young novice named Jonathan Sanger. Born in New York, Sanger moved to Los Angeles in 1976 and his friend, filmmaker Barry Levinson, introduced him to Brooks, who hired him for *High Anxiety;* Cornfeld and Sanger became friends on the set.

The saga of *The Elephant Man* began in earnest when Sanger's babysitter, Kathleen Prilliman, asked him to read a script that her boyfriend, Chris De Vore, had written with his friend Eric Bergren while they were film students in Northern California. Both began their careers wanting to be actors but turned to screenwriting after they happened across a book called *Very Special People,* which included a chapter on the Elephant Man.

Born in Leicester, England, in 1862, and afflicted with maladies that left him severely deformed, the Elephant Man—whose given name was Joseph Merrick—survived a brutal period of work as a sideshow freak then became a ward of London Hospital, where he was nursed and protected by Sir Frederick Treves until he died at the age of twenty-seven. (Treves mistakenly listed Merrick's name as John rather than Joseph in his 1923 book, *The Elephant Man and Other Reminiscences.*)

"I was entranced by the script," Sanger recalled. "I optioned it for a thousand dollars for a year, and they sold it to me with the condition that they got to remain part of the project as the writers."[2] Cornfeld was excited by the script, too, and after reading it he immediately called Sanger and told him, "I know the guy to direct this." He then called Lynch and said, "You've got to read this script."

The Elephant Man is a darkly romantic story and exactly the sort of thing to

get Lynch dreaming, and when Sanger and Lynch met at Bob's a week later, Lynch told him he loved the script and asked if they'd settled on a director. "David talked about how he envisioned the film," said Sanger, "and having seen *Eraserhead* I thought he could do it." After seeing *Eraserhead,* De Vore and Bergren felt the same way. "We thought, Wow, this guy could really do it," said De Vore. "When we met David at the Bob's in Century City, we were convinced that he had the kind of wild mind we wanted for the piece."[3]

With Lynch in mind as director, Cornfeld and Sanger shopped the script to six studios but didn't have the clout to get it to anyone with the power to green-light a film. At that point Brooks intervened. "I gave the script to Mel's secretary, Randy Auerbach, and she gave it to Mel, who read it over a weekend," said Sanger. "He called me Monday morning because my name was on the script and said, 'This script is fascinating. Let's talk.' The next day I met with Mel and his lawyer at the Beverly Hills Hotel and he said, 'Let's do this.' I couldn't believe it."

Brooks was in the process of forming a production company called Brooksfilms, where he planned to do movies other than comedies, which were the exclusive focus of his existing company, Crossbow Productions. "I've always been a secret intellectual who loves Nikolai Gogol and Thomas Hardy, but I was nailed down as a clown very early, and I knew my place," said Brooks. "That didn't stop me from producing serious films, though, and I found that I could do it as long as I kept the name Mel Brooks away from them."[4]

Brooks thought *The Elephant Man* would be a great vehicle for director Alan Parker, but Cornfeld told him, "No, it's got to be David Lynch—he's the guy," and Brooks agreed to meet Lynch. "David came to my office on the Twentieth Century Fox lot dressed like Jimmy Stewart about to star in a film about Charles Lindbergh," Brooks recalled. "He had on a leather bomber jacket and a white shirt buttoned up at the top, and his hair was cut in a kind of provincial manner. He was very straightforward and had a kind of crazy Midwestern accent. We talked about the script, and he said, 'I think this is a heartwarming story,' and that got me. We talked for a long time about this and that, then he left and I said, 'That's the guy. I don't have to meet anybody else.'"

Cornfeld told Brooks he should probably see *Eraserhead* before officially giving Lynch the job. Accompanied by Sanger, Brooks had a private screening of the film in the Darryl F. Zanuck Theater in a basement on the Twentieth

Century Fox lot while Lynch and Cornfeld waited outside. At the conclusion of the screening, Brooks gave Lynch the job.

Brooks said he loved *Eraserhead* "because it's all symbols, but it's real," and told Sanger and Cornfeld where he planned to pitch the project. Cornfeld told him they'd already approached those people and they'd passed. "Mel said, 'They passed to *you*,'" Cornfeld recalled. "'Nobody wants to say no to me, and somebody is going to call back and say they like the project'—and he was right, of course. The script went out with David attached as director, and Paramount and Columbia called back."

Michael Eisner and Jeff Katzenberg were running Paramount at the time, and Brooks gave the script to Eisner. "I said, 'Read it, please,'" Brooks recalled, "and Michael called back quickly and said, 'I love it and want to make it.'" (Film critic Pauline Kael was reviewing material for Paramount at the time and encouraged Eisner to make the film, then sent a note to De Vore and Bergren, telling them that their screenplay neglected Merrick's sexuality.)

Although Lynch has been quick to point out that the original script for *The Elephant Man* was very good, it nonetheless went through extensive revisions. Bergren and De Vore's original draft was two hundred pages long, so the first order of business was to streamline the story.

Cornfeld, who was executive producer of the film, recalled that "David and Mel were the driving forces on the rewrite, and Mel had a lot of input on the script." Sanger concurred: "Mel made important contributions to the script and he made the story more dramatic. It differs in the film from the way it actually happened, but Mel said, 'It doesn't matter what really took place; our concern is how this operates emotionally as a movie.'"

Assigned an office across from Brooks's on the Fox lot, Lynch, De Vore, and Bergren met with him at the end of each week during the two months they worked on the script. "They'd read what they'd written out loud and Mel would make observations," said Sanger, who produced the film. "Mel would throw anything against the wall, because that's how he worked in comedy, and sometimes his observations didn't work and sometimes they were right on— Mel's a very smart guy."

Casting the character of the Elephant Man became a top priority the moment that seed money for the film was secured, and various names were bounced around. A major star would help line up additional financing—Dustin Hoffman was considered, among others—but a major star would have a

harder time disappearing into the character. "We heard about John Hurt's performance in *The Naked Civil Servant*, so Mel and I watched it and were impressed," said Sanger. "David was pushing for Jack Nance to play Merrick, but Mel thought David needed to work with an actor who would take him out of his comfort zone, which Jack wouldn't do, so we started pushing John Hurt for the part."

Hurt was in Montana shooting director Michael Cimino's *Heaven's Gate* at the time, but he came to Los Angeles early in 1979 for the Academy Awards, as he'd been nominated as best supporting actor for his work in *Midnight Express*. "Mel called John's manager and asked to see John while he was in town," said Sanger. "Mel then came up with the idea of having photographs of the real Elephant Man blown up to wall size and hanging them in his office, and he orchestrated this whole thing. Mel said, 'Okay, this is where John will sit, and we'll hang the pictures here, and we're not gonna mention the photos. We're just gonna start talking about the movie.'

"Everybody shows up and sits down and Mel starts pitching the movie, and we could see John's eyes going to these pictures," Sanger continued. "John is being very polite and his manager is saying things like, 'This sounds interesting,' then John suddenly interrupted him and said, 'I want to do this movie.' David stood up and walked over to John and shook his hand, and the two of them developed a special relationship right away. There was something about David that really intrigued John. The two of them are very different, but David is the most winning guy—he really is hard to resist—and the two of them bonded from the get-go."

The film was hurtling forward at a brisk pace and Lynch jumped in with both feet. "He loved the project and the story stirred something in him, but the reality of making a Hollywood movie was completely new to him," said Mary Fisk. "Everything happened so fast and it was a constant barrage of things to do. My brother didn't know whether he'd be able to do it, because David is an artist."

Lynch apparently never doubted his ability to handle the film—he's fearless when it comes to art—and he initially planned to employ the same hands-on methodology for *The Elephant Man* that he'd used for *Eraserhead*. "David said that if he did the movie, he wanted to do the makeup himself," Brooks recalled. "I told him, 'I've directed a few movies and you're pretty busy,' but I let him have a shot at it." So, shortly after Hurt returned to the set of *Heaven's*

Gate, the Lynches traveled to Montana, where David made a full body cast of the actor. "Making the cast was an ordeal," Mary recalled. "There was John, encased in plaster with straws up his nose, but he was a real trooper."

With a finished draft of the script in hand and a lead actor attached to the project, Lynch, Sanger, and Brooks headed to London to begin pre-production. "It started getting really cold right after we got there," Brooks recalled, "so I bought David a blue overcoat, and he wore it every single day of the shoot."

The trio landed in London, then headed for Wembley, a nondescript suburb that's a forty-five-minute drive northwest of the city center. Once a thriving manufacturing area, Wembley didn't have much to recommend it other than its soccer stadium by the time Lynch arrived. However, Lee Studios, a recently remodeled television studio owned by brothers John and Benny Lee, was located there and was a good fit for the film. It was a modest studio measured against London's three major movie facilities—Shepperton, Elstree, and Pinewood Studios—but production manager Terry Clegg chose it because he felt it would be beneficial for the shoot not to have to compete with larger productions for studio services. Prior to returning to L.A., Brooks spent half an hour a day on set for the first three days of the shoot, "being very happy and loving and supportive," Lynch recalled. "He said he was given breaks in life and he wanted to help some young people who were getting going."

With the exception of Anne Bancroft and John Hurt, all the casting was done in London and overseen by casting director Maggie Cartier. Anthony Hopkins was given the lead role of Sir Frederick Treves, and Sir John Gielgud and Dame Wendy Hiller came in to discuss secondary parts. "I was surprised that people at their level would even come in to meet, but they were happy to do it," recalled Sanger. "Wendy Hiller was delightful, and John Gielgud was a sweet, self-effacing man, and he had that beautiful voice and perfect diction. He loved the part and it was always 'whatever *you* want' with him. David said it was terrific working with John because you could just dial it in; you'd tell him you want a little bit more of something and he'd give you exactly what you needed. David was really impressed by his technical skill."

Actor Freddie Jones, who went on to appear in several more Lynch films, including *Dune* and *Wild at Heart,* was a bit harder to recruit. "David liked him right away—he's a dreamy, unusual man, and he fit into David's world perfectly," said Sanger. "But Freddie said the character we wanted him to play was too one-note and that he had to be more than just a guy who beats this

defenseless creature. He wasn't turning us down completely, so David said, 'I really like you; let me track the script from the point of view of that character.' David then agreed that the character's feelings for the Elephant Man needed to be more complex, so Freddie's input is definitely reflected in the final script."

Two scenes in the film feature a cast of carnival freaks of the sort typical of the Victorian period, and this was a challenging bit of casting. Freak shows began declining in popularity in 1890 and had almost completely disappeared by the 1950s. Moreover, medical advances of the twentieth century dramatically reduced the incidence of the bizarre physical anomalies that were central to nineteenth-century freak shows. "Maggie Cartier put an ad in a newspaper in London that said, 'Live human freaks required,'" said Sanger, "and we got such shit over that!"

The Nottingham Goose Fair has occurred annually in England since the Elizabethan period, and one of its primary attractions was its freak show. While the film was in pre-production, Lynch learned that someone affiliated with the fair managed a set of Siamese twins. "David was very excited about this," Sanger recalled, "so we called this guy and he said, 'Yeah, I've got the twins—I manage them.' So David and I drove up to the Goose Fair, which turned out to be this backwater place with a bunch of dumpy trailers. We go to this guy's trailer and knock, and a fat guy in a dirty T-shirt opens the door, and he and his wife invite us in. This place was straight out of David's dreams. So the guy says, 'Honey, go get the twins,' and she went to the far end of the trailer and came back with a big bell jar filled with formaldehyde and the embryo of a set of dead twins. David was disappointed."

Cartier found an agency in London called Ugly that provided the giant and several dwarfs who appear in the film; Lynch and his art department created the other characters in the freak show. Frederick Treves's great-nephew makes a cameo appearance playing an alderman, and writers De Vore and Bergren turn up, too. "We appear briefly in the first scene of the film," De Vore recalled. "We portray minstrels playing a Lyra Box, which was a unique instrument David built with the art director, Bob Cartwright. It was a barrel organ with the weird David Lynch addition of a sort of bladder bag on top."

During the making of the film, Fisk and Lynch lived in a small house in Wembley, with a garage that he transformed into a studio where he worked on the Elephant Man makeup during twelve weeks of pre-production. "David was

the mad scientist working alone in his garage, and nobody knew what was going on in there," recalled Sanger.

There was one person who did get past the no-entry sign. "I was on *The Elephant Man*'s set for a little while," recalled Jennifer Lynch, "and I was Dad's head model when he was working on the makeup. That's a potent memory for me. I remember having straws in my nose and this feeling of warm compression, and him talking, and the sounds he makes, and the thing he does with his lip when he's thinking out loud, and I felt privy to his process. It was nice."

Less nice was the day Lynch unveiled the makeup for his colleagues. "He made something that looked like a sculpture of the real figure, but it was basically a mask," said Sanger. "He hadn't had John Hurt to work on directly, so it was impossible to make it blend into John's face and clearly wouldn't work, and this was devastating to David."

After the film wrapped, Lynch told Sanger that he'd considered getting on a plane and leaving the film at that point because he felt that he'd failed. "David was riding a wave that he could do it all, because he'd done unique, special things all his life," said Fisk. "But as talented as David is as an artist, he didn't have the knowledge to do this. When they realized the makeup had to be redone, David and Jonathan rearranged the schedule so the scenes without John Hurt were shot first. They found a way to work around the problem with the makeup, but David still went into a horrible place. He sat bolt upright in bed for three nights in a row and he was terrified. David always seems like he's on solid ground and is unfazed by things, but that's not always the case. Shortly after the makeup fiasco Mel called and said, 'David, I want you to know we're behind you a thousand percent,' and that helped him. Mel was amazing the way he supported David."

Hopkins was slated to begin shooting *A Change of Seasons* with Bo Derek and had a stop date, so there was no time for hand-wringing over the makeup. Sanger immediately called Chris Tucker, who was born in Hertford, England, in 1946, and had abandoned an opera career in 1974 to become a makeup artist. Tucker declared that in order to do the job he'd need the original life cast of Joseph Merrick, which was in the permanent collection of the Royal London Hospital Museum and Archives, so Lynch and Sanger went to see head curator Percy Nunn. "Initially he was totally uninterested in the project," Sanger recalled. "He thought the making of the movie was a bit of a sacrilege, but after talking with David he realized what he wanted to do was a good thing.

Still, I thought there was no way he would let us borrow the life cast of Merrick—to this day it's mind-boggling that he gave it to us. This is the pièce de résistance of their collection and David just said, 'Could we borrow that?' David was naïve enough to ask, and he just charmed the man."

Having the life cast made things easier for Tucker, but he still worked slowly. Makeup for the head alone required eight weeks to complete and involved fifteen different overlapping sections fashioned out of soft foam; each piece could only be used once, and Tucker cooked a new set of pieces every day in the oven in his warehouse. Applying the makeup took approximately seven hours, so Hurt worked on alternate days. He'd arrive at the set at 5:00 A.M. and sit for seven hours while the makeup was applied. Unable to eat, he occasionally sipped raw eggs mixed with orange juice, then shot from noon until ten at night.

Fortunately, the cast and crew didn't laugh when they first saw the makeup, Hurt has recalled. "You could've heard a pin drop, and that gave David—who was a very young director at the time—confidence. At that moment we knew we had something."[5]

Commencing in September 1979, the shoot continued through Christmas and into early 1980. Lynch wanted a big canvas to work with, so he shot the film in widescreen, which is customarily used for Westerns and epic films. The mood of London in the aftermath of the Industrial Revolution is oddly evocative of the worlds of both *Eraserhead* and *Ronnie Rocket:* All of them involve lots of soot and smoke, and it's a milieu Lynch is brilliant at manipulating for dramatic effect. The film was shot by cinematographer Freddie Francis, a two-time Oscar winner who played a central role in defining the look of the British new wave films; Francis was the DP on several black-and-white classics of the period. The widescreen format Lynch opted for gave Francis plenty of room to play with shadow and light.

The bulk of Merrick's story takes place in the Royal London Hospital, where he spent the final years of his life. It was impossible to shoot there—it's a working hospital; moreover, motifs of the Victorian era had been largely erased from the building by 1979. The film was shot instead at Eastern Hospital in Homerton, a medical facility founded in 1867 that was in the midst of downscaling its services when Lynch arrived. (It was completely closed in 1982 and demolished shortly thereafter.) The hospital had unused wards that were a perfect match for his vision of London Hospital during the Victorian

era. A few scenes in the film are set in London's East End, where the most horrific slums of the Victorian period were located, and short stretches of worn cobblestone street dating from the period remained when Lynch shot the film but are long gone now. Lynch has said it would've been impossible to make *The Elephant Man* in England after 1980. He got there just in time.

Lynch loved the crisp, gleaming world of the hospital, with gas lamps, cast-iron fireplaces, lacquered floors, and exquisite woodwork. Juxtaposed with the darkness and filth of Victorian factories, it was a realm tailor-made to his aesthetic. It took a while for the crew to grasp his visual sensibility, however. "The knock on David early on was that everything was too dark," said Sanger, "and Bob Cartwright, the art director under Stuart Craig, said, 'We're doing all this work and we're not seeing any of it.' David had very clear ideas about what he wanted, though, and when he made choices he knew what the end result would be."

"David was very directorial and authoritative on the set," recalled Brooks, "but right behind that façade was this childlike person thinking, Yeah, we're making a movie! He acted like a grown-up, but the kid in him directed the movie."

With *The Elephant Man* Lynch showed that he was an actor's director, and he mostly worked well with the classically trained performers in his cast. Hopkins gives what is by any measure one of the great performances of his career. "There's a scene where Anthony Hopkins's eyes well up and one massive tear falls, and David got the angle and the lighting—he just got it," said Brooks. "Everybody loved David right away, but there were a few uprisings. John Hurt was always supportive of everything, and John Gielgud and Wendy Hiller were total professionals. If you're a private in the army and an officer walks by, you salute; David was the director, and they saluted him. Anthony Hopkins didn't actually try to get him fired but he did complain, and he said, 'I don't think he has a total grasp of what has to be done here.'"

Sanger recalled, "Hopkins wasn't openly hostile but he was aloof, and one day he called me into his dressing room and said, 'Why is this guy getting to direct a movie? What has he done? He did one little movie. I don't understand this.' So Hopkins wasn't happy. The only time there was a real problem on set was when they shot a scene where Treves brings Merrick home to meet his wife. Hopkins enters the doorway into a hall with a mirror on the wall, and David wanted Hopkins to walk in and look in the mirror. Hopkins refused. He

said, 'My character wouldn't do that.' David, in his straightforward way, tried to persuade him that it was not an illogical thing to do, but Hopkins refused to do it. David finally said, 'Okay, I'll change the shot,' and it wasn't discussed again. At the end of the day David told me he would never make another movie where he didn't create the characters, because he didn't want to be told what a character would or wouldn't do."

Fisk said, "It was a hard movie to make, and David was on trial the whole time. There he was, this kid from Montana, directing John Gielgud and Wendy Hiller, and I think they thought, Who is this American person? They were both at the end of their careers, and did they want it to end like this? I have a photo of John Hurt as the Elephant Man, and John Gielgud wrote on the bottom of the photo, 'I hope it's all worth it.'

"It was tough for David," Fisk continued. "But he went to work every morning at five and had a wonderful driver he had coffee and croissants with on the way to the studio, and there were many things about the making of the film that he loved. David enjoys life. But they worked long hours and Sunday was the only day of the week they had off, and David was catatonic on Sundays."

During her time on set, Jennifer Lynch could see that "Dad was up against a lot of insanity and a lot of talent who thought they were older and smarter than him. I know Hopkins wasn't kind to him then later apologized, but I never got the sense that Dad felt stressed. When I think back on it now, I'm impressed by how beautifully he held everything together, because he didn't seem upset. He handled it very well."

"David grew in competence as the film went on," John Hurt recalled. "There he was in England, this very young man, and nobody knew him. People were wary and quite dismissive of him to start with, and I don't think they were by the end. David's very determined when he's got an idea. He's not easily dissuaded."[6]

As was his habit, Lynch lived modestly during the shoot. He had a cheese sandwich for lunch every day and saved enough of his per diem to buy a car when he got back to Los Angeles. He ran a closed set and there were few visitors. "David made it clear that he didn't want me on the set and wanted to keep his creative life separate," said Mary Fisk. "I was fine with that, but he'd come home every day and tell me what happened that day, and I was a sounding board when he needed one."

Shortly after arriving in London, Fisk and Lynch got a dog. "David liked

Jack Russell terriers, and I went to a breeder and got one," she recalled. "We named her Sparky, and she was insane but she and David got each other. She's the only dog I've ever known David to relate to, and he played games with her that she understood. He wanted her in *Blue Velvet,* and she's in a scene at the beginning of the movie."

Fisk was mostly on her own in a foreign country while Lynch worked, and she became pregnant with twins while the film was in pre-production. "David was excited about it—he said, 'We're gonna call them Pete and Repeat,'" said Fisk. It was a difficult pregnancy, though, and Fisk was hospitalized for three weeks during her first trimester. "David would come every other night and sit with me in the hospital after they'd been shooting all day. He couldn't get there until ten at night, after the ward was closed, but the nurses liked him so much they let him stay with me. Then Mel stepped in and paid all the medical bills—he was just awesome." After Fisk was sent home from the hospital, Lynch's mother came to stay and help out, but Fisk miscarried two weeks later.

Heading into the final phase of the shoot, Lynch found a location an hour outside of London that he felt would work well for a scene set in Belgium. Shooting at the location would've been prohibitively expensive, so Stuart Craig devised a way to re-create it on a soundstage; the set he created required a soundstage of a scale Wembley couldn't provide, however. The Lee brothers had just acquired Shepperton Studios, a much larger facility on the opposite side of London that could also accommodate the film's post-production needs, so Fisk and Lynch moved to a flat in Twickenham and the production moved to Shepperton, where the movie was completed.

There were seven soundstages at Shepperton then (there are fifteen today), and when Lynch arrived there were movies in production on all of them. Julien Temple's *Absolute Beginners* was just gearing up and consumed a great deal of space with a major exterior set. "David and I had to park far from our offices because we were now the little movie in the back," Sanger recalled.

During this final phase of the shoot, Alan Splet arrived at Shepperton, and he and Lynch worked together alone in a room without conferring with the sound crew already in place. "The sound people didn't know why Alan was there, because people didn't understand what sound design was at that point. There weren't many sound designers in movies then and Alan was really one

of the pioneers in the field," said Sanger of Splet, who won an Academy Award in 1979 for his sound design on Carroll Ballard's *The Black Stallion*.

Fisk recalled, "As the shoot was getting close to the end, David felt that the film was bogging down. I knew what he was going for, because we talked about it all the time, so he decided I should see a rough cut. A few people working on the film heard there was going to be a screening and they came, too. Afterward, one of the people who'd seen it called David and said he hated the film and wanted his name taken off of it, and nobody could believe he'd made this piece of junk. I had to scrape David off the floor.

"While David was still editing the film, EMI edited a version without him, then called Mel and told him they had a cut of the film to show him," Fisk continued. "Mel said, 'I'm not even going to look at what you've done. We're going with David's version.' The studio guys will crush you, and they were going to crush David, and Mel was an unreal advocate for him."

The first cut of the film ran for almost three hours and was edited down to a final version that's two hours and six minutes. "There were lots of shots of people walking down long hallways and atmosphere stuff that ended up being cut," said Cornfeld, "but most of what was shot wound up onscreen. Mel had final cut but he deferred to David on that, and he took no credit at all on the film because he didn't want his name to create any expectations about what the film was."

Lynch's idea of relaxing is to make something, and when Fisk returned to America for additional medical care following her miscarriage, he came up with a project for himself. The day she left London, he went to a fish counter and purchased a mackerel, took it home, dissected it, laid out the parts, labeled them for ease in reassembly, then photographed the display. "What the average person sees as grotesque isn't grotesque to me," Lynch has commented. "I'm obsessed with textures. We're surrounded by so much vinyl that I find myself constantly in pursuit of textures." He called his mackerel project a Fish Kit, and it included instructions to "place finished fish in water, and feed your fish." It was the first in a series of kits that included a Chicken Kit and a Duck Kit. He also collected six dead mice for a Mouse Kit he never got around to making, and he left the mice in a freezer in the house in Wilmington, North Carolina, where he lived while making *Blue Velvet*. He was interested in doing kits of larger animals but never got the opportunity.

Filmmakers are photographers, too—it's a crucial aspect of location

scouting—and Lynch began actively pursuing photography at approximately the same time that he was making *The Elephant Man*. The photographs he's produced over the past thirty-eight years have two enduring themes: women and abandoned factories. He's often commented on how compelling he finds the power and grandeur of machinery, and he developed a particular fascination with industrial ruins during his months in England. "I heard that the north of England had the greatest factories, so I organized a trip with Freddie Francis, but I probably missed it by just a few years," Lynch has recalled. "Everywhere we went, the factories had been all torn down. It was a very depressing trip."[7]

Post-production was still in progress when Fisk returned to London in early summer of 1980. "He wasn't on such a pressured schedule by then, and we did watercolors together at home," she recalled. "We also took a week off and went to Paris, which was fantastic. The first night was terrible, though, because David is a penny-pincher and I was always nervous about spending money on anything, so I got a hotel he was horrified by. The neighborhood didn't seem bad to me, but he said, 'I'm not going out of the room!'"

In September of 1980 Lynch returned to L.A. with a finished print of the film, and promotion for it began immediately. Lynch and Fisk were still living in the tiny bungalow on Rosewood when the billboard for *The Elephant Man* went up on Sunset Boulevard, and Fisk recalled that "it didn't seem like much changed when we first got home. David didn't start getting a lot of attention until after the film came out in October, so we just sort of picked up where we left off."

Lynch has an impressive ability to do several different things at once, and on returning to Los Angeles he appeared in director John Byrum's movie adaptation of Carolyn Cassady's autobiography, *Heart Beat*, which starred his friend Sissy Spacek. Lynch plays an artist, and he made the paintings that appear in the film, too.

He also deepened his involvement with photography and shot a series of pictures at a defunct oil well located in the heart of Los Angeles. It was a peculiar relic of the past that's now gone, and the pictures he took there served as a kind of template for all the images that were to follow. Lynch's industrial photographs are classically composed and formal, and his pictures have an ineffable softness; it's as if they've been printed on velvet. The whites are never crisp or shrill, and everything shades into gray. Those early photographs

shot in L.A. depict coiled hoses, pipes, faucet heads, and large tanks bound with neat rows of rivets, as elegant as hand-stitching on a shirt. Twenty years later Lynch was to find the factories of his dreams in Łódź, Poland, and the roots of the pictures he took there are visible in those images he made in Los Angeles in 1980.

Lynch kept busy as *The Elephant Man* edged toward its release date and occupied himself with other things. "David didn't go to the cast-and-crew screening—he was too much a bundle of nerves—but I went and I sat next to John Hurt's good friend Jeremy Irons," recalled Fisk.

Lynch skipped the premiere of the film, as well. "David was too nervous to go, so he stayed home on Rosewood and babysat my six-month-old son, Andrew, while I went to the premiere with our parents and two of our aunts, Margaret and Nonie, who are our dad's sisters," recalled Martha Levacy. "David hadn't told us much about the movie so we had no idea what to expect, and we were just blown away as this incredible movie unfolded in front of us. We were speechless and the audience was mesmerized."

Released on October 3rd, 1980, the film netted eight Academy Award nominations, including best picture, director, actor, adapted screenplay, editing, original score, art direction, and costume design. "I remember Charlie Lutes saying, 'David's entering a whole new world now,'" Levacy recalled, "and his life changed a lot after *The Elephant Man*."

The change came fast, too. "Jack and I always knew how cool David was, but once he did *The Elephant Man* we had to share him with the rest of the world," recalled Sissy Spacek. "Once people work with David they want to work with him again and get near the flame, because he completely surrenders himself to the creative process. Sometimes that's like plowing a field and other times it's like being in a rocket ship, but it's always exciting, and David takes people on that journey."

Mary Fisk recalled how thrilled Lynch was when the film got those nominations. "When we were living on Rosewood, I had a grocery shopping cart and I used to go to the market across the street from this exclusive restaurant called Chasen's," she continued. "I could only spend thirty dollars a week, then I'd walk the groceries home. One night I looked over at Chasen's and saw this big limo pull up and Diahann Carroll and Cary Grant stepped out, which seemed very glamorous. A year or so later a limo pulled up to Chasen's and David and

I got out for a party for *The Elephant Man,* with all the executives, actors, writers, and producers. David always had big dreams, but I've never seen dreams come true the way they have for him. We literally went from rags to riches.

"David always knew he was going to be famous," Fisk added. "He had that vision for himself."

Lynch's career had picked up a great deal of momentum by the end of the year, when Fisk became pregnant again. "When David asked me to marry him I told him I wanted a family," said Fisk, "and he said, 'When I make seventy-five thousand a year we'll have children.' He didn't even have a job when he said that, so the idea of making that much money seemed pretty remote, but that's exactly what his salary was for *The Elephant Man.* Several months later I brought it up again, and he said, 'You can have a baby if Sissy has a baby,' thinking she'd never get pregnant because she was focused on her work. Then Sissy got pregnant in October of 1981, but David still resisted the idea. Finally, I decided to have my tubes tied and had the procedure scheduled, but David didn't like that idea, so on December 28th, he said, 'We'll make love tonight, and if you get pregnant then it's meant to be.' And I got pregnant."

It was time to move out of the tiny bungalow on Rosewood. Lynch and Fisk began looking at real estate, and early in 1982 they purchased a small house in Granada Hills for $105,000. "David didn't love being in the Valley, but we couldn't afford anything in L.A.," said Fisk. "We'd become friends with Jonathan Sanger and his wife, and they lived in Northridge, and Charlie and Helen Lutes and some other meditator friends lived in the Valley, so we gravitated there."

Levacy described their new house as "nice, but real predictable, and not the kind of house David would choose. He knew it was important to Mary, though, and I never heard him complain. They were expecting a baby and it was thoughtful, him buying that house, and he did that for Mary. It didn't seem like a place for him, though."

Lynch and Fisk didn't last long in Granada Hills; the Hollywood elite was finally hip to Lynch, and he was about to experience a whirlwind of attention that would take him out of the San Fernando Valley and knock him slightly off course. Most of the studios and producers who came calling didn't know quite what to do with him, but everyone agreed he was uniquely gifted.

"David really is a bit of a genius, no two ways about it," Mel Brooks con-

cluded, "and he understands the human psyche and emotions and the human heart. He's all screwed up, too, of course, and he projects his own emotional and sexual turmoil into his work and assaults us with the feelings he's being assaulted by. And he does that brilliantly in every movie he makes. I love the guy, and I'm grateful to him for making what may be the best movie Brooksfilms ever produced."

YOU KNOW HOW Bushnell Keeler was such an important person in my life? How we all have important people? Stuart Cornfeld is another one of my important people. One day I came home and Mary Fisk said, "A man named Stuart Cornfeld called." There was something about his name and I started walking around the house saying, "Stuart Cornfeld called, Stuart Cornfeld called." Then he called back, and when I answered the phone he said, "You're a fuckin' genius," and that made me feel good. He wanted to take me to lunch so we went to Nibblers, and he wanted to help me get *Ronnie Rocket* going. Stuart had a great sense of humor and good energy—he's a guy who's just pushing forward and I liked that.

Before I met Stuart a guy named Marty Michelson tried to help me for a while. He liked *Eraserhead,* and I guess he was my agent for a short time, but nothing came of that. I'd also had one meeting at a studio about *Ronnie Rocket,* with this guy who produced *Car Wash.* He said, "Okay, hotshot, whaddya got?" I said, "I have this film called *Ronnie Rocket,*" and he said, "What's it about?" I said, "It's about a man who's three and a half feet tall, with a red pompadour, who runs on sixty-cycle alternating-current electricity." He said, "Get out of my office."

Ronnie Rocket wasn't happening, so it wasn't a stretch for me to consider directing something written by somebody else. I was married, I wasn't working, and I was in a shed-building mode, doing small jobs and maybe working on some art if I had any money. I didn't really care about money and Mary was supporting me. She was a great executive secretary and could get a job in a second. She was totally boss looking and was great at the job, and every morning she'd look like a million dollars as she

headed off to executive world while I stayed home like a bum. I don't remember what I did all day, but I probably just thought about *Ronnie Rocket*. Finally my mother-in-law said to Mary, "Nothing's going to happen with *Ronnie Rocket* and you better light a fire under this turkey. Maybe he could direct something written by somebody else."

I'd been thinking maybe I could do that, too, so I called Stuart and said, "Stuart, do you know of any films I could direct?" He said, "David, I know of four films you could direct—meet me at Nibblers." So I went to Nibblers and as soon as we sat down in a booth I said, "Okay, Stuart, tell me." He said, "The first one is called *The Elephant Man*," and a hydrogen bomb went off in my brain. I said, "That's it." It was like I knew it from somewhere in the deep past. That was absolutely the one, and I never heard what the other three were and didn't want to know. Stuart said, "There's a script," and I said, "I wanna read it."

Jonathan Sanger had bought the script, and he got to know Stuart when both of them worked for Mel Brooks. Mel was busy starting his company Brooksfilms, and somehow Stuart got Mel's wife, Anne Bancroft, to read the script, and luckily she loved it and told Mel to read it. Mel reads it and loves it and says, "This will be my first film for Brooksfilms." So he got everybody together and he pointed to each one of them and said, "You're in." Then he said, "Who is this David Lynch?" They said, "He's the guy who made this film *Eraserhead*," and he said, "I want to see it." They called me and said, "Mel wants to see *Eraserhead* before you can do this," and I said, "It's been nice knowing you guys." I just felt, well, that's it. They said, "He's seeing it this afternoon and you have to come and meet him afterward." So I'm in the lobby outside this screening room and the doors burst open after the film and Mel comes charging toward me, embraces me, and says, "You're a madman, I love you!" It was really great.

Chris and Eric had written a good script that caught the essence of the Elephant Man, but there was no turmoil in the thing and Mel, being a savvy guy, said, "It's gotta be rewritten." And I got to be a writer with Chris and Eric. I'd been doing the paper route and stuff and was making fifty dollars a week, and automatically I was making two hundred a week to do something that's as much fun as writing! My mother-in-law's happy, this is a gravy train—I had it fuckin' made. We worked in an office on the

Fox lot and we'd have lunch in the commissary and it was like suddenly I was in the movie business.

Mel was pretty involved with the rewrite. I like more abstract things, but we needed to get some tension in the script; I don't know who came up with the ideas, but the night porter and the bar and the hookers were born, so there was this force in opposition to the Elephant Man. None of us typed, so either Chris or Eric wrote what we came up with in long-hand, and whichever one wasn't writing was juggling. They had these little beanbags they'd juggle and I learned how to juggle then.

I hadn't flown too many places at that point in my life, but here I am off to London with Jonathan, and we have to stop off in New York to meet this DP who was there shooting Billy Friedkin's film *Cruising*, because maybe he's going to shoot *The Elephant Man*. So we get there and go to see this wealthy friend of Jonathan's who's married to one of these TV news anchormen and lives on Central Park West. We get to the building and there's a doorman, and you take this beautiful old wood elevator and when it stops you're not on a floor; the doors open and you're in their giant apartment. The butler meets us and takes us through these rooms and the walls are lined with deep green, brown, and violet suede. We go into this front room with a huge window overlooking Central Park and the butler starts bringing us hors d'oeuvres and wine, and we're drinking and talking. This was the first time I'd been exposed to this kind of wealth. Meanwhile, Billy Friedkin's in Central Park shooting *Cruising* with this DP we're there to meet, and we're supposed to go down there. I didn't want to go, though, because I never want to go on other people's sets. So Jonathan went and I waited in Central Park, which just reeked of urine. Pitch-black paths, urine, dark vibes everywhere, and I hated it. New York scares the shit out of me, right? So I'm freaking out. I guess we met the DP and he was a good guy, but he didn't commit to anything; then the next day we get on the Concorde.

Three hours and twenty minutes later and we're in London. It was still light out because it was summer, so we walked around for a while, then when we got back to the hotel there was Stuart. We were sitting there talking to Stuart when he said, "Mel's going to come over because he doesn't know if David can hit the emotional points of this film." I said, "What?" Then I stood up and said, "I'm outta here." I went upstairs and

couldn't sleep, and I got a high fever and was sweating like crazy all night long. Like, torment. In the morning I showered and got dressed and meditated, then went downstairs thinking, If someone doesn't apologize and straighten this thing out, I'm going home. The elevator doors open and Stuart's standing there and he says, "I'm so sorry, David. Mel trusts you one hundred percent." I don't know why Stuart said what he'd said the day before, but this is what the making of that film was like. It was a testing thing.

I would've loved to have Jack Nance play the Elephant Man, but I knew very early on that wasn't going to happen. And, just like Dennis Hopper *was* Frank Booth, John Hurt *was* the Elephant Man. It was meant to be that he played that role, and I don't remember any other actors we considered for the part.

I was going to do the Elephant Man makeup, but after I got to London a bunch of strange things happened. The house in Wembley where we lived had a garage where I was working on the makeup using glycerin, baby powder, latex rubber, and some other materials. We were living in this real British little house with knickknacks all around, and one day I was walking through the dining room and suddenly I had a déjà vu. Usually a déjà vu feels like "Oh, this has happened before," but as I entered the déjà vu it got slippery and it went into the future! I saw it and I said to myself, "The Elephant Man makeup is going to fail." Because I saw it. I saw the future. You can go into the future. It's not easy, and you can't do it when you want to, but it can happen. I was quite a ways into the makeup by then, too, but when I tried a piece of it on John Hurt, he couldn't move and he said, "A valiant effort, David."

When Kennedy was assassinated, the country had the four dark days; well, that's when I started my four dark days. When I was awake I couldn't stand being awake, and when I was asleep it was solid nightmares. I thought it would be better to kill myself, because I could hardly stand to be in my body. It was something so powerful that I thought, How can anyone stand to be in a body with this torment? They found Chris Tucker, and he had so much fun bad-mouthing me and letting it be known that I was a joke and he was going to save the day. It was horrible

and I was a fuckin' basket case. Mel said, "I'm flying over and I want to see David," and after four days of waiting, Mel arrives. I went in and Mel smiled at me and said, "David, your job is to direct this picture. You shouldn't have taken this on—it's too much to take on—and thank God for Chris Tucker," and that was the end of it.

In London at that time there were streets you could walk down where you'd swear you were in the 1800s. The people in the streets, their faces, their clothes, the atmosphere—it was like Sherlock Holmes is going to come out a door, or a horse-drawn carriage could come around a corner, or Jack the Ripper's going to pop out. It was incredible. Two years after we finished the film, the great DP Freddie Francis called and told me that almost every location we'd used was gone. Urban renewal hit London right after we finished.

We had a great cast for that film. Alan Bates was originally going to play Frederick Treves but for some reason that didn't work out, and it was Mel's choice that we go with Anthony Hopkins. And John Gielgud was one of the most elegant men ever. He smoked cigarettes but there was never one ash on his clothes, ever. Smoke went away from him! His cigarettes were oval and made especially for him in a shop in London.

Sons and Lovers was a film I really like that sort of caught the feeling of *The Elephant Man*. It's black and white, and I liked Dean Stockwell in it, and Dame Wendy Hiller's in it, and she was going to play Mrs. Mothershead. So I go into this room and there's Dame Wendy Hiller, and she looks at me and grabs me by the neck, and she's small, and she starts walking me around the room, squeezing my neck, and said, "I don't know you. I'm going to be watching you." She passed away, bless her heart, but I loved her, and I love Freddie Jones, too. He's just my kind of guy. There are some people you get a great feeling from, and Freddie is one of them. He's so funny and I love being around him. Freddie Jones was going to be in *INLAND EMPIRE* in the part Harry Dean Stanton wound up playing, but Freddie left his house to come to L.A. and collapsed when he was walking through the airport. I get this phone call, Freddie can't come over and he's under a doctor's care. I don't know what happened, but Freddie's got staying power and he's hanging in there.

Mary got pregnant while we were in London and we found out it was

twins. There are two characters in *Ronnie Rocket* named Bob and Dan, so I wanted twin boys and I'm going to name them Bob and Dan, and they'd have round black shoes, polished, and slick haircuts. Neat little guys. I was pretty pumped about that and then one night I came home and Mary was bleeding and for some reason, who knows why, we went from Wembley to Wimbledon, which is a long way away, to some Catholic hospital. I don't know how long it took us to get there, but I was up until the wee hours of the morning, then I had to get up real early to go to work. I go in that morning and this woman comes up to me and says, "Anthony Hopkins wants to see you." So I go into his room at the end of this long hallway and I'm pale, hadn't had any sleep, and he tears into me and says, among many other things, that I have no right to direct this picture. I said, "Tony, I'm sorry you feel this way, but I'm the director of this picture and I'm going to keep on directing it," and I left. In a weird way Tony Hopkins was right—I had no right to direct *The Elephant Man.* I came from Missoula, Montana, and this is a Victorian drama with these giant stars, and all I'd done is this small film that ten people went to see—it was crazy. But there I was. That film was a baptism of fire. You cannot believe the stuff that went on.

There's a scene early in the film where Dr. Treves sends for the Elephant Man to come to the hospital, so in comes the Elephant Man with the cabbie. There are all these people in the hospital lobby and two women are having a fight and they're pulling at each other's clothes, and all this stuff is going on, and Mrs. Mothershead is at the desk. She's never seen the Elephant Man, so she's looking at him in his cloak and hood, and the people in the lobby are looking at him because he's got a smell, but Mrs. Mothershead doesn't care about the smell. And then Dr. Treves is supposed to arrive. So we're having a rehearsal and Anthony Hopkins comes down, almost running, and he races around and grabs the Elephant Man at hyper speed, and I said, "Wait a minute." I took Tony aside and told him, "You're coming down too fast." And he says, real loud, so everybody could hear, "*Just tell me what you want!*" And this anger comes up in me in a way that's happened just a couple of times in my life. It rose up like you can't fuckin' believe—I can't even imitate the way I was yelling, because I'd hurt my voice. I *screamed* some stuff at him, then

screamed what I wanted him to do, and Wendy Hiller turns to Tony and quietly says, "I would do what he says." So he did. Then at lunch he called Mel and said, "I want this fuckin' guy fired," and Mel talked him down. Tony's perfect in the film, he's absolutely great, but he had a sullen attitude most of the time we were shooting. But it's like those four dark days I had. When it's inside you, it just comes out and you can't really help it. Tony was just pissed off at life.

We were looking for a hospital so we went into Eastern Hospital, which was a derelict London hospital where everything had just been left, and it could not have been better. There was pigeon shit everywhere, and broken windows, but it just had to be cleaned up. The beds were still in the wards, there were these beautiful little stoves and gas lamps—it had gone electric, but stuff was still in place for gas. So I was standing in this hallway and I'm looking into the ward and a wind comes into me and I know what it is to live in Victorian England. I *knew* it. Just like that. No one could take it away from me anymore—I knew the fuckin' thing. Anybody can tune in to something and know it, and it doesn't matter where you're from.

Mary wanted a dog after she had a miscarriage, and that's when we got Sparky. I always say Sparky was the love of my life—you can't believe what a great dog he was. We found out Sparky loved to bite water—he just bites water—and if you get the hose going, Sparky will go in and bite it. You can see him doing it at the beginning of *Blue Velvet*.

After we finished shooting, Al came over to work on the sound, and Al is an outsider, too. The British have their own sound department and they think they know best, right? After *The Elephant Man*, Al said, "I fuckin' *hate* the British!" One day I was in with Al working on the mix at Shepperton, and somebody from the production crew came in and said, "David, don't you think it would be a good idea if you had a screening for the cast and crew?" I said, "Yeah, okay, but it's not finished yet," and he said, "They'll understand—they'd just love to see it." So they have a screening and see the film, and they don't like it, and some of them wrote me letters saying how much they didn't like it and what was wrong with it and how disappointed they were. I finished the film pretty soon after that and left on that bad note.

• • •

Mary and I flew back home, and I carried the one print of the film through customs because Mel wanted to see it right away. John Hurt was in town and he had a bunch of people who wanted to see it, so there's going to be a screening on the Fox lot. I tell Al, "I'm not going, but make sure the sound is good, okay?" So the film is supposed to have started and I get this call from Al and he says, "David, it's not even mono! The sound system broke. It's like the worst sound—it's horrible." So they run the whole film that way and John Hurt, bless his heart, said, "I am so proud to be in this film. I love it." So it went well, and that was the beginning of the turn for the film. Then it started getting these reviews that were more than glowing—they were kind of cosmic. People just loved the film. *The Elephant Man* is a film that should come out every four years, because it helps the world for people to see it. It's a beautiful story and a beautiful experience and it's timeless.

I had to go to Europe to do press and I probably was on the Concorde again, although a lot of times I'd fly TWA. They had first class, and in those days, forget it. A giant 747, you're in the front nose of the plane and they're waiting on you from the time you get on until the time you get off. The silverware is heavy, things are being brought to you before dinner even arrives—really beautiful first-class treatment.

So I go to Germany and meet this guy Alexander, who worked for a film producer and distributor, and his father owned a hotel there. He wanted me to stay in his dad's hotel and it was a nice hotel and I had a giant room. I was fuckin' freezing in that room, though, and I came down after the first night of just freezing my butt off and said, "You Germans are pretty tough." Somebody said, "What do you mean?" I said it was really chilly in my room, and he said, "Did you turn the heat on?" It turned out you had to turn on these radiators I didn't see that were behind the curtains. While I was there I'm being interviewed by this woman journalist, and while we're talking I'm drawing a picture of the Elephant Man because that's what we're talking about. When we were finished she said, "Can I have that?" I said sure and I gave it to her, and Alexander's eyes are like saucers. When I was leaving he said, "David, could you do a drawing like that for me?" I said "Yeah, okay," but I never

did it. A long time later this guy he worked with came to L.A. and I met with him at the Chateau Marmont. He said, "Alexander asked me to remind you that you promised him a drawing of the Elephant Man," and I said, "Yeah, I sure did. How long are you gonna be here?" So I did a drawing and got it to this guy and he gave it to Alexander, who was so happy. Then a short time later Alexander was walking across a street and was hit by a bus and killed. I was so thankful I had finally given him that drawing of the Elephant Man.

Now I'm in Paris and I'm liking these pommes frites—French fries, right? And they're getting me tons of French fries while I do these interviews, and sauce Americaine, which is what I call ketchup. I'm having pommes frites and the phone rings, and I go into the bedroom to get it and it's Mary calling and she says, "David, you just got eight Academy Award nominations." I said, "Who got them?" She said, "You got two, but Freddie didn't get one," and I said, "Are you shitting me?" That's not right! Freddie did incredible work on that film and he stuck up for me and was a true-blue friend.

Going to the Academy Awards was interesting. Martin Scorsese was there for *Raging Bull* and he was sitting behind me. At that time in the world—well, there's no star now that even comes close to the burning-hot fame that Robert Redford had then, and he was there with a film he directed, *Ordinary People*. I went to the Directors Guild Awards and Robert Redford steps up to this podium and the paparazzi would not stop popping pictures. He had to beg them to stop. I've never seen anything like it, he was so hot famous. So *Ordinary People* won everything and Marty and I didn't get anything.

I was still living in the bungalow when all this was going on with *The Elephant Man*, but here's the thing: If I was on my own, I could theoretically still be living in that bungalow. I have more space now, and that's good, but I liked the simplicity of the bungalow, and I could build stuff there. Like, I built Edmund that garage—I had so much fun building it, and I could've built another big room next to it. I could've kept building stuff. You know how some old factory buildings have wood floors, but they're not like oak, they're softwood floors? I have this thing where I want to drill holes through floors, and pour oil in the floors, and have it be dark around the hole. I love plumbing, and then I could do

plumbing of copper pipes coming out, but not shiny new copper—it would be old copper. Then I'd have different kinds of sinks and plumbing and faucets. I don't have a clue why this appeals to me, but the look of it and the design of it is thrilling. Plumbing is guiding water, and controlling water is such a thrill.

We moved over to Granada Hills then, into a little bitty neighborhood house, but it was a house, and it was cheap, and it was then that I started writing *Blue Velvet*. I built a twelve-by-twenty-four-foot shed in the back-yard so I'd have a place to work, then after it was built we had the back-yard decked, so you step out of the house and go down a couple of inches and go across the deck, then you go up a couple of inches and you're in the shed. It was great. Because the deck was raised up a bit it meant that the oranges in the trees were lower to the ground, and Sparky loved fruit. One time I hear this god-awful screaming and I go outside, and Sparky is swinging in this tree with his tooth caught in an orange. He leapt up and bit it, and he's hanging there wiggling around and he can't get his tooth out. It was so funny. I didn't mind living in Granada Hills. You got your own place, and one thing I like about the Valley was that all my neighbors were building things. They've got motorcycles in their front yards, they're working on their cars—they're workers. And you can do whatever you want. It makes a huge difference.

Mesmerized

A few months into 1981 Rick Nicita, an agent at what was then the most powerful entertainment conglomerate in the country, Creative Artists Agency, began representing Lynch. "I was introduced to David by Jack Fisk, who is married to Sissy Spacek, who'd been my client since 1974," said Nicita. "The first time I met David, he came into my office and he was wearing a string around his neck with a pen dangling from it. I said, 'What's that?' and he said, 'It's a pen to take notes.' I asked, 'Do you take notes often?' He said, 'No, never.'

"As is the case with everyone, my first impression of David was that he was a wonderful, funny, smart, unique person," Nicita continued. "When people used to ask me who my clients were and I mentioned David, they'd raise their eyebrows. People assume he's going to be some brooding, dark, black-caped guy, and that's just not who he is."[1]

Offers were coming Lynch's way by the time Nicita came on the scene, but Hollywood doesn't write anybody a blank check; lots of producers were up for another *Elephant Man,* but nobody wanted another *Eraserhead.* "David wanted to do *Ronnie Rocket* after *The Elephant Man,* but people weren't interested in it," said Mary Fisk. "Jonathan and Mel wanted him to do the Jessica Lange picture *Frances,* which Eric Bergren and Chris De Vore were writing, and David was interested, but for some reason it didn't happen. Then he was offered *Return of the Jedi,* and his agent said, 'You're going to bank three million dollars,' so he went up to talk with George Lucas, but he didn't feel comfortable about it."

Lynch reluctantly put *Ronnie Rocket* on the back burner, but he had another original screenplay, *Blue Velvet,* that he tried to set up during this period. Ideas for the film had been coming to him in fragments since 1973, and

the project had become increasingly prominent in his mind, but he couldn't get it financed.

Then Nicita brought him *Dune*. The bestselling science-fiction novel in history, *Dune* is a coming-of-age story set in the distant future, written by Frank Herbert and published in 1965. The first in a series of six *Dune* novels, it's a complex story, and various filmmakers had attempted and failed to bring it to the screen.

The rights to the book were first optioned from Herbert in 1971 by Arthur P. Jacobs, an independent producer who died of a heart attack shortly after acquiring the property. Three years later, a French consortium led by Jean-Paul Gibon bought the rights and hired Chilean filmmaker Alejandro Jodorowsky, who planned to translate the novel into a ten-hour feature with design by H. R. Giger and a starring role for Salvador Dalí. After spending two million dollars and two years in pre-production, the project fell apart. (The 2013 documentary *Jodorowsky's Dune* chronicles this grand folly.)

Dino De Laurentiis bought the rights in 1976 for two million dollars and commissioned a screenplay from Herbert, who delivered a script that was much too long. In 1979 De Laurentiis hired Rudy Wurlitzer to write a script to be directed by Ridley Scott, but seven months into the project Scott left to direct the 1982 science-fiction noir *Blade Runner*. At that point De Laurentiis's daughter, Raffaella, entered the picture: When she saw *The Elephant Man,* she decided Lynch should direct *Dune*.

"I was impressed by David's ability to create a world that was totally believable," said Raffaella De Laurentiis. "We tend to pigeonhole directors, but a good one can work in many different genres, and I felt confident he could handle *Dune*.

"I was there the day David and my father met, and I loved him right away," she continued. "David and I were two kids at the time and we had a fantastic time together, and David became like a member of the family. My father loved directors and he thought David was as good as Fellini. He was really a huge fan of David's."[2]

It was kismet when Lynch met the De Laurentiis family, but their meeting threw a wrench in the works for Stuart Cornfeld. "When David and I met the plan was to do *Ronnie Rocket,* but we couldn't make it happen, because people thought David was a nut at that point," he recalled. "That changed after *The Elephant Man,* and we had a shot at getting *Ronnie Rocket* made. Then

one day David and I went to lunch and he told me Dino De Laurentiis had offered him *Dune* and a fat paycheck. David was a guy in his thirties who'd done great art and really gotten nothing, so when Dino said, 'I'm going to give you everything you want,' he went for it."

De Laurentiis, who died in 2010 at the age of ninety-one, was apparently a hard man to say no to. A larger-than-life character who introduced Lynch to the glamorous world of international cinema, De Laurentiis was born in Naples in 1919 and was an important supporter of Italy's post-war neo-realist style; he produced the early Fellini classics *The Nights of Cabiria* and *La Strada,* for which he won an Academy Award in 1957. De Laurentiis had a lot of range—he produced Roger Vadim's *Barbarella* as well as Ingmar Bergman's *The Serpent's Egg*—and he produced or co-produced more than five hundred films over the course of his seventy-year career. A notoriously tough businessman, De Laurentiis was nonetheless a greatly loved figure and he played an important role in Lynch's life. "Dino was a phenomenon and a master at putting deals together, and he really loved David," said Fisk.

Attempting to bring *Dune* to the movie screen is like trying to condense a Thanksgiving meal into a TV dinner, but De Laurentiis was persuasive, and he succeeded in signing Lynch to a three-picture deal. "I'm sure *Dune* was a case of the siren song of big picture, big money, but it wasn't 'I'll take the money and go home,' because David would never do that," said Nicita. "He felt the story and it resonated with him."

The protagonist in the story is a young hero named Paul Atreides, who's characterized in the novel as "the sleeper who must awaken"; this spoke to Lynch for obvious reasons. Lynch loves inventing alternate worlds, too, and *Dune* involved the creation of three entirely different planets and incorporated a variety of rich textures, dream sequences, and subterranean factories. It's no surprise that Lynch said yes.

A year was spent on the script, which required a PG rating, so limits were in place before Lynch had written a word. He was further hamstrung by the need to please De Laurentiis—who hated *Eraserhead*—and he first tackled the script in tandem with his co-writers from *The Elephant Man,* Chris De Vore and Eric Bergren. "David generously invited Eric and me in as co-writers, so the three of us went up to Port Townsend and spent time with Frank Herbert," De Vore recalled.

"We wrote together in an office on the Universal lot and completed two

drafts of the script, but Dino thought what we'd written was too long and that the project couldn't be broken down into two movies," De Vore continued. "David felt it could be shorter, too, but we worried about straying too far from Herbert's book. David felt it was important to be faithful to the book, but he wanted to put things in the script that aren't in the book, and we couldn't go that way. We absolutely felt David should stay true to his vision, though, and told him by all means, go there." Lynch completed five more drafts of the script before arriving at a 135-page final draft dated December 9th, 1983. Although Lynch says today that he "sold out" with *Dune,* he wasn't aware that was happening while he worked on the script.

"David is eager to make money but he won't compromise and never has, and that's not what was happening at the beginning of *Dune,*" said Nicita. "David keeps it very pure. There are temptations in this business, and his success bred forces that tried to corrupt him—there were many opportunities for him to do big pictures that would've paid him a fortune and he turned them all down. He was offered a lot early on when people thought he'd do what they wanted him to do, but when it became clear he was a true auteur, that aspect of things dried up. All the major stars wanted to work with him, too, but he isn't star oriented. David is an artist and he doesn't want some big gorilla in the middle of his vision."

Lynch was hunkered down in Granada Hills writing *Dune* when Fisk went into labor on September 7th, 1982. "David was in the delivery room, and I never would've made it without him," she said of the birth of their son, Austin. "I was in labor for thirty-six hours, and he cheered me on and pushed on my back because the baby needed to be repositioned." Lynch now had two children. He always had several projects going at home, too: During those years he was making incense holders and string bolo ties that fastened at the throat with a black dot or a white dot. "Lots of his friends had one of those dot ties," Reavey recalled.

In late fall of 1982, casting agent Elisabeth Leustig traveled to several U.S. cities looking for a young unknown actor to play the lead in *Dune,* and she came across Kyle MacLachlan. A recent graduate of the actors training program at the University of Washington, MacLachlan was performing onstage in a production of Molière's *Tartuffe* at the Empty Space Theatre when Leustig

arrived in Seattle. "She asked around about actors who fit the age range of the part and somebody said, 'Well, you've got to see Kyle.' So we met late that December at the Four Seasons Hotel and she put me on tape," recalled MacLachlan, who was flown to L.A. early in 1983 to meet Lynch and Raffaella De Laurentiis.

"I'd seen *Eraserhead* and didn't know what to make of it," said MacLachlan. "My taste in movies ran to swashbucklers like *The Three Musketeers*— that was my speed—so I didn't know what to expect before meeting David. We met in a bungalow on the Universal lot, and I remember sitting there waiting for him to get back from Bob's. He was driving a Packard Hawk, which was a car he loved, and he came in and we talked about growing up in the Northwest and red wine, then he said, 'Here's the script. Learn these scenes, then come back and we'll film them.'"[3]

MacLachlan returned to L.A. a few days later and did a screen test at special-effects artist John Dykstra's Apogee Productions, Inc. "They struggled with my hair, which has been a problem throughout my career—the hair problem started with *Dune.*" MacLachlan laughed. "I was in this huge space with tons of people around and the camera looked like the biggest thing I'd ever seen in my life, but once David arrived I felt connected and grounded. We shot a few scenes, including one where I had to speak right into the camera, and I said, 'David, I don't know if I can do this,' and he said, 'You're gonna be great!' He was very encouraging."

Lynch developed a friendship with MacLachlan—whom he calls "Kale"— that's been one of the key relationships of his career. They've worked together on two of Lynch's best-loved works—*Blue Velvet* and *Twin Peaks*—and MacLachlan has been described as Lynch's onscreen alter ego. They are alike in important ways, too. Both are open and optimistic and have a humorous perspective on things that allows them to operate with a light touch; they both exude a kind of radiant happiness.

"I went back to my hotel and there was a bottle of Château Lynch-Bages on the table," MacLachlan continued of his initial meeting with Lynch. "When David and I talked about wine, he said it was one of his favorites and I thought it was so nice that he sent this. I waited there while they looked at the film, then they called and said, 'We like it, but we want to change your hair and do a second screen test,' and they flew me down to Mexico for that.

"This was January and the film was in pre-production and David's birthday

passed while I was there. They had a party for him and I joined in and I remember thinking, These are really nice people—I hope this works out. Later I was downstairs having a beer in the lobby, and I got a call saying, 'You got the part.' Once David hired me I put my complete faith in him to steer me through the process."

Like everything about *Dune,* the cast was huge, and there were thirty-nine speaking parts. José Ferrer, Linda Hunt, Jack Nance, Dean Stockwell, Max von Sydow, and De Laurentiis's first wife, Italian film star Silvana Mangano, are among those who put in an appearance. A few actors clearly had a ball with the over-the-top characters they were playing; Kenneth McMillan pulls out all the stops as the villain of the story, and Freddie Jones and Brad Dourif play wonderfully weird court advisers.

"When I met David, my first thought was, This is the preppiest-looking guy I've ever seen in my life," Dourif recalled. "Slacks and a jacket, button-down shirt, a voice that sounded kind of like Peter Lorre from Philadelphia. I walked over to him and said, 'Hi, I'm Brad,' and he said, 'I know. I've gotta ask you a question: How do you feel about actors having surgery?' Apparently he wanted to cut a hole in an actor's cheek so they could put a tube through it for this effect of a tooth that emits a gas. I couldn't tell if he was serious or it was an ongoing joke, but I heard him saying to Raffaella, 'But why not?' She said, 'No, you don't get to do that.'

"I hadn't seen *Eraserhead* until he screened it in Mexico for us," Dourif continued. "Before it started he got up and said, 'This is a film I did, and I hope you guys don't leave town.' I had no idea what I was looking at, then all of a sudden I realized it was a surreal exploration of male terror of the female psyche and persona. It's an unbelievable film."[4]

The cast also included the musician Sting, who was exploring acting at the time and had had featured roles in four films by the time he met Lynch. "David was in London casting *Dune,* and I met with him at Claridge's hotel," Sting recalled. "I was a big fan of *Eraserhead* and I expected him to look something like the lead character in the film, but he looked very Midwestern and normal and said things like 'peachy keen.' I never considered myself an actor, but I'd been in a few films and he seemed to like me, and he said, 'Would you come to Mexico,' and I said, 'Sure.' I was in the middle of finishing what turned out to be the Police's biggest album, *Synchronicity,* but I had the summer off and I spent it in Mexico in a rubber suit."

Cast as Feyd-Rautha Harkonnen, a spectacularly beautiful killing machine, Sting first appears in the film emerging from a wall of steam, glistening and wet, wearing nothing but what he described as rubber underpants. "David presented them to me and I said, 'No, I'm not wearing those,' and he said, 'Yes, you are.' That first entrance I made was kind of a bone of contention because I'd never really seen myself as a homoerotic item, but in those flying underpants I felt there was no other way to play the scene, and David agreed."[5]

After being in and out of Mexico for six months of pre-production, Lynch settled in for the shoot in March 1983. Two weeks were devoted to rehearsal, and filming began on March 30th. No expense was spared on *Dune,* which had a budget of forty million dollars, a good deal of money at the time. There were 1,700 people in the cast and crew. Four camera units worked simultaneously on eighty sets that filled eight soundstages, and exteriors were shot in the Samalayuca Dune Fields in Ciudad Juárez, Chihuahua. It was there that the shoot began in 120-degree heat; they were there for two weeks, and a crew of three hundred swept the sand dunes in preparation. Production designer Anthony Masters, who did *2001: A Space Odyssey,* was on board, as was special-effects artist Carlo Rambaldi, who gave us the creatures in *Alien* and *E.T. the Extra-Terrestrial.* It was a massive undertaking and a lot of fun in the beginning.

Early in the project, Lynch had visited Dino De Laurentiis at his villa in Abano Terme, an hour outside of Venice, and the city made a big impression on him. "David loved Italy and we were in Europe a lot on that movie—I can't remember why, but it was probably casting," recalled Raffaella De Laurentiis. "David was a vegetarian then but he loved pâte, and I remember he was always having foie gras."

On one of those trips, Dino De Laurentiis gave Lynch a book on Venetian architecture that proved to be an important source of inspiration for the film, the plot of which revolves around royal houses warring over control of natural resources. Many scenes take place in elaborately ornate palace courts, and there's a great deal of intricately carved wood and many sweeping staircases. There's also a hellish, subterranean industrial world with marching drones evocative of the silent film *Metropolis,* and the Guild Navigator, a gigantic amorphous oracle Lynch described as a "fleshy grasshopper" that speaks through a disturbingly sexualized orifice. There are surprising details through-

out the film, too. The Atreides family has a pug that accompanies them on their adventure, and when spacecraft enter new galaxies they pass through a keyhole. The combination of elements is distinctly Lynchian.

"David could spend hours putting dots on a wall, and that's probably one reason he's never wanted to do another huge movie like *Dune*," said De Laurentiis. "One day we were in the desert in Juárez with two hundred extras in rubber outfits. People were fainting and there was a huge crew, and we'd made this massive effort to make it to this desert, and he was doing a close-up on the eye of one of the leading men! I said, 'David! We can do that on the stage! We've built all this, so shoot it!' He was smart enough from then on to realize that detail is a big part of his vision, and since then he's made movies that accommodate that."

Taking on *Dune* was a leap for Lynch, and Sting recalled being "amazed that David went from making this tiny little movie in black and white to this huge canvas, and I was impressed by how calm he was about it. I never had the sense he was overwhelmed, and everybody loved him. He remained peachy keen throughout."

Jennifer Lynch was on the set for a few weeks and was put to work operating the Guild Navigator's left hand and lower jaw. "I remember how big that production was," she recalled. "That might've been the first time I was aware of Dad feeling the immense size of something. It was so much money and so many people."

Lynch is nothing if not game, and his love life was growing increasingly complex during this period; it was then that Eve Brandstein came on the scene. Born in Czechoslovakia, Brandstein grew up in the Bronx, then moved to Los Angeles in the late 1970s and got a job casting and producing television for Norman Lear's company. In 1983 she joined her friend Claudia Becker, who handled the casting in Mexico on *Dune,* for a vacation in Puerto Vallarta.

"One night Claudia said, 'Let's go to this art show at Galeria Uno.' For some reason I didn't know who the artist was, and when we got there David and I saw each other across the room and eventually we sort of circled around each other. It still hadn't registered who he was, though. After the opening I went with a group of friends to this bar called Carlos O'Brian's, and while we were sitting there David came in with his group and sat down next to me. The rest of the night was magical, and we stayed up all night walking on the beach and

talking. The next morning I was returning to L.A. and he was going back to Mexico City and we ran into each other at the airport. He was flying domestic and I was international, so we were in different areas and there was a curtain between us, and we both went to the curtain and started kissing. That's how it started."6

One of Lynch's great gifts is his ability to focus exclusively on what's in front of him, and once that flight from Puerto Vallarta landed in Mexico City it became all about *Dune* again. "David worked on *Dune* the way he always works, which is to finesse every aspect of the set," MacLachlan recalled. "From the guns and the uniforms to colors and abstract forms, David's hand was in all the scenic design and the effects. His artistic sensibility was there in a really strong way all the time.

"I was in Mexico from March to September of 1983 and I had a great time," MacLachlan added. "I stayed in a house in Coyoacán, and somebody was always having a party. The De Laurentiis family often had dinners at their house, and I was always there." It was by all accounts a rambunctious set; *Dune* was an exhausting movie to make and people blew off steam accordingly. "It was a pretty wild set," said Sting. "I was surrounded by all these great actors and was just a rock star having fun."

Mary Fisk was aware Lynch was in an environment he hadn't previously encountered. He was directing his first big-budget Hollywood movie, which is a complicated bit of business both on set and off. "David was Mr. Clean when we were first married, and he didn't smoke or cuss," said Fisk, "but Raffaella was a big party girl. I called him once and he'd been out drinking vodka gimlets, and that shocked me. It was a wild group down there and I think he started to party. He liked the hotel he was in, he was driven to work, and he lived in a bubble."

A master of multi-tasking, Lynch always does more than one thing at a time, and he made the Duck Kit (which he deemed a failure because the photograph of it was blurry) and the Chicken Kit while he was in Mexico; instructions for reassembly of the chicken are written in both Spanish and English. During the making of the film he also launched *The Angriest Dog in the World,* a four-frame cartoon depicting a growling dog that's chained to a post and strains against its chain. It appeared weekly in the *L.A. Reader,* then the *L.A. Weekly,* for the next nine years, and while the drawings never changed, Lynch phoned in new thought bubbles every Monday. "The humor in the strip is

based on the sickness of people's pitiful state of unhappiness and misery," Lynch explained. "There's humor in struggling in ignorance, but I also find it heroic the way people forge on despite the despair they often feel."

During the production of *Dune,* Lynch also had a young family to tend to. "I was kind of a single parent while David made *Dune,*" said Fisk, "and it was a hard place to take a newborn, because I was breastfeeding. I went down there a few times—I took Martha Bonner, who's Austin's godmother, on one trip—and Austin took his first steps in David's hotel room with David watching. David and I talked on the phone a lot, but it was a long separation and I didn't like it."

In the fall of 1983, when Lynch was six months into the shoot, Fisk purchased a property in Virginia, sold the house in Granada Hills, and moved across the country with Austin. "My brother kind of talked me into moving," said Fisk. "He and Sissy lived there, and I found a five-thousand-square-foot house that was a little rundown but was on a beautiful piece of land, and David said, 'Go for it—I trust you.' So I bought it without David even seeing it, then spent the next six months renovating it."

Lynch took the move in stride, but it was unsettling for his daughter. "It was frightening as hell for me when he moved to Virginia," Jennifer Lynch said. "Up until then my dad had always been around for me and we had a thing. I remember writing him in Virginia and saying, 'I'm afraid I'm never going to see you again,' and he said, 'Are you kidding me? We talk all the time!' And it's true that he used to call me at all hours of the night just to talk. Still, it was horrible and really sad. I actually did see him more than Mary and Austin did, because he was in L.A. a lot."

Principal photography on *Dune* wrapped on September 9th, 1983, then Lynch spent four more months in Mexico working with models and special effects. By that point the enormity of the project was beginning to take a toll. "I never got the sense that David was unhappy when we were shooting, but you have to remember that I was a self-absorbed twenty-four-year-old at the time, so my awareness of what was happening with people around me was different than it would be today," said MacLachlan. "At the time everything seemed to be going well. Working with actors for him is always a joy—I could see that then, and that's still there today. But I do remember him saying, 'This is a very big undertaking,' and I think he got tired. David was still there doing second- and third-unit stuff long after I completed my work."

Lynch finally left Mexico early in February of 1984 and moved into a modest apartment in West Los Angeles, where he lived for the next six months while the film was edited. Brandstein was part of his life during that period and recalled, "David saw me as living the art life, which was something he craved—to be a creator and make art was everything to him. We talked a lot about art and spirituality, and he made me feel good about being an artist and helped me move forward in that regard. The relationship caused emotional conflict for both of us, though. David didn't like it that he was hurting Mary, and he was constantly trying to balance things because he wants both sides. He wants a relationship that exists in an exciting sort of aroused state, but he also wants the comfort of home life, that Midwestern-farm-boy thing. He needs both, and that's been the framework of his life and the motor of his creativity. I would've married David in a minute but he wasn't available, and I felt a kind of emptiness in the relationship, so when I met someone else in 1985 I moved on."

Something that's been a constant throughout Lynch's life is that he's like catnip to women. "There's no malice in Dad and he doesn't do these things out of selfishness—that's not it at all," said Jennifer Lynch. "It's just that he's always been in love with secrets and mischief and sexuality, and he's naughty and he genuinely loves love. And when he loves you, you are the *most* loved, and he's happy and giddy and he has ideas and gets creative and the whole thing is insanely romantic."

Fisk had always been aware of this aspect of Lynch, but she wasn't ready to address the situation in Los Angeles. "David went back and forth from Virginia to L.A. while they were editing *Dune,* and during that period he told me he was very worried about our marriage," Fisk recalled. "My brother said he thought he was having an affair, but I didn't want to think about it. I went out there for the cast-and-crew party and girls were all over him, and I remember thinking, This is weird. But then I realized this was the way it was going to be."

The first rough cut of *Dune*—which Lynch screened once in Mexico—was five hours long. Lynch's intended cut, as reflected in the seventh draft of the script, was almost three hours. The final cut that was released was two hours and seventeen minutes. Needless to say, much of what he wanted in the film wound up on the cutting-room floor, and he was forced to make concessions during the editing process that he regretted making. The months in Los Angeles were hard on him. "A year and a half into *Dune,* I had a feeling of deep

horror," Lynch said. "But I learned a lot about making movies and the busi-
ness of Hollywood with it." In the 2001 BBC documentary *The Last Movie
Mogul,* Dino De Laurentiis conceded that "we destroyed *Dune* in the editing
room." Given that De Laurentiis had final cut of the film, one assumes he
means "I" when he says "we."

"If David had had final cut, it wouldn't have been a better picture—he did
a cut and I saw it," said Raffaella De Laurentiis. "It was five hours long and it
was impenetrable, if you were able to stay awake.

"The biggest mistake we made was trying to be too faithful to the book,"
she added. "We felt like, my God, it's *Dune*—how can we fuck around with it?
But a movie is different from a book, and you have to understand that from the
start."

Distributed by Universal, *Dune* premiered at the Kennedy Center on De-
cember 3rd, 1984. "It was a very big deal," Fisk recalled. "Dino got us invita-
tions to the White House, and we went to a state dinner and met Ronald and
Nancy Reagan [a president Lynch admired], and Andy Williams was there
singing. That was the fun part of *Dune.* Then the critics got to *Dune* and they
decimated it and decimated David along with it." The reviews were almost
uniformly negative. Roger Ebert and Gene Siskel named it "the worst film of
the year," and Richard Corliss, of *Time* magazine, said it was "as difficult as a
final exam." Lynch was halfway through the script for *Dune II* when *Dune* was
released, but the plug was pulled on the franchise following its failure.

The film did have some significant supporters. Science-fiction writer Har-
lan Ellison loved it, and in the introduction to his short-story collection of
1985, *Eye,* Frank Herbert said, "What reached the screen is a visual feast that
begins as *Dune* begins, and you hear my dialogue all through it." Levacy re-
called, "David had a great rapport with Frank Herbert. He was pleased with
how David interpreted the book and gave the film his stamp of approval, and
that was huge for David."

MacLachlan—who appears in almost every frame of the film—has mixed
feelings about his first appearance onscreen. "I look at my performance and
cringe because I was so new to acting in front of a camera," he said. "In some
ways it worked, though, because I was playing a character that moves through
a youthful, boyish period, then is tested and must grow into a leader. I guess
they got me at the right time, because I was really green on that movie.

"I think David did a great job, though," MacLachlan added. "Ultimately

there was no way to flesh out the intricacy of the world Frank Herbert created, because there are just too many things going on in the book. But I can watch *Dune* and enjoy it for the sheer impact of the visuals and the fact that David was able to imprint that material with his vision. The Harkonnens, the train car coming into the palace—my God, it's genius. I call it a flawed masterpiece."

Reflecting on the film, Sting said, "To cram the entire book into a single feature might've been a mistake, and on the big screen I found it a bit overwhelming, but oddly enough, it holds up on a smaller screen for me. And ultimately I always find David's work absorbing. Like Goya and Francis Bacon, he has a vision that isn't particularly comfortable, and everything he does is infused with a sense of the Other. He has a vision and it's serious and not frivolous. I'm always happy to see him in the world doing what he does and I'm grateful to be part of his canon."

After the release of *Dune*, Lynch returned to the home in Albemarle County, outside of Charlottesville, Virginia, that Fisk had purchased, and he focused on what he was determined would be his next film. "He said, 'I don't want to talk about *Dune*,' so we didn't, and he moved on and did the final rewrite of *Blue Velvet*," said Fisk of Lynch, who wrote the script while listening to Shostakovich's *No. 15 in A Major*. "David is an extremely disciplined person, and that's part of why he accomplishes so much. He'll sit down and write for two hours, and although there are days when he may not produce much, he'll sit there for two hours anyway. Then he'll paint for two hours. He goes from one project to the next, and that probably comes from his parents and his Eagle Scout days. David has quite a talent for manifesting things."

Lynch was eager to put *Dune* behind him, but his relationship with the De Laurentiis family remained strong. "David is obsessed with body parts, and I had to have a hysterectomy after *Dune*," recalled Raffaella De Laurentiis. "David said, 'You're having a hysterectomy? Can I have your uterus?' I said sure, why not, and asked the hospital to give it to me, but they looked at me as if I was out of my mind and refused. So I had my stepson go to the butcher and get the uterus of a pig, and we put it in a jar with formaldehyde and taped my hospital ID bracelet to it and gave it to David. Someone told me he kept it in his refrigerator for years, and he once had to go through customs with this jar. One of his wives probably threw it out."

As for Dino De Laurentiis, he never lost faith in Lynch despite the problems with *Dune*, and after the dust settled following the opening of the film, he

asked him what he wanted to do next. Lynch replied that he wanted to do *Blue Velvet*. At that point a turnaround clause on an early draft of *Blue Velvet* that had been pitched to Warner Bros. had lapsed and ownership of the script had reverted to the studio; De Laurentiis called the president of the studio and bought back the rights. Lynch made it clear that he'd insist on having final cut of the picture if they made it together, and De Laurentiis stipulated that if he cut his salary and the budget of the film in half, he could have it. "David loved Dino," said Fisk, "because Dino gave him the chance to make *Blue Velvet.*"

I SIGNED WITH RICK NICITA because I liked him personally. He's not really an agent type and he was Sissy's agent, so I trusted him because of that. I think his secretary typed up *Ronnie Rocket* for me after I finished writing it in longhand, so I sort of knew him long before he became my agent. Rick never tried to push me in any specific direction.

After *The Elephant Man* I maybe could've done *Ronnie Rocket* because Mel got me some money to do it, but not enough, way not enough. I don't remember why I didn't do *Frances*, that film about Frances Farmer. Right around that time George Lucas was gearing up to do his third *Star Wars*, and some people called and asked if I'd come up for a meeting with George. There was a place called the Egg Company near the Warner Bros. lot, and they told me to go there and I'd get an envelope containing a credit card, a key, an airline ticket, and some different things. So I flew into San Francisco airport and got a rental car and drove to this place called Sprocket, which I think was one of Lucas's companies. I went in and met George and he started talking to me about *Star Wars*. I was flattered in a way, but I also don't know why I went, because *Star Wars* is not my cup of tea. Anyway, he's talking to me and I started getting a headache that got steadily worse. We talked some more, then we went in George's Ferrari to lunch at this salad place and had salads. By then my head was pounding and I couldn't wait to get out of there. I called Rick from the airport—I felt crazed and had to tell him before I got in the airplane. I said, "Rick, I can't do it! I felt all this pressure to say yes to George, but I can't do it!" He said, "David, it's okay, you don't have to do it." Then I called George and thanked him and told him I wished he'd direct this picture because it's his thing. George is one of the all-

time great creators around. He's got this touch and he's a special human being, but *Star Wars* wasn't my kind of thing.

A producer named Richard Roth approached me about doing an adaptation of the book *Red Dragon*, and when I told him no he said, "What else you got?" I said, "I've got this film called *Ronnie Rocket*," but he wasn't into that, and he said, "What else you got?" I said, "I don't really have it yet, but I have this idea," and I started talking about *Blue Velvet*, and he said, "Oh, that sounds really interesting." He took me to Warner Bros. and made me pitch it to this guy—I don't remember who it was—and I guess this guy must've given me some money to write a script, because Warner Bros. ended up owning it. I wrote two drafts for them and they hated both of them, and I don't blame them—it wasn't finished.

Then I heard that Dino De Laurentiis wanted to meet me about this thing called *Dune*. I thought he said "June," because I didn't know anything about *Dune*, but all my friends were saying, "Oh my God, that's the number one science-fiction book ever." So I thought, Okay, I'll go meet Dino and I'll *really* get a headache, based on what I'd heard about him. So I go to this office in Beverly Hills and the receptionist was really beautiful and very nice to me. Then I go in and I meet Dino. Dino says, "Hello," and as I sit down I see this guy sitting in the shadows out of the corner of my eye and that's Dino Conti, who's one of Dino's friends. I didn't know why he was there, but I got the warmest feeling from both of them and they fixed me a cappuccino that was out of this world. This guy named Enzo was Dino's barber, and Enzo's wife, Conchetta, did all the hors d'oeuvres for us that day. Enzo used to cut Dino's hair and when Dino had an office on Wilshire Boulevard there was a barber shop in there, and I could go and get my hair cut from Enzo. He was the best barber, just unreal. He studied haircutting in Italy. It was like a "thing."

Then I started getting to know Dino. Dino wasn't born rich and he started out wanting to be an actor. One day he had an audition and he was told to come in a suit, looking really sharp. He had a suit but he didn't have any good shoes, and while he was walking to the train to go to the audition he passed a shoe store. He went in and told the man, "I'm going to an audition and I don't have any money but I need a pair of shoes," and this guy said, "Okay, you can have a pair." Dino sent that man money for the rest of his life.

In the fifties and sixties, Dino would be working in Rome, and on the weekends—now picture this—he gets on a train and he'd travel up through Italy to where you turn left into France, and he'd get out at a station and go to this beautiful little place on the Mediterranean. There were Roman pines and he'd walk down this long, curving driveway to a mansion with a cove on the sea. Le Corbusier died in that cove. It's insane. I went to Le Corbusier's grave, which is in that area. He designed it himself on a hill overlooking the Mediterranean, and it was beautiful. Anyhow, you're in the movie business in Rome and you have this place in Monte Carlo, or wherever it was. Imagine that kind of lifestyle. It was so beautiful.

When I look back on the time when I was getting to know Dino it's as if I was mesmerized. Dino is like an Italian Mack truck and he just goes forward. He had tremendous energy, and he's a real charmer, and he lives the good life, surrounded by great food and great places and great ways to travel and great enthusiasm for projects. So, part of the Dino seduction was being in his world. But don't get me wrong—I loved Dino and Raffaella, and Silvana Mangano, and their daughters Veronica and Francesca, and for a while I was like part of the family. The only place Dino and I didn't get along was with movies. Dino loves film, but not my kind of film, so he had a dilemma with me. He said, "This guy Lynch made *Eraserhead*, which I hate, and *The Elephant Man*, which I love." He wanted *The Elephant Man* director.

So Dino's over at his place in Abano Terme, Italy, with Silvana, and she's taking the mud-bath cure. These mud baths, I'm tellin' you: You'd go into these bathrooms, the tub is huge and it's got all these fantastic, beautiful faucets with hoses, and there's nurses in white uniforms walking around. It was just like in 8½—well, not exactly, because Claudia Cardinale wasn't there. Anyhow, Dino called and told me to come over there, and when I get there he says, "David, I take you into Venice." So we get in this car and it's Raffaella, me in the middle, Dino, and Raffaella's ex-husband. The driver is this stocky guy who has no neck—it's like shoulders with a hat on—and his hands are gripping the wheel, and the left-turn signal is on all the way into town. His foot is made of solid lead, I mean, floorboarding. He'd come up behind cars and race past them at a hundred twenty miles an hour, and we're just flying into Venice, and

the wind is blowing in the car because Raffaella gets carsick and her head is out the window. We drive into St. Mark's Square the back way, which Dino knew about, and then that plaza just opens up. Then we went on this boat up to where Hemingway stayed, this magical place, and ate at a restaurant with a statue of Hemingway, and on the way back the water was pitch-black, and these Italian mansions would just kind of rise up out of the water. That's where I got a lot of ideas for the sets for *Dune*. I talked to Tony Masters about what I saw there, because it was incredible.

Dune is a story of a quest for enlightenment and that's part of why I did it, but I also knew I was going into something that was meant to be for some reason. I didn't know what the reason was, but I was in it. I brought in Chris De Vore and Eric Bergren to work on the script with me because we'd worked together and I really liked them, and they were big fans of the book. Chris, Eric, Dino's son Federico, and I went up to Port Townsend and spent a day with Frank Herbert. Frank and his wife, Beverly, were really nice, and we just talked. I don't even know if we talked about the book. The more I got into the book, the more complicated it seemed, and with Dino not wanting to do this or that, I knew it would be hard to make sense of it. There's the shield wall, then there's the shields, then there's this from this culture and that from that culture, and at the same time it's about this jihad and a bunch of other stuff. Very complicated. The day with Frank Herbert was nice, though. I was taking a plane back to L.A. at the end of that day and Federico was flying to Seattle to get a plane to Alaska. My plane left first so he walked me all the way to my gate, which was so kind of him. Federico, they say, was so handsome that women would almost die when they saw him. On that trip to Alaska, Federico met the pilot that he would be killed with in a plane crash that July.

Once Chris and Eric and I started writing together, I realized pretty soon that each of us had a different idea of what *Dune* was. I knew what Dino liked and didn't like by then, and I knew we'd be wasting our time if we wrote the script the way Chris and Eric wanted to do it, because Dino would never go for it. Dino didn't understand any kind of abstraction or poem, no fuckin' way—he wants action. I felt bad when Chris and Eric left, because they were banking on working on *Dune*, but I just continued working on the script on my own. I don't recall Dino ever say-

ing anything about the script except that he liked it or "I no understand this." He'd never get ideas or anything; he would just react to things. Dino wanted to make money and I didn't have a problem with that—that's just who Dino was.

We were looking in L.A. and New York to find the actor to play the role of Paul Atreides, but we couldn't find anybody that was right. So Dino said, "Okay, now we have to start looking at secondary cities," and this woman in Seattle recommended Kyle and sent a picture. One thing led to another, and Kyle came down, and of all the people I'd met he was a standout. Here's the thing. Kyle is a great guy, but he's also a great actor. Kyle's got two things. Then he had to go meet Dino at "boongalow" nine at the Beverly Hills Hotel. That's how Dino said it: "boongalow." He always stayed in the same one, and it was a huge "boongalow." They met and Dino made Kyle test and he tested great. Then he made Kyle test with his shirt off in a fight scene to see what he looked like fighting—you know, Italian action movies, the beefcake thing. So Kyle did that, then Kyle got the job.

Raffaella and I were in Mexico to look at Churubusco Studios, and she hired a Middle Eastern man with a jet helicopter to take us around and look at landscapes that could represent a foreign planet in the film. This helicopter was huge, and he took us up into this place that was all black lava rock for as far as you could see, except for the green cactuses popping through. It was really weird and beautifully strange.

So we were at Churubusco Studios and I see Aldo Ray in the cafeteria and I thought he'd be perfect for Gurney Halleck. I talked to him and told him I wanted him to play this part, and he was happy. When Dino heard I wanted Aldo Ray, he said, "He's a fuckin' lush," and I said, "Let's bring him down and see if he can do it—he'd be perfect for the part," and Aldo came down with his son, Eric, who was around seventeen years old then. [Actor Eric Da Re went on to appear in the first two seasons of *Twin Peaks*.] In the morning I get to the studio and I'm told, "Aldo's in the green room," and I went up there. It's eight-thirty or nine in the morning and Aldo is flopped on the couch and he'd been drinking all night, and poor Eric is sitting across the room hangdog, with his head down. I brought a chair over and sat down in front of Aldo and said, "Aldo, can you do it?" And he said "No."

We did a lot of location scouting, looking for a place to make the film, and finally Dino found the cheapest place, which was Mexico, and Mexico was fantastic in those days. Mexico City is the most romantic city in the world. No one would believe that unless they've been there, but anybody who's seen it would say, yes, you're right. First of all, the lighting and the colors are so dreamy. It would be completely black in the sky, and there would be these little bulbs that would illuminate these beautiful green or pink or yellow walls. The buildings in Mexico are colored and they have a patina from age, and at night everything would be black but there would be these little funnel shapes of color where light hit the walls. It was a real poetic city, and the young painters there were doing incredible things. There were no drug cartels, and the people were nice and easygoing, even though their leaders were fucking them royally in the ass, stealing all their money. When a president lost an election there he'd just take all the money he could get his hands on and go build a castle in Spain, and everybody sort of accepted it.

I don't know if Dino ever came down to Churubusco—I don't remember him being there—but Raffaella was doing his bidding, because they're cut from the same cloth. Raffaella was such a character. She was super smart, no nonsense, no bullshit, a powerful producer, and so much like Dino, but a woman, and I loved Raffaella. The crew came from all over the world. There were Italians, Brits, Germans, some Spanish—all kinds of people, and there were lots of heavy drinkers on that film, and parties for sure. One time I came home really late and needed to call Mary, and I was so drunk, and for some reason I got in the bathtub fully dressed. I don't know why I got in the bathtub, but I'm leaning back in the bathtub and I have the phone and I had to concentrate hard to dial each number. Then I had to close my eyes and *really* concentrate to sound sober while I talked to Mary. I pulled it off, but I think I vomited afterward.

Charlie Lutes told me that when I took a shower in Mexico, I should take a sip of vodka and hold it in my mouth, then shower, then after the shower spit out the vodka. Otherwise the water from the shower would get in your mouth and it would be like drinking it. I did that every morning and I never got sick, and everybody else got sick. Raffaella said half the crew was missing every day because people were always getting sick.

Churubusco Studios had eight giant stages then—I think they lost four of them to housing or something—and we filled those twice. Churubusco's big and it's spread out, so I had a three-wheel bike I loved and I'd ride from one set to another to check shots, and I'd motor all around because there were four crews going at once. It was crazy. And these sets were fuckin' beautiful! The Mexican craftsmen were unbelievable, and the backs of the sets they made looked as good as the fronts. They were building them out of lauan mahogany from the rain forest—they were incredible. There were at least eighty sets, and some of them were really elaborate. Tony Masters knocked it out of the park. He'd just zero in on something and out would come something magical. He wanted to make the production design more science fiction, but that trip I took up the waterway in Venice was super important, and I talked to Tony about it a lot, so we leaned in that direction. The spaceships in the film were beyond the beyond. They combined this sort of bronze, silver, copper, brass, and pewter, and then some gold, and it was incredible. Carlo Rambaldi designed the Guild Navigator. I wanted it to be like a giant grasshopper. That's what's in the script and that was the starting point, and I talked to Carlo about it, but it's weird: If you look at *E.T.*, you see Carlo Rambaldi. People sculpt themselves, and the Guild Navigator's face is a little bit Carlo Rambaldi.

Dino hired a guy named Barry Nolan to do special photographic effects, and Barry is a great guy who knows what he's doing, and he did a good job, considering what he had to work with. Dino interviewed a lot of people before Barry, and Barry was the cheapest—Dino also probably put the fuckin' screws on Barry to make him even cheaper to get the job, so Barry probably hardly made any money. Dino would knuckle people down to the bare bone.

The Harkonnen world was so much fun to design, that industrial thing. The Harkonnens didn't have any roofs and their world would go up into darkness, then the trains would be up there on platforms, so it was pretty cool. Baron Harkonnen could float up and go above the walls, and the walls were really high. One time we were in Baron Harkonnen's room, and there were about sixty people on a set on this huge stage with walls that were at least a hundred feet tall, really big. The real deal. So people are milling around between takes and suddenly there was this

giant bang! These big heavy pliers had fallen from a catwalk, and if they'd hit a person it could've killed them. Then we hear somebody way high above us running to get away, because they would've been fuckin' fired.

One day we're shooting something that requires motion control, which means you have to do a number of different passes for different reasons, and each pass has to be exactly the same as the one before. There are people who do motion-control things using computers and mechanics that duplicate the move the same way each time, but we're down in Mexico City and we don't have that stuff. So we're going to shoot this thing that involves a dolly move and a crane, and I turn around and see this motion-control setup, and it's like a child's wagon on these rails. Little bitty dolly rails, and the floor is dusty, and this little child's wagon is made out of Band-Aids, lamp cord, and bare wire. This rig is such poor man's stuff—it was bubble gum, rubber bands, and sticks, and this was our motion-control rig! It worked, but it's not the way you picture a forty-million-dollar production.

What Brad Dourif said is true. I did want Jürgen Prochnow to get surgery for a scene in the film. I told Jürgen I wanted to operate, but I don't think he even considered it. But you know, I feel my cheek, and there's not much flesh there, so putting a little hole in a cheek doesn't seem that extreme! But listen to this. Duke Leto—Jürgen—is lying on a table and he's got a poison tooth in his mouth, and he's got to break the tooth and blow out this poison gas to kill Baron Harkonnen, but he's sick and delirious. We'd built this rig to shoot this scene, but you could only shoot it from a certain angle. There was a tube that came up one side of Jürgen's face, then it turns around and goes into his mouth, then it turns around again and goes back up, and the whole thing was taped to his face. So we're shooting on the side where you couldn't see the tube but could see the gas shoot up, and it's the first take. He's lying there and he crunches down and blows out this colored gas. The take looked good, but as soon as the camera stopped, Jürgen jumps up and starts screaming and he rips this thing off and races out of the set. He went to his trailer and he would not fuckin' come out he was so pissed off. The steam, or whatever they had going through the tube, was hot, and this pipe was super hot, and it burned his face very badly. I had to go to his trailer and

talk him down and tell him how sorry we were. He wouldn't shoot it again, though, and that one take we shot is the one we used.

After we finished shooting and I'd been there for a year and a half, we went to L.A. to edit the film, and I had three or four different places in Westwood during the six months that we were editing *Dune*. I don't know why I kept moving. I never hated being down in Mexico, but I got real crazy when we came back to L.A., because by the time we got to the editing room the writing was on the wall. It was horrible, just horrible. It was like a nightmare what was being done to the film to make this two-hour-and-seventeen-minute running time that was required. Things were truncated, and whispered voice-overs were added because everybody thought audiences wouldn't understand what was going on. Some of the voice-overs shouldn't be there and there are important scenes that just aren't there. Horrible. But here's the thing. For Dino it's money. This is a business, and if it's any longer than two hours and seventeen minutes the theaters lose an extra screening. That's the logic, and you've got to hit that number, and it doesn't matter if it kills the movie. I loved Dino. Dino the person was fantastic and he treated me like a son, and I loved the whole family and loved being with them. But he thinks a certain way and it's different from the way I think. It's like if you work real hard on a painting then somebody comes in and cuts it up and throws a bunch of it away, it's not your painting anymore. And *Dune* wasn't my movie.

There was a party after we had a final cut of the film that Mary came out for, and there was a girl fight at the party. I don't know how physical it got, but a little bit, maybe. Then the movie screened at the White House and I went to the White House with Mary Fisk, Raffaella, and her husband. Mary and I stood there with Nancy and Ronald Reagan and he was real interested in talking about *Dune* and movies and stuff, and then we all danced. I've blacked out the experience of sitting through the film, and I didn't read any of the reviews when it opened.

A while later they wanted to cut a television version of *Dune* and asked me to do it, but I said no. I've never seen the cut they did and never want to see it—I know they added some stuff I'd shot and put more narration on it. I've thought about what it would be like to go through all the stuff I shot and see if something could be made from it, but I always

knew Dino had final cut on *Dune,* and because of that I started selling out before we even started shooting. I knew he would go for this, but he wouldn't go for that, and I just started selling out. It was pathetic is what it was, but it was the only way I could survive, because I signed a fuckin' contract. A three-picture deal for *Dune* and two sequels. If it had been a success I would've been Mr. Dune.

Mary and Austin moved to Virginia while I was making *Dune,* and that made sense. Mary's mother is in real estate and she found this incredible deal, and Jack and Sissy had the farm out there, and I was off, and I guess Mary wanted to be near her mom. It was a great place, and that's where we lived when *Dune* was over. By the time I got to Virginia I was so weak—all these nerves, and all that failure. I remember we went for a walk out on the lawn and there were these plants; they were like not weeds really, but kind of between a tree and a weed. There were clumps of them and they were about an inch in diameter, and they went up twelve or fourteen feet, thin little things. I didn't like them there so I got up from where we were sitting and I grabbed one and pulled and the root came right out. I figured I could get rid of these things, so I grabbed two of them and those popped out, too. Then I grabbed five of them, and when I gave a tug I heard and felt something tear in my back. That clump of five didn't come out, so I decided to stop doing that. There wasn't any real pain immediately, so I sat down and we continued talking, but when we finished talking I couldn't get up. That night Mary wanted me to go in and say good night to Austin, so I got on my back and pushed myself out of our room on the floor and across the hallway into Austin's room and he's up in the bed. I pushed myself right next to the bed and told him a bedtime story while I was lying there on the ground. Then I pushed myself back into our bedroom and somehow, in screaming pain, I got into bed and I didn't get out for four days. I couldn't move. A doctor came the next day and told me I'd torn a bank of muscles in my back, and it took a long time to heal. That film took a lot out of me in lots of different ways, but getting to know Dino and his family was worth the nightmare of making *Dune.* And it led to *Blue Velvet.*

A suburban romance,
only different.

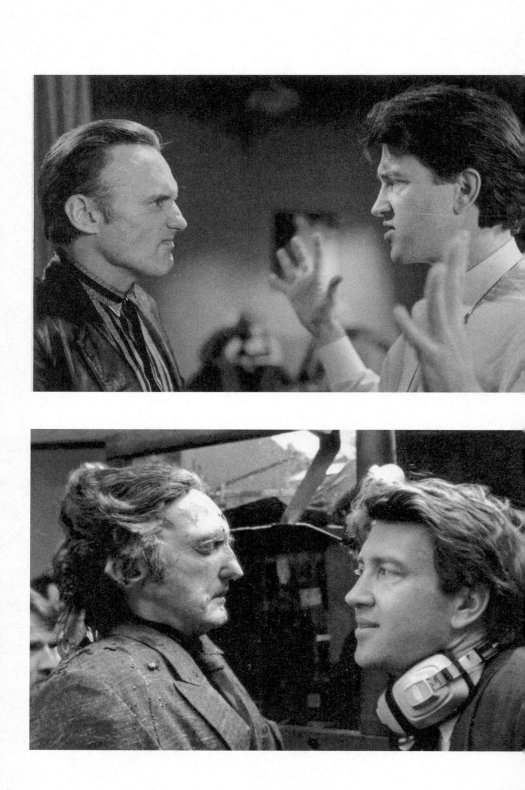

*D*une was the wrong project for Lynch on the most fundamental level, and it brought him to his knees. "Sometimes I guess you're supposed to have a bad experience, and I really had one with *Dune,*" Lynch has commented. A primary aspect of Lynch's genius is his ability to burrow into the microcosm; he finds the mystical and surreal in the tiniest aspects of everyday life and lavishes attention on everything from a small mound of dirt to a scrap of fabric. "Some people open windows of houses, but I like interiors and don't care about windows," he's said. "I like to go deeper into a house and find things underneath things." Clearly, epic battle sequences and vast expanses of empty desert are wrong for Lynch on a purely spatial level. As for outer space and the distant future? Leave that to others.

Dune did, however, play a crucial role in Lynch's evolution as an artist in that it helped clarify precisely who he is as a filmmaker. Lynch is first and foremost an American artist, and while the themes in his work are universal, the location of his stories is America. It's where he was imprinted with the indelible childhood memories that mark his work and where he had the rapturous love affairs of youth that infused his subsequent depictions of romantic love as a state of exaltation. Then there's the country itself: the soaring trees of the Pacific Northwest; suburban Midwestern neighborhoods murmuring with the sound of insects on summer nights; Los Angeles, where the movie business eats the soul; and Philadelphia, the terrifying crucible where his aesthetic sensibility was forged during the 1960s. He's been faithful to all these things since he returned from those difficult months in Mexico City.

Lynch's indomitable creative drive was undimmed by the ordeal of *Dune,* and throughout the shoot he never stopped looking to the future. "David gave me the script for *Blue Velvet* while we were shooting *Dune* and said, 'Take a

look at this,' and I was excited when I read it," said Kyle MacLachlan. "It was erotic and powerful and I was amazed by the journey Jeffrey goes on. For some reason I understood and related to it."

Deeply personal and darkly funny, *Blue Velvet* was the kind of film Lynch was meant to make, and it marked out territory he continues to explore. "The mood of the film is of a small town, of neighborhoods, and of something that's hidden," Lynch has said. "It's not a real upbeat thing. It's dreamy and on the darker side. It's much more open than *Eraserhead,* but it still has a mood of claustrophobia."

Returning to *Blue Velvet* after *Dune,* Lynch realized the script had the darkness but not the light that it needed and was somehow incomplete. A last piece of the puzzle that had eluded him was the climactic finale to the story, and then the solution came to him in a dream. Lynch's dream was set in the living room of the apartment of Dorothy Vallens—*Blue Velvet*'s tragic femme fatale—and involved a pistol in the pocket of a yellow suit jacket and a police radio. With those simple elements Lynch was able to bring the story to a conclusion, and he completed a final shooting script dated July 24th, 1985.

Lynch had a script he was happy with, but this was just one step in the long process of getting the film on the screen. "*Blue Velvet* was a very hard project to get off the ground," recalled Rick Nicita. "David is a final-cut director. If you're going to be in bed with him, you can't quibble over terms—you either enter his vision and his orbit or you don't, and this is both appealing and unappealing for potential investors. In 1984, Tom Pollock at Universal got on board, and God bless Dino De Laurentiis—he was the greatest. He financed all or a lot of that picture."

After De Laurentiis green-lit *Blue Velvet,* he brought in producer Fred Caruso, who began getting gigs as a PA in the early 1970s then worked his way up in the film business. "I did Dino's first picture in the United States, *The Valachi Papers,* then I did a lot of movies for him," Caruso said. "So Dino tells me, 'I want to make this movie with David Lynch, but I don't know if we can make it, because the budget is ten million dollars.' At the time Dino was building a studio in Wilmington, so he says, 'Come and meet David and see what you can do.' I read the script a few times and told Dino, 'I have no idea what

this movie is about, but I'm happy to work on it.' I'm good at budgets and I got the budget down to four million, and Dino said, 'Make the movie.'"[1]

Fred Elmes recalled that "when Dino decided to do *Blue Velvet* he said, 'You'll use local people so I can save money.' The deal was that if David made the film for less money, Dino wouldn't tell him what to do, and David liked that idea because Dino was a first-class meddler."

In May of 1985, Lynch left Virginia to begin pre-production on *Blue Velvet* in Wilmington, which was a five-hour drive from his house. He was already on the set when Caruso arrived. "The first time I met him he was wearing black sneakers, but they were a weird black," Caruso recalled. "I later found out that he'd buy white sneakers and spray-paint them black. I told David I didn't understand the script and he started explaining it to me, and I thought to myself, I still don't understand it."

"Explaining" *Blue Velvet* is a tricky business. Discussing the genesis of the film in 1987, Lynch told *Cineaste* that "the first idea was only a feeling and the title *Blue Velvet*. The second idea was an image of a severed ear lying in a field. I don't know why it had to be an ear, except it needed to be an opening of a part of the body, a hole into something else. The ear sits on the head and goes right into the mind, so it felt perfect. The third idea was Bobby Vinton's song 'Blue Velvet.'"

Lynch's *Blue Velvet* has launched a thousand graduate papers. However, you can't reduce it to a collection of Freudian symbols, although many have tried; the elements of the film are simply too complex and multi-layered for neat and tidy synopsis. Moreover, if Lynch fully understood the story—and intended that audiences be able to easily connect the dots—he wouldn't have been driven to put it on film. Lynch prefers to operate in the mysterious breach that separates daily reality from the fantastic realm of human imagination and longing, and is in pursuit of things that defy explanation or understanding. He wants his films to be felt and experienced rather than understood.

"David is always dealing with some sort of mystery in his work," said Isabella Rossellini, who plays Dorothy Vallens. "He once said something that really helped me understand his work. He said, 'In life you don't know everything. You enter a room and people are sitting there and there's an atmosphere, and you immediately know if you have to be careful about what you say, or if you have to be loud, or silent, or subdued—you immediately know it.

The thing you don't know is what's next. In life we don't know where the story is going or even where a conversation is going to go in the next minute.' David's awareness of this is central to his films. He's very sensitive to the mystery that surrounds everything."[2]

The particulars of *Blue Velvet*'s narrative are fairly simple. College student Jeffrey Beaumont, played by MacLachlan, returns to his small hometown when his father falls ill, finds a severed ear in a field, attempts to unravel the mystery that put it there, and is confronted with the pure evil of Frank Booth, played by Dennis Hopper. Along the way he ventures into a forbidden realm of eroticism he was previously unaware of. Most of us never stumble into the unique set of circumstances that lead us to learn the hidden complexities of our own sexuality: Three of the four main characters in *Blue Velvet*—Jeffrey, Dorothy Vallens, and Frank Booth—have discovered theirs.

"Certain aspects of sex are troubling—the way it's used as power, or the way it takes the form of perversions that exploit other people," said Lynch. "Sex is a doorway to something so powerful and mystical, but movies usually depict it in a completely flat way. Being explicit doesn't tap into the mystical aspect of it, either. These things are hard to convey in film because sex is such a mystery."

Erotic obsession is central to *Blue Velvet* and is one of the foundations of Lynch's work. However, taking a longer view, it's clear that the overarching theme in everything he's done is the issue of the dualities we live with and our efforts to reconcile them. *Blue Velvet* swings dramatically from the purity of the bluebirds of happiness to the savagery of the psychotic Frank Booth, and the film suggests that the dualities of life aren't as clearly delineated as one might hope. Frank Booth is brutal, yet he's reduced to tears by a sentimental pop song. He tenderly strokes a scrap of blue velvet while watching Dorothy Vallens sing, and the longing and agony on his face humanize him. While remaining the film's sympathetic protagonist, Jeffrey Beaumont is also a voyeur who casually steals another man's girlfriend. Dorothy Vallens is a fragile, heartbroken mother who enjoys it when men hit her. The virginal Sandy harbors a vision of compassion and perfect happiness but sneaks around behind her boyfriend's back. Nobody is all one thing.

Our guide through *Blue Velvet*'s world of darkness and light is Jeffrey Beaumont. "Having worked with David on *Dune,* I got to know him pretty well and I see a lot of him in Jeffrey," said MacLachlan. "David is good at taking the is-

sues in his own life and making them part of his art, and it's amazing how emotionally candid he is in his work. As to whether I've functioned as a kind of alter ego for him in the things we've done together, I guess I'd just say that it's easy for me to absorb and adapt some of who he is when I go into roles in his work."

Lynch isn't coy about the degree of his presence in some of his fictional characters, and he said, "I do see a lot of myself in Jeffrey, and I identified with Henry in *Eraserhead,* too. Both of these characters are confused about the world. Many of the things I see in the world seem very beautiful, but it's still hard for me to figure out how things can be the way they are, and I guess that's one of the reasons why my movies tend to be open to many different interpretations."

Fred Caruso's list of duties included finding an on-set assistant for Lynch, and he hired one, sight unseen, named John Wentworth. As a student at Brown University in the early 1980s, Wentworth had been impressed by *Eraserhead,* so after moving to Los Angeles in 1982 he decided to attend when he heard that Lynch was speaking at a venue in Venice Beach. "I loved the positive force he was putting out," Wentworth recalled. "It's very charismatic, but it's not a hustle—it's sincere and beguiling—and I thought, man, I'd like to work with that guy." Wentworth met George Stevens, Jr., founder of the American Film Institute, when he attended the AFI from 1983 to 1984, and he asked Stevens to put in a word for him with Lynch. Then, early in 1985, he got a call from Caruso. "Fred told me that if I could get to Wilmington in a week they'd give me a job as David's assistant," Wentworth said. "Before I went down there I talked with David on the phone and he said he was hand-designing the logo for *Blue Velvet* and he needed some flocking for it. My duties as his assistant included the usual things like running errands and scheduling appointments, but there were also uniquely David kinds of projects like finding flocking.

"Not long after I got to Wilmington, David had this idea that he had to do something called a Chair Pull that involved several young women, some old furniture, and long lengths of rope," Wentworth continued. "It was my job to find the furniture and the women. So we set this thing up out on one of the lots, and these women were out there pulling this furniture around, and they were filming it for some reason. There were projects like that happening all the time. David can make art out of anything, and working for him was like work-

ing with an inspired person who has a vision, knows what he's doing, and enjoys the insanity of it all."[3]

Although the *Blue Velvet* shoot would start in July, they were still casting in the spring when the crew arrived in Wilmington to start setting up. Prior to heading to Wilmington, Lynch met casting director Johanna Ray, who was to become a mainstay in his filmmaking practice; he's never worked with another casting director since meeting her. Born in England, Ray moved to the United States in 1960 and married actor Aldo Ray. Following the birth of their two sons, and a divorce in 1967, she began edging toward a career as a casting director. She landed her first big job in 1984 when she cast Mark Lester's adaptation of the Stephen King novel *Firestarter,* which was produced by Dino De Laurentiis. He then recruited her to cast three more films for him, and *Blue Velvet* was one of them.

"Dino's daughter Raffaella called and said, 'Why don't you come in and meet David Lynch,'" Ray recalled. "He was working on *Dune* in some out-of-the-way office in the Valley, and we talked about the roles and what he was looking for. I fell in love with him when he said, 'For Dorothy Vallens, I do *not* want an actress with a perfect body'—that endeared him to me.

"He was hard to get to know in the beginning because I think he was shy," she continued. "I was shy, too, and that may've been why he liked me, because I wasn't aggressive. Eventually he became a really personal friend and I found myself easily confiding in him. We're very affectionate with each other."[4]

Laura Dern, the daughter of actors Bruce Dern and Diane Ladd, had starred in two films—*Mask* and *Smooth Talk*—but was just seventeen years old when she first met Lynch to discuss *Blue Velvet*. "I was pretty stunned by the script, but I also thought it was incredible," said Dern, who plays Sandy Williams in the film. "And my character isn't part of the darkest aspects of the story. Everyone talks about the violence and cruelty in David's films, but he's also a profound believer, and that's where the characters I've played for him have hung out; that's the part of David I have access to as an actor."[5]

It took Lynch a bit of time to wend his way to Dennis Hopper for the character of Frank Booth. Willem Dafoe came in to discuss the role, and Lynch offered it to Harry Dean Stanton, who said, "I didn't want to go on that violent trip," and turned it down. Hopper didn't have much of a profile in movies by the mid 1980s and had a wild reputation that had long eclipsed public awareness of his gifts as an actor. "When his name came up, people said, 'Oh my

God, he's a crazy person!'" Wentworth recalled. "But he'd just gotten sober and he showed up and said to David, 'Look, I'm sober, I know what I'm doing,' and he did a great job—Dennis really inhabited the character of Frank Booth."

Hopper's performance in *Blue Velvet* went a long way toward restoring his professional credibility; he's devastatingly great in every scene he plays. When he prepares to pummel Jeffrey Beaumont, smears his own face with lipstick, kisses him, then whispers the words "forever, in dreams," he's terrifying. Lynch's dry sense of humor appears throughout the film in funny little flourishes. After being beaten, Jeffrey regains consciousness the following morning and finds himself lying in muddy gravel outside a bleak lumber mill. As he stumbles away, a street sign informs him that he's leaving "Meadow Lane." That location is mentioned elsewhere in the film, and Lynch has said that in his mind "it's an important place where something happened," but it is yet to be revealed what that something is.

It took a bit of time for everyone in the cast and crew to adjust to Hopper. "The way David works is, when he gets ready to shoot a scene he clears the stage, works with the actors to figure things out, then brings me in and shows me how we're going to shoot it," recalled Elmes. "My God, the first time I saw Dennis's first scene with Isabella, I was shocked. It's completely overwhelming the way the words in David's script lifted off the page with Dennis's performance.

"I liked Dennis once I got to know him, and he became the most responsible actor on the set," Elmes added. "When he came to *Blue Velvet* he was coming off his bad rep and he was on good behavior. In fact, he got upset at other actors who didn't know their lines, and people who didn't come to set on time were on his shit list."

Hopper took the opportunity Lynch had given him seriously; he knew he didn't have a lot of leverage at that juncture in his life and that it was a great part. "This is an unusual movie," Hopper said in a conversation in Wilmington, "and although your basic horror-film audience will probably turn out for *Blue Velvet,* it's much more than a horror film. Looking at it on another level, it's about the schizophrenia of America, and if people allow themselves to relax and go with the film, I think they'll recognize a sort of collective nightmare up there on the screen."[6]

"Frank Booth, to me, is a guy Americans know very well," said Lynch. "I'm sure most everybody has met someone like Frank. They might not have shook

his hand and gone out for a drink with him, but all you've got to do is exchange eye contact with someone like that and you know that you've met him."

It was purely by chance that Isabella Rossellini came to be cast as Dorothy Vallens. The daughter of actress Ingrid Bergman and director Roberto Rossellini, she was raised in Rome, mostly by her father. She moved to New York in 1972 and worked as a journalist for Italian state television until her modeling career took off in the late 1970s. Rossellini had acted in just one American film when Lynch met her in New York.

"I was at a restaurant with some girlfriends and two of them worked for Dino," Rossellini recalled. "We were at Dino's restaurant, which was called Alo Alo because that's how Dino said 'hello hello.' David was there with another member of the De Laurentiis family—I think it was Raffaella's ex-husband—and we pushed our tables together, so David and I met. I mentioned I'd just finished shooting a film with Helen Mirren called *White Nights,* and he told me how much he wanted her for a film he was casting called *Blue Velvet.* The following day he sent me the script with a note that said, 'Maybe you'd like to read for the part.'

"I asked Marty [Scorsese, Rossellini's husband from 1979 to 1982] about David, and he told me to go see *Eraserhead*—Marty has an incredible eye for art and is the best film scholar I've ever met, and he had a huge admiration for David. I'd seen *The Elephant Man,* and the range between that film and *Eraserhead* is so vast, and that's when I understood that he was a very talented director. So I called David and told him I'd like to test with Kyle to see if I captured the character for him, and David gave me a lot of time rehearsing with Kyle. It wasn't as if we were rolling around on a bed or kissing—it was more conversation. How would I seduce him? How would I surprise him with my behavior? How would I portray a woman who was a victim but also a perpetrator of crimes against herself? We discussed the most difficult scenes, and after we'd tested, David offered me the part. I felt confident I could handle it because David had given me so much time during the test."

Rossellini more than handled the part and gave a searing performance that was every bit a match for the volcanic Hopper, whom she initially approached with trepidation. "Everybody knew he'd been in rehab—for years, I think. Before I met Dennis I asked David what he was like, and he said, 'It's like sitting next to a ticking bomb.'

"David thought we should shoot the kind of ceremonial rape scene first so

we'd get it over with, and I thought, We're going to start with that scene? That's terrible," Rossellini continued. "I hadn't met Dennis yet, so I asked the first assistant director to ask him if we could meet for breakfast before we went to the set. So we met for breakfast and he was very cold and seemed annoyed, like, what did I want? We're doing a film and you don't need to know me. Yes, we're going to shoot a difficult scene but this is our job. He scared me, and I thought maybe professional actors don't ask to meet one another before they begin shooting. Looking back, I think he was cold because he was as afraid as I was. Of course he was afraid. He was returning to acting after years of rehab and David started with this very difficult scene.

"In that first scene I have to sit in front of Dennis and spread my legs, and he leans over and looks at my vagina, like a crazy kind of worship," she continued. "Then he punches me and I fall, but when I fell backward my robe opened and you could see that I was wearing underwear. David asked me to take my underwear off and I said to Dennis, 'I'm sorry, but I've been asked to take my underwear off because it shows in the shot when I fall backward.' So when we did the first run-through and he leaned over and stared at my vagina, I said, 'I'm sorry,' and he just looked up at me and said, 'I've seen it before.' That made me laugh, and when he saw me laugh I could see that he liked me. Later, after we'd become good friends, he told me about when he was very sick and lost his mind and was high on drugs, and how frightening it was. And here he is playing a character on drugs who is completely out of his mind. It was difficult for him, and I understood that later.

"By the way, David laughed throughout the shooting of that rape scene! I said, 'David, what is there to laugh at? Are we doing something ridiculous?' I don't know why, but he was laughing. There is something about *Blue Velvet* that is funny, though. When I saw it years later I found that it had a naïveté that made it slightly comical. But I still don't know why David was laughing!"

The ceremonial rape is one of several scenes where Rossellini is violently assaulted by Hopper, and one of the most potent and puzzling aspects of these scenes is that her character enjoys being hit. This made sense to Rossellini, however. "When I was young I once had a boyfriend who beat me up, and I remember that I was so surprised," she recalled. "While he was beating me up I didn't feel any pain, and I remember thinking, Oh my God, I see stars like Donald Duck does when he's hit over the head in a cartoon. I thought about that experience in relation to Dorothy being hit. She was so shocked

when she was hit that her anguish would vanish for a moment—sometimes physical pain can interrupt psychological anguish."

As with *Eraserhead, Blue Velvet* had a modest budget and a little had to go a long way. "Everyone was working for scale or less and we had a small crew," said Caruso. "Instead of four electricians we had three, and the hairdresser on the set had been a hairdresser in a shop in Wilmington the previous day. We used a lot of untrained residents in Wilmington, and they loved us."

De Laurentiis was still in the process of building his production facility in Wilmington when *Blue Velvet* was shot there, so having movie people in town was still a big deal for the locals. Even though major portions of the film were shot at night, interested observers invariably turned up, and the whole neighborhood turned out with picnics and chairs to watch the shooting of a particularly volatile scene where Rossellini wanders into the street battered, clearly in shock, and nude. "David once told me that when he was a little boy he and his brother were walking home and they saw a naked woman walking down the street and he understood that something very wrong was happening," said Rossellini. "This scene is based on that memory, and it's not meant to be arousing."

The assistant director warned the spectators that the scene about to be shot contained nudity that they might find objectionable, "but they stayed there as if, Oh, that's a good part of the show!" recalled Rossellini. The next day the police informed the production office that no additional scenes for *Blue Velvet* could be shot on the streets of Wilmington; De Laurentiis stood by Lynch through this and a few other challenges that were yet to come. "Dino would occasionally see dailies," recalled Caruso, "and I'd say to him, 'Dino, what do you think,' and he'd just shrug his shoulders. But Dino gave David his word that he would have final cut of the movie, and Dino always kept his word."

Rossellini's fearless performance wasn't lost on the rest of the cast. "I was a little bit in awe of her," recalled MacLachlan. "And, of course, before we began shooting I was intimidated knowing I was going to have to do these intense nude scenes with her. There's one scene where I have to get completely undressed in front of Isabella, and when we shot it I kept repeating to myself, 'You're not really here, you're somewhere else at this moment, it's just a body, don't even think about the fact that you don't have any clothes on.'

"There's another scene when Isabella asks me to hit her, and I thought, I can't do this," MacLachlan continued. "I didn't actually hit her, but the fact that I had to go through the motion of hitting her was upsetting. When Jeffrey is in his room at home later and realizes what has taken place, he breaks down, and those scenes were challenging. I trusted David to guide me through them."

Amid all this mayhem, Lynch maintained a sunny disposition, tooling around the set on a pink bicycle with streamers fluttering from the handlebars, his pockets full of peanut M&M's. "David is a genuinely happy person, and this is one of the remarkable things about him—I've never met anyone as serene as he is," said Rossellini. "I remember saying to him, 'You wake up in the morning and you're happy.' Is it a gene he has that should be cloned?"

"David would say meditation is the source of his happiness," said Laura Dern, "and I'm sure that's true. He knows who he was and who he became almost immediately after he started meditating, so he's the best judge of that. I would add, though, that I think part of his happiness has to do with the fact that he places no limits on himself as a creative person. There's a lot of self-judgment and shame in our culture, and David doesn't have any of that. When he makes something he never wonders what people will think of it, or what he should be making, or what the zeitgeist needs. He makes what bubbles up out of his brain, and that is part of his joy."

Lynch's modest office on the Wilmington set was littered with plastic toys, drawings scribbled on scraps of paper, and tubes of paint. On the walls were two paintings, in varying states of completion, and a kitsch clock inscribed with the words LUMBERTON FISHING CLUB. On the floor were cartons of popcorn and a photograph of the Chicken Kit he'd made in Mexico. On the windowsill was an orderly row of water glasses holding potatoes in the process of sprouting.

"*Blue Velvet* is a story about innocence and the impossibility of it," said Brad Dourif, who plays Frank Booth's sidekick, Raymond, "and when I worked with David he was truly an innocent. His innocence manifested as total enthusiasm—he could look at a pair of tennis shoes and get completely excited, and the way he thought of women seemed pretty innocent, too."

Caruso recalled, "The mood on that set was happy because David had a great aura—everyone, including the crew, loved him. David's daily meditation

is a key part of his aura, too. When he'd come back on the set after his afternoon meditation, he had this ring of energy around him, and he'd just bring you into it and you'd be calm."

MacLachlan said that "David has the ability to lead without making anybody feel bad, and if somebody doesn't get something, he teaches with humor. As far as how he goes about eliciting what he wants from actors, there are certain phrases he uses—'it needs a little more wind,' for instance—that alter the mood of the performance, and I just rolled with those. David's never given me any direction I didn't understand."

For Rossellini, Lynch's directing bordered on the nonverbal. "Sometimes when we were shooting close-ups he would be very close to the camera, and even if I had my eyes closed or had to look in another direction, I could feel his presence and knew if he wanted me to do a little more or a little less. Kyle does an imitation of David that captures exactly this quality David has when he's directing. David directs by expressing varying degrees of enthusiasm."

Dourif said, "I do a little dance in the background while Dean Stockwell is singing 'In Dreams,' and we improvised that—David was always open to ideas. He's a painter, and the way he gave direction was subtle. He put his brush on the canvas very specifically at certain times and could be quite exacting about tweaking certain moments.

"You felt love on that set, too," Dourif added. "I sat there and watched David fall in love with Isabella. When she was singing 'Blue Velvet,' he was just completely taken with her, and she was taken with him, too."

As always, Jennifer Lynch spent time on her father's set, and this time she was hired as a PA. "I was seventeen at the time and I was there for all of the prep but only part of the shoot because I had to go back to school," she recalled. "I knew my dad was falling in love during the making of that film, but he was always falling in love or looking for love, and he always finds it." Wentworth concurred that "David's marriage was coming apart when he was shooting the film, and it was obvious by the end of the shoot that he and Isabella had fallen in love."

"For me there was an understanding between us," said Rossellini, who went on to have a five-year bicoastal relationship with Lynch. "He's so funny and sweet, and I understood exactly what he wanted in the film—I felt like I could read his mind. I was very wrong about that! But at the time I felt I could

read his mind and felt a closeness to him that grew into me falling in love with him. I fell deeply in love with David, so I don't know if I could've helped it, but looking back it must've been very tough for Mary Fisk."

Rossellini is right about that. "David and I talked every day on the phone, and I didn't feel that our marriage was in jeopardy until I met his leading lady on set," Fisk recalled. "But think about it: How many wives send their husbands off to work with a woman dressed in a black lace bra and panties? I saw the train wreck coming down the track, and although it didn't hit until August it was obvious to me the minute I met Isabella, even though David was still telling me how much he loved me. Neither of them was innocent, but something happened between them that I guess you could call chemical."

The look of a Lynch film is largely shaped by Lynch's unique relationship with time and the fact that he feels no fidelity to historical accuracy in regard to period styles. In Lynch's realm, America is like a river that flows ever forward, carrying odds and ends from one decade into the next, where they intermingle and blur the dividing lines we've invented to mark time. *Blue Velvet* is set in some indeterminate period where time has collapsed in on itself. At the Slow Club, where Dorothy Vallens performs, she sings at a vintage microphone from the 1920s, and her place in the Deep River Apartments smacks of a 1930s art deco set from *The Thin Man*. She has a television with a 1950s rabbit-ears antenna, though. Arlene's, the Lumberton diner where Jeffrey and Sandy conspire, also evokes the 1950s, but Jeffrey's pierced ear and Sandy's clothing are distinctly 1980s. Sandy—a teenager in what are ostensibly the 1980s—has a poster of Montgomery Clift on her bedroom wall, and classic American cars roam the streets of Lumberton.

Lynch's visual style is freewheeling in certain respects, yet everything in every frame is freighted with intention and meaning. "Half of the shooting schedule was at night, and the lighting in those scenes was complicated," recalled Elmes of how light was used to enhance the mood Lynch was after. "When you look at the tree-lined sidewalk outside of Sandy's house, it's not just a block of trees; it's green trees with texture and detail, and there are streetlights up in there, and we put all that stuff there. We shot on a street without streetlights, and we had the power company come and put in

streetlights—it's insane they actually did that for us! But they put in poles and we wired them up with lights. The lighting created a richness that David and I really wanted."

Lynch's movies usually include unique props that he makes, often on set. *Blue Velvet* features a wall plaque inscribed with the word LUMBERTON pieced together out of bits of wood, and there's a clumsily painted sign outside Lumberton's police station. There's also a bizarre sculpture on Jeffrey's bedroom wall, a pinhole camera he uses when he stakes out Frank Booth's place, and a nutty maquette of a snow-covered mountain flanked by single trees that sits on a counter in the Lumberton police station. Lynch made all of them.

"There's a night scene that has a red-brick building in the background, and the shadow of an oil derrick goes up and down on the side of it," said Caruso. "Onscreen it looks huge, but there was David on the ground with a pair of scissors and a piece of cardboard, cutting out this miniature derrick, taping and stapling it together, and hooking it up to a piece of string that made it go up and down."

Blue Velvet editor Duwayne Dunham recalled finding Lynch on his hands and knees, carefully placing dust bunnies under a radiator in Dorothy Vallens's apartment, "just in case the camera might pick them up—which it never did," said Dunham. "But that's how deep into his storytelling David is."[7]

After graduating from film school in 1975, Dunham was hired as an editor by George Lucas, who employed him for the next seven years. "David planned to cut *Blue Velvet* at Lucas Ranch, and it's a small community up there so he knew about me," Dunham recalled. "I flew down to L.A. and met David at Raleigh Studios, and I told him I found the script for *Blue Velvet* disturbing and that it wasn't my cup of tea. He said, 'You're just gonna have to trust me on this.' I kept putting him off and finally he called and said, 'I'm leaving for North Carolina tomorrow and I need to know if you're coming,' and I went, fortunately. It's an honor to work with his material, because that's sacred clay he produces."

Lynch seems to relish solving the weird creative problems that arise in the making of a film, and a case in point is the robin that appears in *Blue Velvet's* final scene. Robins and their nests are protected under the Migratory Bird Treaty Act, so it's not as if you can simply catch a robin and put it to work in a movie. But Lynch needed a robin.

"Fred Caruso found a trainer who said he had a trained robin, but they brought it to the set and it was awful," recalled Elmes. "It was a molting robin in a cage that looked so sad; plus, there's no such thing as a trained robin! We were getting close to the end of the shoot and getting nervous about this. Then, strangely, a robin flew into the side of a school bus and fell down dead. We had our feelers out for robins so we heard about this.

"Some kids saw the dead robin and decided the biology department at school could use a robin," Elmes continued, "so they had it stuffed, and on the way back from the taxidermist it took a detour past our set. David mounted the robin on a windowsill and put a live bug in its mouth, and now we had a stuffed robin that didn't move. So David took monofilament threads, tied them to the robin's head so it would move, then got down in the bushes below the window and manipulated the threads. He's down there asking, 'Is he looking the right way?' I said, 'I think you got the puppetry down as good as it can get, but it still looks kind of mechanical.' He said, 'Yeah, yeah, that's it!' The robin had this unearthly quality, and I think he loved the artificiality of it."

Alan Splet worked with Lynch to create a wildly original audio-scape for *Blue Velvet.* When Dorothy and Jeffrey make love, we hear a groaning roar that morphs into the sound of a guttering flame; Frank Booth erupts with rage and we hear a metallic screech; the camera journeys into the interior of a rotting human ear and the sound of a sinister wind seems to deepen and expand. "David has a wonderful handle on how to combine images and sound," said Elmes. "There's a scene where Kyle wakes up in the morning after being beaten, and the first image you see is a close-up of his face in a puddle. All you see is dirt and water and you hear this strange repetitive sound, but you have no idea where you are. Then you pull back and see he's in a logging yard and that the sound you're hearing is a sprinkler keeping a stack of wood wet. The quality of that sound is magical. If it had been the sound of birds it wouldn't have given you anything, but there was something about that mechanical unexplained sound that made it special. David has an understanding of how things go together that's purely sensory-based, and he knows how to play with sounds and images until they sort of ignite each other."

Lynch's innovative sound effects are interwoven with music in a way that's unique to him, and beginning with *Blue Velvet,* music became a primary part of his creative practice. The songs in *Blue Velvet* are like characters that ad-

vance the narrative, and this is particularly true of Roy Orbison's hit record of 1963, "In Dreams," a mournful ballad of longing and loss that functions as a kind of key to the door of Frank Booth's roiling subconscious.

As torch singer Dorothy Vallens, Rossellini was required to deliver a rendition of Bobby Vinton's "Blue Velvet," so Lynch hired a local band to accompany her. "They didn't understand the interpretation I wanted to give," said Rossellini, and at that point Caruso called Angelo Badalamenti, a friend from New York. "I told him, 'Angelo, you've got to help me with this girl who can't sing,' so he came to Wilmington."

Rossellini recalled, "I explained to Angelo that Dorothy Vallens is transported to another world when she sings—I think David named her Dorothy as a reference to *The Wizard of Oz,* and when she sings she's transported over the rainbow. So I needed to sing in a languid way that allowed me to savor that world over the rainbow, and Angelo completely understood this. I can't carry a tune at all, so Angelo took a syllable here and a word there and edited them together to create the rendition you hear in the film, and he did an amazing job. It turned out so beautifully that after the film came out, people would call and ask, 'Can you come to this gala and sing?'"

Badalamenti's skillful work with Rossellini led to one of the most enduring creative partnerships of Lynch's career. Subsequent to their meeting, Badalamenti has scored almost every film and television project Lynch has done, appeared as an actor in *Blue Velvet* and *Mulholland Drive,* and written and performed dozens of songs with Lynch. "I'm not a trained musician, but Angelo—who's a great musician—and I had an instant dialogue," Lynch said.

Their collaborative relationship began with lyrics Lynch wrote on a napkin for the song "Mysteries of Love," which is featured in *Blue Velvet.* "One day Isabella came in with a little yellow piece of paper—I have it framed—and it says 'Mysteries of Love' in David's handwriting, and it's the whole lyric," recalled Badalamenti. "I looked at it and thought, This is awful. What the hell am I going to do with this? It's not a song. I called David and said, 'Isabella gave me this lyric you wrote; what kind of music do you hear for this?' He said, 'Just make it float and make it endless like the tides of the ocean at night,' so I sat down at the piano and out came the music for 'Mysteries of Love.'"[8]

Badalamenti then called Julee Cruise, a vocalist he'd met in the early 1980s when they worked together in a Minneapolis theater company. "We just clicked," recalled Cruise of her initial encounter with Badalamenti, "and I told

him to call me if anything came up. When Angelo explained what kind of performance he wanted for the song he'd written with David, he said, 'Be really soft; take your high voice and bring it down.' He wanted it very pure.

"It's a widely held misconception that David is weird, but he's not weird at all—he's the funniest, most charismatic man in the world," Cruise continued. "'Mysteries of Love' was on the *Blue Velvet* soundtrack, and that led to my being signed to Warner Bros. Records. David launched my career, and working with Angelo and David made me come into my own."[9]

Badalamenti's contribution to *Blue Velvet* didn't end there. "David wanted to use a piece by Shostakovich which he couldn't afford," said Badalamenti, "and he asked me, 'Can you write like Shostakovich?' I told him I can't compare myself to him, but I can give you that Russian sound." Lynch realized he had a gold mine in Badalamenti, whose knowledge of music is vast and wide.

By the time the shooting of *Blue Velvet* wrapped in November 1985 the editing of the film was already well under way. Lynch is an intuitive but not impulsive filmmaker, and Caruso said, "David didn't shoot a lot of film because he knew what the scene should be, what the camera angle should be, what the lenses were going to be, and he knew when he'd gotten what he needed and moved on." Efficient though Lynch is, the original cut of *Blue Velvet* ran for three hours and fifty-seven minutes. "It worked at that length, too," said Dunham, "and when I screened it for David he said, 'It's great, but I have one problem: We need to cut the length in half.' We had to lose entire sequences from the film, and a lot changed from the first to the final cut."

Elmes feels that the material that was lost was ultimately unnecessary. "There are scenes we photographed that aren't in the film, but when I saw the cut David made, I realized they didn't really add anything. He had the thread of the film so clearly up there on the screen. It's as if all the footage we shot had been distilled, and I was completely blown away by it."

Lynch and Badalamenti then traveled to Prague to record the score for the film. "The country was still under communist control then, and it was winter when we arrived," Badalamenti remembered. "The people on the street, the musicians, the house engineers—everyone you met was afraid to speak, and there wasn't a smile on anyone's face. It was so strange. Our hotel rooms were bugged, we were videotaped in the dining room, and there were men in black coats trailing us. We'd walk on icy streets to the studio, and there would be garbage cans in the doorway, then we'd enter a dark hallway with low, flicker-

ing lights and climb a long staircase into an even darker studio room. The mood of the people, the buildings, and the deep quiet were the perfect environment to record music for *Blue Velvet,* and David loved it.

"While we were there David said, 'Angelo, I want you to make me some tracks that we'll call firewood that I can use to create sound design. Get some low instruments, like the cello and basses, and record some long, slow passages of music,'" Badalamenti continued. "I wrote out ten minutes of whole notes and let them sustain to a really slow click track and interspersed it with some scratchiness on the bows. When David worked with these slow recordings he'd play them at half speed, sometimes quarter speed. He puts this firewood underneath things, and we've done this a lot."

After the film wrapped, Lynch got an apartment in Berkeley, where postproduction was done. "That was a tense time," recalled Fisk, "and I gave him a lump of coal in a leather traveling bag for Christmas. At that point we were trying to keep it together and David spent Christmas with me, and New Year's Eve with Isabella. We were open about what was going on, and I told David we could stay married and he could be free to live as he wanted—maybe we can get through this. I tried to live with the situation, but I couldn't. My heart was truly broken, and I was walking around like a lost person with blood dripping from every pore. I'd lost my best friend.

"We always remained in communication, though," she added. "I'd grown up without my father, and I wasn't going to deny my son his relationship with his father. I set up a separate phone in the house so David and Austin could always reach each other, and they talked every day. David was right there—he never abandoned us and he took care of us. I had a strange and restrictive upbringing and I owe David a lot because he taught me so much about life. He's such a good guy and I'm eternally grateful to him."

Lynch's personal life was in disarray by the time the film was screened for the first time at De Laurentiis's headquarters on Canon Drive in Beverly Hills. That first screening was a bit rocky, too. "A handful of people were there," recalled Caruso. "Dino, Fred Sidewater, who was Dino's right-hand man, David, and a few others. So we play the movie, it finishes, the lights come on, and there's silence. Everybody is looking at each other, and finally Dino says, 'Nobody's gonna want to distribute this picture, so I'm gonna form my own distribution company and distribute it myself.' Dino paid for distribution, prints, and ads."

The film was then taken on the road for a few preview screenings. "I remember going to a preview in the San Fernando Valley, and it was the worst preview I've ever been to," said Rick Nicita. "The rawness of the characters, what Isabella goes through—it just seemed like a bad dream, and there weren't just walk-outs, there were run-outs! In my memory people were running up the aisles! The next day David, myself, Raffaella, Dino, and a few other people were sitting in Dino's office going over the cards, and it was gloomy. The comments were along the lines of 'Kill the director. Who did this? Terrible!' So we're reading these cards and Dino looks around and says, 'Fuck 'em. They're wrong. This is a brilliant movie, we're not gonna cut a single frame, and we're gonna release it exactly as it is. The critics will love it, and the audience will be there.' Dino was a fabulous guy."

De Laurentiis was right, of course, but it took a while for *Blue Velvet* to find its audience. When the film screened in early September at the 1986 Telluride Film Festival—where the hippest film audiences in the country can be found—Laura Dern attended the screening with Lynch and MacLachlan, and she recalled, "People didn't know whether they were supposed to laugh or run from their seats. Audiences now are quick to find unusual things hilarious or delicious, but David's bravery when it comes to tone is like nothing we'd seen before that. Before David, nobody made it sad and funny at the same time, or terrifying yet hilarious, or sexual but odd, and *Blue Velvet* is all of those things. With the opening of the film you're immediately thrust into a world where everything feels real but unreal, everything's perfect but you can't trust it, and then you descend into the underbelly. The intro is just mind-blowing, and the audience at that screening wasn't ready for it."

The film had officially premiered in competition at the Montreal World Film Festival in August of 1986, and it opened commercially in the United States on September 19th, 1986, in ninety-eight theaters across the country. Although many viewers found the film intolerably disturbing, *Blue Velvet* netted Lynch a best director nomination in that year's Academy Awards, resurrected Dennis Hopper's career, and went on to become a staple of film school curricula around the world.

It caused quite a stir when it came out, too. "I didn't know the film was going to be so controversial," said Rossellini. "The controversy was pretty rough and I think I bore the brunt of it. If people liked the film, David was given credit—and of course he deserved it. The film is above all else David's expression. But

if they didn't like it they often said things about me being a model and Ingrid Bergman's daughter, and being bent on destroying my image by playing this character, that I was rebelling against myself, and so forth. There was a lot of projection that was pure fantasy."

Film critic Roger Ebert was particularly incensed by the film. Accusing Lynch of misogyny, Ebert asserted that Rossellini was "degraded, slapped around, humiliated, and undressed in front of the camera. And when you ask an actress to endure those experiences, you should keep your side of the bargain by putting her in an important film." Ebert's critique hasn't aged quite as well as that of Pauline Kael, the high priestess of film criticism, then in residence at *The New Yorker.* Describing Lynch as a "populist surrealist," and lauding MacLachlan's performance as "phenomenal," she summarized *Blue Velvet* as an inquiry into "the mystery and madness hidden in the 'normal,'" and commented that "Lynch's use of irrational material works the way it's supposed to: we read his images at some not fully conscious level."[10]

Caruso recalled, "We were surprised when the film was such a sensation. We didn't think it was going to be a disaster, but we didn't think it would be a movie people talked about for decades. Most critics loved it when it came out, though, and I think critics who wrote negative reviews didn't understand what they were seeing. *Blue Velvet* is a movie you have to see a few times to get all the nuance and detail."

"*Blue Velvet* might be David's greatest film," said Jack Fisk. "He came off of *Dune,* which was a horrible experience for him, and as a kind of consolation prize Dino said, 'You can make the picture you want to make.' He had these things pent up in him that he wanted to express, and *Blue Velvet* was an unleashing of all this stuff he'd had to hold back."

Decades after the film was released, MacLachlan hosted a screening of *Blue Velvet* for a charity event and recalled, "I hadn't seen it probably since it came out and didn't know what to expect, and I really got caught up in the story. I think it's a perfect film."

I WAS SICK, JUST sick and devastated after *Dune*. Meditation has saved me a lot of times and that was one of them. It was a dark time. It helped that I had other scripts and I was thinking about what was next, but I couldn't *not* think about all the time I'd just spent on that film. When you don't have the freedom to do what you want and it goes bad, you feel like you've sold out and you deserve what you get, and I sold out right from the beginning. I knew the way Dino was, I knew I didn't have final cut, and I had to adjust all along the way—it was a horrible thing.

I learned about failure, and in a way failure is a beautiful thing because when the dust settles there's nowhere to go but up, and it's a freedom. You can't lose more, but you can gain. You're down and everybody knows you're down and that you fucked up and you're a loser, and you just say, "Okay," and you keep working.

I get ideas and a lot of times I don't know what they are or how they fit, but I write them down and one thing leads to another, so in a way I don't really do anything. I just stay true to the idea. I probably wrote four drafts of *Blue Velvet*. They weren't totally different, but I was finding my way, and I gave Kyle an unfinished draft of the script when we were shooting *Dune*.

I didn't like the song "Blue Velvet" when it came out. It's not rock 'n' roll, and it came out during the birth of rock 'n' roll and that's where the power was. "Blue Velvet" was schmaltzy and didn't do a thing for me. Then I heard it one night and it married with green lawns at night and a woman's red lips seen through a car window—there was some kind of bright light hitting this white face and these red lips. Those two things,

and also the words "and I still can see blue velvet through my tears." These things got me going and it all married together.

If a character comes along and you're the only writer around, they kind of introduce themselves to you and then you know them. Then they start talking and you go deeper in, and there's stuff that's surprising because everybody is a mix of good and evil. Almost everybody has a bunch of stuff swimming in them, and I don't think most people are aware of the dark parts of themselves. People trick themselves and we all think we're pretty much okay and that others are at fault. But people have desires. Like Maharishi says, built into the human being is always wanting more, and that desire leads you back home. Everybody finds their way eventually.

An important piece of the *Blue Velvet* script came to me in a dream, but I didn't remember the dream until quite a while after I woke up from it. So, imagine me for some reason going over to Universal Studios the day after I had a dream that I didn't remember. I went there to meet a man and went into the secretary's room and the man was in the room behind her. In this secretary's room there was either a couch or a chair near her desk, and because the man wasn't ready to see me I went and sat down on this chair and waited. Sitting on that chair I remembered my dream, and I asked the secretary for a piece of paper and a pencil, and I wrote down these two things from the dream: a police radio and a gun. That did it for me. I always say I don't go by nighttime dreams because it's daydreaming that I like. I love the logic of dreams, though. Anything can happen and it makes sense.

So Richard Roth and I went and pitched this *Blue Velvet* idea to a friend of his who worked at Warner Bros. I'm telling this guy about finding an ear in a field and a few other things about the story, and he turns to Richard and says, "Is he making this stuff up?" I went ahead and wrote two drafts of the script and showed this gentleman at Warner Bros. the second draft and he hated it. He said it was horrible.

I had a lawyer who didn't tell me that pitching *Blue Velvet* to this guy at Warner Bros. put the thing into turnaround and that if I wanted it back I had to do something about it. I don't know what happened exactly—this is a horror story to me. I went off to Mexico and made *Dune*, and during that time I thought I had the scripts for *Blue Velvet* and *Ronnie*

Rocket and that they belonged to me. When the dust settled after *Dune*, I sat down with Dino and Rick Nicita, and somehow it came out that Warner Bros. owned the script for *Blue Velvet*. I just about died. So Dino picked up the phone and called the head of the studio—and the story was that Lucy Fisher was running down the hall to tell him not to sell the script, but Dino got it from them and that was that. I guess you could say he gave it back to me, because he made it possible for me to make the film and gave me final cut, but that's how Dino ended up with the script. Richard Roth was attached to the film up to a certain point, but eventually he decided it was best to let Dino run the show. But Richard's listed as executive producer of the film and he made his contribution. It was Richard who came up with the name the Slow Club, which is where Dorothy Vallens sings.

Fred Caruso was the producer on *Blue Velvet*, and I love Fred, bless his heart. There are some people that talk in a way that gives you a feeling of assurance and safety, and Fred had that. He was very calm, very Italian. He just had a way about him and he could always talk me down. Fred often said to me, "I don't know what you're doing," but he was really a good producer.

We went to Wilmington and Dino was making thirteen films at the studio and we were the lowest on the totem pole, but we had the greatest time. We were the poorest film on the lot, but *Blue Velvet* was like going from hell to heaven, because I had tremendous freedom. I didn't really give up anything when the budget had to be reduced, either, because I could work around things. There weren't so many rules in those days, and now there are many more rules, and it's harder and harder to keep the money down. It forces you to either give up something or blow your brains out.

We all had a blast and became really close. We were away in a place, and we'd all have dinner together, we'd see each other every day, and everybody was there for a long period of time, and that doesn't happen anymore. People come in quick now, then they go away, and you don't have dinners. I don't know what's changed. Now it's like tremendous pressure. Tremendous. And it just kills me, I can't tell you. Shoots have to go faster. *Blue Velvet* started in May and went until Thanksgiving, and the days of long shoots like that are over.

I remember Dino came to dailies the first day of the shoot and we'd done a day of Steadicam up and down the staircase to Dorothy's apartment, and when we got it back from the lab Fred realized the lens in the camera he'd used was broken and it was so dark that you almost couldn't see anything. Dino sees that and he starts screaming, and I said, "Dino, calm down; the lens was broken, and we've just gotta reshoot it."

Kyle played Jeffrey Beaumont because Kyle is an innocent, and he's kind of all-American in a way that makes you think about the Hardy Boys. Jeffrey is curious and he's a detective—well, everybody's a detective—but he's got that going on, and he likes women, and he likes a mystery. I looked at a lot of people before I found Laura Dern, and she's perfect for Sandy. Sandy is smart and she has this playful nature. She's a good girl, but that mind . . . she's got a dreamy thing swimming in there, and a curious thing. She's the daughter of a detective. Laura embodied this person that Jeffrey could be pals with at first then fall in love with, and they didn't have a dark love. They had a pure love.

Dennis Hopper is a great actor, and I really liked him in *Giant* and *Rebel Without a Cause* and *The American Friend*. I was told not to hire Dennis. They said, "No, you cannot do that—he'll get fucked up and you'll never get what you want," but I always wanted Dennis and I knew he was the perfect Frank Booth. I talked to a few other actors about the part, then somewhere in there his agent called and said Dennis was clean and sober and had just shot another picture, and that that director loved working with him and would be happy to talk to me. Then Dennis called and said, "I have to play Frank Booth because I *am* Frank Booth," and I said that's good news and bad news. I had no reservations about hiring him.

To me, Dennis is about the coolest there is. He's the rebel dream guy, and he has romance and tough guy rolled all into one, and it's just perfect. And it's a fifties thing, born out of the fifties. There's a scene with Dennis watching Dorothy sing and Dennis cries in that scene and that was totally perfect. That's a side of this romantic fifties rebel thing, where a guy could cry and it was totally okay and cool and then beat the shit out of somebody in the next minute. Macho guys don't cry now, and it's false, really, but the fifties had this poetry swimming through them.

When Dennis has his first scene as Frank Booth with Dorothy I was

laughing uncontrollably, partly because I was so happy. The intensity, the obsession, the drivenness of Frank—and that's the way it was supposed to be. When people get that obsessed there's humor in it to me, and I loved it. He just nailed it. Dennis was Frank from the first second all the way through.

Dennis was originally supposed to sing "In Dreams," and the way it got switched to Dean Stockwell was fantastic. Dean and Dennis go way back and were friends, and Dean was going to help Dennis work on the song and they were rehearsing. Here's Dean and here's Dennis, and we put the music on, and Dean is in perfect lip synch. Dennis is going along fine at the beginning, but his brain was so fried from drugs he couldn't remember the lyrics. But I saw the way Dennis was looking at Dean and I thought, This is so perfect, and it switched around. There's so much luck involved with this business. Why did it happen like that? You could think about it for a million years and not know it was the way to go until you saw it right in front of you.

So we know now that Dean's going to sing. Frank says, "Candy-colored clown" and puts in the cassette and Dean picks up the light. Patty Norris [the production designer] didn't put that light there. I didn't put that light there. Nobody knows where it came from, but Dean thought it was for him. It was a work light, and nothing could be better than that being the microphone. Nothing. I love it. We found a dead snake in the street around the time we shot that scene and Brad Dourif got hold of it, and while Dean was doing "In Dreams," Brad was standing on the couch in the background working this thing, and it was totally fine with me.

I met Isabella in this restaurant in New York on July 3rd, and that was a weird night. Real weird. I was with Raffaella De Laurentiis's ex-husband, and we were going to go down to some club and we had a limo. I was in Dino's world and I flew Concorde all the time and had limos to drive around in. I don't know how it happened. So I was in Dino's restaurant; one thing about Dino, the Italian food he made sure was the best. So we saw a couple of people from Dino's office sitting over there, and when we were on our way out we stopped to say hello. We sat down and I'm looking at this girl sitting there and I said, "You could be Ingrid Bergman's daughter." And somebody said, "Stupid! She *is* Ingrid Bergman's daughter!" So that's the first thing I ever said to Isabella, and then we

started talking and in my mind I'm thinking and looking at her. I talked to Helen Mirren about playing Dorothy and she didn't want to do it, but she did say, "David, something's wrong. Dorothy should have a child," and that made perfect sense. Helen Mirren is a great actress and that was her idea. There are women who wouldn't need to have a child to react exactly the same way to somebody like Frank Booth, though—they're kind of like victims, and with a great manipulator like Frank they could get into a place where they'd be like Dorothy. But it's easier to understand Dorothy's behavior when you see her as a mother protecting her child.

Isabella is so perfect for *Blue Velvet*—I was really lucky. She's a foreigner in a country that's not her own, so she's already vulnerable to being manipulated, so that's one thing Isabella has. And she's got this incredible beauty—that's another thing she's got going. But you can see in her eyes that she could be a troubled person, and there's a fear in there, and the combination of all those things was perfect for Dorothy. I knew she'd just done one movie when we met, but I didn't care because I knew she could do it. People get used to seeing a certain kind of handsome and a certain kind of beauty in movies, and then you go on the street and see real faces and a lot of them have the stuff. Maybe they can't carry a whole picture, but they can sure play a character.

There was a bar beneath the apartment where we shot the scene with Dean Stockwell called This Is It, and we went to this bar and were scouting it and they had cages where go-go girls were dancing. I met one of the dancers named Bonnie, and I loved her. The way she looked and the way she talked—she was incredible. I asked her if she'd be in the film, and she wound up dancing on top of Frank's car, and the way she danced was perfect. And this is a found thing, this girl I met in some bar in Wilmington. I love her so much.

I don't have it all together in my head when I get to the set. I like to rehearse and work it out, and then you show it to the DP, and, like Freddie [Francis] used to say, he'd just watch where I'm sitting during rehearsal and he knows that's where the camera goes, and that's sort of true. You see it for the first time when you're on the set or on the location; they're fully dressed, made up, and you have a rehearsal, and that's when the idea comes to life and you kind of see a way to get it. It's that

rehearsal that's important. I don't do a lot of takes—maybe four, six at the most. You get a shorthand with people, and if you heard some things I say to actors you'd say, What the hell! But if you're really looking at somebody a different kind of communication kicks in, and actors and musicians pick up on this. It goes right in them. I don't know why, but some little word or gesture, and the next time it's way better, and the time after that it's perfect.

Some local people hung around when we were shooting, but I didn't see them. I was looking at the actors, and I don't care about what's behind me. In fact, if I'd seen it, it would make me crazy. I've got to focus and get this thing and that's it. The rest is bullshit—it drives me nuts. I tune out everything; you keep your eye on the donut not the hole.

People get this story of what happened with Isabella's performance of the song "Blue Velvet" wrong, and here's what happened. Isabella learned the song from sheet music that was given to her by an old lady who was teaching her, and what she learned was different from the Bobby Vinton version. I got a local band—not fancy, but they were good musicians—but Isabella had learned the wrong version of the song. It was apples and oranges; it was all over the place. I said to Fred Caruso, "Fred, we can get this if we just keep working," and Fred said, "David, it's not going to work; let me call my friend Angelo," and I fought it. I said, "I want to get this thing," but finally I knew it wasn't happening and I said, "Fred, call your friend Angelo." So Fred called Angelo and he flew down to Wilmington the next day. Isabella was staying in this bed-and-breakfast that had a piano in the lobby, and Angelo worked with her there. That same day we were shooting the scene where Mr. Beaumont has his attack, and my dog, Sparky, the love of my life, appears in that scene. At lunchtime Fred brought Angelo down the driveway, so I say hello to Angelo, and he plays me this thing on his little cassette player of Isabella singing and Angelo playing piano, and I said, "Angelo, we could cut this into the film right now, it's so beautiful. Way to go."

I wanted "Song to the Siren," by This Mortal Coil, for the film, and I wanted that song, I wanted it, and I told Fred, "You fucking get that thing, man," and Fred said, "David, there are a bunch of problems," and it was mainly money—money, money, money. So Fred said, "David, you're always writing little things on paper; why don't you send Angelo

some lyrics and he can write a song." I said, "Fred, first of all, there are twenty-seven zillion songs in the world. I don't want one of them. I want this song. I want 'Song to the Siren' by This Mortal Coil. I don't think I'm gonna write things on a little piece of paper and send them to this guy I hardly know, and he's gonna write something that will top what I want. Not in a million years. Get real, Fred."

Angelo and Fred are crafty Italians, though, and Fred knew that if you send your lyrics you're invested and that you're going to have more of a chance of liking something if you helped make it. It was sort of a trick of theirs. So I was outside one night and these ideas came, so I wrote them down and sent them to Angelo, and he laughed when he saw them. He said, "These are the worst fuckin' lyrics! They don't rhyme and there's no form!" Angelo is old school in those ways. But he thought and thought, and he did a version of the song he put together with a singer, but it didn't have the quality I wanted. I told him I loved the melody but it needed to sound more ethereal. Then he brought Julee Cruise in to sing it, and they got this thing going, overdubbing again and again, and Julee just did beautiful, and Angelo did beautiful, and I had to admit I liked it. Maybe I liked it because I wrote the lyrics, I don't know, but I did really like it.

Still, I hesitated because I wanted "Song to the Siren," so nothing was going to come up to that, even though I really liked "Mysteries of Love." "Song to the Siren" is sung by Elizabeth Fraser. I hear she's a recluse and is super private, but she has got the stuff. I think it was her boyfriend playing guitar on the song, washed in reverb like crazy, and they conjured magic. It goes into a cosmic kind of thing, while "Mysteries of Love" is warmer and it's for two people. It's got some cosmic thing that opens up, too, but it's warmer.

I finally got "Song to the Siren"—it's in *Lost Highway*—and "Mysteries of Love" ended up being pretty perfect for *Blue Velvet*. You never know how things happen, and Angelo, bless his heart, he's the greatest. He's like my brother, and he can write music that is so beautiful. It's fate, that's the only way I can figure it. It's so much pleasure to work with Angelo.

Angelo and I went to Prague to do the score for *Blue Velvet*, and it was incredible there. There are rooms that have certain kinds of wood and

acoustics, and they produce what I call Eastern European air, and it comes into the microphone. It's a sound and a feel, and it's not sad but it's old and it's so beautiful. When Angelo and I went to Prague the communists were still running things, and you're walking down the street and you look into a clothing store and see beautiful dark wood shelves and there would be maybe three sweaters on them. Empty. And bleak. No one talks. You go into the hotel, there's prostitutes all lined up in the lobby; it was fantastic. And you figure there are cameras and microphones everywhere, you just get this feeling. I'd lie in my bed and listen to see if I could hear high tones. I loved it there. We went up this one hill and looked out and it was like a Pieter Bruegel painting.

Patty Norris's touch is everywhere in *Blue Velvet*. Patty is a genius with costumes, beyond the beyond. People come out of the dressing room, Frank is more Frank, Jeffrey's more Jeffrey, Sandy's more Sandy—it's uncanny. Patty started with me on *The Elephant Man*, then on *Blue Velvet* she asked me if she could be production designer as well and I said fine. She thinks the same way about rooms as she does about costumes—she really thinks about it. We talked about everything, and when I would come up with something she would add stuff to it. Dorothy's apartment—the color of it was perfect, but when I first saw the couches they were totally wrong. They were stand-alone couches and I wanted them built in. So we designed these arm things and then I loved them. Patty did a great job.

We shot film of feet walking up a flight of stairs and a hand with a gun that you see on the television in Jeffrey Beaumont's house. We also filmed a Chair Pull to use that way, but we didn't end up using it. You know how people have Olympics? People do running, there's a hundred-yard dash, the fifty-yard dash, the mile run, and they pass off batons. The Chair Pull is like that, like an Olympic event. You have these overstuffed chairs, and there's rope tied around the chair, and a long piece of rope comes off the chair. The girls competing in this race are wearing prom dresses, and each girl has a chalk lane, and they're all lined up at the starting line with the chairs behind them, and the goal is fifty yards. A starting pistol fires to start the race and whoever pulls their chair across the finish line first wins. It was a hundred degrees and really humid the day we shot this thing, and it was too hot to do it but we did it anyway,

and one of the girls passed out and had to see the medic. I invented this. It's a Chair Pull.

Alan Splet is a true sound thinker, and of course I wanted him to work on *Blue Velvet*. So there he was, working in his room in Berkeley, and one day he just stopped. Alan has this stubborn streak in him, and he came to me and said, "David, I can't work on this film anymore. I can't stand this film. I can't stand Frank Booth and I can't do it. It's making me sick." I said, "Jeez, Alan, holy smokes," but that was it. We had half of the picture done, and I finished the sound with the rest of Al's team.

The film wrapped at Thanksgiving, and about a week before that, Duwayne Dunham set up the editing room in Berkeley, and I got an apartment in Berkeley and we started on post. It seems like we were doing post for a long time. The first cut of nearly every movie I've done is usually four hours long, and I can't remember what we had to lose from *Blue Velvet*. I think what I lost was a certain pace, maybe, and lingering on a few things here and there. Austin came to see me in Berkeley a couple of times. He was three or four years old. How the hell did he get out there?

I think Dino got *Blue Velvet*. The first time he saw it was in a little screening room in L.A. and there were maybe thirty people there. After Dino saw it he came out of his chair super happy and he was smiling. He thought maybe this could be a breakthrough film, so he wanted to screen it for a more regular crowd to see if they'd go for it. Kyle and Laura were living together on Blackburn Avenue then, and I lived with them for a while and then I got a place in Westwood. I had a few different places in Westwood—I don't know why I kept moving around. The last one I had there I really loved. It was brand-new and I had very few things then and it had clean, empty rooms. I was doing small black-and-white oil paintings there. Anyhow, the night of this screening, which was in the San Fernando Valley, I was at Kyle and Laura's and I didn't go to the screening. Laura's mom and her girlfriend went, though, and Rick Nicita was there with some other CAA agents. After the screening Rick called from a car and they were screaming, "It's so fuckin' great, David, so great!" Then Laura's mom came home with her friend and they were sitting in

the dining room and they were kind of quiet, like worried quiet. The next morning I call Dino and he gets on the phone and I say, "Hey, Dino, how did it go?" He says, "I put you on with Larry," who's in charge of distribution, and Larry says, "David, I'm sorry to tell you, but it's maybe the worst screening I've ever been to." I said, "You're kidding me! I got a call from Rick and he said it went great," and he said, "It did not go great. You should read the cards. People were asked to write what they liked best about the movie and they wrote things like 'Sparky the dog,' or 'the end.'" So Rick and I go see Dino and he was great. He said, "It's not for certain people, but it's all gonna be okay."

If I remember correctly, *My Little Pony* and *Blue Velvet* were the only ones out of those thirteen films he was making then that did anything in the theater. I think Dino was proud of *Blue Velvet*, too. One thing I admired about Dino was that when he got behind something, he just did not give a shit what anybody else thought. *Blue Velvet* probably wasn't his cup of tea, but I think he was glad he made it.

I don't know how I got to that thing of not caring what other people think, but it's a good thing. The thing is, you fall in love with ideas and it's like falling in love with a girl. It could be a girl you wouldn't want to take home to your parents, but you don't care what anybody else thinks. You're in love and it's beautiful and you stay true to those things. There's this Vedic line that goes, "Man has control of action alone, never the fruit of that action." In other words, you do the best you can and how the thing goes into the world, you can't control that. It's lucky when it goes good and it's gone good for me, and it's horrible when it goes bad and it's gone bad for me. Everybody's had those experiences, but so what? You die two deaths if you've sold out and not done what you were supposed to do. And that was *Dune*. You die once because you sold out, and you die twice because it was a failure. *Fire Walk with Me* didn't do anything out in the world, but I only died one time with that picture, because I felt good about it. You can live with yourself perfectly fine if you stay true to what you love.

I was invited to Swifty Lazar's Oscar party at Spago because I was nominated for best director for *Blue Velvet*, but I lost to Oliver Stone, who won for *Platoon*. I was at the party with Isabella, and people were there with their Oscars, and Anjelica Huston comes over and says,

"David, I know you know my father," because I met John Huston in Mexico. I had an art show in Puerto Vallarta and John Huston came. Freddie Francis was at this art show, too, and Freddie shot B roll on John's picture *Moby Dick*, so we talked and we had a great night. He was such a good guy. Anyhow, Anjelica says, "My father's in the other room; why don't you go and say hello." I say, "I'd love to," so I open up the door to this private room and there's John, and at the table with him are George Hamilton and Elizabeth Taylor. I love Elizabeth Taylor and *A Place in the Sun* so much. That kiss she has with Monty Clift? That's one of the best-filmed kisses ever. Grace Kelly moving in on Jimmy Stewart in *Rear Window* is a great filmed kiss, too.

Elizabeth Taylor presented the best director award that night, and there we are in that back room and she said, "I love *Blue Velvet*," and my heart is going. I was surprised she saw it and loved it. I told her, "I wish I'd won, because when you presented the award to Oliver Stone he got to kiss you," and she said, "Come here." So I go over and she's sitting down and I'm standing, and there's Elizabeth Taylor's face right there and I lean down and I see these violet eyes and this face and I go down on these lips and I keep going down, her lips are miles deep. So incredible. I kissed her and it was so fantastic, then we talked a little bit with John Huston and I left. I kissed her another time at Cannes. I was sitting at her table and I reminded her that I got to kiss her at Spago and asked her if I could kiss her again. I was there with Mary Sweeney, and Elizabeth called my room later and wanted to know if I was married. She liked to marry people and got married like seven or eight times, but I didn't want to marry Elizabeth Taylor. I also kissed her at this amfAR event, then I went to lunch with her and she told me stories. That was the last time I saw her.

Wrapped in Plastic

The year 1986 was a good one for Lynch. *Blue Velvet* ushered him into the pantheon of cinema's great auteurs, but equally important was a fortuitous meeting he had early in the spring of that year when he crossed paths with writer Mark Frost. Born in New York in 1953, Frost spent his teenage years in Minneapolis, where he worked at the Guthrie Theater, then studied acting, directing, and playwriting at Carnegie Mellon. After graduating in 1975, he went to L.A. and landed a series of jobs writing for television. In 1981 he became a staff writer for Steven Bochco's acclaimed series *Hill Street Blues* and remained with the show until 1985. The following year he met Lynch.

"An agent at CAA brought us together to work on a feature called *Goddess,* for United Artists," Frost recalled of a project chronicling the final months in the life of Marilyn Monroe, based on Anthony Summers's book *Goddess: The Secret Lives of Marilyn Monroe.* "David struck me as a straightforward guy with a great sense of humor and we clicked on that level right away—we made each other chuckle. He had a friendliness I responded to and we just got along well. Sometime in 1986 David set up shop at Dino's place on Wilshire Boulevard, and that's where we worked on *Goddess.* We both wanted to expand the story beyond strict realism and inject lyrical, almost fantastic elements to it, and we started seeing a synchronistic way of working together."[1]

Also titled *Venus Descending,* the script they completed in November of 1986 implicated Bobby Kennedy in the death of the actress, and the project was quickly abandoned. "*Goddess* was a great subject and we wrote a good script," said Frost. "Unfortunately, United Artists and the producer who hired us [Bernie Schwartz] hadn't sussed out that there were revelations in the

book about the Kennedys that we now take for granted but were new at the time. We dealt with those things in the script and that was the end of that."

Directing opportunities were coming Lynch's way during this period, but he had no interest in making a big studio film. "David and I used to joke that he wants a big salary and a little budget," said Rick Nicita of Lynch, who learned a lesson with *Dune* that he didn't forget. Lynch tried to set up *Ronnie Rocket* with De Laurentiis but said, "Dino couldn't relate to it." De Laurentiis believed in Lynch, though, and they continued to look for a film they could do together. One possibility was *Up at the Lake,* a project Lynch had spoken to Raffaella De Laurentiis about while they were shooting *Dune.* She encouraged him to take the idea to her father, who committed some development money, but the project never went anywhere.

One inarguably significant occurrence during that period was Lynch's acquisition of what's referred to as the Pink House. A mid-century modern residence ornamented with Aztec-inspired chevrons, the Hollywood Hills house was designed by Frank Lloyd Wright's son, Lloyd Wright, and built in 1963. Restored for Lynch by Lloyd Wright's son, Eric, the house has interior walls of violet stucco, and Lynch has always kept the place sparsely furnished. The Pink House allowed Lynch to live for the first time in an environment that was precisely what he wanted it to be, and the house is important to him. He's never left it and subsequently purchased two contiguous properties to create the complex where he continues to live and work.

There were other lifestyle changes then, too, because Lynch needed a staff for the first time in his life. His staff has expanded over the years and now includes an engineer who runs his sound studio, an in-house editor, a full-time handyman, an archivist who manages his art and exhibitions, an in-house producer, and a personal assistant. Initially, it was a streamlined operation of just two or three people, though. One reason Lynch is able to accomplish so much is that the people who work for him are invariably highly capable and devoted to him. Debby Trutnik was installed as office manager in 1987, and John Wentworth assumed the post of jack-of-all-trades.

Goddess was a misfire, but Frost and Lynch still wanted to work together. Frost said, "One day we were sitting at the Carnation Dairy coffee shop and David said, 'I've got this idea about a secure research facility in the fictional city of Newtonville, Kansas, and two cretinous guys who work there. One of them laughs and a bubble floats out of his mouth and goes down a hallway,

around a corner, and into a room where it lodges in the housing of a sensitive piece of equipment and shorts it out. Then you cut to outer space and see a satellite deploy a kind of ray-gun weapon that fires, and then a countdown starts.' That was all David had when he first came in, and we started spinning it into this comic phantasmagoria called *One Saliva Bubble.* We were six weeks away from shooting it with Steve Martin and Martin Short when Dino reveals he's out of money and the company is going away along with all the projects."

That was the end of *One Saliva Bubble,* but things were moving forward on other fronts. In June of that year Lynch's career as a fine artist advanced when he met art dealer James Corcoran, owner of the James Corcoran Gallery in Los Angeles. "David was living in a small apartment in Westwood at the time, and I went to his place and met him," remembered Corcoran, who gave Lynch a solo show the following year. "David has a lot of spirit and I liked him immediately—he's a very legitimate guy. He was doing large pastel drawings then, and one of the things that intrigued me about them was that they were very dark compared with work by the artists I was showing at the time, like Ken Price and Ed Ruscha."[2]

Lynch's exhibition did well in terms of sales and critical reception. *Artforum* described the work as "deeply affecting and deliciously quirky," while the *Los Angeles Times* called it "authentic and fresh." Isabella Rossellini subsequently showed Lynch's work to Milan gallerist Beatrice Monti della Corte, who encouraged legendary art dealer Leo Castelli to look at it. Castelli mounted Lynch's first exhibition in New York in February of 1989, and Corcoran gave him a second show in L.A.

It was immediately apparent in the work in those exhibitions that anything dark that was lurking in Lynch's soul was channeled directly into his art. Titles like *Shadow of a Twisted Hand Across My House, On a Windy Night a Lonely Figure Walks to Jumbo's Klown Room,* and *Oww God, Mom, the Dog He Bited Me,* all from 1988, give an idea of the mood of the work. Large, murky fields of gray, brown, and black paint applied with a loose hand, the pictures are perfumed with a sense of menace and dread. Carefully deployed passages rendered in flesh tone introduce a human presence in the work, but forms are never more than crudely sketched stick figures; the touches of flesh tone feel more like wounds. They're scary pictures.

Lynch was leading a bicoastal life during his years with Rossellini, spending half his time with her in New York and the other half in L.A. His divorce from

Fisk was quietly finalized in 1987. "I didn't want to go through courts and dredge up stuff and make a mess of things," Fisk said. "We married without lawyers and could separate without them, and we wanted it as simple and quick as possible. It was hard, though. I saw an article on David with Isabella in *Vanity Fair* the day our divorce was finalized."

In 1987 Lynch began what would prove to be an important friendship when he met producer Monty Montgomery, who had co-directed the 1981 indie cult film *The Loveless* with Kathryn Bigelow. "I met a guy named Allan Mindel who had a modeling agency in L.A. named Flick, and they were trying to break into everything—I crossed paths with him because of music videos," said Montgomery. "Allan represented Isabella and he told her that she and David should meet me, so I went up to David's place. He was sitting in his empty house with one piece of furniture and he was friendly; we spoke the same language as far as movies and ideas, and he seemed very honest—we just hit it off. When we were first getting to know each other we went to Musso & Frank's for lunch a lot, and we'd pass these characters on Hollywood Boulevard and David would look at them and say, 'I wonder what his story is?' He's curious about everything.

"When David and I met, he'd just finished shooting a commercial and needed some post-production work done," Montgomery continued. "[Production company] Propaganda Films was up to speed with video, so I hooked him up with a guy and he had a good experience, and that's how we started working together."[3]

Montgomery wasn't a partner at Propaganda but he was instrumental in all the projects Lynch did there. The seeds of Propaganda were planted in 1978 when Icelandic producer Joni Sighvatsson was a student at the AFI and met Steve Golin, who was a fellow in the producing program there. They began developing projects together, then teamed up with three additional producers and founded Propaganda Films in 1983. Golin and Sighvatsson met Montgomery in the mid-eighties when they found themselves in pursuit of the same project. "Steve and I liked this book by Richard Hallas that was published in 1938 called *You Play the Black and the Red Comes Up,* but it was under option by some guy in Texas, so we called the guy and that was Monty," said Sighvatsson. "We developed the project together, and that was the first thing the three of us approached David with. He liked it but didn't want to do a period film, and he was trying to get *Ronnie Rocket* going at that point. We got involved in that, and a couple of times the financing seemed to be coming to-

gether but it always fell apart. Then David started writing *Twin Peaks* with Mark."[4]

Lynch's activities were expanding in multiple directions at that point, and his involvement with music was deepening. Roy Orbison initially had reservations about the use of his song "In Dreams" in *Blue Velvet* but eventually came around, and in April of 1987 he went into the studio and recorded a new version of it produced by Lynch and T Bone Burnett. Then, in 1988, Lynch was invited by *Le Figaro* magazine and Erato Films to do a short film for the French television series *The French as Seen By . . . ,* and he wrote and directed *The Cowboy and the Frenchman.* A twenty-four-minute catalog of clichés about Americans and the French, the film stars producer Frederic Golchan as a dazed Frenchman wearing a beret and toting exotic cheeses and a baguette; he arrives out of nowhere at a dude ranch, where he encounters clueless ranch hands, a country-western vocal trio, and a native American in a loincloth and feathered headdress.

Co-starring as the cowboy was Harry Dean Stanton, in the first of seven Lynch projects he appeared in. "I'd always been impressed with David's films and we had a natural bond," Stanton recalled. "We understood each other. We talked about Taoism, Buddhism, and meditation and have a rapport based on our shared interest in Eastern thought."[5]

Golchan said, "Johanna Ray called and said, 'I have a director who's looking for a French actor; would you be interested in meeting him?' I told her I wasn't an actor but would love to meet him, so she arranged for me to go to David's house, which I remember as an empty space. I think there were two speakers and two chairs sitting very far apart from each other. It was stark but he was warm and friendly, and whatever I was saying made him laugh. He said, 'I think you're perfect,' and three days later we were shooting. I was initially intimidated by the prospect of playing this part, but David takes you along, and it was such a fun ride that I stopped worrying."[6]

Also on set with Lynch for the first time was script supervisor Cori Glazer, who went on to become a mainstay on his crews. She was offered fifty dollars a day to work as a PA, and her career course was set. "I remember thinking, If I only ever work for one director, this is the person I want to work for," she said of Lynch. "I fell in love with his creativity, and he's got the hugest heart of anyone I know. I remember that Isabella came to visit him on the set and he sent a green M&M over to her. He's always cheerful, at the end of the day he

thanks people, and he knows everyone's name on the crew, down to the lowli-est PA. If one of them brings him a cup of coffee he'll look them in the eye and say, 'Thank you, Johnny, thank you so much.'"[7]

That same year Lynch made his debut as an actor in a significant role, in Tina Rathborne's *Zelly and Me,* a coming-of-age story about a little girl torn between an abusive grandmother and a loving governess portrayed by Rossel-lini; Lynch played the governess's mysterious boyfriend, Willie. "Tina [who went on to direct episodes three and seventeen of *Twin Peaks*] did a film about a married woman with an illness that I found quite beautiful, so when we met to talk about *Zelly and Me,* I was interested," said Rossellini. "I play a babysit-ter who has a boyfriend, but none of the actors we tested for the role were right. The story is evocative of another century when people didn't consum-mate their love as quickly, and the actors we tested were too modern and sexy. David is gentle and polite, and when he tested for the part Tina was convinced."

The film premiered at the Sundance Film Festival on January 23rd, 1988, and opened on April 15th to middling reviews. Lynch had mixed feelings about appearing in the film and has rarely spoken of it, but he seemed comfortable with his new position in the cultural landscape. He was becoming famous.

"I remember the first time someone asked him for an autograph when he was with me," said Martha Levacy. "It was around 1988 and we were at a Denny's or someplace like that, and two people walked up with a napkin and asked him to sign it. He took it in stride and said, 'Yeah, some people are start-ing to recognize me.' He didn't seem to feel one way or another about it. It was just a statement of fact, and he was real gracious about it, always. Our folks taught us to behave that way."

Lynch was about to become *really* famous. Tony Krantz, a young agent who started in the mailroom at CAA in 1981 and moved up the corporate ladder, felt that Lynch's approach to storytelling could translate well to the episodic structure of television. "When I heard that David was collaborating with a se-nior writer on *Hill Street Blues,* I thought, There's a weird possibility there! I wanted to make a hit series and I saw an opportunity, so I got a meeting with them and convinced them to give it a shot. They came up with a thing called *The Lemurians* about the continent of Lemuria, a place where evil prevailed.

The continent disappeared into the ocean leaving a few survivors, and the show was about FBI agents with Geiger counters who search out and kill the remaining Lemurians. We took it to Brandon Tartikoff, who was head of NBC, and he ordered it as a movie, but David didn't want to do it as a movie because he thought it was a series. So even though we sold it, it just died.

"David and I had lunch frequently," Krantz continued, "and one day we were at Nibblers and I looked around and said, 'David, this is your world, these people, the flotsam and jetsam of L.A. This is what you should do a series about.' I rented *Peyton Place* and screened it for David and Mark and said, '*Peyton Place* meets your world, David.'"8

Although Lynch hated *Peyton Place,* Frost recalled that at that point he and Lynch "knocked some stuff around. Then we went into ABC for a how-do-you-do meeting with some executives, including ABC's head of dramatic programming, Chad Hoffman. We talked about this idea, which was originally called *Northwest Passage,* and they lunged at it."

Lynch and Frost had this successful pitch meeting in March of 1988, just as a Writers Guild strike that was to stretch into August began. "Because of the strike, everything got put on hold for almost a year, so there was a hiatus after that first meeting at ABC," said Frost. "When the strike ended they called and said, 'We want to proceed with that project you pitched,' but by that point neither of us could remember much of what we'd said! So we talked about it some more, then met with them and were told to go write. We knew it was going to be some kind of serial about the murder of a homecoming queen, and the first image we had was of a dead body washing up on the shore of a lake."

A study of small-town intrigue set in the same indeterminate time zone as *Blue Velvet, Twin Peaks* had a clear narrative arc, but the story was elastic enough to accommodate new ideas along the way. While Frost and Lynch were writing early episodes for the show, for instance, Lynch had the opportunity to meet the Dalai Lama, who spoke to him about the plight of Tibet. This led to a scene with Agent Dale Cooper giving a lecture on the subject to the staff of the Twin Peaks Sheriff's Department.

This highly unconventional material made its way onto network TV partly because Frost knew how to navigate that world. A seasoned television writer who understood the rhythms and limitations of the medium, Frost was a good foil for Lynch, and each brought different things to the table. "Initially, part of my contribution was that I knew the ground rules of television more than

David did," Frost said. Lynch has recalled that Frost had an office with a chaise longue like a psychiatrist's couch and that he'd lie on the couch and talk as Frost typed.

"We'd toss things in the air and bat them back and forth like a game of ping-pong," said Frost. "Scenes would suggest themselves and we'd hammer them into shape, and there were certain characters that one or the other of us had the voice for more authoritatively. Structure might be a little more my strong suit, but David's got tremendously enhanced ideas about mood and character and small details and behaviors that are indelible and unique. David's tastes run darker than mine, and that was a point of departure on occasion, but we somehow always resolved it. Neither of us ever said, 'That won't work,' and walked away."

"We weren't wildly excited, like, This is it!" Frost said of the completion of the two-hour pilot script. "It was more a case of, Here's another thing we're taking a crack at. We wrote the pilot fairly quickly—I don't think it took more than a month—and that first draft was the final draft. I remember David sitting in my office while I printed out two copies, and David went home and read it, then called me that night and said, 'I think we have something.' "

Lynch had drawn a map of the town of Twin Peaks (the map now hangs in Krantz's office), and they took it with them when they turned the script in to ABC and referred to it as they described the world they were evoking in the script. Brandon Stoddard, the president of ABC Entertainment, was charmed and ordered the pilot for a possible fall series in 1989.

"Then they called us in for a notes meeting," Frost recalled. "I remember an executive taking a list of notes out of his pocket and saying, 'I've got some notes if you're interested,' and David said, 'No, not really,' and the guy quietly put the list back in his pocket with a sheepish look on his face. That set the tone of, You wanted something different so don't screw it up! And they did very little meddling."

Looking back on that period, Montgomery recalled that "there were a lot of projects happening on top of each other. David can do a lot of things at once, but he wasn't paying much attention to *Twin Peaks* in the early period of pre-production. That train was definitely heating up at the station, though. So I told David, 'Why don't you come to Propaganda?' We had a new office with plenty of room, and I suggested he put Mark Frost in an office and have Johanna Ray do the casting there."

The casting of *Twin Peaks* involved a bit of the serendipity typical of Lynch productions. Michael Anderson, who dances and utters sentences in reverse in the show, was someone Lynch met in 1987 at the Manhattan nightclub Magoo's. Anderson was dressed in gold and pulling a wagon at the time, and Lynch immediately envisioned him as Ronnie Rocket. Deputy Andy Brennan was played by Harry Goaz, who happened to be driving a car Lynch hired to take him to a tribute to Roy Orbison. As for Kyle MacLachlan's casting as the series' star, Agent Dale Cooper, Lynch has said that "Kyle was born to play this role." MacLachlan does deliver a pitch-perfect performance as Cooper, a kind of innocent sage who marvels at the wonders of the world while attempting to understand its darkest mysteries. MacLachlan has crack comic timing and is irresistibly charming and funny as Cooper.

Actor Ray Wise, who played Leland Palmer, observed, "For David it's all in the casting. He's very intuitive, and for one reason or another he'll feel a connection with an individual and know how to place that person in the piece. The actors feel the trust he has in them, too, and it encourages them to let down their inhibitions and just go with whatever happens in the scene."[9]

Leland Palmer's grief-stricken wife, Sarah Palmer, is played by Grace Zabriskie in the first of five projects she's done with Lynch. Sarah Palmer seems to carry the anguish of the entire town, and Zabriskie is required to operate at an extreme emotional pitch every time she appears onscreen; she turns in a bravura performance that's wrenching, too. "I remember being on set one day and David asking 'You got another one?' I replied, 'David, I went over the top seventeen takes ago!'

"You don't realize how much you're withholding until you work with someone who doesn't want you to hold back," said Zabriskie. "I can present just about anything that comes into my head to David and if he can use it, he will. Every project I've done with him has been deep fun. There's a back and forth between us that's subliminal and unspoken, and all the more precious for that somehow."[10]

Twin Peaks launched several careers, and the actors he discovered for the show remain deeply grateful to him. "I was so young and nervous when I met David that I sat on my hands because they were shaking so badly," said Sheryl Lee, who played Laura Palmer. "But David has such a kind, warm way about

him that he puts you at ease immediately. He asked me how I felt about being dipped in gray paint and wrapped in plastic and being in cold water, and I said, 'No problem!' "[11]

The part of Nadine Hurley, which was originally envisioned as a minor character but grew to be more, went to Wendy Robie, who said, "I had a wonderful conversation with David and Mark, then David said, 'One of your eyes is going to be shot out,' and I said, 'Oh? Which one?' He liked that and laughed, and a friend of mine who worked in the office where we met told me that after I left David said, 'There goes Nadine.' "[12]

Mädchen Amick, who played waitress and abused wife Shelly Johnson, was running late the afternoon she was slated to meet about the show. "I didn't get to our meeting until eleven at night," she recalled. "And David waited! Johanna, Eric [Da Re], and Mark were there, too, and Eric read with me, then David said, 'So, do you wanna do a TV show?' And I said, 'Yes, I do!' "[13]

Twin Peaks also featured a handful of veteran actors who hadn't been seen in a while. Russ Tamblyn, Piper Laurie, Peggy Lipton, Richard Beymer, and Michael Ontkean were among them, and they all came to the show in different ways.

"In January of 1986 Dennis Hopper had a fortieth birthday party for David, and I was living with Dean Stockwell at the time and Dean took me with him," said Tamblyn. "I was a big fan of David's, and there was a point at the party when everybody gathered around him while he opened cards, and he opened one with a picture of a naked woman surrounded by a bunch of guys. He turned to me and said, 'Hey, Russ, wouldn't you like to be this guy?' That was an opening and I said, 'David, what I'd really like is to work with you,' and he said, 'Next project.'

"People say lots of things in Hollywood without meaning them, but David's not like that," Tamblyn continued. "Two years passed, and then when he was casting *Twin Peaks* he got in touch. I'll never forget the first words out of his mouth after we sat down. He said, 'Russ, the part I want you to play is so and so . . .' All I could think about was that he didn't say he wanted me to *read* for the part; he said he wanted me to *play* it."[14]

Tamblyn, of course, shot to stardom in 1961 with a lead role in the classic musical *West Side Story*. Starring opposite him in that film was Richard Beymer, who, purely coincidentally, also made his way to *Twin Peaks*. "My

first impression of David was that he was available," recalled Beymer of his meeting with Lynch at Propaganda. "It wasn't the usual kind of meeting where you go in to meet a director. It was relaxed. I left and a few hours later Johanna Ray called and said, 'He wants you to play a character called Dr. Jacoby,' then she called again and said, 'No, he wants you to play a businessman named Ben Horne.' I thought, shit, Jacoby sounded so much more fun, but I actually got the fun role."[15]

Canadian actor Michael Ontkean, who began performing on television as a child and went on to co-star with Paul Newman in the 1977 film *Slap Shot*, has a vivid memory of meeting Lynch. "His hair stood thick, tall, and post-modern rockabilly, and I was walking tall with the recent birth of my second daughter," he recalled. "Twilight time, late fall, indoors in smog-filled L.A., but it felt like we were outdoors somewhere in Maine or Oregon. David had on a meta-cool fishing jacket, and I kept looking around for the open box of tackle and a big bucket full of river trout."[16]

The casting of the show went smoothly, and Lynch continued to tend to other things. "David went to New York to work on music with Angelo, and this *Twin Peaks* thing is moving," recalled Montgomery. "They'd hired a production manager in Seattle who was putting the budget, schedule, and locations together, and I'd check on things periodically, and one day I told David, 'I don't think pre-production is being handled properly.' He asked me to look into it, and after getting into it deeper we realized this was a big train wreck waiting to happen. I gave David the prognosis and he said, 'I want you to be a producer.'

"So I was in the trenches with him the whole damn shoot, even to the point where a few times he sent me off to actually film something, which is unheard of with him," Montgomery continued. "He didn't want to do it but there was no alternative. We were there in rain, sleet, fog, and snow, and it was round the clock, sleeping in your expedition gear. It was an ambitious, demanding shoot, and David did a wonderful job with it."

Completed in twenty-two-and-a-half days on a budget of four million dollars, the pilot was primarily shot in Snoqualmie, North Bend, and Fall City, Washington. "They put the whole cast and crew in a Red Lion hotel and we filled the entire place," said Amick. "It was like being in a college dorm, with people running around and visiting each other's rooms."

Cast as Lucy Moran, the eccentric secretary at the Twin Peaks Sheriff's

Department, Kimmy Robertson recalled the shooting of the pilot as "heaven. It was pure fun, and there were silly things with David that were magical to me. If I asked him nicely, he let me run my fingers through his hair. The hair that grows on top of that head and what's inside that head—you can feel that in his hair. David's hair does something and it has a function and the function has to do with God."[17]

Exterior scenes for the pilot were also shot in wooded areas of Malibu, and interiors were mostly done in a warehouse in the San Fernando Valley. Scenes for the soap opera within the show, *Invitation to Love,* were shot in Frank Lloyd Wright's historic Ennis House in Los Angeles. It was in Washington, though, that the cast proved its mettle.

"I remember it being a very long day," says Lee of shooting *Twin Peaks'* memorable opening scene, when her nude body is found wrapped in plastic. "I kind of went into a meditative state, and I remember thinking, This is my first set and I'm lying here very quietly and I get to be like a sponge. I'm hearing everything and learning what all the different departments do—it was a great way to learn, playing a corpse."

Lynch doesn't confine people to the box they're in when he finds them and often sees things in people they themselves aren't aware of. A case in point is Deepak Nayar, who was newly arrived in the United States in the late eighties, having come from India, where he'd worked for the Merchant Ivory franchise. Nayar had experience in filmmaking, but the only position available to him on *Twin Peaks* was the job as Lynch's driver. He took it.

"I remember sitting in an office waiting and he walked in, a man full of energy, and he stuck out his hand and said, 'Nice to meet you, Deepak,'" recalled Nayar, who worked with Lynch in various capacities over the next decade and co-produced his 1997 film, *Lost Highway.* "We talked about meditation and me being Indian and that was that. I got hired as a PA and driver and it was great.

"He called me Hotshot, and we used to have one-dollar bets all the time," Nayar continued. "One day a bunch of us were standing around waiting while we shot a scene by some train tracks, and David was throwing stones. I said, 'One dollar, David, that you can't hit that pole over there.' He missed the pole, then said, 'Double or nothing you can't do it, either,' and I hit it. He accused me of picking up a bigger stone! He was so much fun and such a great director on set. He never loses his temper, never raises his voice, and, more impor-

tantly, never leaves the set. Some of the amazing things that happened on *Twin Peaks* happened because he was there on the set and could respond creatively to unforeseen things that came up."[18]

A central part of Lynch's gift is the fluidity of his imagination: He builds on what's around him as opposed to looking for what isn't there, and it's something everyone who works with him comments on. "One of the most important things David's taught me is to be really present," said Sheryl Lee. "He pays attention to everything and can adapt to whatever is happening around him and transform it into art because he's not attached to what's supposed to be. That's part of what makes it so thrilling to be on set with him and why it's so alive."

Richard Beymer recalled that "David took the script seriously, and of course we were expected to learn our lines, but he often made twists and turns that came to him spontaneously. I came in one day while they were shooting and I was standing in the back waiting, wearing a new pair of shoes that were kind of stiff. As a kid I'd learned to tap dance, so I was doing a little of that to loosen up the shoes, and he sees me and comes over and says, 'Do you dance?' I said, 'I used to dance a little,' and he said, 'Why don't you dance in the next scene?' I said, 'David, in the next scene I'm talking about murdering someone,' and he says, 'It will be great! In fact, you should dance on your desk.'"

Lynch did accord great respect to the *Twin Peaks* script, but at the same time the show operated as a work in progress and characters took on added depth along the way. "David doesn't tell you who the character you're playing is," said Mädchen Amick. "He let me find Shelly and watched how I started to crawl into her skin, then he responded to that."

Several parts were expanded beyond their original conception, usually because Lynch liked what the actor brought to the character. "I think I know why David gave Nadine more to do," said Wendy Robie. "There's a scene where a camera was set up across the street, looking at the picture window in the Hurley house, and I was inside opening and closing the drapes. There was no dialogue—you just see this figure in the window working these drapes back and forth, and while we were shooting I could hear David laughing on the walkie-talkie a PA had in the room. David kept the camera running and continued laughing, so I kept it up to the point that my hands were bleeding."

. . .

Amick describes Lynch's style on set as "very hands on. There's a scene where I'm riding in a car with my boyfriend, Bobby, and David was on the floorboard of the car while we were shooting, saying things like, 'Okay, nuzzle up to him now.' There was another scene where I was on the phone and David suddenly says to me, 'Mädchen, I want you to very slowly drift your eyes up to the ceiling. Just slowly drift them up there, keep drifting, drift, drift'—then 'Cut!' I said, 'David, what's my motivation with this?' And he said, 'It just looks good.'

"It's kind of magical the way he gets what he needs from actors," Amick continued. "I remember shooting a scene where Shelly shares some painful things with her boss, Norma Jennings, and David knew I needed to get to this deep place. We did a few takes, then he came up to me, put his hand on my arm, and looked at me, then he sighed and walked away, and it was as if he'd infused me with the emotion the scene called for. Without saying a word, he gave me what I needed."

Tamblyn was struck by the fact that "David sits as close as he can get when he directs. There's a scene where Dr. Jacoby is in the hospital talking to Agent Cooper and Sheriff Truman about hearing Jacques Renault being murdered in a nearby bed, and David gave me the strangest direction for it. We did a take and David said, 'Russ, let's do it again, and this time don't think about the words you're saying or what they mean. Just think about ghosts.' That was typical of the way he directed and it really worked for the scene."

"David established the mood and the tone for what was to occur," said Ray Wise, "and he had the uncanny ability to say just the right thing that pointed you in the right direction. The characters were all, in their own way, raw wounds that had to be expressed, and there were no limits on the expression. He opened us up and allowed us to give a thousand percent, and you see that in all his work. Look at the performance he got out of Dennis Hopper! He allows actors to go all the way."

He's willing to wait until they get there, too. "David is the only director in forty years who ever requested that I slow down and take more time with something," said Michael Ontkean. "Hours past midnight Sheriff Truman is keeping a vigil staring into the daunting abyss that is the Black Lodge, hoping, praying, to find some sign of his buddy Cooper. Five or six increasingly slow takes come and go, and the only sound after each take is David's clear, spooky

WRAPPED IN PLASTIC 255

whisper suggesting that Harry take even *more* time. Eternity is not too long to wait."

Remembering her time on set, Kimmy Robertson said, "David has this whole process when he directs. He sits you down and makes a cone of silence around the two of you with his energy, then he sets the scene. The first scene I shot was the one where Lucy transfers a phone call to Sheriff Truman, and David said, 'An important phone call has come in. Lucy is efficient, meticulous, she cares about everyone in the room, she wants to make sure nobody misunderstands, and she's got her finger on the pulse of the town. How would Lucy say, The phone is for you?' "

Amick has particularly fond memories of the day her character is kissed by FBI agent Gordon Cole, a part played by Lynch himself. "I felt so honored to be the one he kissed! All the girls were a little jealous, and it became a thing like, oh, teacher's pet." As for the kiss? "It was adorable and very soft." Kimmy Robertson confessed that she, too, kissed Lynch. "It was at a wrap party a long, long time ago. I think it was the one day in his life that he wasn't with anybody, and we danced to a song about kissing and I kissed him and then skipped off."

The terms of the ABC deal stipulated that Lynch shoot a closed alternate ending that would allow the pilot to be released as a feature in Europe. This requirement led to the series' final scene in the Red Room, a mysterious kind of bardo where riddles are presented and secrets are revealed. Those in the Red Room speak in reverse, an idea that had been percolating in Lynch's head since 1971, when he had Alan Splet record him saying "I want pencils" backward for a scene in *Eraserhead* that was never shot. An extended version of *Twin Peaks* that concluded with the scene in the Red Room was released as a straight-to-video film in the U.K. five months before the pilot aired in the United States.

"The minute David steps on set he knows exactly how everything is supposed to be, down to where a glass is sitting on a table," said Sighvatsson. "He just knows it, and when he arrived on set the day we built the Red Room he went crazy because the door was on the right-hand side rather than the left. I said, 'David, who fucking cares?' He cared, and he insisted it be rebuilt because he'd already seen the scene in his head, and what he shoots has to match what he sees in his mind."

Industry insiders who saw the pilot were impressed. "The pilot is really still and quiet, and the first half hour is almost entirely people grieving and getting

bad news," said Frost. "It has an air of reality and a pace people weren't used to—it takes its time, and although it tells an intricate story, it doesn't do it in a flashy way. It has touches of the mythical that take it into another realm, but it remains grounded. David's spiritual beliefs are a big part of the power of the show, and it has a kind of solemn purity that's comparable to Robert Bresson's *Diary of a Country Priest*."

Robie points out, "Before *Twin Peaks* you didn't see work that was multi-layered on television. It would be a comedy or drama or a thriller, but it would never be all those things at once. You could see the humor in *Twin Peaks* right away, but David would also show you the pain and fear and sexuality without losing what was funny. I used to arrive on set thinking I knew the material pretty well, but David always saw so much more."

Brandon Stoddard, who'd ordered the pilot for ABC, left the network in March of 1989, a month after the *Twin Peaks* shoot began, and it fell to programming executive Robert Iger to shepherd the show onto the air. "We knew it was something special when we were shooting the pilot," said Ray Wise, "and I remember going to the first screening at the Directors Guild and thinking, Wow, this is amazing. How all the people who watch ABC were going to take it, though, I had no idea."

Iger liked the pilot, but he had a tough time persuading the ABC brass to air it, and a final showdown occurred during a bicoastal conference call between Iger and a room full of New York executives. Iger won, and in May of 1989 ABC finally picked up the series as a mid-season show and ordered seven more episodes. Budgeted at 1.1 million dollars each, the shows were all written and completed months before the pilot aired.

"David and I wrote the first two episodes of the first season together, then I started developing a writing staff that included Harley Peyton and Robert Engels," said Frost. "When other writers came in they were given ground rules and detailed story lines, and we'd talk about what the content and tone of the scenes would be. We'd record those sessions and give the tape to the writers so they could refer to it as they worked."

Lynch's participation was limited because the month after ABC picked up the show, he headed to New Orleans to shoot his fifth film, *Wild at Heart*. Lynch is good at keeping several balls in the air, and shortly after *Wild at Heart* wrapped in the fall of 1989 he went to New York to work on the film's score with Badalamenti.

Apparently Lynch figured that as long as he was in New York he might as well stage a theater piece, and on November 10th he presented *Industrial Symphony No. 1: The Dream of the Brokenhearted* at the Brooklyn Academy of Music. A collaboration with Badalamenti produced on extraordinarily short notice, *Industrial Symphony* was a masterpiece of cross promotion, and the forty-five-minute program included an array of disparate elements: There was a film clip of *Wild at Heart* stars Nicolas Cage and Laura Dern portraying a couple breaking up on the phone, and actor Michael J. Anderson played a character called the Woodsman, who patiently sawed a log of wood onstage. Julee Cruise performed four songs from her 1989 debut album, *Floating into the Night,* which had been released two months earlier and was produced by Lynch and Badalamenti, who wrote all the songs for it.

John Wentworth produced the BAM show and remembers it as "an amazing experience. I was recording sound effects for *Wild at Heart* while I was working on *Twin Peaks,* and then all of a sudden we were doing *Industrial Symphony,* too—BAM offered him a slot on their schedule and David said okay. He didn't even know what we were going to do when we arrived there, but he turned his vision on and we pulled that whole thing together in two weeks. It turned into a gigantic production, too. There were Vegas showgirls, people on stilts, midgets, lawnmowers—it was crazy. All of David's projects are wonderful, but that one was really special because it was this idiosyncratic gestalt thing, and it was a blast."

The featured performer in the piece, Julee Cruise, said, "I really can't tell you what *Industrial Symphony* was about. I was in a harness floating around in prom dresses and this awful Afro wig, and David was calling it live on set off the top of his head, sweating bullets. We did a quick run-through and then we did two performances of the piece. It was chaotic but really fun." (A DVD of the show was subsequently released by Propaganda, which co-produced it.)

Lynch's entrée into the music business with Cruise's album *Floating into the Night* was engineered by CAA music agent Brian Loucks, who contacted him while *Blue Velvet* was in production, hoping to assist with music for the film. "David said, 'I've got my guy Angelo,'" said Loucks, who continued to check in with him periodically.[19] Then, in 1987, Lynch told him he was interested in making a record with Julee Cruise, and Loucks helped get him signed to Warner Bros. Records.

Lynch was producing work at a dizzying pace during this period, and a few

days prior to the performance at BAM, the music video he'd directed for Chris Isaak's song "Wicked Game," which is featured in *Wild at Heart,* was released. Before the year was out he'd directed four commercials for a Calvin Klein fragrance and had an art exhibition at the N. No. N. Gallery in Dallas.

Meanwhile, the *Twin Peaks* pilot had become bogged down in a quagmire of network programming indecisiveness, and an entire year passed between its completion and its premiere at 9:00 P.M. on April 8th, 1990. By the time the show finally aired, the audience for it was already in place. "There were advance screenings and some writers who saw it flipped for it, so there was a drumbeat for the show before it aired," recalled Frost. "By the time it went on the air there was real anticipation, and it debuted to gigantic numbers.

"The whole thing moved really fast," Frost continued. "*Twin Peaks* was like riding a bull in the eye of a hurricane, and it was enormously destabilizing for everybody involved. Being under that much scrutiny is a ridiculous thing to go through, and it wasn't just in the States—it was global. It became a real distraction in the second year, when we were trying to make the show at the same time that it had this other life as a cultural phenomenon, and those forces were often at odds with each other."

Broadcast internationally, the show was hugely successful, and in October of 1990 Lynch appeared on the cover of *Time* magazine; the accompanying article hailed him as "the Czar of Bizarre." The cottage industry of *Twin Peaks* merchandise was no small thing, either. There were bow ties, action figures, dioramas, a coffee-scented T-shirt, throw pillows, key chains, coffee mugs, posters, greeting cards, tote bags, and jewelry, among other things. Jennifer Lynch wrote *The Secret Diary of Laura Palmer,* which was published on September 15th, following the first season and prior to the second. In a matter of weeks it made it to number four on *The New York Times* paperback-fiction bestseller list. John Thorne and Craig Miller launched *Wrapped in Plastic,* a fanzine for *Twin Peaks* fanatics that ran for thirteen years.

ABC seemed determined to kill the goose that laid the golden egg, though. From the start, the engine of the show was the question "Who killed Laura Palmer?" This mystery was central to the narrative tension that fueled every episode, but midway through the second season the network insisted that the identity of the killer be revealed. Things went downhill from there. "We fought to keep the mystery alive, but we got a lot of pushback from the network," Frost recalled. "ABC had been bought by Capital Cities, which was as conser-

vative a media outlet as there was anywhere in the country. I think the show made them intensely uncomfortable, and that's part of the reason they moved it to Saturday night for the second season. That was a horrible move, given what the show had done for them in its original slot."

Lynch returned to write and direct the first and last episodes of the second season and also directed two additional episodes, but the bloom was off the rose by then. "Some of the air went out of the tires after the identity of the killer was revealed," said Frost. "Then television was kind of hijacked by the Gulf War, and we were preempted by the war for six out of eight weeks. People couldn't keep up with what was a complex piece of storytelling when they could only see the show sporadically."

Moving the show to an inferior time slot where it aired irregularly didn't help things, but the show had other problems. "There were certainly some weaknesses in the storytelling in the second season," Frost admitted. "David was off doing *Wild at Heart,* and I'd signed up to direct a movie called *Story-ville,* so we were stretched too thin, plus we'd stupidly listened to our agents and sold another show to Fox, called *American Chronicles.* There weren't enough hours in the day to do all these things the right way."

The cast of the show was acutely aware of the fact that the series was dis-integrating during the second season. "When David left I felt like he aban-doned the show," Kimmy Robertson said. "This isn't on the people who worked on the second season—they did what they were supposed to do, and I hon-estly don't know whose fault it is. All I know is that I didn't like the constant bringing in of new women and abandoning the original story lines. People would come in and put a kaleidoscope on the camera and say, 'Oh, look how Lynchian.' Nobody liked where the show was going.

"I remember sitting in the dressing room, waiting to do another scene where Lucy's angry at Harry—she was angry at him endlessly," Robertson continued. "They wrote her that way because she was no longer seen as a valuable part of the show. David and Mark valued Lucy, and there was no way the show could work unless they were there together.

"David's got a connection to God, the universe, and the creative highway, and there are all these on-ramps and off-ramps in his head leading to files and rooms and libraries, and he can go to all of them at once," Robertson added. "Mark is the librarian. He's up there checking things in and out and saying, 'No, you can't take those all out at once, but we can do it in a certain se-

quence.' It had to be the two of them together for the show to work, and they weren't there as a team for the second season."

On June 10th, 1991, a week after the fifteenth episode of season two placed eighty-fifth out of eighty-nine shows in the ratings, ABC put the show on indefinite hiatus. "The network treated the show very badly and the audience had fallen off, but David did a brilliant job of rewriting and redefining the last episode, which brought the Red Room into play," said Frost. "He did something extraordinary in the last episode, and that gave them pause about saying no to a third season, which they ultimately did. But by that point I think David and I felt like we'd had our run and done our thing, and it was on to the next thing."

Reflecting on the demise of the show, Krantz said, "I don't know if David thought through what would happen to the show when he left to do *Wild at Heart*. He knew enough about the way television works to know that the show had to go forward, and although they needed his magic dust, they couldn't stop production if it came late, because they had to move on."

There was no shortage of talent involved with the second season of *Twin Peaks,* but there was no denying that friction had developed between Lynch and Frost. "The tension was partly attributable to the frustration Mark felt about the fact that the show was seen as David Lynch's *Twin Peaks,*" said Krantz. "They created the show together, and what Mark brought was an approach to storytelling that allowed David's art to exist on television, and that was a critical piece. One doesn't exist without the other, and they were a perfect unit. But Mark felt that David was getting all the credit, and his ego got in the middle of it.

"Mark got the recognition he wanted with the second season, when he was sort of in charge and had an opportunity to finally make Mark Frost's *Twin Peaks,*" Krantz continued. "He and Harley Peyton created new stories for the second season that introduced new characters rather than focusing on the core series regulars. David wasn't happy with the scripts, though, and there were story lines he hadn't pre-approved. It was like, 'Hey, wait a minute, you're misperceiving the dream that made the first season of *Twin Peaks* so great. You're mimicking and making faux versions of them.'

"Then the network forced him to reveal who killed Laura Palmer, and he was right to resist that," Krantz added. "It was clearly a mistake on ABC's part, but there were other reasons the second season didn't succeed. There has to

be some creative responsibility, and David and Mark's creative relationship had been destroyed. There was a restaurant called Muse that David, Mark, and I used to go to, and one day I was there with them and I said, 'You guys just got seventeen Emmy nominations.' Then I literally took their hands and brought them together and said, 'You need to hold hands and be a team.'"

The relationship between Lynch and Frost wasn't over, but they needed a break from each other, and Lynch shifted his attention to other things. "We did several commercials together and a public-service announcement about rats for the city of New York," said Montgomery. "I think David had fun doing them—David loves shooting anything, and if you put him in a room with some materials, he's ingenious enough to come up with something. David can adapt to whatever the limitations might be, and lots of people can't do that."

Meanwhile, as *Twin Peaks* was limping to the finish line, *Wild at Heart* came, conquered, and went. Lynch's love for the world he'd created with Frost was undiminished, however, and the mark he left on the actors in *Twin Peaks* is immutable.

"With David it's always soulful," said Ontkean, "and it's always some form of homemade circus transformed into an offbeat pagan ritual. *Blue Velvet* confirmed that David is some kind of ancient alchemist and out of thin air he creates a palpable, enduring atmosphere. You don't see the strings or the wires or the rabbit unless David wants you to."

Sheryl Lee said, "I used to joke that it was as if he was hypnotizing me, because David has a way of taking you in a direction that may not seem logical at first, but he breaks down your resistance and you wind up in a wonderful world of play where you're not overthinking things. You know when you step on set with David that you're going to do something you've never done before, and that's thrilling."

The actors in *Twin Peaks* are indebted to Lynch in terms of their careers, but he affected them on a personal level, too. "David cares deeply for people and knows about the lives of the people he works with, and that's what touches me the most about him," concluded Mädchen Amick. "I feel so lucky that I was touched by this beautiful star shooting through our galaxy, and I cherish our relationship. He set me on a path and taught me to keep my standards high, but nothing's measured up to the experience I had with David."

O FFERS FOR WORK weren't pouring in after *Blue Velvet*. I did turn down one thing called *Tender Mercies*, which starred Robert Duvall and turned out to be a great film, but I didn't think it was right for me. Rick wasn't encouraging me to do anything in particular—he was always really good that way.

I started living a bicoastal life after *Blue Velvet*, and I didn't like that. I liked being in New York with Isabella and I loved being in Europe when I went there, but I'm way more of a homebody. When you're moving around all the time you don't get any work done. Still, some really cool things happened during that time. One time I was in Italy with Isabella when she was doing a movie with some Russian director, and Silvana Mangano was in the film, too, and I knew her really well. They were shooting south of Rome in the most magical places. The ground there seems to rise up into these plateaus where there are these dreamy, minimal Italian mansions with staircases going up to beautiful terraces— they're incredible.

One night Silvana invited Isabella and me to dinner and we went to this outdoor restaurant with twinkling lights. It was mushroom season, so the entire meal was mushrooms—the mushroom for the main course was huge and thick as a steak, and there were all these mushroom courses that all tasted different. There's Silvana, me, Isabella, and also at dinner was Marcello Mastroianni. I have to admit I was a little starstruck. He and Silvana went way back and were good friends, and he's the nicest guy and he's telling stories—it was just the greatest thing. Somewhere in there I told him that Fellini and I were born on the same day and that I was a giant fan of Fellini. My favorite Fellini film is 8½, but I love *La*

Strada, too, and there's great stuff in all of them. The next morning I walk out of the hotel and there's a Mercedes and a driver who tells me, "I'm taking you to Cinecittà. Marcello has arranged for you to spend the day with Fellini." So we drive into Rome, where Fellini is shooting *Intervista*, and he welcomes me and I get to sit with him while he works and we became kind of pals.

Way later, like years later, I was at Isabella's place on Long Island — Bellport, I think it's called — and one night we went out with friends of hers for a ride on their boat. They had a runabout, kind of like a wooden jeep that I loved, and I asked them where they got it and they said, "We got it from Steen Melby." So I went and met Steen Melby, great guy, boat restorer, and knowledgeable like crazy. He said, "I've got a boat for you — it's called the Little Indian," and I see this thing and it was way beautiful, and I had to have it and I got it. It was a 1942 Fitzgerald & Lee runabout designed by John Hacker, and they used boats like that for taxis in the Thousand Islands lake region of New York.

One day Isabella said, "We're going crab fishing," and the plan was for her to go with her friends on their boat that could pick her up right near her house. I was going to go in the Little Indian and meet them at this place to fish. They gave me directions how to get there and this was a magical afternoon, just beautiful, and I'm excited. So I get into the Little Indian and go up the river, then I pass through this kind of St. Louis arch. By then you're out quite a ways and you start seeing buoys. They told me, "Go out that line of buoys, then the buoys will end and you turn right. Go along another line of buoys, then turn left and you'll see us."

So I get there in, say, a half hour and we go crab fishing. They have these metal cages they drop in the water and the crabs grab on to them and you bring them up. It's, like, what is this all about? I guess there's some people like that, people who just hang on when they shouldn't.

Now it's getting to be five-thirty, so we decide to pack it in and we both head back in our separate boats. It's still sunny when we leave, but when I get to the end of the line of buoys I turn left and when I turn it was like the Twilight Zone. It went from a sunny day to the darkest night and a full storm. Like in an instant. I had to stand up in the boat because the

rain was pelting and I couldn't see out the windshield, and I had an engine on the boat that had a top speed of twenty miles an hour, and the waves are getting bigger and bigger. Then I remembered that I hadn't measured the gas before I headed out, which is something you're always supposed to do. So I'm going along in these waves and I lost track of how many buoys I counted, then I come up behind this giant fishing vessel, like two or three stories high. It was all lit up, and I got in its wake and it was real smooth and I'm going along enjoying being in this boat's wake. Then it starts veering off to the left and I think, This boat is going out to sea and I don't want to go out to sea. So I turned right and the waves are really big now, and it's pitch-dark, just fog and storm. Suddenly I see shore lights and there's the arch to the mouth of the river, and I drove in and parked. That's a chickenshit story for real sailors, for sure, but it was hair-raising for me.

I was living in an apartment in Westwood after *Blue Velvet,* but I like modern architecture and I wanted a modern house of my own. I heard Crosby Doe Real Estate was the place to go, so I called them and there was a guy there named Jan who was my guy to talk to. He took me to a couple of places that I didn't like, and then I left for New York. Not long after I got there I get a call from him and he said, "I think I found your house." I came back to L.A. and he picked me up to go see it and told me the house was pink. We're winding through the Hollywood Hills and I see the house, and the second I look at it I had to have it. I said, "That's it," and I was trembling. We went in and met this guy, Will, who owned the house, and he had white wall-to-wall shag carpet in there, but I didn't care. I knew what the house was. Will said, "I want David to have it and this is the price," and I said, "Okay," and I moved in in June of 1987. When I moved into the Pink House I set up a studio in the basement and I did a lot of painting down there.

I was able to buy this house, yeah, but I wouldn't say I felt rich then. I've never felt rich. In fact, when I was living on Rosewood I was richer than I was when I bought the house. When I moved into Rosewood my rent was eighty-five dollars a month and I had a big room with a dividing wall, so I had a bedroom, a sitting area, a kitchen, and a bathroom with

a tub and shower. I'd built a shed outside for all my tools. I had a drawing table set up, I had a refrigerator, a stove, and a washing machine, and on the flat roof was a clothesline. I had a car, a television, chairs, lamps, and a telephone, and I could go to this gas station called "Y-Pay-More" on Santa Monica Boulevard and San Vicente and fill up the car for three dollars.

Money's a funny thing. The whole point of having money is to feel free, and relatively speaking, I guess I have some money now, but I've never felt free. It's the weirdest thing. I've never really felt free. One time right after Peggy and I decided to split up, I had a euphoria of freedom. I remember I was riding in a convertible on one of those freeway clover-leafs in downtown L.A., and I was on a section where it seemed to soar up into the air and I felt real freedom for a moment or two. And that's pretty much the extent of my ever feeling free. I don't know what it is that I feel is constraining me, but I do know that I have obligations, so I'm not really free.

A lot of different stuff was happening in that period. I acted in Tina Rathborne's film *Zelly and Me*, and I don't know how that happened, but I did it and didn't regret doing it. It's Tina's story and she grew up in the world that's in that film, and Isabella liked Tina and wanted to do it.

It was right around then that I met Monty Montgomery and we be-came friends. Monty is a very gracious human being and he was always inviting me places, and he was such a character. During that period I made a commercial for the first time; it was for Yves St. Laurent's per-fume Opium, and it was fun. Monty said that I love to shoot anything, and that's pretty much true. You do commercials for money, but I always learn something when I do them, because they use the latest and greatest technology, so you learn what's going on. There's an efficiency you learn making them, and commercials are little stories that can be really beauti-ful. Pierre Edelman got that commercial for me, then Monty helped me with post-production and that's when we began working together.

I met an art dealer named Jim Corcoran then who wanted to show my work, and Jim is a great guy. Mr. Minimal. He knows everybody in the art world, and him liking my work was a thrill. I loved Leo Castelli, too. He was a friend of Isabella's, two Italians, and she introduced us. It wasn't about art at all when we met, just talking to him and hanging out, and I

don't know how or where he saw my work. He gave me a show, but I wonder if he did it for Isabella or some kindness or something. Anyway, I had a show with Leo Castelli! And it was great.

There was a guy named Jeff Ayeroff at Virgin Records then, and when *Blue Velvet* came out he wanted me to do a music video of "In Dreams." Then I found out that Roy hated the way his song was used in *Blue Velvet*. This song was super personal to Roy because his first wife, Claudette, had been killed in a motorcycle accident in 1966 and even though he'd recorded "In Dreams" three years before she died, the song sort of became about that for him. Then a friend of his said, "Roy, you gotta go see the movie again—it's super cool." And being the great Roy Orbison, he went back and saw it and he said, "You're right." One thing led to another and I get to meet Roy, and Roy is a woodworker and we start talking shop, saws and stuff, and I just loved him. He was a down-to-earth, really good guy, super sweet.

The record company that owned all his songs had gone bankrupt and his songs were locked in some kind of legal thing, so he couldn't gain any revenue from them and had decided to rerecord all of them and sell them on late-night TV. Remember those ads at two in the morning? Jeff went to him and said, "Roy, Virgin Records will do this. You don't have to do this—we'll pay for the album." Roy had already made all the recordings, though, and Jeff sent them to me and they were not good. I called Jeff and said, "You can't put this out. They're so far away from the original, you've gotta *not* do this." Jeff said, "It's too late, he's going to do it, but if you want to try to redo 'In Dreams,' we could do that one." I said, "That's not what I'm saying! There shouldn't be a remake with *anybody* doing it!" He said, "I know, but this might be a good thing for you and Roy to do." So we went into the studio with T Bone Burnett. The recording we made doesn't have the quality the original has, but how could it?

Roy said, "David, during sessions in the old days, there would always be a director-type guy like you who'd say, 'Come on, Roy, give it more power! Remember what you wrote the song about and give it some feeling!'" So I was kind of directing Roy and it was really fun. One time it was late and in come Bono and Bob Dylan. Bono wasn't a big star then and was just coming up, but I figured since he was with Dylan he's going to be big. I didn't really meet Dylan then—I met him with Dennis Hop-

per, actually. I went with Dennis to a Bob Dylan concert at the Greek Theatre and Dennis and I went up to Bob Dylan's dressing room, and it was kind of flattering. Bob says, "Oh, hey, David," like he knew me, and it was great. Bob Dylan? Fuckin' A, man. The best.

Anyhow, Bono and Bob Dylan were talking to Roy, and after they left I asked the engineer if there was a room where I could go meditate, and he said, "Sure, I can get you a quiet room." Then Barbara Orbison comes up to me and says, "What kind of meditation do you do?" I said Transcendental Meditation and she said, "Roy and I do Transcendental Meditation!" So Barbara and Roy and I went into a room and meditated together. It was fantastic meditating with the great Roy Orbison. The Big O.

That was the same year I made *The Cowboy and the Frenchman*. Frederic Golchan isn't an actor—he's a producer—but he was absolutely perfect for *The Cowboy and the Frenchman*. He has this crazy look in his eyes, and he's French, and he did it great. Harry Dean Stanton's in it, too, and what isn't special about Harry Dean? One of the greatest guys in the world and I love him to pieces. I could sit next to him for hours, because everything that comes out of him is natural, no pretense, no bullshit, just beautiful, and he's the kindest, gentlest soul. He's got a melancholy thing, and he's got his own spiritual thing going, too. He would never do TM. His meditation is just life, he says. And this guy can sing. A girl named Sophie Huber did a documentary on Harry Dean called *Partly Fiction*, and there's a trailer for the film with some footage of Harry Dean at his house with a friend who's playing the guitar. Harry Dean's sitting on a couch leaning back, and first of all there's a close-up of his face and there is some stuff going on in that face. He's singing "Everybody's Talkin'," the song Harry Nilsson made popular, and tears were just shooting out of my eyes when I saw it. The way he sings it, it's like, forget it. It's so incredible. I can't really believe he's gone. . . .

Like I said, I was doing a lot of different things then, and right after I finished shooting *Wild at Heart* I went to New York and *Industrial Symphony No. 1* happened. We only had two weeks to get it together, and I wrote this sort of factory thing and did some drawings, and I wanted Patty Norris to work on it. But she said, "David, you can't use me, because it's in New York and if I come into their world they'll turn against me. You

need somebody from there." So I got this woman who had a factory in New Jersey and she did the most beautiful set.

Angelo and I wrote a few new things for it, but mostly it was Julee Cruise doing four songs from her album, then I shot this thing with Nic Cage and Laura Dern that was projected. I was working with Johnny W. [Wentworth] on this thing, and most of the sound was to playback. The morning of the day of the show these guys bring in this giant state-of-the-art digital playback machine. We want to see how it sounds, so we start rehearsing and this thing crapped out. I said, "That can never happen." They started it up again and it crapped out a second time, so we know we can't use that. Johnny W. and I each had one of these tiny little Panasonic DAT players, and we said, "Fuck it, we're gonna run the whole show on these DAT machines." So Johnny W. and I are with somebody from BAM at this little card table set up way back against the wall at the highest part of the theater. Johnny's DAT and my DAT are on the table and we push them at the same time so if mine craps out we can switch over to the other one and they're perfectly synchronized, and these little bitty machines filled that hall with sound like you cannot fuckin' believe.

We had one day to rehearse and it's the day of the show and people work a little bit and an hour's gone by and we really haven't even started! Then I got this idea that saved the day, and this idea is something I would use again for sure. You take each person by the shoulders and you look them straight in the eye and you say: "You see that thing over there? When this thing happens, you go over there and you do this and then you do that, and when you finish you run off that way. Have you got that?" Then you do the same thing with the next person, and you tell each person what they're going to do at a certain time and that's the *only* thing they have to remember. We had to do two shows back to back and I had to get twenty people to do some task and everybody did their task fine.

Part of the show was this skinned deer played by John Bell that was twelve or thirteen feet tall. He's got big antlers and he's on stilts that are wrapped in rubber that looks like skin and he's got hooves at the bottom of the stilts and he doesn't have any fur because he's a skinned deer. The people I worked with there made all this stuff. It's un-fuckin'-real what

they did! Two hospital gurneys are strapped together, and at the opening of the show the skinned deer is lying on these gurneys. Isabella's daughter, Elettra, was little then, and she sees this thing on the gurney and it's not moving and she knew it was going to move at some point, and she was so afraid of that skinned deer lying there.

John Bell was a stilt-walker and he's playing the deer, so he's inside this costume lying down and it's warm in there. All of a sudden there's a point in the show where these workmen wearing hard hats come rushing out with these yellow light bulbs that they're waving and twirling around the deer, who comes to life and stands up. And he's huge. The deer starts walking and little Mike [Anderson] is down there with a searchlight lighting him up, so the guy on stilts has this blinding light shining in his eyes and the blood is rushing from his head because he's been lying there for a long time, and he starts tilting forward and falling into the orchestra pit. The guy on the snare drum caught him. Half the audience thought this was horrible, and the other half thought it was part of the show. So it's time for the second show and the fuckin' deer won't come out of his dressing room. I had to go from the tiny card table way up in the back of the theater all the way down to these sub-basement dressing rooms and beg him to do it. There was this big water tank onstage, and I told him, "You can hang on to the water tank," and he said, "Okay, if I can hang on to the water tank I'll do it." So he did it. Live theater. It was sort of thrilling and it worked perfect except for the deer.

I didn't know if I could work with Mark Frost when we met, but I was willing to check it out. He was tied to this *Goddess* thing at the time, and like ten million others, I like Marilyn Monroe, so we started working together on that. It's hard to say exactly what it is about Marilyn Monroe, but the woman-in-trouble thing is part of it. It's not just the woman-in-trouble thing that pulls you in, though. It's more that some women are real mysterious. *Goddess* didn't fly because of the Kennedy connection — Marilyn Monroe was this loose cannon there at the end and they had to get rid of her. But it's a story I kept loving. You could say that Laura Palmer is Marilyn Monroe, and that *Mulholland Drive* is about Marilyn Monroe, too. Everything is about Marilyn Monroe.

After *Goddess* didn't happen, Mark and I started working on *One Saliva Bubble* and we were laughing our butts off. Even though we're really different we get along great when we're writing, and we were having fun when we were writing that and it cemented our relationship. For a little bit of time I was friends with Steve Martin because he loved *One Saliva Bubble* and wanted to do it with Martin Short. I think Steve got pissed off at me when I asked him if he wanted to buy it—he got really upset—but before that he took me to his house in Beverly Hills and he had a beautiful art collection, really incredible.

Tony Krantz was a hotshot up-and-coming TV agent, and he was always bugging Rick Nicita that he wanted to talk to me about doing TV. Television seemed like a horrible thing to me, and in those days it was pathetic. All the commercial interruptions—network television was the theater of the absurd and this was the nature of the beast. But one thing led to another and Tony talked Mark and me into writing something for TV and we wrote this thing called *The Lemurians*. We laughed a lot when we were writing it, but it wasn't going to happen and we never sold it that I recall.

Tony's version of how *Twin Peaks* came about may be where it came from in Tony's mind, but it's not how I remember it. Still, I have to say that Tony did a lot of good for me, because he got me to do *Twin Peaks* and I love *Twin Peaks*. I love the characters and the world and the humor and the mystery combo.

I saw the pilot as the same thing as a feature film, and as far as I'm concerned the only thing in the entire first two seasons that's really *Twin Peaks* is the pilot. The rest is stage stuff and was done like TV, but the pilot really got the mood. That had everything to do with the fact that we were shooting on location. The place itself is so important. It's always arduous to shoot on location but it was really beautiful there, and there was a feeling of freedom, because we weren't bothered by ABC at all. They sent notes a couple of times about language and made me change some lines, but the lines I made up turned out to be better than the original ones ABC didn't like.

And it was the greatest cast. When I met Sherilyn Fenn I could see that she could play a girl like Audrey Horne, and even though Piper Laurie was known, I knew she could disappear into Catherine Martell.

It's just a coincidence that Piper and Richard Beymer and Peggy Lipton and Russ Tamblyn are all from the same generation and had similar kinds of careers. I've got Dennis Hopper to thank for Russ, because Dennis threw me my fortieth birthday party and Russ was there, and when it was time to cast Dr. Jacoby, something in my head went ding! And he became Dr. Jacoby.

In the script for the pilot there's a scene where Cooper and Sheriff Truman are riding in an elevator and when the doors open Cooper notices a one-armed man walking away. And that was what Al Strobel was hired for. That was gonna be his time in Twin Peaks and he was gonna go home. Then I heard Al Strobel's voice, which is an incredible voice, and I had to write something for that voice. I think Deepak was driving the car and I remember exactly where we were. We were coming off the freeway going down a ramp and I was writing this thing that started out, "Through the darkness of future past, the magician longs to see." So I wrote a new scene where Al meets Cooper in his room and he recites this thing, and we shot it and sent it to Duwayne who was editing. It's late at night and Duwayne's about to go home when he gets this footage, and he says, "What the fuck?" But that scene with Al started a whole bunch of threads that bring him into this story.

Richard Beymer's been meditating longer than I have and he was with Maharishi for a long time, but I didn't know that when I cast him as Ben Horne. I didn't even talk to him about meditation when we met—I just loved Richard. Isabella was supposed to be in Twin Peaks but she didn't want to do it, so the character she was going to play became Josie Packard, who was played by Joan Chen. Joan is beautiful and she's a foreigner like Isabella, and she felt perfect for Josie Packard. I knew Peggy Lipton had been a big TV star in the sixties when she was in The Mod Squad, but I never saw that show, because I wasn't watching TV during the time when it was on the air. I cast Peggy because she was Norma Jennings. That's kind of how it was with the actors in Twin Peaks. Nobody else but them could've played the characters they played. When you think about it, nobody but Kyle could play Agent Cooper. I always wanted it to be Kyle, but at first Mark said, "Isn't he a little young?" Then Mark came around and the rest is history.

The character of Agent Cooper came from a lot of different things.

For instance, Uma Thurman's father is tight with the Dalai Lama, and she had a thing for him at her house that I went to, and I met him and that's what led to Agent Cooper being for the Tibetan people and the rock-throwing scene. It was nice meeting the Dalai Lama. He doesn't give a meditation technique but he's for peace.

The Log Lady was a character I'd been thinking about for Catherine Coulson since 1973. The Log Lady originally lived where Jack and Catherine lived, which was on the second floor of a Spanish-style apartment building off Beachwood Drive in L.A. I pictured the Log Lady's stories starting in that room, and the fireplace would be boarded up, her husband having died in a forest fire. His ashes were in an urn on the mantel along with his pipes that he smoked. She always carried a log and she had a little son, maybe five or so, and she starred in *I'll Test My Log with Every Branch of Knowledge*, which was kind of a learning show. She doesn't drive, so they always take cabs. If they go to the dentist she carries the log, and the dentist would put the log in the chair and put a little bib around the log, and then look for cavities, talking all the time so the kid would understand something about dentistry. He would talk about decay, and how they fill a cavity and what they use to fill it, and the importance of brushing your teeth and keeping the oral cavity clean.

For some episodes they'd go to a certain diner and they'd sit together, her carrying the log, and the little boy next to her, and they'd order something and sit there. In my mind the diner held possibilities for side stories that could be interesting. So Catherine and I would occasionally talk about this idea.

Years later we're shooting the *Twin Peaks* pilot and we're about to shoot a scene in the city hall, where Agent Cooper and Sheriff Truman are going to talk to the people about this murder that's occurred. I thought, Okay, this is an opportunity, so I call Catherine and tell her, "You're going to be carrying the log, and your job is to flip the light switch on and off to get everybody's attention that it's time to start this talk." Catherine said, "Great," and she flew up and we got her the log and she did the scene and one thing led to another. The log has this quality, and people started wondering what her story was. She doesn't make any sense, but she makes sense, and there are people like this in every town and they're just accepted. She's a special Twin Peaks person.

Gordon Cole, who I play, came when we were shooting a scene where
Agent Cooper needs to call his unnamed boss in Philadelphia. I decided
to do the voice just to make it more real, never thinking it would actually
end up in the show. I was talking quite loud so Kyle could hear me, and
that was when that character was born. The name Gordon Cole comes
from *Sunset Boulevard*—in the film he's the man from Paramount Stu-
dios who starts calling Norma Desmond about renting her car. People
come up with names in different ways, and when I was thinking about
Gordon Cole I said to myself, Wait a minute. Driving to Paramount,
Billy Wilder passes Gordon Street and he passes Cole Street, and I'm
sure that's where he got the name. So the character I play in *Twin Peaks*
is named in honor of Hollywood and Billy Wilder.

The character of Bob wasn't originally in the pilot script, and he came
while we were shooting in Everett, Washington, in the Palmer house.
I'm on the second floor on my hands and knees for some reason, under-
neath the fan, and from behind me I hear a woman's voice say, "Frank,
don't lock yourself in that room." Frank Silva was the set dresser, and
while he was moving things around in the room he slid a set of dresser
drawers in front of the doorway. She said that to him as a kind of joke, but
in my head I see Frank locked in Laura Palmer's room and I just had a
feeling. I said, "Frank, are you an actor?" He said, "Why, yes, David, I
am," and I said, "Okay, you're gonna be in this scene."

We're shooting a slow pan in Laura Palmer's room, and we do three
takes with no Frank. Then I say, "Frank, go down to the foot of the bed
and crouch down as if you're hiding, grip the bars in the bed frame, and
look right at the camera." So Frank gets in there and we do another pan
with Frank in it and I have zero idea why I did that. Later that night we're
shooting a scene in the living room of the Palmer house and there's
Sarah Palmer, devastated; her daughter's been found murdered. She's
lying on the couch in torment and she suddenly sees something in her
mind's eye that frightens her, and she sits bolt upright and screams. And
that's the shot. The camera operator is a British guy named Sean Doyle,
and we do the shot then I say, "Cut!" Grace Zabriskie is one of the all-
time great actresses, and I say, "Perfect!" Then Sean says, "No, David,
not perfect—someone was reflected in the mirror." I said, "Who was it?"
He said, "Frank was reflected in the mirror," and at that second Bob was

born. And that's the way ideas come in. Where do they come from? They're all gifts. Frank was a good guy and people who knew him told me he wasn't like Bob at all, but he got Bob. His face, his hair—his whole being was perfect for Bob, and he understood Bob.

In the beginning *Twin Peaks* was huge, but ABC never really loved the show, and when people started writing in and asking, "When are we going to find out who killed Laura Palmer?" they forced us to tell and then people stopped watching. I told them if they revealed the killer it would be the end of it, and it *was* the end of it. And there was something else going on. There was a time when a continuing story was accepted and people stayed with it, but then the advertisers started saying, "People miss a couple episodes, then they can't get back into the show and they stop watching, so we've got to do closed endings," and that changed the feeling of the show, too. I think it's all run by money. By the time Bob Iger came to us and said, "You gotta solve this mystery," I was sort of fed up, anyway.

When I came back from *Wild at Heart* I didn't know what was going on with the show. All I remember feeling is that it was a runaway train and you had to commit to it 24-7 to keep it on track. I think if it had been Mark and me writing together on every episode we would've been okay, but we didn't do that and other people came in. This is nothing against any of them, but they didn't know my *Twin Peaks* and it just ceased to be anything I recognized. When I came back to do an episode I'd try to change things and make it what I wanted, but then it would go off again on other stupid fuckin' things. It just wasn't fun anymore. Then the show got moved from Thursday to Saturday night and that wasn't a good thing, either. I have no idea why it got moved.

I guess you could say I got more famous from *Twin Peaks*, but everything's relative. What is famous? Elvis was famous. And really, the whole thing is just ridiculous. If Mel Brooks walked down the street today, anybody under twenty-five probably wouldn't even know who he is, and that kills me. All the people who really knew what he did and how great he is are dead now. You see what I mean? When you get old nobody's around that remembers what you did.

Around ten years ago I went to the Egyptian Theatre with Emily Stofle, who I married in 2009. A friend of hers was showing her film there.

At one point, I went outside to take a smoke and I'm standing there smoking and this woman—I think she was a prostitute—comes up and starts going on and on about *INLAND EMPIRE*! She knew everything about that film. Fame, or whatever you want to call it, is weird.

In the late nineties I was suing a production company because they wanted to renege on a contract, so I go with Mary Sweeney, who lived with me at that time, and these high-powered, sharp young lawyers, George Hedges and Tom Hansen, down to city hall, where the courtrooms are. These courtrooms are so beautiful, from the twenties and thirties—these are the old real deal ones. We went in and waited to see this judge because Mary Sweeney was going to be deposed, then we were told we could go and we all wandered out front. We're standing there talking about strategy and stuff, because it's the first time we've been together for a while, and way in the distance is this bag lady, pushing a cart just loaded with shit. She's wearing purple and she's pushing this cart and coming closer and closer and closer. Finally she's passing right in front of us and she looks over at me and says, "Love your films!" We were laughing until the cows came home. That's like perfect fame. It was so fantastic. I loved that bag lady.

The massive success of *Twin Peaks* didn't mean anything to me. I always say failure's not all bad because there's nowhere to go but up, so you have a sense of freedom from failure. Success can screw you because you start worrying about falling and you can't ever stay in the same place. That's just the way it is. You should be thankful for successes, because people really loved something you did, but it's all about the work.

People eventually stopped loving *Twin Peaks*, but at least it ended in a good way, because that's when the Red Room came. I can't talk about what the Red Room is, but I remember when the idea came and how thrilling it was to me. That opened up a thing in *Twin Peaks* and led to many things. So it's the pilot and the Red Room and where they led—put those things together and you've got the real *Twin Peaks*. It's a beautiful, delicate thing, and there's more going on than meets the eye, and there's mystery in the air.

Most people's lives are filled with mystery, but things move super fast nowadays and there's not much time to sit and daydream and notice the mystery. There are fewer and fewer places in the world now where you

can see the stars in the night sky, and you've got to go a long way out of L.A., to the dry lake beds, to see them now. One time we were out there shooting a commercial and at two in the morning we turned off the lights and lay down on the desert floor and just looked up. Trillions of stars. Trillions. It's so powerful. And because we're not seeing those stars we're forgetting how grand the whole show is.

Finding Love in Hell

In 1989, while *Twin Peaks* was in production, Steve Golin and Joni Sighvats-son hired Lynch to write an adaptation of a 1940s noir crime novel. At approximately the same time Monty Montgomery acquired a manuscript for Barry Gifford's novel *Wild at Heart: The Story of Sailor and Lula*. "Barry was the editor at Black Lizard Press, which was republishing old pulp noir novels, and one day he just sent me his book, which hadn't been published yet," Montgomery recalled. "I read it and called Barry and said, 'I'd like to option this and try to direct it.'"

Montgomery then approached Lynch and asked if he'd consider executive-producing the film. When Lynch expressed an interest in directing an adaptation of the book himself, Montgomery passed the project on to him, and he and Golin provided funds for Lynch to write a script. "It seemed like everybody wanted the film to take off, and it had momentum," recalled Montgomery. "David was having rehearsals before we knew it and Polygram put up the financing."

This sudden turn of events came as a surprise to *Twin Peaks* editor Du-wayne Dunham, who thought he'd already been given his marching orders. "We were finishing the pilot for *Twin Peaks* and David said he was going to take a break," said Dunham, "then a week later he walked into the room and told me he was going to direct *Wild at Heart* and wanted me to edit it. This was the middle of May, and he told me he planned to start shooting in July even though he didn't even have a script yet. I told him I'd taken another job and couldn't do it, and David asked, 'What would it take for you to edit *Wild at Heart*?' I told him if I had an opportunity to direct I'd do it, and he said, 'Okay, we just got picked up for seven episodes of *Twin Peaks,* and you can direct the first one and a few more. Now will you edit *Wild at Heart*?' I said, 'You're on.'"

Lynch completed a draft of a script in just a week but felt that what he'd produced was downbeat and charmless, so he wrote a second draft that incorporated significant changes. He shifted the sequence of events, sprinkled allusions to *The Wizard of Oz* throughout the story, and added characters. The final result is a kind of tone poem about the immensity of young love, how consuming and vast it can be. Starring Nicolas Cage and Laura Dern as a couple on the run, the film pivots on an unbridled sexuality and is simultaneously a violent road picture, a comedy, and a love story that pushes things just beyond the realm of realism. Set in a world in the process of imploding, it's the most pop film Lynch has made. The colors are electric, and fire is a recurring motif; the opening titles unspool against a raging wall of fire—Lynch finally got to shoot that opening image he wanted for *Ronnie Rocket*.

"David felt I'd never played a role that really captured my sexuality and he was excited about the prospect of doing that with the character of Lula," recalled Laura Dern. "I remember sitting with him in a conference room at Propaganda talking about Sailor and Lula and suddenly he said 'I need bubble gum,' and at that point the character completely fell into place. He also had the feeling that Nic and I were the perfect match, and he was right—the minute we got together Sailor and Lula really started to come alive."[1]

Music plays a crucial role in the film, and the soundtrack features big-band swing, speed metal, classic rock 'n' roll, the heavy dub of African Head Charge, and "Im Abendrot," one of the final compositions by Richard Strauss. Cage's character is loosely inspired by Elvis Presley, and Cage delivers convincing renditions of two Presley classics in the film, while blues great KoKo Taylor performs the Lynch-Badalamenti composition "Up in Flames." The music is mixed at a very high volume.

The characters in *Wild at Heart* are extreme and the creeps are extra creepy. Cast as Lula's mother, Diane Ladd gives a histrionic performance evocative of Shelley Winters's work in *Lolita,* and it netted her an Academy Award nomination. Grace Zabriskie plays a sinister hired killer who speaks in a Cajun drawl, and a character called Mr. Reindeer, played by W. Morgan Sheppard, sits on a toilet while ordering an execution.

Isabella Rossellini plays the evil tramp, Perdita Durango, and explained that her take on the character went back a ways. "Years before he made *Wild at Heart,* David and I were in a bookstore and I saw a book on Frida Kahlo. This

was before she'd been discovered by pop culture, and I called David over and said, 'Look at this woman.' She's appealing and repellent at the same time. Sometimes she portrays herself with visible wounds; other times she has a mustache and eyebrows that grow together. She had an incredible aesthetic, and I said it would be wonderful to create a character like her. Years later David said, 'I think I have that character.' Perdita Durango was based a little bit on Kahlo—the eyebrows are definitely an homage to her."

Also appearing in the film is Willem Dafoe, who plays a psychotic Vietnam vet who's among the most memorable characters Lynch has created. "When David was casting *Blue Velvet,* I met with him in Dino De Laurentiis's office in the Gulf and Western Building in Manhattan," Dafoe said, "and like most people, I was quite taken by his manner. His sweet, golly-gee, boyish excitement is really disarming, and we had a good meeting. After I left I thought, If he doesn't use me now, he's going to use me sometime, and a few years later he got in touch and said, 'You wanna do this?' I said, 'Fantastic.' They didn't have to persuade me to take the part, because the writing was brilliant and I love David.

"Because David is so good and his set was so much fun, *Wild at Heart* was the least stressful movie I've ever made," Dafoe continued. "I was doing my fantasy of a cracker criminal psycho, and I knew how this guy's hair should be and had the idea of his little mustache. But the key thing with the character was the teeth. It says very specifically in the screenplay that he has these funky, stumpy teeth, and I just assumed they'd put some shit on my teeth. Then in one of my first conversations with David about the character, he said, 'So, you gonna go to the dentist?' I said, 'What do you mean?' He said, 'To get the teeth!' This had never occurred to me. I wound up getting an entire set of teeth that fit over my own teeth, and they became the crucial trigger for the character. They were a little oversized and forced my mouth to always be a little bit open in a kind of lascivious way, and they gave him a stupid, slack-jawed look that was key to the character. The teeth were David's idea."[2]

Cast as Cousin Dell, an emotionally unstable loner obsessed with bizarre rituals, was Crispin Glover, who'd met Lynch the year before, during the casting of *One Saliva Bubble.* "I've worked with David twice," Glover recalled. "The first time was in *Wild at Heart* and the second was in *Hotel Room,* and the directing style was different in each piece. In *Wild at Heart* the direction was

probably the most precise I've ever had. There's a scene where the character I play is making a sandwich, and the timing of it was exactingly specified by David."

Prior to meeting Lynch, Glover had vivid memories of seeing the trailer for *Eraserhead* when he was a fourteen-year-old student at a private school that visited the Nuart as part of a cinema program. "I didn't know what the movie was, but I said to myself that as soon as I could drive I'd go see it. Luckily, it was still playing at the Nuart when I turned sixteen, and I drove to see *Eraserhead* at least twelve times over the next few years. There weren't many people in the audience at the midnight screenings at the Nuart in 1980, and I remember people would get mad and shout things at the screen and leave the theater. At other times the audience would get very quiet and concentrated. Seeing a thirty-five-millimeter print of *Eraserhead* projected in a theater was experiential, and it's been an important film to me. David's been truly supportive to me throughout the years, too," said Glover of Lynch, who executive-produced Glover's directorial debut feature, *What Is It?* "It's difficult to express how grateful I am to have someone I admire so much be so helpful to me."[3]

Dern had particularly fond memories of Glover's character and recalled, "I love the scene where I'm talking about my cousin Dell. We got the giggles when we shot that scene and when I say 'we' I mean the entire crew. We worked on that scene for hours and we kept having to start over because someone was always laughing. David had to wear a bandana across his face so we couldn't see him laughing, and he put bandanas on some crew members, too. We finally got through a take without anyone cracking up and that's the take that's in the film."

The filming of *Wild at Heart* began on August 9th, 1989, in New Orleans, and then moved on to Texas and Los Angeles. Budgeted at ten million dollars, the film was produced by Golin and Sighvatsson, along with Montgomery, who was on set throughout the shoot. "Before the shoot David and I went scouting in New Orleans, and I remember going to Galatoire's Restaurant one night with Patty Norris," said Montgomery. "We were walking home through the French Quarter where all the strip clubs are, and we passed this place with a sign that read, 'Live Sex Acts.' David said, 'Let's check this out.' This was research for him, and what was in there was what the sign said. He was abso-

lutely interested, too, in the way a doctor is interested in a body he's just cut open. David sort of approaches everything that way."

A fascination with the intricacies of the human body is a key part of Lynch's sensibility; it's central to *Eraserhead,* of course, and is embedded to varying degrees in all of his paintings and films. It's definitely part of *Wild at Heart.* "I was on the set the day they shot the scene when Bob Ray Lemon gets killed, and Nic Cage throws this guy downstairs and he's supposed to be bleeding," remembered Barry Gifford. "They finish the shot and David says, 'The blood isn't black enough! I want it black! It's got to be blacker!' They fiddled with the fake blood for a minute, and he says, 'No! Blacker! Blacker!' David had a very specific idea about the blood and was absolutely in control on set."[4]

Montgomery said, "Yes, David is a very efficient director, but he can get sidetracked. You can have all the elements in place to shoot something, the actors and the key people are there, and you know exactly what you have to do. Then you go for a coffee and by the time you get back David might be doing something completely different, or focusing on some bit of minutia like a bug crawling across the floor. There was a scene in *Wild at Heart* where David wanted a shadow on the ground of an eagle flying overhead. That would've been a second-unit thing for most directors, but we spent a good bit of a day shooting that shadow while the actors stood around waiting. Of course, these touches are what give David's movies their flair, so he must go with his instincts and I rarely interfered."

The freedom Lynch insists on is crucial for him, and everything—props, lines of dialogue, characters—must remain fluid in order for him to do his thing. "He used to hate production meetings," Deepak Nayar recalled. "I remember he would arrive and say, 'Okay, I'm here, but you see this script?' Then he'd throw the script in a garbage can."

Because he has such a unique approach to filmmaking, Lynch tends to surprise the people he works with. "I remember being on set the day David shot the scene in the bathroom with Nic and Diane Ladd and thinking, This is so fucking weird, what are we doing," recalled Sighvatsson. "Then I saw the dailies and it was remarkable. David didn't go off script and he shot exactly what was on the page, but what I saw onscreen was nothing like what was on the page, and I've never experienced that with another director. He's unique in another way, too. Many directors thrive on conflict, but David doesn't toler-

ate any conflict on his set, and if there's somebody around that he thinks isn't sending a good vibe, they're not there the next day."

The tale of Sailor and Lula seems to be dictated by fate, and at a certain point in the story an ill wind blows and their luck changes. The stars are suddenly aligned against them and everything begins to go wrong. Notions of fate and luck are an essential part of Lynch's worldview, as those close to him can attest. "I lived down the road from David then, so we drove to the *Wild at Heart* set together every day when we were shooting in L.A.," said Montgomery. "We couldn't go to the set until David had done his numerology with license plates and seen his initials on license plates. Sometimes we'd have to keep driving around for a while until we were able to find that 'DKL' on a plate. On the rare occasion that the letters were in sequence, it was a particularly good omen."

Lynch says he's been "looking at license plates" since before he made *Eraserhead* and that his lucky number is seven. "Ceremonies and rituals are important to Dad," said Jennifer Lynch, "and part of the way his brain works is that things should be a certain way and there are little miracles. Like his thing with license plates, and the dime lands heads up and you work the dime—all those things are strategies he uses to do something magical that will change things. He's always been that way."

The *Wild at Heart* shoot wrapped just as *Twin Peaks* was getting into high gear and Dunham was completing his direction of episode one. "When I started the episode I asked David for advice, and he said, 'Don't ask me— you're the director, so do it the way you want to do it,'" Dunham recalled. "Then he explained things to me. He said, 'First, clear the set so there's nobody there except you and the actors. Start rehearsing and staging and blocking with the actors, and then when you kind of have it rough, bring the DP in and the two of you fine-tune from there. When you and the DP got it, bring the cast in and do your last rehearsal and make any adjustments you need. Then you turn the set over to the crew, actors go for hair and makeup, then they come back and you shoot it.'

"We both finished shooting on the same day," Dunham continued, "then David went off and directed the second episode of *Twin Peaks*. So we've got my episode of the show, *Wild at Heart,* and David's episode of *Twin Peaks* stacked up in the editing room and more episodes funneling in all the time. We had buckets of film everywhere and cards on the walls and it was so fun. We were working at Todd AO in West L.A., and every day at around three o'clock

Monty Montgomery would walk in with cappuccinos and bags of peanut M&M's for everybody.

"We were working madly on everything, then David said, 'I want to take *Wild at Heart* to Cannes. Can we make it?' I told him it would be really tight, but we decided to go for it," Dunham said. "David was up at Skywalker mixing the film before I'd even finished editing it—I'd give him the first half of a reel of film to mix while I finished editing the second half. Alan Splet wasn't around much, so David was doing the mix and adding all kinds of things to it. Whenever he asked me to listen to a playback, I'd leave the room thinking, That guy is nuts.

"Editing *Wild at Heart* and *Twin Peaks* at the same time was crazy, and nobody in their right mind would do it," Dunham continued. "The first cut of *Wild at Heart* came in at four hours, and the first time we screened it for a few people David played the music way too loud—but, wow, it made your fingernails rise! It was the creepiest, coolest thing. It was rambling and all over the place, though, so we had a big board covered with index cards and we started moving things around. In the first cut, the fight scene in Cape Fear was deep in the story, and when we moved it to the beginning of the movie it made a big difference.

"The first time we ran the final cut of the film was at midnight at Skywalker, and the speakers blew out," he said. "We had an eight A.M. flight to L.A. the next morning and that afternoon we were flying to Cannes, and we didn't know if the problem was in the speakers or in the print, so all we could do was take the master print with us to screen at Cannes. We got on the plane, both of us carrying cans of film, and went to Paris to subtitle, then two days later my assistant arrived with a new print. So we've got a print and we've subtitled it, but we've never actually seen it.

"We got to Cannes on a Friday, and each movie in competition was allotted twenty minutes to do a sound and picture check. Ours was scheduled for midnight because we were the closing movie, so we went out to David Bowie's yacht for a party, then it was time to get in the dinghy and go watch our twenty minutes. I was still cutting stuff into the titles the day it was screening, and we *still* haven't seen it! So when we went in, David told the projectionist, 'We've never seen this movie, and we're gonna watch the whole thing.' The guy hemmed and hawed and David said, 'Look, that's just what we're doing.' We left there at three in the morning, the film premiered the following night, it got

a great reception, and it won the Palme d'Or. It was very exciting." When jury president Bernardo Bertolucci announced it as the winner, there were boos as well as cheers, but it still took the prize.

By the time *Wild at Heart* got to Cannes, Lynch's relationship with Rossellini was in trouble and soon to end. "Mary Sweeney was an assistant editor on *Blue Velvet,* so she was there from the beginning and was one of the many people who hovered and worked on David's films," recalled Rossellini of the breakup. "I don't know when that story started, or if it was parallel to me all the time, but at the beginning it probably wasn't. I remember vaguely some tension on the set of *Wild at Heart,* and there was another thing that caught my attention. I once arrived late at night to work and was given a room, and I expected David to be there but he wasn't. I just figured he needed to sleep. When I went in the morning to do makeup, I heard on the walkie-talkie that David had arrived but he didn't come to say hello to me. Two hours later he came and said, 'Oh, how are you,' with fake enthusiasm, and I remember thinking, What's going on? Then, when David and I were in Cannes for *Wild at Heart,* he suddenly said, 'Let's go to the airport to pick up Mary.' I said, 'Mary? Mary's coming?' He said, 'Yes, she worked so hard.' I thought, How sweet of David to invite an assistant editor. I didn't read it then. [Sweeney was the script supervisor on *Wild at Heart.*]

"David has this incredible sweetness, but shortly after that he completely cut me out of his life and left me with a phone call telling me he never wanted to see me again," Rossellini said. "I didn't see it coming and it was shocking. There might be something I did or something he saw in me, or he may've just lost interest in knowing me. Sometimes I wonder if the fact that I wasn't meditating was one of the reasons he left me. I tried for a while but I never could do it. I'm Italian, and in Italy we're tormented by Catholicism—the Vatican made me allergic to anything spiritual. It was really tough when he left me, though, and it took me years to get back on my feet. I was so angry with myself, because I had a daughter and a beautiful career, and I couldn't believe I could be so demolished by a boyfriend. But I loved David immensely and thought he loved me, so it was devastating. I saw there was some unhappiness, but I thought it was due to his work. In fact, he'd fallen in love with another woman."

Jennifer Lynch observed that "Isabella is elegant, joyful, and social, and everybody recognized her and wanted to speak to her, which she found lovely.

Dad is a very kind person, but he'd really rather not have a lot of public con-versations, and it became challenging for him to be out with her. For a while it was great, then it became hard." The breakup came as no surprise to Sigh-vatsson, who said, "I remember David saying to me, 'Joni, it's a full-time job being Isabella Rossellini's boyfriend.' I was there when it all began with Mary, too, and I saw her sneaking into David's room while we were mixing *Wild at Heart* up at Lucasfilm. I like Mary a lot, by the way, and think she was great for David. She started limiting access to him, and he needed that."

Wild at Heart won at Cannes but had yet to be released in the United States, and its distributor, the Samuel Goldwyn Company, spent the next eight weeks gearing up for a late-summer opening. Lynch had never liked test screenings, but with *Wild at Heart* he conceded the value of seeing a film with a non-industry audience after a specific scene triggered a mass exodus at two test screenings for several hundred people. "Harry Dean Stanton gets shot in the head and his brains splatter against the wall," Dunham recalled, "then the two characters who kill him laugh manically over the stump of the neck, stick their heads down into it, then come up and do this frantic, wild kissing. The second that scene went up on the screen, a hundred twenty-five people walked out of the theater. We went outside and the people from Goldwyn and Propaganda were crazed, and we said, 'Hey, this is a Disney crowd—we need a David Lynch crowd.' We talked them into letting us do another screening a few days later for a different kind of audience. This audience was glued to the screen, but when that scene popped up, a hundred twenty-five people got up and left, and this crowd turned violent. People started yelling, 'This guy is sick! He should be put in jail and never allowed to make another movie!'"

"People ran out of that screening like they were evacuating from a disas-ter," said Montgomery. "If David had his choice he wouldn't have cut that scene—he would've made it longer! But it had to go because it went too far."

That scene wasn't the only roadblock the film encountered. "Samuel Gold-wyn, Jr., David, Steve, Joni, and I went to lunch at Muse," continued Mont-gomery, "and Samuel said, 'I like the film, I want to do it, but I can't deal with the ending'—and the original ending really was not pretty. Everybody was kind of depressed by the end of lunch, then on the way home David said, 'I'll give you a fucking happy ending,' and that's what he did. He crafted an em-phatically happy ending and he did it pretty ingeniously."

What Lynch did was bring in Glinda the Good Witch from *The Wizard of Oz*

and have her hover in the sky, singing the praises of true love. "I was up there sixty feet above the ground and it was terrifying," remembered Sheryl Lee, who played Glinda. "I'm ashamed to admit it, but I lied to get that part. I was in Colorado visiting my family and David called and asked, 'How do you feel about heights?' I'm terrified of heights, but I said, 'I feel fine about heights!' He said, 'Good, because I'm going to hang you from a crane by piano wire,' and I said, 'Oh, that's fine!' When I got to the set they had the stunt team, the airbags, the whole deal, and I was floating so high up there that David had to direct me through a megaphone because I could barely hear him. I remember floating up there feeling terrified and at peace and grateful at the same time. David can get you to do things you wouldn't do under any other circumstances. Hang from fish wire in service of telling David's story and bringing his vision to life? I'm there one hundred percent."

The film opened on August 17th to modest commercial success, and Lynch finally took a night off. "When *Wild at Heart* opened in L.A., we planned this big evening with Nic, David, Steve Golin, myself, and I think [executive producer] Michael Kuhn," remembered Montgomery. "We went to Il Giardino in Beverly Hills, a restaurant David loved because when we walked in they'd play the theme from *Twin Peaks.* It was summer and we were sitting outside in the garden and everybody got thoroughly intoxicated. Fortunately none of us were driving—we had a car service—and after dinner Nic, David, and I decided to go to this bar in Los Feliz called the Dresden Room, where an elderly couple performed standards on an electric piano. After we'd had a few drinks one of them said, 'We've got Nicolas Cage and David Lynch in the audience tonight! Why don't they come up and sing a song?' David was wearing Elvis-type sunglasses, and he and Nic got onstage and sang an Elvis Presley song."

It's a law of nature that what goes up must come down, and right around then Lynch began sensing the beginnings of a backlash targeting him and his work. He knew he was powerless to stop it, too. The critics were very tough on *Wild at Heart;* Lynch was accused of drifting into self-parody, and although the film has been reassessed over the years and is now regarded as a valuable part of Lynch's canon, that wasn't the case when it came out.

It's never been without champions, though, and among them is Montgomery, who concluded, "*Wild at Heart* won at Cannes because it's a strong movie and it just kicked some ass that year at the festival. David opens new frontiers

for people, and although many filmmakers might not want to acknowledge it, they were highly influenced by that film."

The film has held up for many people, too. "Neither David or I had seen *Wild at Heart* since we made it, and when we started work on *INLAND EMPIRE* we watched it together and it was an amazing experience for both of us," said Dern. "When it ended we felt really moved. It was like looking through a scrapbook and all the memories came flooding back. I love the bed scenes the most. I love working with David when we're in a car or a bed and there are isolated characters and everything else sort of stops in a way that only happens with David."

S OMEWHERE ALONG THE way *Twin Peaks* became like a TV show rather than a film, and when it stopped being just Mark and me I kind of lost interest. And then I read *Wild at Heart* and really liked the characters. The way that happened was Monty came to me and said, "David, I read this book called *Wild at Heart* and I want to direct it. Would you consider being executive producer?" I said, "Let me read the book," and then as a joke I said, "Monty, what if I really love this book and want to direct it?" and Monty said, "Then you'll direct it, David"—and that's what happened.

It was the perfect time to read that book, because the world was coming unglued then. There were drugs on Hollywood Boulevard and it was scary to go down there at night; there were gangs out in the Valley and you'd hear gunshots every night—the world was going insane and I saw this as a love story in the middle of hellish insanity.

Barry Gifford is a killer fuckin' writer and I've got a lot of respect for him. His writing is pure and minimal and it sparks things and gets your imagination going. There are things in the book he just mentioned in passing, but they'd get my mind going and I would expand them. Barry's got these characters and they're not going to be doctors or lawyers, but they're smart and they live in a kind of subterranean culture, and I really love that world and the things that can happen there. It's wild and free and there's a kind of fearlessness, yet there's also some kind of deep understanding of life.

There are certain places I tend to like to go in my films. All artists have a particular machinery and specific likes and dislikes, and the ideas that they fall in love with are going to be certain kinds of ideas. It's not like

you set out to do the same thing over and over again, but there will be similarities. It's like jazz. There are certain themes that appeal to you, and although there are many variations on the theme, those themes you love are going to always be there. The ideas come and they give the orders, and it may be a different slant on the theme, or different characters, but the ideas are in charge and your job is to be true to them.

The casting happened almost immediately for *Wild at Heart*. I felt like Nic Cage could do almost anything, including Elvis Presley, who's part of the character of Sailor. He's a fearless actor and super cool, and he's the only one I thought of to play Sailor. I met with Nic and Laura for the first time at Muse, and the night we met, this beautiful old art deco building down the street called Pan Pacific Park was on fire.

Willem Dafoe is a friend of Monty's and Monty probably brought him up, and Willem was like a gift from God. Once he got those teeth in, man, Bobby Peru just came to life, and he gave an absolutely flawless, perfect performance. It wasn't just the teeth, though. You could put the same teeth in somebody else's mouth and you wouldn't get the same thing. It's the marriage of the character with the actor, like, this person can do this thing and no one else can. Willem had the stuff. And I love Crispin Glover. His character is in Barry's book, but I think maybe he's just mentioned. I don't think the cockroaches in his underpants are in the book, and his sandwich-making might not be, either. But Crispin was the perfect actor to do those things, and that's another flawless performance.

I don't know if Mr. Reindeer was in the book and don't know where he came from. He just arrived. Harry Dean's character is in the book but I don't know how much, and I don't think Grace Zabriskie's character is in there. Grace is from New Orleans, and when I met her for *Twin Peaks* she started doing a Cajun kind of talk that burned a hole in my head. I remembered that and when I was writing that character it was like I was channeling that Cajun thing. I knew it was right and Grace loved it.

Sheryl Lee plays Glinda the Good Witch, who comes in at the very end when it looks like everything is lost and she saves Sailor and Lula's love. In those days a happy ending made people puke—they thought it was a fuckin' sellout and that the more down something was, the cooler it was. But it just didn't seem right to end *Wild at Heart* on a down note.

Everything is possible and sometimes something just appears out of nowhere and makes everything right. That can happen in life. But if you count on that happening, you might be let down.

And you should always stay on your toes, because something *could* happen at any time. For instance, there's a lady who walks through one scene in the film waving her hands, and she's not in the script. I saw that lady in a restaurant and I had her do this thing, and it sticks in people's minds how beautiful she is.

There's a lot of rock 'n' roll in *Wild at Heart*. Rock 'n' roll is a rhythm and it's love and sex and dreams all swimming together. You don't have to be young to appreciate rock 'n' roll, but it is kind of a youthful dream about reveling in freedom.

Wild at Heart was shot in Los Angeles and New Orleans, which is a great city. One night we were at this club there and it was kind of brightly lit and music was playing. In any restaurant in New Orleans you find all different kinds of people, and we were sitting next to this black family. The father wasn't there but there was a mother and her daughters and maybe a brother, and they were visiting the city from someplace rural. This family had no pretense at all; they were just themselves, really enjoying life. We started talking and I asked one of the daughters to dance and she was solid gold. She was so pure. There we were, talking away, from completely different worlds. She knew nothing about my world, and she was such a good girl. I like that about that city, that different kinds of people are all together and it's a city of music. There's music everywhere and interesting food and lots of French things, and it's a magical place that's really dreamy at night.

I don't remember going to that club in New Orleans Monty described, but, sure, we could've gone there. I think peoples' memories are different. Sometimes their memories are flat-out wrong, but mostly they're just different. I do remember lots about New Orleans, though, and that's a city I really love.

I'm mostly in cities now and I don't miss being in nature anymore. I guess I got it out of my system, and I don't really long for it. When I was growing up in Boise, the forests were healthy and rich and the way it smelled walking through the woods was incredible. A bunch of things have happened since then, though. There are pickup trucks with gun

racks and brightly colored off-road vehicles racing around in the woods, and those things don't go together. And there's also global warming and the bark beetle. When it gets super cold the bark beetle dies, but it doesn't get cold enough for them to die anymore and they're killing all the trees. My dad told me that when you see a tree that looks like it's dying, it's already been dying for ten or fifteen years. By the time you start seeing it it's too late, and they say that a huge proportion of the forests are dying. That world of nature I grew up in isn't really there anymore. There are all these people with backpacks and fancy camping stuff going into the woods and it's crowded! When I used to go in the woods I never saw anyone. No one. You might see some weird people in the woods now and then, but mostly they were empty.

So, places change, but not completely. When I went back to Boise in 1992 it was way different, but a lot of it stayed the same. Something about the way the land is formed to make a certain kind of weather and light—those things don't change. But other things disappear. When you have those growing-up years in a place you get a feeling for it, and you always have a warm spot for it, and your heart feels good thinking about the things you experienced there. They're gone now, though, and you can't explain it to anybody. I could meet some kid now and tell him about Boise, but I couldn't give him the feeling I get when I remember it, and he'll have the same problem when he's an old geezer explaining to somebody what life was like when he was sixteen.

Making *Wild at Heart* mostly seemed pretty easy and the world seemed ready for that film. There was one scene that was just a hair too much, I guess, and we had to cut it. You can't predict what's going to freak people out, because you only have your own taste to judge things by—and I've come up with stuff that was too upsetting to me, too, and I couldn't go there. When you fall in love with an idea that's powerful you have to check the air and see how it would go in the world. And sometimes you sense that, no, it's the wrong time for that.

When I get an idea I usually have a real good clear feeling of where it goes. Sometimes I don't, and I don't enjoy being in that zone where I'm not sure. Sometimes you think you know and then you realize, no, I was wrong, that isn't working. Like painting—it's a process of action and re-action and you find your way. Sometimes that takes a lot of time, but

when you find it you know it, and as soon as you decide, I want to go to New York, from then on you're just going to New York and anyplace else is out of the question. You made a choice and now you're going to New York and free will then is gone. Once you have a film you've decided to make, it becomes a road and your road is set. You can veer off here and there, but if you go too far off you're in a different film.

I have more ideas than I can handle and I don't get to them all. I get ideas for paintings, but I can't paint now because I'm busy doing other things, and by the time I have the chance to paint, the ideas I have today won't be thrilling to me anymore. I'll be able to remember the ideas that went before, but they won't be exciting to me. I miss painting when I'm not painting.

The year *Wild at Heart* was at Cannes, Fellini showed his film *The Voice of the Moon*, and I was so thrilled that a film I made was going to fall on the screen right after a film by Fellini. It was just incredible. That whole experience was exciting, and we were working on the film right up to the very end, that's for sure. Duwayne and I went into the screening room really late on the night before *Wild at Heart* screened, and you go up this ladder into the projection room and the projectors they have are like from a Russian science-fiction film. They're huge, and we were running a dual system, picture and sound separate, full-coat mag analog, and this mag held so much smooth power. Unbelievable power.

It's rare now for people to get the chance to see a good print of a film projected right, and that's a real shame. There are two things I think might happen next. Home systems could get really good, and you could have a TV screen the size of one wall of your house and sound that's incredible. If you wanted to see a film you'd turn the lights down, turn off your phone, and crank the sound, and you'd watch this thing and could maybe go into that world pretty good. Unless you invited a lot of friends over it wouldn't be a shared experience, though, and that's an important part of it. The other thing that could happen is, movies will be streamed directly to your phone, and that wouldn't be so good. As for what people want right now, well, they don't want to go to the movie theater, and feature films have lost their allure. Cable television is the new art house.

At Cannes you don't know if you won until the last minute. If they tell you to stay until Sunday, you know you're going to win something but you don't know what it will be. I remember going up the red carpet that night with zero idea that I would win. You go up and shake hands with Pierre Viot, this cool guy who's been with Cannes from the beginning and was the president then. He said, "David, it's something and it's definitely not nothing." Then we went in and sat down, and before the ceremony started, Gilles Jacob, who was president of Cannes from 2001 through 2014, came by and said, "You won the Palme d'Or."

Lynch's life was transformed by the juggernaut that was *Twin Peaks*, followed by *Wild at Heart's* win at Cannes, and at that point he became a brand and an adjective. Suddenly you could describe something as "Lynchian" and people knew what you meant. This level of success has its pros and cons, of course. When you permeate popular culture completely it responds by absorbing you, then assuming it knows you, then assuming it has *rights* where you're concerned. During the early 1990s the number of people wanting to get at Lynch, to get something from him, to share themselves with him, to express their opinions about him, just to breathe the same air he was breathing, increased exponentially, and the walls separating him from those people grew thicker. Cultural avatars live in bubbles; they have no other choice than to do that, because the demands made on them are simply too vast. Those forces were in play now for Lynch, and they brought about changes in his daily life. His staff got bigger and the chances of anyone spotting him at an L.A. coffee shop became slim.

Winning at Cannes was a mixed blessing for Lynch, but something happened at that year's festival that was inarguably good for him: He ran into an old acquaintance named Pierre Edelman. A colorful character known for his ability to make big plans hatch, Edelman has led an adventurous life that includes a stint in prison for deserting the French army; a fortune made in the garment trade; several years lost to drugs; a bankruptcy; a long stretch spent living at Jack Nicholson's house; and a period as a journalist. In 1983 Edelman visited Churubusco Studios to write a piece on the making of *Dune* for a French magazine and met Lynch at the studio cantina. "We immediately clicked," said Edelman, who attempted to produce some commercials for Lynch in the years following their meeting.[1] Propaganda already had Lynch

under contract in that department, so Edelman struck out there, but he wanted to work with Lynch and he isn't someone who gives up easily.

In 1990 French industrialist Francis Bouygues decided to get into the movie business. Founder of one of the largest construction companies in the world (he played a central role in the building of the Chunnel and Charles de Gaulle Airport), Bouygues launched his personally funded studio, Ciby 2000, and set out to corral the best directors in the world to work for him. Edelman was consulted as to which directors the company should recruit, and he drafted a list that included Lynch.

"I crashed a party for *Wild at Heart* at Cannes and took David aside and told him that it would be great if he came to Paris to meet with Francis Bouygues," said Edelman. "I explained to him who Bouygues was and told him that he would probably be able to make any film he wanted to with him. He told me that *Ronnie Rocket* was what he wanted to do. A short time later I organized a dinner with David at a restaurant in Los Angeles called Il Giardino. [Lynch's lawyer] Tom Hansen was there, and I arranged for something funny to happen. A few months earlier I'd met Clint Eastwood in Saint-Tropez and we became friends, and I asked Clint to show up at the restaurant and say, 'Oh my God, it's Pierre!' which he did. I don't know if David was impressed, but I think he was surprised." Surprised or not, Lynch did go to Paris to meet with Bouygues and signed a three-picture deal with Ciby 2000 stipulating that he would submit proposals for three different films, one of which was *Ronnie Rocket*.

"David's always had a great relationship with the French," observed Mary Sweeney, who was officially Lynch's partner by the time Bouygues came into the picture. "David believes that creativity is our birthright, and part of the reason he loves France is because you're a rock star there if you're a creative person, and your creative rights are respected."[2]

Those were early days in Lynch's relationship with Sweeney, who went on to become a major part of Lynch's creative life and lived with him for fifteen years. Born and raised in Madison, Wisconsin, Sweeney discovered she had an affinity for editing while she was a student in the cinema studies program at NYU. On graduating in 1980, she began hunting for a job, and at that point Warren Beatty had commandeered most of the editing facilities in New York to complete his epic film *Reds*. Legendary editor Dede Allen was in charge of a crew of sixty-five, and she took Sweeney on as a seventh sound apprentice

editor. In 1983 she landed a job at George Lucas's Sprockets and moved to Berkeley, where Duwayne Dunham hired her as an assistant editor on *Blue Velvet*. She finally met Lynch in November of 1985, when he moved to Berkeley to do post-production on the film. "I remember the day David walked into the cutting room," said Sweeney. "He was so happy, this sunshiny guy walking in, very sweet, hearty handshake, the whole nine yards."

In the spring of 1987 Sweeney relocated to L.A. for three months to edit the television version of *Blue Velvet*, which was a contractual requirement for Lynch, and in 1989 she moved to the city permanently to be script supervisor and first assistant editor on *Wild at Heart*. In 1990 she was script supervisor for the first episode of the second season of *Twin Peaks*, and in September of that year she worked directly with Lynch for the first time when she edited the seventh episode of the show.

During the period when Lynch and Sweeney were growing closer Lynch was preparing for his first museum survey, which opened in Tokyo at the Touko Museum of Contemporary Art on January 12th, 1991, and was accompanied by a modest catalog. Included in the show were several of the dark, turbulent paintings from the late 1980s that had been exhibited at the Corcoran Gallery, and a series of exquisite pastel drawings produced from 1985 through 1987. Uncharacteristically tender, the series includes renderings of a shaft of light touching down on a barren landscape; a spiral form that hovers above a field of white mist; and a lozenge-shaped cloud that stretches like a UFO above an empty black field.

On returning from Japan he launched his production company, Asymmetrical, and began working toward his next film. Lynch has said he was in love with the character of Laura Palmer and wasn't ready to leave the world of *Twin Peaks* when the series was canceled in June of 1991, and shortly after it went off the air he began talking about making a movie set in the dreamy town he and Frost had cooked up. Toward that end he teamed up with Robert Engels, who'd written ten episodes of the show, and by July of 1991 the pair had produced a script called *Twin Peaks: Fire Walk with Me*, chronicling the final days leading up to Laura Palmer's murder. Slated to be executive-produced by Lynch and Frost, a *Twin Peaks* prequel wasn't met with uniform enthusiasm from the cast of the show. Lynch has said that approximately 25 percent of the actors didn't support the idea, and among the naysayers were Sherilyn Fenn, Lara Flynn Boyle, and, most significant, Kyle MacLachlan. The script as

originally conceived relied heavily on his character, Agent Cooper, and on July 11th Ken Scherer, the CEO of Lynch/Frost Productions, announced the project wouldn't go forward due to MacLachlan's refusal to participate.

Lynch is a master at adapting to any boundaries that are placed on him, however, and he revised the script to introduce new FBI agents played by Chris Isaak and Kiefer Sutherland, and prepared to move forward. MacLachlan reconsidered and agreed to be in the film but in a diminished capacity. Harry Dean Stanton turns up in the *Twin Peaks* story for the first time, as the manager of a decrepit trailer park, and David Bowie gives a mesmerizing cameo performance as the mysterious Phillip Jeffries, an FBI agent with a Southern accent who appears to be having a breakdown.

The first draft of the script was considerably longer than the final shooting script, dated August 8th, 1991, and entire characters were cut from the story, as were the flourishes of humor that balanced out the grislier aspects of the television show. *Fire Walk with Me* is essentially a story of incest, and it's hard to put a cheerful spin on that.

Filming began in Washington on September 5th, 1991, and principal photography was completed in a little over three months. On set in Seattle as unit publicist was Gaye Pope, a widely loved figure who went on to be Lynch's personal assistant and a trusted confidante. She worked with him until April of 2003, when she died of cancer. Deepak Nayar was there, too, this time as first assistant director. "Instead of me driving David to work, I rode with him, and Kyle's brother [Craig MacLachlan] drove us," said Nayar. "[DP] Ron Garcia and the script supervisor, Cori Glazer, were usually there, too, and we'd ride together and discuss the day's work.

"We were on nights—one thing you can be sure of with David's films is that you'll be shooting nights at least thirty percent of the time—and one day David said, 'So tell me, Hotshot, what time do you think we'll finish on Saturday? We're gonna finish before midnight.' I told him that was impossible because we wouldn't wrap the Friday night shoot until Saturday morning and couldn't do that fast a turnaround. Nonetheless, at two on Saturday afternoon I get a call from David and he says, 'Where are you? I'm waiting for you at the lunch table! You're wasting time on purpose!' I said, 'Nobody's going to be at the set but the teamsters,' and he said, 'See! You're always sabotaging!' At that point we made a twenty-dollar bet about when we would finish. I arrived on set that afternoon and I was right—nobody was there but four crew mem-

bers, and when the first teamster arrived he had a look on his face like, Am I late? Word begins to get around about this bet David and I have, and the crew gets to work. At one point Sheryl needed to leave the set to change clothes and David says, 'Nonsense! You're wasting time! Bring her clothes here. You guys form a circle facing outward and Sheryl can change in the middle!' Finally, at two minutes to midnight he looks at me and says, 'Do you want to call it a wrap or should I?' I said, 'David, you deserve it, you call it.' I gave him twenty dollars, then turned around and took a hundred dollars from a producer. I'd bet against myself and he was so angry! He said, 'You're buying drinks for everybody,' and he made me spend the money I made on drinks.

"One day we were driving home from the set," Nayar continued, "and David said, 'Stop the car, Craig!' Then he said, 'See that woman over there on the street? Get her telephone number.' I said, 'What for?' and he said, 'I don't know, just get her number.' So I did and the matter was forgotten. A few days later he says, 'Remember when I told you to get that woman's telephone number? She's in the next scene with Harry Dean.' She played the old woman who lives in the trailer park and says to Harry Dean, 'Where's my hot water?' David enjoyed throwing curveballs then watching people scurry around."

Sweeney accompanied Lynch to Seattle, and by the time they returned to L.A. to start post-production she was pregnant. While Lynch began working on music for the film with Badalamenti, Sweeney got to work editing. "Mary tuned in to David in a way probably no other editor could have," said Ray Wise, who co-starred in *Fire Walk with Me*. "They had a kind of unspoken language between them."

Lynch and Badalamenti had one, too, and the score for *Fire Walk with Me* was the most comprehensive collaboration they'd ever attempted. With songs by Lynch and Badalamenti, instrumentals by Lynch and David Slusser, and instrumentals by Badalamenti, the soundtrack is unique for a Lynch film in that it includes no pop recordings by other artists. Lynch and Badalamenti had fun building a score from the ground up.

"We were recording a song called 'A Real Indication,' and David was in the recording booth," Badalamenti recalled. "He'd written this lyric that called for some kind of vocal improvisation, and I thought, I don't give a damn, I'm gonna go for it and do something that's really not me, I'm going to be outrageous. I ran the gamut of nuttiness, yelling and ad-libbing, and David was laughing so hard he got a hernia and wound up needing surgery."

Having rounded up many of the principals from *Twin Peaks,* Lynch re-cruited a few of them to star in three television commercials he shot for Geor-gia Coffee that aired in Japan. And, in May of 1992, Lynch's first European museum exhibition opened at Sala Parpalló in Valencia, Spain, just as Lynch and Sweeney headed to Paris, where they spent several weeks on final prepa-rations for the *Twin Peaks: Fire Walk with Me* premiere at Cannes. A party featuring performances by Julee Cruise and Michael J. Anderson was thrown in honor of Francis Bouygues, who was thrilled to be at Cannes with a new David Lynch film.

The powers that be were not on Lynch's side at that point, though, and the reception the film received was less than generous. *Fire Walk with Me* is a complex, challenging work, and Ray Wise and Sheryl Lee—who essentially carry the film—both give searing performances. Wise is nothing short of ter-rifying and Lee is at turns sultry, baffled, and devastated. Nonetheless, audi-ence members hissed and booed while it screened, and at a press conference that followed Lynch encountered open hostility. Accompanied by Robert En-gels, Angelo Badalamenti, Michael J. Anderson, and Ciby 2000 producer Jean-Claude Fleury, Lynch was asked by a French reporter if his return to the world of *Twin Peaks* was the result of "a lack of inspiration." Another reporter declared, "Many would define you as a very perverse director: Would you agree?" Quentin Tarantino was on hand and made the observation, "[He's] disappeared so far up his own ass that I have no desire to see another David Lynch movie."

Sheryl Lee feels lucky she missed it. "I couldn't go to Cannes, because I was doing a play in New York and I was really bummed, but when I heard about the reaction the film got, it's probably a blessing that I wasn't there," she said. "I don't know if my skin would've been thick enough to deal with it.

"It's not a comfortable film to sit through, and sometimes when an audi-ence sees a film that makes them uncomfortable they get angry at the direc-tor," continued Lee, who's in nearly every frame of the second two-thirds of the film. "I think there was some of that going on. I don't think it's David's in-tention to provoke people, but rarely do people see anything of his and say, 'Oh, that's interesting.' His work always has complexity and depth and layers of meaning, and it can be upsetting for people if they feel like they're sup-posed to understand a film but they can't distill it down into a simple story."

In Sweeney's view, the rough ride the film was given at Cannes came down

to the fact that "people were addicted to *Twin Peaks* and wanted more of it, and they got a David Lynch film instead. *Fire Walk with Me* is dark and unrelenting and it made people angry."

Ray Wise feels the film requires no explanation or apology. "*Fire Walk with Me* is David's masterpiece," he said. "Every aspect of his work is embodied in that film, and the fact that it was a prequel to a television series? Only in the mind of David Lynch could something like that happen, and he executed it beautifully.

"There's a scene in the film where I'm in a convertible with Laura, and I think that's some of the best work I've ever done," Wise continued. "It was very hot the day we shot that scene, and there were lots of different takes and we were all kind of short-tempered, but we used that tension and channeled it into the work. And the last twenty minutes of the film are almost like a religious experience. People were hard on *Fire Walk with Me* when it came out, but I think the film has been reassessed and will be around for a long time." Wise is right about this. In September of 2017, *The Guardian*'s Martyn Conterio wrote, "A quarter of a century on, the film is being rightly rediscovered by fans and critics as Lynch's unsung masterwork."

Fire Walk with Me opened in Japan on May 16th, directly on the heels of Cannes, and it did well there. The Japanese are rabid Lynch fans. Things didn't go as well when it opened in America on August 28th, 1992. *New York Times* critic Vincent Canby wrote, "It's not the worst film ever made. It just seems like it." Jennifer Lynch recalled that "*Fire Walk with Me* was really important to Dad, and I remember his terrible confusion at how it was misunderstood. He started to have a lot of trouble with Hollywood bullshit around that time."

Sweeney was in the final days of her pregnancy at Cannes, and on May 22nd, just a few days after the film screened, Riley Lynch was born in Paris. "As soon as we got back from Cannes, we spent five weeks in Wisconsin with my mom in her house on Lake Mendota, and we started looking for property there," Sweeney recalled. "Madison is a very enlightened, idealized Midwestern place, and the people there are friendly. David could go to the hardware store and gab with the guys, and he loved my mom and my big Irish Catholic family. By the end of that first summer we'd found a place, and we spent several months there in 1993 and 1994. I remember David watching the O.J. trial there, all day every day, while he thought about *Lost Highway.*"

Montgomery remembered visiting the couple in Wisconsin and said, "That's something David never would've done if it weren't for Mary—she got him out of his world. They bought a house there and he had a vintage wooden speedboat he loved and he seemed real relaxed."

Lynch began turning inward at that point and embarked on an extensive series of modifications to his house in Los Angeles. It was then that he hired Alfredo Ponce, an ingenious jack-of-all-trades who's been working for him ever since. "I was doing landscaping for one of David's neighbors and he saw me over the fence and said hi—that's how we started," recalled Ponce, who was born in Mexico in 1951 and moved to Los Angeles in 1973. "He kept saying hi and then he asked me if I wanted to do some cleaning in his yard, and I wound up working on his pool house, and one project led to the next." Over the years Ponce has done plumbing, landscaping, electrical wiring, mechanical repairs, created an irrigation system for Lynch's property, and carved out the pathways that traverse the land. He knows how to pour a foundation, frame a house, and build furniture, and has built sets for film experiments Lynch has done at home. "Peggy Reavey once said, 'There's no way David could run an ad in the classifieds to find a person like you,'" Ponce said. "David's a hard worker who always has ideas for things he wants to build and I like working with him because he just tells me what to do then lets me figure out how to do it. When he was working on *INLAND EMPIRE* he needed a set and he took a stick and drew what he wanted in the dirt and said, 'Can you make this?' That's kind of the way we do things."[3]

Ponce has been at Lynch's place full time, five days a week, for years, and he sees everything. "People see me here cleaning or raking leaves and they think nothing—they don't know how much I know," he said. "I can smell things from far away, and I can see it immediately when someone comes up here who doesn't have David's best interest at heart. The negative energy—I can see that, and I've seen a lot of people come and go. David's an easygoing, nice person and he can be taken advantage of, so I try to protect him. Anybody who works here has to be somebody I trust."

Sweeney remembers their early years together as creatively fruitful ones for Lynch. "During those years David painted nonstop, he got a kiln and was doing pottery for a while, and he designed and built furniture in his shop. He did lots of photography and had several exhibitions in the United States and abroad. He never gets tired and has lots of energy, although he doesn't physi-

cally exert energy. I was always after him to get some exercise and stop smoking [he took it up again in 1992 after quitting in 1973], but no luck there. He's like a teenager about smoking."

Robert Engels's wife, Jill, had become pregnant at the same time as Sweeney, and after the two women gave birth to their babies just a week apart, the Engels family became regular guests at Lynch's house. They'd visit on Saturday nights with their baby, and Lynch and Sweeney would order takeout. Mostly, though, they didn't have much company. "David's a hermit," said Sweeney.

Lynch's nesting instinct is strong, and when his next-door neighbor died in 1992 he acquired her house, then built a pool house designed by Lloyd Wright above the Pink House. Slowly, his house was becoming a compound. "We had a beautiful setup," said Sweeney. "We both had painting studios, I had an editing suite, David had a woodworking shop, and then he built a mixing stage. We loved working and being home."

Lynch and Frost then embarked on a television series called *On the Air.* Lynch is a fan of broad comedy, and as is the case with his unproduced scripts *One Saliva Bubble* and *The Dream of the Bovine*—which Lynch describes as "the story of two guys in the San Fernando Valley who are cows but don't know it"—*On the Air* was a vehicle for sight gags, pratfalls, and unbridled silliness; all three of these projects reflect his admiration for the French comic genius Jacques Tati. Starring *Twin Peaks* alumnus Ian Buchanan, and set in 1957 at the New York headquarters of the Zoblotnick Broadcasting Corporation, the show chronicles the endless disasters that befall *The Lester Guy Show,* a variety program that's televised live.

ABC responded well to the pitch for *On the Air* and ordered six episodes in addition to the pilot, which Lynch co-wrote with Frost and directed himself. Various friends then pitched in: Robert Engels wrote three episodes, Jack Fisk directed two, and Badalamenti did music. Although the show got good marks when it was screened for test audiences, ABC shelved the completed episodes for more than a year. They finally aired the pilot on Saturday, June 20th, 1992, and it did not do well. Even the late David Foster Wallace, a self-described "Lynch fanatic," dismissed the show as "bottomlessly horrid." It didn't have many supporters.

"ABC just hated the show, and I think it only aired three times before they yanked it," Frost recalled. "It was goofy and too off the wall for network televi-

sion, but I think it was just ahead of its time. David and I looked at some of it recently, and it still makes both of us laugh and has some really funny stuff in it. After *On the Air* was canceled, David and I went our separate ways for a while. It had been an intense six-year period and I wanted to go write a novel."

Tony Krantz, who helped get the show on the air, was mystified by the response it got. "*On the Air* was the lowest-rated show on TV at the time, but I loved it and thought it was great. Maybe it was too quirky or the bloom was off the David Lynch/Mark Frost rose—I honestly don't know why, but it failed miserably."

Lynch was immediately onto the next thing, of course, which in that case was the television project *Hotel Room*. A trilogy of teleplays set over several decades in the same room at New York City's Railroad Hotel, the show was based on an idea of Monty Montgomery's and developed by Lynch with Barry Gifford. Gifford wrote two episodes, which Lynch directed, and Jay McInerney wrote a third before the project was canceled. Shot late in 1992, Lynch's two episodes—"Tricks," set in 1969, and "Blackout," set in 1936—are arguably the most actor-driven works he's produced. The writing is quite spare, each episode was shot in a single day in extraordinarily long takes, and Crispin Glover, Alicia Witt, Harry Dean Stanton, Freddie Jones, and Glenne Headly turn in bravura performances.

"There was one day when David was rehearsing with the actors all morning through lunch and people were starting to panic because nothing was being shot," recalled production coordinator Sabrina Sutherland. Born in Massachusetts, Sutherland studied film at UC San Diego, then got a job as a tour guide at Paramount Studios. By the mid-eighties she was working regularly as a production coordinator, and landed that job with Lynch on the second season of *Twin Peaks*. She's worked with him regularly ever since, and produced *Twin Peaks: The Return*. "After lunch, people are just freaking out, then suddenly David started shooting these ten-minute takes, one after another. It was the weirdest day, but if what he envisions in his head isn't happening with the actors, he keeps working with them until they get where he wants them to be—and that's one of the things I admire about him. He'll never settle for something or say, Okay, that's good enough; let's go forward. He won't do that."[4]

HBO aired the pilot, comprising all three episodes, on January 8th, 1993. Although the *Los Angeles Times* hailed the show as "marvelously absorbing," *The New York Times* dismissed it as a "setbound omnibus drama" that "plays

like a listless visit to a Lynch-style *Twilight Zone* where stories go nowhere." "We shot three episodes and HBO hated them," said Montgomery. "They were just too weird for them.

"David and I were always trying to cook something up," continued Montgomery, who oversaw production for the music videos created for Michael Jackson's 1991 album *Dangerous*. When it came time to produce a commercial teaser in 1993 announcing the release of the collection of short films made in conjunction with the album, Montgomery suggested Lynch, and Jackson thought it was a great idea.

"David's a star, but Michael Jackson? That's a whole other can of worms," Montgomery said. "This was the type of deal where Donatella Versace herself came over to deliver two vans of clothes for Michael—and he was only going to be shot from the neck up!

"I don't think Michael understood what David wanted to do, but the plan was to shoot Michael's face in an extreme close-up with a high-speed camera. Finally, after much ado in the trailer, Michael came on set and goes over to David, and they're having a conversation about *The Elephant Man* and getting to know each other. Then David said, 'Let's do it,' so Michael gets in front of the camera, and he has to be really close to the lens, and as soon as the camera stopped, Michael ran into his trailer. Maybe forty-five minutes go by and David started getting impatient, so I knocked on Michael's trailer door and said, 'What's going on?' When you're that close to the camera in the kind of lighting he was in, it's as if you're looking in the worst mirror at a truck stop, and what Michael saw freaked him out. Another hour went by and I finally got him back on set, but David was pretty fed up by then."

Lynch directed six commercials that year, and when Francis Bouygues died that July, his relationship with Ciby 2000 began to fray. By the end of the decade he would meet the company in court. That same year Lynch began a friendship with an aspiring young producer named Neal Edelstein, with whom he was to work throughout the following decade. Born and raised in Chicago, Edelstein moved to L.A. in 1992 to pursue a career in film. "I met David through Jay Shapiro, who was production coordinator on a PSA for breast-cancer awareness that David directed in 1993, and Jay brought me in as a PA," Edelstein recalled. "David was an auteur in another universe to me, and to be able to work with him, and seeing how friendly and approachable he was, and watching him direct—I was in awe of how he handled things.

"Not long after we met, David hired me to work on an Adidas commercial that we shot on a freeway down by LAX," Edelstein continued. "Then in 1994 I get a call from Gaye Pope and she says, 'David wants to talk to you.' Then David gets on the phone and said, 'I need you to produce a music video for this Japanese guy named Yoshiki,' who was the leader of the band X Japan and was kind of the Michael Jackson of Japan. I said, 'I can't produce! I'm only a production manager!' And he said, 'If you're production manager you're already doing the job! Come to the office and we'll figure it out.' I was around twenty-five years old and I hung up the phone and thought, Wow, I'm going to produce a music video directed by David Lynch. I didn't think I was ready by any stretch, but David had confidence in me and it went swimmingly well and was a brilliant piece of directing.

"We were once shooting a commercial at Point Dume in Malibu, and the call time was six in the morning," Edelstein continued. "David and I drove out there together and arrived a bit early and the sun's not up yet. David wanted the sand flat and very organized, so these PAs are out there raking the sand, and David runs out and starts raking the sand with them! There he is, the director, raking the sand in the dark. It was so David, so about who he is, and his respect for other people, and his love for that homespun filmmaking experience. What I've learned from him about life and filmmaking and how to treat people is something I can't put a value on."[5]

*P*IERRE EDELMAN IS an adventurer and a character and my oldest French friend, and he played a part in many of my films. I love him. I met Pierre on the set of *Dune* and Raffaella threw him off the set because she didn't want me talking to journalists, and he was a journalist then. Pierre knows everybody, he's been all around the world, and he can give directions in any city. It's amazing. He was in Hollywood in the sixties and knew everybody, and he made a fortune in blue jeans, but the money went away because of some bad behavior. He was in prison for a while, and the prisoners must've been so happy to have Pierre in there because he made prison fun. He organized cockroach races, where they'd paint the cockroaches and the prisoners would bet. I can just see him. Pierre has a company called Bee Entertainment and he wears a little bee pin on his lapel and Pierre is a bee—he pollinates. He'll put this person together with that person, and he's done this for countless numbers of people. So he told me at Cannes that Francis Bouygues loved *Wild at Heart* and that he had a new company and wanted to meet me, and this is a thing Pierre does. He puts people together.

Pierre is a good person, but some people have a problem with him because he can get in a sarcastic put-down kind of mood and he insults people. One time I was sitting next to him on an airplane, and when the stewardess came over he said something unpleasant to her. After she left I said, "Pierre, I don't like the way you're acting; don't do that around me. Why do you treat people like that?" He apologized to her and by the end of the flight Pierre and the stewardess were best friends, so he's got the charm, but he's also got this thing where he's got to insult people.

You can get derailed by rude behavior. All people have drives that

could derail them if they allow them to—drugs, sex, food, strange thinking, and you can get in trouble with your attitude, too. Most people have a little bit of corral around things and they stay okay, but prisons are filled with people whose corral got broken.

There used to be this great Italian restaurant across the street from the Beverly Hills post office called Il Giardino. It was this nondescript place and wasn't any great shakes looks-wise, but the food was incredible. I went to dinner there one night with Pierre, Tom Hansen, and Jean-Claude Fleury, who was running Ciby 2000. I found out that night that Jean-Claude and I were born ten or eleven hours apart on the very same day, him in France, me in Montana. Fellini was born on my day, too, and so was George Burns. George was exactly fifty years older than me, and in 1991, on my forty-fifth birthday, George and I shared a cigar. Not the same cigar—we each had our own cigar, and we had a smoke together. George Burns was little and light as a feather, and you felt like you could just pick him up like a piece of cardboard. George fell in the bathtub and hurt himself and that ended up taking him down. That was the beginning of the end. If he hadn't fallen he could still be alive.

Anyhow, Pierre was always talking about his buddies, and a lot of people thought he was full of hot air. That night at Il Giardino he said something about his buddy Clint coming by, and two-thirds of the way through dinner we look up and in comes Clint Eastwood, and he comes over and says, "Pierre!" and he gives him a big hug. I wasn't surprised, because I knew Pierre by then and I figured Clint would show up.

So I went to Paris to meet with Francis Bouygues at his office on the top floor of a building on the Champs-Élysées. Tony Krantz and Tom Hansen went to Paris with me, and they were supposed to be at this meeting. We'd been at the Maison du Caviar the night before and Tony had been shooting these cherry vodkas and it had snowed. There was six inches of snow in Paris, and Tony puked his guts out at the curb—I could see him out the window puking into the snow. Pierre brought all these girls—it was quite a night. Tom and Tony didn't show up at this meeting, so there I was without my team, and right across from me was Mr. Bouygues and on either side of him are these two French guys that worked for him. These guys were the smarmiest lowlifes, and they were looking at me with these smiles that said, We're going to crucify you.

They didn't like Bouygues going into the film business, and the vibe coming off them was so bad.

At a certain point Mr. Bouygues said, "Tell me the story of *Ronnie Rocket*," and it was sort of like, If you don't tell me, then there's no deal — you know, prove yourself. I thought we already had a deal, but then this thing came about. I started thinking, Okay, I'm so fuckin' out of here; this is not a bunch I want to be with. I wanted out of that fuckin' building and I got up and started walking to the elevator; I was going to get a cab and go straight to the airport and say goodbye to these fucks. Those assholes sitting next to him with those French smiles on their faces — the worst part of France is this certain smugness, and it says so much, those smiles. I got a lot of that in the early days talking about meditation. Journalists loved to talk to me about film, but once I brought up meditation, here come those smiles.

Anyhow, Pierre sees me leaving and comes running after me and talks me down. I went back into the meeting and said, "I'll tell you the story, but only if Pierre translates," and I'm sitting there looking right at Mr. Bouygues, and Pierre is standing there translating, and these guys were quiet. When I stopped talking there was silence, then Mr. Bouygues said, "*Bon*," and that was it. The deal was done. I just had to do the dog-and-pony show. He said yes to *Ronnie Rocket*, but when it comes down to it, I've always been afraid to make that film. Something isn't right with the script and I don't know what it is; plus, I started thinking about Laura Palmer then.

Francis Bouygues wasn't really sophisticated about movies, but he loved *Wild at Heart*. I think he liked its power and strength. He and his wife, Monique, were real people and I got along with him really well, although in business he was probably different. In business he was a tough guy who surrounded himself with tough people, and a lot of people didn't like him because of that. But Francis and I liked each other. We'd ride around on his golf cart and talk like he was a relative. He was a regular guy who understood how to get things done. He built the Chunnel and the Grande Arche, which is in Puteaux, northwest of Paris. He took me to see it with his top engineer, and there were fifteen vans filled with bodyguards and people. He once visited Stockton, California, and he loved the people and the factories in Stockton so much that he

almost stayed there. He went back to France instead and formed this giant company, which was his destiny. Francis once asked me how many employees I had and I told him, "Three," and he told me he had three hundred thousand employees. He had a lot of power.

I love France because everything they do there is art. The buildings, the chairs, plates, glasses, railroads, cars, tools, food, drinks, fashion—everything is an art form, and they believe in good-quality materials and great craftsmanship and killer design. The Italians and the French both have this thing. The Italians are a little bit different, but the Italians do great stuff, too. I like the hotel I stay in in Paris, and the people, and I like foie gras, and Bordeaux, and croque madame. I even like the coffee, although it's not as good as David Lynch Signature Cup. It has a certain taste that makes me feel like I'm in France, though, so I love it.

I don't know why I loved Laura Palmer but I just loved her, and I wanted to go back and see what she was going through during those days before she died. I wanted to stay in the world of *Twin Peaks*, but it was a strange time. People were put off *Twin Peaks* at that point, so it was a hard sell. Bouygues went for *Fire Walk with Me*, but other people in the business wouldn't have done it. Some of the *Twin Peaks* cast didn't want me to do it, either. When an actor signs on for a series they've got to make a commitment, and a lot of actors worry they're going to get known just for that role and nothing else will come along. A lot of the actors in *Twin Peaks* wanted to move on for different reasons, and when the series ended it gave people freedom and they could go off to stardom or whatever.

When somebody doesn't want to do something it's not the end of the world. You think of something else, and I love that in a way. We had to rework the script so we needed less from Kyle. The original script had a lot more actors in it, but lots of stuff was cut. I didn't make those cuts because it was too long, though—that stuff was cut because it didn't fit into the film. It was the film it needed to be. So some people got cut and other people got added. I have no idea how we got David Bowie in there, but I just love him. I don't think he liked his accent, though, probably because somebody told him that's embarrassing or something. All it

takes is one person to make a comment like that and it can wreck something for you. He's great in it, though, just great.

The Red Room is an important part of *Fire Walk with Me*, and I love the Red Room. First of all, it has curtains, and I love curtains. Are you kidding me? I love them because they're beautiful in and of themselves, but also because they hide something. There's something behind the curtain and you don't know if it's good or bad. And contained spaces? There's nothing like a beautiful contained space. Without architecture everything's just open, but with it you can make a space, and you can make it beautiful or you can make it so hideous that you can hardly wait to get out. Maharishi talks about this thing called Sthapatya Veda, which is about how to build a house that helps you have a better life. They say the soul builds the body and the body builds the house, and just as the body is a certain way, a house should be a certain way. The things people live in these days are absolutely not correct. A south-facing door is the worst direction. Facing east is best and north is good—the Pink House has a north-facing door—but all the rest is not beneficial to the human being. That's the number-one thing, the orientation of the house. To really do it right, the kitchen's got to be at a certain place, where you meditate has to be at a certain place, where you sleep, where you go to the bathroom—they have to be situated in a certain way and have a certain proportion.

Before I went to shoot *Fire Walk with Me*, Angelo and I were recording a song called "A Real Indication," which ended up being used in the film. We were working with a killer bass player, Grady Tate, and Angelo was on keyboards and they did this great track. I had these lyrics I loved and I said, "Angelo, I don't know who we're gonna get to sing this," and he said, "David, I'm gonna do it." Angelo sings sometimes while he plays, and it almost makes me cringe, but I said, "Okay, give it a try." So Angelo goes into the booth and he's sort of bouncing in there, and [engineer] Artie [Polhemus] hits the button and the thing starts and he did it so perfect! He got me going so hard I just buckled over laughing, then it was like there was a light bulb in my stomach that suddenly broke, and I had a hernia. Angelo gave me a hernia. I was in a lot of pain but I didn't know what I had, so we went up to Washington to shoot. I was in so

much pain that they brought a woman doctor over who was just beauti-
ful, and she examined me and said, "You've got a hernia." I said, "I've
gotta shoot this film," and she said, "That's okay, but you need to get an
operation when you finish." I had to mostly sit down during the shoot.

Anyhow. People were finished with *Twin Peaks*, and *Fire Walk with
Me* didn't go over well at Cannes. It was just one of those times in life
when you can't get arrested. Oh man, that was a horrible, horrible, stress-
ful time, and I got really sick. And when you're down, people just love to
kick you. But it could've been worse. Like I said, with *Dune* I died twice
because I didn't believe in the work I'd done *and* it flopped. I only died
once after *Fire Walk with Me*, so it wasn't nearly so bad. You don't like
the film? Fine. I like it and you really can't hurt me. Well, you can hurt
me a little bit, but I still really like the film. Ray and Grace and Sheryl—
the Palmers are fantastic and I love their world.

I recovered pretty quickly from *Fire Walk with Me* and bounced back
and got to work. It's not about being tough, either. It's about getting ideas
that you fall in love with, and I just stayed home and worked. I didn't
ever really like going outside the house, and now I really don't like it.

Going to Lake Mendota was something new then, and I liked going
there. Mary has six brothers and sisters and her family is great, and the
Midwestern people are so kind and up-front. There's no game-playing
and they're really friendly and nice. I ended up buying a two-story house
on the lake that was a good deal, then I designed a top story and had that
built. Then Johnny W. brought the Little Indian out from Long Island
on a trailer. Johnny wasn't really on my payroll, but he worked on pretty
much everything I did back then and he got the boat for me. I got a big-
ger engine and there was a boat dock there and it was a great setup for
summer. I could paint in the basement, and I also worked at Tandem
Press in Madison, making monoprints with Paula Panczenko, who runs
the place. They had this squeezing machine and a paper that was a quar-
ter of an inch thick. The master printers handmade this paper in the
summer, and that was beautiful stuff.

During the summer of 1993 I was in Madison and a musician named
Yoshiki, who's in a band called X Japan, asked me to make a music video
for him. I said, "Okay, let me hear some music and I'll see if I get any
ideas." So they sent one piece of music over that was basically just talking

with some kind of music in the background, like a poem. I said, "I don't have any ideas," and turned it down, and they called back in a giant panic and said, "We've already announced it!" They offered me more money, so I did this thing for a song called "Longing" that wound up being really fun. I wanted smoke, fire, rain, and different-colored lights, and we went out to the dry lakebeds with rain machines and these thirty-five-foot columns of fire.

We were out there in the dry lakebeds with these lawnmower smokers that put out tremendous billowing clouds of white smoke, but it was windy and all the smoke was blowing out into the desert. So we decided to work on something else, a rain thing or something, and all of a sudden—it was one of the most incredible things—all the smoke that had blown away came rolling back in like a wall. Some of the frames are so fuckin' beautiful you can't believe it. There were a lot of cool things in that video, but it all sort of fell apart and I don't know if Yoshiki ever used it. He wanted the video to end with him sitting at a Victorian desk, writing with a feather quill in his hand and a bottle of ink on the desk, but I thought, That's not going to go with this desert scene, so I didn't shoot it. He hired me and wanted me to come up with an idea, but it's still his video, so I gave him all the footage I shot and that was the end of it.

Another time I'm in the living room in L.A. and my phone rings and there's Michael Jackson on the phone, telling me he wants me to do some kind of trailer for his album *Dangerous*. I said, "I don't know if I can do it; I don't have any ideas for it," but as soon as I hung up and started walking toward the hall, all these ideas came up. I called back and said, "I got some ideas," and I worked on that with John Dykstra in his studio. We built this miniature world that was a red room with a little teeny door, and in the room were these weird modern-shaped wooden trees and a mound with silver fluid that was going to erupt in flames and then reveal Michael Jackson's face. It was stop-action, and it took a long time to do. For me, things don't have to be so exact, but these people working on it plotted it out to the nth degree. The trees were lacquered red or black, and the people who went in to move them wore white gloves and moved them along this precisely marked-out route. That was one part of the thing. The other part was shooting Michael's face, and we had a camera rig for that with a circle of lights that created this fantastic

look of focus with no shadows. All Michael had to do was stand in one place for a few minutes, but he was in makeup for eight or ten hours. How could somebody be in makeup for ten hours? It's someone very critical about their looks. Finally he was ready and he came out and I met him for the first time and all he wanted to do was talk about the Elephant Man. He tried to buy the bones and the cloak and all his stuff from the museum, and he asked me questions and was a really nice guy. Then he stood there and we shot it and one minute later he was done. Obviously he had final cut over it and if he didn't like it he wouldn't release it, but it came out in theaters and it looked cool and I loved doing it.

Hotel Room was based on an idea Monty Montgomery had. The first episode, "Tricks," was written by Barry Gifford and starred Glenne Headley and two of my all-time favorites, Freddie Jones and the great Harry Dean Stanton. I'm sure Harry Dean was a total inspiration to actors, and I didn't want Harry Dean to leave this world. *Hotel Room* was set in the Railroad Hotel, where every room had train pictures on the walls and a view out the window of some railroad tracks down below. The idea was that throughout the years this one hotel room would have hundreds of guests and we would see what happened on a particular day in this room. We did three episodes, and Barry wrote the two I directed and I loved them. I don't know how Jay McInerney got involved with *Hotel Room*—I guess Monty brought him in. Anyhow, the networks hated *Hotel Room*.

They'd hated *On the Air*, too. The idea for that was this live-television thing and all the things that can go wrong. You get a bimbo actress and a foreign director and you try your best and nothing can go wrong, right? And then you see what can happen. That's the humor of it. But nobody wanted it. You know, people go up and then usually they go down, and if they come back up after they've been down, then they've got staying power. Actors like Jimmy Stewart and Henry Fonda and Clark Gable went up, then something happened and they went out of favor a little bit and then they came back. People liked them again and wanted to hold on to them, and they didn't go away again.

Things change, though, and they're always going to keep changing. In October of 1993 I was shooting a Barilla pasta commercial in Rome. We were in this beautiful plaza and the star was Gérard Depardieu, who's great to work with, and it was a funny commercial. The DP was Tonino

Delli Colli, who'd also been the DP for *Intervista* so I met him way long ago when I met Fellini, and now he's my DP on this thing. The production manager on this commercial also worked with Fellini, and one day the two of them were talking and they said, "David, Fellini is in a hospital in the north of Italy, but he's being moved to a hospital here in Rome." I asked if it might be possible to go say hello to him, and his niece made a plan to visit him on Friday night. We wrapped on Friday, and when Friday night came there was the most beautiful sunset. I get in the car and Mary Sweeney is there and some other people—the car is full—and we get to this hospital and out in front are tons of, like, they're not homeless but they're sick people or something, on these steps, and inside it's really crowded. The niece came out of the hospital and leaned into the car and said, "Only David and Tonino can come in," and we got out and started walking with her deeper and deeper into the hospital, until finally we got to a place where there was nobody, just all these hallways, and we went down a long hallway and finally got to the door of Fellini's room. We go into this room where there are two single beds, and Fellini's in a wheelchair between the two beds, facing out. He'd been talking to a journalist named Vincenzo who was in there, and Tonino knows Vincenzo, so the two of them start talking. They got me a chair and I sit down in front of Fellini's wheelchair with a little table attached and he holds my hand. It was the most beautiful thing. We sit for half an hour holding hands, and he tells me these stories about the old days and how things have changed and how it's depressing him the way things are. He said, "David, in the old days I'd come down and take my coffee, and all these film students would come over and we'd talk and they knew everything about film. They weren't watching TV, they were going to cinema, and we'd have these great talks over coffee. Now I come down and there's nobody there. They're all watching TV and they're not talking about film the way they once did." After our time was over I stood up and told him the world was waiting for his next film and then I left. I ran into Vincenzo much later and he told me that after I left that night, Fellini said, "That's a good boy." He went into a coma two days later, then he died.

I think things happen the way they're supposed to happen. When you get old you remember the way it was when you were doing your stuff,

and you compare it with what's happening today and you can't even begin to explain the way things were to young people, because they don't give a shit. Life moves on. One day these days will be *their* memories, and they won't be able to tell anyone about that, either. That's just the way it is, and I think Fellini was in that place. There was a golden age of cinema for Italy and France and he was one of the kings then, really important, so important to cinema, beyond the beyond important. Damn.

Next Door To Dark

Lynch has a vast library of ideas archived in his head, and he often gets an idea and shelves it until another one comes along that marries well with the first one and both ideas ignite to their full potential. On the final night of shooting *Twin Peaks: Fire Walk with Me* in 1991, the idea of disturbing videotapes arriving on the doorstep of an unhappily married couple came to him. The idea wasn't ripe yet, though, so it percolated in the back of his mind while he did other things. Lots of other things. Between 1993 and 1994 Lynch directed six commercials. He built furniture and tried unsuccessfully to get funding for a script he'd written based on Franz Kafka's "The Metamorphosis," set in Eastern Europe in the mid-1950s. Then there was *The Dream of the Bovine,* the absurdist comedy he'd co-written with Bob Engels; that never got off the ground, either.

In 1995 Lynch was invited to be one of forty directors participating in *Lumière and Company,* a celebration of the hundredth anniversary of the birth of film. Participants were asked to make a fifty-five-second film comprising one continuous shot using the original Lumière Brothers camera. In an effort to simulate conditions at the turn of the twentieth century when the camera was invented, the directors were allowed just three takes, couldn't use artificial light, and there were to be no cuts; it was to be a single fifty-five-second shot. "The Lumière project is bite-size David Lynch, but it's as satisfying to watch as any of his feature films," said Neal Edelstein of Lynch's *Premonition Following an Evil Deed.* "Gary D'Amico is a practical-effects guy and a wonderful human being who lives in La Tuna Canyon on a huge piece of property, so we built a set in Gary's front yard. It was one of the most fun things I've ever done. David was massaging four or five segments at once, each had to go off per-

fectly, and it was high-risk filmmaking. We were all laughing like kids that we were managing to pull this cool thing off."

Lynch's film is widely acknowledged to be the most ambitious and successful of the forty shorts. "They thought we cheated," recalled D'Amico of the visual sophistication of the film. Born and raised in the San Fernando Valley, D'Amico got a job sweeping floors at Disney when he was nineteen, worked his way up to the props department, and by the end of the 1980s was a skilled special-effects artist. In 1993 Deepak Nayar called D'Amico to the set of *On the Air* and asked him to create a machine that spit plumbing parts. "I rigged that up and David came over to my trailer to check it out," D'Amico recalled, "but he was more interested in looking at my stuff, because he's a nuts-and-bolts guy. David is very hands on and loves building things, and the day we met he struck me as inquisitive, low-key, very polite, and calm as a Hindu cow.

"When they were preparing the Lumière project, I got a call from his office and they said, 'David wants you to work on this thing.' They gave me the date and I said, 'I booked a commercial and can't get out of it.' I hear his assistant holler, 'Gary's on a commercial that week and isn't available,' and David said, 'We can't do it without Gary,' and pushed the shoot until I got back! Every director should go to the David Lynch school for how to treat people on set. He's a total pro and a super guy, and there's not a finer person in the industry."[1]

Lynch went to work on a new script during that period, too. In 1992 he'd optioned a novel by Barry Gifford called *Night People,* and some passages of dialogue in the book stuck in his head. Two phrases in particular seemed to sidle up next to that idea he'd had back in 1991 about mysterious videotapes. "That's a beautiful thing David does," said Sweeney. "He takes random things and unifies them to create a world."

Early in 1995 Lynch contacted Gifford. "David called one day and said, 'Barry, I want to do an original film together, and we're gonna do it if I have to finance it myself,' and he came to my studio in Berkeley," Gifford recalled. "He said he was struck by two bits of dialogue in *Night People.* A woman says, 'We're just a couple of Apaches riding wild on the lost highway,' and Mr. Eddy says, 'You and me, mister, we can really out-ugly the sum'bitches, can't we?' So those were the starting points.

"David was staying at a nearby hotel," Gifford continued, "and at seven

minutes to nine every morning he'd call and say, 'Barry, I'll be there in exactly eight and a half minutes,' and eight and a half minutes later he'd walk in with a big cup of coffee. We spent a couple of weeks writing what we liked on a legal pad, then Debby Trutnik typed it up."

A second draft of what came to be titled *Lost Highway* was completed in March, and a shooting script dated June 21st was finished three months later. As with *Hotel Room,* the writing in *Lost Highway* is minimal; you don't learn what the story is about through the things people say, and the physical action is deliberate and slow. The story of a man who may or may not have murdered his unfaithful wife, *Lost Highway* explores themes of paranoia and shifting identity and is Lynch's most classically noir film. It's one of his toughest and darkest, too.

Lost Highway was a joint production of Ciby 2000 and Lynch's company, Asymmetrical, but early on, Joni Sighvatsson was interested in getting on board. In 1994 Sighvatsson partnered with Tom Rosenberg and Ted Tannebaum to launch the production company Lakeshore Entertainment, and he recalled, "I wanted to do *Lost Highway* at Lakeshore and offered David a budget of six million dollars. He had the check in his hand, but before going forward I said, 'David, nobody is going to understand what's going on with one actress playing two different characters and two different actors playing the same character.' He said, 'What do you mean? It's obvious!' He was adamant this wasn't a problem, so Lakeshore didn't make that picture."

Ciby 2000 was totally game, despite the unconventional aspects of the script. Challenging the veracity of linear time, *Lost Highway* is a kind of existential horror film that was summarized by *The New York Times*'s Janet Maslin as "an elaborate hallucination that could never be mistaken for the work of anyone else." The story of an avant-garde jazz saxophonist who morphs into a teenage garage mechanic, and a suburban wife who morphs into a porn star, it's a startlingly original film that has echoes of Ingmar Bergman's *Persona* and Robert Altman's *3 Women.*

Bill Pullman plays a jazz musician named Fred Madison who's in the grip of a psychogenic fugue, a psychological condition that causes him to abandon his own identity and take on a new one. A form of amnesia, psychogenic fugue allows the mind to protect itself *from* itself when reality becomes unbearable. Lynch has said the film was partially inspired by the murders of Nicole Brown

Simpson and Ron Goldman, and the televised trial of O. J. Simpson, which he found riveting. Like Fred Madison, Simpson seemed to have persuaded himself that he had no complicity in the crime that had been committed.

It's a sinister story, but Lynch's set was copacetic. "When I met David I felt like I was meeting a member of the family," recalled Pullman. "It was like we were tuning forks humming together, and once we got on the set I could see that everybody else felt the same way about him—David's very good at narrating the day so everybody feels like they're part of the same creative act. I loved his sense of humor, and the way he expresses himself felt very familiar, maybe because he has that country background. David has a sense of the bounty of the land and we share a Montana connection. He spent time there with his grandparents as a child, and his son Riley worked on the ranch my family has there.

"We had a little shorthand for my character," Pullman continued. "I don't know which of us said it, but the shorthand was 'it goes kabuki,' which meant that what happens in the scene moves into some kind of ritualistic modality and unknowable mystery involving masks. Kabuki meant all that."[2]

Co-starring as Pete Dayton is Balthazar Getty, who made his film debut at the age of fourteen in Harry Hook's 1990 film adaptation of *Lord of the Flies*. The great-grandson of J. Paul Getty, he was cast in *Lost Highway* after Lynch saw a photograph of him in a magazine and called him in for a meeting. "David's a very intuitive guy, and he basically said then and there that I was the guy for the job," Getty said of the meeting.

"The only person who has the big vision on a Lynch movie is Lynch, and Patricia [Arquette] and I didn't even know what kind of movie we were making when we were shooting," Getty continued. "When I finally saw the film I had no idea it was going to be so frightening. Patricia and Bill coming in and out of that dark hallway, the heavy sounds—none of that came across in reading the script, and so much in it was open to interpretation. Part of David's technique is to keep his actors guessing, because it creates a certain atmosphere on set.

"David's very into details of production design and wardrobe, and I remember him dressing the set as we prepared to shoot a scene," Getty added. "He went to the corner of the room and placed something there—some coffee beans, I think—that the camera and the audience would never see, but David has his process and he needed that to be there."[3]

Getty had just turned twenty-one when he was cast in *Lost Highway,* and

the shoot was challenging for him. "Early on we shot a scene where Pete is sitting at home with his parents, and I was supposed to just look at them," Getty recalled. "We did take after take and finally, when we got to around take seventeen, David said, 'Let's break for lunch and we'll get it when we come back.' I went to my trailer and was just devastated. David's somebody you want to make happy and I was actually crying, thinking that I couldn't deliver. Then he sent a note during lunch that said, 'Imagine being a child and seeing a hummingbird buzzing around your father's head as he speaks to you. What would that child's face look like? What would it be like to see fire for the first time? What kind of wonder and amazement would you feel?' Pretty out-there stuff, but it was effective, and after lunch we got it in one take and moved on.

"There's another scene where Patricia and I meet at a hotel and she lays out a plan she has for a robbery," continued Getty of Lynch's directing strategies. "I was struggling with the scene and finally David had me sit on my hands and do the scene that way. Actors use their hands to communicate, so sitting on my hands forced me to go deeper and play the scene entirely with my face, which is what David wanted."

Pullman had to pull off challenging things, too, including a frenzied saxophone solo that spins out into the stratosphere. "Angelo wrote a piece of music, and a session musician named Bob Sheppard was hired to perform it," Pullman recalled. "David said, 'This will be easy for you. You'll just get with the guy who played it and he'll show you how he played it.' I got hold of Bob and said, 'I'd like to film you playing the solo,' and he said, 'I can't play it again like that.' Apparently David was in the studio with him and after each take David would say, 'Crazier! I want the whole thing crazier!' So he got into a state and gave David what he wanted, but he said, 'I can't get that back and I don't *want* to get it back. You're on your own.' It was one of the hardest things I've ever done, and the applause I got from the crew after I did it is one of the most cherished of my career."

Lost Highway has not one but two Frank Booths, one of whom is a menacing pornographer named Mr. Eddy, played by Robert Loggia. While Pullman was working with him on the 1996 science-fiction blockbuster *Independence Day*, he gave the *Lost Highway* script to Loggia, who immediately loved the character of Mr. Eddy. Loggia turns in a hilarious set piece in the film, too. When a driver unwisely decides to tailgate him, Mr. Eddy proceeds to use his own car as a battering ram and forces the offending driver to the side of the

road, where he gives him a lecture on the dangers of tailgating as he beats him to a bloody pulp. This is Lynch's sense of humor at its wicked best.

Equally terrifying is the Mystery Man, played by Robert Blake. A child star who grew up to turn in an acclaimed performance in Richard Brooks's 1967 film adaptation of Truman Capote's *In Cold Blood,* Blake gives an eerily detached performance that conveys how subtly evil can invade everyday life. Blake's character makes the point that evil never arrives without being beckoned. "You invited me," the Mystery Man tells Fred Madison. "It's not my custom to go where I'm not wanted." Five years after *Lost Highway* was released, Blake was arrested and charged for the 2001 death of his wife, Bonnie Lee Bakley, and was then acquitted in 2005. *Lost Highway* features his final screen performance and the last onscreen appearances for Richard Pryor and Jack Nance, too.

Following the 1994 death of the owner of the house next door to the two houses Lynch owned, he purchased this third house with plans to transform it into a soundstage with a recording studio. The property was poised to be gutted when location scouting for *Lost Highway* began, and after searching unsuccessfully for a site for the Madison house—a primary location in *Lost Highway*—they decided to temporarily transform Lynch's new house into a set. Some key plot points in the film revolve around the Madison house, which has peculiar architectural elements, including windows in the façade that are best described as a network of vertical and horizontal slots, and a long hallway leading into darkness.

"David's very specific about what he wants," said assistant location manager Jeremy Alter, who was raised in Fort Lauderdale, Florida, and came to L.A. in 1989 to study film at UCLA. "I spent almost the entire shoot looking for the house where Balthazar Getty's character lives. David said, 'I want a house with views into adjacent yards, a garage on the left side, a big living room, a serving area in the kitchen, a backyard without a pool, a hallway off of the main area, and a bedroom big enough for a motorcycle. I must've looked at a hundred and fifty houses."[4]

After two weeks of rehearsal with Pullman, Getty, Arquette, and Loggia— "Robert Blake required no rehearsal," said Lynch—the shoot commenced at Lynch's house on November 29th with Peter Deming manning the camera. A graduate of the AFI's cinematography program, Deming entered Lynch's orbit

in 1992 when he shot six episodes of *On the Air* and all three episodes of *Hotel Room*. *Lost Highway* was the first feature they made together, and Deming has worked steadily with Lynch ever since.

"I read the script, and the first day of shooting was a daytime scene in the Madison house," Deming recalled. "I set up the lights, but once I saw the first rehearsal I turned to the crew and said, 'We've got to start over.' You don't get what's going on in that scene from the words on the page. Although the dialogue in that scene is banal, there's a huge amount of tension in it. Less is always more with David, and he can do so much with so little in terms of dialogue and where he has people pause; we were shooting a simple conversation where nothing much is said, but the mood between the two characters is incredibly intense."[5]

A key part of Deming's learning curve with Lynch involved lighting, which is a crucial element of Lynch's visual style. "David wanted some of the night scenes so dark—even the interiors—that it became a joke between us and we created a scale of darkness," said Deming. "He'd say things like, 'This is next door to dark.' There's a scene where Balthazar's character is heading out for the night and he passes his parents in the living room and they say, 'Sit down, we need to talk to you.' There were two lamps in the living room, and when David came on set he said, 'Why are those lamps on?' I said, 'They're sitting in the living room. You don't want them sitting in the dark, do you?' Which was a stupid question to ask David Lynch. He said, 'No, but there shouldn't be lights on in here. The room should be lit from the porch light outside.' So we ripped everything out and relit it with one light out in front of the house."

The film was produced by Sweeney, Tom Sternberg, and Deepak Nayar, who had a vivid memory of a night shoot in the Southern California city of Downey. "We'd taken over a big street and we had cars and there was a stunt sequence and everything was outside," he recalled. "At six o'clock on the evening of the shoot, I get a call from Peter Deming saying that it's raining. We'd already shot the scenes that preceded and followed the scene we were shooting that night, and it wasn't raining in them, so I called David and said, 'This is one of our biggest days, the cost of running this thing is huge, and we need to carry on shooting tonight. Can we shoot this indoors?' He immediately said, 'Nope. We're gonna shoot outside. Get me two hoses, two good-looking boys, two good-looking girls, and have them there when I get to the set.' David came

up with the brilliant idea of having these four kids playing with hoses and getting each other wet, so the water in the scene looked like it was coming from the hoses rather than from the sky."

As is probably clear by now, everyone who works with Lynch marvels at his ability to think on his feet, including Deming, who recalled, "The last night of shooting was a desert scene involving a dilapidated shack, and we'd actually wrapped when David turned to Patty Norris and said, 'What's gonna happen to the shack?' She said, 'The art department will take it apart tomorrow,' and David said, 'Can we blow it up?' She laughed and David said, 'Seriously, can we blow it up?' Then he called Gary D'Amico over and said, 'You got any gasoline, Gary?' Gary said, 'Gee, David, I wish you'd told me about this—I'm not sure I have what I need to do it.' Gary then set out to find what he needed, and shortly after that he was planting gasoline charges in the shack."

D'Amico concurred: "David pulls lots of stuff out of his hat. When we blew up the shack I expected a huge explosion, but the wind was blowing so intensely that it was hard to get anything to blow outward, so the building kind of went up like the Hindenburg. It wasn't what I planned, but the second I pressed the button David said, 'That's the most beautiful thing I've ever seen.'"

Filming continued through February 22nd of the following year, making it a relatively long shoot. "Typically you can't wait for a shoot like that to end, because it's exhausting," said Deming, "but everybody was sad when we wrapped because it's such a fun adventure working with David. There's an element of surprise every day and he challenges you to come up with stuff."

"David's never happier than when he's shooting," said Sweeney, "because it's like he's got this big machine helping him realize the vision in his head." Lynch was able to take his time with *Lost Highway*, too, and after wrapping principal photography, the film was in post-production for months. "Those were the glorious old days of gestation," said Sweeney, "and the post on *Lost Highway* lasted for six months, which is unheard of today. The second house turned into a hive, and the top floor was taken over by benches and assistants running around.

"There was a stretch of four or five months during post when we had Friday night cocktail parties," she continued. "Marilyn Manson came, Monty Montgomery, sales agents from Ciby—word got around, and people who came

regularly would bring other people. Late nights, lots of red wine, cigarettes, and David regaling everyone with stories."

In 1995, Lynch's family expanded with the birth of his only grandchild, Syd Lynch. "Dad's been extremely generous to me in many ways, and he's the reason I was able to have my daughter," said Jennifer Lynch. "I got pregnant and didn't know what the fuck I was gonna do, and I didn't have a good enough reason not to have the baby, and Dad said he would help. And he did." Lynch is something of an absentee father—you aren't likely to see him at a high school play—but he shows up for his children when they really need him.

Lynch lost a family member of sorts on December 30th, 1996, when Jack Nance died under mysterious circumstances at the age of fifty-three. An alcoholic who'd been sober throughout the 1980s and early 1990s, Nance's life took a dark turn in 1991 when his wife of six months, Kelly Jean Van Dyke-Nance, committed suicide. Nance himself died of a head injury following an altercation with two men outside an L.A. donut shop, and although his death was investigated as a homicide, no arrests were ever made. His presence is a pungent seasoning in Lynch's work from *Eraserhead* through *Lost Highway*— with the exception of *The Elephant Man* he appears in all of Lynch's films— and his premature death was a significant loss for Lynch.

Distributed by October Films, *Lost Highway* opened in the United States on February 21st, 1997, and didn't do well at the box office. And as is usually the case with Lynch's work, critics were split regarding the merits of the film. "Lynch has forgotten how boring it is listening to someone else's dream," said *Newsweek*'s Jack Kroll, while *Film Threat* hailed *Lost Highway* as a "wholly fascinating look into the psychoses of the human mind," and *Rolling Stone* summarized it as "the best movie David Lynch has ever made." Nobody is neutral on the subject of Lynch.

And you've got to hand it to him. He was on probation with the critics when he decided to make *Lost Highway,* but he charged forward anyway and turned out one of the most inscrutable, difficult pictures of his career. With a running time of two hours fifteen minutes, this is not a user-friendly movie. Unrelentingly dark, with a fractured, nonlinear plot that defies easy explanation, and sex scenes that opened him to accusations of misogyny, *Lost Highway* is a

kind of declaration of independence. Critics didn't like *Twin Peaks: Fire Walk with Me,* but with *Lost Highway* Lynch reminded the film community that he wasn't making movies for them and was answering to the higher authority of his own imagination. When writer David Foster Wallace did a location piece on *Lost Highway* for *Premiere* magazine he raised the question of whether David Lynch "really gives a shit about whether his reputation is rehabilitated or not. . . . This attitude—like Lynch himself, like his work—seems to me to be both grandly admirable and sort of nuts."[6]

As usual, Lynch had a lot more than a movie going on; in 1996 he had art exhibitions at four venues in Japan, and the following year there was an exhibition at Galerie Piltzer in Paris, a city that was to become a kind of second home for him. The paintings he was producing during this period are potent and disturbing. In *Rock with Seven Eyes,* from 1996, a black ellipse with seven randomly placed eyes hovers in a mustard-colored field; it could be read as a portrait of consciousness, a UFO, or a black hole. In *My Head is Disconnected,* from 1994–1996, a male figure waves to the viewer as his head drifts away encased in a cube. The bluebirds of happiness that occasionally turn up in Lynch's films rarely make an appearance in his visual art.

In April of 1997 the Salone del Mobile, in Milan, Italy, presented a collection of Lynch's furniture that had been produced in a small edition by the Swiss company Casanostra. Selling for between fifteen hundred and two thousand dollars, and drawing on various sources of inspiration including the Bauhaus, Pierre Chareau, Richard Neutra, and Charles Eames, Lynch's pieces tend to be more sculptural than utilitarian. He thinks most tables are too big, too high, and cause "unpleasant mental activity," and his Espresso Table (designed in 1992) and Steel Block Table feature small surfaces best suited to a coffee cup or an ashtray.

By the time Lynch's furniture made it to that Italian showroom, his deal with Ciby 2000 had totally unraveled. "That was an unusual deal for David to make, because it was a little restrictive," recalled Sweeney. "They were guaranteeing total creative control, but there were all these markers on the path to a green light that we had to meet, and we worked vigilantly with our lawyers to make sure we hit all those marks. But things still went south after Francis Bouygues died between *Fire Walk with Me* and *Lost Highway*.

"David had a pay-or-play three-picture deal, but he'd only made one film when Francis died, and by 1997 they were saying we were in breach of meet-

ing the terms of the contract—terms we'd been careful to satisfy to the letter," Sweeney continued. "They claimed they didn't have to pay millions of dollars that David was owed for pictures two and three, but we had a paper trail documenting everything that transpired. The case started in Los Angeles, then they managed to get it in the jurisdiction of France, and David's brilliant lawyer, George Hedges, got the French courts to freeze the assets of the company until this was resolved, and they were forced to settle the case."

Movie business skirmishes of this sort remind Lynch of the way he really likes to work: Given his druthers, he'd rather be alone in a studio, building every part of an artwork—be it a film or a painting—by himself. At that point he decided to stay home for a while and make records instead.

Lynch's home recording studio was operational by the end of 1997, and musician and engineer John Neff had come on board to run it. On August 25th, 1998, Lynch released *Lux Vivens* (*Living Light*), a collaboration with British musician Jocelyn West. Lynch had met West—who was married to Monty Montgomery at the time and went by the name Jocelyn Montgomery— two years earlier, when he was working in a New York recording studio with Badalamenti and she stopped by to meet him. She wound up spending the next seven hours recording a vocal for "And Still," a song Lynch wrote with studio owner Artie Polhemus's wife, Estelle Levitt. Lynch and West worked well together, and once the studio was completed he invited her to work with him. The music on *Lux Vivens* is based on verses by Hildegard von Bingen, a twelfth-century German artist, musician, and visionary Benedictine abbess whose compositions are largely comprised of single melodic lines.

Shortly after winding things up with Montgomery, Lynch met another singer who inspired him. Born in Texas in 1978, Chrysta Bell was lead vocalist for the gypsy swing band 8½ Souvenirs as a teenager, and by the time she was nineteen was a solo act managed by Bud Prager, the powerful music-industry figure who gave the world Foreigner. Prager landed a meeting with Brian Loucks, who listened to Chrysta Bell's demo and said that she and Lynch might work well together.

"Several weeks later I met David in his studio," Chrysta Bell said. "We knock on the door and David opens it, and he has a cigarette hanging out of his mouth, and the hair, and the white shirt half tucked in, and the khaki pants splattered with paint, and he gave me a hug and said, 'Chrysta Bell!' I wasn't expecting that warmth—he was really helping me out.

"That first meeting lasted for hours. I played David the demo for a song called 'I Want Someone Badly,' and he said, 'I love your voice,' then he played some tracks he'd done and went downstairs and brought back lyrics he'd written. David had tracks and lyrics, and my job was to bring melodies that would tie those things together. We recorded a song that day called 'Right Down to You,' and at the end of the day David said, 'I'm thinking of starting a record label, and I'd like to make more music with you.' I told him I was signed to RCA, and it seemed like that was the end of things."[7]

As it turns out, that wasn't the end of things for Chrysta Bell and Lynch, but it took a while to get their partnership on track. Lynch was about to get insanely busy with other things.

W HEN I'M NOT working on a film, I never feel anxiety like, Oh, I should be working on a film. No. You make something when you get fired up and you have a desire, but if nothing's coming along, or you don't have any ideas for something, or you're in the idea pool for painting, then that's what you do. It was a while before I caught another movie idea. For many years I didn't have an idea for a film, and during that period I saw the cinema world changing before my eyes. The transition to digital was happening, people weren't interested in cinema, and the art houses were dying like the plague. Eventually there will be no theaters and the majority of people will see films on their computers or their phones.

A lot of different stuff was going on then, and I got talked into a lot of things in those days. People would come and ask about something and I'd say okay, even though it wasn't something I was trying to get going, and they just wanted me to be involved in their thing. I don't know that I've learned to stop doing that, but I think I have. I'm not a company and I say no to a lot of things.

In 1995 Lumière and Company called and said that forty directors from all over the world were being asked to make short films using the original Lumière Brothers camera made out of wood, glass, and brass. It's a hand-cranked camera with a little wooden magazine that holds fifty-five seconds of film, and I thought it sounded cool, but I had no ideas. Then I was in the woodshop and I got this idea of a person who's been killed—I still have the original drawing I made when I got the idea—and we got working on it pretty fast. We built a hundred-foot dolly track in

Gary D'Amico's yard and [special effects engineer] Big Phil [Sloan] was running it, and another Phil who worked with Gary made this big box that went over the camera, and when you pulled this wire these doors in the box would fly open and you could shoot. Then you'd pull it again and the doors would bang shut for a tiny instant while the camera moved on the dolly from one set to the next. There was a shot of a body in a field, a woman on a couch, two women dressed in white with a deer, a huge tank Gary built with a nude woman in it, and some men walking around carrying these stick-like things. Then you move through smoke to a sheet of paper that explodes into fire and reveals the final set. You couldn't miss a single mark, and you only had fifty-five seconds to make all these changes, and it was thrilling. They had a Frenchman cranking the camera—he went everywhere with it—and we had six or seven people on the dolly, and there were like a hundred people there and everybody had a thing to do. The woman in the tank was named Dawn Salcedo, and she did a great job. She could only hold her breath for so long, but everything had to happen at a precise time and she had to be in the tank holding her breath when we arrived at the tank. At the beginning of the film there's a woman sitting on a couch who's having a premonition, and as soon as we got that shot, these guys had to get in there and move the couch to the last set. It was so much fun.

During that period after *Fire Walk with Me*, I was trying to get this film going called *Love in Vain*, based on a script I read a long time ago by this fellow from Brooklyn named Alan Greenberg. It came out later, in 2012, as a book called *Love in Vain: A Vision of Robert Johnson*, but he wrote it as a script first. This Jewish guy from New York wrote the blackest story and I wrote to him and told him I really liked his script and he came around with producers a few times over the years, but it never happened. It's Robert Johnson's crossroads story, and it would be an abstract period film set in the South. The feeling in the script was that there are the blacks and their world and there's no way a white person could ever know what that is. It's a thing, and music comes out of it, sex comes out of it, Sterno, rabbit's foot, piney woods, juke joint, milling around, and people calling out. It doesn't matter if you spent the day picking cotton. It's what happens after you finish picking cotton, and it's beautiful, all the little sheds, these women and the way they communicate without

talking, and the magic of this music. The myth is that Robert Johnson couldn't play guitar until he met the devil at the crossroads, and after that he could play like crazy. He was asked to play at a party at a man's house, so the party is going on and the man's wife is getting drinks for Robert while he plays. When she took the drinks to him she was rubbing herself on him, and Robert's getting drunk. The husband sees what his wife is doing and puts poison in Robert's drink, and Robert Johnson dies crawling in the grass in agony.

Around that time I was also trying to get *Dream of the Bovine* going. *Dream of the Bovine* is sort of in the same realm as *One Saliva Bubble* in that they're both about misunderstanding and stupidity, but *One Saliva Bubble* is more normal and is kind of a feel-good movie. *Dream of the Bovine* is an absurd comedy. The script needs a lot of work, but there are things in it that I really like. Harry Dean and I went up to talk to Marlon Brando about the two of them doing it together, but Brando hated it. He looked me in the eye and said, "It's pretentious bullshit," and he started telling us about these cookies made out of grass that grows in salt water that he wanted to promote. Then he told us about a car he wanted to build that had this bladder underneath that would cook this grass and make fuel, like the car would digest the grass. You could never tell if Marlon was putting you on or he was serious.

The thing about Marlon was, he just didn't give a shit about anything. Every business has bad behavior going on, but there's something about this business, with all the egos and lies and backstabbing, that makes you want to do something else rather than be in it. For sure, if anybody had that feeling it was Brando. He played the game for a while, then he couldn't do it anymore because it made him sick, and he'd reached a point where he just wanted to have fun. In a weird way I think he was having fun, too, and it was fun talking to him. This was around the time he went on *The Larry King Show* and kissed Larry King.

He came here to the house a couple of times. One time he came up here by himself—I guess he'd driven himself—and he came in big, you know, just being Brando in this house. It made me a little nervous because I didn't know why he was here or what we were going to do. I figured I'd make him a coffee, but right after he got here he says, "So, you got anything to eat?" I thought, Oh my God, but I said, "Marlon, I don't

know, let's go look." There was one tomato and one banana in the kitchen and he said, "Okay, that will do," so I got him a plate and a knife and fork and we sat down and started talking. Then he says, "You got any salt?" So he was salting the tomato and cutting it up and eating it while we were talking. Then Mary came over with Riley, and Brando says, "Mary, give me your hand, I want to give you a gift," so she put her hand out. He'd made a little ring out of the Del Monte sticker that had been on the tomato and he slipped it onto her finger.

Marlon was dressing in drag now and then during that period, and the thing Marlon really wanted to do was dress up as a woman and have Harry Dean dress up as a woman, and the two of them would have tea together and ad-lib while they were drinking tea. Think about that. It would've been fucking incredible! All I'd have to do is turn the camera on, but Marlon chickened out. It would drive me nuts. He should've done it!

One of the ways *Lost Highway* started was with the idea of videotapes being dropped off outside the house of a married couple. Another beginning idea was based on something that happened to me. The doorbell at my house was hooked to the phone, and one day it rang and somebody said, "Dick Laurent is dead." I went running to the window to see who it was, but there was nobody there. I think whoever it was just went to the wrong house, but I never asked my neighbors if they knew a Dick Laurent, because I guess I didn't really want to know. So I had these ideas and they married up with some ideas I got from Barry Gifford's book *Night People*, so I called Barry, then I flew up to Berkeley and met with him. I told him my idea and he didn't like it, then he told me his idea and I didn't like it, so we sat there and looked at each other for a little bit. Then I think I told him the idea of being at a party and meeting someone who tells you that they're at your house at the same time that they're talking to you, and Barry said, "I like that idea." Somewhere along the line we started riffing and *Lost Highway* came out.

It's not a funny film, because it's not a good highway these people are going down. I don't believe all highways are lost, but there are plenty of places to get lost, and there's some kind of pleasure in getting lost—like

Chet Baker said, let's get lost. And look what happened to him. He fell out of a window. Everybody's searching for somebody, and when things get crazy you have a desire to get lost and do something, but lots of things you do get you in trouble. Taking drugs is a way of getting lost. There are so many good things about drugs that it's a hard sell telling people not to take them, but you pay a price for taking them that's worse than the good feeling they give you.

Around that time I had an office on Santa Monica Boulevard and I wanted to talk to some police detectives, so this man, Commander White, came to the office. Beautiful suit, kind of gray-white hair, movie-star good looks—Commander White comes into a conference area where a few of us had gathered and he talked to us. Afterward he invited me to visit the LAPD robbery/homicide division, so I go down to his office and he's sitting in there with Detective Williams and Detective John St. John. I got to ask them a bunch of questions, and one thing I asked them was whether they'd ever met a criminal they were afraid of. They said never. Never! It's like they were almost offended that I'd think they could be afraid of these scumbags—"dirtbags" is what they called them. You get the feeling that you have to be a certain way to do that job. These fucks don't bother them—they just get 'em.

After the meeting, John St. John took charge of me and he put me in a room with stacks and stacks of photos and left me alone to look at them. One murder victim after another, the real deal. I met with him two or three times and he would tell me stories, and the stories were interesting, but they didn't ever conjure anything for me. They were mostly kind of sad stories. He told me about these homeless guys that somehow got the money to get a forty—a forty-ounce bottle of beer. It was one of their birthdays, so they go into an abandoned house with this beer and start drinking, and then they start fighting. The bottle of beer gets broken and one of them grabs the neck of the bottle, which now has a super-jagged edge, and jams it into the chest area of the other guy. This guy bleeds out in the front yard of this abandoned house on his birthday.

John St. John was the second detective on the Black Dahlia murder, which is a story that gets people going all over the world, and he knew I was interested in that story. So one day he calls me—and this is like getting a call from Clark Gable—and he says, "Let me take you to dinner at

Musso & Frank's." This is a real honor, I'm not kidding. So I'm sitting in a booth at Musso & Frank's with John St. John and we have dinner, and after dinner he looks at me and sort of smiles. Then he turns away and goes to his briefcase, pops it open, and takes out a beautiful, glossy black-and-white photo that he lays on the table in front of me. It's a picture of the Black Dahlia lying in the grass, and it's in mint condition. The focus and the detail were perfect. He says, "What do you see?" I'm looking at this thing, just marveling, and I study every single detail and I'm thinking and thinking. He let me look at it for a long time, and I knew there was something he wanted me to see, but after a while I finally had to say to him, "I don't see it," and he smiled and took the photo away. He would've been proud of me if I'd seen what he was trying to show me, and that would've been worth a lot, and I fuckin' failed. So I kept thinking of this thing like a burning anvil in my head, then suddenly I knew what it was. That picture was taken at night with a flash, and that opens up a whole realm of possibilities regarding that case.

I'd always wanted a recording studio, and when I signed with Francis Bouygues I got a good advance and that's maybe when I felt the richest I'd felt in my life. So I got a third house so I could build a studio and use it for *Lost Highway*. The Madison house is sort of based on the Pink House, but it had to be reconfigured in certain ways for the film; the house needed to have windows that make it impossible to see who's at the front door, and it needed a long hallway that leads into darkness. We shot at the house for only ten days, then Alfredo [Ponce] and the team started tearing it apart. Then it took two years to put everything back together and build the studio. This acoustic architect named Peter Grueneisen, who was one of the founders of Studio Bau:ton, designed my studio, and it was as big as I could get it. The studio is huge and it's beautifully put together. There are two sets of foot-thick walls with neoprene rubber in between, three floors and three ceilings, and there's so much money in concrete and steel in the thing it's unreal. I'm glad I built it, but nowadays you don't really need all this, and people mix great stuff in their garage. Dean Hurley runs the studio, and Dean is solid gold.

The first record we produced in the studio was this thing called *Lux Vivens: The Music of Hildegard von Bingen*, which I did with Jocelyn Montgomery in 1998. Hildegard von Bingen composed elaborate music that's mostly built on a single note, and Jocelyn could take off from that single note and go into all this beauty. I wanted the music to feel like it was made in nature, so there's all this other stuff going on, too, like sound effects of rain, and her voice floating, and drones. This record happened because of Monty Montgomery. I don't know how Monty met Jocelyn, but I was in New York at Excalibur Studios working on a song with Angelo, and Monty calls and says, "David, I know this girl, and would you mind if she came by and sang for you?" Artie Polhemus ran that studio, and his wife, Estelle, had been a lyricist in the sixties and she was really good. She didn't come to the studio much, but whenever she did, Artie would just sit her on the couch and she'd stay there. She was there that time, and she and I were working on this song together called "And Still." I'd write one line of lyrics and give it to Estelle, then she'd write the next line and give it back to me, and we'd go back and forth. So Monty calls, then Jocelyn comes over and we ask how would you like to sing this thing, and she says, "Fine." She brought her fiddle along—she's also a fiddler—and she plays fiddle on the song, too. Her fiddle playing and her voice are beautiful.

Francis Bouygues died in 1993, but the deal with Ciby stayed together until *Lost Highway*. Then somebody—probably one of those men sitting next to Francis at that meeting I told you about—got ahold of the whole thing and they just stopped making films. Those were the people I ended up suing, but that didn't happen until a couple of years later.

When it was time to cast *Lost Highway*, I thought of Bill Pullman to play Fred Madison because I'd seen him in lots of films always playing sort of second fiddle, but there was something in his eyes that made me think this guy could play somebody strange and tough and different. Fred Madison is a sax player but he's possibly a little bit deranged, so he plays a certain way, especially when he's really getting into it. So we're recording Fred's sax solo with this musician named Bob Sheppard in the recording studio at Capitol Records, and Bob does a take and I tell him,

"I can barely hear you. It sounds like church music." So he'd play a little harder and I'd say, "It's a mosquito; there's no feeling there at all; you're not wild at all." I had to push him, but he finally got into this place, and once he got there he killed it. The same thing happened with Robert Loggia in the tailgating scene. I told him, "You're whispering, Robert. What are you doing? There's no power there *at all*." He said, "David, I'm yelling!" I said, "No, you're not! Come on! This is a man who is obsessed!" And finally he got there and did it just great.

The way Robert Loggia came to be in *Lost Highway* went back to *Blue Velvet*. One day when I was casting that film, I was working on a scene with two actors, and Robert Loggia was waiting to test for Frank Booth. I was so long working with these two actors that we ran out of time, so somebody went and told Robert Loggia, "You're not needed," and he hit the fucking roof. He came in screaming at me, like so mad — it was scary. But I remembered that and that's how he wound up playing Mr. Eddy in *Lost Highway*. See, one thing leads to another, and when we worked together on *Lost Highway* we got along like Ike and Mike. We had so much fun.

This is how Robert Blake became the Mystery Man. I once saw Robert Blake on *The Tonight Show* being interviewed by Johnny Carson, and I remember thinking, Here's a guy who doesn't give a shit about this so-called industry. He just tells it like it is and is his own guy, and I really liked that. So I had that in the back of my mind, and when I was casting *Lost Highway* he came up and met with me at the Pink House and we had a great talk. I don't know if they dated, but he was close with Natalie Wood, and he told me she never would've gotten in a boat, ever, because she was so afraid of water. Robert Blake was a child actor and was in the second generation of the *Our Gang* comedies, which I loved. His parents put him on the stage when he was three years old and he hated his parents, his mom in particular. I remember him saying, "I hated being in her womb." I don't know what they did to him, but the poor guy was just filled with hate for his parents. Robert was good to me, though. He called me Captain Ahab and said he didn't understand shit about the script but that he still liked doing it—and he's really good in it. The makeup for his character was my idea, but it was his idea to shave off his eyebrows. Richard Pryor is someone else I saw on a talk show and kind of

fell in love with. He'd been through a lot in his life but he had a wisdom that was really beautiful, and there was greatness in him that just came through. So when there was a spot for him in *Lost Highway* I really hoped he'd do it, and it was great having him in the film.

The music in *Lost Highway* came along in different ways. I somehow got involved with Trent Reznor and went down to see him in New Orleans, where he had a recording studio in a funeral home. On that trip he introduced me to Marilyn Manson, who was there doing his first album with Trent. Trent's a hell of a musician and a hell of a drummer, and he did these great drum things for *Lost Highway* and gave me lots of tones and sounds. He had a wall twenty feet high and thirty feet long lined with synthesizers that could do different things. Lou Reed's version of "This Magic Moment" is in the film, too, and it's the all-time best version of that song. I love the drums in that song and I love the way Lou sings it and it's perfect for that scene. And Bowie's song "I'm Deranged" was perfect for the opening; the lyrics are just right. I met David Bowie on *Twin Peaks* and then I saw him two more times. I saw him at the Masonic Lodge on Highland Avenue when we were both there to see Portishead. We were in the back, smoking. I love Portishead, but this room had so much echo that the music was just mush.

Around that time I was making a lot of furniture, too. I look at furniture and everything's subjective, but I just don't see a lot of furniture that thrills my soul, and it drives me to think, What kind of furniture would I love? I like furniture from the 1930s and 1940s, and I like atomic furniture because it floats, and the legs are thin, and you can see under it—a lot of furniture blocks views. I like Vladimir Kagan, and Charles Eames, too—Charles Eames is the guy. I love his stuff. I had lunch with him once when he visited the AFI while I was a student there, and he was one of the nicest people I've ever met. He was filled with enthusiasm like a bright star, and you could feel that he loved what he was doing.

Furniture and sculpture obey a lot of the same rules, but you don't have to be able to sit comfortably on a sculpture. Furniture has to be somewhat practical, but I like furniture that borders on sculpture, and you need a pure room for furniture to be in, too. Most rooms, if you put something in them, it gets lost because they're so cluttered, so the more pure the room, the more the people and the furniture can come forth.

Lost Highway was in post-production for almost a year, which is, like Mary said, something you could never get away with now. We had a real dirt problem with that film, and the negative was just filthy. We were at CFI but they couldn't clean it, so we went someplace else and they couldn't clean it, then we went to a specialty place and they couldn't clean it, either. Then Dan Muscarella at CFI said, "All my relatives are over at FotoKem. Take it over there and I think they can clean it." They put it in the hottest bath, super slow, and massaged it with their hands, and the emulsion swells up and releases these little dust things, and they got it super clean, but it took a long time.

We'd finished shooting in February of 1996, but the film was still in post-production in December, which was when Jack Nance died. Some people think Jack was murdered, but Jack wasn't murdered. I'll tell you what happened to Jack. Jack had started drinking again by the time we shot *Lost Highway*, but he always came to work sober, and we had a great time working together on that film. Before that he'd been clean and sober for nine years, then one day he said to me, "Lynch, one morning I woke up and I just said fuck it," and he started to drink again. When Jack drank hard liquor he'd get surly and mean, and although he never got that way around me, I could see that he had this mean streak in him. He and Catherine were a perfect couple in a way. She took care of Jack and she was a kind of Dorothy Vallens.

So I know what happened to Jack, even though I wasn't there. He goes into this donut shop at about five in the morning, and he's not really drunk but he's been drinking and he may've been on a binge. He's still got a lot of darkness in him. So he's in there probably having coffee and there are two Hispanic guys in the place, and Jack might've looked at them funny and said, "What are you fuckin' looking at, beaners," or something like that. These guys left but they waited for him outside, and when he left the donut shop they popped Jack hard, I don't know how many times. Then he just went home. Jack had these two neighbors who sort of looked after him—they'd do his laundry and stuff like that—and they see him later that day and Jack tells them he has the worst headache of his life. When you get hit hard in the head they can do things to alleviate the pressure from the swelling if you get to a hospital in time, but

these neighbors didn't know what was happening in Jack's brain, and when they went to his place the next day the front door was open and they found him dead in the bathroom.

Jack was like Harry Dean. You could sit with Jack for hours not talking, just sitting there, or he might tell a story. Very few people ever heard the end of any of Jack Nance's stories, because he'd take these huge, long pauses when he talked, and they'd think the story was over and stop paying attention. It was like a fade-out, and after a while you're in the black and you think this thing's got to be over, but then he'd fade back in to another part of the story if you waited long enough. I remember one day he said to me in his slow, kind of soft way, "You ever see an alluvial fan?" When rocks come down out of a mountain, if there's really a lot of them they flow out and make a fan. So Jack saw one of these things somewhere and he brought up this alluvial fan, and then he said, "But someone put up a concrete wall." Then he waits for the longest time, I mean *really* long, and he says, "And it stopped the alluvial fan." He was devastated that this concrete wall had stopped nature. I can see him spending hours studying this mountain and what was happening to it. Other people walked by and didn't notice anything, but not Jack. He'd study it and then he'd realize, that's an alluvial fan. Jack never rushed anywhere. Jack lived in slow motion and he'd notice things and give long, detailed descriptions of things. If he was telling you about a dog trying to get out from behind a screen door, he'd describe the screen door in detail, the shape of the dog's head — every little thing. He was a brilliant guy, really smart and he read a lot, and there's a lot hiding in this guy. Jack was my buddy and it's a terrible shame he's gone. *Lost Highway* was the last thing we did together, but he never got to see it.

I showed *Lost Highway* to Brando after I finished it but before it was released. We rented this theater and told the owner Brando was going to come to see this film, and the theater owner was pretty pumped. So we get this thing all set up and Brando comes into the theater by himself and they have all these treats out for him. He's already got a burger and fries with him, but he fills his pockets with candy anyway and goes into the theater eating candy with his burger. He called me later and said, "It's a damn good film, but it won't make a nickel." It was good. He liked

it. A lot of people thought *Lost Highway* wasn't a commercial choice, and that was true, but it did okay. Siskel and Ebert gave it two thumbs down, so I got the guy at October Films, Bingham Ray, to run a big ad that had an image of two thumbs down and text that said: "Two more great reasons to see *Lost Highway*."

A Shot of White
Lightning and A Chick

While Lynch was in the midst of making the first season of *Twin Peaks,* he was at dinner one night with Tony Krantz and mentioned an idea for a series called *Mulholland Drive.* "The plan was that if *Twin Peaks* succeeded, the second season would end with Audrey Horne—Sherilyn Fenn—coming to Los Angeles to build a career in Hollywood," Krantz said. "That story would've been told in a movie released that summer—*Mulholland Drive*—which would've served as the pilot for a new fall television series about Audrey Horne making it in show business. It would've been a kind of dance between film and television, and nobody's done that to this day, but David could've done it." They commemorated the moment at Muse by signing a placemat Krantz taped to his refrigerator door.

During this period Neal Edelstein began playing a more prominent role in Lynch's professional life. "By 1998 I was working in David's office every day, gearing up for his website and producing smaller stuff, and I noticed that the scripts and books that were always coming in weren't getting looked at," he said. "I started reading things and reaching out to the people who'd sent them, and I finally said to David, 'Why don't we start a production company? There are opportunities here for you to executive-produce stuff, and I'll read through this material and meet with everybody.' I knew there were people who wanted to be in business with David and he was agentless by this time, so we launched Picture Factory. The plan was for it to oversee the website, new media, and tech stuff. I'd develop things David could executive-produce, Mary and I would produce David's movies, and it would all come under one roof."

Many opportunities were laid at Lynch's door, but he mostly passed on them. He was invited to direct *American Beauty,* which wound up being di-

rected by Sam Mendes in 1999, and Jonathan Lethem's novel *Motherless Brooklyn* was offered for optioning, but he said no. Today, Lynch has no memory of any of these projects. He was also asked to direct the American remake of the 1998 Japanese horror film *The Ring;* Lynch can't recall getting that offer, either, and Edelstein wound up producing the film, which starred Naomi Watts.

After Lynch's experiences with *On the Air* and *Hotel Room,* he'd pretty much washed his hands of television, but by the end of the 1990s Krantz and Edelstein were encouraging him to reconsider it. "Then one night we had a meeting on the patio at Orso and David agreed to go forward with *Mulholland Drive,*" recalled Edelstein. "He'd had the idea in his head several years earlier, but it had to sit in there for a while."

As is invariably the case with Lynch, he was already busy with other things when that dinner at Orso took place, and he was gearing up to shoot the feature film *The Straight Story.* The true story of Alvin Straight, a seventy-three-year-old World War II veteran who drove a 1966 John Deere lawnmower two hundred and forty miles to visit his estranged brother who'd suffered a stroke, the film was developed and co-written by Mary Sweeney.

"I read about Alvin Straight when he was actually making his trip in the summer of 1994," Sweeney recalled. "It was in the media a lot, and because I'm from the Midwest it spoke to me. When I looked into getting the rights to his story I learned Ray Stark had optioned them but he wasn't doing anything with them, so I kept tracking it. Four years passed and Stark let the rights lapse; then in 1996 Alvin died and the rights reverted to his heirs. I visited them in Des Moines and got the rights, and in April of 1998 I started working on a script with a friend from Wisconsin named John Roach.

"We weren't writing the script for David—he made that crystal clear—and I never tried to convince him to direct it, because that would've worked against me," Sweeney continued. "He said, 'It's an interesting idea but not my cup of tea.' I gave him the script in June of 1998 just to see if he thought it was any good, and it struck an emotional chord with him. I wasn't surprised he responded to it, because there's a *Twin Peaks* small-town quirkiness to it, and there's tenderness. There's tenderness in all his films, but this is a sweeter tenderness, and I was surprised when he said, 'I think I should make this.'"

The elements of the film fell into place quickly, and it was in pre-production in August of 1998 when Lynch and Krantz—who'd left CAA by that point to

become head of Imagine Television—pitched *Mulholland Drive* to Jamie Tarses, president of ABC Entertainment, and senior executive Steve Tao. (At the time, Imagine Television was producing shows in partnership with the Walt Disney Company, which owns ABC.) Lynch's two-page pitch laid out the story of a beautiful actress who suffers amnesia after a car accident on Mulholland Drive. ABC liked it and committed 4.5 million dollars to a pilot, and Disney's Touchstone Television put in an additional 2.5 million, with the proviso that Lynch shoot a closed ending. Disney's Buena Vista International planned to recoup their investment by releasing *Mulholland Drive* as a feature film in Europe.

Shortly after getting those ducks in a row, Lynch left for the Midwest to shoot *The Straight Story,* which wrapped at the end of October. Returning to Los Angeles, he hunkered down to write *Mulholland Drive.* "David planned to write the script on his own, but Tony wanted a co-writer to help guide it, so he hired Joyce Eliason," said Edelstein. "David met with her a few times, then they parted ways because he wanted to write it himself. She had almost no input on that script—and the original script was amazing. David knew where the trajectory of the story was going and the first season was totally mapped out. It was by no means simply an homage to Hollywood, but certainly David's love of Sunset Boulevard as the street of broken dreams is in there."

On January 4th, 1999, Lynch turned a ninety-two-page script in to ABC, and the following day Tarses and Stu Bloomberg (who was then co-chairman of ABC Entertainment Television Group) called Krantz and told him the project was a go. The expectation was that *Mulholland Drive* would premiere as part of ABC's fall season. The network had ordered seven pilots and could only pick up three or four, but Lynch's series seemed like a strong contender.

Two weeks later Tarses and Bloomberg called a "notes" meeting in an ABC conference room that included representatives from the network, Imagine, and Lynch's production company. There were twenty people in attendance and Lynch was there, but he declined to share much about what he intended to do with the series. Notes meetings have never been his thing. He just got to work making the film he saw in his head.

The plot of *Mulholland Drive* is complex, but it makes sense in light of the fact that life doesn't unfold in a clear, straight line. All of us flicker in and out of memories, fantasies, desires, and dreams of the future as we move through what's actually happening around us over the course of a day. These zones of

the mind bleed in and out of one another, and *Mulholland Drive* has a fluid logic that reflects these multiple levels of awareness, and it explores various themes. Among them are the hopes and shattered dreams of creative young people; what the movie business does to people and the diabolical power brokers who attempt to control the artists who work in it; and erotic obsession that degenerates into murderous hatred. The city of Los Angeles is also a theme in the film, which was shot on locations throughout Southern California.

During the making of *The Elephant Man,* Lynch made a drawing for Mel Brooks that depicts the words "City of Dreams" in soft gray pastel, and this is how he sees the city. Infused with a drowsy sensuality tainted with corruption, Los Angeles is a city of extremes of abject misery and deliriously glamorous success, and it's a place for dreamers. Lynch loves Billy Wilder's *Sunset Boulevard* partly because it embodies much of this, and *Mulholland Drive* includes several nods to Wilder's film; there's a shot of the entrance to Paramount Studios that *Sunset Boulevard's* Norma Desmond passes through, and a car parked on the lot that's identical to one that appeared fifty years earlier in Wilder's film.

Mulholland Drive operates in an indeterminate time zone where graceful old apartment buildings with lush courtyards and softly curving interior walls coexist with grim coffee shops with dirty pay phones. Several scenes were shot in just such a coffee shop at the corner of Sunset and Gower, which was formerly the site of the Copper Penny, where extras would line up in the morning during the 1920s, hoping for work in one of the many Westerns being produced at the time. Hollywood's streets are full of dreams, but they're full of creepy things, too.

"David always wants to try new things and experiment," said Deming of the way the mood of *Mulholland Drive* was developed. "Whenever we come across a weird new piece of equipment we always show him and he plants it in his brain, then figures out where to apply it. There are certain kinds of lighting apparatus we carry when we work with David that we don't carry on any other jobs, and one of them is a lightning machine. In fact, we now have different sizes; there's a giant one for nighttime exteriors, and a little one for interiors that sort of whites everything out for a second.

"I can never anticipate what he's going to want from reading the script," Deming continued. "There's a scene where Rita says the words 'Mulholland Drive' for the first time, and David said that even though she's indoors we

should have the sense of a cloud passing over the sun when she says those words. That's the kind of lighting direction you only get from David."

Mulholland Drive is a very big picture considering its budget, and it required the creation of a few key sets. Production designer Jack Fisk said that "it was hard dealing with ABC and Disney, and they wouldn't give us our money to start filming. I met with the construction people at Disney and told them what I needed to build the main set, which was Betty's apartment, and they said, 'Our construction people can't build it that cheaply.' I said, 'But I can.' They didn't give me an okay to go forward for six weeks, so we only had four weeks to build the set, and they said, 'You can build it at that price, but there's no overtime or extra labor.' They made it almost impossible.

"David did a little drawing on a paper bag of a sofa he wanted in Betty's apartment, and he did a sketch of her apartment, but when I looked at them I couldn't make any sense of the drawings." Fisk laughed. "And, of course, he made the little blue box that's part of the story."

Lynch has little interest in whoever's hot at a given moment, and Johanna Ray knows he prefers working with relative unknowns. With that in mind, she set to work finding actresses for the two key characters in the story: an innocent blonde named Betty, and Rita, a sultry brunette.

"When it comes to casting women, the actress has to have an air of mystery first and foremost," said Ray. "From *Blue Velvet* through *Lost Highway,* he often cast a part based on a photo, but with *Mulholland Drive* we started working differently. After we'd gone through all the photos and he'd picked actors, he'd have me tape them having a conversation with me. He said, 'I want to feel as if I'm in the room with them, getting to know them.' He's occasionally picked someone for a part and I've said, 'David, I don't think this person can act,' but that didn't stop him from casting them if he had a good feeling about them."

Laura Elena Harring was cast as Rita after a single meeting. A Mexican American actress whose movie career was jump-started in 1985 when she was crowned Miss U.S.A., Harring made her movie debut in the 1989 horror film *Silent Night, Deadly Night 3*. She appeared in six more films prior to meeting Lynch, and actor Eric Da Re was in one of them.

"I met Eric's mother, Johanna Ray, and she took me to the premiere of *Twin Peaks: Fire Walk with Me*," Harring recalled. "She introduced me to David, who struck me as very shy—he doesn't like the limelight—and I re-

368 ROOM TO DREAM

member thinking, Wow, he's handsome! A few years later—it was Monday, January 3rd, 1999, to be exact—Johanna called and said, 'David Lynch wants to meet you. Can you stop by right now?' In the excitement of going, I had a minor car accident, and when I got to his house and told Gaye Pope about it she said, 'Have you read the script? Your character has an accident at the beginning of the story.' I thought, There's a little bit of magic going on here. I walked in and David looked at me and all he said was 'Good, good.' And I started giggling.

"All women feel love for David," Harring continued. "He's drop-dead gorgeous, and when he smiles at you it's like the sun is shining on you. He's a loving, charismatic, funny genius and we had a special bond—everyone thinks there must've been something going on, but we had a platonic, spiritual connection. David's kindness really impressed me. The lady who dressed me sent a letter saying she wanted me to lose weight, and when I told David about it he said, 'Don't you lose one pound, Laura!' He made me feel like I was okay the way I was and gave me the confidence I needed to play Rita. One day we were on set and [actress] Ann Miller wanted to stop by and pick up something she'd left there. David kept the set at a standstill while we waited for her, and after she left he said, 'Isn't she cute!' He had such respect for her, and her comfort came first."[1]

Lynch came along just in time for Naomi Watts, who was cast as Betty. "I'd had ten years of auditioning and no real breaks, and I was carrying around all those years of rejection like a wound that was always with me," said Watts. "I was walking into these rooms with such desperation and intensity and trying to reshape myself constantly, and it's no wonder nobody would hire me. What do you want? Who should I be? Tell me what you need and I'll be that. It wasn't going well for me. I'd met Johanna Ray several times but she'd never cast me in anything; then she called my agent and said David was interested in meeting me."[2]

Watts was living in New York at the time and she flew to L.A. the next day. "I walked in the room and David was just beaming with light, like no one I'd ever seen in an audition room before," she remembered. "I felt like his eyes were real and true and interested. I didn't know anything about the character he was casting, and that probably worked in my favor because I didn't feel like I had to be someone else—I felt I could be myself. He asked me some questions, and after I gave a long answer to one of them I stopped and said, 'Do you

really want to talk about this?' He said, 'Yes, tell me the story!' I felt like we were two equals and he was interested in me, and I was shocked by that because it hadn't happened before. I had no faith in my ability at that point and my self-esteem was at an all-time low, so I didn't go out of there punching the air, but I did walk out with the sense that something great had happened, and I was grateful for the experience.

"I'd just come off the plane and must've looked like shit the day we met, and the next day I got a call and was asked to go back to his house," Watts continued. "They told me to put on makeup and look a little more glamorous, and I thought, Oh no, I'm never going to get it; he wants a supermodel. But I got my hair blown out and wore a tight dress and he obviously saw something he was looking for. When I finally read the script, I couldn't believe how much Betty's story matched my own, and I thought, Oh my God, I know how to play this part. I don't know if Johanna told David about how long I'd been struggling, but he definitely tapped into that part of me.

"I don't know if he even looked at any of my work," Watts added. "David works from his gut and it's all intuition, and he can get a performance out of anyone. Sometimes he'll turn to someone in his crew and say, 'Here, put this costume on,' and next thing they know they're speaking pages of dialogue."

Starring as Adam Kesher, the male lead in the film, is Justin Theroux, who recalled, "I got a phone call from Johanna Ray saying, 'David would like to meet you, today if possible.' I live in New York so I flew out the next day, and after I got in I was on my way to my hotel and the production office called and said, 'Why don't you go straight to the house?' I was a huge David Lynch fan, but I didn't know what he looked like or what his demeanor was, and he answered the door in his buttoned-up white shirt, with that big shock of hair, and he was wonderfully disarming. The first thing that struck me was what a warm smile he had and his unique way of speaking. He's very endearing. I've never had a bad moment with David."[3]

Ann Miller turns in her final onscreen appearance as an eccentric, straight-shooting landlady named Coco. Prior to the making of the film, Gaye Pope happened to sit behind Miller at an Academy function and later enthused to Lynch about how charismatic she was. Lynch remembers things like that. Also appearing in the film in a memorable cameo is Monty Montgomery, who'd never acted in anything before.

"When David made the deal with Ciby 2000, there wasn't room for me, so

even though we were always talking about what we were working on, we didn't work together again," Montgomery said. "We were still friendly after we stopped working together, though, and David used to come up to my house pretty regularly.

"In late 1998 my wife and I moved to an island in Maine, and several months later David started calling, saying, 'I want you to do this part I've written for you.' I said, 'Forget it, I'm not doing that.' He kept calling, and then he started saying, 'We're going to film this thing pretty soon,' and I'd say, 'I'm not gonna do it! I'm not an actor, and this just isn't on my radar.' Then the production manager started calling and asking, 'What day will you be here?' They kept changing the schedule to accommodate my part, then they scheduled a whole night for it, and it got to the point that I just couldn't say no. I didn't even look at the script until I got on the plane, and Johanna Ray and Justin Theroux sat with me and crammed. Justin really worked on the scene with me and he was terrific, so hats off to him and Johanna."

Theroux recalls shooting the scene vividly. "I remember going into Monty's trailer to meet him the night we shot that scene and I shook his hand and asked him if he wanted to run the lines. He said, 'No, that's okay, I'm pretty good,' and I thought, Did he look at his lines or did he learn them? We get on set and David says, "Action," and Monty gets a few words into his first line and he freezes—so we pasted his lines on my chest and forehead and David shot Monty over my shoulder. We worked on the scene for a while then David said, 'Cut, let's move on,' and I went over to him and said, 'David, I think we might want to reshoot that because Monty gave a very wooden performance. It's very flat.' David said, 'No, we got it, that was gangbusters.' And then, of course, I saw it and Monty's character comes across as the most disturbing character in the movie."

To her surprise, script supervisor Cori Glazer appears in the film, too. "The script had been written and there was no Blue Lady in it," she recalled of the mysterious woman she plays in the film. "Then we get to this beautiful old theater in downtown L.A. and David notices this opera balcony above the stage. It was a long lighting setup that day, and at a certain point somebody says, 'Cori, David's looking for you,' so I run in and say, 'Yes, David,' and he just stares at me, which was unusual, then he said, 'Never mind.' I went back to work, and ten minutes later he calls me over again and he pushes my hair out of my face and stares at me. Then he yelled, 'Get makeup and wardrobe

over here!' The makeup girl came running over and he said, 'How fast could you make someone's hair blue? Like a big blue bouffant—how quick could you do that?' Then wardrobe shows up and he said, 'How fast could you get a blue Victorian dress?' The wardrobe girl said, 'I need to know who the dress is for,' and he said, 'It's for Cori, but I haven't told her yet.' I said, 'David! I can't act! I get really nervous!' He put his hand on my shoulder and said, 'You're with your buddy Dave. You'll be fine.'" And she was. As for how the Blue Lady fits into the story, Glazer said, "David's favorite thing to say is, 'I don't care—it's modular!'"

Shooting began in late February of 1999, and Edelstein remembered it as a "blissful, brilliant experience. There's a sequence in a hotel where a woman gets hit by a bullet through a wall, and shooting stuff like that, you're just dying laughing," he added. "Everyone's laughing, like thirty people gathered around the monitor giggling, seeing David's magic work."

Lynch can do a lot with a little, but sometimes he needs a lot; a case in point is the spectacular car crash that kicks off the story of *Mulholland Drive*. "That car crash was probably the trickiest thing David and I ever did together," said Gary D'Amico. "It took us three days to set up that shot. We had a hundred-foot construction crane in Griffith Park and a car cabled to a six-thousand-pound weight that we free-fell from the crane—that's what launched the car. It was a crazy rig, and for sure we only got one crack at that shot."

Harring recalled, "I was sleeping in the trailer while they did final preparations for that scene, and when David came to wake me up he said, 'Laura, we need you to get dirty. I think it'd be easiest if you just get down and roll on the floor,' and he got down and rolled around to show me what he wanted me to do. We shot that scene in January at four in the morning and it was maybe forty-eight degrees out. I was wearing a little spaghetti-strap dress, but David was out there directing in a ski suit. He had on a onesie!"

In March of 1999 the shoot was wrapping, and initially the executives at ABC were thrilled with the dailies. Then they began getting twitchy. They felt the pace was too slow and that Watts and Harring were "a little old." Lynch began receiving nitpicking memos from the standards-and-practices department concerning things like language and images of gunshot wounds, dog shit, and cigarettes. Lynch is good at tuning out static of this sort, though, so he just kept working and spent April mixing the soundtrack at his home studio.

At the end of the month he sent a cut that ran for two hours and five minutes to Tarses and Bloomberg; on receiving it they immediately responded that it needed to be cut to eighty-eight minutes. The following night Tony Krantz arrived at Lynch's house with two bottles of Lynch-Bages, and a list of approximately thirty notes from Steve Tao.

"I think the minute they saw it they knew they weren't going to pick it up," Sweeney speculated. "For starters, it was supposed to be one hour and David just didn't adhere to the running time, but Tony nonetheless came over with pages of notes. I think David felt that Tony was saying, Yes, they're right, because he made a very impassioned argument for why we should make the changes they were asking for. David objected to every note, but after Tony left we stayed up all night and did the notes, and we cut the pilot down to eighty-eight minutes and turned it in to them."

In retrospect, Krantz felt he did what needed to be done. "When I looked at *Mulholland Drive,* I told David the truth," said Krantz. "I said, 'It's not that good and it's slow and I agree with the ABC notes.' In many ways that burst the bubble of our relationship, because to David it was like, You're one of them now and you're not on my side. And in that case I wasn't.

"Maybe it was my mistake to try to get a compromised version of *Mulholland Drive,*" Krantz continued. "But David's unwillingness to compromise and sort of blend in with Mark Frost and form that bond is part of what led to the demise of *Twin Peaks.* David has the art part, but he doesn't have the piece that guarantees success in the entertainment industry, which is very much a collaborative community. You can't win and beat show business. The town is littered with people who've tried."

Needless to say, nobody in Lynch's camp felt that ABC's response to the pilot was justified. "The notes were ridiculous and so politically correct that they leached any sense of creativity out of the thing," said Edelstein. "Why would you green-light a pilot with David Lynch and then not want David Lynch's vision? It was like, are you serious? In the original script Justin Theroux had an Asian gardener who was a font of Zen wisdom. ABC thought an Asian gardener was a racist stereotype, so that character had to be cut."

"It was a very joyous, fun set that felt like summer camp," Theroux recalled, "and we were all devastated when the show wasn't picked up."

Lynch found out the series officially wasn't a go in mid-May, as he was leaving for the airport headed to Cannes with *The Straight Story,* and he's admit-

ted to feeling a wave of euphoria when he heard the news. He felt that the cut of the show that was then in play had been butchered and was relieved to learn it would die a quiet death. ABC gave the *Mulholland Drive* time slot to *Wasteland,* a series about six twenty-something college friends who move to New York and try to find themselves. The show premiered on October 7th, 1999, and a week later, on October 15th, *The Straight Story* opened in selected theaters throughout the country. *Wasteland* was canceled after three episodes.

Lynch has said that *Mulholland Drive* had the journey it needed to have, and it certainly triumphed in the end: Its resurrection was initiated by his old friend Pierre Edelman.

"Ciby was gone by the time the *Mulholland Drive* pilot was rejected, and Pierre was at StudioCanal," said Sweeney. "It was Pierre who put together the deal and massaged all the difficulties that allowed it to be turned into a film. This is an impossible situation and nobody can make this deal work? That's like a drug to Pierre, who is a terrier who won't let go until he fixes it, and he got Alain Sarde to take *Mulholland Drive* under his shingle at StudioCanal. ABC didn't want it and had put it on the shelf, so they were happy to sell the negative."

Edelman described the *Mulholland Drive* experience as complex. "It wasn't until many months after that episode with ABC that David finally told me about the pilot," said Edelman, who persuaded Sarde to purchase the pilot for seven million dollars for Le StudioCanal Plus, a film subsidiary of a French subscription channel that's funded several American independent films. "But when he told me about it he said, 'I don't want to hear anything about this anymore.' I asked for his permission to look at the pilot, and he said okay but said again that he wanted nothing more to do with it. I watched it, then told him I was convinced it would be a wonderful feature film.

"At that point I didn't foresee all the troubles waiting for me," Edelman continued. "I had to raise four million dollars, and most of that went toward buying back the rights. Then I had to transform a TV pilot shot at twenty-five frames a second into a print that was twenty-four frames a second for cinema. I also had to get the entire cast and crew to sign an agreement for the film to become a theatrical release. Mary Sweeney handled those negotiations for a

while, and some of them were complicated. These people had worked on a TV pilot for much less than they would've been paid for a theatrical release, and some people insisted on additional money. And, of course, we needed money to shoot the footage needed to turn it into a feature."

Sarde agreed to put in two million dollars more to cover the costs of additional shooting; however, Lynch was ambivalent about returning to the project. The sets had been clumsily dismantled and damaged, Disney had lost all the props and costumes, and he still had a bad taste in his mouth from the debacle the series had become. His reluctance to go forward proved to be the last hurrah for his relationship with Krantz.

"*Mulholland Drive* was a seven-million-dollar investment for Disney, and when Pierre Edelman came to me and said, 'I can get Canal to buy it from Disney,' I thought that was great," said Krantz. "Then right before the deal was consummated, David says, 'I don't want to do it.' I asked why not and he said, 'We destroyed the sets.' I said, 'What do you mean you destroyed the sets? You don't even have a script for what you're going to shoot, so what sets are you talking about?' At that point the thing was sitting there dead because of what I considered a chickenshit, bullshit excuse, and I got pissed off. I knew there was money in it for Brian [Grazer] and Ron [Howard] and me, and I thought David was being a baby. I'd gone way out on the line with Disney getting them to buy the pilot, and my relationship with them was at stake, so I got Disney to say, 'We are going to sue you to compel you to do this,' and that was the end for David and me. And I don't regret doing what I did.

"But at the end of the day would I rather have David Lynch in my life? Yes, absolutely," Krantz added. "David is authentically himself, always, and he's humble and funny and sweet and shrewd and brilliant, and he has the same wide-eyed optimism and integrity he had the day I met him. Success didn't change him at all. I miss him, and I wrote him a note apologizing for the things I did and told him I hoped he could forgive me and that we could work together again one day. He said that he did forgive me but he didn't leave the door open to working again, and I can understand that."

Lynch may have forgiven Krantz, but most of Lynch's colleagues haven't forgotten the episode. "It's disgusting that Tony threatened to sue David," said Edelstein. "David's got an old-school set of rules—actually, it's not old school, it's more like the golden rule. If you look someone in the eye and shake their hand and tell them, This is what I'm going to do, then that's what you do.

You don't need lawyers and you don't need to threaten people with lawsuits. People who do that when they don't get their way are like babies throwing temper tantrums."

Temper tantrums aside, negotiations for the project were well under way before Lynch finally got an idea for how to transform the pilot into a film; one evening at six-thirty it came to him, and by seven o'clock he knew how to conclude the story. At that point he began to get excited and contacted Harring and Watts.

"When ABC didn't pick up the show I thought, Great, I'm in the only David Lynch project that's never going to see the light of day and I'm back to my struggle," said Watts. "Then he got the call from Canal Plus saying, 'We want to buy it back and make it into a feature,' and David wrote eighteen pages that introduced the character of Diane. I remember going up to his house to read those eighteen pages and thinking, Oh my God, this is incredible. You couldn't ask for a more exciting character, and the fact that Betty and Diane are so different—you don't get two roles like that in one career, much less one movie."

"After a year of David saying, 'Mulholland Drive is dead in the water and nobody will ever see it,' he called Naomi and me to come to his house," Harring recalled. "So, we're sitting there, with Naomi on his right and me on his left, and he said, 'Mulholland Drive is going to be an international feature film—but there's going to be nudity!'"

Much of what Lynch added during seventeen days of shooting, which commenced in late September and wrapped in early October, never would've flown on network television. Betty and Rita were friendly co-conspirators in the original pilot, but as is revealed in a graphic sex scene, they're lovers in the feature. "David was right to add the love scene—it's one of the key parts of the story—but it was hard," said Harring. "I was nervous and felt very vulnerable when I walked on set, then David said, 'Laura, what are you worried about? The set will be dark.' It was dark, too, so I relaxed, then for the last take he said, 'Pump it up, Pete,' which meant pump up the lights, so it was much brighter. He told me he wouldn't show details, though, and against everyone's wishes he blurred my pubic hair because he'd given me his word that he would."

Considerably tougher than the love scene between Watts and Harring is a wrenching scene of Watts tearfully masturbating. "David usually gets things in

one take, and will maybe do three at the very most, and he made Naomi do at least ten takes of that scene," Glazer recalled. "By the tenth take she was incredibly angry, and I think he made her do all those takes because he wanted her to be completely fried in the scene, and he needed to put her through that in order for her to get to that place."

Watts has vivid memories of the shooting of the scene. "I had a bad stomach situation that day because I was so freaked out," she recalled. "How do you masturbate in front of an entire film crew? I tried to talk David into shooting it another day, and he said, 'No, Naomi, you can do it, you're fine, go to the bathroom.' He wanted angry desperation and intensity, and every time the camera got close to me I'd say, 'I can't do this, David, I can't do it!' He'd say, 'That's okay, Naomi,' and just keep the cameras rolling, and that made me angry. He was definitely pushing me, but he did it in a gentle way."

It's abundantly clear that much of the brilliance of *Mulholland Drive* pivots on Lynch's ability to take actors to places they haven't been before. "There are two scenes where Naomi delivers exactly the same dialogue but the scenes are completely different," observed Deming. "It's like a master class in directing."

Lynch got what he wanted during the shoot, but Edelman felt he wasn't out of the woods yet. "When David was editing the film, he asked me to come to his studio to watch an assembly of a section, and after I left I was walking in the street crying," he said. "I thought, This is a catastrophic situation and no one will ever see this film. I felt I should get a second opinion, so I called Alain Sarde, who was the signatory for the film, and asked him to come to L.A. to see the assembly. He came to David's studio and watched it and afterward he said to me, 'I don't understand why you had me come here. This is a masterpiece.'"

While Lynch was doing post-production on *Mulholland Drive,* another layer was added to his life: That layer was the country of Poland. "David's interest in Poland began when these guys from Camerimage Film Festival, which is a festival devoted to cinematography in Poland, came around in February of 2000," said Sweeney. "They came en masse—there were six or seven of them—and they seemed like wild and crazy guys, which tickled David. They wanted him to attend their festival and kept begging and sending him stuff until he agreed to go."

Founded by Marek Żydowicz in Torun, in 1993, the International Film Fes-

tival of the Art of Cinematography runs for one week every year and had just moved to Łódź when Lynch became involved. The Camerimage Gang—a term Lynch came up with—is a revolving crew of musicians, artists, and filmmakers that includes Kazik Suwała, Agnieszka Swoińska, Adam Zdunek, Michał Kwinto, Paweł Żydowicz, Kamil Horodecki, Dariusz Wyczółkowski, Mateusz Graj, and Ewa Brzoska. "I used to say, 'David Lynch will come and visit us one day,' and people thought I was crazy," recalled Żydowicz, who continues to direct the festival. "When David and I first met, I was at a crossroads and the plans for Camerimage Festival weren't going well, but the meeting with David changed it all.

"He's like one of those Renaissance giants capable of creating enormous frescoes," Żydowicz added, "and he loved Łódź, which is a city of dark secrets, devastated factories, fog, shadows, broken streetlamps, and eerie noises. It has a mood of mystery evocative of a violent dream where things have an odd, alluring logic."[4]

When Lynch attended the festival that November, he met Marek Zebrowski, a Polish composer based in L.A. who's worked with the festival in various capacities since 2000. "David fell in love with Łódź and started getting all kinds of ideas," Zebrowski said. "The winter atmosphere, abandoned factories, opulent residences from the late nineteenth century—all these things came together to create the beautifully mysterious film *INLAND EMPIRE,* which he made in the early years of his relationship with the country. A few years after he began attending the festival, the project with Frank Gehry began germinating, too."[5]

The project with Gehry that began germinating was nothing less than a master plan for rebuilding the Łódź city center, which included facilities for the festival, a renovated railway station, stores, hotels, and a museum. Beginning in 2005, Lynch worked closely with Gehry and the Camerimage team, and funding was secured from the European Union, the city, and private sponsors. "Frank Gehry's grandparents were all born in Łódź, so this was a personal project for him," said Zebrowski. At the conclusion of the 2000 festival, several members of the gang accompanied Lynch to Prague and shot a documentary of him working with Angelo Badalamenti on the score for *Mulholland Drive.*

On returning from Prague in January, Lynch met a new assistant, Jay Aaseng, who would work closely with him for the next eight years. "Erik Crary, a

friend who'd started working for David four months earlier, called and said, 'We might have a position here,'" Aaseng recalled. "I was a film student in Madison and had just turned twenty-one, and right before Christmas Mary Sweeney and Riley were in Madison and we met at a Starbucks. I followed up by phone and Mary said, 'Let's give it a shot and try it out for six months. How soon can you get here?' I said, 'I'll get in my car tomorrow.' I think I got the job because Riley liked me.

"In those days David would come into the gray house in the morning and have some kind of shake for breakfast, and he'd sit down and go over things with us," Aaseng continued. "The first day I was there he walked in, and in that very direct way he has, he walked up and said, 'Hey, Jay! Good to meet you, buster! Let's get to work!'"[6]

That spring Lynch put the finishing touches on a two-hour-and-twenty-seven-minute cut of *Mulholland Drive,* which wound up being a co-production of Les Films Alain Sarde, StudioCanal, and Picture Factory. Krantz has a producing credit on the film but says, "I was minimally involved. David and I didn't stop speaking and I went to the set, but it was fractious between us."

In the end, Lynch's conflict with Krantz proved irrelevant and *Mulholland Drive* turned out to be worth the wait. "We assumed it would never see the light of day, then David called a year later and said 'It's gonna be a movie,' and we did a few more days of shooting," said Theroux. "A few months later he invited me and Naomi to a screening of the film and we were just blown away by how wonderful it was. It was like hearing *Sgt. Pepper's* for the first time. There's so much to digest, and it raised a lot of questions, and I immediately wanted to see it again.

"I knew the script but I didn't really know what the movie was when we were shooting it, and the finished product is so unlike our experience of shooting it—and that speaks to David's genius as a filmmaker. His use of sound and music, the juxtaposing story lines—he did a masterful job of conjuring a mood we couldn't have anticipated while we were shooting. I was surprised by how dark and moving and haunting it is. Sometimes you can't even identify the emotion you're feeling, whether it's discomfort or joy or sadness, while you're watching *Mulholland Drive*—David is very good at creating characters that carry multiple emotions at the same time. One of my favorite scenes in the film is Patrick Fischler's monologue in Winkie's Coffee Shop about a nightmare he's had. He recounts his dream to someone, then the scene moves

outside and goes behind the coffee shop, and even though it's in the middle of a sunny day in Los Angeles, it's absolutely terrifying."

Mulholland Drive premiered in May of 2001 at Cannes, where it won the Prix de la mise en scène (best director award), which Lynch shared with Joel Coen for *The Man Who Wasn't There.* "When we were in Cannes at the photo call the photographers started chanting my name, and as I walked onstage I passed David and he said, 'Hotshot,'" recalled Harring. "The way he said it meant so much to me."

The trip to Cannes proved to be a huge turning point for Watts, too. "For years I hadn't been able to get anyone to call me back or look me in the eye when I was auditioning, and there I was walking the red carpet at Cannes," Watts remembered. "The film got a five-minute standing ovation, and Todd McCarthy wrote an incredible review in *The Hollywood Reporter* that singled me out and that was it—my life changed overnight. I suddenly had every agent calling and sending me flowers and I never had to audition again, and it was all because of David. He literally changed my life. I've met a lot of people and worked with some brilliant directors, but there's no one else like him. David is just one of a kind. He loves actors, and you trust him and want to give anything and everything to him, and you want to please him. He radiates good energy and I always feel well taken care of when I'm with him."

In the fall of that year Lynch took *Mulholland Drive* to the Toronto Film Festival, and the Twin Towers fell in Manhattan while he was in Canada. Lynch and Sweeney were temporarily stranded there, and Aaseng speculates, "That event made him feel like it was important for him to share TM with the world. I think he thought that if everyone was meditating, things like that wouldn't happen, and at that point he offered to pay for everyone in the office to have TM training."

The seeds had been planted for the David Lynch Foundation for Consciousness-Based Education and World Peace, which would launch in 2005. In the meantime, things were finally wrapping up for *Mulholland Drive.* Universal Pictures released it in the United States on October 12th, 2001, and it netted Lynch a best director Oscar nomination. The film's stature has grown exponentially since then, too. In a poll conducted by BBC Culture in 2016, *Mulholland Drive* was declared the greatest film of the twenty-first century.

L OTS OF PEOPLE can start companies and make money, but that's never worked out for me. Picture Factory was an idea Mary and Neal Edelstein came to me with, and I liked the name Picture Factory so we set this thing up, but almost instantly I had zero interest in it. It would just take time, and it wasn't fun at all, and I don't think I ever even read anything for it. I never knew *American Beauty* was offered to me, I've never heard of *Motherless Brooklyn*, and I definitely don't remember seeing the script for *The Ring*. Neal ended up doing that with Naomi Watts, so that was good for him.

Everybody's got their own version of what happened with *Mulholland Drive*, but I don't remember a dinner at Orso or that dance between movies and the TV business Tony talks about. I remember Tony wanted me to do something, and the idea of something called *Mulholland Drive* as some kind of offshoot of *Twin Peaks* is something I might've talked about for ten minutes with Mark Frost. But it was never solidified, and all I remember about it was that it would be called *Mulholland Drive* and would involve a young girl coming to Hollywood. Tony always wanted me to write with somebody else—I don't know why—but I wrote *Mulholland Drive* on my own and I let the people at ABC read the first couple of pages when we pitched it. Doing a pitch is a kind of performance, and I don't enjoy doing them.

Mulholland Drive is a magical street, and many people feel that when they drive on it at night. It twists and turns and Hollywood is on one side and the Valley is on the other and you kind of get lost on it. It's an old road, too, and there's a mood to it, and you can feel that many people from the golden age of Hollywood drove on that road. It's really got a

history, and if you're in Los Angeles long enough you start hearing stories about things that have happened on it that get your mind going.

It's not necessarily true that I don't know what the film is until I get in there and shoot it. If that were true, then you wouldn't be able to trust a person like me. You have a script and a definite idea of what you want, but sometimes when you get there you see things and possibilities and things can grow. Or because it's not exactly what was in your head, you adapt and something even better appears. There's the essence of the scene, you've got to get that, but different things can trigger ideas, and that's why shooting on location is great. If you build a set based on your mind, then that's what it will be, but when you go on location all kinds of stuff can happen.

It's pretty much true that I prefer working with relatively unknown actors, but the fact that they're unknown isn't the thing—it's that they're the right person for the part. That's what you go for. I trust Johanna to tell me if someone can or can't act, but sometimes it's not a problem if they can't, because you work with them and there's something about them that's right.

When I cast something I like to start by looking at pictures, so I'm looking at pictures and I see this girl and I say, 'Whoa, she is beautiful and I want to meet her,' and that was Naomi Watts. They got word to her and she flew out from New York and she came in and she looked nothing like her picture. Nothing like her picture! She didn't look bad, but she didn't look like her picture, and I wanted the girl in the picture. I thought, This is crazy! I'm imagining a person who doesn't exist! She'd come to meet me directly from the plane, so I asked her if she could come back again made up and she came back. Gaye Pope's son is named Scott Coffey, and Scott worked with Naomi on something, and he's in the kitchen when Naomi comes back. Scott and Naomi were talking and laughing about something, and I saw a side of Naomi because Scott was there, and I said, "Okay, she's perfect; she can do it," and that was it. She's perfect and the rest is history.

I remember Justin Theroux coming out and we had a good talk and he's just a great actor. Chad Everett was perfect for the part he played, and Ann Miller was perfect, too. I loved Ann Miller! Oh my golly, she was so much fun to work with. She *was* Coco, and that character fit her

like a glove. Billy Ray Cyrus came in to talk about another part, but he was Gene the pool guy—he couldn't have been better. It happens a lot that people come in for one thing and I'll see they're perfect for something else. Cori Glazer doesn't show off her beauty, but she's got a beautiful face. You have to isolate it, though, and I remember staring at her for a long time, and then I knew she was the Blue Lady, and she got the last word in the film.

The Cowboy kind of wandered into the film. I'm sitting in my chair and Gaye is over at the keyboard, and Gaye had this special quality. Gaye was fantastic. She wasn't particularly good as a secretary and was a little bit of a ding-a-ling, but she had good energy and that's way more important. When push came to shove, she was able to give orders and say no, so she had the stuff, but she always treated everybody well. Her sweetness made this beautiful cocoon where I could think of anything and not be afraid to say it out loud. She never judged anybody, and when I was with her I felt like I could say anything. A person like that is perfect for writing, and I could try things out and it was fine with her. The atmosphere of freedom she created was real conducive to catching ideas, so I'm sitting with Gaye and in walks the Cowboy and I start talking, and as I'm talking I'm picturing Monty.

I knew Monty could act because of something that happened on *The Cowboy and the Frenchman*. Monty was with Propaganda and they produced that thing, and we were working on a scene with this character named Howdy, a bulldogger who's trying to take down this bull. Harry Dean is yelling at him to get some beer nuts, and Howdy can hear him but Harry Dean doesn't think he can hear him, so he keeps yelling. Howdy gets pissed off and his anger helps him bring the bull down; then he jumps the fence and takes off because he's fed up with Harry Dean. There's so much noise in the scene that you can't understand what Howdy's saying, so I said, "We're gonna have to loop this thing; who can we get to loop Howdy?" I hear Monty say, "I'll do it, David," and I thought, Oh, this is gonna be embarrassing, but I said, "Okay, Monty, you can try," and he nailed it perfect on the first take. I thought, I'm gonna remember that. Monty can't remember lines, though, so it was a struggle to get that scene out of him. Monty's super smart, but I don't think he did well in school and he just couldn't remember some things. We stayed

until we got it, though, and it worked out. Monty's delivery was always perfect, but Justin had to have Monty's lines pasted to his chest.

I get these happy accidents. Brian Loucks calls during *Mulholland Drive* and tells me, "David, I have someone I'd like you to meet, named Rebekah Del Rio," so Rebekah was going to come up to the studio, maybe have a coffee and talk, and sing something to me. So she comes up to the studio, and before five minutes go by, before any coffee, she went into the vocal booth and sang the exact thing that's in the film. It wasn't changed at all. That's it. That's the recording. There was no character like Rebekah in the *Mulholland Drive* script before she came to the studio that day, and she was the one who picked that song to sing for me. So I'm thinking about this scene I'd written for Club Silencio, "No Hay Banda," which in Spanish means there is no band, and it fed into Rebekah because she sang that song without a band. So she's brought out onstage and she's singing beautifully, then she falls over and the singing continues.

We had a great crew on *Mulholland Drive* and I got to work with some of my favorite people. I love working with Pete Deming. He loves curveballs and taking advantage of what comes up and he's not afraid to try any goofball thing, so we developed some strange techniques together. Sometimes they work and sometimes they don't, but it's a great collaboration, and everything goes in the toolbox and has a purpose. There's definitely a lightning machine in the toolbox, and the best one we ever had was one Sabrina [Sutherland] found in Riverside for *Lost Highway*. These two machines she found were as big as railroad cars, and they arrived on two flatbed tractor-trailers. When you hit that lightning, that thing put out power like you cannot believe—it lit everything up for a mile around, like real lightning.

It was incredible when we did the shot of the car accident at the start of *Mulholland Drive*. You've got this taut cable attached to a six-thousand-pound weight a hundred feet in the air on one end, and the car is attached on the other end, and the weight is going to get dropped. If that cable snapped before it was supposed to, it would've been like a whip, and you don't know where it's going to go, but if it hits you it's like a hot knife through butter. It was really dangerous. There were three cameras at least on that shot, and Pete and I were there, but everybody else had to

go away. Gary's up with the crane and there's a pin in the ground holding the six thousand pounds and that cable is just dying to break, and there's this special charge that works like a cable cutter. When they cut the cable and the weight is in free fall it launches the car with the joy-riding kids in it so that it hits that limo so hard—man! It was fantastic! Gary did a great job on that and it was so much fun.

Jack Fisk is my best friend and we got to work together on *Mulholland Drive*. Jack can get stuff done. It wouldn't have mattered if they'd given him ten bucks, he would've built that set, and that set is just beautiful. There's a scene where Betty says to Rita, "Look in your purse; your name must be on something in there," so Rita opens her purse and there's all this money in there, and there's a unique blue key to something unknown. There had to be something it was to, and I don't know why it ended up being to a blue box instead of a door or a car.

John Churchill was second AD on *Mulholland Drive*, and he was a great guy who came into his own as an AD. He was a PA on *Lost Highway* and *The Straight Story*, but he was born to be an AD and took to it like a duck to water. There are many skills needed to do that job. The person has to get along with the director and the crew and keep things moving forward. They also take care of background, like getting things quiet, getting the cameras and the sound rolling, and get the next fuckin' shot. Keep it moving. They're a combination of enforcer, diplomat, and scheduler. What do we shoot first, what do we shoot second, that sort of thing. That leaves directors free to think and not have a lot of stuff clouding their heads—the director has to think about what the next scene needs to deliver and nothing else. In some ways I hate this thing of pushing forward and making a fuckin' day, but you have to do it, and the AD helps you get what you want. It's a tough job and Churchy was good at it and he was my friend and he had a great sense of humor. He'd make me tell stories. We'd see someone on the street and he'd say, "Okay, what's their story," and I'd tell him about that person. And he remembered everything. He was a fantastic guy.

I do love *Sunset Boulevard* and I got to meet Billy Wilder several times. I was at Spago once when he was there with his wife, Audrey Young, and he came up behind me and put his hands on my shoulders and said, "David, I love *Blue Velvet*." Then we had breakfast together at

some restaurant and I asked him tons of questions about *Sunset Boule-vard*. I also love *The Apartment*—those are two incredible films—and I was a lucky guy to meet him.

It's true that Los Angeles is kind of a character in the film. A sense of place is so important. The thing I love about Los Angeles is the light and the fact that it's spread out. It's not a claustrophobic place. Some people love New York, but I get claustrophobic there. It's too much.

I used to think I liked the desert in Southern California, but I really hate the desert. I had a large piece of beef for dinner in the desert. I never eat red meat but that's what they served on this particular night, and I slept in someone else's bed that night and had a dream that was so hor-rible and diabolical that the whole next day I had to mentally fight a thing that was going on. I don't remember what the dream was, but I remember the feeling, and I couldn't talk to anybody and had to be alone to fight it mentally. It was only when I got back to L.A. that it lifted. That ended the desert for me. There are places with bad vibes and places with good vibes, and I slept and ate in a bad place.

There are weird things in L.A., too, for sure. I remember the Sunday I went to the Copper Penny with Jennifer and had a Grand Slam. Jen and I were sitting in the booth and behind me I heard people talking and they were fantastic. It was Sunday and they were having a discussion about God and many passages in the Bible. They seemed intelligent and nice. I thought, It's great that people are talking like that on a sunny Sunday morning. Then we get up and walk out and Jen said, "Do you know who that was sitting behind us?" It was the head of the satanic church.

I loved making the *Mulholland Drive* pilot but ABC hated it, and even though we cut something together and sent that over to them, I had a bad feeling. I remember thinking, I'm in with the wrong bunch. The way some people think is they think money, and all of their decisions are based on the fear of not making money. It's not about anything else. Their jobs are at stake and they have to make money, and they think people won't like this, we won't have a hit, we won't make money, and I'll lose my job. It's the wrong way to think, but that's what happens.

The first cut I sent to ABC was too slow, but because we had a dead-line there wasn't time to finesse anything, and the second cut lost a lot of texture, big scenes, and story lines. But when I look back on it now I can see that it was fate, and what happened with *Mulholland Drive* was the most beautiful thing. This film took a strange route to become what it became, and it needed to do that apparently. I don't know how come it went like that but it went like that and now it's there and it was meant to be this way.

Pierre Edelman was in L.A. and he came up to the painting studio and I told him about what happened with *Mulholland Drive*. I told him it was dead, but in my head . . . I'm not saying I knew it wasn't dead, but I knew it wasn't finished, so always there's possibilities. Pierre saw it and really liked it, so we discussed turning it into a feature and he went to work. As Mary Sweeney used to say, "Pierre is the straw that stirs the drink." He connects people, but he's not running a studio so he can only do so much, and it took a year from Pierre coming to my studio for the negotiating to be done. A year. And I'll tell you what it is—it's the mid-dlemen. If you're the one who's going to give money to me, wouldn't it make sense for you and me to sit and talk? In a couple of hours we could work it out. How come it took a year? Because so-and-so over in France is busy, and they call someone over here, and this person says, I'll get back to you, and some days go by and finally they call back and talk, and that person is now on vacation, then they call and say, Let's make a time when we can talk about this on a conference call, then it's a week later, and then so-and-so is sick so we better wait, and so on. See, these people aren't that excited about your thing, because they've got a lot of things going, and one thing leads to another and months go by. That whole deal could've been done in six minutes.

A year later I got a call saying it's green-lit, we can do it, then I called to find out about the sets, the props, and the wardrobe. I was told that the wardrobe had "gone back into the stream." I asked the guy, "What does that mean?" He said, "It means that stuff wasn't saved for you." Who knows where it is? Sally may be wearing the same damn thing we're look-ing for in some show right now, and you'll never get it back. Then I found out that all the props had gone back into the stream, too, and that the sets had been improperly stored and were in bad repair, and it wasn't

Jack's fault. On top of all that, I had no ideas for how to finish this thing when the green light came.

Just about that time I tell Tony, "I don't think it's possible to go back into this world because everything's gone." He said, "If you don't do this I'll sue you," and the way he said it ended any friendship or good feeling about that person. I couldn't believe he'd say that, and I saw a side of him that made me think, That's not for me. I never got a call from Disney about them suing me—Tony said that to me on the phone. People are themselves, and Tony was the one who got me to work on *Twin Peaks* and *Mulholland Drive* and that's a good thing. At the same time, there are things that ruin a friendship, and although I forgive Tony, I don't want to work with him again. Tony's right that the entertainment industry is "a collaborative community," but I can't stand that way of thinking. It's not a collaborative thing at all. Yes, you work with people who help you, and you can ask a hundred people their opinion, but in the end all decisions have to be made by the director.

The same night Tony said that to me I sit down to meditate, and like a string of pearls, one idea after another came along, and when I finished meditating I knew exactly how to finish the film. Then I worked with Gaye and fleshed out my ideas, and there were the eighteen pages I needed.

There was some sex in those eighteen pages, and Laura and Naomi were great about it. I did promise Laura I would airbrush out parts of her body in the nude scene, and there's one place in the scene where she's standing and that had to be taken care of. They'll freeze that frame, make a still of it, and it will be in every magazine, so you have to do that.

I didn't do lots of takes of Naomi's masturbation scene because I wanted her to be in a particular frame of mind for that scene. I don't do that. We kept doing takes because she wasn't getting it, and you keep going until you get it. This girl is doing this because she's hurt and angry and desperate, and a whole bunch of emotions are swimming and swirling inside her and it has to be a certain way. There's a certain thing the scene has to do, and Naomi got all those things in there.

The night we were shooting the dinner party at the end of *Mulholland Drive*, we got shut down for something. Angelo was set to fly back to New Jersey that night and that was our only chance to shoot him, so all these

people are around shutting us down and I went over and talked to Angelo, then I went over to Pete and said, "You've gotta be careful, but put the camera on Angelo and focus that puppy—that's good right there, that's nice, Pete," and I signal Angelo, and he did what I'd told him to do, and we stole that shot while these people are running us out of there.

So we finished the film and it was exactly what it was supposed to be and we went to Cannes. It went well in the world but it never made a lot of money, but nothing I do ever really does. We're all just working for the man now. We get a shot of white lightning and a chick and that's about it.

A Slice of Something

L ynch loves working free of the strictures of Hollywood, and *The Straight Story* was as close to an in-house family affair as he could get it. Sweeney co-produced, edited, and co-wrote the script; Jack Fisk did production design; Harry Dean Stanton and Sissy Spacek were in the cast; Angelo Badalamenti did the music; and Freddie Francis was the DP. The budget was small, Lynch had final cut, and he produced a quiet masterpiece.

"In early summer of 1998 David told me Mary Sweeney had written a script called *The Straight Story* and he wanted to make the film," recalled Pierre Edelman, who was a producer on the film. "At the time I was a consultant for Canal Plus which was a subsidiary of StudioCanal, and everyone in France was away on vacation, so I was alone in the offices when I began negotiations with David. But I managed to finalize a deal for a budget of around seven million dollars, and in late September he started shooting."

Sweeney gives Edelman a lot of credit for getting the project off the ground. "Tony Krantz, Rick Nicita, and CAA were gone by the time we did *The Straight Story,* and along comes Pierre," she said of the film, which was a co-production of Picture Factory and Canal Plus. "It was the end of June and the entire country of France is on vacation, and Pierre is tracking down people in the south of France. We had a bidding war because it was a low budget and people weren't afraid of it the way they're always afraid of David's projects. Even people who can't handle his work love David himself, and they were delirious at the thought of what he was going to do with that material and thrilled to work with him."

Produced by Sweeney and Neal Edelstein, and executive-produced by Edelman and Michael Polaire, *The Straight Story* initially included Deepak

Nayar as part of the producing team, but he reluctantly left the project, and Lynch's life, following a budgetary dispute. "David changed my life and career," Nayar reflected. "He gave me the spark I needed, but more important than that was the love and affection he gave me. I came from India not knowing a soul in Los Angeles, but it didn't matter to him that I was just a driver. He treated me with dignity and respect and gave me the opportunity to do more. I have my own company now and have lots of projects going on, but my fondest memories of my entire career are of working with David. He single-handedly made me what I am today, and I can never thank him enough for giving me a break."

Starring in the film and carrying almost every scene is the late Richard Farnsworth. After answering a casting call in 1937 for five hundred Mongolian horsemen needed for *The Adventures of Marco Polo,* Farnsworth drove a chariot for Cecil B. DeMille in *The Ten Commandments,* had his first speaking role in 1976 in *The Duchess and the Dirtwater Fox,* and was nominated for a best supporting actor Oscar for his work in Alan J. Pakula's 1978 Western, *Comes a Horseman.*

It's hard to imagine anyone else in the part of Alvin Straight; Farnsworth's wise, beatific face *is* a movie. "The minute I read the script I identified with this old character and I fell in love with the story," said the actor, who was seventy-eight years old when the film was shot. "Alvin is an example of fortitude and guts."[1] Farnsworth had retired in 1997 but decided to go back to work when he read the script for *The Straight Story.*

Sissy Spacek played Rose, a character based on Straight's daughter, and recalled, "David, Jack, and I had been talking about different projects we could do together for years, and *The Straight Story* fit us all. I think David thought it would be great to be up there with Jack, you know, 'We can bust out a wall with sledgehammers if we need to, like in the old days.' They've been busting out walls with sledgehammers together for fifty years.

"The character I play speaks with an unusual stutter, so I had to wear an elaborate dental prosthetic and didn't know if I'd be able to do it," Spacek continued. "David believed in me, though, so I thought, Maybe I can do this, and it was a great experience. He was as lovely on set as he is in real life and was delightful to work with. Funny, kind, knew what he wanted—it's easy working with David. One day, one of the actors who was up in years had a lot

to do in a scene and he kept moving at the wrong time and messing up the shot, and he started getting really upset with himself. David was so patient and sweet. He said, 'I'm just gonna tie a little string to your belt loop, and every time I want you to move I'm gonna give that string a little tug and you'll know what to do.'

"People have said, 'Oh, *The Straight Story* is so different for David, it doesn't really belong in his world,'" Spacek added, "but if you know David you know it's also part of who he is."

Harry Dean Stanton, who plays Lyle Straight, had already appeared in four Lynch films prior to *The Straight Story* and was always happy to work with him. "David's sets are very relaxed and he never yells at anybody—he's not a yeller—and he gives me the freedom to improvise as long as I don't mess with his plot," said Stanton. "We always have a good time working together.

"I'm only in one scene in *The Straight Story,* and I needed to cry in it," Stanton continued. "A while back Sean Penn gave me a copy of a speech by Chief Seattle, who was the first Indian to be put on a reservation, and I always cry when I read it, so David had me read some lines from the poem prior to shooting my scene. And it worked."

Lynch's colleague from *The Elephant Man,* cinematographer Freddie Francis, captured a Midwestern America that barely exists anymore. Shot along the two-hundred-forty-mile route Straight traveled in 1994, from Laurens, Iowa, to Mount Zion, Wisconsin, the film has an elegiac grandeur. Punctuated with images of the weathered red paint on the exterior of a small-town bar, stray dogs running down an empty main street, and aerial shots of the sleepy Mississippi River, it's a beautifully paced film with a bittersweet mood that's enhanced by exquisitely deployed periods of silence, along with Badalamenti's wistful version of American roots music.

Jack Fisk is particularly good at films involving vast landscapes—he's done most of Terrence Malick's films, Paul Thomas Anderson's *There Will Be Blood,* and was nominated for an Oscar for Alejandro Iñárritu's 2015 film, *The Revenant*—and *The Straight Story* was a natural fit for him. "From back in the days when we were sharing studios, David and I had always been a little competitive, so it was better that we didn't work together," said Fisk. "But by the late nineties I realized, I'm working with other directors, trying to make their

visions real, and I miss David and want to spend time with him. We had a blast on *The Straight Story.*"

Reflecting on the enduring bond between Lynch and Fisk, Spacek said, "David and Jack were first for each other. They were two young people in Virginia who both wanted to be artists and live that life, and from the moment they met they supported that in each other. That made it real for them, and they went to art school and traveled in Europe, then they went out into the world together and realized this dream they'd shared. Their friendship goes really deep and I think that's why."

Gary D'Amico, who was also in Iowa for the shoot, recalled *The Straight Story* as "the most fun project I ever did with David. And I got a SAG card out of it! I had a nice mountain bike with me on location, and David said, 'I like that bike and want to put it in the movie, and I want you to ride it.' Then he said, 'Hey, let's give Gary a line! How about "On your left, thank you."'"

As for his effects work on the film, D'Amico said, "There's a scene where a semi passes Alvin as he's going down the highway and it blows his hat off. The camera was shooting him from behind and David said, 'I want that hat to come right at the lens,' and I said, 'David, a passing truck would blow his hat forward, not backward.' He said, 'Yeah, but this is my movie and I want it to blow backward,' so I said, 'Backward it is.' The hat had to travel around fifty feet, so I rigged a system with eight pulleys, and each one pulled the hat around eight feet. The AD said, 'David, we don't have time to do this, and it's not even going to make the movie,' and David said, 'How do you spell horseshit? Gary spent a lot of time rigging this and we're gonna shoot it.' And it did make the movie."

Lynch completed post-production on *The Straight Story* while the *Mulholland Drive* drama was playing out, and the series had been scrapped by the time he took *The Straight Story* to Cannes in spring of 1999. The film did well there and was an audience favorite, but was passed over as far as prizes. "I organized a party for the losers at the Carlton after the Palme d'Or ceremony," said Edelman, "and David was there with Pedro Almodóvar and some other people. It was a fantastic party and David was happy and he forgot about the awards."

"The audience at Cannes loved the film," said Sweeney, "and the screening there was a moving experience. It was the first time everybody in the film had seen it, and Richard, Sissy, and Jack were there, and it was so fun. We

came out of the Grand Palais and Angelo's music was playing through outdoor speakers, that Italian soul Angelo's got with a trace of yearning country twang added to it—we were all so happy. It was the last time Freddie Francis worked, and the last time Richard Farnsworth worked, and it was just a beautiful major chord."

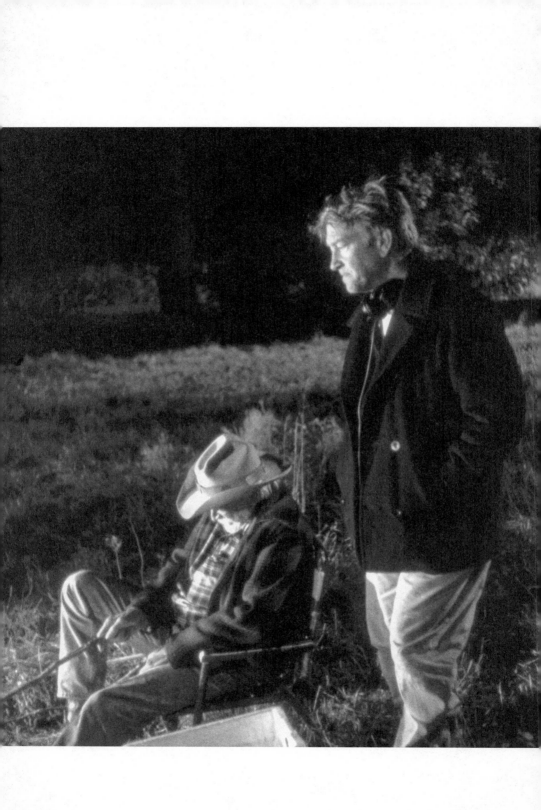

I T TOOK MARY and John Roach a long time to write the script for *The Straight Story*, and I kept hearing about it but I had zero interest, and then they asked me to read it. Reading something is like catching ideas — you picture it in your mind and your heart, and I felt all this emotion coming out of the characters in this script and I thought, I want to make this. In the years leading up to that movie I'd been spending time in Wisconsin and getting a feeling for the kind of people who live in that part of the country, and that probably helped me love the script.

I can't remember when Richard Farnsworth's name came up, but once it did he immediately became the guy. Richard was born to play Alvin Straight, and every single word he spoke had the ring of truth. Richard had innocence, and that's part of what made me fall in love with him for the part. Alvin Straight was like James Dean except that he was old — other than that, he was a rebel who did things his own way, and Richard was that way, too. People really don't have an age, because the self that we talk to doesn't age — that self is ageless. The body gets old but that's all that changes.

Richard's been in a lot of movies, and every time I've seen him I've felt like, I like that person. I don't know why he wasn't a superstar, but I don't know if he even wanted that. In a way he didn't consider himself an actor, because he came to acting from rodeos and stunt work, but Richard was the perfect Alvin Straight and we were thrilled when he said he'd do it. Richard doesn't like negotiating, and he said, "This is my fee," and it was reasonable, but he didn't even want to talk about it. So we said peachy-keen, fine. Then, lo and behold, he said he couldn't do it. He

didn't say why but it could've been his health, because Richard had cancer then. We said, Oh no, this is horrible—horrible for Richard and horrible for us. That's when I thought of my dear friend the great actor John Hurt. He's so good that I thought he might be able to do this character, and I talked to John and he said he'd do it.

Every year Richard came to L.A. from New Mexico where his ranch was, and met with his manager/agent and they had lunch. It was a tradition for them. So he came in after he'd turned down the part, and when they met for lunch she said, "Richard, you look really good," and he says, "I'm feeling really good." She said, "You know, Richard, maybe you should do *The Straight Story*," and he said, "You know, I think I should and I can and I will." So he called and then I had to call John Hurt, who totally understood, and we had Richard. We were so thankful and he did everything so well and was always cheerful, always Richard.

Richard was seventy-eight and Freddie Francis was nearly eighty-one when we shot the film, but they were more than keeping up with everybody—Freddie and Richard were setting the pace. Freddie's health wasn't so good, either, and although he lived for eight more years, *The Straight Story* was the last film he shot. It was dangerous for Richard to drive that thing, too. It wasn't the safest rig, but he'd broken lots of bones as a stunt guy and Richard was brave as can be, and he got younger as we went along. It was impressive what Richard did. No one realized how much pain he was in throughout the shoot—he kept that to himself. He was a cowboy.

I love Sissy and I've known her for a long time. Jack brought her around when he started going with her when I was working on *Eraserhead*, and for a while she was my sister-in-law. Her agent was Rick Nicita and he became my agent, and they were there all along, sort of setting the stage for different things. Jack and Sissy gave money to *Eraserhead*, and they're family. I always wanted to work with Sissy and she was the perfect person to play Rose. Other than Sissy and Richard and Harry Dean, the actors in the film are all from that part of the country, so they had a feel for the way people live and talk there.

That film came together very fast. We started shooting in late summer, and we had to work fast because that part of the country gets really cold early in the fall and most of the picture is set outdoors. Because we

traveled the same route Alvin Straight actually took, it made sense to shoot in sequence, so that's what we did.

My favorite scene in the film is the ending. What Richard and Harry Dean did together is just incredible. Jack built Lyle's house, which was a beautiful house, and it was up high and was surrounded by mountains and there was sort of a dip in the mountains where it sat. So Richard is going down this incline toward the house with the heavy weight of the trailer behind him, and he turns into Lyle's and the thing stops. Richard gets off and walks partway to the house and he calls out to Lyle. The light was just beautiful and the sun was right on him and he calls out to Lyle and the *second* after he did that the sun goes behind the mountain. If we'd been seconds later we would've missed that completely. We were so lucky to get that. Then, when Richard spoke to Lyle he had this little choke in his throat, and that little choke of the heart is incredible. Harry Dean and Richard Farnsworth? The word "natural" is them. Harry is as pure as can be and Richard's that way, too, and you can feel that in that scene.

I also love the scene in the barroom when Richard is talking to Verlyn [actor Wiley Harker] about World War II. That scene is completely about what's inside Richard and Wiley, and the only thing I did was keep everything quiet and let them sit with each other and set up two cameras on them, both in close-up. There was no rehearsal and that scene was shot in one take.

Everything is relative. *The Straight Story* is a peaceful story, but there's violence in it, too. When Alvin's lawnmower threatens to go out of control, that's very violent for Alvin, but it's balanced — there has to be balance in a film. Once you start down a path you've got rules, and you have to obey the rules of the path you're on, and you can't go down two roads at the same time. Maybe the people in this story seem saintly, but we're seeing only a part of them in one specific circumstance, and this doesn't mean *The Straight Story* is the truth about the Midwest, or that Dorothy Vallens is the truth about all women. It's a slice of something. A slice can ring true, but it's not the whole truth.

I've always said that *The Straight Story* is the most experimental film I've made, and it is pretty different from movies I'd made before, but really, everything is an experiment. You gather pieces you think are cor-

rect, but you never know if they're right until you actually combine them. You've got to have image, sound, music, and dialogue going in a really delicate balance to get the emotion. How the music comes in, how loud it gets, how it goes away—these things have to be perfect, and the music Angelo wrote for that movie was so important to it.

The Straight Story was in competition at Cannes, so a whole bunch of the crew and cast went over and we had a great screening. It was such a good feeling in the room; it was just beautiful. Mira Sorvino was sitting in a row ahead of me, and when it was over she turned around and looked at me and touched her hand to her heart and she was just sobbing. She felt what was happening in the film. It was a real emotional screening, and that's the night Harry Dean told the story.

After the screening we all ended up at the Petit Bar at the Hotel Carlton. Angelo and Pierre and Harry Dean and I and a couple of other people were sitting at one end of the bar where it was kind of quiet and we ordered drinks, and we're sitting there and Harry Dean said a sentence. None of us can remember exactly what it was—something about chocolate bunnies and a dream Harry Dean had—but he said this sentence and we laughed, then he said a second sentence and we laughed twice as hard. We're thinking that's the end of it, but then he said a third sentence, and a fourth sentence, and each sentence topped the previous one, so we were really laughing, and he went on for eighteen more sentences! You know how they shoot compressed air in your mouth and your cheeks expand? That's how my head felt by the ninth sentence. I was dying laughing and my tear ducts were dry from crying-laughing. He just kept topping himself, and nobody can do that! Something will break it! But the delivery, the timing, the words, the sequence of words, it was fucking flawless, unbelievable—I've never seen a stand-up comic do anything like what Harry Dean did. We could hardly stand it we were laughing so hard, and by the end of this we were dead. We still talk about this thing. If Angelo and I are together for more than fifteen or twenty minutes we always get back to that night, but neither of us can remember what Harry Dean was talking about. Harry Dean is so pure, pure self, pure Harry Dean.

Richard Farnsworth was in Cannes with us, then after the dust settled on The Straight Story he went back to his ranch. Maybe a year later he

went. He figured, When it's beginning to look like tomorrow I won't be able to move my arms, then I have to do it, and that's what he did. He shot himself. It's a cowboy story, really.

David Cronenberg was the head of the jury at Cannes that year, and *The Straight Story* was definitely not his cup of tea. He probably thought it was total bullshit. It's the luck of the draw who's the head of the jury, and that's the person who sets the tone of the festival that year. We thought this film could reach a broad audience because it was tender and heartfelt, and the people in it were so good and the themes of brotherly love and forgiveness were so beautiful. And when the ratings people called and said the picture had a G rating, I said to the guy, "You have to tell me that again!" It was a weird time, though. The Christian fundamentalists didn't embrace the film, because it had the word "hell" in it, and although Disney put it out, I don't know what they really thought of the film. Whatever they did to promote it, it just didn't catch. I guess it's partly my destiny, but it didn't catch. I was at this party once and Spielberg was there and I said to him, "You're so lucky because the things you love millions of people love, and the things I love thousands of people love." He said, "David, we're getting to the point where just as many people will have seen *Eraserhead* as have seen *Jaws*." I don't know about that. All I know is that there are lots of films out there and I don't know if anybody cares.

We shot that film in the late nineties. You know how you pass a cornfield and normally you'd see corn and maybe a fence around the field? When we were shooting *The Straight Story* I saw these signs in front of different rows of corn and I thought, What is this? What it was is they were experimenting with GMOs, and I'm pretty sure all those farms I saw are GMO farms now and there's no more Mother Nature corn. In the old days there were many little family farms. Then the bigger farms—the rich people—started buying the little farms and now there are just a few giant farms, so there are fewer farmers and all the little communities are completely gone. You know, you meet somebody, Farmer Bill's daughter, and you fall in love, and you stay in that area and have a farm and you do your work. That's gone now. All the little schoolhouses are gone and there are rows and rows of GMO soybeans and corn.

It used to be that a farmer would save a portion of his seeds for plant-

ing next season and he'd give them to collectors, who stored them in silos. These seed collectors are sobbing now, and all the farmers they had relationships with are under pressure to be GMOs, and you've got to buy your seeds from Monsanto next year. Those seeds only last one year and they're packed with insecticides and herbicides. If the farmer next door doesn't want those seeds, some of them still might blow onto his land, and if they do Monsanto sues that farmer, saying "You stole this; we have a patent on this." They pit one farmer against another, the seed guy's sobbing, his kids are sobbing, and the neighborliness of that world is gone. They probably say the food is fine and we have to feed such a big population, how else are you going to feed them? You've got to get scientific to feed so many people. Maybe. But Mother Nature has been crushed and all of this happened because of money.

The Happiest of
HappY Endings

After the frenzy of activity surrounding *The Straight Story* and *Mulholland Drive,* Lynch embarked on a kind of return to his first principles. He began to simplify and staffed his office with energetic young people eager to devote the kind of time and commitment to his work that *Eraserhead* required. He doesn't like it when things get too big and unwieldy, and he wants to be left in peace to make whatever it is he's decided to make; it's never been about fame or money for him, and that became increasingly apparent as he moved into the twenty-first century.

"The most challenging thing about representing David was trying to get his work into even the edges of the movie mainstream, and I failed to do that," said Rick Nicita. "Although *Twin Peaks* got him to the very center of television and popular culture, his movies were always marginalized. But he didn't *want* to be in the center, and while that was initially frustrating to me, I began to savor it after a while. I don't think David's ever had the intention of doing a lot of movies. He could've played the game and pushed it harder, but I don't think he was interested in that, because he had other things to think about. And he's always been happy within the world he's created for himself."

By the end of 2001, movies had become a low priority for Lynch, who was already deep into his next creative adventure. "David was one of the first people I knew who got involved with the Internet, and when he started doing programming it was like he was starting his own TV station," said Neal Edelstein. "He got bored after a while because the technology couldn't stay far enough ahead of him, but at the beginning he was really fired up about it."

Among those with a front row seat for this was Erik Crary. Raised in Lodi, Wisconsin, Crary moved to L.A. in January of 2000 and began working for

Lynch in September of that year. "It was surreal going from a job stuffing envelopes at a management company to sitting across a table from David Lynch," Crary recalled. "It was completely crazy to have that opportunity.

"David's daily life is very busy even when there's not a film going on," Crary continued. "He's shooting photos, painting, writing, building things—he does a lot—and when I arrived they were focused on the launch of the website. We'd meet with David in the morning to go over what would be happening that day, and somehow that meeting morphed into what we called a 'power walk.' We'd have the same meeting only we'd be walking up this steep hill and around a big block. It took half an hour and it would be David, Jay Aaseng, me, and sometimes Austin."[1]

When you launch a website there's got to be something on it, and Lynch devoted a good deal of time during this period to creating content for his site. "I was mostly assisting David with what he called experiments, shooting in the backyard or around L.A. One thing that excited him about the Internet is that it introduced technology that allowed you to do a lot with a little, so if he had an idea he could say, 'We're going to build a set in the backyard and light it and there will be these props, then we'll shoot,'" recalled Crary of Lynch, who has no trouble keeping up with assistants decades younger than him. "Some days were crazy because we'd have a normal day of doing assistant stuff, then we'd shoot all night. David was putting those hours in, too, and I have no idea how he maintains the energy level he has.

"Initially I think David thought the Internet could be a source of revenue," Crary speculated of the site, which charged ten dollars a month for membership. "The idea was that subscribers would generate money so David could shoot more things for the site, and it would be kind of like a mini-studio. Everybody was launching websites then, and nobody knew what the model was capable of."

Edelstein was in on the ground floor of Lynch's website but was gone from the office by the time it launched. "I hit the ceiling at my job with David, but I stayed in touch with him after I left," Edelstein said. "I still have so much love for him. He's a great person and I've never seen him do anything bad to anybody. He gave me my career, he's loyal, he believes in people, and he practices what he preaches in terms of meditation."

• • •

The website launched with considerable fanfare that began with an email blast:

THIS IS THE DAVIDLYNCH.COM NOTIFICATION!!!!!!!!!!!!! ON MONDAY, DECEMBER 10, 2001, AT 9:45 AM PACIFIC STANDARD TIME, DAVIDLYNCH.COM WILL LAUNCH ITS MAIN SITE. . . . THIS WILL BE FOLLOWED SHORTLY BY THE LAUNCH OF "NEW SERIES" EXCLUSIVELY FOR THE NET, AND IN TURN, THEY WILL BE FOLLOWED BY THE OPENING OF THE STORE. . . . THANK YOU FOR YOUR INTEREST IN DAVIDLYNCH.COM. . . . I LOOK FORWARD TO SEEING YOU THERE!!!!!!

DAVID LYNCH

"It was a pretty big morning up there," said Crary. "Alfredo built a big light box we switched on in the studio at the exact time the site went live. We also held a 'Lunch with Lynch at Bob's Big Boy Raffle' that all subscribers were eligible for. The winner was a girl from England, who came over with a friend."

The content for the website expanded throughout 2002 and was created almost entirely by Lynch. He provided a daily weather report—he simply looked out his studio window and shared his thoughts on how he expected the day to shape up—and produced a series of shorts. There were three episodes of *Out Yonder,* which feature Lynch and his son Austin conversing in a bizarre dialect that combines moronic babbling with flashes of insight. *DumbLand,* a series of eight crudely animated shorts, also completed in 2002, chronicles the misadventures of a belligerent half-wit named Randy, his son Sparky, and his long-suffering wife. Emanating from the same realm as *The Angriest Dog in the World, DumbLand* is an explosively violent symphony of gross, puerile humor; there's lots of farting and belching. An online store sold *Eraserhead* posters, caps, film stills, pins, coffee cups, and T-shirts, *DumbLand* coffee cups, *Angriest Dog in the World* T-shirts, and various short films.

The most widely known of the shorts Lynch produced during this period is *Rabbits,* which premiered on June 7th, 2002, and was later incorporated into his tenth film, *INLAND EMPIRE.* Comprising nine episodes set in a middle-class living room furnished with an ironing board, among other things, *Rabbits* features three rabbits speaking in mannered haikus occasionally punctuated with a sitcom laugh track or the distant whistle of a passing train. They're

among the most inscrutable works Lynch has produced. Starring as the rabbits—and hidden in life-size rabbit suits—were Scott Coffey, Laura Harring, and Naomi Watts.

"I feel an incredible debt to David, and anything he asks me to do I have to do," said Watts. "I owe him a lot and it's always fantastic to spend time with him. Wear a bunny suit you can't breathe in that's seven thousand degrees inside? I don't care; I'll do it for David. Those suits were really heavy, though, and once you put the head on you couldn't see anything. I'd hear him saying, 'Okay, Naomi, finish your ironing and go out of the room.' I'd start walking and bump into a wall and he'd say through his bullhorn, 'Not that way, Naomi, turn right; go to your right, Naomi.' I said, 'David, I can do this voice later and you can get one of your assistants to actually wear the suit in the scene,' and he said, 'No, it has to be you in there.'" Harring, who's claustrophobic, said, "I had to close my eyes and just breathe. It was intense and David never explained to us what we were doing. We just followed his instructions."

Lynch also used his website as a platform for various musical collaborations he was involved with. At the end of 2001 he released *BlueBOB,* an album of what Lynch has described as "industrial blues" made in collaboration with John Neff for Lynch's label, Absurda. Recorded from 1998 to 2000 and completed in March of that year, it was originally released as a CD available only through Lynch's website. Lynch and Neff did one live performance to promote the record, at the Olympia in Paris on November 11th, 2002, which Lynch remembers as "a torment."

A French journalist visited Los Angeles to write an article about *BlueBOB* in 2002, and Crary recalled Lynch saying, "'If we're gonna do this, let's make it fun.' He had Alfredo build a cave in the backyard, and there was a little mini-sculpture hanging over the entrance to the cave, and we put a smoke machine and a strobe light in there, and a sexy girl was wandering around, and David came out of the cave with his shirt off, smeared with mud, and did the interview." This is probably the only opportunity Lynch's fans will ever have to see him without his shirt on.

In May of 2002 Lynch was president of the jury at Cannes, where Roman Polanski's *The Pianist* took the Palme d'Or, then, back in Los Angeles, Chrysta Bell reappeared. "After my meeting with David in 1998, we didn't stay in touch, but Brian Loucks maintained a relationship with me. In 2002 Brian was at a party and ran into David, who never goes to parties, and he said, 'Hey,

what's going on with Chrysta Bell?' David and I went back into the studio and finished that first song we'd done together, then whenever David had pockets of time I'd jump in there.

"I'd made demos of the songs I'd written for my first album," she continued, "and when I played them for David he said, 'I'm proud of you, Chrysta Bell, but I think you should wait for our record to come out as your debut.' I said, 'Okay, David, but we need to step on the gas,' and he told me how long it took to make *Eraserhead* and that it was worth it to take time with things. But he started making more time for us to work together."

Early in 2003 Lynch's life changed course when he met Emily Stofle, whom he subsequently married. Born in 1978 in Hayward, California, Stofle was raised in Fremont and moved to Los Angeles in 2000 with her older sister to pursue a career in acting. They found an apartment in Beachwood Canyon, and Stofle studied with acting coach Diana Castle while working a string of odd jobs—assistant to the manager of a nightclub, waitressing gigs. She and her sister befriended a neighbor, Eli Roth, who'd researched a project on Nikola Tesla for Lynch, and was director of the 2002 horror film *Cabin Fever,* which Lynch executive-produced. "One night I visited Eli at his apartment," Stofle recalled, "and I noticed a photograph of one of the props from *Fire Walk with Me* on his wall. I asked him where he got it and told him I was a huge fan of David's. He said he'd worked with David and that David was producing content for his website and maybe there was something he'd like to do with me.

"Eli talked to David, then called me and said, 'David has cameras on some birdfeeders at his house, and people can log in to his site and watch the birdfeeders. He has this idea that he wants a golden ball to drop and then you come out in a coat, which you take off. You'll be nude and you'll spin around, then you'll stand there for five minutes, then go off the screen,'" she continued. "I thought, Oh, I don't know. The Internet? Nude? I don't know if those are the circumstances I want the first time I meet this filmmaker I admire. A few days later Eli called again and said David was looking for models to pose for photographs and that he'd pay the models and give them three signed prints, so my sister and I went up and met him on February 20th. We sat around a table in his conference room and talked, and he later told me that when I was leaving I turned around and waved goodbye to him and that's when he fell in love with me.

"He photographed me and I was nervous and that was it," Stofle added. "He was very professional and I had no idea he was interested in me. I didn't have a crush on him, either—I was just fascinated by him and excited to work with him. He called a month or two later and wanted to photograph me for another project, then in June I moved in with my mom in Fremont and began attending San Francisco State."[2]

Shortly after meeting Stofle, Lynch ran into Laura Dern on the street outside his house. She'd just moved into the neighborhood and both agreed it was time for them to work together again, so he wrote a scene for her. He didn't have a feature in mind, and at that point the scene he came up with was just another of his film experiments. "We shot it in the painting studio," said Aaseng, "and Laura memorized this incredibly long scene. I've never seen anything like it in my life—she was just knocking this monologue out of the park and going for long stretches. The only time we'd break would be to change film in the camera. She was just going."

Sitting opposite Dern in that very long scene was Erik Crary. "I'm not an actor and I have no idea why David picked me to be in that scene," Crary said. "He told me, 'Get yourself a suit jacket,' and I brought up all my old glasses and let him pick the pair he wanted me to wear. I think I have a paint scraper in my pocket. Laura is really intense in that scene and has to do a lot, so I asked her what I could do to help her and she said, 'Just stay with it and look at me.'"

Dern remembers the night as being "very magical and a little trancelike. A warm wind blew through the painting studio and the night got super quiet and the coyotes calmed down and the night sky was above us and everything felt mysterious and unknown. I was a nursing mom at the time and I thought, Oh my God, how am I going to remember anything, but somehow I did. David set the tone with his reverence— his respect for the ritual of storytelling is always palpable. He wants it quiet and you know you're just gonna keep going until it's done."[3]

It took only four hours to shoot the scene, and Aaseng said that "after we finished and Laura had gone home, David was having a smoke in the painting studio and he was really excited. His eyes were just lit up. He looked at us and said, 'What if this is a movie?' I think that was the moment when *INLAND EMPIRE* was born."

Gaye Pope died that spring, on April 20th, which was a great loss for Lynch;

the two of them had a deep and unique friendship. He spent the month of June doing intensive study in the Netherlands with Maharishi, and on returning to L.A. he began gearing up for *INLAND EMPIRE* and called Jeremy Alter. "David said, 'I'm doing this thing, and I don't know what it is but I want you to produce it,' and we started doing these shoots," Alter said. "David would write pages and Jay would type them and that was about the extent of the script. At the beginning the shooting was sporadic, but once Jeremy Irons came on board it became a more full-time thing."

As Catherine Coulson was to *Eraserhead*, Aaseng and Crary were to *INLAND EMPIRE:* They did anything and everything. "I think he was thrilled to be working that way, because it was super bare bones," said Aaseng of Lynch, who wrote, produced, edited, and shot the film with a Sony DSR-PD150. "Peter Deming helped on one or two scenes but David was basically the DP, and Erik and I were often running cameras. We were doing call sheets, finding props, paying people, I was an assistant editor for a while and a makeshift script supervisor—we all learned a lot and David was very patient with us.

"I was David's writing assistant throughout *INLAND EMPIRE,* too, but in no way was I his collaborator," Aaseng continued. "I just wrote down what he said. He'd say, 'Let's write,' and he'd dictate and I sat at a computer and typed. Sometimes when we were on set, we'd finish shooting a scene and inspiration would strike and he'd say, 'Jay, come over here,' and I'd go over with a pad of paper and get it all down. David wanted to go renegade and didn't want to be constrained by people telling him he couldn't do this or that, and Jeremy Alter was an important part of that equation. Whatever David came up with, Jeremy would say, 'Cool, we'll do it,' and he was able to get David into places because he knew lots of people."

"Part of my job was to make sure David could smoke at any location where we were shooting," said Alter. "I had to find some unusual things, too, of course. One day he said, 'Jeremy, get a piece of paper and a pen and write this down. I need six black dancers, including one that can sing, a blond Eurasian with a monkey on her shoulder, a lumberjack sawing wood, Nastassja Kinski, a tattooed person, [meditation instructor] Penny Bell, Dominic who's an ex–French Foreign Legionnaire, Laura Harring in her *Mulholland Drive* outfit, and a beautiful one-legged girl." Alter got it all.

"It was a crazy experience," said Aaseng of the making of the film. "One night we were shooting a scene where Justin Theroux is lying dead in an al-

leyway, and we ordered a pizza. It arrived and David ate a slice, then he looked at the pizza and scraped all the topping off of it and smeared it on Justin's chest so it looked like a wound."

Laura Dern carries the film almost entirely and is onscreen for pretty much all of the second half. Like a little girl lost in a dangerous forest, Dern stumbles in and out of various realities, her identity periodically shifting along the way. Lynch began toying with the idea of doubles and doppelgängers in *Twin Peaks,* and with *INLAND EMPIRE* he just let it rip. Dern's journey takes her far and wide, too, from a prostitute's hotel room in Poland, to a barbecue in a trashy suburban L.A. backyard, to a movie set, a mansion, a therapist's office, and a European circus. As the film unfolds she's alternately terrified, mystified, and serene. There are extraordinary little set pieces within the film, too. When Dern dies of a stab wound on a dirty Hollywood Boulevard sidewalk, she's in the company of three homeless people, played by the Asian actress Nae Yuuki, Terry Crews, and Helena Chase, who looks at Dern and tells her, "You dyin' lady." Chase lived in one of the houses used as a location in the film, and although she wasn't an actress, something about her resonated with Lynch, so there she is onscreen.

Also on board for *INLAND EMPIRE* was Justin Theroux, who said, "I had no idea what we were doing on *INLAND EMPIRE.* That was really seat-of-the-pants, let's-get-the-band-back-together filmmaking, and David was extremely visionary as far as embracing the technology that was newly available fifteen years ago.

"When I finally saw the film I was moved by it—*INLAND EMPIRE* is as close to a spiritual opus as you're gonna get," Theroux added. "It's powerful and full of inexplicably unforgettable images—a character standing behind a tree holding a Christmas light, for instance. So strange, and yet you remember it."

The budget for *INLAND EMPIRE* was nebulous. StudioCanal eventually kicked in four million dollars, but the film was well under way by the time the funds materialized. "I remember asking David what he wanted the film to cost," Alter recalled, "and he said, 'Jeremy, you're gonna tell me something costs a hundred and forty dollars and I'm gonna give you a hundred and forty dollars.'"

On June 26th, 2004, Lynch's parents were in a car accident and his mother was killed. "Death doesn't disturb David the way it does most people, but I think he was changed by his mother's death," Sweeney reflected. "It was shocking the way she died, of course, but they also had a complex relation-

ship. David's a lot like his dad, who was dreamy and sweet, but his mom was the one who recognized his talent and cultivated it, and he told me they were very close when he was growing up. She was an incisive, analytical, smart woman, and they had the same dry sense of humor and joked with each other in a way nobody else in the family did."

That fall Lynch embarked on a new musical partnership when he began working with his friend from Łódź, Marek Zebrowski. "David loves dissonant, far-out music and is a big fan of Polish avant-garde composers like Krzysztof Penderecki and Henryk Górecki," said Zebrowski, "and when he discovered I was a pianist he invited me to work with him at his studio. Prior to my first visit in 2004 I asked, 'What do you want me to do? Should I bring music paper? Are we going to compose something together?' He said, 'No, no, just come up.' So I arrived at the studio and there were two keyboards set up and he said, 'Okay, let's do something.' I said, 'But what are we doing?' He said, 'Oh, anything, as long as it's very contemporary and avant-garde sounding.' I asked him to give me a thought or two before we started, and he said, 'It's dark. It's a cobblestone street. A car goes very slowly down that street and another car follows it.' And that's David—absolutely of-the-moment creativity. So he started playing, then I joined in and we entered a completely different world. After we'd played for a while I felt like we were approaching an ending, so I looked at David, and he looked back with an expression on his face that said he was feeling exactly the same thing. We both nodded and it ended."

The INLAND EMPIRE shoot was still under way in October when Stofle returned to L.A. and moved in with a friend in Monterey Park. "David started hiring me to work on things—I did the voice-over for a film he did called Boat—and when I went up to see it in December we were in his office and he kissed me," recalled Stofle, whom Lynch subsequently cast as one of the seven Valley Girls who serve as a kind of Greek chorus in INLAND EMPIRE. "I knew it was complicated and that he lived with someone he had a child with, but I think I was in a bit of denial about what was happening. It just didn't seem to be in the realm of possibility that I'd have a serious relationship with him. But over time I fell in love with him and then that was all I wanted."

Lynch was spending a lot of time experimenting with music then, and in January of 2005 Dean Hurley took over the running of his recording studio. Born and raised in Waynesboro, Virginia, Hurley came to L.A. in February of 2003 to work in film as a sound supervisor. Trained as a visual artist, Hurley is

entirely self-taught as far as his work as a sound engineer. "When I came up to interview for the job, David showed me the studio and said, 'We do sound experiments up here, and I need somebody to help me with this equipment,'" Hurley said. "'You'd know how to run all this stuff, right?' I said, 'Yeah, sure.'"

Hurley asked for two weeks to learn the room, then jumped into the fray. "When I first started working for David, I was confused when he'd say things like 'Dean, you gotta put on "Mama, I Just Killed a Man," by Queen, or "I Just Believe in Love" by John Lennon,' and then I realized that the thing he remembers from a song—and considers its title—is the lyric that encapsulates the emotional pinnacle of the song," said Hurley. "That's kind of revealing in terms of how his brain works.

"One of the first things we worked on is a song called 'Ghost of Love,' which is on the *INLAND EMPIRE* soundtrack," Hurley continued. "We started working on it the way we often start, which is with David talking about a particular song or artist and the feeling he wants to capture. For that song he talked about Janis Joplin's 'Ball and Chain,' and when we listened to it he was just drilling me, saying, 'What is it? What makes this song the thing that it is?' I told him the chords are minor and it's three-chord blues, and he said, 'Yeah! Three-chord blues in a minor key! Give me those chords!' I gave him a set of chords that he liked and he said, 'Give me a drumbeat!' Then he looped it over and over and sat there with a pad of paper and wrote lyrics.

"There are things David's consistently drawn to in terms of sound and music," Hurley continued. "He talks about the B-52 bombers he heard circling overhead when he was a child and wanting his guitar to sound like that. And he loves three songs from the Monterey Pop Festival: Jimi Hendrix's 'Wild Thing,' Janis Joplin's 'Ball and Chain,' and Otis Redding doing 'I've Been Loving You Too Long.' When you listen to that Hendrix track, there's an interlude that sounds a lot like the way David tries to play, all whammy bar, with this giant rumbling bomber distortion underneath."[4]

INLAND EMPIRE was an all-hands-on-deck affair, and among those hammering nails were Aaseng, Alter, Crary, Hurley, Austin and Riley Lynch, Alfredo Ponce, and Stofle. Also there was Anna Skarbek, an artist who became part of the Lynch crew in 2005 after she moved to L.A. from Maryland to work in film.

"I was a prop buyer, there was some set dressing and painting, and I helped buy building materials," said Skarbek. "Everyone on the film was really young,

and it felt like a summer project you do with a college professor—it was so much fun. David was often covered in paint, and if he wasn't actually directing he was making something. We were working for a modest rate, but everyone really wanted to be there."[5]

Sweeney and Riley Lynch spent the summer of 2005 on Lake Mendota in Wisconsin while Lynch remained in L.A. working on *INLAND EMPIRE*. In July of that summer he also launched the David Lynch Foundation for Consciousness-Based Education and World Peace. Legally established as a 501(c)(3) in Fairfield, Iowa, the Foundation now has offices in L.A., San Francisco, Chicago, New York, and Washington, D.C., and works in thirty-five countries providing scholarships for schoolchildren, veterans, and victims of domestic abuse. It's a very big operation that's come to occupy an increasingly prominent part of Lynch's life.

Bob Roth played a key role in the launch of Lynch's foundation. Born in 1950, Roth grew up in a liberal family in Marin County, California, and enrolled at UC Berkeley in 1968. A political activist who worked for Bobby Kennedy's presidential campaign, Roth was profoundly disillusioned when Kennedy was killed, and that same year he discovered TM. "Our paths crossed for the first time in 2003, then the following year I was in Washington, D.C., teaching at American University, and I heard that David was on his way to Paris," said Roth of his initial encounter with Lynch. "I called and asked him to stop in D.C. overnight and give a talk about meditation and he said, 'Fine.' The talk was on a Friday night and I didn't get a confirmation from him until Thursday night, and the weather was horrible, but it was still standing room only and a total mob scene. When I saw the response David got from young people, how they liked and trusted him and recognized him as an honest person, I realized what an effective spokesperson he could be.

"He went off to Europe and we continued talking, and the idea for the Foundation came up," Roth continued. "David, Dr. John Hagelin [a former physicist who's now president of the Maharishi University of Management in Fairfield, Iowa], and I worked on the plans together, and then I asked David if we could use his name. I don't think he was paying much attention, and he said, 'Yeah, fine,' thinking not much was going to come from it. Then we sent out a press release and a week later it was on the front page of a thousand newspapers around the world that David was starting a foundation."[6]

"I was on the set of *INLAND EMPIRE* the day the Foundation became offi-

cial, and David was really excited about it," Skarbek recalled. "In those early years Bobby Roth was around a lot, and a lot of time was devoted to promoting TM. David doesn't like traveling and he was doing a lot of public appearances, which he doesn't enjoy, but when it comes to anything involving TM or Maharishi the normal rules go out the window. He's game."

When Sweeney and Riley Lynch returned from Madison that fall, Lynch moved out of the house they shared and into his studio, and he and Sweeney began discussing a separation. That was put on hold, however, until he completed a nationwide tour on the benefits of TM titled "Consciousness, Creativity, and the Brain."

"We had no idea how big the Foundation was going to be or what would happen, and I knew David hated to travel, but that fall I said, 'Let's do a tour of thirteen college campuses and talk about TM,' and that's what we did," said Roth. "He got nervous before going onstage—he hates public speaking—so he started going out there and saying, 'Does anybody have any questions,' and things would flow from there. David doesn't do anything he doesn't want to do, and when he did all that traveling for the Foundation I think he felt it was the right thing to do at the time. I would never ask him to do it now, but there was a moment in time when it was the right thing to do."

Lynch and Sweeney were still sorting things out when he returned from the speaking tour, and he picked up where he left off with *INLAND EMPIRE*. "Once we got through the running-and-gunning phase, the MVP on *INLAND EMPIRE* became Sabrina Sutherland," said Aaseng. "She's an incredibly fastidious person and knows everything backward and forward in terms of producing, and once everyone else was gone, Sabrina was the last one standing in terms of tying up loose ends."

"*INLAND EMPIRE* was a turning point for David, and I think it rejuvenated him," said Sutherland. "He was able to get his hands dirty and really finesse everything from effects to props and sets, and it was freeing for him to shoot with a small camera. Not having a huge crew allowed him to work with the actors on a very personal level."

Another candidate for MVP on *INLAND EMPIRE* was editor Noriko Miyakawa, who came to L.A. from Japan in 1991 to study film at California State University at Northridge. She worked her way up through post-production facilities and assistant-editing gigs, then was hired by Mary Sweeney in 2005 to help edit a commercial for Lynch. "The first time I met him, he just walked up

and said, 'Hey, I'm David,' and I really liked that," Miyakawa recalled. "Many directors barely see the people who work for them, but David's very down to earth."[7]

After working with Lynch on the commercial, Miyakawa moved on to other jobs, then a year later she got the call asking if she was interested in helping with *INLAND EMPIRE*. "We didn't have a script when we were editing, but David had a map—literally, he drew a map," Miyakawa recalled. "The most unusual thing about the way David edits is that he's not afraid to change things. Yes, there was some kind of a script and we had dailies, but footage is a living thing to explore for him. If he sees a possibility for change in a scene he'll just go for it, even though it might require restructuring the whole story.

"*INLAND EMPIRE* is an expression of David's belief in different worlds and dimensions," Miyakawa continued. "Everything's in it and everything is connected and it's my favorite of his films. I should add that I *hated* it by the time we finished editing it, because it's a three-hour movie I watched more than fifty times and it became like torture. But when I see it now, I see how personal and intimate it is, and I enjoy the freedom it gives the viewer as far as how they interpret it. The parts of the film you don't understand point to places in yourself that need examining."

Lynch was still shooting *INLAND EMPIRE* when Miyakawa came on board, and early in 2006 he went to Poland, accompanied by Stofle, to shoot a few final scenes for the film. "I think it was pretty obvious on the set that we were in love," Stofle recalled, "and it was so cool to be able to see him work. It was magical."

The shoot in Poland came together with remarkable ease, largely thanks to Lynch's friends in the Camerimage Gang. "David called and said he wanted to shoot scenes for *INLAND EMPIRE* in Łódź," Żydowicz recalled. "I asked him what he needed and he said he wanted a green, poorly furnished room, an actor who looked like he'd just come out of a forest, an actress of delicate, ethereal beauty, and four or five older actors. I called a Polish actor named Leon Niemczyk, who's known for his work in Polanski's *Knife in the Water,* and contacted two great actors—Karolina Gruszka and Krzysztof Majchrzak— who thought I was joking when I invited them to collaborate with David Lynch. We rented an apartment where we were allowed to paint the walls green, the owners let us use their furniture, and we had everything prepared by the following evening. I'll never forget David's face when we took him to the set. Ev-

erything was ready, I introduced him to the actors while the set was being decorated, and we started shooting the next day.

"David then wanted to shoot a scene in a historical mansion that involved the effect of lightning striking," continued Żydowicz, who appears in the film as a character named Gordy. "There was no such equipment in Poland then, so we came up with the idea of using a welding machine. In order to use it in the museum where we were shooting, we devised a construction with fire-proof blankets and managed to convince the museum director it was safe. David also wanted to shoot at a circus with dancing horses. There were only two circuses in all of Poland and I called one of them and, incredibly, the manager told me he was just setting up the tent in Łódź. A few members of Camerimage performed in that scene as a team of circus artists."

On returning to the United States he finalized his break with Sweeney. In May he married then immediately filed for divorce from her, a move that allowed them to make a financial split that was clean and clear. "He did that because he wanted to do right by her—at least that was my take on it," Aaseng speculated. "I know he was very generous and it certainly must've been some kind of financial hit to take." Lynch and Stofle continued to date for the remainder of the year.

INLAND EMPIRE screened for the first time on September 6th, 2006, at the Venice Film Festival, where Lynch received the Golden Lion Lifetime Achievement award for his contribution to the art of cinema. The film premiered in the United States at the New York Film Festival on October 8th and was released in the States on December 9th. Initially booked in only two theaters in the country, it then expanded to one hundred and twenty venues for its widest release. Although *The New Yorker* said it "quickly devolves into self-parody," *The New York Times* described *INLAND EMPIRE* as "fitfully brilliant," and *Rolling Stone*'s Peter Travers said, "My advice, in the face of such hallucinatory brilliance, is that you hang on."

The film's total gross was just $4,037,577, a number that meant nothing to Lynch. "David is his own unique breed," Stofle observed. "He's not a Hollywood person and he's not looking at box-office numbers. He thinks all of that is disgusting and doesn't care about it. He likes making things, and once something is completed he's sad that it's over, but he never wants to deal with the things that come after the project is finished."

Lynch isn't keen on the business end of things but he's willing when it in-

volves an element of fun, and the release of *INLAND EMPIRE* coincided with the launch of David Lynch Signature Cup Coffee. Nobody could question Lynch's belief in this particular product—he's lived for decades with a steady IV drip of coffee providing him with the fuel that powers him through his very busy life, and the company has operated successfully for more than a decade.

On October 22nd, 2006, Zebrowski and Lynch made their performing debut before an audience of one hundred in a candlelit room at the Polish Consulate, which is housed in the De Lamar Mansion in New York City. "Initially David didn't want to perform, but he enjoyed it," Zebrowski recalled. "With our concerts he's relaxed and he has fun." Since then they've performed approximately a dozen times at venues in Milan, Paris, and the United States.

Two weeks after returning from his gig with Zebrowski, Lynch decided to show the world how proud he was of Laura Dern's performance in *INLAND EMPIRE.* On November 7th he parked himself on the lawn of a church at the corner of Hollywood Boulevard and La Brea with a live cow, a FOR YOUR CONSIDERATION banner pitching Dern for an Oscar nomination, and another banner that read, WITHOUT CHEESE THERE WOULDN'T BE AN *INLAND EMPIRE.* "I'm here to promote Laura Dern," Lynch explained. "Academy members love show business, and this is the show-business approach." As for the cheese banner, Lynch explained, "I ate a lot of cheese during the making of *INLAND EMPIRE.*"

Reflecting on the film, Dern has no regrets, despite its commercial failure. "We worked on it for three years and it was the greatest experience I've had as an actor. David's the bravest artist I've ever known and his goals are different from other artists. He started that project saying to me, 'I want the crudest camera and I wanna do something that any seventeen-year-old sitting in Phoenix with their grandparents can do with a camcorder. Why can't I just grab a camera and see what that looks like? What is digital? How can we take it further? How are we blending these new and old technologies?' That's filmmaking. If you're in it for the result then you can't experiment, but if you're there to redefine art you can do anything. David's gift to all actors is that he propels them into a void where there are no rules.

"I remember being in Paris with David and him saying, 'Let's write a scene,' so we sat with cappuccinos in the morning and he wrote a scene and said,

'Okay, learn this. Now, what should you wear?' So we put on our coats and went down the Champs-Élysées to Monoprix, and we picked out clothing and a lip color, then we went back to the hotel, I got ready, and we shot this scene where I'm on the phone wearing sunglasses doing a tormented monologue. There was nothing like it, just the two of us alone, using the sound on David's camcorder.

"The people who responded to that film most enthusiastically were other actors and directors," Dern added. "When I worked with Jonathan Demme on *Rachel Getting Married,* he loved hearing stories about the making of *INLAND EMPIRE,* and even Spielberg told me he was haunted by it. I remember hearing Philip Seymour Hoffman talking about why it scared him, and what made him uncomfortable, and his effort to understand it—listening to him talk about *INLAND EMPIRE* was magnificent."

Lynch spent Christmas of that year with Stofle's family in Northern California and continued to maintain a high profile on multiple fronts. On December 28th, 2006, Jeremy P. Tarcher/Penguin published *Catching the Big Fish: Meditation, Consciousness, and Creativity,* a collection of Lynch's observations and anecdotes compiled during his speaking tour of the previous year. Explaining the genesis of the book, Roth said, "David's answers to questions about life, not just about TM, were so real and true, and everywhere we went, from Estonia to Argentina, the questions were basically the same. So I thought, Why not record his talks then edit them down into a book so more people have access to them." Reviews were courteously respectful, sales of the book were unexpectedly brisk, and Lynch was impressively obliging about promoting it. All proceeds went to the Foundation.

Lynch was keeping all these balls in the air—a book, a website, a film, a foundation, a new relationship, and several music projects—while undergoing a major upheaval on the home front. Over the years Sweeney had become an integral part of Lynch's film projects, and the end of their long-term partnership was no small thing. Through it all, Lynch seemingly never missed a step. "David has the ability to put things in closets in the mind and deal or not deal with them on his own terms," Hurley observed. "He's got a mastery of his own mind and the world's best poker face."

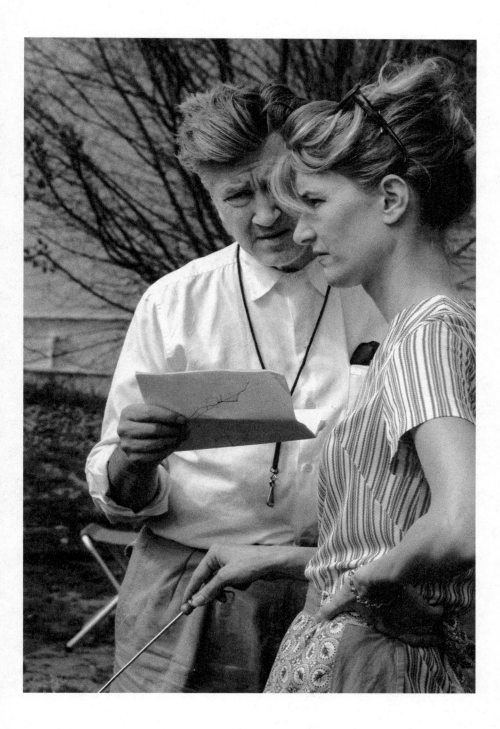

Eric and Neal and Churchy went to school together in Arizona, and they brought me into the world of computers. One night Eric and Neal set up a computer in the crow's nest [a small structure at the highest point on Lynch's property] and they sat me down and said, "We're going to teach you about Photoshop." They gave me the mouse and said, "Here are all your tools over here." I don't know how I got on to this Clone Stamp tool, but I said, "What does this do?" They said, "Click on it and see," so I clicked, then I made a mark, and I'm looking, and then I make a bigger mark, and what was happening on the screen was a miracle to me!

I still don't know how to do more than one tiny fraction of what Photoshop probably can do, but whoever dreamed it up and keeps making it better should be awarded a special place in heaven. I worship these people. They invented something that's mind-blowing. The first thing I did in Photoshop was my distorted nudes series, and it was inspired by 1,000 *Nudes*, a book of a thousand vintage nude photographs that were mostly anonymous and had been collected by this German guy named Uwe Scheid. He passed away in 2000, bless his heart, but his son honored the agreement I had with his father and gave me free rein to work with these nudes, and I just loved it.

My website got up and running and it took forever to get it the way I wanted. A website can be really deep and go anywhere, but all this stuff has to be built—and then in a single afternoon a person can sit down and see everything. And then what? They won't have to come back to this thing! It's over! You have to keep updating the site and making new stuff and it becomes all-consuming. Everything takes time to make, so how do

you feed this thing? Once I realized that you can't charge people for a site you don't update all the time, I lost interest in the Internet. I saw that it would be a full-time job. I liked doing the weather report every day, though, and I liked going in the chat room. I learned how to type with one finger then, too—I finally learned where the letters are! I couldn't believe it! My spelling got better because of the website, too.

I was making a lot of stuff for a while there, and there were all kinds of things to get lost in. I made this thing called *Head with Hammer,* and there's a mechanical device that brings this hammer back and back and back, then it slams into a rubber head. People understand that life is like that sometimes, and the hammer keeps hammering over and over again. I don't know where *Out Yonder* came from, but it appeared in my head and I started writing. The idea is that this family is heavy into quantum physics and they talk in abstract ways about things. They're interested in medicine and science, and they're quantum physicists. The guys in *Dream of the Bovine* aren't exactly quantum physicists, but they're a little bit in that family, too. They watch carefully and analyze things.

One day the rabbits in *Rabbits* just arrived, and I learned Flash animation doing *DumbLand.* I didn't know anything about it when I started, so the first ones are real crude, but they got better. The way that *DumbLand* came is, one day this man came in a big limo and he was from Shockwave. He told me, "I'm hiring you, Tim Burton, and somebody else to do animated series for Shockwave, and in return I'll give you shares in the company that should be worth seven million dollars when we go public or whatever." I said okay and started working. He came up a few times and he was kind of pumped and things are going good. Stop right there. At that very moment there were offices around the world full of guys and gals who'd just been given fifty million dollars to develop something they sold by talking. They're laughing and drinking cappuccinos, and they were giddy with this money so they all had new sneakers and T-shirts, and Apple computers, and they're having catered lunches and sitting on top of the world. Then the dot.com bubble burst and all those new-sneaker people, including the Shockwave guy, went up in smoke and those shares were absolutely worthless. I have the worst money luck.

For another experiment, we built a small room up on the hill. It was three walls and it didn't have a roof, but when we filmed it the camera

saw a room. It was carpeted and furnished and there was a chair in the corner with a chunk of beef on it, because I wanted coyotes to come in to the room. I had a whole thing I was going to do there, but I discovered that coyotes are super skittish and they're smart and they wouldn't just go in and eat the meat. They know that these walls are not nature and they go carefully, and it took them a long time to go and grab the meat. They got used to Alfredo's scent and eventually they started to tentatively come in and we got some film of one of them.

I met people from all over the world in the chat room on my site, and I made a few friends I'm still in touch with. I met this Japanese girl, Etsuko, and sent her a script for a game called Where Are the Bananas? The game centered on phone numbers and you have to try to find these numbers, and when you find a number you dial a beautiful rotary phone and you go somewhere. Etsuko would say, "Where are the bananas?" then she'd say, "This is the view out my window," and we'd see out her window in Tokyo. Then she'd say, "This is my kitchen sink," and while you're looking at her kitchen sink you notice there's a phone number in the bottom of the sink. You write that down, then you go to the phone and dial it, and you go somewhere. I did the animation for Where Are the Bananas? but I don't know if it ever got going.

The only things that stayed current on the site were the chat room and the weather report, so people liked those two things. And all kinds of things went on in the chat room. Toward the end I started this thing called Interesting Questions, and I'd sure like to do that again. It *was* really interesting and I wanted to ask many different questions, but I only got to ask two before dl.com ended. The first one was: Is there still gold in Fort Knox? Man, people wrote in so much stuff on that! They won't let anyone in there, and the new generation probably hasn't even heard of Fort Knox and doesn't give a shit if there's gold in there or not. I don't think there is any, though, and that means that our entire system of currency is based on nothing.

The second question I asked was: How did a 757 airplane get into the Pentagon through an eighteen-foot hole on 9/11? People wrote in tons and tons and tons. One person who called herself or himself Carol was CIA or a government person, I think, and she would attack people who didn't believe 9/11 was a terrorist thing. This person was very knowledge-

able, too. This other guy, also probably from the government, posted elaborate renderings illustrating how a plane could get into that hole. I said, "Nice try, buddy." I just asked the questions, then stepped back and didn't participate in the conversations they triggered, but those two questions generated talk that went on for months.

One day I was out in the street and there was Laura Dern. She said, "David! I'm your neighbor!" I hadn't seen her for a long time—during the years she was with Billy Bob [Thornton] I never saw her—and we said at the same time, "We've gotta do something together!" My dear assistant Gaye had cancer then and was at her husband's house in Escondido, and every day I'd eat lunch in the studio, then I'd call Gaye. She was always up and cute as a button, and she didn't seem to have any fear. We'd talk about what she had for lunch and stuff like that, then I'd write on a yellow pad. It took me about two weeks to write the scene for Laura that turned out to be the beginning of INLAND EMPIRE. At that point I thought, This is just an experiment and it may not be anything, but Laura still had to tell her agent, who was Fred Specktor at CAA at that time. Fred said, "Well, I guess so if she wants to do it. How much are you paying her?" I said, "The Internet rate is one hundred dollars," and he said, "Okay, David, I'm going to pin that ten-dollar check on my wall."

We shot the scene with Laura pretty soon after I wrote it. We made a little set in the painting studio and shot on a balmy winter night and it was really quiet. Laura started speaking and we stopped only twice— once for an airplane and once to reload the camera—but those interruptions didn't break the mood. Other than that it just went, and those were forty-five-minute takes. Laura's very smart and I don't think it took her long to memorize it, and she hardly missed a thing. Later, when I looked at the scene on the big screen in the studio I thought, Yes, this is a standalone thing, but it also indicates something way bigger and holds the key to everything.

Later I got another idea but I didn't know it related to Laura's scene. I liked it, though, so I shot it, and a little bit later I got another idea that didn't relate to either of the two things I'd shot. Then I got a fourth idea that united everything, and that started it. After I got that unifying idea,

Canal Plus put in money. I don't know how much they put in. I can do a lot with a little—not *super* little, but reasonable. These hundred-million-dollar movies are totally fuckin' crazy.

I shot the film with a Sony PD150. I'd started it with that camera, and once things got rolling I didn't want to change the look of the film, so I shot the whole thing with it. I loved my Sony PD150. It's not good quality, but it's the quality *INLAND EMPIRE* lives in. I feel like I'll never shoot anything on film again. It's not that I don't love film, though. Celluloid is like analog in sound. As good as it is, digital seems brittle compared with analog, which is thick and pure and has a smooth power. It's like the difference between oil paint and acrylic paint. Oil is heavier and I always want to go with the heavy one, but there are things you can do with acrylic that you can't do with oil.

Toward the end of the *INLAND EMPIRE* shoot, a bunch of us went to Poland to film some scenes. I fell in love with that place like you can't believe. In the summer it's not so good, but in the winter it's got a mood and it's got these beautiful factories and there was this feeling in the air that you could do anything. Laura Dern, Emily Stofle, and Kristen Kerr were there and they had to be dressed in their San Fernando Valley summer clothes for the scenes we shot. It was thirty below and we were shooting outside, so they could only go out for about a minute, tops, because they'd die if they were out longer than that. You could see the muscles tighten up in their bodies the second they got out there, and as soon as we said, "Cut," we raced them back into the van. We had the heat up full blast, and when they went out they'd stay warm from the van for about three seconds, then they'd have to tough it out. We had this fantastic goulash soup and vodka, and that stuff keeps you alive in that weather.

INLAND EMPIRE did well when it premiered at the Venice Film Festival. After it screened, we were on a boat at night, whizzing across the water, and I remember feeling so relieved. Laura Dern sat next to Catherine Deneuve, who said she loved the film, which made me feel good. When we got back to the States we went to different cities and sort of four-walled *INLAND EMPIRE*. I'd get a musician to play first, then I'd read a poem, then the film would start. It didn't do any business at all, though. A three-hour film hardly anyone understood? Absolutely dead. Most people got lost and bored and had zero interest. I think it's being

reassessed in the same way *Fire Walk with Me* was, but more slowly. I love *INLAND EMPIRE*, though, and I loved making it. I recently watched it for the first time in a while, and I dug it. It's deep in interesting ways, and it goes into different places and has different textures that hook together. You enter the film in one place and you come out in another. The film seemed short to me, though.

After the film came out, I got this idea that I'd have a cow and a sign saying CHEESE IS MADE FROM MILK, and I'd sit on the lawn of a church at the corner of Hollywood Boulevard and La Brea. I was doing it for Laura, and I had a big picture of her and a sign saying VOTE FOR LAURA. I sat there from late morning until five or six at night and it was real low-key. The news media never showed up, but two guys came and filmed their talk with me, and by seven that night their film had gone around the world. It was fun being out there. It was a beautiful day and people were great—they'd stop and see the cow and say things like, "What are you doing here, David?" If they didn't know who I was, they just said, "What are you doing here?"

Plenty of people don't know who I am. Are you kidding me? Plenty of people! I went to Lowe's to get some electrical supplies the other day and no one recognized me in there. Another time I had to go to a meeting with the president of the Producers Guild or the Directors Guild or something, and Erik Crary is driving me and I'm dressed sort of like a bum. Erik drops me off and drives off to park and I finish a smoke then go into the lobby. There are these big policemen-type guys at the desk and they're seeing me there. Fine. Then Erik comes in and I march over and slap the desk and say, "I'm here to see the president!" They look at me and say, "Oh yeah?" I say "Yeah! He's on the sixth floor." They say, "That's interesting. This building only has five floors, buddy." We were in the wrong place and they sure didn't know who I was, and they were on the verge of calling somebody—like the police or the men in white coats.

Building the recording studio was a huge job, and it was complicated. After it was done I walked into the studio and hardly knew how to turn the lights on. In a way that's still the way it is—I don't know my own

studio. There are so many things you have to know, and I need technical help. This guy named John Neff was working, sort of, for Studio Bau:ton, the acoustic architects of the studio, and one day I said, "Who's gonna run this place?" and John raised his hand.

Not long after we finished the studio, we formed a band called blueBOB and made a record with nine or ten songs on it. Some of them are good, and we got invited to play the Olympia in Paris, where the all-time greats have played. I never wanted to do it. Play live? It was ridiculous. I can experiment, but I can't play the same thing twice, but I said "Okay, we'll be the opening act and we'll do four songs." Beth Gibbons from Portishead was supposed to close the show, and the only way it could've worked was if we opened the show. But they made us the closing act and put my name on the thing. Beth Gibbons was great and didn't get bent out of shape, but the audience was upset because we only played four songs. One of them was a cover of Bo Diddley's "You Can't Judge a Book by the Cover." It was a night to remember, like the *Titanic* going down. I won't do anything like that again.

Dean Hurley runs the studio now. Dean looks like he's fourteen years old today, but when he showed up I thought, Where are his parents? Who's going to change his diaper? He looked really young. But he was recommended by Ron Eng, who's been on mixes for a lot of my films, and Ron's a really good sound man and a good guy. And Dean is solid gold.

Relationships are like films, and people come and they go. Lots of things have a beginning, a middle, and an end, and when I was in junior high I had a different girlfriend every couple of weeks. Things change, and they changed when I met Emily. Emily and her sister were neighbors of Eli Roth, and he brought them up to model for nude photographs. Then Emily did the voice-over for *Boat* and she did really well. One thing led to another and now we have Lula.

One day I was in the office, watching the Maharishi channel, and they announced that Maharishi was offering a monthlong enlightenment course. It was expensive, but walking home I thought, I could do this. I could do this! And I'm going to do this! I filled out the form and sent in

my money, then they called and said, "David, we can't accept your money. You're a regular meditator and you have to be a Siddha to do this course, so we're returning your money." I said, "No, keep the money; put it toward world peace." They said, "You really want to do that?" and I said yes. Pretty soon I heard that Maharishi said he'd offer a course on the Siddhis to me and to a girl named Debbie, who lived in the D.C. area and also wanted to go and wasn't a Siddha. So I got to go.

A year or so later I was in the living room of Dr. John Hagelin's house in Fairfield, Iowa, and he said, "David, how would you feel about starting a foundation with your name?" I'd never thought about it and I don't know what he envisioned as being the purpose of the Foundation, but since he was asking I figured he wanted me to say yes, so I said okay and I put the first money into it. Then—I didn't even know quite how it happened—I suddenly realized I was on a tour, talking about meditation, and I'd think it was over but it was just beginning. It unfolded and it was pretty amazing. I did a sixteen-country tour and a thirteen-university tour—I did more than that, but those were the big ones.

Bobby Roth got it going by asking me to speak at a few small gatherings. At first I tried to memorize what I'd say, and that was a nightmare. If the thing was a week away I'd be tormented for a week. If it was two weeks away I'd be tormented for two weeks, night and day. One time I had to speak at this golf course/country club–type place in L.A., and I hyperventilated and was stumbling on words even though I'd memorized them perfectly. So I decided I'm just going to do questions and answers, and that was much better. But still a total torment.

At the beginning of all this I was speaking in small rooms. Then I'm backstage in Detroit, and Bobby, all excited about what he's going to show me, motions me over and pulls the curtain back a little and I saw like ten million people! Tiers and tiers of people! It was a giant place and I almost passed out with fear. I remember walking to the microphone, one foot in front of the other, and it was thousands of miles to that microphone. When we got to the East Coast we were driving from one university to the next and Bobby's organized all these phone interviews, and I'm on the phone all the time in the car. *Catching the Big Fish* was Bobby's idea, too. That whole period was intense and tormenting and

seemed to go on forever. I did it for Maharishi and I learned a lot and now I'm very thankful that I did it.

Dr. John Hagelin once said that the Bible is written in a code, and under incandescent lights it's one thing but under a spiritual light it's something else. I'm in the living room one day and I get out the Bible and I'm reading along, and lo and behold, the page just lit up and there it was. The page seemed to almost turn white, and whatever was on the page lit up a much bigger thing and it all became clear. It hit me that the trip we're on as human beings is so beautiful and it has the happiest of happy endings. Everything is okay. There's nothing to worry about. Everything is just beautiful.

In the Studio

With the building of his recording studio in 1997, Lynch completed what he's described as his "setup." At that point he began living in an environment where he could develop pretty much any idea that came to him without leaving home, and the urgency surrounding film deals diminished. He'd been working in his compound for quite a while by the time Stofle moved in at the beginning of 2007. "We'd talked about it, then one day I just started bringing clothes over and he said okay," she said.

Another turning point that year was a show of Lynch's artwork at the Fondation Cartier pour l'art contemporain in Paris called *The Air is on Fire*. Organized by Hervé Chandès, it opened on March 3rd and was a massive undertaking that was pulled together in surprisingly short order. Films were screened in a theater with opulent velvet curtains and a checkered floor fashioned after the stage in *Eraserhead,* and photographs, paintings, and drawings dating back to his childhood were exhibited. Lynch and Zebrowski performed at the Fondation Cartier while the show was up, and in conjunction with the opening, German book company Steidl published *Snowmen,* a selection of black-and-white photographs Lynch shot in Boise, Idaho, in 1992.

All of this happened quickly and necessitated additional staff. "The people in David's office knew I'd worked for artists, and in 2006 they called and told me David had a big exhibition coming up and asked me to work on it," recalled Skarbek, who played a crucial role in the production of both the exhibition, the catalog, and the Steidl book. "It was a huge job. David is a pack rat who saves everything, and part of my job was to organize his visual art, which was completely disorganized when I arrived. All his work dating back to Philadelphia was there, and things were casually stored, stacked up, and leaning on things in the garage. At that point there wasn't anyplace on the property

strictly devoted to his artwork, and there were bits and pieces all over the place." *The Air is on Fire* was a very big show that traveled to three other cities (Milan, Moscow, and Copenhagen), and it kept Skarbek busy for the next three years.

When Lynch went to Paris to oversee the installation of the first iteration of the show, he met Patrice Forest, proprietor of the lithography workshop Idem. "Hervé Chandès is a friend, and Idem is just a few blocks from the Foundation," Forest said. "There were periods when David had to wait while things were being built, and Hervé asked him, 'Do you want me to show you a place you might love?' David came and opened the door and fell in love."[1]

Born and raised in Lyon, Forest was a radio journalist covering the arts until 1987, when he established a lithography workshop in Paris. Ten years later, a historic printshop dating back to 1881 and located in the heart of the city was for sale, and he moved his operation there. A fourteen-thousand-square-foot space with skylights, outfitted with beautiful old presses that printed work by Picasso and Miró, among many others, Idem has become a haven that Lynch returns to annually.

"I asked David if he'd ever made a litho and he said, 'Never and I'm very curious,' and he went to work immediately," Forest recalled. "He worked on zinc plates and made three lithos that were included in the exhibition, and those three lithos turned into a series of twelve called *The Paris Suite.* After we finished that I asked if he was interested in working on a stone, and he said yes and understood it immediately. Since that time we've made more than two hundred lithos, and when he comes to Paris he has as much time in the studio as he wants.

"Cinema is big, and David works with hundreds of people when he makes a film," Forest continued. "At Idem he works basically alone and can conceive of a work and make it come alive in a single day. It's quiet in the studio and some of the people who work there have never heard of him, and I think he appreciates that because it allows him privacy. He loves hotel life, and he always stays in the same room at the same hotel, within walking distance of Idem. He arrives at around eleven in the morning; he likes the coffee from around the corner, and he can smoke in the studio." The work Lynch produces at Idem is only available through Forest, who sells directly to collectors. "It's rare to see David's prints on the market. We don't do galleries or auction houses, and the work sells well and is quickly absorbed by the market."

In July of 2007 Stofle accompanied Lynch to Paris for the opening of an exhibition of work by Lynch and Christian Louboutin; the French designer produced a series of fetish shoes, which Lynch photographed. During their time in Paris Stofle got to know Louboutin, who offered her a job organizing events at his L.A. boutique, and she worked for him for the next five years. The hours were flexible, which was a necessity for her. "David and I traveled a lot in 2007," she said, "and David needs a lot of care when he travels. He doesn't like to call and order his own coffee, he doesn't want to be there when room service comes—that sort of thing. He's a happy person but he also has a lot of anxiety."

Returning to L.A., Lynch met a new staff member, Mindy Ramaker, who was to become an integral part of his operation. Ramaker moved to L.A. in June of 2007 from Madison, where she'd studied screenwriting with J. J. Murphy, who'd been one of Jay Aaseng's professors. When Lynch had a position open, Aaseng asked Murphy for suggestions, and Ramaker started in late July. At approximately the same time Lynch purchased a twenty-four-acre parcel of land outside of Łódź, Poland, which he's yet to develop. "It's really good land," said Lynch. "My parcel abuts a woods that's state property so it can never be developed, so it's private and beautiful with loamy earth that gently slopes to the east."

At the end of the year, Donald Lynch died in a Riverside hospital with Lynch and Levacy in attendance, then, on February 5th, 2008, Maharishi died. "The only time I've ever seen David cry was the day Maharishi died," Skarbek said. "He didn't talk about it but the tears said it all, and it was a side of him I'd never seen before. He was really moved by it."

After jumping through hoops to obtain the necessary visa, Lynch boarded a plane and attended the funeral in India, a country he was seeing for the first time. "In India, people drive really fast and come right at you, then they swerve off at the last second," said Bob Roth. "You really think you're going to die at any moment, and as we were driving along I looked at David and could see he was completely shocked by the way people drove.

"I remember watching David watch the funeral pyre as it passed, and there was such a softness on his face," Roth continued. "David has a huge heart, and he was really grateful to this person for what he'd given him. Other than Maharishi, David is the most authentic person I've ever met, and he's fearless. I'll watch a movie and there are parts when I have to look away, but David

never looks away. He appreciates the whole of creation and is as enchanted watching a little hamster grow up to maturity as he is watching the body decay after it dies. He finds delight in all of life, including the dark parts, and I admire that in him."

After returning from India, Lynch said goodbye to Aaseng, who was leaving his post after seven years. "David helps you realize parts of yourself you hadn't previously been aware of," said Aaseng, who gives a memorable performance as a bloodied drunk being held in the Twin Peaks jail in *Twin Peaks: The Return.* "The day I left everybody got together for lunch and I gave a speech. I went around the table and said something about each person, and everybody got emotional. Afterward, David said, 'Jay, you need to do acting! After what I saw you do there, man, that's the thing for you!' Acting was the furthest thing from my mind when I started working for David, but now I do some acting."

Early that spring, the music Lynch had been creating with Zebrowski for four years finally became available to the public when he released *Polish Night Music,* a recording of four extended improvisations largely inspired by the city of Łódź; he put it out on his own label, the David Lynch Music Company. By that point, Lynch's relationship with Stofle was into its fifth year and she was ready to move forward. "Early that year I told David I wanted to get married and have kids and that if that wasn't something he was interested in he needed to let me know, and in May of that year we got engaged," she recalled. "We were at Les Deux Magots in Paris and he started drawing rings on a drink coaster, then he said, 'I'm asking you to marry me.' We went back to the hotel and he called my parents and asked for their blessing.

"David and I had a great time during our first few years together," she continued. "I learned to cook when I moved in, and I think he enjoyed that. I cooked without giving any thought to fattening ingredients and just made things that tasted delicious, and we both gained a bunch of weight. It was fun. There were all sorts of things he was working on, too, and he'd ask me to organize actors for different projects. Whether it was for a job or simply to explore an idea, all the projects were of equal importance—it was about seeing the idea through and making it real. He once made a video for a film festival that was honoring him, and he wanted to shoot it backward like the Red Room sequences in *Twin Peaks.* He asked me to get some girls for this and I asked my friends Ariana Delawari and Jenna Green, who often worked on these things with us. We nicknamed these projects 'high school skit night' because

they had a kind of homegrown vibe. We all adored David and looked up to him so much. David asked me to find showgirl costumes for this particular film, so I rented beautiful satin leotards, I bought patent-leather heels and fishnet hose, and David painted dove bird props that we held while we danced backward."

Noriko Miyakawa was working for Lynch full-time by the time the high school skits were being hatched, and she had a hand in many of these projects. "It's tricky to say I edit with David, because it's always his vision entirely," Miyakawa pointed out. "We work well together because I understand that. David's not looking for a collaborator, because he doesn't need one, and if he could do everything himself without asking for anybody's help he would. The people who work for him have to be skilled, but basically we're like his brushes."

Shortly after Aaseng left, Michael Barile arrived. Born in 1985 and raised in Florida, he landed a job as an unpaid intern at Lynch's office in April of 2008 and wound up running the office. "David was entirely focused on painting when I started working for him, and he'd just go from his house to his painting studio every morning," Barile recalled. "I worked for him for a month before I even met him."[2]

Lynch's career as a visual artist was indeed barreling along by then, and he had seven exhibitions in 2009. He and Stofle made it official that year, too, and got married at the Beverly Hills Hotel on February 26th. "It wasn't a big wedding—there were maybe a hundred people there—and when an Elvis impersonator who happened to be at the hotel saw that David was getting married, he hopped in and started singing," recalled Skarbek. "I think he did 'You Ain't Nothin' But a Hound Dog.'" Chrysta Bell, who was among the guests at the wedding, said, "Emily and David are amazing together. Emily is a force of nature and he loves her and she gets it. There are kites and there are kite holders, and she's happy to be the kite holder and let her partner soar."

Two months after marrying, the Lynches traveled to Moscow for the opening of *The Air is on Fire*. "It wasn't the honeymoon I envisioned, but David just works, always," Emily Stofle observed. After Russia, Lynch stopped off in Iceland, which had just suffered a systemic banking collapse that left its economy in free fall. "For years David said he was going to open a meditation center in Iceland," recalled Joni Sighvatsson, "and in May of 2009 we were talking on the phone and he said, 'Joni, we've gotta do something for Iceland. I'm going

to Russia in five days and I'll stop by on my way home.' Iceland is small, and in five days you can let the entire country know somebody's coming, and thousands of people showed up for David's lecture in a university auditorium. Then David's foundation put up two hundred thousand dollars, I put up one hundred thousand, and we opened a meditation center in Reykjavik, which is still going."

Later that year Lynch began working on a documentary about Maharishi that he's yet to finish. Accompanied by Bob Roth, [assistant producer] Rob Wilson, and actor Richard Beymer, he went to India and traveled the same route Maharishi took from the Himalayas to the southern tip of India following the death of his teacher, Guru Dev, in 1953; the footage shot on Lynch's trip was to serve as one of the foundations of his documentary. It took Maharishi from 1955 to 1957 to complete the pilgrimage Lynch and company made in just over a week, and their travels are chronicled in *It's a Beautiful World,* a documentary directed by Beymer that was released in 2014.

Beymer began meditating in 1967 after seeing Maharishi speak at the Santa Monica Civic Auditorium in Los Angeles, then spent two years on staff with him in Switzerland. When Maharishi died, Beymer attended the funeral and filmed it, unaware that Lynch was there, too. "David heard about my film and asked to see it and he really liked it," Beymer said. "Several months later when he decided to go to India to begin his film about Maharishi, he asked me to go along."

Lynch arrived in India from Shanghai, where he'd just shot a short film, and when his plane landed he was exhausted and sick with a bad cold. The trip was a bit of a struggle for him, but Lynch isn't a person who cancels things, and he rose to the occasion. "We were there for ten days and we went everywhere," Beymer said. "We drove, we flew in helicopters and planes, and we were out all day every day and had a lot of fun. I was usually in the front seat of the car filming David, who would be in the back with various people. If David's just looking out a window, he pulls you in—even when he's doing nothing, he's fascinating. Odd little things about India delighted him, too. One day we were driving somewhere and he looked out the window and spotted a monkey in the distance, and suddenly it was as if he was eight years old. 'Look! Look at the monkey!' He was so excited! He couldn't believe a monkey was out there just running around loose in the world."

In December of 2009 there was a grand unveiling of the Gehry plans for the

Camerimage Film Festival center in Łódź, which had been in the works since 2005. Gehry and Lynch attended the ceremony, and spirits were high. "Then, two months later, the mayor of the city, Jerzy Kropiwnicki—a great, forward-thinking man David nicknamed 'Old Boy'—was recalled, and a new government came in and destroyed the project," Zebrowski recalled. "During that same period David and Marek [Żydowicz] had developed the EC1, an abandoned power plant they'd bought from the city in 2005 and transformed into a post-production studio. The building won all kinds of architectural prizes, then in the summer of 2012 that same new mayor visited David in L.A. and said, 'Mr. Lynch, you can come to Łódź anytime, we'd love to have you, but the property is ours. You can be our guest.' David—who'd put his own money into this—just looked at her and said, 'How do you dare? If I don't own it, I'm not coming.' Marek filed several lawsuits in Poland, but you can't fight city hall. So David and Marek built this place, then the government expropriated it and simply took it away from them." In 2010 the Camerimage Festival relocated to Bydgoszcz, a small town two hundred miles from Łódź. EC1 continues to be referred to as the David Lynch Studio.

Shortly after the unveiling of the Gehry plans, Lynch collaborated with John Chalfant on an installation titled *Diamonds, Gold, and Dreams* for the Fondation Cartier Pavilion at the international fair Art Basel Miami. A seven-minute digital film projected onto the ceiling of a domed tent, it depicted shimmering diamonds floating across a night sky.

Obviously, Lynch had no shortage of things to do, and filmmaking seemed to be a remote aspect of his life at that point. "When I first started working for David, it seemed like he was in a funk about movies," said Barile. "He hadn't made anything for a long time, and the last thing he'd made was *INLAND EMPIRE,* which got mixed reviews. Then, in 2010 he wrote an incredible script called *Antelope Don't Run No More,* and he shopped it around but nobody offered him the funding he felt he needed to make it. When he couldn't get it financed I don't think he was horribly upset, though. David believes that if a thing is meant to be it will happen." Set mostly in Los Angeles, *Antelope Don't Run No More* braids threads from *Mulholland Drive* and *INLAND EMPIRE* into a narrative fantasia that incorporates space aliens, talking animals, and a beleaguered musician named Pinky; it's impressed everyone who's read it as one of the best scripts Lynch has ever written.

On July 12th, 2010, Capitol Records released *Dark Night of the Soul,* a col-

laboration between Danger Mouse (Brian Burton) and Sparklehorse that was accompanied by a limited-edition book of one hundred photographs Lynch took in response to the music. It was the final recording by Sparklehorse, whose lead singer and songwriter Mark Linkous committed suicide on March 6th of that year, and the record included guest vocals by numerous musicians, including Iggy Pop and Suzanne Vega. Lynch handled the vocals on two songs, including the title track. That same year saw the presentation of *Marilyn Manson and David Lynch: Genealogies of Pain,* a two-person exhibition at the Kunsthalle Wien in Vienna. He returned to television in 2010, too, voicing the character of Gus the bartender on *The Cleveland Show,* an animated sitcom that premiered on Fox in the fall of 2009 and ran for four seasons.

On New Year's Day of 2010 Lynch had stopped smoking—a very big deal for him—then began editing "Lady Blue Shanghai," a sixteen-minute Internet promotion for a Dior handbag that was released in June of that year and stars French actress Marion Cotillard. Lynch loves the French, and in August of 2011 he and his staff traveled to Paris for the opening of Silencio, a nightclub inspired by the club of the same name that serves as the setting for a scene in *Mulholland Drive.* Created in collaboration with designer Raphael Navot, architectural firm Enia, and lighting designer Thierry Dreyfus, the club is described by Skarbek as "almost like a bunker. It's six floors underground and very small and dark and beautiful. It's like a little jewel box inside."

That fall, the album Lynch had been working on with Chrysta Bell since 1998, *This Train,* was completed. "It took us years to make that album, and it seemed like it was never going to happen," she said. "I felt ridiculous for even thinking it could happen, but I learned so much every time I got to be with David that I felt I shouldn't ask for more.

"The way we work is, David talks, then I start feeling melodies and singing, and he guides me by explaining where he sees the song going," she continued. "We did a song called 'Real Love,' for instance, and I remember David saying, 'Okay, you're Elvis and it's late and you're driving a car fast and your lover's done something bad and there's a gun in the glove box and you don't know what you're gonna do, but you know something is fucked.' I never get what David wants right off the bat—it's sculpted, for sure. If he feels like I'm really in the moment, he'll do a couple of takes of the whole song, then he might go back to a particular part of a take and say, 'Chrysta Bell, listen to this. Feel that mood there? You're delicate but you're strong—feel more of

that,' and I'll go into that place. I can tell sometimes he's frustrated when I'm not getting it, but he knows how to bring me back in without hurting my feelings. David knows exactly what he's looking for, but he doesn't bark orders. He creates a space where what he wants to happen can happen."

On completing the record, Chrysta Bell shopped it to several labels but was unable to generate much interest. So she launched her own label, La Rose Noire, paid to have the record pressed, released it on September 29th, then assembled a band and booked a tour. She did all the heavy lifting at that point because she felt that Lynch had already made his contribution to the record. "David is like a steward for ideas, and he's set his life up in a way that allows him to receive and develop them," she observed. "If he gets an idea at four in the morning, he's going to get out of bed and write it down, and he doesn't take a single idea for granted. It's like, hey, you came to the right person!"

It was a big music year for Lynch, and on November 8th he released his first solo album, *Crazy Clown Time,* made in collaboration with Dean Hurley. Concurrent with its release, a video for the title track was shot at the home of Gary D'Amico, who said, "We completely trashed my backyard with set dressing, and after we yelled, 'Wrap,' the first one out there picking up trash was David."

Recalling the making of the album, Hurley said, "We started working on it in 2009, but we didn't set out to make an album. David never puts the cart before the horse, and it's always just about having fun doing the work and seeing what comes together organically. After working with David for so long my brain has sort of aligned with his, and the work we've done together is a collaboration, but it's David's vision, and the overarching statement is always his. I'm fine with being the behind-the-scenes guy helping him realize his vision, too, and I prepare for anything when he comes in to work. I have lots of stuff permanently ready to go, so if he wanders around the room and starts tinkling on something, I can open that channel and start rolling. He doesn't take no for an answer when he has an idea he wants to develop, either, and if you tell him no he'll persist until he finds a way to express what he wants to express. He doesn't really play guitar, for instance, but he said, 'There's got to be a thing that lets you play guitar without actually knowing how to play it,' and we figured out how to use a Roland pedal so we can program chords into his guitar and he can move through the vibe of a song."

Included on the album is a guest vocal by Karen O of the Yeah Yeah Yeahs

on the song "Pinky's Dream," which came to pass courtesy of Brian Loucks. "David had a fantastic instrumental track he'd written with Dean, and I told him he should put a vocal on it and suggested Karen O," Loucks said. "David said, 'You mean that skinny girl you brought over who drank beer?' So David wrote some amazing lyrics and Karen came in and sang them and she was incredible.

"David's gone different places in his collaborations with people and learned something from all of them, and he's developed as a musician over the time I've known him," Loucks continued. "He can think musically and has the ability to reimagine and transpose things. There's a duo called the Muddy Magnolias who have a great version of 'American Woman,' and when Dean played it for David he said, 'Play that song at half speed,' and he wound up using it that way in *Twin Peaks: The Return*. He's able to take artists to places they haven't been before, too. Dave Alvin was once in his studio with a band, and David was explaining how he wanted them to play and saying things like, 'A hot Georgia night and the asphalt's melting . . .' Afterward, Dave commented on how good David was at conveying what he wanted."

Emily Stofle had been eager to start a family since she and Lynch married, and in November she finally got pregnant. "Before we had our daughter, David said, 'Why can't I be enough? Why do you have to have a baby?'" she recalled. "I said, 'I'm sorry, I just really want a baby,' and he said, 'Then I need you to know that I have to do my work and I don't want to be made to feel guilty. Things change when a woman has a baby, and it becomes all about the baby, but I have to do my work.' Then after I had Lula he disappeared into his work, which is what he does. David is kind, he has integrity, and he totally believes in the things he does—he would never do something just for the money. He's not good at close relationships, though, and it's not like he has a group of friends he spends time with. He works and that's where he gets his joy."

Lynch has never been one to hang out and party—he'd rather be making something—but he has a unique gift for intimacy. He has nicknames for many of his close friends—Laura Dern is "tidbit," Naomi Watts is "buttercup," and Emily Lynch is "puff"—and people tend to confide in him. "I was breaking up with a girlfriend and went into the painting studio one morning," Barile recalled, "and David said, 'Michael, something's not right.' I said, 'Yeah, I'm having a bummer day,' and he said, 'Pull up a chair,' and we talked and he

gave me really solid advice. David lives this art life that's somewhat disconnected from the world, but he has an understanding of life that's really deep."

"David exists in an art bubble he created himself, and he's rampantly creative," Zebrowski agreed, "but he's still a loyal friend I can always count on. I know that if I picked up the phone and said, I need your support, David would be there immediately. Most of us have very few people in our lives we feel we can even ask, and with David I know the support will be there. I think of him as a kind of benevolent uncle."

The people who work for Lynch tend to remain connected to him, and although Erik Crary left his job in 2008, he checked in with Lynch when he co-wrote and produced his first film, *Uncle John,* which was released in 2015. "We finished mixing the film on a Friday and I called David and said, 'Is there any way I can show you the film? I'm not asking for anything, but it would be incredible to show it to you.' So on Monday morning we showed it to him, and he dug it and we had a nice talk afterward. A few weeks later I called and asked if it would be okay if we used one of the nice things he said as a quote. For us, who are nobodies in the film world, that would be huge, and he said, 'Why don't I just write you something?' Which he did."

On Christmas Day, Lynch announced that all he wanted for Christmas was cigarettes, and he resumed smoking. Coincidentally or not, he slid onto the saddle of his next massive project then, too. "Right after Christmas, David met Mark Frost for lunch at Musso & Frank's, and that's when they started talking about doing *Twin Peaks* again," said Emily Stofle. "It was a secret and he didn't want to talk about it, but in 2012 Mark started coming up for lunch and they'd sit in David's painting studio and write. That went on for many years."

As *Twin Peaks: The Return* began emerging from the mist, Lynch's focus remained on painting, and in 2012 he had exhibitions in the United States, Europe, and Japan. In May of that year Lynch was contacted by Louis C.K. with an invitation to guest-star on his self-titled television series as Jack Dall, a cynical show-business veteran who's seen it all and had his fill of entertainers. To Louis C.K.'s surprise, Lynch said yes.

"David does maybe one percent of the things he's asked to do," said Mindy Ramaker. "He doesn't like to go out, he doesn't stay current with people working in the industry other than his circle of longtime collaborators, and his favorite thing is to be home working. He doesn't even like going out for dinner.

When Rick Nicita left CAA, David said, 'If I can't have Rick, I won't have an agent, and it will be fun, because I don't want people to find me, anyway.' He loved being off the grid, and he doesn't have things like managers, agents, and publicists around.

"I don't know how Louis C.K. got my email address, but he wrote these beautiful emails explaining why he wanted David to be on his show," Ramaker continued. "David said, 'I can't do it. Why don't you get somebody like Martin Scorsese?' Louis C.K. said, 'No, it has to be you,' and David said, 'All right, send the scripts,' and that sealed the deal, because the scripts were funny. Then David said, 'Okay, what are we really talking about here? Can I wear my own clothes? Can you find a hotel where I can smoke?' They found a hotel where the fine for smoking was five hundred dollars and just paid it, and David flew to New York by himself and shot it."[3]

The emails from Louis C.K. were indeed persuasive. "I can tell you all kinds of things about how well received our show has been in the last two seasons with reviews and nominations and bla bla bla but I'd rather take the time you're giving me by reading this to say that I have a feeling you would enjoy the work and be proud of the outcome," the comedian wrote. "In case this is the only communication I ever have with you, I want to thank you for your work and for your generosity of spirit and for communicating to the world your views about creativity and life. Watching your films (and *Twin Peaks*) gave me license as a film maker and a writer, to commit to the stories, moments, feelings, characters, moods, open questions and colors that I might have otherwise let my fears and other people's fears talk me out of."

When Lynch agreed to do the show, Louis C.K. replied, "Holy Toledo. That's amazing." Then, a few weeks after the shoot wrapped in New York, Ramaker received another email from him. "I am cutting the episodes with David now and they are electrifying. He is Henry Fonda incarnate. It's really unbelievable. Such a great performance. The best actor I had on the show this season. And it's David Lynch. How great is that?" Lynch's episodes—"Late Show, Part 2" and "Late Show, Part 3"—aired in September, shortly after the birth of his fourth child, Lula Boginia Lynch, on August 28th. (*Boginia* is the Polish word for goddess.)

Right around then Ramaker contemplated quitting her job. "I thought, Okay, I've learned everything there is to learn, it's time to move on," Ramaker recalled, "and when I told David he said, "Is it something I did?" When I reas-

sured him it wasn't, he said, 'Can I help in any way? Is there someone I can call on your behalf?' He was really generous. It's a testament to David that the people who work for him stay for a long time. Most of his assistants are there for at least seven years, and I still haven't left David's world."

Throughout 2012 Lynch and Frost chipped away at the *Twin Peaks: The Return* script, and during that period he continued to spend a good deal of time in recording studios. In 2013 he released *The Big Dream,* his second collaboration with Hurley, and did one-off projects with Swedish singer Lykke Li, Nine Inch Nails, and Dumb Numbers.

Lynch is a good sport, and on August 27th, 2014, he participated in the Ice Bucket Challenge. A stunt conceived to increase awareness and raise funds for research into ALS, a motor-neuron disorder also known as Lou Gehrig's disease, the challenge requires the participant to submit to having a bucket of water with ice dumped onto his or her head. Lynch was challenged to participate by both Laura Dern and Justin Theroux, so he was doused twice by Riley Lynch, who manned the bucket. Lynch added coffee to the first bucket, so it was an iced-coffee shower, and he played "Somewhere Over the Rainbow" on the trumpet throughout. He then challenged Vladimir Putin to participate in the challenge.

On September 13th, 2014, *The Unified Field,* a survey of Lynch's early work, opened at his alma mater, the Pennsylvania Academy of the Fine Arts. "The show at PAFA had special meaning for him because he has fond memories of the time he spent there," said Skarbek, who accompanied Lynch to the show, which was curated by Robert Cozzolino. "Philadelphia was a place where he was able to dive deep into his art, and he worked uninterrupted on his painting there as a young man alongside his best friend, Jack.

"He was seeing Philadelphia for the first time in quite a while when we went to the show, and he thought it had become way too clean," Skarbek continued. "What he'd loved about the city was its grittiness and danger, but it's gentrified now, and of course there was graffiti. David hates graffiti and the way it's taken over places he loved, because it dates things. When he lived in Philadelphia he could walk down an empty street and feel like it was 1940, and graffiti erases that possibility."

Fundraising for Lynch's foundation was an abiding concern, then and now, and in September of 2015 Ramaker shifted her energies there. "Erik Martin offered me a job at DLF Live, a division of the Foundation developed in 2012

by Erik and Jessica Harris to organize live fundraising events. I got to know Erik through the Malkovich project, which we both worked on," said Ramaker of *Playing Lynch,* a twenty-minute film created by photographer Sandro Miller and director Eric Alexandrakis, which stars John Malkovich portraying eight different characters created by Lynch. Funded by website builder Squarespace, the film premiered in October of 2016 at the Foundation's Festival of Disruption fundraiser in Los Angeles.

On October 6th, 2014, Lynch confirmed via Twitter that he and Frost were working on a new season of *Twin Peaks,* and the game was on. Lynch didn't anticipate what a struggle it would be to nail down an acceptable deal with a network, but the show began picking up momentum. As Lynch became ever more consumed by his work, Stofle focused on being a mother and co-founded Alliance of Moms, an organization that works with pregnant teenage mothers in foster care.

Lynch still hasn't had a major retrospective exhibition in America, but he's been the subject of quite a few in countries around the world. In December of 2014 the Middlesbrough Institute of Modern Art in the U.K. mounted *Naming,* a survey of work from 1968 through the present that included drawings, paintings, photographs, and films. A respectful review broadcast on the BBC described Lynch as "an artist engaged with many aspects of art in the postwar United States: the urban environment, the strangeness of language, and the legacy of Surrealism."

Four months later, *Between Two Worlds* opened at the Queensland Art Gallery/Gallery of Modern Art in Brisbane, Australia. Organized by José Da Silva, senior curator at the Australian Cinémathèque, the show began percolating in his mind in 2013. "David is criminally underrated as a visual artist," said Da Silva. "Other than the Fondation Cartier, no one has really paid attention to his studio practice, and people simply aren't aware of the breadth of his work. When I researched what had been written about his art, I was amazed by how little critical analysis there was, and his body of work is enormous. *Between Two Worlds* was a very dense show, with a lot of material, but I still felt like it was just skimming the surface.

"David's a multi-faceted artist who happens to use film for some of his work, and today it's not unusual for artists to work across media," Da Silva continued. "David came of age before that started being done, though, and it put him at a disadvantage in terms of how seriously his art is taken. The re-

views of our show were mixed. Critics accustomed to interdisciplinary work loved it, and conservative art historians didn't like it and responded with a kind of base critique—you know, 'bad painting, juvenile ideas.' You got the sense they went into the show predisposed to feel that way. Reviews aside, it was an extremely popular show, particularly with young people, who loved it and found it simultaneously compelling and disturbing."[4]

By the beginning of 2015, Lynch was dickering with Showtime over the terms of the contract for *Twin Peaks: The Return* and was involved in a complicated snarl of other projects that would drive most people nuts. He's structured his life so that multiple projects can be handled, though, and to a remarkable degree his life is an exercise in pure creativity. "David sort of lives like a monk, and it's my job to relieve him of any distraction," said Barile. "He hasn't pumped gas in thirty years, he doesn't think about where his next meal's coming from—lunch just appears—and that allows him to dedicate all his time to daydreaming about the next project. It's amazing how he's managed to set his life up. He's in good health, and I think that's because he doesn't have the stress that ravages most people. I think he's going to outlive me."

It's a privileged life, and Lynch relishes some of the perks of his position. In other respects he lives as modestly as he always has, for no other reason than he likes it that way. "David's been through a lot but he hasn't changed at all," observed Jack Fisk. "I was staying at his house not long ago when I came to L.A. for a meeting, and I remember looking out the window in the morning and seeing him in his driveway dressed in a white shirt and dirty khaki pants—he's always loved khaki pants—picking weeds out of the cracks in the concrete and putting them in a bag. He still loves doing things like that."

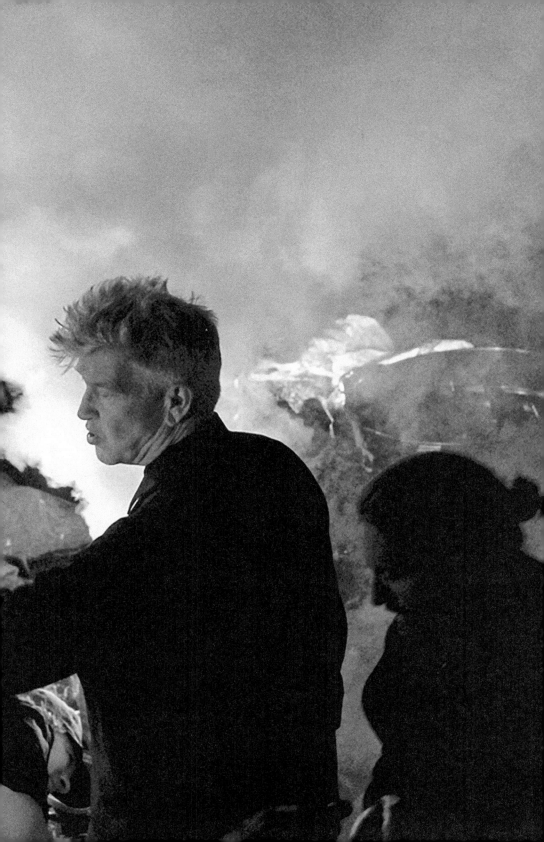

T HE AIR IS ON FIRE was the first time I was able to see a lot of my work together, and that was a beautiful thing. It's always been the case that if you do one thing you're not supposed to do other things — like, if you're known as a filmmaker and you also paint, then your painting is seen as kind of a hobby, like golfing. You're a celebrity painter and that's just the way it was. But around the time I had that exhibition, the world started changing, and now people can do anything. It's way, way good, and that show put me on the map. I have Hervé Chandès to thank, big time, Melita Toscan du Plantier, the head of the Fondation Cartier, Alain Dominique Perrin, and Matte, who was Alain's wife at the time.

I met Matte at a party at Dennis Hopper's house and we ended up sitting on a couch talking. A few days later Dennis's wife, Victoria, brought Matte by the house, and she saw a big painting I did called *Do You Really Want to Know What I Think?* Matte sometimes organized exhibitions for a place in Bordeaux, and she contacted me later and said, "I know you're a photographer and I'd like to show some of your pictures. Could you bring some with you the next time you come to Paris?" The next time I was there she and a friend came to see me at the Lancaster Hotel, and we sat in the living room and looked at photographs. They loved them and she showed some in Bordeaux.

Daniel Toscan du Plantier was a friend of Isabella's and was a refined, knowledgeable guy who produced films. Whenever I showed a film at Cannes, Daniel was always the first one waiting for me outside and he'd give me a little synopsis and tell me what he loved about the film — he was a really good guy. One night in Paris I was invited to a dinner and Daniel was there, and Jean Nouvel, the architect who designed the

Fondation Cartier building, was there, too. That night I think I also met Daniel's wife, Melita, and somehow she was involved with the Fondation—she didn't work for them, but she had some sort of association with them. After dinner they wanted me to see the show at the Fondation, so we all went over there and I saw the show and the space and that was it. Not long after that, Daniel was at the Berlin International Film Festival, and when he stood up after having lunch with someone, he fell over dead. Then Melita was a widow with two kids.

A while later, Melita came to visit and she said, "You know, you should really have a show at the Fondation." She was sort of speaking on behalf of them, and I said maybe so, and one thing led to another. So it was Melita who got the thing rolling, but it was also Matte—the two of them got word to Alain and Hervé, and next thing I know, Hervé is here looking at work. We just kept finding more and more and more, too. Stuff was coming out of everywhere. It was kind of weird because I hadn't done anything in the art world for a while.

I went to Paris for the installation, and the second day I was there Hervé said, "I want to show you this place," and I met Patrice [Forest] and saw Idem. I walked in and smelled that printer's ink, and I caught the mood and the vibe of that place and instantly fell deeply in love. Patrice said, "Would you like to do a lithograph?" and I said, "Do birds fly?" Because of piracy, digital images become cheaper and cheaper, and they're easy to steal and share. A lithograph is something you can *have*, though, and when you have it you see the beauty of the paper and you smell the ink. It's so different from a digital image.

That started things and Idem became my home away from home. Everything about working there is great. The coffees from the place next door are great, the mood of a Paris printers' studio that's nearly one hundred and fifty years old, the machines, the stones, and the people that work there. I do woodcuts there too, and I've started painting in the back room. I love the environment and I love France.

I like to do little drawings of kind of old-fashioned interiors, sometimes with people and sometimes just furniture and rugs and walls, and I made one of these drawings when we were installing the show in Paris. When Hervé saw it he said, "We've gotta build this," so they built it as

part of the exhibition. I got so many offers for shows after *The Air is on Fire*, and it inspired me.

After *The Air is on Fire* opened, Maharishi put me on the tour of sixteen countries. Unreal. We went everywhere and I loved doing this for Maharishi. Before a talk I always felt low, but every time I finished one I felt high, so even though it was a torment it was worth it, and every day I'd talk to Maharishi and tell him how the talk the night before went.

I finished the tour in September of 2007, and not long after I got home my father died. I don't know if anybody's ready to go when the time comes to die—maybe if you suffer enough you're ready. My father was born on December 4th, 1915, and he died on December 4th, 2007, so he was ninety-two years old. He was kind of out of it by the end and was pretty much gone already, and I was there with Austin and Riley and Jennifer. My brother couldn't make it but Martha was there, and one by one we all went in and said goodbye to my dad. Then everybody left and my sister and I went in. They'd pulled the plug and were just going to let him go, and I thought it would be good to meditate. I meditated for an hour and a half, and then as soon as I went outside to have a smoke he left.

In October of 2007, Maharishi knew he was going and he stopped seeing anyone. Then, on my birthday in 2008, the people who were with him called me on Skype, and I was told later that Maharishi was shushing the pandits taking care of him, telling them to be quiet because he wanted to see this. After we hung up he said, "The world is in good hands," and two and a half weeks later he dropped his body.

When Maharishi died Bobby Roth called me in the woodshop and said, "I think he'd like you to be there," and I said, "Okay, that makes up my mind; I'm going to the funeral." There's no Indian Consulate in L.A., so I had to go to San Francisco to get a visa. Before I went up there they said, "No problem, all you need is your passport and you fill out these forms," so Emily and I flew to San Francisco the next day. We got to the consulate and I went up to the window and gave them my passport and the forms and they said, "All the visa pages in your passport have been

used up. You have to go to the American Embassy to get more visa pages, and we close in a little while. I don't think you'll be able to travel to India tonight." I said, "I *have* to go tonight."

We hightailed it over to the American Embassy, and there's a line of two or three hundred people and a really rude guy at the desk. He said, "Take a number and wait in line." After a while I go up to the window and say, "I need some visa pages right now," and he said, "Settle down, bud; take this number and we'll call you." I said, "No, I've gotta have them now," and he said, "You *can't* have them now. Take a number and wait. We'll get to you when we have the visa pages, and that may take a couple of hours." I said, "No, no! They're gonna close the Indian Consulate!" He said, "I can't help that." So they give me a number and I'm waiting and waiting and finally I got the visa pages and went straight to the Indian Consulate and they were closed.

Then Anna Skarbek told me, "I have a friend who said you can go over to this place and get this taken care of," so we got the address and went to this little house with an Indian flag in front. We went up the steps into a living room that was like a lobby with chairs and a desk. There was nobody in the place except for a woman who was sitting there, so I gave her my passport and papers and she said, "Wait over there." Then this girl comes out and says, "Okay, done." This thing that was *impossible* to get done on the other side of town is done in an instant here! I said goodbye to Emily and went straight to the airport.

I went from San Francisco to Munich, where I changed planes, then I flew to New Delhi and arrived in a big, big airport. I'm supposed to be met by someone but that someone isn't there, so I go upstairs to this restaurant and have a coffee and a smoke. After a while I start to panic because I don't know where to go, then finally people arrive and they take me from the big airport to a tiny airport several hundred yards away that's not like any airport you've ever seen. You could go into this place and be lost for eternity, but they took me to the right place and I ended up on a little plane that flew us to Varanasi. We land in Varanasi and there are two great big SUVs, white, matching, and I let it be known that I was going to smoke in the car, so a bunch of people went in the other car, and that was fine. They still cared for me but they didn't want smoke, and we all took off for the four-hour drive to Allahabad. Every second on

the road in India that you don't get killed is a miracle. There are no stop signs or lights there, and you pass trucks that are so close you couldn't slip a piece of paper between the truck and the car you're in. There are animals in the road, little dogs, monkeys, water buffalo, cows— everything. Bicycles, pedestrians, pickup trucks with thirty people in them—everybody's honking their horn and pedal to the metal. It's high drama just getting a hundred feet. Drivers there say a prayer before they get on the road, then they leave it up to God. They just go.

We drove directly to Allahabad, which is where Maharishi's ashram was, and his body was there surrounded by flowers in a big tent. People were going in and paying respects to Maharishi and taking a seat and spending time in there. I stayed for a little while, and I saw my friend Fatima and we sat together for a bit then I had to leave to find my hotel. I got in Dr. John Hagelin's car and he doesn't worry about the driving because he's so highly evolved, and his driver was the worst I've ever seen. I said, "Please, tell him I'm gonna have a heart attack if he doesn't slow down!" They just laughed, so I'm white-knuckling this thing like nobody's business. We get to their hotel, then I get in another car to go to my hotel, which is a block away. I'm with a few other people and it's dark now, so we drive and we're looking for the hotel but it's not there. We went around this strange, big block four times and then the fifth time there it was. How did we miss it? You had to go around four times and then it appeared.

There are beautiful grounds at this hotel, mowed lawns and beautiful plants, and when we went inside there was a giant wedding going on— they go crazy for weddings in India, and this was the wedding season. I go to my room and it's filled with mosquitos. There are modern hotels in India that probably don't have mosquitos, but this one was old and that was okay with me. There's no wine—you're not going to get any Bordeaux in this place—so I order these Kingfisher beers and they turned out to be bigger than forty ounces. When they brought the beers they also brought a little gadget to plug in the wall that emits a scent that makes the mosquitos leave, so as the beers came in, the mosquitos went out and I'm kind of happy. It's a nice room.

The next morning Bobby calls and says, "Bring Mr. So-and-So; he's staying at your hotel." I go to the front desk and say to the man, "Could

you let Mr. So-and-So know we're here and we have to go," and he goes through this pile of messy little cards and says, "He's not here." I said, "Yes, he is," and he said, "No, he's not." So I go back to my room and call Bobby and he insists the guy is there. I go back to the desk and ask him to check again and he checks and says, "He's not here." Then this other guy comes along who's going to the funeral and I say, "We're looking for Mr. So-and-So and he's not here," and he said, "He's in the room next to yours." I love India. It's magical.

On the second day of the funeral, Maharishi's body was cremated in a different part of his ashram where they had the funeral pyre, and thousands of people were there for that. It was incredible how they set up this huge funeral pyre built out of special wood—everything's got to be exact. A helicopter passed overhead and scattered millions of rose petals, but the blades of the helicopter were stirring up dust, so rose petals and dust were swirling around. It was something. The funeral pyre was still burning when I left to go back to the hotel.

On the third day we went back to the ashram and the fire has gone out, and the special pandits are gathering the ashes and dividing them up and putting them in urns that will go to different places. Then we all headed down to the convergence of the Ganges, the Yamuna, and the Transcendental Saraswati rivers. The rivers come together and merge there, and the place where you dip is called a sangam. Dipping there is about the most holy thing you can do in a life. You dip there and you're gold.

There were all these boats waiting there and Bobby tried to get me on the big white boat where Maharishi's ashes were, but they said no. Then a German guy named Conrad came out of nowhere and took me to a boat and I got in with a few other people and out we go, surrounded by hundreds of boats. We go out into the Ganges and the big white boat carrying Maharishi's ashes is coming along, so I get undressed and Conrad gave me a shawl and I get out of the boat. You have to plug your ears, your nose, and close your eyes when you dip, because of the pollution. You say your prayers then you dip backward three times. I'd always thought, I, David, will never go to India, and there's no way I'm going to ever dip in the Ganges in this life. But not only am I in India, but I'm in the sangam, and not only am I in the sangam, but I'm dipping, and not

only am I dipping, but I'm dipping at a time in eternity when Maharishi Mahesh Yogi's ashes are in the water around me. That's something.

Later on that year I'm in Paris, sitting in a café across the street from a Cartier boutique, and I asked Emily to marry me. We got married the year after that, in February of 2009, on the lawn at the Beverly Hills Hotel, and at one point I went out to take a smoke and ran into an Elvis impersonator who was doing a gig at the hotel. I said, "You gotta come over," and he came over and people were dancing.

That same year I decided to make a film about Maharishi, and I went back to India to start working on it. Bobby Roth went with me, and Richard Beymer was there filming. Richard is a very special human being. He's a character and a longtime meditator and a highly evolved guy, and he's Benjamin Horne in *Twin Peaks*. He's a great person to travel with and he shot great stuff and made a film about our trip, called *It's a Beautiful World*. It's not a film people are going to go in droves to see—look at the way the world is—but maybe one day they will. Not right now, though.

I went to India from Shanghai, and when I was leaving Shanghai I knew I had a fever and thought I might have bird flu. When you enter India you stand in line to go through passport control, and they have a thing that measures your temperature; if you have a high enough temperature, they pull you out of line and put you in quarantine and they don't let you out until you're well. So I'm in the line, then suddenly I saw this TV screen that was reading people's temperature and I'd already passed it, so I made it into India. I was sick the whole time I was there, though, and I wish I hadn't been. We followed Maharishi's footsteps and I wanted to be in tippy-top shape, but I wasn't myself.

After Maharishi's teacher, Guru Dev, dropped his body in 1953, Maharishi built a little house next to the Ganges in Uttarkashi, the Valley of the Saints, where he pretty much stayed in meditation and silence for two years. After that he began traveling and teaching this technique, Transcendental Meditation, and everywhere he went he was met by people who wanted to help. Everywhere he went he set something up before he left, too, and he stayed in touch with these meditation centers

that were springing up and built a worldwide movement to teach this technique. Maharishi's two missions were enlightenment for the people and peace on earth, and before he dropped his body he said it's all in place, it's done. It's like the train has left the station and it's on its way. Peace on earth is coming. It's just a question of how long before the train arrives. It's all meant to be, and it's happening now because the time demands it.

I've been experimenting with music for a long time, but it's disrespectful to great musicians to say that I'm a musician. I play music but I'm not a musician. Marek Zebrowski is someone I met through the Camerimage Gang, and he's a composer and a brilliant guy who speaks eight languages. He has perfect pitch, so I can play anything and he'll play along with me and it sounds like I know what I'm doing. The whole thing is improvised, though, and the only reason it works is because of his perfect pitch. The way a piece works is, I'll start it by reading a little poem, then I usually hit a note on a keyboard, then Marek comes in. He's listening to my changes and finding things and taking off from them—it's pretty freewheeling stuff. It's a mood jam based on the feeling of the words of the poem. I write new poems for these sessions with Marek, short things just to set a kind of mood, and then the music starts. We performed in Milan, Paris, Łódź, and at the Polish Embassy in New York City, and I enjoy these performances because I don't have to memorize anything. With blueBOB I had to memorize changes and it was total torment having to play in front of people. Being in front of people and jamming is way better.

Another music project from around that time was *Fox Bat Strategy*, which came out in 2009 and was a tribute to Dave Jaurequi, who died in 2006 in New Orleans. That all started in the early nineties when I was in the hallway at the Pink House and I started humming a kind of bass line. I know how to read music because I play trumpet, but again, I'm not a musician, so I did a little drawing of these bass notes so I wouldn't forget them, and I booked a session at Capitol Records, not really knowing what I was going to do. I knew I wanted to have Don Falzone on bass, though, and I said, "Don, this is really embarrassing, but I have this bass

line," and I hummed it for him. He said, "That's cool, David! Can I do a little variation on it?" I said sure, and he did and it was beautiful. Then Don played it for Steve Hodges, who started drumming and they got the groove from that, then Andy Armer played some stuff on keyboards. There were a few guitarists I knew about, but none of them were available, and somebody said, "There's this guy Dave Jaurequi," so he got hired, but Dave hadn't shown up yet.

We got the track recorded, then finally here comes Dave Jaurequi, "up from the islands," I'm told. I don't know which islands but it sounded cool, and he was wearing an island-type shirt and dark glasses and he sits down with his guitar. I tell him, like I always say, that it's got a fifties vibe, and he started playing and he was so good I was going crazy. Just incredible. We recorded "The Pink Room" and "Blue Frank," which are in *Fire Walk with Me*, and those guys are in the film, too. They're in the scene at the Canadian nightclub the Power and the Glory.

Then some time goes by and I've written all these lyrics and want to go into the studio with those guys again. We check ourselves into Cherokee Studios. I end up working primarily with Dave Jaurequi; I'm giving him lyrics and he's playing and singing, trying to find the tune. We wrote maybe six songs together that we recorded and mixed with Bruce Robb at Cherokee. It was just a blast, but nothing ever happened to those things and they just sat. When I finished my studio I wanted to bring Dave in and work with him, then suddenly I hear from his girlfriend, Kay, who has this bar in New Orleans called the John, that Dave was sitting on a barstool and fell over dead from internal bleeding. Kay and I stayed in touch and we did this tribute album to him that included those songs we did at Cherokee, but the music industry was in the toilet by then and nobody made a nickel. It was really great working with those guys, though. They're great musicians and great guys.

Music has helped the David Lynch Foundation a lot. Laura Dern and I were the MCs at the Change Begins Within concert, which was a fundraiser held at Radio City Music Hall in April of 2009. I introduced all the people, and oh my God, it was high tension and the place was packed. Paul McCartney and Ringo Starr? Are you kidding me? It was only the second time they'd been together since the breakup, and they performed "With a Little Help from My Friends." Then Paul did a whole set. He

brought two super-long semi-trucks filled with his equipment. *Super long*. Piano, every single thing, comes with him.

People don't know how important the Beatles were to our lives. People who lived through it know, but young people don't know. I lived through it, though, so meeting Paul and Ringo was beyond the beyond. On their first trip to America in 1964 they flew into New York City, then they went down to Washington, D.C., and put on their first American concert, and I was there. They were in a boxing ring [they performed for eight thousand fans at the Washington Coliseum on February 11th, 1964] and it was a giant room and you could barely hear them — it was like little tiny squeaks in the middle of wall-to-wall screaming. I was a senior in high school and I wasn't planning on going, but at the last minute I wanted to go and I talked my dear brother out of his ticket and I went instead. I got to tell Ringo and Paul that I was there at their first American concert, and of course it didn't mean anything to them but for me it's incredible.

Ringo's like Harry Dean. He's a guy you can just sit with and not have to talk and feel comfortable with — he's a real human being, this guy Ringo, he's a special one. Every year I go to Ringo's birthday party at the Capitol Records building. They play music for the crowd, then at noon Ringo announces peace and love and throws out armbands that say PEACE AND LOVE. He does this every year on July 7th. Paul's a real good guy, too. I got to watch him rehearse for the Radio City show, and when he rehearses it's down to the millisecond as far as timing. He's a perfectionist and he just keeps everybody absolutely there, so when they go on it's no fooling around and it's tight. A lot of people drift over time, but when he plays one of his old songs it sounds exactly like the original recording. Paul and Ringo have been meditating since they were with Maharishi in Rishikesh in 1968, so they're meditators and they love it and they're both supporters.

During that period Mindy came to me one day and said, "Danger Mouse wants to meet you," and I said, "Who's Danger Mouse?" She told me who he was and I said, "He must want me to shoot a video or something." So Danger Mouse came up and he's a cool guy and a great producer, and it wasn't a video he wanted me to do. He wanted me to shoot still photographs inspired by the music on this record he'd done with

Sparklehorse, and we approached it like a cinema motion-picture shoot. We went to locations and the only difference was, instead of motion pictures we were shooting stills.

People loved Sparkehorse and they hadn't done anything for a while, so Danger Mouse coaxed Mark Linkous into doing something, and they built these tracks. By the time they finished the tracks, Mark had become too embarrassed to sing, though, so they invited different singers to write lyrics and do what they wanted to do on these tracks. At one point I jokingly said to Danger Mouse, "I thought you were gonna ask me to sing," and he said, "Do you sing?" I said, "Yes, I just started singing on some stuff," so he listened to some of it, then he calls and says, "I want you to sing." So I ended up singing on two tracks and I came up with the title *Dark Night of the Soul*, which is nothing new. Everybody goes through a dark night of the soul. They decided to name the album that.

I absolutely loved Danger Mouse and I loved Mark, too. He came to visit a couple of times and he was so comfortable to just sit with. He loved music, and he and Dean and I would sit in the studio and talk and he smoked unfiltered cigarettes down to where they were less of an eighth of an inch, so his fingers were orange and brown. He was a Southern boy. He had a lot in him, really a lot. Some musicians just carry a lot, and you can immediately spot the ones who do.

Watching Janis Joplin in *Monterey Pop*, oh my God, I just break into tears. No one knew her then—it's hard to imagine now, but nobody knew her—and she comes onstage and these guys play this guitar intro that's so cool, then it sort of settles down and she starts in and it's just fucking perfect. She does these things that are perfect, just the best, and it's a great fuckin' song and she kills it. At one point in the film they cut to Mama Cass, who's in the front row while Janis is performing, and she's saying, "Wow," like she can't believe what she's seeing. That is solid gold. Then here comes Jimi Hendrix, and he and his guitar are one thing. His fingers are playing no matter where the guitar is—they are one. It's unreal. The coolest fucking thing. So he knocks "Wild Thing" out of the park, and then Otis Redding is onstage. The song he did that night? That is *the* version of "I've Been Loving You Too Long." So much comes out of that vocal that it's hard to believe someone could get all of that into a single song.

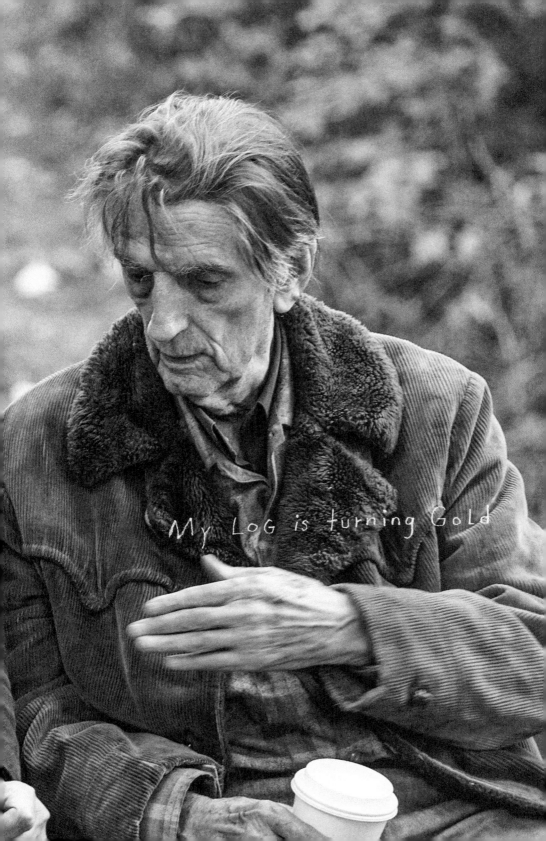
My LoG is turning GoLd

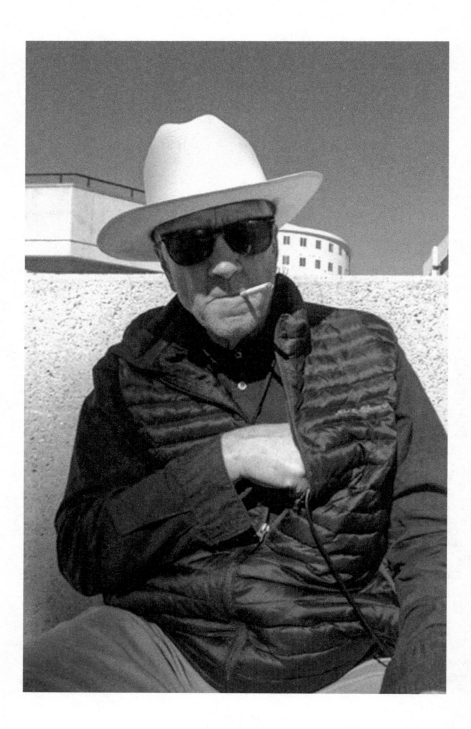

By the time Lynch's exhibition opened at the Pennsylvania Academy of the Fine Arts in 2014, he was starting to achieve a degree of recognition in the art world that had been slow to come, but at precisely the same time he began disappearing again down the rabbit hole of television. The journey that was to take him back to *Twin Peaks* commenced in 2011 with that Musso & Frank's lunch with Mark Frost, and it essentially took over his life for four years.

Lynch was attempting to line up financing for *Antelope Don't Run No More* when *Twin Peaks: The Return* first materialized in the distance, but the film proved impossible to make. French producer Alain Sarde had assured Lynch he could set up any picture he was interested in making, but with an estimated budget of twenty million dollars, *Antelope* fell between the cracks of the current filmmaking paradigm: You can get a huge movie or a tiny movie made but anything in between drifts into a no-fly zone. That was increasingly apparent to Lynch as his writing sessions with Frost became more frequent. They wrote mostly by Skype—Frost's home in Ojai is a two-hour drive from Hollywood—and they formed the production company Rancho Rosa Partnership, Inc. Lynch then tapped Sabrina Sutherland to produce the show they were developing; Sutherland had been brought into Lynch's operation full-time in November of 2008 to do forensic accounting for his various businesses, some of which were in disarray, and she'd become an indispensable part of his working life by the time *Twin Peaks* got rolling. He trusts her implicitly, and she multitasks for him as a producer, accountant, agent, lawyer, and business manager.

By the beginning of 2014, Lynch and Frost had completed enough of a script to begin looking for financing, and their first stop was cable network Showtime, which is a subsidiary of the CBS Corporation. "I heard rumors that

David and Mark were thinking of reviving *Twin Peaks* and begged David through his representatives to meet with us," said Showtime CEO David Nevins. "In February of 2014 he and Mark came in to meet with Gary Levine and me, and David sat on my sofa and listened quietly while I tried to convince him this would be a good place to bring his baby. He was reserved, polite, well dressed in his black suit and white shirt, and was trying to size up whether I'd be a safe collaborator."[1]

Negotiations continued for six months, then in October Showtime announced the reboot of the series and ordered nine episodes. In January 2015 Lynch and Frost turned in a 334-page script to the network, and at that point Frost shifted his energies to writing a book about the series, *The Secret History of Twin Peaks,* while Lynch continued working on the script. Negotiations dragged on and grew increasingly irritating to Lynch, and on April 6th, after fourteen months of haggling, Showtime presented him with a budget for the show that he found woefully inadequate, and he announced by tweet that he was pulling out of the project.

"Showtime had it in their heads that this was episodic television and didn't understand David's vision," said Sutherland of the contractual skirmish. "It was never television for David; it was always a feature film, and they couldn't grasp where he was coming from. For instance, David wanted a complete feature-film crew there every day, including lightning machines, standby painters, and special-effects technicians, and that isn't how television works. They don't have big crews there all the time, so Showtime resisted this because in their minds it was television. When David said, 'Fine, I'm out,' he didn't leave because he wanted more money for himself; he left because of the gap between what was being offered and what he'd need to make what was in his head. David doesn't make a lot of money, actually."[2]

Walking out on the project wasn't something Lynch did blithely. "Seeing him do that reminded me of how much integrity he has when it comes to his work," said Emily Stofle. "That took place at a time when his accountant had just talked to him about how much it takes to run this place and he knew he was overspending on his staff. He'd just done a commercial for Dom Pérignon and that allowed him to sustain another year, but he hadn't made a film since 2006 and didn't have a reliable revenue source. But there was no way he would compromise his vision of what *Twin Peaks* should be."

After making his decision, Lynch called several of the actors who'd com-

mitted to the show and told them he was out but that it might still go forward without him. "I don't think any of us would've touched it with a ten-foot pole if David hadn't been involved," said actor Dana Ashbrook, who played juvenile delinquent Bobby Briggs in the first two seasons of the show.[3] At that point Mädchen Amick organized a video campaign, and eleven actors—Amick, Ashbrook, Sheryl Lee, Sherilyn Fenn, Kimmy Robertson, Peggy Lipton, James Marshall, Gary Hershberger, Wendy Robie, Catherine Coulson, and Al Strobel—filmed testimonials on Lynch's behalf, as did his daughter Jennifer.

"I was in Japan when negotiations broke down," said Nevins. "In television you negotiate a budget on a per-episode basis, and our lawyers were dealing with *Twin Peaks* the way they always dealt with television, but this wasn't a typical project. David made it clear from the start that he saw it as a movie and didn't want to have to say going in how many episodes it would be—he said, 'It could be thirteen, but it may be more.' Our lawyers got dug in on this point and said they didn't want to pay thirteen times our episodic fee, but that wasn't what David was asking for.

"As I was flying home he tweeted that he was leaving the project, and after I landed, Gary and I went to David's house. He said, 'I keep saying it's more than nine episodes, and no one is listening to me.' I told him, 'I can't give you a blank check and I need to know what I'm going to spend,' and David said, 'Figure out what you can spend and I'll figure out if I can make what I want to make for that amount.' So we budgeted the whole thing and gave him a pot of money we were comfortable with and said, 'Make as many hours as you feel you need.' He used the money efficiently and it ended up being very reasonable on a per-episode basis.

"We never considered going forward without David," Nevins added. "What is *Twin Peaks* in somebody else's hands? This isn't a franchise that needs to be reinvented by a new director, and we already know what happens to *Twin Peaks* when David's not involved. It becomes an ersatz version of itself."

On May 15th, 2015, Lynch announced that he was back on board and preproduction officially began. Although a script had been submitted to Showtime months earlier, he continued to write for several months after the show was green-lit. "David is the first one to say there wouldn't be a *Twin Peaks* without Mark, and the overall arc of the story was there when Mark left to write his book, but David expanded the story substantially after he left," Sutherland said. "Things that had been in his head for years were woven into

the script, and the directorial vision is entirely David's. He knew exactly what he wanted—how everybody looked, what they wore, the sets, the nuts and bolts in a piece of furniture, the zipper in a skirt—every visual you see is one hundred percent David."

"He worked so hard on the writing," Stofle remembered. "During the period that he was writing with Mark, he'd come home every night and, because I didn't like him smoking in the house, he'd sit outside and smoke and write on legal pads. He'd sit out there for hours. He spent so much time out there on this vintage lounge chair that we had to have a new cushion made for it. On cold nights he'd be bundled up in a blanket. There was an overhang on our house, and when it rained he'd turn his chair sideways so he wouldn't get wet."

Lynch had hoped Jack Fisk would be the production designer for the show, but Fisk was just coming off Alejandro Iñárritu's *The Revenant* and recommended his art director, Ruth De Jong, for the job instead. Duwayne Dunham was back as editor, Angelo Badalamenti was handling music, and Johanna Ray and Krista Husar did the casting. With more than two hundred speaking parts, *Twin Peaks: The Return* was the biggest project Ray had ever tackled.

Principal photography began in September 2015, and by all accounts the 140-day shoot was a glorious experience for everyone, including Lynch. "It seemed so fucking natural," said Michael Barile. "Starting on day one, sitting there in his chair with his bullhorn, it was if he'd done it a million times. He was in his place, where he belonged."

The first and most crucial piece of casting was, of course, Kyle MacLachlan. "They'd been writing but hadn't finished the script and needed to know if I was on board, and I said I'm in one hundred percent," said the actor, who was first approached by Lynch and Frost in 2012.[4]

"It wasn't just one great role—it was three great roles, and I'd never been challenged like that as an actor. The process into bad Cooper was quite a journey, and it was very slow and steady the way David and I found that character. The most difficult scenes for me were the ones with bad Cooper opposite David and Laura Dern. David and I are kind of goofy together, and being a dominating character in a scene with him was hard. And I have such a strong heart connection to David and Laura that shutting that off was hard."

Dern plays opposite MacLachlan as his love interest, Diane, and although she concedes that the shoot had its challenging moments, for her it was al-

most pure pleasure. "Acting with David and Kyle was like being at a family picnic," she said. "David created a reunion for Kyle and me—it's as if he wrapped up a Christmas present and handed it to us. The story that unfolds between Cooper and Diane over the course of the series is a story about love, too, and that made it even more meaningful.

"The love scene between Kyle and me was tough to do, though—not because of the intimacy, but because the emotions Diane is feeling are so intense," she added. "David didn't have a preordained idea of what he wanted the scene to be. He talked me through it as he shot it, and I don't think he knew it was going to be so anguished. Diane is Cooper's true love because she understands the split in him that he's battling, and she's been the most victimized by it—perhaps more than Cooper himself. For me, the scene is haunted rather than anguished, and it's haunting because she knows that they will never be innocent again. It's heartbreaking and erotic and damaged and confusing. I don't know what David intended, but that's how I experience that scene."

Michael Horse, who plays Deputy Hawk in all three seasons of the show, said, "David called and said, 'We're getting the old gang together,' and a day or two into the shoot I thought to myself, Oh, I'd forgotten who David is and how special this is. There are so many things that are out of the box with David, and I had a ball."[5]

Lynch shrouded the show in a cloak of secrecy, and with the exception of MacLachlan, the actors arrived on set knowing nothing more than the lines they'd be expected to recite. Nobody seemed to mind that, either. "The fact that there was such a mystery about the script added a beautiful dimension to the interaction between the actors," said James Marshall, who plays moody loner James Hurley. "When you shot your scenes, there was a quality of extreme privacy about it that I think comes across onscreen."[6]

Among the twenty-seven alumni of the original series who returned for season three was Al Strobel, who plays Phillip Gerard, the one-armed man who first appears in season one as Bob's evil partner in crime. Gerard has evolved into a kind of an oracle by season three. "I was living in Portland and my agent submitted a photo and résumé to Johanna Ray," said Strobel of how his relationship with Lynch began. "David saw something in me he could use in his art, and I fell in love with him immediately. It was like being invited to play in this fantastic sandbox with somebody who was having more damn fun than

you could imagine—and David was very playful back then. He seemed much more serious this time around, but, then, season three is a more serious piece of work. Back in the day we were having fun with the conventions of television, but David has gotten more deeply into his art and didn't seem to care this time whether the show would be popular. He just wanted to express his art."[7]

Grace Zabriskie also noted how time and experience had marked Lynch. "As you grow as an artist—and as an asset—there are pressures you couldn't have imagined earlier in your career. Now you're dealing with expectations that are new, and you still have to come up with the goods and be even better at it. Those pressures have made David a bit less available over the years, but I understand why that is, and he hasn't changed at all in important ways.

"I remember sitting and talking on the set of *Twin Peaks: The Return* while we waited for something to be set up," Zabriskie added. "We share a love of wood and making things by hand, and usually our conversation is about nothing but tools, so that's probably what we were talking about. We kept being interrupted by people who needed his approval for one thing or another, but after each person left he'd pick our conversation up exactly where we left it. David is completely present when he talks to someone."

Actor Carel Struycken, who plays the enigmatic Fireman, observed a change in Lynch, too. "He didn't tell me anything about the character I was playing," recalled Struycken of his first appearance as the Giant in episode one of season two. "He just walked up and shook my hand and said, 'Everything is going to be peachy keen,' which sounded so fifties.

"David was never in a hurry," Struycken continued, "and he was always telling the actors to do everything slower. Hank Worden played a waiter in that first scene I did, and he was eighty-nine years old and was already shuffling very slowly, but David told him to shuffle more slowly. And this time he wanted things even slower. I didn't know what he was trying to achieve back then, but now, watching the reboot, it made sense to me. The pacing is really kind of radical."[8]

Also back for season three was Peggy Lipton, who plays the queen of the Double R Diner, Norma Jennings. "When I went in to meet David in 1988, he was sitting at a huge desk he'd made himself and the only thing on the desk was my picture," she recalled. "Nobody had ever honored me like that. I hadn't seen any of David's films at that point, but I felt drawn in by his personality. When David looks at you, you're the only person in the world. He's never

distracted, his eyes don't roam, everything is focused on you, and you get all of him. I think he offered me the part that day.

"Jumping forward two decades, I got a message on my phone machine—'Hi, David Lynch here'—so I called him back and we gossiped for a bit," Lipton continued. "He loves to get into your head and he asked me about my life, then he told me about the show and I said of course. Then I thought, My God, how am I going to re-create her, but I didn't have to do anything, because it was all written. I love the way David integrated the diner into this phantasmagorical thing. Okay, it all started here and these are our roots and our anchor, and it all tied together so beautifully. To have David come back into my life after all these years has been very special."[9]

Lipton's love interest in the show is Big Ed Hurley, played by Everett McGill, who retired from acting in 1999 and moved to Arizona. "I didn't maintain ties to anyone in L.A., and David had been looking for me for a while; then Mark said to him, 'Why don't you see if someone in your Twitter crowd has a contact for him,'" said McGill. "Somebody got back to him with a number for a little house down the street that belonged to my father-in-law, who passed on years ago. I go down there every few weeks to check on things, and the chances of me being there and picking up the phone are slim, but the phone rang and I picked it up and it was David. We started talking as if we were picking up a conversation we'd left off the day before. We talked about the good old days and his Packard Hawk, which is an odd-looking car he had that he loved, and as our conversation was winding up he said, 'If I need to be in touch with you, is this a good number?' I said, 'This is *not* a good number,' and gave him a different one, and then I got a nondisclosure agreement in the mail and a call from Johanna. Long ago I said to David, 'Anytime anyplace you need me, you just call and I will be there.' He knew he didn't need to ask if I wanted to be in the show.

"Big Ed was always a joyous thing for me, and that was such a moving moment when Norma puts her hand on my back and the two of us kiss," added McGill of a scene in season three when the two star-crossed lovers finally get together. "It was just a beautiful feeling, and David did that in one take with no reshooting."[10]

"When we shot that scene, David had the Otis Redding song ['I've Been Loving You Too Long'] playing on the set," said Lipton, "and when I looked over at him after he said cut, he was crying like a little baby."

The resolution of the Big Ed/Norma love affair was one of many changes in the town of Twin Peaks. "As a young lad playing the young Bobby Briggs, I had free rein to be an asshole, so that was fun," said Ashbrook. "I knew season three would be different and I wasn't shocked when I found out Bobby had become a cop, because a scene between my father and me in season two kind of set that up. Back in the day my direction from David was a little more out there, but this time he wasn't as ethereal with me as I've heard he was with some other people. My scenes were very specifically written out, and I just wanted to jump in there and not mess it up.

"Every job I've ever gotten has had something to do with *Twin Peaks,* and David's the reason I can still be an actor," Ashbrook continued. "He's like the greatest teacher you ever had and is the truest artist I've ever met. When we were shooting the pilot, Lara Flynn Boyle and I once ran into him in the hall at the Red Lion hotel, where we all stayed, and he invited us into his room to see a poster he was working on. After twelve hours of shooting, he was going back to his room and making more art—I love that about him."

Ashbrook's character matured over the twenty-five years that passed since the close of season two; James Marshall's character got moodier. "I think David approaches each character as a different aspect of himself. He's attracted to characters with innocence, and I think that's what James Hurley is about for him," said Marshall. "James is a deeply tormented character, and I think David enjoys it when the soul rises to the surface as a result of sorrow or joy. He's a master at moving energy around, too.

"There was a scene in season one where Lara Flynn Boyle and I were sitting on the couch and were supposed to kiss. David wasn't getting the vibe he wanted, though, so he'd come over and talk to Lara, look at me and say nothing, then go back to his chair. He did this several times but he still wasn't getting something, so this time he comes over to me and squats down and his hands come up and he starts closing his hands then opening them and extending his fingers. He didn't want to say the wrong thing but we weren't there yet, so he opened and closed his hands for two or three minutes without saying a word, then stood up and said, 'Go for it,' and walked away. He'd basically shifted the energy completely by making us be still with him for a few minutes. He just turned up the gas and left us to light the flame."[11]

Inevitably, the original cast suffered signs of attrition. Several actors—Frank Silva, David Bowie, and Don S. Davis—died before the shoot began.

Others—Warren Frost, Miguel Ferrer, and Harry Dean Stanton—died after it wrapped. The presence of all of them in the show underscores how porous the line separating the living from the dead is for Lynch. A particularly poignant figure is Log Lady Catherine Coulson, who almost didn't make it onscreen. She died on Monday, September 28th, 2015. The previous Tuesday, a friend visited her at her home in Ashland, Oregon, and discovered that on Sunday she planned to fly to Washington to shoot scenes on Monday and Tuesday. Coulson was under hospice care by then and advised not to travel, but she was determined to be in the show and had hidden from Lynch how ill she was. The friend contacted the director and advised that if he wanted her in the show he should get to Ashland immediately and shoot her there in her home. The following day, Noriko Miyakawa traveled to Ashland where a local film crew was pulled together, and Coulson shot her scenes that night with Lynch directing by Skype. She died five days later. One week earlier, Marv Rosand, who plays Double R Diner employee Toad, had passed on, as well. On October 18th of 2017, Brent Briscoe, who played Detective Dave Macklay, died unexpectedly at the age of fifty-six of complications after a fall.

The show included actors from other Lynch films—Balthazar Getty, Naomi Watts, Laura Dern, and Robert Forster—and marked the acting debut of a handful of people in key roles. "One day during a recording session David looked at me and said, 'I think there's a role for you in my new project,'" said Chrysta Bell, who plays FBI agent Tammy Preston. "It wasn't until he gave me my pages that I realized Tammy was a significant role. I doubted whether I could do it, but when I expressed my reservations David said, 'It will be fine, trust me.' I asked if I should take some acting lessons and he said, 'No! Don't you dare!'

"David had a vision of the character, and I had several fittings to get the outfits right," she added. "He looked at every picture [costumer] Nancy Steiner sent and he'd say, 'No, it's not that,' or 'You got that part right but you gotta work on this other part.' He kept honing in until he had this Jessica-Rabbit-as-an-FBI-agent look."

Lynch visualizes his characters in his mind's eye long before he walks on set, but he fleshes them out with the actors he casts. "The dialogue alone shapes the character of Diane pretty definitively and there were other parts of her that were already in place," said Dern of her character. "David wanted a lip color for Diane that didn't exist. We tried everything from every makeup

line we could find, and finally he just created his own lipstick palette and mixed colors until he found the one he wanted. Every day I was on set, he spent fifteen minutes mixing lipstick colors until he got this pink that was almost white, but it had to have a lot of gold and yellow in it.

"He's very specific. But at the same time, David loves watching actors find things for themselves," Dern continued. "Whether he's playing Shostakovich over loudspeakers on the set of *Blue Velvet* for Kyle and me, or sending Nic Cage and me on a road trip together and telling us what music he'd like us to listen to while we're becoming Sailor and Lula for *Wild at Heart*—he cares deeply about helping you discover that mood and mystery for yourself."

Among those making their onscreen debut in the show was Jake Wardle, a young British actor who caught Lynch's eye with a 2010 YouTube video titled *The English Language in 24 Accents*. "In 2012, Sabrina Sutherland emailed me and said, 'Hi, I work for a director who's interested in casting you in one of his projects and he'd like to Skype with you,' and David and I had our first Skype," said Wardle, who was just twenty years old at the time. "He was really easygoing and he told me how impressed he was with my video and that he liked my sincerity, and we continued Skyping every few months. We'd talk about random things, just getting to know each other, like he'd ask me what I had for lunch or what kind of dog I had. Then in 2014 he said, 'Have you ever seen *Twin Peaks*? We're making a new one and you're gonna play a Cockney guy called Freddie who has a magic green glove that gives him super strength.' He wrote my part in Cockney rhyming slang, which he's very interested in. He actually knows more about it than I do.

"I finally met David on March 1st, 2016, when I went in for my costume fitting. I was invited to visit the set and David was filming the scene from episode eight with the Fireman and Señorita Dido. He gave me a massive hug and let me sit next to him and watch him direct for several hours. If David hadn't found me I don't know if I would've had the confidence to act, but I know now that it's my destiny. David changed my life because he helped me get on the right path. I'm a lot like Freddie: Freddie was chosen by the Fireman, and I was chosen by David. The Fireman gave Freddie the glove, and David gave me the role."[12]

At the opposite end of the spectrum in terms of experience was Don Murray, a seasoned veteran who earned an Oscar nomination for his performance opposite Marilyn Monroe in the 1956 film *Bus Stop*. "I'd never met David, so I

was surprised when I got the call that he wanted me," said Murray. "Originally the part was written for a forty-five-year-old man and I was eighty-seven, but he said, 'I really like Don Murray so I don't care.' I have no idea what David saw in me, but he has a strong vision of what he wants, and when he casts someone he's already seen something in that person that's exactly what he wants to see on the screen. You get very little direction from him, and nobody has to struggle to play the characters he casts them as.

"David's was the happiest set I've ever been on," Murray added. "There's a thing he does I've never seen another director do: Even if somebody has a very small part, when they complete their work he stops production, gathers the cast and crew around, and says, 'That was a wrap for Miss So-and-So's last day, and I'd like to thank her and give her a round of applause.' There was an atmosphere of joy on that set that was unique."[13]

The cast also included a handful of young actors who'd been scuffling around the industry for a while and will probably look back on *Twin Peaks: The Return* as their big break. "I don't know how the audition came about, but I drove deep into an industrial section of the San Fernando Valley and went into a waiting room full of the kind of people you'd expect to run into in David Lynch's casting office," said Eric Edelstein, who plays a giggling police detective named Fusco. "I didn't get the part I went in for, but I was later told that David was trying to find something for me, and a few months after that I got a call and I was doing a wardrobe fitting the next day. When I got to the set, David walks in and says, 'Okay, you three are the brothers Fusco and, Eric, you're the baby of the family and your brothers just love you.' Then he used my laugh like a musical instrument and choreographed it in while we were shooting—I'm guessing I must've giggled in the audition and that's why I got the part.

"Prior to *Twin Peaks* I kept getting cast as bad guys, and I thought, Am I going to be messing with this dark energy from now on? In *Twin Peaks* not only was I *not* playing a bad guy, I was playing myself, and now I'm getting offered stuff for the giant giggly guy. The path of my career changed entirely because of David seeing that in me."[14]

Actors make their way to Lynch down different avenues; George Griffith, who plays hired assassin Ray Monroe, got there through a family connection. "*Catching the Big Fish* had a big impact on me, and in 2009 I suggested he be a guest on an episode about meditation for *The Dr. Oz Show*," said Griffith,

who's married to Oz's daughter. "David agreed to be on the show and I did the interview, then afterward they invited me to lunch with them. I managed to get seated next to him and I couldn't believe I was sitting there with him. David's kind of a patron saint for a lot of people, and that lunch marked a huge shift in my life. I told him about a movie I was working on and sent him a copy after I finished it, but I didn't expect him to watch it. Then two weeks later I got an effusive email from him telling me that he loved the film. Tears were running down my cheeks after I read that.

"When I heard *Twin Peaks* was coming back, I thought, Maybe I can make coffee or something, so I wrote him and told him I was available to do anything," Griffith continued. "Then Johanna Ray asked me to come in and I thought it was just another kindness from David. I met with Johanna, who didn't know anything about me and was probably wondering how I got there, and afterward I thought, There's no way I'm going to get on the show after the way that went. Then I got an email from them saying, 'Welcome aboard.' I couldn't believe it!

"I didn't see David until the day I shot my first scene, which was meeting Mr. C. at Beulah's house. When I walked on set David said, 'George Griffith, I love your movie,' which was such a cool thing for him to do, because nobody knew who I was and it allowed me to arrive with some kind of weight. All my scenes were with Kyle, and he and David have such a history together, and I was nervous, of course. But on my first day Kyle said, 'The boss always gets what he wants,' and that was exactly what I needed to hear."[15]

Also new to Lynch's world was celebrated comic actor Michael Cera, whose nutty cameo as motorcycle guy Wally Brando is one of the funniest sequences in the show. "In 2012 I went with Eric Edelstein and another friend to do the introductory TM training at the center in L.A.," Cera recalled. "On the fourth day a woman who works there approached us and said, 'Would you guys like to meditate with David?' We were stunned and said that would be amazing, but we kind of took the invitation with a grain of salt. Then a month or so later she called and said, 'How about Thursday at David's house?' It was just him and us, and it was so open of him to have strangers into his home. He was so kind that I lost the sense of being an intruder and we meditated together and it was one of the most special things that ever happened to me. And then getting the chance to work with him? That I was even on his radar in the slightest

way was incredible to me. My greatest hope was that I wouldn't waste his time and he wouldn't regret hiring me.

"We didn't really discuss the character," added Cera of Wally Brando. "I'd been watching a Dick Cavett interview with Marlon Brando and was trying to copy that as best I could, and David told me to adhere to the grammar in the script, which was helpful. He has a very light touch. It was two in the morning when we shot the scene, and we finished the whole thing in about forty minutes."[16]

Things moved quickly throughout the shoot. "David's always been efficient, but he took it to a new level with this," said MacLachlan. "I was like, jeez, you just want to do one take? We all knew he wouldn't go forward if he didn't have it, though, and he was absolutely clear about what he wanted. I remember the day we were doing the conga-line scene through Dougie's office, and Jim Belushi ad-libbed something. After David says cut, there's always a moment where you're waiting to hear what's next, so there's a pause, then David said in the megaphone, 'Mr. Belushi? Do I need to report you to the principal's office?' Jim said, 'Nope, got it.' David handles things like that in such a charming way and makes his point without embarrassing anybody."

Just how streamlined the production was is reflected in how the musical performances at the Roadhouse were handled: There were approximately two dozen of them, and they were all shot in a single day at a location in Pasadena after a preliminary test shoot of Riley Lynch and Dean Hurley's band, Trouble. Audience members were rotated for variety and shot on another day. Everything moved fast.

This isn't to suggest that the shoot was a breeze for Lynch. "He had fun, but it was hard on him," said Barile. "He had his seventieth birthday during the shoot and we worked at least twelve-hour days—many days went for seventeen. He got sick several times, and there were a few days when he had crap in his lungs and a fever and could barely get upstairs when we dropped him off. But there he'd be six hours later, up and back at work. One day we were shooting in the Red Room and he fell and banged up both knees pretty good, but he just got up and walked it off. Before the show I hadn't known how tough he is."

Given how consuming the entire undertaking was, it's no surprise that it took a toll on Lynch's marriage. "It was challenging because he basically just

disappeared," recalled Stofle. "And he was exhausted. Eighteen hours of content? That's like making at least nine feature films and is a massive undertaking. His schedule was grueling, he was flipping back and forth from day shoots to night shoots, and Sunday was his only day off. He always had a production meeting on Sunday night, though, so he never caught up on sleep. At one point he told me, 'Puff, I was in my trailer meditating and I fell asleep and when I woke up I didn't know where I was. Everybody on the set is younger than me and I'm so tired.' He got really sick but he never stopped working.

"Not long into the shoot he said, 'When I come home at six A.M., you and Lula are starting your day and running around, and I need silence and blackout curtains,'" Stofle continued. "We looked into getting him a room at the Chateau Marmont but it was too expensive, so I turned one of the guest rooms in the gray house into a room for him with blackout curtains stapled over the windows and he loved it. When he came back from shooting in Washington, he moved over there, and one night I visited him and he was watching TV and smoking, and I thought, This is permanent. Because of the smoking. For two years he'd been complaining about having to smoke outside and he was able to smoke inside over there. Smoking is a big piece of this puzzle."

Twin Peaks: The Return employs a much broader canvas than the preceding seasons did. Set in New York City; Las Vegas and a neighboring suburb; the fictional cities of Twin Peaks and Buckhorn, North Dakota; Philadelphia; the Pentagon; Odessa, Texas; and, of course, the Red Room, it's a sprawling story with multiple plots. There are personal touches embedded throughout the story, though. That bronze statue of a cowboy installed in the plaza outside the Lucky 7 Insurance Agency? It was based on a photograph of Lynch's father taken when he was nineteen years old and working at a forest lookout station. There's nothing random in the show, and things have multiple layers of meaning, yet it all came together fluidly. "I'd see David sitting over in a corner writing," recalled Struycken, "then somebody would walk up to me and hand me a slip of paper torn out of a notebook with the lines I'd be saying in the next scene."

"My favorite scene in the show was completely improvised," said Chrysta Bell. "One day Laura and David and I were sitting together on set waiting to do something, and it was nice watching Laura and David together—they have

such a sweet thing between them. David was making an effort to include me in the conversation—he's always so considerate—then he looks at us and says, 'We're gonna do a scene that's not in the script. We're gonna go outside and stand on the steps and we're just gonna be there and at some point I'll take a drag of Laura's cigarette.' The whole thing was awkward and I was basically just holding space in this long scene, but David was using the dynamic between the three of us and taking it to another level. He's always creating. We were just chitchatting and he thinks, Wait a second, this is cool, let's put this in *Twin Peaks*. So he told Peter Deming, 'We're going outside,' and they had to move the porta-potties."

"I love that scene," said Peggy Lipton. "They just stand there looking out into space, and I laughed so hard. There's air to breathe in that scene, and that's a beautiful quality in all of David's work. When he asks the viewer to spend several minutes watching a guy sweep out a bar and be completely focused on that sweeper, it gives you a minute to sink into your own thoughts, and it's like an ongoing meditation."

Reflecting on that scene, Dern observed, "David doesn't abandon his characters when they're not doing something big that moves the plot forward. He'll stay with them while they stare into space making a decision."

That room to breathe is a crucial part of the magic of Lynch's work, and as Struycken pointed out, his approach to pacing is radical. The show is punctuated with lingering close-ups, long, silent pans of landscape and road shot from inside a car, a solitary figure slowly eating a bowl of soup, a train passing through a railway crossing at night. These scenes lead nowhere and exist solely to harness the pace of the storytelling.

The narrative style is leisurely, but Lynch tended to spring things on his actors during the shoot. "My first day on set, we shot the interrogation scene with William Hastings, and when David told me that's what we were doing I went white with fear, because it's a highly charged scene," said Chrysta Bell. "He didn't give me any direction beyond 'You're gonna stand here and then you're gonna sit there,' but the script was so finely written and I knew not to change a letter. So he was sitting in his director's chair and I was standing across from him, and he just looked at me and gave me an infusion of confidence. His gaze told me, This is a beautiful experience in your life, so just take it and run with it—I know you've got it in you."

Playing opposite her in that scene was Matthew Lillard, who didn't meet

Lynch until his first day on set. "I walked over to him and said, 'Hi, I'm Matt Lillard,' and he said, 'Hello, Bill!' I thought he thought I was the prop guy or something, so I said, 'No, I'm Matt,' and he said, 'Hello, Bill Hastings!' again and didn't give me any direction for the scene. When I saw him at the premiere he still called me Bill Hastings."[17]

As Don Murray said, Lynch trusts his actors to deliver what he needs from them and never raises the emotional temperature of the set, regardless of how intense the scene at hand might be. "At the end of my first day, David very casually said, 'We're gonna get you bloodied up tomorrow and you're gonna have a fight with an orb with Bob's face on it,'" recalled Jake Wardle of the biggest action scene in the show.

"The fight was choreographed on the spot by David, who was on his megaphone, saying, 'He's above you! Hit him! He's below you now, he's knocked you down, get back up and hit him again!'" continued Wardle, who had no idea the fight scene was coming. "He wanted me to actually hit the camera, so they put padding on it and told me not to hit it too hard, but after the first take David said, 'Hit it harder!' So I did and the camera made a weird noise and everyone gasped, but he didn't just leave it there. No. David got them to put a lens protector on it and had me hit it again, and he kept saying, 'Hit it harder!' Finally the lens protector broke. I think they might've used that take."

After the show wrapped in April 2016, Lynch hunkered down for a year of post-production, and during that period he barely left the house. He took a break in October to curate the first annual Festival of Disruption, a two-day fundraiser for his foundation that featured appearances by Robert Plant, Frank Gehry, Kyle MacLachlan, and Laura Dern, among many others. Mostly, though, he just worked up until the first episode of the show aired on May 21st, 2017.

Nobody had seen the show before it aired, so the people who helped make it were as excited about the premiere as everyone else. "I was surprised by the incredible range of tones it had," said David Nevins. "The funny parts were really funny, there's unnerving nightmare stuff, and there are incredible surreal elements that felt different to me than they felt in the original *Twin Peaks*. It was unquestionably a business success, and it's a show people will talk about for years to come."

The show was a different kind of revelation for Don Murray. "My God, David's such a wonderful actor! One of the things I love most about the film is his

acting," Murray said. "That's a marvelous character he's created with Gordon Cole, just great. And there's such humor in the show. The New York *Daily News* described it as 'the most hysterical comedy of the year.'"

Critical response to the show was generally ecstatic, and when the first two episodes screened at the Cannes Film Festival on May 25th, Lynch received an extended standing ovation and the series was hailed as a work of genius. "I didn't know until I saw the show that it included all of David's animations, sculptures, paintings—all of the stuff he'd been working on for years," said Chrysta Bell. "But then I realized, how could we expect anything else? That's what a real artist does. They use every part of themselves and take everything they've learned and make a piece of art that combines all of it with no fanfare."

"This is absolutely the David Lynch of right now," said Eric Edelstein. "It incorporated every bit of filmmaking he's refined over the course of his life and was a giant commentary on today. It was the *Twin Peaks* of 2017. He just nailed that."

As for what it means? Lynch isn't about to answer that question, but clues abound. The show spurred a reappraisal of *Twin Peaks: Fire Walk with Me,* which many viewers looked to as a kind of decoder ring for the new series. Numerous motifs from the film do reappear and are developed further in the series, including the Blue Rose case, the jade ring, Laura Palmer's diary, and electricity as a metaphor for the invisible energies that propel existence. The show is swimming in numbers, too; coordinates, phone numbers, addresses, room numbers, voltage rates, clocks and watches, and car mileage serve the story in various ways. Many dots can be connected to create many different scenarios, but those who truly love and surrender to the show have no interest in deconstructing the narrative. It's a work of art, and that's not what it's for.

"There are things we all know that we don't look at very often," said Robert Forster, who plays Twin Peaks sheriff Frank Truman. "Everybody knows some things are eternal, and it isn't names or houses and it isn't even the stars; we know in our bones there's something eternal, though, and that it has to do with human beings. Whatever David is doing, it is of a high order, and he may be a portal to the eternal, because he asks us to find that connection to the eternal in ourselves. His work suggests that we are not just isolated atoms and that if we understand that connection to the eternal we're capable of making better choices. Each individual can pull in a direction, and if enough of us pull

in the same positive direction, there is movement that brings humanity along with it. He is leading his audience toward the good."[18]

"David's trying to tell people that this world we live in isn't the ultimate reality and that there are many dimensions of existence that need to be considered," ventured Michael Horse. "There's deep stuff there, and you can't multi-task while you're watching Twin Peaks."

"It's too advanced for most people to understand," said Al Strobel. "When I was seventeen years old I had a car accident and technically died, and I had an experience many people have described having: I left my body and went to another place. It wasn't as harsh as the Red Room—it was more pastel and warm—and the hardest thing I ever had to do was to come back into my body. I know there's a place between this existence and the next one, because I've been there; I think that's what the Red Room represents and that this is a realm David is familiar with."

"David's spiritual life has always been part of his work, and that's deepened in a way that's reflected in his work," said MacLachlan. "I can't point to something and say, 'Oh, now he's doing this,' because the change has been more subtle than that. It's like his work has gotten richer. Twin Peaks has confounded many people, but David's an artist and the work he does isn't supposed to be easy. I don't think he feels compelled to tell a story people want him to tell, and he seems totally comfortable with that."

"The show did exactly what it was meant to do," said Barile. "The original series fucked with the conventions of television and made its mark, and season three—which is basically an eighteen-hour film that he somehow got on television—did it again."

"I love the way David ended the show," said Dern. "Trying to understand it is kind of mind blowing. David taps into the subconscious in an amazing way. and I think we've all observed that the work he makes gets digested a decade after he creates it."

The final episode of the series suggested there could be more to come, and there was speculation as to whether there might be another season. "If everything lined up perfectly, he'd probably say, 'Sure, let's do it,' but he's not going to waste his time at a negotiating table," said Barile. "He'd rather be painting and smoking and drinking coffee and daydreaming. David's at peace with himself and with the way things are. Emily's great and they're a good couple. He likes to drive slowly, he eats a grapefruit for breakfast and half a

chicken sandwich with tomatoes for lunch, and I think he likes the simplicity of that. In his mind he's still poor in lots of ways. He likes to sweep."

Twin Peaks: The Return has aired and Lynch is on to other things, but the process of making it changed his marriage permanently; he still lives in the house next door with the blackout curtains. "He says he needs uninterrupted time for thinking and complains that he's never alone, but he's in charge of the world he's created for himself," said Stofle. "I tease him all the time that he is finally living 'the art life,' something he has fantasized about since he was in art school. Being alone and having ultimate freedom to do what he wants and to create—and now he is doing this. He even has a small twin bed now . . . something I have always heard him fantasize about. A small bed for sleeping and lots of space for work."

On September 15th, ten days after the final episode of *Twin Peaks* aired, Harry Dean Stanton passed away at the age of ninety-one. Two weeks later his final film, *Lucky,* opened in a limited release. Directed by actor John Carroll Lynch, it featured David Lynch as a small-town eccentric distraught over the disappearance of his pet tortoise. "David was pretty stressed about working with Harry Dean, because he loves him," said Barile. "He still gets giddy about the fact that he acted with Harry Dean. That's huge in his book, like being knighted or something."

Until he's pushed back out into the world again, Lynch is spending as much time as possible in his painting studio. A small concrete bunker perched on the side of a hill, it has lots of windows and a wide opening onto a concrete deck, where he often works. Lynch likes to paint outdoors. The studio is cluttered with an assortment of stuff that's been accumulating for decades. A beautiful, unusually large light bulb sits on a windowsill, and messy piles of paper scraps scribbled with enigmatic musings and ideas are scattered here and there. A reproduction of Hieronymus Bosch's *The Garden of Earthly Delights* is taped to a wall near an expansive desk; two panels of the triptych have had too much sun and faded, but the third continues to glitter like a nasty jewel. The desk is littered with several small, crudely sculpted clay heads, and there's a rusting set of metal file drawers. One drawer is labeled DENTAL TOOLS, and when you open it that's exactly what you find: dozens of gleaming dental tools. Lynch keeps his collection immaculately clean and good to go. There are a few dirty folding chairs available for visitors and an old-fashioned wall phone he continues to use. Cigarette butts are flicked on

the floor, and he pees in the sink. The sole visible concession to the twenty-first century is a laptop computer.

Poised atop one pile of stuff on the desk is a dusty cardboard box with the word "bugs" scribbled on it in pencil. Lynch is excited to report that he once befriended a "bug man" who regularly delivered specimens to him. Lynch has kept each and every one of them, because you never know when a dead bug might be exactly what you need. His aren't labeled and as neatly organized as the ones he saw as a child in those flat files at the Experimental Forest, but they still thrill him.

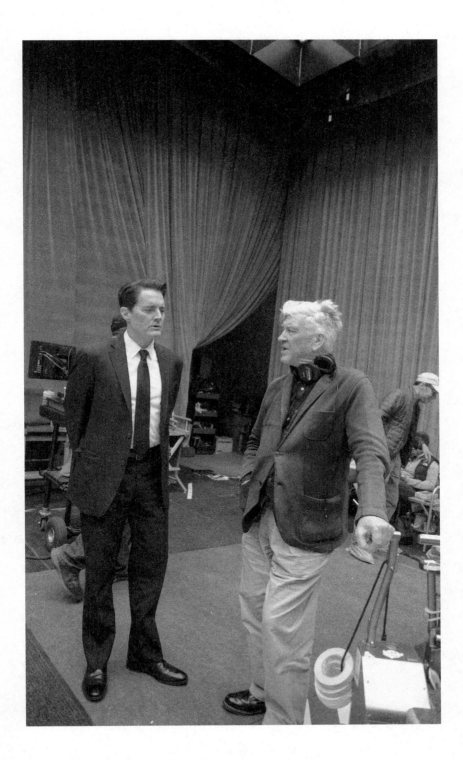

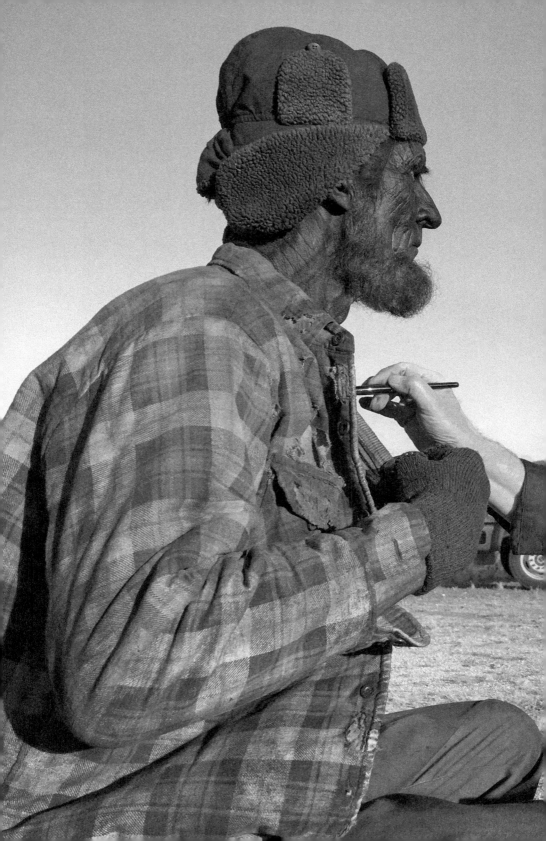

THERE'S SOMETHING ABOUT stopping something before it's finished that leaves you wanting it, and *Twin Peaks* wasn't finished. In music you hear a theme and then it goes away, then the song goes along for a while, then you sort of hear the theme again, then it goes away again. It feels so good and then it goes and you can't get it out of your mind. So when it comes up later, the full theme, it has so much more power because you've already heard it and felt it a couple of times before. It's what goes before that sets up the power and meaning of things.

Mark and I met with Showtime about doing *Twin Peaks*, then Sabrina came up with numbers and everybody freaked out. They were realistic numbers, but Showtime thought the budget was stupid high. I hadn't made anything since *INLAND EMPIRE* and nobody went to see that, and you could tell they were a little bit like, "Yeah, we want to do this, but we don't know if we can go with the money you're asking for. And this business of more than nine episodes? We definitely don't know about that." Then, when I saw the budget they were offering, I said, "Fuck this," and then they made another offer that was worse than the bad one they'd already made! I said, "I'm fuckin' out! If they want to do it without me I'll probably let them, but I'm out," and I felt a tremendous sense of freedom mixed with sadness when I made that decision. That was on a Friday. Then I hear from David Nevins and on Sunday night he and Gary Levine come up. Gary brought cookies and they were here for about forty-five minutes. By the end it wasn't happening at all, then when they stood up to leave David said, "I'm going to work up an offer for you." I said, "Well, maybe I'll work up an offer for you." With not a fuckin' thing to lose, Sabrina and I drew up a list of everything we'd need and I

said, "Okay, Sabrina, you're gonna go in there and say, 'This is not a negotiation. If you want to do it, this is what it takes.' If they start quibbling about stuff, say thank you very much and stand up and leave." But David Nevins said, "We can make this work," and that was it—I'm back in the thing.

People came into the show in lots of different ways. I knew I could count on Kyle being able to go that dark, and he played a great bad guy. A certain type of bad person can come out of any good person, but each person has their own kind of bad person. Kyle couldn't play Frank Booth, for instance—it just wouldn't work—but he can play a Kyle bad guy, and he found that guy. Both Mark and I are nuts about Michael Cera, and Michael came up to the house with Eric Edelstein a few years ago to talk about Transcendental Meditation. When we were casting and it came to Wally Brando, Michael, of course, was the guy. I love Eric Edelstein and he became the third Fusco brother because of his giggle—that's why he's there; it's the greatest giggle. I love the Fusco brothers and we had a lot of fun together.

My friend Steve sent me a link and said, "Check this guy out," and there was Jake Wardle in the shed in his backyard in London, doing accents from all around the world, and so natural and funny. So we started talking on Skype. I had the green-glove idea from long ago and originally Jack Nance was going to wear it, and that would've been a whole different thing. The power of the green glove and the way it's found in the hardware store were perfect for Freddie Sykes, though, and Jake was perfect for Freddie. You see a thousand people on the Internet, but I knew Jake could do this. He's super smart and he's like Harry Dean—he's just a natural.

Dr. Mehmet Oz has a daughter and she's married to George Griffith. I know Dr. Oz because Bobby [Roth] and I talked to him and his family and the people that work for him about TM. Dr. Oz is a really good guy. George made a film called *From the Head*, about the bathroom attendant at a strip club, and when I saw it I knew he'd be a great Ray Monroe.

I met Jennifer Jason Leigh in 1985 when she came in to talk about the part of Sandy for *Blue Velvet*; I always wanted to work with her, and lo and behold this thing comes up. I saw Tim Roth in Robert Altman's film *Vincent & Theo* and thought he would be perfect for Hutch. I didn't

know that Jennifer and Tim had just worked together with Quentin Tarantino and were good friends. So it was perfect, but they were cast independently.

The character of Bill Hastings had to have certain qualities, and Matthew Lillard seemed like he could be a believable high school principal—intelligent, open face, all this stuff—but he could also be one of these guys who does something crazy and people who know him say, "He was the nicest guy, I can't believe he'd do something like that." So he had these things swimming together and the rest is history. It's true that I always called Matt Bill Hastings. I call most of these actors by their characters' names because that's how I know them. I swear I don't know many of their real names.

Robert Forster was the original pick to play Sheriff Truman in the first season of *Twin Peaks*, and Robert told me then that he really wanted to do it, but he'd promised a friend that he'd be in his low-budget film and he said, "I have to honor my promise." That's the kind of guy Robert is—he's so great. And all Johanna Ray had to do was say "Don Murray." Some people might've had some kind of thing about his age, but he was an incredible Bushnell Mullins. I recently saw him speak on a panel at Comic-Con and this man is one of the nicest human beings ever, and intelligent. We were so lucky to get him and I loved working with him. He was so great start to finish. Chrysta Bell was fantastic, too. I knew she could do it, because she's a singer and is used to going in front of people. I love her and everybody else who worked on the show, and we had so much fun together.

I was only sleeping four hours a night and the schedule wasn't easy, but it was still fun. You wake up early and have coffees and meditate, and your mind is going on what you're doing today. There's this ravine and you've got to build a bridge to the other side, and the bridge is the scene you're going to shoot. You get to the set or the location and people are coming in and you picture minutes going by, minutes turn into half hours, half hours pop into hours, and the thing is moving slow. If you're in a new place, they're moving in equipment and you've got to get people out of their trailers to rehearse and they're not dressed and maybe they've got their makeup napkins on. You do a rehearsal, then the actors go to get dressed and Pete starts lighting. All of this time you're building

a bridge across this ravine, but the bridge is made of glass right now, because it could all go funny. So you keep adding pieces and it's still glass, but then finally you add the last piece and the glass turns to steel and it's there. You know you've got it and you've got a euphoria. Every day when you finish you get a high and you can't go to sleep. You don't *want* to sleep, so you drink red wine and stay up too late, then you have to get up the next day and build another bridge. And you can't walk away from anything until it feels correct.

The shoot was really pretty grueling. Other people, they're fuckin' wimps and they fold like cheap tents, but I can't stop even though I got sick as a dog several times. You get sick because you get tired. You find your groove but then it doesn't end, because you finish shooting and you've got post. We had six or seven editors working at the same time, and I'm editing, too, and some special effects are being done by BUF. But some we have to do in-house; then there's sound effects, music, mixing, and color correcting. How many times did I sit in a dark room at FotoKem color-correcting eighteen hours of shots? That's a lot of shots. But there's no way I could delegate anything. No way. You're hands-on with every single thing, and that's the only way. It's kind of a dream job but it doesn't let up.

This show is different from the *Twin Peaks* that's gone before, but it's still securely anchored in Twin Peaks. We shot it in the same town, and we lucked out in so many ways because pretty much all the locations we'd used were still there. They weren't the same as when we left them, but the buildings were there, and the essence of the town was definitely the same. There's so much influence of trees and mountains and a certain kind of crispness and smell in the air, and you recognize the feeling. *Twin Peaks* holds all different kinds of feelings, too. You've got Dougie and you've got Bad Cooper and there's a big difference between the two of them. You've got the woodsmen and all these different textures and people you love, and it ends up being such a beautiful world, and it's understandable, too, in an intuitive way.

And it's got the woods. Because of where I grew up and what my father did, nature is a big part of *Twin Peaks* and the woods are really important. That's a huge part of the thing. And you've got the Fireman and you've

got the frog-moth, which came from Yugoslavia. When Jack and I were in Europe we caught the Orient Express in Athens to take us back to Paris, so we're going up through Yugoslavia and it's really, really dark. At a certain point the train came to a stop and there was no station, but we could see people getting off the train. They were going over to these canvas stalls with dim little lights, where they had these colored drinks — purple, green, yellow, blue, red — but it was just sugar water. When I got off the train I stepped into this soft dust that was like eight inches deep and it was blowing, and out of the earth these huge moths, like frogs, were leaping up, and they'd fly and flip and go back down again. So that was the frog-moth. Things just sort of show up in the world of *Twin Peaks*.

Fire Walk with Me is very important to this *Twin Peaks*, and I'm not surprised people made that connection. It's very obvious. I remember thinking how lucky I was to have made that film. Everybody has theories about what the show is about, which is great, and it wouldn't matter if I explained my theory. Things have harmonics, and if you're true to an idea as much as you can be, then the harmonics will be there and they'll be truthful even though they may be abstract. You could come back in ten years and see it in a completely different way, and you may see more in it — that potential is there if you've been true to that original idea. That's one of the beautiful things cinema can do: You can go back into that world later and get more if you've been true to the basic notes.

Things went pretty good with *Twin Peaks: The Return*, and who really knows why? It could've gone different. There's a tradition at Cannes that when a picture goes over well, everybody stands up and applauds. I'd forgotten about that, so when the screening of the first two hours of *Twin Peaks* ended at Cannes, I stood up and I was looking to get out and go have a smoke, but there was Thierry [Frémaux] telling me, "No, no, you can't go." The applause went on and on. It was a beautiful thing. I've been to Cannes when things didn't go that way.

My childhood was very happy, and I think that set me up in life. I really did have a great family that gave me a good foundation, and that's super important. I may not've been the best father to my kids, because I wasn't around much, but my father was never around much, either. And yet he was around, you know? In those days there seemed to be a kids'

world and an adult world and they didn't really mix much. Maybe it's not the presence of the father but the love that you feel coming through that's important. Still, I think my father was a better father than I am.

I didn't know I was going to be famous, but mostly I had a feeling everything was going to be okay. There was never a moment when I thought, Wow, look at this big life I'm living. It was sort of like the way I gain weight—kind of slowly and evenly all over the place—it creeps up on you. But there have been major turning points in my life. The first one was meeting Toby Keeler in Linda Styles's front yard in the ninth grade. From that moment on I wanted to be a painter. Then I met my best friend, Jack Fisk. Jack and I were the only kids in our huge high school who were serious about painting. We inspired and supported each other, and this was extremely important for the future. Making the moving painting *Six Men Getting Sick*, and getting a grant from the AFI, and finishing *The Grandmother*, and being accepted to the AFI were all turning points. Starting to meditate in 1973 was maybe the biggest change of all—that was huge. The crew of *Eraserhead* probably didn't notice my lack of self-assuredness, but it was there. I knew what I wanted, but I was not confident, and a lot of studio guys could've killed me real easy, so meditation really helped with that. Finishing *Eraserhead* and having Mel Brooks trust me enough to hire me to make *The Elephant Man*, and having that get eight Academy nominations, was a big jump up. And the failure with *Dune* was a revelation—that was a good thing to have a humiliating major failure. Then the freedom of working on *Blue Velvet* and getting on the right track, and meeting the art dealer Jim Corcoran, who believed in me—those things were important. Each one of my love affairs was life-changing, and although there were similarities, they were all different and great.

It's next door to impossible to jump up without the help of others, and I realize how lucky I've been. As I've said before, my mother and father played pivotal roles in my life, and so did Toby and Bushnell Keeler. When I first got to Philadelphia I was in a strange place, trying to make my way and Peggy Reavey believed in me and supported me, so she was really important. Toni Vellani, George Stevens, Jr., Dino De Laurentiis, and Mr. Bouygues were also important. Anybody who believes in you and has the wherewithal to make things happen—we all really need

those people. David Nevins is one of those people, because he made *Twin Peaks: The Return* happen, and maybe somebody else wouldn't have done that. And the great Angelo Badalamenti—what a gift, finding Angelo and his music. Charlie and Helen Lutes, who ran the center where I learned TM, gave me a powerful and great start down the meditation road, and Bobby Roth has been my brother on the path. Bobby was always with me in the world of Maharishi—the tours and talks on meditation, and the forming of the David Lynch Foundation. Bobby is the brains and powerhouse behind the DLF. Maharishi played the biggest role of all, though. He changed things cosmically and profoundly, and everything else pales in comparison.

There was a day during the time when I had my bungalow on Rosewood that I've never forgotten. It was a beautiful morning, and at around eleven-thirty I went down to San Vicente and Santa Monica Boulevard to fill up my car with gas, and the sun was warming the back of my neck, and I filled my gas tank from empty to full, put the cap back on, and looked at the gas pump and it read three dollars. I made fifty dollars a week delivering *The Wall Street Journal*. I drove ten minutes to get the newspapers; I got my route down to one hour, then ten minutes to get back home. I worked six hours and forty minutes a week and I made two hundred dollars a month and I was able to live nicely on that. My route went through two different zip codes so there were two different garbage nights, and people would throw out wood, and I'd leap out and load this stuff up and I got so much found wood. My landlord, Edmund, collected wood, too, and he let me use it, and I built a whole shed in the backyard with found wood, found windows, found everything. It was a beautiful world. There's a whole bunch of negative things going on these days and many diversions keeping us from knowing what's really going on. There's so much harm being done to us and our world because of love of money over love of humanity and Mother Nature.

I'm happy I went on the sixteen-country tour for Maharishi. Even though I don't like public speaking, I get blissful telling people about the knowledge and technologies Maharishi revived for the world. Maharishi had two goals: the enlightenment of individuals, and peace on earth. He put everything needed in place for both to happen. It's now just a question of time. If we humans—or even a few of us—work together on this,

we can speed through this transition and the goals will be a living reality. Enlightenment for the people and real peace on earth. Real peace is not just the absence of war, but the absence of all negativity. Everyone wins.

If I look at any page of this book, I think, Man, that's just the tip of the iceberg; there's so much more, so many more stories. You could do an entire book on a single day and still not capture everything. It's impossible to really tell the story of somebody's life, and the most we can hope to convey here is a very abstract "Rosebud." Ultimately, each life is a mystery until we each solve the mystery, and that's where we are all headed whether we know it or not.

MAY EVERYONE BE HAPPY

MAY EVERYONE BE FREE OF DISEASE

MAY AUSPICIOUSNESS BE SEEN EVERYWHERE

MAY SUFFERING BELONG TO NO ONE

PEACE

ACKNOWLEDGMENTS

My first thanks go to Martha Levacy, Peggy Reavey, Mary Fisk, and Michael Barile. Their patience and support throughout the making of this book were crucial and I'm eternally in their debt. Thanks also to Anna Skarbek, whose encouragement and knowledge were immensely helpful, and to Sabrina Sutherland and Mindy Ramaker for their kindness and generosity. Noriko Miyakawa was a godsend.

Ottessa Moshfegh made the key connection that launched the long journey of *Room to Dream*—thank you, Ottessa—and Chris Parris-Lamb and Ben Greenberg made the book a reality. I couldn't have asked for better colleagues. The many people who agreed to speak with me for the book provided the heart and soul of the narrative, and I thank them all for the time they gave me and their willingness to share their experiences with David. Many thanks to Loren Noveck for her impeccable copy editing and for making me seem smarter than I am.

Thanks also to Ann Summa, Jeff Spurrier, Steve Samiof, Kathleen Greenberg, Hilary Beane, the Asolas family, Lianne Halfon, Michael Bortman, Laurie Steelink, Nick Chase, Jack Cheesborough, Samantha Williamson, Mara De Luca, Michael Duncan, Glenn Morrow, Exene Cervenka, Dan & Clare Hicks, Kati Rocky, Joe Frank, Richard Beymer, Adrienne Levin, Merrill Markoe, Marc Sirinsky, Cannon Hudson, and Jennifer Bolande. Leonard Cohen and Diane Broderick are reliable northern stars, Walter Hopps is always there, and Gideon Brower was an essential presence throughout my work on the book—

much gratitude to all of them. Lorraine Wild taught me how to make books; thank you, Lorraine. My deepest thanks go to David Lynch. I'm honored that he trusted me enough to allow me to take part in the telling of his story and feel very lucky to know him. A surprising thing happened during the making of this book on David, in that the closer I got the better he looked. David is an extraordinary and generous man who's helped many people. I am one of them.

—*KRISTINE MCKENNA*

1967
Six Men Getting Sick (Six Times)
1 minute / color / animation projected onto sculpted screen

Director, producer, editor, and animation: David Lynch

Fictitious Anacin Commercial
1 minute 5 seconds / color / live action

Director, writer, producer, and editor: David Lynch
With: Jack Fisk

Absurd Encounter with Fear
2 minutes / color / live action and animation
Director, writer, producer, and editor: David Lynch
Music: Krzysztof Penderecki

1968
The Alphabet
4 minutes / color / live action and animation

Producer: H. Barton Wasserman
Director, writer, photographer, and editor: David Lynch
Sound: David Lynch
Title song: David Lynch, performed by Robert Chadwick
With: Peggy Reavey

1970
The Grandmother

34 minutes / color / live action and animation

Director, writer, photographer, editor, and animation: David Lynch
Producer: David Lynch, with the American Film Institute
Assistant script consultants: Peggy Reavey and C. K. Williams
Still photography: Doug Randall
Sound editing and mixing: Alan Splet
Music: Tractor
With: Richard White, Virginia Maitland, Robert Chadwick, and Dorothy McGinnis

1974
The Amputee (two versions)

5 minutes / black and white / live action

Director, writer, producer, and editor: David Lynch
Photography: Frederick Elmes
With: Catherine Coulson and David Lynch

1977
Eraserhead

1 hour, 29 minutes / black and white / live action and animation

Production company: American Film Institute, distributed by Libra Films
Director, writer, and editor: David Lynch
Producer: David Lynch
Photography: Herbert Cardwell and Frederick Elmes
Production design and special effects: David Lynch
Sound design and editing: David Lynch and Alan Splet
Assistant to the director: Catherine Coulson
With: Jack Nance, Charlotte Stewart, Allen Joseph, Jeanne Bates, Judith Roberts, Laurel Near, Jack Fisk, Thomas Coulson, Hal Landon, Jr., Neil Moran, and Jean Lange

1980
The Elephant Man

2 hours, 4 minutes / black and white / live action

Production company: Brooksfilms
Director: David Lynch
Writers: David Lynch, Christopher De Vore, & Eric Bergren
Producer: Jonathan Sanger
Executive producer: Stuart Cornfeld (uncredited, Mel Brooks)
Photography: Freddie Francis
Editor: Anne V. Coates
Production manager: Terrence A. Clegg
Production design: Stuart Craig

Sound design: Alan Splet and David Lynch
Costume design: Patricia Norris
Music: John Morris
With: John Hurt, Anthony Hopkins, Anne Bancroft, Wendy Hiller, John Gielgud, Freddie
Jones, Michael Elphick, and Hannah Gordon

1984
Dune
2 hours, 17 minutes / color / live action

Production company: Dino De Laurentiis Company/Universal
Director: David Lynch
Writer: David Lynch
Based on the novel by Frank Herbert
Producer: Raffaella De Laurentiis
Executive producer: Dino De Laurentiis
Photography: Freddie Francis
Second unit photography: Frederick Elmes
Editor: Antony Gibbs
Production design: Anthony Masters
Sound design: Alan Splet
Costume design: Bob Ringwood
Music: Toto; "Prophecy Theme" by Brian Eno
With: Kyle MacLachlan, Sting, Francesca Annis, Leonard Cimino, Brad Dourif, José
Ferrer, Linda Hunt, Dean Stockwell, Virginia Madsen, Silvana Mangano, Jack Nance,
Jürgen Prochnow, Paul L. Smith, Patrick Stewart, Max von Sydow, Alicia Witt, Freddie
Jones, and Kenneth McMillan

1986
Blue Velvet
2 hours / color / live action

Production company: De Laurentiis Entertainment Group
Director: David Lynch
Writer: David Lynch
Producer: Fred Caruso
Executive producer: Richard Roth
Photography: Frederick Elmes
Editor: Duwayne Dunham
Casting: Johanna Ray and Pat Golden
Production design: Patricia Norris
Sound design: Alan Splet
Music composed and conducted: Angelo Badalamenti
With: Kyle MacLachlan, Laura Dern, Isabella Rossellini, Dennis Hopper, Dean Stockwell,
Brad Dourif, Jack Nance, George Dickerson, Frances Bay, Hope Lange, and Ken Stovitz

1988
The Cowboy and the Frenchman
24 minutes / color / live action

Production company: Erato Films, Socpresse, Figaro Films
Director and writer: David Lynch
Producers: Daniel Toscan du Plantier and Propaganda Films
Executive producers: Paul Cameron and Pierre-Olivier Bardet
Associate producer: David Warfield
Co-producers: Marcia Tenney, Julia Matheson, Scott Flor
Photography: Frederick Elmes
Editor: Scott Chestnut
Production design: Patricia Norris and Nancy Martinelli
Sound: Jon Huck
Set decoration: Frank Silva
Camera assistant: Catherine Coulson
Script supervisor: Cori Glazer
Choreography: Sarah Elgart
Music: Radio Ranch Straight Shooters, Eddy Dixon, and Jean-Jacques Perrey
With: Harry Dean Stanton, Frederic Golchan, Jack Nance, Michael Horse, Rick Guillory, Tracey Walter, Marie Laurin, Patrick Houser, Talisa Soto, Debra Seitz, and Amanda Hull

1990
Industrial Symphony No.1: The Dream of the Brokenhearted
50 minutes / color / video production of live theater piece

Production company: Propaganda Films
Director: David Lynch
Musical director: Angelo Badalamenti
Created by: David Lynch and Angelo Badalamenti
Producers: John Wentworth, David Lynch, and Angelo Badalamenti
Executive producers: Steve Golin, Sigurjón Sighvatsson, and Monty Montgomery
Assistant producers: Eric Gottlieb, Jennifer Hughes, and Marcel Sarmiento
Coordinating producer: Debby Trutnik
Production design: Franne Lee
Lighting design: Ann Militello
Choreography: Martha Clarke
With: Laura Dern, Nicolas Cage, Julee Cruise, Lisa Giobbi, Félix Blaska, Michael J. Anderson, André Badalamenti, and John Bell
Video production crew
 Editor: Bob Jenkis

1990–1991
Twin Peaks
2-hour pilot and 29-episode television series, approximately 60 minutes each, broadcast on ABC / color / live action

Production company: Lynch/Frost Productions, Propaganda Films, Spelling Entertainment
Created by: David Lynch & Mark Frost
Directors: David Lynch (episodes 1.1, 1.3, 2.1, 2.2, 2.7, 2.22); Duwayne Dunham (1.2, 2.11, 2.18); Tina Rathborne (1.4, 2.10); Tim Hunter (1.5, 2.9, 2.21); Lesli Linka Glatter (1.6, 2.3, 2.6, 2.16); Caleb Deschanel (1.7, 2.8, 2.12); Mark Frost (1.8); Todd Holland (2.4, 2.13); Graeme Clifford (2.5); Uli Edel (2.14); Diane Keaton (2.15); James Foley (2.17); Jonathan Sanger (2.19); Stephen Gyllenhaal (2.20)
Writers: David Lynch & Mark Frost (1.1, 1.2, 1.3); Harley Peyton (1.4, 1.7, 2.2, 2.13); Robert Engels (1.5, 1.6, 2.3); Mark Frost (1.6, 1.8, 2.1, 2.7); Jerry Stahl, Mark Frost, Harley Peyton, & Robert Engels (2.4); Barry Pullman (2.5, 2.11, 2.17, 2.21); Harley Peyton & Robert Engels (2.6, 2.12, 2.15, 2.18, 2.20); Scott Frost (2.8, 2.14); Mark Frost, Harley Peyton, & Robert Engels (2.9, 2.22); Tricia Brock (2.10, 2.16); Mark Frost & Harley Peyton (2.19)
Producers: Gregg Fienberg (1.1–1.8); Harley Peyton (2.1–2.22); David J. Latt (European version)
Supervising producer: Gregg Fienberg (2.1–2.22)
Associate producer: Philip Neel
Photography: Ron Garcia (1.1) and Frank Byers (1.2–2.22)
Editors: Duwayne Dunham (1.1, 2.1); Jonathan P. Shaw (1.2, 1.3, 1.6, 2.2, 2.5, 2.8, 2.11, 2.14, 2.17, 2.20); Toni Morgan (1.4, 1.7, 2.4, 2.10, 2.13, 2.16, 2.19, 2.22); Paul Trejo (1.5, 1.8, 2.3, 2.6, 2.9, 2.12, 2.15, 2.18, 2.21); Mary Sweeney (2.7)
Casting: Johanna Ray
Production design: Patricia Norris (1.1); Richard Hoover (1.2–2.22)
Sound: John Wentworth
Music composed and conducted: Angelo Badalamenti
With: Kyle MacLachlan, Sheryl Lee, Piper Laurie, Peggy Lipton, Jack Nance, Joan Chen, Richard Beymer, Ray Wise, Frank Silva, Russ Tamblyn, Sherilyn Fenn, Mädchen Amick, Dana Ashbrook, James Marshall, Michael Ontkean, Catherine Coulson, Everett McGill, Wendy Robie, Eric Da Re, Lara Flynn Boyle, Al Strobel, Michael Horse, Kimmy Robertson, Harry Goaz, Miguel Ferrer, Don Davis, Grace Zabriskie, Heather Graham, Warren Frost, Chris Mulkey, David Duchovny, Michael J. Anderson, Julee Cruise, Walter Olkewicz, and David Lynch

1990
Wild at Heart
2 hours, 5 minutes / color / live action

Production company: Propaganda Films for PolyGram Filmed Entertainment, distributed by the Samuel Goldwyn Company
Director: David Lynch
Writer: David Lynch
Based on the novel *Wild at Heart: The Story of Sailor and Lula,* by Barry Gifford
Producer: Monty Montgomery, Steve Golin, and Sigurjón Sighvatsson

Executive producer: Michael Kuhn
Photography: Frederick Elmes
Editor: Duwayne Dunham
Casting: Johanna Ray
Production design and costumes: Patricia Norris
Sound design: David Lynch and Randy Thom
Music composed and conducted: Angelo Badalamenti
With: Nicolas Cage, Laura Dern, Willem Dafoe, J. E. Freeman, Crispin Glover, Diane Ladd, Calvin Lockhart, Isabella Rossellini, Harry Dean Stanton, Grace Zabriskie, Sheryl Lee, W. Morgan Sheppard, David Patrick Kelly, Sherilyn Fenn, Freddie Jones, John Lurie, Jack Nance, and Pruitt Taylor Vince

Wicked Game
3 minutes, 31 seconds / color / live action

Director, writer, and editor: David Lynch
Music: Chris Isaak
With: Chris Isaak, Laura Dern, Nicolas Cage, and Willem Dafoe

1992
Twin Peaks: Fire Walk with Me
2 hours, 14 minutes / color / live action

Production company: Twin Peaks Productions, Ciby 2000, New Line Cinema
Director: David Lynch
Writers: David Lynch & Robert Engels
Producer: Gregg Fienberg
Executive producers: David Lynch & Mark Frost
Photography: Ron Garcia
Editor: Mary Sweeney
Casting: Johanna Ray
Production design: Patricia Norris
Sound design: David Lynch
Music composed and conducted: Angelo Badalamenti
With: Sheryl Lee, Ray Wise, Mädchen Amick, Dana Ashbrook, Phoebe Augustine, David Bowie, Grace Zabriskie, Harry Dean Stanton, Kyle MacLachlan, Eric Da Re, Miguel Ferrer, Pamela Gidley, Heather Graham, Chris Isaak, Moira Kelly, Peggy Lipton, David Lynch, James Marshall, Jürgen Prochnow, Kiefer Sutherland, Lenny von Dohlen, Frances Bay, Catherine Coulson, Michael J. Anderson, Frank Silva, Al Strobel, Walter Olkewicz, Julee Cruise, and Gary Hershberger

On the Air
7-episode television series, broadcast on ABC / color / live action

Production company: Lynch/Frost Productions
Created by: David Lynch and Mark Frost

Directors: David Lynch (1); Lesli Linka Glatter (2, 5); Jack Fisk (3, 7); Jonathan Sanger (4); Betty Thomas (6)
Writers: David Lynch and Mark Frost (1); Mark Frost (2, 5); Robert Engels (3, 6); Scott Frost (4); David Lynch and Robert Engels (7)
Producers: Gregg Fienberg (1); Deepak Nayar (2–7)
Co-executive producer: Robert Engels (2–7)
Photography: Ron Garcia (1–3); Peter Deming (2, 4–7)
Editors: Mary Sweeney (1); Paul Trejo (2, 5); Toni Morgan (3, 6); David Siegel (4, 7)
Casting: Johanna Ray
Production design: Michael Okowita
Music composed and conducted: Angelo Badalamenti
With: Ian Buchanan, Nancye Ferguson, Miguel Ferrer, Gary Grossman, Mel Johnson Jr., Marvin Kaplan, David L. Lander, Kim McGuire, Tracey Walter, Marla Rubinoff, Irwin Keyes, Raleigh and Raymond Friend, Everett Greenbaum, and Buddy Douglas

1993
Hotel Room
1 hour, 55 minutes / color / live action three-act teleplay broadcast on HBO

Created by: David Lynch and Monty Montgomery
Directors: David Lynch (*Tricks* and *Blackout*); James Signorelli (*Getting Rid of Robert*)
Writers: Barry Gifford (*Tricks* and *Blackout*); Jay McInerney (*Getting Rid of Robert*)
Producer: Deepak Nayar
Executive producers: David Lynch and Monty Montgomery
Photography: Peter Deming
Editors: Mary Sweeney (*Tricks*); David Siegel (*Getting Rid of Robert*); Toni Morgan (*Blackout*)
Casting: Johanna Ray
Production design: Patricia Norris
Sound design: David Lynch
Music composed and conducted: Angelo Badalamenti
With: Harry Dean Stanton, Freddie Jones, Glenne Headly, Crispin Glover, Alicia Witt, Griffin Dunne, Chelsea Field, Mariska Hargitay, Camilla Overbye Roos, John Solari, Deborah Kara Unger, Clark Heathcliff Brolly, and Carl Sundstrom

1995
Premonition Following an Evil Deed
55 seconds / black and white / live action

Director and writer: David Lynch
Producer: Neal Edelstein
Photography: Peter Deming
Costume design: Patricia Norris
Special effects: Gary D'Amico
Music: David Lynch and Angelo Badalamenti

With: Jeff Alperi, Mark Wood, Stan Lothridge, Russ Pearlman, Pam Pierrocish, Clyde Small, Joan Rurdlestein, Michele Carlyle, Kathleen Raymond, Dawn Salcedo

Longing
5 minutes / color / live action

Music: Yoshiki

1997
Lost Highway
2 hours, 14 minutes / color / live action

Production company: Ciby 2000, Asymmetrical Productions
Director: David Lynch
Writers: David Lynch & Barry Gifford
Producers: Deepak Nayar, Tom Sternberg, and Mary Sweeney
Photography: Peter Deming
Editor: Mary Sweeney
Casting: Johanna Ray and Elaine J. Huzzar
Costume and production design: Patricia Norris
Sound mix: Susumu Tokunow
Music composed and conducted: Angelo Badalamenti
With: Bill Pullman, Patricia Arquette, Balthazar Getty, Robert Blake, Robert Loggia, Richard Pryor, Jack Nance, Natasha Gregson Wagner, Gary Busey, Henry Rollins, and Lucy Butler

1999
The Straight Story
1 hour, 52 minutes / color / live action

Production company: Asymmetrical Productions, Canal Plus, Channel Four Films, and Picture Factory
Director: David Lynch
Writers: Mary Sweeney & John Roach
Producers: Mary Sweeney and Neal Edelstein
Executive producers: Pierre Edelman and Michael Polaire
Photography: Freddie Francis
Editor: Mary Sweeney
Casting: Jane Alderman and Lynn Blumenthal
Production design: Jack Fisk
Costume design: Patricia Norris
Location sound mix: Susumu Tokunow
Music composed and conducted: Angelo Badalamenti
With: Richard Farnsworth, Sissy Spacek, Harry Dean Stanton, Everett McGill, John Farley, Kevin Farley, Jane Galloway Heitz, Joseph A. Carpenter, Leroy Swadley, Wiley Harker, Donald Wiegert, Dan Flannery, Jennifer Edwards-Hughes, and Ed Grennan

2001
Mulholland Drive
2 hours, 26 minutes / color / live action

Production company: Les Films Alain Sarde, Asymmetrical Productions, Babbo Inc., Canal Plus, Picture Factory
Director and writer: David Lynch
Producers: Mary Sweeney, Alain Sarde, Neal Edelstein, Michael Polaire, and Tony Krantz
Executive producer: Pierre Edelman
Co-producer: John Wentworth
Photography: Peter Deming
Editor: Mary Sweeney
Casting: Johanna Ray
Production design: Jack Fisk
Costume design: Amy Stofsky
Sound design: David Lynch
Music, composed and conducted: Angelo Badalamenti; additional music composed by David Lynch and John Neff
With: Justin Theroux, Naomi Watts, Laura Elena Harring, Dan Hedaya, Robert Forster, Ann Miller, Michael J. Anderson, Angelo Badalamenti, Billy Ray Cyrus, Chad Everett, Lee Grant, Scott Coffey, Patrick Fischler, and Lori Heuring

Head with Hammer
14 seconds / color / live action

Director, writer, producer, and editor: David Lynch, for Davidlynch.com

Out Yonder: Neighbor Boy
9 minutes, 38 seconds / black and white / live action

Director, writer, photographer, and editor: David Lynch, for Davidlynch.com
Sound design: David Lynch
With: David Lynch and Austin Lynch

Out Yonder: Teeth
13 minutes, 24 seconds / black and white / live action

Director, writer, photographer, and editor: David Lynch, for Davidlynch.com
Sound design: David Lynch
With: David Lynch, Austin Lynch, and Riley Lynch

Pierre and Sonny Jim
3 minutes, 31 seconds / color / animated puppets

Director, writer, producer, and editor: David Lynch, for Davidlynch.com
Sound design: David Lynch

Ball of Bees

Seven versions: 1—5 minutes, 5 seconds; 2—5 minutes, 6 seconds; 3—5 minutes, 25 seconds; 4—5 minutes, 21 seconds; 5—5 minutes, 42 seconds; 6—4 minutes, 46 seconds; 7—4 minutes 26 seconds / color / live action

Producer: David Lynch for Davidlynch.com
Written, filmed, and edited: David Lynch

2002
Darkened Room

8 minutes, 16 seconds / color / live action

Director, writer, producer, photographer, and editor: David Lynch, for Davidlynch.com
Sound design: David Lynch and John Neff
Music: Angelo Badalamenti
With: Jordan Ladd, Etsuko Shikata, and Cerina Vincent

The Disc of Sorrow Is Installed

4 minutes / color / live action

Director, writer, producer, and photographer: David Lynch for Davidlynch.com

Rabbits

9-episode sitcom / color / live action

Director, writer, producer, photographer, and editor: David Lynch, for Davidlynch.com
Costume design: Tony Candelaria
Location manager: Jeremy Alter
Music: David Lynch
With: Naomi Watts, Laura Elena Harring, Scott Coffey, Rebekah Del Rio

DumbLand

8-episode sitcom / black and white / animated

Written, drawn, voiced, and edited: David Lynch, for Davidlynch.com
Sound design: David Lynch

The Coyote

3 minutes, 46 seconds / color / live action

Director, writer, producer, and editor: David Lynch
Sound design: David Lynch

2006
INLAND EMPIRE

3 hours / color / live action

Production company: StudioCanal, Camerimage Festival, Fundacja Kultury, Asymmetrical Productions, Absurda, distributed by 518 Media

Director and writer: David Lynch
Producers: Mary Sweeney and David Lynch
Co-producers: Jeremy Alter and Laura Dern
Associate producers: Jay Aaseng and Erik Crary
Associate producer: Sabrina S. Sutherland
Casting: Johanna Ray
Art direction: Christina Ann Wilson
Set decoration: Melanie Rein
Sound design: David Lynch
Production sound mixer: Dean Hurley
Costume design: Karen Baird and Heidi Bivens
Music consultant: Marek Zebrowski
Music: Krzysztof Penderecki, Marek Zebrowski, David Lynch, Dave Brubeck, Etta James, Little Eva, Nina Simone, and others
With: Laura Dern, Jeremy Irons, Harry Dean Stanton, Justin Theroux, Karolina Gruszka, Grace Zabriskie, Jan Hencz, Diane Ladd, William H. Macy, Julia Ormond, Erik Crary, Emily Stofle, Jordan Ladd, Kristen Kerr, Terryn Westbrook, Kat Turner, Mary Steenburgen, Helena Chase, Nae, and Terry Crews

2007
Out Yonder: Chicken
17 minutes, 9 seconds / black and white / live action

Director, writer, producer, photographer, and editor: David Lynch, for Davidlynch.com
Sound design: David Lynch
With: David Lynch, Austin Lynch, and Emily Stofle

Boat
7 minutes, 15 seconds / color / live action

Writer, photographer, and editor: David Lynch
Narration: Emily Stofle
With: David Lynch

Ballerina
12 minutes, 19 seconds / color / live action

Director, writer, producer, and editor: David Lynch
Music: David Lynch

Bug Crawls
5 minutes / black and white / animation

Writer, producer, photographer, editor, and animation: David Lynch
Sound design: David Lynch

Absurda / Cannes: Scissors
2 minutes, 22 seconds / color / live action and animation

Director, writer, producer, and editor: David Lynch

HollyShorts Greeting
3 minutes, 57 seconds / black and white / live action

Director, writer, producer, and editor: David Lynch
Sound design: David Lynch
Costume design: Emily Stofle
With: David Lynch, Emily Stofle, Ariana Delawari, and Jenna Green

Industrial Soundscape
10 minutes, 28 seconds / black and white / animated

Director writer, producer, photographer, editor, music, and animation: David Lynch

Intervalometer Experiments: Three Experiments in Time-Lapse Photography, including Steps
3 minutes, 45 seconds / black and white

INLAND EMPIRE: More Things That Happened
1 hour, 16 minutes / color / live action

Production company: Absurda and StudioCanal
Director, writer, photographer, and editor: David Lynch
Co-producer: Jeremy Alter
Music: David Lynch
With: Karolina Gruszka, Peter J. Lucas, William Maier, Krzysztof Majchrzak, Laura Dern, and Nastassja Kinski

2008
Twin Peaks Festival Greeting
4 minutes, 15 seconds / black and white / live action

Director, writer, producer, and editor: David Lynch
With: David Lynch

2009
Shot in the Back of the Head
3 minutes, 15 seconds / black and white / animated

Director, writer, producer, editor, and animation: David Lynch
Music: Moby

42 One Dream Rush; Dream #7 (Mystery of the Seeing Hand and the Golden Sphere)
42 seconds / color / animation

Released as part of *One Dream Rush,* a compilation of 42 short films based on dreams by various directors
Director, writer, producer, and editor: David Lynch

2010
Lady Blue Shanghai
16 minutes / color / live action

Short film for handbags by Dior
Director, writer, and editor: David Lynch
Producer: Sabrina S. Sutherland
Photography: Justyn Field
Music: David Lynch, Dean Hurley, and Nathaniel Shilkret
With: Marion Cotillard, Gong Tao, Emily Stofle, Nie Fei, Cheng Hong, and Lu Yong

2011
The 3 Rs
1 minute / black and white / live action

Trailer for the Vienna International Film Festival
Director, writer, producer, and editor: David Lynch
With: Mindy Ramaker, Anna Skarbek, and Alfredo Ponce

I Touch a Red Button Man
5 minutes, 42 seconds / color / animated

Director, writer, editor, and animation: David Lynch
Music: Interpol

Duran Duran: Unstaged
2 hours, 1 minute

Director and writer: David Lynch
Producers: Sabrina S. Sutherland, Andrew Kelly, Michael Goldfine, Blake W. Morrison, and Nick Barrios
Executive producer: Joe Killian
Photography: Peter Deming
Editor: Noriko Miyakawa
Sound mixer: Dean Hurley
With: Duran Duran

Good Day Today

4 minutes, 41 seconds / color / live action

Director, writer, producer, and editor: David Lynch
Music: David Lynch and Dean Hurley

2012

Crazy Clown Time

7 minutes, 5 seconds / color / live action

Director and writer: David Lynch
Producer: Sabrina S. Sutherland
Music: David Lynch and Dean Hurley

Meditation, Creativity, Peace

71 minutes / black and white / live action

Documentary of 2007–2009 Transcendental Meditation tour
Producers: Bob Roth, Adam Pressman, and Sam Lieb
Editor: Noriko Miyakawa
Sound: Dean Hurley
With: David Lynch

Memory Film

4 minutes, 17 seconds / color / live action and animation

Director, producer, and photographer: David Lynch
Editor: Noriko Miyakawa
Sound mix: Dean Hurley
With: David Lynch

2013

Idem Paris

8 minutes, 5 seconds / black and white / live action

Director, producer, and photographer: David Lynch
Editor: Noriko Miyakawa
Sound mix: Dean Hurley
With: Christian Charpin, Khindelvert Em, Patrick Pramil, and Phaythoune Soukaloun

Came Back Haunted

4 minutes, 15 seconds / color / live action and animation

Director and writer: David Lynch
Music: Nine Inch Nails

2014
Twin Peaks: The Missing Pieces
One hour, 31 minutes / color / live action

Production company: Absurda and MK2 Diffusion
Director, writer, and editor: David Lynch
Producer: Sabrina S. Sutherland
Special effects: David Lynch and Noriko Miyakawa
Music: Angelo Badalamenti, David Lynch, Dean Hurley, and David Slusser
With: Chris Isaak, Kiefer Sutherland, C. H. Evans, Sandra Kinder, Rick Aiello, Elizabeth Ann McCarthy, Steven Beard, Gary Bullock, Kyle MacLachlan, David Bowie, Hirsh Diamant, Stefano Loverso, Jeannie Bonser, Alex Samorano, Michael J. Anderson, Carlton Lee Russell, Calvin Lockhart, Jürgen Prochnow, David Brisbin, Jonathan J. Leppell, Frances Bay, Frank Silva, Sheryl Lee, David Lynch, Miguel Ferrer, Dori Guterson, Gary Hershberger, Dana Ashbrook, Moira Kelly, Grace Zabriskie, Ray Wise, Brian T. Finney, Jack Nance, Joan Chen, Ed Wright, Mädchen Amick, Peggy Lipton, Andrea Hays, Wendy Robie, Everett McGill, Marvin Rosand, Warren Frost, Mary Jo Deschanel, Eric Da Re, Victor Rivers, Chris Pedersen, Dennis E. Roberts, Al Strobel, Pamela Gidley, Phoebe Augustine, Walter Olkewicz, Michael Horse, Harry Goaz, Michael Ontkean, Russ Tamblyn, Don S. Davis, Charlotte Stewart, Kimmy Robertson, James Marshall, Catherine E. Coulson, Heather Graham, Therese Xavier Tinling, and Chuck McQuarry

2015
Pozar (Fire)
10 minutes, 44 seconds / black and white / animation

Written, drawn, and directed by: David Lynch
Animation: Noriko Miyakawa
Music: Marek Zebrowski

2017
Twin Peaks: The Return
18 episodes, approximately 60 minutes each / color / live action

Production company: Rancho Rosa Partnership, Inc., for Showtime
Created and written by: David Lynch and Mark Frost
Director: David Lynch
Executive producers: David Lynch and Mark Frost
Producer: Sabrina S. Sutherland
Associate producer: Johanna Ray
Line producer: Christine Larson-Nitzsche
Photography: Peter Deming
Editor: Duwayne Dunham
Art direction: Cara Brower
Costume design: Nancy Steiner

Production design: Ruth De Jong
Casting: Johanna Ray and Krista Husar
Sound design: David Lynch
Music: Angelo Badalamenti
With: Kyle MacLachlan, Sheryl Lee, Michael Horse, Chrysta Bell, Miguel Ferrer, David Lynch, Robert Forster, Kimmy Robertson, Naomi Watts, Laura Dern, Pierce Gagnon, Harry Goaz, Al Strobel, John Pirruccello, Don Murray, Mädchen Amick, Dana Ashbrook, Brent Briscoe, David Patrick Kelly, Jane Adams, Jim Belushi, Richard Beymer, Giselle DaMier, Eamon Farren, Patrick Fischler, Jennifer Jason Leigh, Robert Knepper, Andréa Leal, Grace Zabriskie, Amy Shiels, Russ Tamblyn, Tom Sizemore, Catherine E. Coulson, George Griffith, James Marshall, Peggy Lipton, James Morrison, J. R. Starr, Tim Roth, Wendy Robie, Harry Dean Stanton, Larry Clarke, Sherilyn Fenn, Josh Fadem, Jay R. Ferguson, Eric Edelstein, Ashley Judd, Caleb Landry Jones, Matthew Lillard, David Koechner, Sarah Jean Long, Clark Middleton, Carel Struycken, Jake Wardle, Nae, Amanda Seyfried, Christophe Zajac-Denek, Jay Aaseng, Joe Adler, Owain Rhys Davies, Erica Eynon, David Dastmalchian, Balthazar Getty, Nathan Frizzell, Hailey Gates, James Grixoni, Andrea Hays, Linda Porter, Karl Makinen, Jessica Szohr, Jodi Thelen, Adele René, Nafessa Williams, Candy Clark, Charlotte Stewart, Max Perlich, Emily Stofle, Gary Hershberger, John Paulsen, Zoe McLane, Bérénice Marlohe, Warren Frost, Joy Nash, Kathleen Deming, David Duchovny, Don S. Davis, Lisa Coronado, Richard Chamberlain, Michael Cera, Monica Bellucci, Alicia Witt, Riley Lynch, Marvin Rosand, Madeline Zima, Everett McGill, Walter Olkewicz, Sabrina S. Sutherland, Jay Larson, Ray Wise, Nicole LaLiberte, and Cornelia Guest

What Did Jack Do?

20 minutes / color / live action

Director, writer, and editor: David Lynch
Producer: Sabrina S. Sutherland for Absurda / Fondation Cartier
Photography: Scott Ressler
Special effects and assistant editing: Noriko Miyakawa
Sound and set design: David Lynch
Sound mix: David Lynch and Dean Hurley
Music: David Lynch and Dean Hurley
With: Jack Cruz, David Lynch, Emily Stofle, and Toototaban

COMMERCIALS

1988

Opium, Yves St. Laurent fragrance
Obsession, Calvin Klein fragrance, four segments, each referencing an author: D. H. Lawrence, F. Scott Fitzgerald, Ernest Hemingway, Gustave Flaubert
Public-service announcement for the New York Department of Sanitation *We Care About New York* campaign

1991
Georgia Coffee, four segments, featuring Kyle MacLachlan, Catherine Coulson, Mädchen Amick, Michael Horse, Harry Goaz, and Kimmy Robertson

1992
Giò, Giorgio Armani fragrance

1993
Trésor, Lancôme fragrance
Alka-Seltzer Plus
Barilla pasta with Gerard Depardieu
Adidas "The Wall" campaign
Background by Jil Sander, *The Instinct of Life*
Public-service announcement for the American Cancer Society Breast Cancer Awareness campaign
Teaser for Michael Jackson's *Dangerous* video compilation

1994
Sun Moon Stars, Karl Lagerfeld fragrance

1997
Sci-Fi Channel, four promotional segments: *Aunt Droid, Nuclear Winter, Dead Leaves,* and *Kiddie Ride*
Clear Blue Easy, home pregnancy test
Mountain Man, Honda

1998
Parisienne cigarettes, "Parisienne People" campaign
Opium, Yves St. Laurent fragrance

2000
Welcome to the Third Place, Sony PlayStation 2
JCDecaux, street furniture and bicycle rental systems, by the Jean-Claude Decaux Group

2002
Do You Speak Micra? Nissan
Bucking Bronco, Citroën

2004
Fahrenheit, Christian Dior fragrance
Preference: Color Vive, L'Oréal

2007
Gucci, Gucci fragrance
Music: Blondie

2008
Revital Granas, Shiseido

2011
David Lynch Signature Cup Coffee

2012
David Lynch Signature Cup Coffee, with Emily Lynch

2014
Rouge, Christian Louboutin nail polish

CHRONOLOGY OF EXHIBITIONS

1967
Vanderlip Gallery, Philadelphia, Pennsylvania

1968
The Samuel Paley Library at Temple University, Philadelphia, Pennsylvania

1983
Galería Uno, Puerto Vallarta, Mexico

1987
James Corcoran Gallery, Santa Monica, California
Rodger LaPelle Galleries, Philadelphia, Pennsylvania

1989
Leo Castelli Gallery, New York, New York
James Corcoran Gallery, Santa Monica, California

1990
N. No. N. Gallery, Dallas, Texas
Tavelli Gallery, Aspen, Colorado

1991
Touko Museum of Contemporary Art, Tokyo, Japan
Strange Magic: Early Works, Payne Gallery at Moravian College, Bethlehem,
 Pennsylvania

1992
Sala Parpalló, Valencia, Spain

1993
James Corcoran Gallery, Santa Monica, California

1995
Kohn/Turner Gallery, Los Angeles, California

1996
Painting Pavilion, Open Air Museum, Hakone, Japan
Park Tower Hall, Tokyo, Japan
Namba City Hall, Osaka, Japan
Artium, Fukuoka, Japan

1997
Dreams, Otsu Parco Gallery, Osaka, Japan
Galerie Piltzer, Paris, France
Salone del Mobile, Milan, Italy (furniture exhibition)

1998
Sinn und Form, Internationales Design Zentrum, Berlin, Germany (furniture exhibition)

2001
Centre de Cultura Contemporània de Barcelona, Barcelona, Spain
Printemps de Septembre, Toulouse, France

2004
Atlas Sztuki, Łódź, Poland

2007
The Air is on Fire: 40 Years of Paintings, Photographs, Drawings, Experimental Films, and Sound Creations, Fondation Cartier pour l'art contemporain, Paris, France; La Triennale di Milano, Milan, Italy
INLAND EMPIRE, Galerie du Jour agnès b., Paris, France
Prints in Paris, Item Gallery, Paris, France
Fetish, Galerie du Passage, Paris, France

2008
David Lynch: New Photographs, Epson Kunstbetrieb, Düsseldorf, Germany

2009
David Lynch and William Eggleston: Photographs, Galerie Karl Pfefferle, Munich, Germany

Fetish, Garage Center for Contemporary Culture, Moscow, Russia
Dark Night of the Soul, Michael Kohn Gallery, Los Angeles, California; OHWOW Gallery, Miami, Florida
New Paintings, William Griffin Gallery in conjunction with James Corcoran Gallery, Santa Monica, California
I See Myself, Galerie des Galeries, Paris, France
Hand of Dreams, Item Gallery, Paris, France
The Air is on Fire, Ekaterina Cultural Foundation, Moscow, Russia
Dark Splendor, Max Ernst Museum, Brühl, Germany
Ars Cameralis Culture Institution, Katowice, Poland

2010

Crime and Punishment, From Goya to Picasso, group exhibition, Musée d'Orsay, Paris, France
Marilyn Manson and David Lynch: Genealogies of Pain, Kunsthalle Wien, Vienna, Austria
David Lynch: Lithos 2007–2009, Musée du Dessin et de l'Estampe Originale, Gravelines, France
David Lynch: Darkened Room, Six Gallery, Osaka, Japan; Seoul, Korea
David Lynch: I Hold You Tight, Musée Jenisch, Vevey, Switzerland
The Air is on Fire, GL Strand, Copenhagen, Denmark
David Lynch, Mönchehaus Museum, Goslar, Germany
David Lynch: Photographs, Galerie Karl Pfefferle, Munich, Germany
New Prints and Drawings, Item Gallery, Paris, France

2011

New Paintings and Sculpture, Kayne Griffin Corcoran Gallery, Santa Monica, California
Works on Paper, Item Gallery, Paris, France
Mathematics: A Beautiful Elsewhere, group exhibition, Fondation Cartier pour l'art contemporain, Paris, France

2012

David Lynch: Man Waking From Dream, Fonds Régional d'Art Contemporain Auvergne, Clermont-Ferrand, France
Tilton Gallery, New York, New York
Dark Images: David Lynch on Sylt, Galerie Chelsea Sylt, Kampen, Germany
Tomio Koyama Gallery, Tokyo, Japan
Lost Paradise, group exhibition, Mönchehaus Museum, Goslar, Germany
It Happened at Night, Galerie Karl Pfefferle, Munich, Germany
Chaos Theory of Violence and Silence, Laforet Museum Harajuku, Tokyo, Japan
David Lynch: Lithographs, Galeria Miejska BWA, Bydgoszcz, Poland

2013

Circle of Dreams, Centre de la Gravure et de l'Image imprimée de la Fédération
 Wallonie-Bruxelles, La Louvière, Belgium
Hypnotherapy, group exhibition, Kent Fine Art, New York, New York
David Lynch: Naming, Kayne Griffin Corcoran, Los Angeles, California
New Works, Kayne Griffin Corcoran, Los Angeles, California

2014

Small Stories, Maison Européenne de la Photographie, Paris, France; Cinéma Galeries,
 Brussels, Belgium
The Factory Photographs, the Photographers' Gallery, London, U.K.; Fondazione MAST,
 Bologna, Italy
Women and Machines, Item Gallery, Paris, France
Frank Gehry: Solaris Chronicles, Part 2, group exhibition, Atelier de la Mécanique,
 LUMA Arles Campus, Arles, France
Dark Optimism. L'Inedito Sguardo di Lynch, Palazzo Panichi, Pietrasanta, Italy
The Unified Field, the Pennsylvania Academy of the Fine Arts, Philadelphia,
 Pennsylvania
David Lynch: Lost Visions, L'Indiscreto Fascino della Sguardo, Archivio di Stato, Lucca,
 Italy
David Lynch: Naming, Middlesbrough Institute of Modern Art, Middlesbrough, U.K.

2015

David Lynch: Between Two Worlds, Queensland Art Gallery / Gallery of Modern Art,
 Brisbane, Australia
Stories Tellers, group exhibition, Bandjoun Station, Bandjoun, Cameroon
Voices of 20 Contemporary Artists at Idem, group exhibition, Tokyo Station Gallery,
 Tokyo, Japan

2016

Plume of Desire, Item Gallery, Paris, France
It Was Like Dancing With a Ghost, KETELEER Gallery, Antwerp, Belgium
*The Conversation Continues . . . Highlights from the James Cottrell + Joseph Lovett
 Collection,* group exhibition, the Orlando Museum of Art, Orlando, Florida
Arte y Cine: 120 Años de Intercambios, CaixaForum, group exhibition, Barcelona,
 Spain

2017

Arte y Cine: 120 Años de Intercambios, CaixaForum, group exhibition, Madrid, Spain
Small Stories, Belgrade Cultural Center, Belgrade, Serbia
One Hour / One Night, Item Gallery, Paris, France
Highlights, group exhibition, Seoul Museum of Art, Seoul, Korea

Les Visitants, group exhibition, Centro Cultural Kirchner, Buenos Aires, Argentina
Smiling Jack, Galerie Karl Pfefferle, Munich, Germany
Silence and Dynamism, Centre of Contemporary Art, Toruń, Poland

2018
David Lynch: Someone is in My House, Bonnefantenmuseum, Maastricht, Netherlands

SOURCES

Barney, Richard A., *David Lynch: Interviews.* Jackson: University Press of Mississippi, 2009

Chandes, Herve, *The Air is on Fire.* Gottingen, Germany: Steidl, 2007

Cozzolino, Robert, *David Lynch: The Unified Field.* Philadelphia: The Pennsylvania Academy of the Fine Arts in association with University of California Press, 2014

Da Silva, José, *David Lynch: Between Two Worlds.* Queensland: Queensland Art Gallery / Gallery of Modern Art, 2015

Davison, Annette and Erica Sheen, *The Cinema of David Lynch: American Dreams, Nightmare Visions.* London: Wallflower Press, 2004

Forest, Patrice, *David Lynch—Lithos 2007–2009.* Ostfildern, Germany: Hatje Cantz Verlag, 2010

Frydman, Julien, *Paris Photo.* Gottingen, Germany: Steidl, 2012

Gabel, J. C., and Jessica Hundley, *Beyond the Beyond: Music From the Films of David Lynch.* Los Angeles: Hat & Beard Press, 2016

Giloy-Hirtz, Petra, *David Lynch: The Factory Photographs.* Munich: Prestel Verlag, 2014

Godwin, Kenneth George, *Eraserhead: The David Lynch Files, Book 1.* Winnipeg, Manitoba: Cagey Films Books, 2016.

Henri, Robert, *The Art Spirit.* Philadelphia: J.B. Lippincott, 1923

Heras, Artur, *David Lynch.* Valencia, Spain: Sala Parpalló Diputacion Provincial De Valencia, 1992

Lynch, David, *Catching the Big Fish: Meditation, Consciousness, and Creativity.* New York: Jeremy P. Tarcher / Penguin, 2006

Nibuya, Takashi, et al., *David Lynch: Drawings and Paintings.* Tokyo, Japan: Touko Museum of Contemporary Art, 1991

Nieland, Justus, *David Lynch.* Chicago: University of Illinois Press, 2012

Nochimson, Martha P., *The Passion of David Lynch: Wild at Heart in Hollywood.* Austin: University of Texas Press, 1997

Nochimson, Martha P., *David Lynch Swerves: Uncertainty from Lost Highway to INLAND EMPIRE.* Austin: University of Texas Press, 2013

Panczenko, Paula, *The Prints of David Lynch.* Madison, Wisconsin: Tandem Press, 2000

Rossellini, Isabella, *Some of Me.* New York: Random House, 1997

Spies, Werner, *David Lynch—Dark Splendor, Space Images Sound.* Ostfildern, Germany: Hatje Cantz Verlag, 2009

Zebrowski, Marek, *David Lynch.* Bydgoszcz, Poland: Camerimage, the International Film Festival of the Art of Cinematography, 2012

AMERICAN PASTORAL

1. Tim Hewitt, , from *David Lynch: Interviews,* edited by Richard A. Barney. Jackson, Mississippi: University Press of Mississippi, 2009.
2. Martha Levacy, all quotes from a conversation with the author in Riverside, California, August 30, 2015, unless otherwise noted.
3. John Lynch, all quotes from a conversation with the author in Riverside, California, August 30, 2015.
4. Mark Smith, all quotes from a telephone conversation with the author, September 2, 2015.
5. Elena Zegarelli, all quotes from a telephone conversation with the author, November 3, 2015.
6. Peggy Reavey, from a conversation with the author in San Pedro, California, September 2, 2015.
7. Gordon Templeton, all quotes from a telephone conversation with the author, November 19, 2015.
8. Jennifer Lynch, all quotes from a conversation with the author in Los Feliz, California, December 22, 2016.
9. David Lynch, all quotes from conversations with the author, 1980 through 2018, unless otherwise noted.

THE ART LIFE

1. Toby Keeler, all quotes from a telephone conversation with the author, November 19, 2015, unless otherwise noted.

2. David Keeler, all quotes from a telephone conversation with the author, November 11, 2015.

3. Jack Fisk, all quotes from a conversation with the author in Brentwood, California, July 22, 2015.

4. Clark Fox, all quotes from a telephone conversation with the author, April 12, 2016.

5. Mary Fisk, all quotes from a series of telephone conversations with the author, July 2015.

6. Toby Keeler, quoted in *Lynch on Lynch,* edited by Chris Rodley. London: Faber and Faber Inc., 2005, p. 31.

SMILING BAGS OF DEATH

1. Bruce Samuelson, all quotes from a telephone conversation with the author, December 4, 2015.

2. Eo Omwake, all quotes from a telephone conversation with the author, November 24, 2015.

3. Virginia Maitland, all quotes from a telephone conversation with the author, November 19, 2015.

4. James Havard, all quotes from a telephone conversation with the author, November 19, 2015.

5. David Lynch letter, from the archives of the Pennsylvania Academy of the Fine Arts.

6. Rodger LaPelle, from a telephone conversation with the author, December 3, 2015.

SPIKE

1. Doreen Small, all quotes from a telephone conversation with the author, December 31, 2015.

2. Charlotte Stewart, all quotes from a telephone conversation with the author, October 17, 2015.

3. Catherine Coulson, all quotes from a telephone conversation with the author, July 6, 2015.

4. Fred Elmes, all quotes from a telephone conversation with the author, August 10, 2015.

5. Jack Nance, from *Eraserhead: The David Lynch Files.* An invaluable resource on the making of *Eraserhead,* Godwin's book includes interviews with the cast and crew conducted during the seventies when memories were still fresh.

6. Sissy Spacek, all quotes from a telephone conversation with the author, April 27, 2017.

7. Martha Levacy, all quotes in this chapter from a telephone conversation with the author, December 18, 2015.

THE YOUNG AMERICAN

1. Stuart Cornfeld, all quotes from a conversation with the author in Los Angeles, September 5, 2015.
2. Jonathan Sanger, all quotes from conversations with the author in Beverly Hills, February 5 and March 3, 2016.
3. Chris De Vore, all quotes from a telephone conversation with the author, April 21, 2016.
4. Mel Brooks, all quotes from a telephone conversation with the author, September 29, 2015.
5. John Hurt, interviewed by Geoff Andrew II for *The Guardian,* April 26, 2000.
6. John Hurt interviewed for *David Lynch: The Lime Green Set,* November 25, 2008.
7. David Lynch, from *Lynch on Lynch,* p. 110.

MESMERIZED

1. Rick Nicita, from a conversation with the author in Century City, California, June 23, 2015.
2. Raffaella De Laurentiis, all quotes from a conversation with the author in Bel Air, California, September 21, 2017.
3. Kyle MacLachlan, all quotes in this chapter from a telephone conversation with the author, June 25, 2015.
4. Brad Dourif, all quotes from a telephone conversation with the author, July 1, 2015.
5. Sting, all quotes from a conversation with the author in New York City, May 17, 2016.
6. Eve Brandstein, all quotes from a conversation with the author in Beverly Hills, February 18, 2017.

A SUBURBAN ROMANCE, ONLY DIFFERENT

1. Fred Caruso, all quotes from a conversation with the author in Los Angeles, June 30, 2015.
2. Isabella Rossellini, all quotes from a telephone conversation with the author, July 24, 2015.
3. John Wentworth, all quotes from a telephone conversation with the author, July 10, 2015.
4. Johanna Ray, all quotes from a conversation with the author in Los Angeles, March 31, 2017.
5. Laura Dern, all quotes in this chapter from a telephone conversation with the author, August 4, 2015.
6. Dennis Hopper, from a conversation with the author on the set of *Blue Velvet,* Wilmington, North Carolina, October 1985.
7. Duwayne Dunham, all quotes from a conversation with the author in Santa Monica, California, July 30, 2015.

8. Angelo Badalamenti, all quotes from a telephone conversation with the author, May 25, 2016.
9. Julee Cruise, all quotes from a telephone conversation with the author, June 28, 2015.
10. Pauline Kael, "Blue Velvet: Out There and In Here," *The New Yorker,* September 22, 1986.

WRAPPED IN PLASTIC

1. Mark Frost, all quotes from a telephone conversation with the author, July 12, 2016.
2. James Corcoran, all quotes from a conversation with the author in Los Angeles, February 3, 2016.
3. Monty Montgomery, all quotes from telephone conversations with the author, June 16, June 18, and July 16, 2016.
4. Joni Sighvatsson, all quotes from a conversation with the author in Los Angeles, December 2, 2016.
5. Harry Dean Stanton, all quotes from a telephone conversation with the author, May 11, 2016.
6. Frederic Golchan, all quotes from a telephone conversation with the author, July 11, 2016.
7. Cori Glazer, all quotes from a telephone conversation with the author, March 8, 2017.
8. Tony Krantz, all quotes from a conversation with the author in Los Angeles, August 2, 2016.
9. Ray Wise, all quotes from a conversation with the author in Los Angeles, October 20, 2016.
10. Grace Zabriskie, all quotes from a telephone conversation with the author, January 4, 2018.
11. Sheryl Lee, all quotes from a telephone conversation with the author, August 25, 2016.
12. Wendy Robie, all quotes from a telephone conversation with the author, August 26, 2016.
13. Mädchen Amick, all quotes from a conversation with the author in Los Angeles, August 24, 2016.
14. Russ Tamblyn, all quotes from a conversation with the author in Venice, California, September 14, 2016.
15. Richard Beymer, all quotes from telephone conversations with the author, September 2 and September 23, 2016.
16. Michael Ontkean, all quotes from an email exchange with the author, October 26, 2016.
17. Kimmy Robertson, all quotes from a conversation with the author in Pasadena, California, September 23, 2016.

18. Deepak Nayar, all quotes from a telephone conversation with the author, August 24, 2016.
19. Brian Loucks, all quotes from a conversation with the author in Los Angeles, February 17, 2017.

FINDING LOVE IN HELL

1. Laura Dern, all quotes in this chapter from a telephone conversation with the author, November 30, 2017.
2. Willem Dafoe, all quotes from a conversation with the author in New York City, May 16, 2016.
3. Crispin Glover, all quotes from an email exchange with the author, August 11, 2016.
4. Barry Gifford, all quotes from a telephone conversation with the author, August 18, 2016.

PEOPLE GO UP AND THEN THEY GO DOWN

1. Pierre Edelman, all quotes from a telephone conversation with the author, October 17, 2016.
2. Mary Sweeney, all quotes from a conversation with the author in Los Angeles, September 24, 2016.
3. Alfredo Ponce, all quotes from a conversation with the author in Los Angeles, November 17, 2017.
4. Sabrina Sutherland, from a telephone conversation with the author, July 13, 2016.
5. Neal Edelstein, all quotes from a telephone conversation with the author, December 5, 2016.

NEXT DOOR TO DARK

1. Gary D'Amico, all quotes from a telephone conversation with the author, February 9, 2017.
2. Bill Pullman, all quotes from a telephone conversation with the author, March 15, 2017.
3. Balthazar Getty, all quotes from a telephone conversation with the author, March 2, 2017.
4. Jeremy Alter, all quotes from a conversation with the author in Los Angeles, March 15, 2017.
5. Peter Deming, all quotes from a telephone conversation with the author, March 10, 2017.
6. David Foster Wallace, "David Lynch Keeps His Head," *Premiere,* September, 1996.

7. Chrysta Bell, all quotes from a conversation with the author in Los Angeles, February 25, 2017.

A SHOT OF WHITE LIGHTNING AND A CHICK

1. Laura Elena Harring, all quotes from a conversation with the author in Beverly Hills, February 22, 2017.
2. Naomi Watts, all quotes from a telephone conversation with the author, May 9, 2017.
3. Justin Theroux, all quotes from a telephone conversation with the author, December 31, 2017.
4. Marek Żydowicz, all quotes from an email exchange with the author, May 15, 2017.
5. Marek Zebrowski, all quotes from a conversation with the author in Los Angeles, May 29, 2017.
6. Jay Aaseng, all quotes from a conversation with the author in Los Angeles, March 2, 2017.

A SLICE OF SOMETHING

1. Richard Farnsworth, from the production notes for *The Straight Story,* 1999.

THE HAPPIEST OF HAPPY ENDINGS

1. Erik Crary, all quotes from a telephone conversation with the author, March 15, 2017.
2. Emily Stofle Lynch, all quotes from conversations with the author in Los Angeles, May 17 and May 27, 2017.
3. Laura Dern, all quotes in this chapter from a telephone conversation with the author, November 30, 2017.
4. Dean Hurley, all quotes from a telephone conversation with the author, April 21, 2017.
5. Anna Skarbek, all quotes from a telephone conversation with the author, April 9, 2017.
6. Bob Roth, all quotes from a telephone conversation with the author, April 19, 2017.
7. Noriko Miyakawa, all quotes from a conversation with the author in Los Angeles, April 28, 2017.

IN THE STUDIO

1. Patrice Forest, all quotes from a conversation with the author in Los Angeles, April 30, 2017.
2. Michael Barile, all quotes from a conversation with the author in Los Angeles, May 24, 2017.

3. Mindy Ramaker, all quotes from a conversation with the author in Los Angeles, April 21, 2017.
4. José Da Silva, all quotes from a telephone conversation with the author, May 16, 2017.

MY LOG IS TURNING GOLD

1. David Nevins, all quotes from a telephone conversation with the author, September 19, 2017.
2. Sabrina Sutherland, all quotes in this chapter from a conversation with the author in Los Angeles, September 4, 2017.
3. Dana Ashbrook, all quotes from a telephone conversation with the author, September 13, 2017.
4. Kyle MacLachlan, all quotes in this chapter from a telephone conversation with the author, September 20, 2017.
5. Michael Horse, all quotes from a telephone conversation with the author, September 11, 2017.
6. James Marshall, from a telephone conversation with the author, September 16, 2017.
7. Al Strobel, all quotes from a telephone conversation with the author, September 5, 2017.
8. Carel Struycken, all quotes from a conversation with the author in Los Angeles, September 12, 2017.
9. Peggy Lipton, all quotes from a telephone conversation with the author, September 14, 2017.
10. Everett McGill, all quotes from a telephone conversation with the author, September 8, 2017.
11. James Marshall, from a telephone conversation with the author, September 6, 2017.
12. Jake Wardle, all quotes from a telephone conversation with the author, September 11, 2017.
13. Don Murray, all quotes from a conversation with the author in Los Angeles, September 15, 2017.
14. Eric Edelstein, all quotes from a telephone conversation with the author, September 28, 2017.
15. George Griffith, all quotes from a telephone conversation with the author, September 28, 2017.
16. Michael Cera, all quotes from a telephone conversation with the author, September 12, 2017.
17. Matthew Lillard, all quotes from a telephone conversation with the author, September 6, 2017.
18. Robert Forster, all quotes from a conversation with the author in Los Angeles, September 11, 2017.

PHOTO CAPTIONS AND CREDITS

All photographs are from the collection of David Lynch unless otherwise noted.

Half-title: Lynch on location in downtown Los Angeles during the making of *Eraserhead,* 1972. Photograph by Catherine Coulson.

Title page: Lynch at Pierre Koenig's historic Case Study House #22 in the Hollywood Hills, shooting a commercial for L'Oréal, 2004. Photograph by Scott Ressler.

Contents: Lynch and Patricia Arquette during the 1995 shooting of *Lost Highway* at Lynch's home in Hollywood. Courtesy mk2 Films. Photograph by Suzanne Tenner.

1: Lynch and his second-grade teacher, Mrs. Crabtree, in Durham, North Carolina, c. 1954. "That was the only time I got straight A's." Photograph by Sunny Lynch.

2–3: Lynch with his younger brother, John Lynch, in Spokane, Washington, c. 1953. "We drove this car across the country when we moved to Durham. My father had a cast on his arm on that trip because he'd been fixing a rusted wagon for my sister and he cut right through the tendon in his hand." Photograph by Donald Lynch.

4: Edwina and Donald Lynch, c. 1944. "My dad was chief of the engine room on a destroyer in the Pacific. He and a bunch of guys were charged with making smoke screens and my dad mixed up some kind of concoction and they said, hands down, he made the best smoke." Photograph by Arthur Sundholm.

13: John and David Lynch in Sandpoint, Idaho, c. 1948. Photograph by Sunny Lynch.

14–15: Left to right: David, John, and Martha Lynch on the steps of the Lynch home in Spokane, Washington, c. 1950. Photograph by Sunny Lynch.

16: Lynch playing trumpet with friends on the street where the Lynches lived in Boise, Idaho. "That's right in front of my house, probably sometime around 1956. One day

we just were playing music. I don't know who the kids carrying the music are, but that's me on trumpet, and Mike Johnson and Riley Cutler both on trombone. That kid walking in front of us is Randy Smith. We called him Pud." Photograph by Mark Smith.

33: Lynch, c. 1967. "This picture was taken in Philadelphia in the Father, Son, Holy Ghost house." Photograph by C. K. Williams.

34: Lynch with one of his paintings at his parents' home in Alexandria, Virginia, in 1963. "That's an oil on canvas wharf scene, and I think I gave this painting to Judy Westerman. I think her daughter has this painting." Photograph by Donald Lynch.

45: An untitled oil on canvas painting (c. 1964) that Lynch produced while attending the Boston Museum School. Photograph by David Lynch.

46–47: The mural Lynch painted on the ceiling of his bedroom in Alexandria, c. 1963. Photograph by Sunny Lynch.

48: The living room of the apartment where Lynch lived while he was a student in Boston, 1964. Photograph by David Lynch.

61: Lynch working on the set of *The Grandmother* at his home in Philadelphia, 1968. Photograph by Peggy Reavey.

62: Peggy Reavey and Lynch outside Reavey's parents' home in Philadelphia, c. 1968. Photograph by Bernard V. Lentz.

74–75: Reavey and Lynch in the coffee shop next door to the Pennsylvania Academy of the Fine Arts in Philadelphia, c. 1967.

76: Lynch and his best man, Jack Fisk, at the party following Lynch's 1968 marriage to Reavey; the reception was held at Reavey's parents' home. Photograph by Peggy Reavey.

91: Lynch and cinematographer Fred Elmes on one of the *Eraserhead* sets at the American Film Institute in Los Angeles, c. 1973. Photograph by Catherine Coulson.

92: Top: Lynch and sound designer Alan Splet jamming in the food room that was part of Lynch's makeshift *Eraserhead* studio in Los Angeles, c. 1972; bottom: Lynch, Reavey, and Jennifer Lynch outside Catherine Coulson and Jack Nance's home in the Beachwood Canyon section of Los Angeles on Christmas Day, c. 1972. Photographs by Catherine Coulson.

114–15: Lynch on the set for the lobby of Henry Spencer's apartment in *Eraserhead,* c. 1972. Photograph by Catherine Coulson.

116–17: Charlotte Stewart and Lynch on the set for the front porch of the X family's house in *Eraserhead,* 1972. Photograph by Catherine Coulson.

118: Mary Fisk in the home she shared with Lynch on Rosewood Avenue in Los Angeles, 1977. Photograph by David Lynch.

137: Anthony Hopkins and Lynch during the making of *The Elephant Man* in London, 1979. Courtesy of Brooksfilms. Photograph by Frank Connor.

138: Lynch on *The Elephant Man* set in London, 1979. Courtesy of Brooksfilms. Photograph by Frank Connor.

157: Mary Fisk in the Louvre, Paris, 1979. Photograph by David Lynch.

158–59: During the making of *The Elephant Man* at Lee International Studios in London, 1979. Back row, left to right: Stuart Craig, Terry Clegg, Bob Cartwright, Eric Bergren, and Jonathan Sanger; front row, left to right, Lynch, Mel Brooks, and Chris De Vore. Courtesy of Brooksfilms. Photograph by Frank Connor.

160: Mary Fisk and Sparky in London, 1979. "The vet said Sparky was a complicated dog and she could've been a hermaphrodite." Photographs by David Lynch.

171: Austin and David Lynch at Churubusco Studios in Mexico City during the making of *Dune,* 1983. Photograph by Mary Fisk.

172: Cinematographer Freddie Francis and Lynch during the making of *Dune,* 1983. Courtesy of Universal Studios Licensing LLC. Photograph by George Whitear.

187: Lynch and actress Alicia Witt on the *Dune* set, 1983. Courtesy of Universal Studios Licensing LLC. Photograph by George Whitear.

188–89: Kyle MacLachlan, Raffaella De Laurentiis, and Lynch at Churubusco Studios, c. 1983. Photograph by Mary Fisk.

190: Lynch on one of the *Dune* location shoots, 1983. "We were holed up in El Paso and each morning we'd drive across the border past the sleepy little town of Juárez and go off into the dunes. We were there for quite a long time. Juárez was such a peaceful little town then." Courtesy of Universal Studios Licensing LLC. Photograph by George Whitear.

201: Isabella Rossellini during the making of *Blue Velvet* in Wilmington, North Carolina, 1985. Photograph by David Lynch.

202: Lynch and Dennis Hopper during the making of *Blue Velvet,* 1985. Courtesy of MGM. Photographs by Melissa Moseley.

223: Dean Stockwell on the *Blue Velvet* set, 1985. Photograph by David Lynch.

224–25: Lynch and actor Fred Pickler on the *Blue Velvet* set, 1985. Courtesy of MGM. Photograph by Melissa Moseley.

226: Kyle MacLachlan and Lynch during the making of *Blue Velvet,* 1985. Courtesy of MGM. Photograph by Melissa Moseley.

239: Lynch, Heather Graham, and Kyle MacLachlan on set in Los Angeles, shooting the final episode of the second season of *Twin Peaks,* 1990. Photograph by Richard Beymer.

240: Lynch and set dresser Mike Malone during the shooting of *Fire Walk with Me,* 1991. Courtesy of mk2 and Twin Peaks Productions, Inc. Photograph by Lorey Sebastian.

262–63: Left to right: Michael J. Anderson, Catherine Coulson, Harry Goaz, Kyle MacLachlan, and Piper Laurie on the *Twin Peaks* set, 1989. Photograph by Richard Beymer.

264: Lynch and sidekick during the making of *Twin Peaks,* c. 1989. "This is something we made up for *Twin Peaks.* It's Tim & Tom's Taxi-Dermy, which is a taxi company that also stuffs animals. We shot this outside my house in Los Angeles, and that's me in the front seat. I'm not sure if it ever made it into the show." Courtesy of CBS and Twin Peaks Productions, Inc. Photograph by Kimberly Wright.

280–81: Set dresser Daniel Kuttner and Lynch on location in Texas during the shooting of *Wild at Heart,* 1989. Courtesy MGM. Photograph by Kimberly Wright.

282: Lynch and Sherilyn Fenn on location in Lancaster, California, during the making of *Wild at Heart,* 1989. Courtesy MGM. Photograph by Kimberly Wright.

294–95: Lynch, Fred Elmes, Nicolas Cage, Mary Sweeney, and Laura Dern on location in downtown Los Angeles shooting the final scene of *Wild at Heart,* 1989. Courtesy MGM. Photograph by Kimberly Wright.

296: Grace Zabriskie and Lynch on location in New Orleans during the making of *Wild at Heart,* 1989. Courtesy MGM. Photograph by Kimberly Wright.

303: Lynch and Sheryl Lee shooting the train car scene for *Twin Peaks: Fire Walk with Me,* 1991. Courtesy mk2 Films and Twin Peaks Productions, Inc. Photograph by Lorey Sebastian.

304: Kiefer Sutherland, Lynch, and Chris Isaak shooting at an airport in Washington during the making of *Fire Walk with Me,* 1991. Courtesy mk2 Films and Twin Peaks Productions, Inc. Photograph by Lorey Sebastian.

317: Sheryl Lee, Grace Zabriskie, and Lynch on the set of *Fire Walk with Me,* 1991. "That's the Palmer house in Everett, Washington." Courtesy mk2 Films and Twin Peaks Productions, Inc. Photograph by Lorey Sebastian.

318–19: Sheryl Lee and Lynch in the Red Room during the making of *Fire Walk with Me,* 1991. Courtesy mk2 Films and Twin Peaks Productions, Inc. Photograph by Lorey Sebastian.

320: Sheryl Lee, Lynch, and Moira Kelly on location in Washington for *Fire Walk with Me,* 1991. Courtesy mk2 Films and Twin Peaks Productions, Inc. Photograph by Lorey Sebastian.

331: Patricia Arquette, Lynch, and Bill Pullman in the Madison house in Los Angeles during the making of *Lost Highway,* 1996. Courtesy mk2 Films. Photograph by Suzanne Tenner.

332: Bill Pullman and Lynch on the *Lost Highway* set, c. 1995. Courtesy mk2 Films. Photograph by Suzanne Tenner.

345: Lynch and Jack Nance at a location on La Brea Boulevard in Los Angeles during the making of *Lost Highway,* c. 1995. Courtesy mk2 Films. Photograph by Suzanne Tenner.

346–47: Patricia Arquette, Balthazar Getty, and Lynch during the making of *Lost Highway,* c. 1995. Courtesy mk2 Films. Photograph by Suzanne Tenner.

348: Richard Pryor and Lynch on location for *Lost Highway,* c. 1995. Courtesy mk2 Films. Photograph by Suzanne Tenner.

361: Geno Silva, Lynch, and Rebekah Del Rio onstage at Silencio during the making of *Mulholland Drive,* c. 1999. Photograph by Scott Ressler.

362: Laura Elena Harring, Naomi Watts, and Lynch on set during the making of *Mulholland Drive,* c. 1999. Photograph by Scott Ressler.

380–81: Naomi Watts, Lynch, and Laura Elena Harring on set for *Mulholland Drive,* c. 1999. Photograph by Scott Ressler.

382: Lynch and Justin Theroux on the *Mulholland Drive* set, c. 1999. Photograph by Scott Ressler.

392–93: Jack Fisk, Lynch, and crew members during the shooting of *The Straight Story* in Iowa, c. 1998. Photograph by Scott Ressler.

394: Jack Fisk, Lynch, Sean E. Markland, unidentified, and John Churchill during *The Straight Story* shoot, c. 1998. Photograph by Scott Ressler.

400–401: Lynch and cast members (left to right: Joseph A. Carpenter, Jack Walsh, Ed Grennan, and Donald Wiegert) from *The Straight Story,* c. 1998. Photograph by Scott Ressler.

402: Richard Farnsworth and Lynch on set in Laurens for *The Straight Story,* c. 1998. Photograph by Scott Ressler.

409: Lynch and Emily Stofle Lynch in Paris. Photograph by Jennifer "Greenie" Green.

410: Lynch with his son Riley on the set of *Twin Peaks: The Return,* 2015. Courtesy Rancho Rosa Partnership, Inc. Photograph by Suzanne Tenner.

427: Lynch and Laura Dern shooting in the San Fernando Valley during the making of *INLAND EMPIRE,* c. 2004. Courtesy Absurda and StudioCanal. Photograph by Deverill Weekes.

428–29: Lynch and cow on Hollywood Boulevard in November 2006, promoting Laura Dern's performance in *INLAND EMPIRE*. Photograph by Jeremy Alter.

430: Lynch and Harry Dean Stanton on set at Paramount Studios during the making of *INLAND EMPIRE,* c. 2004. Courtesy Absurda and StudioCanal. Photograph by Michael Roberts.

440–41: Lynch and his daughter Lula, drawing at Les Deux Magots in Paris, 2016. Photograph by Emily Lynch.

442: Lula and David Lynch, c. 2016. Photograph by Emily Lynch.

458–59: Lynch in Gary D'Amico's yard in La Tuna Canyon, California, during the making of the music video for *Crazy Clown Time,* 2011. Photograph by Dean Hurley.

460: Lynch with Lula, Emily, Jennifer, Austin, and Riley Lynch at Lynch's Hollywood home, 2013. "What I love about this photo is that little doll Lula is holding. It goes from real little to bigger, clockwise." Photograph by Erin Scabuzzo.

472–73: Lynch and Harry Dean Stanton on the set of *Twin Peaks: The Return,* 2015. Courtesy Rancho Rosa Partnership, Inc. Photograph by Suzanne Tenner.

474: Lynch outside a hospital in Van Nuys, California, during the making of *Twin Peaks: The Return,* 2016. Photograph by Michael Barile.

495: Kyle MacLachlan and Lynch in Los Angeles on the Red Room set for *Twin Peaks: The Return,* 2015. Courtesy Rancho Rosa Partnership, Inc. Photograph by Suzanne Tenner.

496–97: Anthony Maracci and Lynch on location in Southern California during the making of *Twin Peaks: The Return,* 2016. "That was the last thing we shot." Photograph by Michael Barile.

498: Lynch in his recording studio, c. 2015. Photograph by Dean Hurley.

507: David and Jennifer Lynch in a Bob's Big Boy, Los Angeles, c. 1973. Photographs by Catherine Coulson.

508–9: Lynch shooting a commercial for Sci-Fi Channel in Los Angeles, 1997. Photograph by Scott Ressler.

510: Lynch and his grandfather Austin Lynch, in Sandpoint, Idaho. Photograph by Sunny Lynch.

536: Lynch and Cori Glazer at Silencio during the making of *Mulholland Drive,* c. 1999. Photograph by Scott Ressler.

546–47: Lynch and Laura Dern on set in the San Fernando Valley during the making of *INLAND EMPIRE,* c. 2004. Photograph by Scott Ressler.

548: *Uncle Pete Releasing His Children,* 1986. Photograph by David Lynch.

578: Top: Lynch wearing his grandfather's jacket, in the photo he submitted with his application to the Pennsylvania Academy of the Fine Arts, 1965. Bottom: Kristine McKenna, c. 2012. Photograph by Ann Summa.

580: A note Lynch sent to his parents in 1977. Photograph by David Lynch.

INDEX

ABOUT THE AUTHORS

DAVID LYNCH advanced to the front ranks of international cinema in 1977 with the release of his first film, the startlingly original *Eraserhead*. Since then, Lynch has been nominated for three Best Director Academy Awards for *The Elephant Man*, *Blue Velvet*, and *Mulholland Drive*, was awarded the Palme d'Or for *Wild at Heart*, swept the country with *Twin Peaks* mania in 1990 when his groundbreaking television series premiered on ABC, and has established himself as an artist of tremendous range and wit. He is the author of a previous book, *Catching the Big Fish*, on Transcendental Meditation.

KRISTINE MCKENNA is a widely published critic and journalist who wrote for the *Los Angeles Times* from 1977 through 1998, and has been a close friend and interviewer of David Lynch since 1979. Her profiles and criticism have appeared in *Artforum, The New York Times, ARTnews, Vanity Fair, The Washington Post,* and *Rolling Stone*. Previous books include two collections of interviews and *The Ferus Gallery: A Place to Begin*.

Dear Mom and Dad
please don't see the film
Eraserhead and Don't
tell anyone I did.